PICASSO

Arianna Stassinopoulos Huffington was born in Greece, moved to England when she was sixteen, studied Economics at Cambridge and, in 1971, became President of the Cambridge Union. Her first book, *The Female Woman*, was published in 1974 and translated into eleven languages; her second book, *After Reason*, on politics and culture, was published in 1978. Her biography *Maria: Beyond the Callas Legend*, published in 1980, quickly became an international bestseller and is now being made into a film. She is also the author of *The Gods of Greece*, a celebration of the Greek gods as 'guides to forgotten dimensions of life and of ourselves', and she lectures frequently on both sides of the Atlantic. She is married to Michael Huffington and lives in the United States.

Arianna Stassinopoulos Huffington

PICASSO

Creator and Destroyer

Pan Books
London, Sydney and Auckland

First published in Great Britain 1988 by
George Weidenfeld & Nicolson Ltd
This edition published 1989 by Pan Books Ltd,
Cavaye Place, London SW10 9PG
9 8 7 6 5 4 3 2
© Arianna Stassinopoulos Huffington 1988
All rights reserved
ISBN 0 330 30745 2

Printed and bound in Great Britain by
Richard Clay Ltd., Bungay, Suffolk

We have made every effort to appropriately acknowledge all source material and to secure permission
from copyright holders when required. In the event of any question arising as to the source of any
material, we will be pleased to make the necessary acknowledgement in future printings. Thanks are
due to Françoise Gilot and Carlton Lake and to McGraw Hill for their permission to use excerpts
from *Life With Picasso*, © 1964 Françoise Gilot and Carlton Lake, Letter from Picasso to Gertrude
Stein, April 1917, published with permission of the Yale Collection of American Literature, Beinecke
Rare Book and Manuscript Library, Yale University. Poem by Picasso dated 5 May 1953 published
with permission of the archives of the Harry Ransom Humanities Centre, University of Texas at
Austin.

For my husband, Michael

CONTENTS

PREFACE

SURPRISE WAS A KEY CHARACTERISTIC of Picasso's art, and it was the most persistent emotion evoked in me during the years this book has been in the making. I was brought up, like so many of my generation, to see Picasso as the most extraordinary, the most compelling, the most original, the most protean, the most influential, the most seductive and certainly the most idolized artist of the twentieth century. After a day at the massive Picasso retrospective at the Grand Palais in 1980, I walked the streets of Paris as if a physical act were needed to absorb the boundless energy that had engulfed me from the nearly one thousand Picassos that made up the exhibition—the paintings and the drawings, the sculptures, the prints and the ceramics. The legend of Picasso, the sorcerer and magician, was confirmed; but buried in admiration, fascination and sheer physical exhaustion, there was an uneasy feeling.

Two years after the retrospective I began work on this book. Five years and countless surprises later, the Picasso of legend seemed like the fantasy hero of a collective act of make-believe compared with the Picasso I came to know and have tried to re-create in the pages that follow. I felt like Henry James brought face to face with "a jewel brilliant and hard. . . . It twinkled and trembled and melted together; and what seemed all surface one moment seemed all depth the next." The man who appeared to be a towering creative genius one moment turned into a sadistic

manipulator the next. What seemed a life guided by burning passions—for painting, for women, for ideas—seemed a moment later the story of a man unable to love, intent on seduction not in the search for love, not even in the desire to possess, but in a compulsion to destroy. "I guess," he said once, "I'll die without ever having loved."

It was, in fact, this struggle between the instinct to create and the instinct to destroy that was at the heart of his life; and it is this struggle which is at the heart of this book. The evidence of Picasso the creator is vast and glorious, his prolific creativity almost mythical. He stamped his images and his vision not just on the world of art but on the whole of the twentieth century. The evidence of Picasso the destroyer is tragic. The suicides of his second wife, of his grandson and of Marie-Thérèse Walter, his mistress of many years; the psychic disintegration of his first wife; the nervous breakdowns of Dora Maar, the brilliant artist who was his mistress during the time of *Guernica*—all are part of a formidable list of casualties among those who came too close to the destructive fallout of his personality. There was a great deal more evidence of Picasso the destroyer which I came upon unexpectedly, and at first reluctantly, in the course of the hundreds of interviews that I or one of my research assistants conducted in Paris, Barcelona, the South of France or wherever we could find those who knew Picasso during his life and who, either inadvertently or because they had not been blinded by the legend, revealed facts that fleshed out the dark side of his genius.

Facts have their own undeniable authority. But they do not in themselves make a life or a biography. They are woven together by the cluster of convictions, emotions and ideas that, knowingly or unknowingly, for good or ill, form the biographer's vision of life and the world; I tried throughout to be conscious of mine. In telling Picasso's story I have been guided by a statement of his that I found tucked away in a French book; I translated it and kept it framed on my desk until its message began to feel like Picasso's personal instructions to me: "What is necessary is to speak about a man as though painting him. The more you put yourself in it, the more you remain yourself, the closer you get to truth. To try to remain anonymous, out of hatred or respect, is to do the very worst—to try to disappear. You've got to be

there, to have courage; only then can it become interesting and bring forth something."

I put myself in it until I found that he stirred in me all the emotions present in an intimate relationship. I was seduced by his magnetism, his intensity, that mysterious quality of inexhaustibility bursting forth from the transfixing stare of his black-marble eyes as much as from his work. I was both fascinated and appalled by his unparalleled power to invent reality in his life no less than in his art and to persuade his women to inhabit the reality he had created, however big the gulf between it and the truth. "I love you more each day, you are everything to me, I will sacrifice everything that I have for you for our love for always," he wrote to Marie-Thérèse at the same time that he had chosen to set up house with Françoise Gilot. In search of an explanation for his compelling attraction, I went back to the original Spanish tales of Don Juan and the Indian myths of Krishna, the lover-god for whose love, however brief and shared by many, women would abandon everything; and I understood that Picasso was for the women and for many of the men in his life both the irresistibly sensual and seductive Don Juan and the divine Krishna who promised access to a heightened reality. As a result, many became addicted to him and were prepared to pay—even with life and sanity—the high price of their addiction.

I was struck by his instinctive brilliance in using publicity to build his celebrity and then his legend. "A picture lives only through the one who looks at it," he said. "And what they see is the legend surrounding the picture." I loved—admittedly with a certain wryness—his contradictions: the man of the world full of peasant superstitions; the man of the people who spent millions to keep himself in bohemian splendor; the monumental egoist who became a proud member of the Communist Party.

But there was more to him, and darker. I was chilled by the way that he fought throughout his life the deepest existential battles of our century until he was ultimately destroyed by them. This realization was for me the turning point of the book. I suddenly saw that Picasso's life was not just the life of one of the most gifted artists who ever lived; it was not just the life of an extraordinary and extraordinarily complex man who would have been fascinating even if he had never held a paintbrush; it was,

in a very real sense, the twentieth century's own autobiography. And it was by mirroring, reflecting and epitomizing our century and all its torments both in his life and in his art that he became a culture hero and the legendary personification of our tumultuous times.

A champion and troubadour of our century's longing to explore the limits of human sexuality, he exuded raw sexual power, free of all restraint, at the same time that he vilified women as devouring monsters. Another profound way in which he mirrored our century was in his deep ambivalence toward God and the divine. He would push religion out the door and watch it come back through the window. He trumpeted his atheism at the same time that he identified with the crucified Christ and returned to this theme in his work during all the great ordeals of his life. He was the chief witness to the darkness and inhumanity of the century, a century dominated by political ideologies in the name of which unspeakable atrocities were committed. In his life he endorsed one of these ideologies by joining the Communist Party with great fanfare in 1944. In his work he threw the glaring light of his genius on the depths of evil in man and in our times. Like Freud, that other great reporter of our discontents, he saw deeply and accurately the tormented sexuality, violence and pain sheltering beneath the leaky roof of civilization. That was his triumph.

His tragedy was that while consecrating destruction in his art, he practiced it relentlessly in his life. Terrified of death and convinced that the universe was evil, he wielded his art as a weapon and meted out his rage and his vengeance on people and canvases alike. "A good painting," he explained, "ought to bristle with razor blades." And a good relationship too.

The only woman who survived the razor blades and then went on to flourish, both as a human being and as an artist, was Françoise Gilot. As soon as I began work on the book, I asked to interview her. She told me that she did not want to reopen the Picasso chapter of her life and declined. Two years later, she and her husband, Dr. Jonas Salk, came to spend a weekend with me at my home in Los Angeles. It was a weekend that was the beginning of an amazing journey of discovery. She had suddenly decided, as a result of her "inner guidance," she explained, to talk

to me and reveal the many facts and insights that she had left out of her own book on Picasso, published while he was still alive and while, she felt, her children were still too young to be exposed to the full truth. Over the next year I spent many days and nights talking with her in Los Angeles, in La Jolla, in New York and in Paris. She not only re-created for me in great intimacy her years with Picasso, but gave me access to letters, trial files and photographs which greatly enriched my understanding of those years. And she urged me not to write about the dead Picasso, symbol and legend, but to engage in a personal encounter with the man and the artist: "It should not be a biographer writing at arm's length about Picasso," she told me, "but you, Arianna, in a living, present relationship with him."

There were certain key encounters which strengthened that sense of being involved in a living relationship. Maya Picasso, Picasso's daughter by Marie-Thérèse Walter, was one of them. "These are my most important Picassos," she said in her apartment on the Quai Voltaire, pointing to her son and daughter, who had just walked into the living room. Picasso had refused ever to meet his grandchildren, and as I looked at them, I felt a pang at how much vibrant life he had separated himself from during his last years of isolation and despair.

In Mougins, not far from where Picasso died, lives Inès Sassier, who had been Picasso's maid, housekeeper and confidante for more than a quarter of a century. She had not answered any of my letters or phone calls, and it was only when I arrived at her doorstep that she finally agreed to talk to me about the man who had become her life and who for many years painted her portrait as a gift for her birthday. Listening to her relive her life with Picasso was deeply moving—for both of us. As she was walking me to my car late one evening after our last meeting, she took the knitted shawl she was wearing and draped it around my shoulders. "You need it to protect you from the cold night air at this time of year," she said. "I'm used to it." In that one gesture, I experienced all the nurturing qualities she had brought to Picasso and understood what he meant when he said once, "I owe her the whole of my life."

"You keep the shawl," Inès said, when we got to the car. I did not protest. "And you keep my earrings," I said, giving her the

earrings she had admired earlier. The exchange was symbolic of an infinitely more important one that had taken place over the past few days.

There were many others who fleetingly, or for years, had been close to Picasso and who provided much of the personal knowledge and intimate detail that I needed if I was to have any hope of turning the man who had become a symbol into a living reality: Maître Bacqué de Sariac, his lawyer during many pivotal events in his life, including the lawsuits he brought against Françoise Gilot's book *Life with Picasso* and her struggle to legitimize her children, Claude and Paloma; Geneviève Laporte, still convinced in her old age that she was Picasso's only true love; the Countess de Lazerme, who had provided refuge for him in her castle in Perpignan; Kostas Axelos, the Greek existentialist philosopher with whom Françoise Gilot was having a relationship at the time she left Picasso; Maurici Torra-Bailari, a friend of his youth and a frequent visitor in his old age; Hélène Parmelin, one of the few intimates of the last twenty years of his life; his barber, the only man Picasso trusted enough to let him cut his hair—a major honor, since he believed that in the wrong hands, his hair trimmings could be used to control him; his gardener, living in the South of France in a modest home filled with Picassos—all these and many others provided a foundation of fact and understanding on which I began to build the book.

The more I discovered about his life and the more I delved into his art, the more the two converged. "It's not what an artist does that counts, but what he is," Picasso said. But his art was so thoroughly autobiographical that what he did was what he was. His was a destiny that transcended his personal fortunes and misfortunes. Re-creating it has turned out to be not only a personal but a passionate encounter with a man whose life spanned ninety-one years of an extraordinary journey of creation and destruction.

1

"I, THE KING"

HE WAS BORN DEAD—or so they thought. There was no breathing and no movement from the baby boy born to Doña María Picasso de Ruiz at 11:15 on the night of October 25, 1881. After futile efforts to revive the child, the midwife finally abandoned the lifeless body on a table and turned her attentions to Doña María. Don José Ruiz, Doña María's husband, and the many family members who had gathered to witness the birth gave up the baby as stillborn. But not Don Salvador, José's younger brother and a doctor of considerable skill and authority. Leaning over the baby, he blew smoke from his cigar right into his nostrils. Where the midwife had failed, the cigar puff produced a reaction. The first male heir of the Ruiz family, the boy they would name Pablo, entered into the world "with a grimace and a bellow of fury."

On November 10, he was christened at the Church of Santiago: Pablo, after his dead uncle; Diego, after his paternal grandfather and eldest uncle; José, after his father; Francisco de Paula, after his maternal grandfather; Juan Nepomuceno, after his godfather, a lawyer friend of his father's; and Maria de los Remedios, after his godmother, who was breast-feeding him as well as her own first child, Doña Maria having been left both physically and emotionally exhausted by the traumatic delivery. The last names on the long list were Cipriano and Santísima Trinidad (the Most Holy Trinity), from an old custom according to which the most blessed name was left for the end, as if declaring "That's as far as

15

we can go." Pablo Diego José Francisco de Paula Juan Nepomu-
ceno Maria de los Remedios Cipriano Santísima Trinidad Ruiz y
Picasso. But most of these names were to be no more part of his
life than the registry at the Town Hall of Malaga where they
appeared. It was as Pablo Picasso that he would forever be
known.

The world had been all of a piece for Pablo Ruiz, the uncle for
whom the child was named. A man of God, a doctor of theology
and the canon of the cathedral of Malaga, he had also been a
man who understood other men, their frailties and their dreams.
When, in October 1878, he had suddenly died at the age of forty-
six, it was a dark moment for the Ruiz family—for his two un-
married sisters, Josefa and Matilda, whom he supported; for his
married sisters and brothers, for whose families he was a tangible
presence of God in their lives, and above all, for his younger
brother. José—or Pepe, as everybody called him—was the fam-
ily's dreamer. Six years younger than his brother, he was in every
way dependent on him. His great love was painting. He did not
love it as a pleasant way to pass an hour of leisure; he loved it
passionately, doggedly, tenaciously. And the canon had not only
provided the money with which José could pursue his studies and
subsidize the scant living he made from teaching and selling his
pictures, he had also provided the encouragement, the vision and
the faith that José needed to continue his work. For José was
riddled with doubts about his talent and about himself, doubts
nurtured by the conventional wisdom of Malaga which held that
"a painter and a good-for-nothing are one and the same thing."

Pablo Ruiz realized that for his brother painting was as much
of a calling as the Church was for him, and he had none of that
cold dogmatism of the Church he served which downgraded the
human in order to extol the divine. What is more, he had a
special tenderness for his redheaded brother. José was known in
Malaga as "the Englishman"; tall, thin, pale, with blue eyes and
a dark-blond beard, he was very distinguished-looking. He had a
quiet charm that women loved and an unexpectedly mischievous
side that found its outlet in playful pranks, some of which had
become legendary in the small town. People still talked about the
time he bought a fresh egg from an egg-seller and after consum-
ing it raw in front of her, took out of his mouth a five-peseta

piece. The egg-seller's awe grew as José ate one egg after another, each time taking out one more five-peseta piece. As he walked away he could hear the egg-seller breaking all her fresh eggs, frantically looking for the ones with pesetas in them. But even more than he liked to play pranks, he liked to sit at the Café Chinitas talking with the other local artists about painting. And more than anything he liked to be alone, working on his meticulous paintings—especially of lilies and pigeons. He liked his friends best, he said, when they were gone. He understood why one of his ancestors, who was still alive when he was born, would choose to live for sixty years as a hermit in the mountains near Cordova.

Pablo Ruiz had always responded to the loner in his brother with a desire to protect him from the hardships and pitfalls of life. But now Pablo was gone, and José was left without his protector and counselor—the one man in whose trust he could immerse himself to renew his own. It was a particularly vulnerable time in his life, for only six months earlier he had found the woman he wanted to make his wife. He had met Maria Picasso López at the house of her cousin Amelia, whom his family had been urging him to marry. He fell in love instead with Maria, and she was immediately drawn to the brooding "Englishman." Seventeen years younger than José, she looked as though she came from a different race: small, sturdy, dark-haired and dark-eyed, with a little mole over her upper lip. They differed no less from each other temperamentally. What she lacked in imagination, of which José had ample reserves, she made up in determination, for which he had always depended on Pablo. And while he approached the world with the detached openness of a man who was not entirely of it, she looked at everyone with a deep skepticism and mistrust. Life had wounded her at an early age. Her father, Don Francisco Picasso Guardenso, had taken off on a journey to the Antilles and had never returned. Her mother, Doña Inés López de Picasso, left alone with four girls, had brought them up as best she could while growing fatter with each year that passed. Maria's oldest sister had died, and the other two, who were unmarried, lived with her and her mother in a modest apartment close to the Plaza de la Merced.

Maria accepted José's proposal with alacrity, and Pablo made

plans to marry them at the parish church of the Merced. Instead, in October 1878, he was buried there. The marriage had to be postponed, both because of the deep mourning into which the family was plunged and because José, with Pablo gone, had to find some regular source of income before he could marry. In July 1879, he was appointed an assistant teacher of drawing at the San Telmo School of Arts and Crafts, but the pay there was meager. His younger brother, Salvador, who became the unofficial head of the family when Pablo died, used his connections to find José another job. Don Salvador, married with two daughters, Concepción and Maria, was health inspector for the district, the principal doctor of the first-class health office of the port of Malaga, a cofounder of the Malaga Vaccination Center and unpaid doctor to the Augustinian nuns of the Assumption and to the Capuchin nuns. Already overburdened, he nevertheless set great store by his family obligations. It took his considerable influence in the town to find his brother a second job as curator of the new Municipal Museum. José was appointed in June 1880. He was finally ready to get married, but not before the two years required for the mourning of a family member had passed, and not in the church of Merced, which was now associated with the painful memories of his brother Pablo's funeral.

On December 8, 1880, José Ruiz and Maria Picasso became husband and wife in the Church of Santiago. The groom was forty-two and the bride twenty-five. Within a month of their wedding, Doña Maria was pregnant. So the bachelor dreamer became a husband and, soon after, the father of a baby boy. Pablito's early universe consisted entirely of women. Together with the maid, there were five women to pamper him, meet his needs and obey his whims: his mother; his grandmother Doña Inés, who was enormously fat as well as enormously imposing, and his two unmarried aunts, Eladia and Heliodora. All had moved in with the newlyweds and now spent a large part of their ample free time indulging Pablito. The phylloxera that had struck Malaga had ravaged some of the vines the Picasso women owned. The only income they now had was what they could make through their embroidery and braiding. So Don José was all at once responsible for four women as well as his little son. There

was Salvador, on whom he could occasionally lean, but nobody on whom he could depend as he had on his elder brother.

And then suddenly the post of curator at the Municipal Museum was abolished. It was an appalling blow for Don José, who was already having trouble meeting his financial obligations. Now he could not avoid getting into debt, and his universe seemed more threatening than ever. He protested to the Town Council and even offered to stay on in his job without being paid, in the hope that should there be a reversal of policy, he would at least have no competition for the post. As well as restoring paintings for the museum, he could also do his own painting there, and that was invaluable now that privacy at home was a luxury of the past. A new Town Council did in fact reinstate his post, which increased his income but did not wipe out his debts. What made life less threatening was the move to a new apartment in the Plaza de la Merced, where the landlord agreed to accept paintings in place of the often overdue rent.

Pablito was from the beginning a special gift to Doña Maria, whose dreams of recognition had been throttled by the ordinariness of her life. Now she could at least boast of having an exceptionally handsome little boy, whose bright, alert eyes magnetized people: "He was an angel and a devil in beauty," she was to say later. "No one could cease looking at him!" Doña Maria, alternately sickly and willful, sluggish and dominating, had one constant in her life: her total absorption in her son.

In December 1884, when Pablito was three, she gave birth to a daughter, Lola. It was a shattering event for Pablo, made all the more traumatic by the earthquake that shook Malaga a few days earlier and with which Lola's birth would be forever associated in his mind. As soon as the first tremors began, Don José rushed home and took everybody to the house of Antonio Muñoz Degrain, a man he loved as a friend and regarded as his master in painting. The rooms were smaller there, he argued, and the house built on rock. An element in his decision, if not his reasoning, was the feeling of solidity and security that the mere thought of Antonio engendered in him—even though Antonio himself was in Rome at the time.

Pablo would remember clearly the moment they left their

home, fleeing the earthquake: "My mother was wearing a kerchief on her head. I had never seen her like that. My father grabbed his cape from the rack, threw it over himself, picked me up in his arms, and wound me in its folds, leaving only my head exposed." They spent anxious days at Don Antonio's house—anxious for the earth that had not yet settled and anxious for Doña Maria, who was so close to giving birth. Not even Christmas was cause for celebration. And three days later, on December 28, "in the midst of all the tribulations," as Pablo remembered it, Lola was born. For the little boy who had been accustomed to limitless attention, this was the worst tribulation of all.

Don Antonio's return to his house, where Don José and his family were still staying, coincided with the arrival in Malaga of King Alfonso XII, who had come to visit the city after the devastation of the earthquake. Malaga was festooned with banners and flags flying in honor of the King. Pablo watched, fascinated, as Don Antonio arrived home. "You can't imagine. It's beyond belief," he was to say fifty-seven years later, still awestruck by the simultaneous appearance of Don Antonio and of "a procession of carriages filled with gentlemen in top hats" that he was sure had accompanied Don Antonio home. He was equally convinced that all the flags and the banners were celebrating the great painter's return to Malaga, a conviction as real to him as the most concrete reality. At that disturbed moment in his young life, it seemed "beyond belief" to see so many honors bestowed on the painter his father already idolized. He would later describe Don Antonio as "crowned with laurels," and whether the details he remembered were actual or invented, a momentous association was made at that moment in the mind of the three-year-old between painting and glory.

Before he could even speak, he learned to make his wishes known by drawing. He would draw spirals which represented to him *churros*, "the long, twisting, sugar-dusted fritters one buys hot from stalls all over Spain." It must have seemed quite miraculous for a little boy to discover that he could get sugar-dusted fritters by drawing them.

At four he started magically giving birth to animals, flowers and strange creatures of his imagination by cutting them out of paper and projecting them against the wall like Chinese shadows.

He even cut out a look-alike of the young man his aunt Heliodora was secretly in love with and projected it on the wall, making everybody in the house, all of whom, of course, knew her "secret," burst into laughter—everybody, that is, except Heliodora, who blushed to her ears. At other times he would draw his creatures in pencil. The first word he had uttered was "piz," his baby word for *lápiz*, a pencil. "Piz, piz," he demanded, and his mother would give him a pencil.

Like all magicians, Pablo needed an audience, and his young cousins Concha and Maria were the first to succumb to the fascination of things emerging out of nothing. "Do us a portrait of that Newfoundland of Doña Tola Calderón," they would cry; or "a cut-out of the cock that Aunt Matilda sent from Alhaurinejo." "And now what?" he would ask. "Where do you want me to begin?" Maria loved him to do donkeys for her, sometimes beginning at the back, sometimes at the feet, sometimes at the ears. Wherever he began, whether with pencil or with scissors, it always ended in the magical appearance of the creature they had asked for.

School was, from the beginning, an ordeal for Pablo. A restless boy, he hated obeying the rules and most of the time did not. Whenever he felt like it, he would get up, go to the window and tap on it, hoping that his uncle Antonio, married to one of his father's sisters and living opposite the school, would see him. He often did, and then came round to save his little nephew from boredom and take him for a walk. But he came after *one* hour of noticing him, because that was what Pablo had asked him to do, thinking that one, being the smallest number, also meant the least time to wait. The impatient Pablo could not understand why *one* hour took so long; why, in fact, it seemed to take forever. He got what he asked for, but not what he really wanted.

His rebelliousness went hand in hand with a deep fear of being left alone. Ever since Lola had dethroned him from his place at the center of his mother's existence, he had clung fiercely to his father, whom he had begun to worship. He loved watching him paint, and later in life he often described to his friends the "enormous picture of a dovecote swarming with pigeons" that his father had painted. "Imagine," he would say, "a cage with hundreds of pigeons. With thousands and millions of pi-

geons . . ." When the picture was unearthed in the museum at Malaga, it was far from "enormous" and there were only nine pigeons. Pablo had idealized the picture in the same way that he then idealized Don José.

At times it seemed as though he could not breathe outside his father's presence. The only way he would let go of Don José's hand, once they had reached his school, was after he had extracted from his father some tangible guarantee that he would not forget to come back for him: his paintbrushes or his walking stick or a stuffed pigeon he used as a model, which Pablo would then put on his desk and draw, oblivious to any teaching and learning going on in the classroom. "If he left the stick or the pigeon with me, I was sure he would return," he recalled later. "But rather than the stick, I preferred the pigeon or the brushes because I knew he could not do without either of these."

In a futile attempt to foster some independence in him, his father asked Carmen Mendoza, the "moustached, mannish" family maid, to take him to school. But Pablo wept so hard and made such terrible scenes that in the end his parents had him moved to the Colegio de San Rafael, a private school, "well lighted and well ventilated, the best to be found in the city." It was run by a friend of the family, who was prepared to make allowances for Pablo, so they thought he might be happier there. In fact, he ended up spending most of his time following the headmaster's attractive wife around "like a puppy." "If you want your son," the headmaster told Don José, "to learn from my wife how to cook or how she bathes our baby, we can continue with the same conditions, but if you want something more, there will have to be some changes."

But changes were not easy. Pablo was terrified of being left alone at school, bored with the teaching and willful and seductive enough to know how to move his world in the direction he wanted. And when his powerful will failed to produce the desired effect on the adults, he turned it against himself and fell sick, sometimes sick enough for his mother to keep him at home for a day and sometimes really sick. An infection of the kidneys kept him away from school for a good long time and forced many additional privileges out of his parents when the brave little boy was well enough to go back to the classroom. One of these privi-

leges was sending the maid with him so that she could hold the pigeon Pablo wanted to draw; another was to try to have him, as much as their finances allowed, tutored at home.

At school, all his attention was absorbed by the clock, watching its hands move, as though he could will them to move faster to one o'clock, when his father would return to fetch him. "It's incredible," he recalled later. "I stared at the clock like an idiot, eyes raised, head sideways . . . Like an idiot." However hard he tried, he could not master the basics of reading, writing and arithmetic. "One and one, two . . . " he remembered. "Two and one . . . etc. It never sank in. Don't think I didn't try. I tried hard to concentrate. I used to say to myself, now I'm going to pay attention. Let's see. Two and one . . . One o'clock . . . Ah! That's not it. And I would start all over again from the beginning, but immediately I'd be lost, embroiled in the thought of the hour for going home, of whether they would or would not come to get me. Then I would get up and go to the toilet or some place, without bothering to ask permission." Or he would get lost in thoughts of drawing the teacher, the table, the clock—anything, as long as he did not have to learn words or retain numbers.

Dyslexia, which may have been the cause of Pablo's problems at school, was, of course, unknown at the time, and everyone around him was confounded and concerned. "What are we going to do about it?" they asked themselves. "He'll learn later on. The boy is not stupid. Someday everything will become clear to him all at once." But school continued to be a nightmare, and reading and writing unfathomable mysteries. To conceal his learning problems, he tended to shirk whatever he could not achieve with the effortless brilliance he displayed in his drawings. And so he missed as well the opportunity to build from the small successes of mastering those early problems a solid base of trust in himself

On October 30, 1887, when Pablo was six, Doña Maria gave birth to a second daughter. She was baptized Concepción, and Uncle Salvador was her godfather. Ever since he had breathed life into little Pablo, he had been like a good genie to Don José's family, coming to the house every time Pablo or Lola ran a fever or seemed sickly, helping through his contacts to find a better school or another commission for José, or another pupil for private drawing lessons. Don José found chasing after commissions

humiliating, and painting pictures he wanted to paint but hardly anyone wanted to buy disheartening. As for his private pupils, the only one he relished was his son. "It is rather curious," Pablo was to say later, "that I never did any childish drawings. Never. Not even when I was a very small boy." The first picture he ever painted was of the port of Malaga, with its lighthouse. But the first oil painting that had enough emotional significance for him to keep for his whole life was of a mounted picador in a bullring. It was painted around 1889, when Pablo was eight years old, by which time his father, who was a great *aficionado*, had initiated him into the rituals and the passions of the bullfight.

"When I was a little boy," Pablo would recount years later with fresh childish pride, "Carancha, who was a great bullfighter, came frequently to our house, because he was a good friend of my father's, and he quite often let me sit on his lap." Once he was so taken by a bullfighter's "suit of lights" that he would not stop crying until he had touched it. Don José, defeated in his attempts to quiet his son, had in the end to take Pablo to the boardinghouse where the bullfighter was staying. "Are you a father?" he asked him. "Yes, sir," the bullfighter replied, rather surprised. "Well, then I'm sure you'll understand. My son insists on touching your 'suit of lights.' " "Come on, then," the bullfighter said, and he stood still while Pablo, full of wonder, explored the magical suit.

Painting and drawing were already Pablo's way of displaying his magical powers and creating his own reality. In November 1890, he made a drawing of *Hercules with His Club*, signed it P. Ruiz Picasso and dated it. "I still remember one of my first drawings," he said later. "I was about six years old at the time, or less. In the passage at home there was a picture of Hercules with his club. Well, one day I sat down in the passage and drew this Hercules. But it was not a child's drawing; it was a true drawing, a real representation of that Hercules, club and all." He was three years older than he fantasized, but it was still a drawing of amazing authority for a boy of his age; there was a sense about it that it "could not be otherwise." Even the fig leaf that covered the hero's genitals seemed oddly appropriate.

Around the time that Pablo drew the defiant and all-powerful Hercules, the Municipal Museum of Malaga announced that it

would be closing down. By December 1890, his father was out of a job and so desperate that he was prepared to accept a position anywhere—even far away from his beloved Malaga. When he heard that there was a job for a drawing teacher in the new Da Guarda Institute that was soon to open its doors in Corunna, he decided to apply for it. In April 1891, his appointment was confirmed.

Corunna is on the Atlantic coast in the most northwesterly corner of Spain. As the family prepared for the long journey, one of Don José's chief concerns was to arrange for Pablo to take his examination for entry into secondary school. He knew that his son would never pass it without some string-pulling, and there would be no strings to pull once they had left Malaga. So he went to see the local examiner, who, like a good Andalusian friend, agreed to give Pablo the necessary certificate. He wanted, however, to "ask him a couple of questions so that no one will be able to talk." "Let us see," he asked Don José: "what does he know?" "Nothing" was the father's stark reply.

On the day of the bogus exam, Pablo was given a few numbers to add. When he got it all wrong, the examiner asked him to concentrate. "You can't imagine," Picasso recalled later, "what I suffered trying to pay attention. As soon as I got to thinking that I had to pay attention, I'd be distracted by the thought that it was necessary to pay attention, and this would confuse me." The only thing he could concentrate on during the exam was his father's promise that if he passed he could paint a picture in oils. Very soon, the examiner realized that he had to bend the rules even further if he was going to get the correct answer out of his friend's son: he had to let him glance at it.

The diploma he clutched in his hand as he walked home was tangible proof to Pablo of the importance of concentration. "Had he not concentrated," his friend Jaume Sabartés would write, "he would not have noticed the slip of paper on the teacher's desk, he would not have been able to memorize the total." So the lesson of the exam was that even cheating required concentration. Yet that lesson too was translated quickly into his own reality. "I'll show them what I can do!" he resolved on his way home, visualizing the pigeon he was going to paint using the numbers of his test. "They'll see how I can concentrate. I won't miss a

single detail. . . . The little eye of the pigeon is round like a o. Under the o a 6, underneath that a 3. The eyes are like 2's, and so are the wings. The little feet rest on the table, as if on a horizontal line. . . . Underneath it all, the total."

In October 1891, around the time of Pablo's tenth birthday, Don José and his family boarded the ship that would take them to Corunna. For the first time, the five of them were alone, cast adrift from all the people who had helped sustain and ease their lives—from Uncle Salvador and grandmother Inés and Aunt Heliodora and Aunt Matilda and Uncle Antonio and all the little cousins. The storm that broke out at sea during the voyage matched the disturbance that Don José and Doña Maria must have felt at the thought of all they had left behind.

Corunna proved no more hospitable than the sea that bore them there. Don José loathed everything about it—the wind, the rain, the fog, the gray skies; the Galician language, so different from the Andalusian; the Galician people, subtle like their language and much less straightforward than the Malagueños. Corunna was exile for Don José. A vital part of him had been amputated, and with every year that passed he effaced himself more and more; his first care now was how best to protect and serve his son. The change must have been disturbing for Pablo, whose attachment to his father was prodigious: "In Corunna my father did not leave the house except to go to the School of Arts and Crafts. He returned home and amused himself painting, but not so much anymore. The rest of the time he spent watching the rain through the windowpanes. . . . No Malaga, no bulls, no friends, nothing."

His mother, mistrustful by nature, became embittered and still more mistrustful. She taught her son "not to say anything about anybody or anything." He was deeply affected by her strictures, but even so he was discovering the joys of play and comradeship. He showed his classmates how to organize their own special bullfight in Pontevedra Square, in front of their school. One of them would be the bull, another the matador, and somebody's jacket, no matter what the color, would act as the red cape. When Pablo was not improvising bullfights, he liked to lead his gang in an assault on the street cats, shooting at them with their toy guns. "In Damas Street we had a real massacre once," he said, looking

back on these tribal rites of passage. "The alarm that spread through the neighborhood was phenomenal, and the result was that I was watched more. My mother watched over me carefully, anxious about what I was doing in the street. But her vigilance was limited by the fact that she could see only part of Pontevedra Square where we played. She had to stand on tiptoe on the toilet seat to watch me play through the tiny bathroom window."

At school he doodled compulsively, filling the margins of his schoolbooks with drawings, and transforming ink blobs into animals and people. At the end of his copy of *Literatura Preceptiva o Retórica y Poética*, he drew two donkeys coupling and wrote a raunchy doggerel verse:

> *Without so much as a how-d'ye-do,*
> *The she-ass lifts her tail.*
> *Without so much as a by-your-leave,*
> *The donkey drives in his nail.*

Punishment became another source of fun: "For being a bad student, they would send me to the 'cells.' They consisted of whitewashed walls and benches. I loved it when they sent me there, because I could take a pad of paper and draw nonstop. Those punishments were a holiday for me, and I even provoked situations that obliged the professors to punish me. I could be isolated with no one bothering me there, drawing, drawing, drawing . . ."

In September 1892, Don José decided that it was time for his son to begin his formal art training and applied to the principal of the School of Fine Arts: "Don José Ruiz Blasco, a resident of this city, hereby requests that you be so kind as to admit his son, Pablo Ruiz, as a pupil in the School you so worthily direct." He had used his own full name in applying—both his paternal and maternal last names, as was the custom in Spain—but only the paternal last name of his son. The application was approved, and Pablo was at first enrolled in his father's class in ornamental drawing.

So Don José continued in his dual role of father and teacher, and perhaps even before the father allowed himself to believe it, the teacher knew that he had a prodigy in his class. Pablo fol-

lowed the rigorous academic training of the school, copying from plaster casts, enrolling in the figure-drawing class, producing studies in charcoal of the right foot, of the left hand, of the right leg. Later he would say that "they should put out the eyes of painters, as they do to goldfinches to make them sing better." But for the moment the coordination of his eyes and his hand produced drawings that displayed astonishing powers of observation. The results of his examinations varied from "Excellent" to "Excellent with honorable mention."

Don José continued the training at home. "My father cut off the feet of a dead pigeon," Picasso remembered. "He pinned them to a board in proper position, and I copied them in detail until he was satisfied." Soon, so satisfied was Don José that he had Pablo paint the feet of the pigeons in his own canvases. Pigeons' feet seemed to be one of Don José's main obsessions. Hands were another. "In the hands is where you see the artist's hand," he used to tell his son.

In the fine albums that his parents gave Pablo for his personal drawings, clearly recognizing the value of what he would produce, disciplined and traditional drawings were juxtaposed with drawings in which his instinctive need to break all molds began to make itself felt. In the second Corunna album, Hercules makes another appearance, but this time the fig leaf is off. There is a new vigor and audacity in this Hercules and in all that Pablo did in Corunna, in his landscapes and in his portraits of his sister Lola, in *The Old Couple* and even in the newsletter that he produced in the fall of 1893 to send back to Malaga. It was called *Asul y Blanco* (Blue and White) after the most popular Spanish weekly and was full of drawings and a little writing from "P. Ruiz, *el director*," about life in Corunna. "The wind is blowing and will go on blowing until there is no Corunna left," read a caption under a drawing of a windstorm with women's skirts swept up and people trying to keep their balance. There was even a section reserved for advertisements, with one advertisement paid for by Pablo's ever-loyal supporter Don José: "Wanted to Purchase: Thoroughbred Pigeons. Address, 14 Payo Gómez Street, 2nd floor."

If the true birthplace is where one's eyes are first opened to one's hidden treasures, then despite the rain, the cold and the

wind, Corunna was Pablo's true birthplace. It was there that he recognized the mysterious gift of creation he carried within him and the attention it commanded. It was also in Corunna that he first experienced the mystery of love. He was fascinated by the story of the British general Sir John Moore, glorious victor over the Emperor Napoleon in the Battle of Corunna, who had died of his wounds with the name of his beloved on his lips. Pablo was not yet thirteen, but precocious in his desires as in his talents, he chose for his own beloved one of the only two girls in his class. Her name was Angeles Méndez Gil, and he transformed her initials, intertwined with his own, into drawings in his textbooks —AP, or, dreaming of a more formal union, APR: Angeles Pablo Ruiz.

It did not take long for their innocent love to come to the disapproving attention of Angeles' parents. All too aware, in a small provincial town, of the social differences between their own semi-aristocratic family and the family of the newly arrived drawing teacher, they were determined not to let their daughter's feelings get in the way of a suitable match. They placed all sorts of obstacles in the young lovers' way, and when Angeles and Pablo continued to exchange letters and seemed set on their "star-crossed love," her parents decided to take more drastic measures. On the last page of one of Pablo's textbooks, next to Angeles' initials, is the word "pamplona." Her family, not trusting her in the same town as Pablo, had removed her from temptation by sending her away to Pamplona.

The secrecy with which Pablo enveloped his love was a measure of its importance to him. Doña Maria's son had already learned enough mistrust at her feet to keep anything that mattered, anything that stirred him deeply, a well-guarded secret. He was only thirteen, but, as Palau i Fabre, the Catalan chronicler of his early years, put it, "something very tender and profound was destroyed in him." And because he had been rejected for being poor and of an inferior social class, for being thought to be worthless, the pain was stronger and the wound deeper. Now he had reason to distrust even love.

The year 1895 brought his initiation into two more mysteries: the mystery of power and the mystery of death. On January 10, his eight-year-old sister, Conchita, died of diphtheria. Pablo

watched her deteriorate from the smiling little girl with the blond curls whom he had so tenderly drawn to the ghost of herself that he drew just before death snatched her away. He watched the desperate comings and goings of Dr. Ramón Pérez Costales, a friend of his father's and "a dyed-in-the-wool republican"; he watched his parents' struggle to save his sister; and he watched bewildered as they celebrated Christmas and Epiphany and gave presents to all the children, trying to shield Conchita from the knowledge of her approaching death.

In his anguish, Pablo made a terrible pact with God. He offered to sacrifice his gift to Him and never pick up a brush again if He would save Conchita. And then he was torn between wanting her saved and wanting her dead so that his gift would be saved. When she died, he decided that God was evil and destiny an enemy. At the same time he was convinced that it was his ambivalence that had made it possible for God to kill Conchita. His guilt was enormous, the other side of his belief in his enormous power to affect the world around him. And it was compounded by his primitive, almost magical, conviction that his little sister's death had released him to be a painter and follow the call of the power he had been given, whatever the consequences.

The mystery of that power was most forcefully brought home to Pablo soon after Conchita's death when his father gave him his brushes and colors and swore never to paint again. It was a confession, an abdication and an anointment that must have been awesome for the thirteen-year-old. The man who was not only his father but his teacher was bowing before the genius he had sired. Painting, his first love, had been sacrificed at Pablo's altar; Conchita, the child most like him, was gone; Malaga, his hometown, belonged to his lost past. Only Pablo mattered to Don José now, and he lavished on his son a fathomless devotion.

In February 1895, Don José applied for a transfer. Corunna had been oppressive to him from the beginning, but after Angeles had been sent away and Conchita died he could see also how oppressive it had become for Pablo. And that he could not tolerate. In March, an exchange of jobs was arranged with an art teacher in Barcelona who wanted to return to his home in Corunna. Before they left, Don José arranged for an exhibition of Pablo's paintings to be held in the back room of a shop that sold

drapery, umbrellas and knickknacks. Not many paintings were
sold, especially after people discovered at the small opening that
the painter was not yet fourteen, but it was still Pablo's first one-
man show, arranged by his father, who had never had one. The
family planned to spend the summer in Malaga before setting off
for their new life in Barcelona. They took the train south, and on
the way they stopped for a day in Madrid, where Don José intro-
duced his son to the glories of the Prado—to Goya, Zurbarán
and Velázquez.

In Malaga, they stayed at Uncle Salvador's. Pablo had left as a
boy of ten who could not pass his school exams, and had returned
as a painter whose extraordinary talent his relatives recognized
with pride in the paintings he brought from Corunna. There
were *The Barefoot Girl, Old Man in Galicia, Beggar in a Cap,
Old Pilgrim, Head of a Galician Woman* and many paintings of
bearded old men among the works that Don José put proudly on
display in his brother's house. Pablo was still only thirteen, but
there was a deep empathy and tenderness in his portrayal of these
men and women whom age, poverty or renunciation had re-
duced to the margin of life. Whatever burdens they carried, they
remained rooted in their humanity, and there was an inex-
haustible richness in the faces of even the most destitute. Don
Salvador was so impressed that, while Pablo was in Malaga, he gave
him five pesetas a day, found him a studio in the Health Inspec-
tion Bureau and hired an old sailor as a model for him. He also
insisted that his nephew go regularly to Mass. "My uncle Salva-
dor," Pablo would say, "told me one day that if I didn't go to
communion he wouldn't take me to the bullfight, and so of
course I did go to communion. I would have gone to communion
twenty times for a chance of going to the bullfight!"

When the family arrived in Barcelona, the prodigy who had
dazzled Malaga had to become an ordinary student again, sitting
for his entrance exams to the Llotja (the Exchange), as the Bar-
celona School of Fine Arts was called, housed as it was in the
imposing neoclassical building of the Barcelona Stock Exchange.
He did not like having to descend from the heights of genius to
the prosaic world of exams and mediocre students, and in the
two drawings he produced of the male model he was instructed
to draw, he was clearly thumbing his nose at those who had the

gall to examine him. He drew the model, once naked and looking bad-tempered, and once looking even more ridiculous wrapped in a sheet that was supposed to be a toga draped around a dignified Roman nobleman. The feet were left unfinished, as though he could not be bothered with such details for a mere admissions test. "Picasso was in a hurry," Sabartés would write, "in a far greater hurry than the members of the examining board, in a far greater hurry than any of us. . . . In this sense, presenting the exercise as he did present it has something of the air of a challenge; it is as though he were saying that his time was much more important than that of the examining board." He was also saying that if they wanted to admit him it would be on his own terms, and if they did not, it would be their own loss.

The examination quickly became one of the stories in the legend he began creating for himself, made up partly of what he did and said and largely of what others repeated. He claimed that he was given one month in which to complete the drawings, but that he finished them "all in one day." "I took a good look at the model to see what I could add. But there was nothing, really nothing." And everybody repeated this claim until the drawings were unearthed; they bore the official stamp and two different dates, September 25 and September 30.

Beneath the fabrications and the arrogant assurance lay the deep sense of inadequacy of the schoolboy who could not deal with rules, regulations, curricula and structure. If he was asked to do something, the mere fact that it was a request rather than his own choice created resentment and turned the simplest task into a problem. And that in which he could not excel he despised. So he turned an inability to master the simplest concepts or anything analytical into a badge of honor. He would often brag about his early inability to read and write; in Barcelona, he bragged just as often that there was nothing the teachers of the Llotja could teach him, nothing that he owed his elders or the past.

It was an attitude which fitted perfectly with the mood of rebellion and anarchy that pervaded Barcelona at the time. The uprisings of the Spanish peasants who worked all day for a loaf of bread went hand in hand with the revolt of intellectuals against all political, cultural and aesthetic conventions. Barcelona was

the anarchist capital of Europe, and the newspapers were filled
each day with news of bombings, raids, arrests, tortures and pub-
lic executions. Alongside the movement calling for the indepen-
dence of Catalonia, with its own language and traditions and with
Barcelona as its capital, was an anarchist movement nurtured on
the passionate conviction that "the Spanish government has al-
ways been the chief enemy of Spain." Two years before Pablo
arrived in Barcelona, the anarchist bombing of the Gran Teatre
del Liceu, Barcelona's opera house, had killed twenty-two and
wounded fifty. Terror bred terror, and it was reported that
"hundreds, even thousands, were arrested and thrown into the
dungeons of Montjuich, the prison fortress seven hundred feet
above the sea, whose guns dominate the harbor and city of Bar-
celona and foredoom any revolt by that chronically rebellious
city." The public strangling of Santiago Salvador, the anarchist
who had bombed the opera house, became the subject of *Vile
Garroting*, a painting by Ramón Casas, who, like many of the
young painters working in Barcelona, identified with the anar-
chists in politics, the nihilists in philosophy and the symbolists in
art. "Better to be symbolists and unbalanced, even crazy and
decadent, than vile and cowardly," said the painter Santiago Ru-
siñol, one of the leaders of the "Modernist" movement that
sought to usher Spain, crazily and decadently if necessary, into
the twentieth century. "Common sense is choking us; prudence,
here, is overdone."

During his early days in Barcelona, Pablo did the astounding
drawing *Christ Blessing the Devil*, which was evidence of the
deep conflict raging within him. Christ, with a shining aura
around his head, is blessing with his left hand an overwhelmed
Devil. At the same time, he painted *The Holy Family in Egypt*
and *Altar to the Blessed Virgin*, while in 1896 came an abundance
of religious pictures of Christ being taught by the Virgin how to
read, Christ appearing to a nun, Christ being adored by the an-
gels, of the Annunciation, of the Last Supper, of the Resurrec-
tion. Most of these pictures are too intimate to be seen as the
routine exercises of an adolescent painter in a Catholic country.
Was Pablo torn between Christ and the Devil he had depicted
being blessed by Christ? Was the Devil associated, in his mind,

33

with daring rebellion and defiant genius? He too was a rebellious genius, but he was also a young man longing to experience a reality beyond himself and his everyday life.

His religious crisis was born of the religious crisis of Spain. "The anger of the Spanish Anarchists against the Church," wrote the historian Gerald Brenan, "is the anger of an intensely religious people who feel they have been deserted and deceived." It was but a short step from anti-clericalism to anti-Christianity, and an even shorter step from anti-Christianity to a rejection of God. Pablo was hesitating. A year after he drew *Christ Blessing the Devil* he gave tender expression to some of the most powerful symbols of religious worship, but he also did a picture of Christ with no face, impersonal, unreal and with no answers. Catholicism with its emphasis on ethical rules and the rewards of heaven held no answers for Pablo with his growing passion for freedom and this world. He would reject the Church, but he could not stop himself from returning throughout his life to the figure of Christ, as a symbol of his own suffering, in the same way that he would bury his transcendent longings but could not extinguish them.

It was an air of rejection and rootlessness that Pablo breathed all around him as he began to roam the streets and cafés of Barcelona. The Llotja, much more than a source of teaching, became a source of friends with whom to explore the secrets outside its walls. Manuel Pallarès was Pablo's first close friend in Barcelona. They sat beside each other in the class in pictorial anatomy and, although Pallarès was five years older, became instant friends. In the portrait Pablo did of his friend soon after they met, Pallarès looks solid and serious, distinguished and handsome with his light brown hair and his full mouth. "He was appealing, and way ahead of the others," Pallarès said of Pablo. "He grasped everything very quickly; paid no apparent attention to what the professors were saying. . . . Sometimes very excited, at other times he could go for hours without saying a word." Pallarès accepted from the outset that to be Pablo's friend one had also to be his follower, obedient to his moods, his needs and his caprices.

The Eden Concert, a café with singers, became their favorite haunt. Before it changed its name, it was called the Café de la

Alegría (the Happiness Café), but under either name it was known as "the center of perdition," unmentionable by the God-fearing people of Barcelona and supposed to be frequented only by those beyond hope of salvation. It was there that Pablo met Angel de Soto and Ramón Reventós, who worked for a food-importing company and, through Angel, his brother Mateu, who was a sculptor. Together, these young men walked jauntily along the Rambles, the broad, teeming thoroughfare of Barcelona, along the narrow streets of the old town or through the notorious Chinatown, overflowing with brothels. It was in these brothels, most often accompanied by another student from the Llotja, Joaquim Bas, that Pablo had his first sexual experiences. He spent endless hours, in one brothel after another, before he was fifteen, satisfying both his raging sexuality and his urge to spend his talents only in areas in which he excelled.

Curiosity played as great a part as sexual ardor in these encounters where the women put on their passion together with their rouge; love, no part at all. Love and intimacy were, in fact, much more alive in Pablo's relationships with his men friends. He and Pallarès dressed up as women for the Barcelona Carnival in 1896, but whatever physical attraction was present in his male friendships was sublimated in his passion for his work and in his feverish dreams of glory.

Glory eluded him. In April 1896 he was represented by *The First Communion* in the Exhibition of Fine Arts in Barcelona, along with Rusiñol, Casas and the best-known of Catalan painters. He was eager to win one of the prizes or at least sell the picture, which was priced at 1,500 pesetas, but beyond the honor of being admitted to the exhibition, he received only a lukewarm mention in the *Diario de Barcelona*: "*The First Communion*, by Pablo Ruiz Picasso, the work of a neophyte, in which we can see a certain feeling in the principal characters and some parts firmly outlined."

It was *Science and Charity* that first brought him some recognition—an honorable mention at the Madrid General Fine Arts Exhibition of 1897 and a gold medal at the Malaga Provincial Exhibition. Don José was the model for the doctor who, taking the pulse of a sick woman, represented Science, while a nun, a boy disguised in a borrowed habit, represented Charity. The

model for the sick woman had been found begging in the streets with her child in her arms. Pablo had painted *Science and Charity* in his own studio which his father had got for him in the fall of 1896. It was in the carrer de la Plata, on the way from the Llotja to the family's new home in the carrer de la Merced. When the news of Pablo's Madrid award reached his father's painter friends, one of them, Don Joaquim Martínez de la Vega, proposed to christen him a painter by pouring champagne over his head.

His father's generation had recognized him as their peer, his school friends and followers had inducted him into the "community of geniuses," but Pablo was still not sure about the direction he would take. He was torn between revolt against tradition and the creation of big, conventional pictures that might win him awards at exhibitions. Sometimes he loved indulging in dreams of power and fame, and scheming about the fastest way to achieve them. At other times he found himself totally possessed by his work, and nothing else mattered. In quick succession, he painted the *Self-Portrait with Close-Cropped Hair*, thoughtful, boyish and a little uncertain, and the *Self-Portrait as an 18th-Century Gentleman*, dignified, imposing and a little disdainful in a white wig.

The precarious balance between adolescence and maturity tipped toward childishness when he and Pallarès amused themselves by throwing small stones from the roof of his studio at hapless passersby. One day, their target was a gentleman's gleaming top hat. They succeeded in hitting it, but not in hiding in time. Their victim saw them and rushed to fetch a policeman. Crouching behind the canvas of *Science and Charity*, they heard the policeman repeatedly knocking on the studio door. The knocking finally stopped, but they did not emerge until the concierge shouted to them that the coast was clear.

Many of Pablo's conflicts had for some time now centered on his father. In his attempt to free himself from the passion that as a little boy he had had for Don José, he tried to diminish him in his mind and in his work. His ambivalence was first clearly seen in the last two portraits he drew of his father in his Corunna album: "These two drawings," wrote Palau i Fabre, "seem to have been done one immediately after the other—one would be tempted to say simultaneously, if that were possible. In one of

them Don José still shows a certain euphoria as he looks at the work he is painting or has just finished painting. But in the second his face is altogether—and quite deliberately—pessimistic; its expression has altered radically. The 'framing' of the sitter on the paper (the chair and the position of the body, the hands and the legs) is identical in the two portraits, but the state of mind of the character they present is absolutely different."

Was it the state of mind of the father that changed so shockingly in a day, or the state of mind of the son toward the father? In Barcelona, Pablo continued to portray his father drained of life and despairing. Was the cruelty of these portrayals the truth or a lie? Perhaps it was a dramatic exaggeration that for Pablo became a truth he hoped would liberate him from all that Don José was and represented: a perfectionist who revered precision and order; a painter of intimate, realistic pictures, who nevertheless endowed his realism with a metaphysical quality by augmenting the sensation of depth and space; a man of integrity, who set great store by the simple virtues of modesty and selflessness; a gentleman, calm and courteous and slightly detached, even looking like the gentleman of popular imagination tall, handsome, elegant and dignified. As a young man, Pablo began to see the father he adored as a rival. Short and squat, he could never match his father's physique and elegance. "Every time I draw a man," he would say later, "I think of my father. To me, man is Don José, and will be all my life."

But Don José was a teacher by profession and a pedagogue by inclination, and Pablo was growing tired of his advice and criticism. Don José probably understood his son's strengths and weaknesses all too well, and Pablo soon began to find his mother's adoring incomprehension much less demanding. So even though from the earliest years of his young life it was his father who supported, often at his own expense, his every step as a painter, it was his mother whom he later idealized when he re-created his past; and it was his mother's name that he finally adopted.

He remembered his mother as "so small that her feet did not touch the ground when she was sitting." There was something domineering about her, however, and despite her limited intelligence, she ruled over her introverted husband and her household. In a watercolor by her son from 1896, she sits tight-jawed

and sour, some unknown anger festering in her. But he was rarely the target of that anger. She believed in him unconditionally. "If you become a soldier," she told him, "you'll be a general. If you become a monk, you'll end up as the Pope!" If her son had not learned anything at school, she felt sure that he knew it all already—or at least, all that was important. As for his egocentricity, it seemed perfectly natural to his doting mother.

While she understood nothing and worshiped everything, Don José, as well as encouraging his son, getting him a studio and endlessly posing for him, continued to discriminate between his good work and his not-so-good. On some quickly drawn sketches, he wrote "Excellent" on six and "Failure" on four. But his son did not want to be graded. In his *Flight into Egypt*, Joseph is Don José, right down to the red beard, kneeling at the feet of the Christ Child. So he may have recognized Don José as a protective entity, perhaps even as indispensable to his life. And it was this sense of dependence which finally made him all the more eager to break free. He was compelled to diminish and destroy his father so that he could emerge as an autonomous creator, who owed nothing to tradition, to the past or to his ancestors. In his pictures of Don José as a defeated man, the son, rebellious and impatient with small virtues, could not wait to emerge from the shadow of the father. And it was his portrayal of his father— both in words and in images—as an ineffectual and broken man that was later accepted as the essential Don José.

Pablo was sixteen in the fall of 1897 when he arrived in Madrid to continue his studies at the Royal Academy of San Fernando, the highest artistic training that Spain had to offer. He described himself on the official forms as a pupil not of his father but of Don Antonio Muñoz Degrain, who taught landscape at the Academy. It was one more act in the chain of acts disowning the father, as well as an act of identification with the hero of his childhood. But that hero too was soon dethroned. Picasso had found Don Antonio too much of a pedagogue and bound too closely to the academic past. "I detest that period of my studies in Barcelona," he was to say, looking back on his years at the Llotja. He hoped that Madrid would be very different—an escape and an opportunity to expand and explore his own artistic vision. Almost everyone on both sides of Pablo's family had contrib-

uted toward the considerable expense of sending the family's hope for glory to Madrid—each according to his means, from Uncle Salvador to Aunts Eladia and Heliodora, who provided a peseta a month. But gratitude forges bonds, and more than anything Pablo wanted to be free. So he minimized the help he received: "Bah! A pittance!" he said in response to remarks about his handsome allowance. "A few pesetas. Barely enough to keep from starving; no more."

In a letter to Joaquim Bas, his friend from the Llotja, he also deprecated all the teachers at the Academy who labored under the misconception that they were teaching *him* about painting:

What painters, dear Bas! They haven't a grain of common sense! They just go on and on, as I suspected they would, about the same old stuff: Velázquez for painting, Michelangelo for sculpture, etc. . . . Moreno Carbonero told me the other night at the life class, which he teaches, that the figure I was doing was all right in proportions and in drawing, but that I should draw with straight lines, which was better, because what you have to do above all is the boxing-in (not any other sort of boxing, I hope). He means that you have to make a sort of box to wrap the figure in. You can hardly believe the nonsense they talk, can you? But there's no doubt about the fact that, however much or little it has to do with the way he thinks, he certainly knows more and he doesn't draw badly. And I'll tell you why he's the one who draws best around here: because he went to Paris and to several of the academies there. But don't deceive yourself, for here in Spain it's not that we are as stupid as we've always been made out to be, it's just that we're very badly educated. And that's why, as I told you before, if I had a son who wanted to be a painter I wouldn't keep him here in Spain for a moment. And I certainly wouldn't send him to Paris either (though that's where I'd like to be now myself), but to Munik (if that's how you spell it), for that's a place where they study painting seriously, without bothering their heads over diehard notions about pointillism and all that. It's not that I think that painting in that way is necessarily bad; what I don't like is that just because one painter has been successful in some style they all have to follow in his tracks. I don't believe in following any particular school, for all it leads to is mannerism and affectation in the painters who do it.

The museum of paintings is wonderful: the Velázquez's first-class; some magnificent heads by El Greco; as for Murillo, I'm not sure that I like all his stuff. . . . And there are girls everywhere in Madrid that leave the prettiest houris of Turkey in the shade.

I'm going to send you a drawing to take to the Barcelona cómica; if they buy it, you'll have a good laugh. It will have to be Art Nouveau, since the paper is so much in that line. Neither Nonell nor the Young Mystic nor Pichot nor anyone else has ever done anything half so outlandish as my drawing is going to be. You'll see.

And so goodbye. Please excuse me for not saying goodbye in Barcelona. Kisses to [here there is a drawing of a little hand holding a flower] del [here a drawing of a coin with a woman's profile on it and under the profile the words 'one ounce' between brackets]. Yours ever, P. Ruiz Picasso.

Bas had been his chief companion on his nights out in Barcelona's Chinatown, and the kisses were intended for Pablo's favorite, to whom he was to return many times on his brothel rounds. She was known by the name of Rosita del Oro, a name that Pablo's love of codes transformed on paper into a flower and a gold coin.

Pablo may not yet have figured in many eyes in Madrid, but he was determined to spare himself the ponderous counsel that passed for wisdom at the Academy. In fact, after the first few disillusioning days, he hardly set foot in the Academy. He explored the girls of Madrid, who left "the prettiest houris of Turkey in the shade"; he rarely got up before noon; he spent a lot of time in Retiro Park and filled sketchbook after sketchbook observing his fellowmen and his surroundings; he moved from lodging to lodging, perhaps because he was restless or perhaps because his landladies disapproved of his bohemian lifestyle; he did very little painting. It did not take long for news of his unruly life to reach Malaga, and even less time for Don Salvador and the rest of the aunts and uncles to discontinue his allowance. Their rules of propriety and hard work applied equally to geniuses and to lesser mortals. Only his father continued to send "all he could afford."

In the spring, Pablo fell sick with what some said was scarlet

fever, some pleurisy and some syphilis. Whatever it was, his stay in Madrid came to an inglorious end. As soon as he felt well enough, he returned to Barcelona. *Picasso Bewildered*, the self-portrait he drew at the time, shows him emaciated, his cheeks hollow, his eyes peering anxiously into the future. Together with Pallarès, he left Barcelona almost immediately for Horta de Ebro, Pallarès' village in the mountains. There he not only recovered his strength but spent eight of the most significant months of his life. "Whatever I know," he said later, "I learned in Horta." He did not just mean learning about nature and animals and chopping firewood and cooking simple meals and taking showers in a waterfall. He meant learning about depths of intimacy he had never known before; he meant learning about himself.

After a few days in the Pallarès family home, Pablo and Manuel left, together with a young gypsy boy, to explore the mountains. They stayed first in a cave on a mountain in Santa Barbara and then, in search of even more rugged adventure, they climbed up to the Ports del Maestrat and spent almost a month near a spring, in a cave created by a boulder. Every few days, Salvadoret, Manuel Pallarès' younger brother, would make the eight-mile journey on a mule and then the long hike up to the cave to bring them fresh supplies of food. Their beds were made of grass, and every night they built a big, crackling fire to keep themselves warm.

The gypsy was two years younger than Pablo and was also a painter; the three of them spent a large part of the day painting, until Pablo learned to differentiate the trees, like an Eskimo who has many different names for snow. The gypsy taught him the meaning of the random chirping of the birds and the faraway movement of the stars, and how to forge an alliance with nature, animals, trees and the invisible. Together they watched the daily miracle of dawn and took long walks on the rough mountain paths. Theirs became a burning friendship, and whether they were in their cave or back in the village, they were always together. Pallarès, suddenly displaced and excluded, took his revenge later when he omitted any mention of the gypsy from his account of Pablo's life in Horta. The way Pallarès told the story, just he and Pablo explored Horta; the way Pablo told it, on the

only occasion when he talked about his passionate friendship, it was always he and the gypsy. "Pallarès was the sturdy piece of bread," he added.

"I have no true friends; I have only lovers," Pablo would say years later. In his relationship with the gypsy, it is likely that this was physically as well as metaphorically true. Pablo was in love—with the gypsy and with the world. To celebrate that love, he painted landscapes and shepherds and animals and peasants working. "The predominant note in the output remaining from that stay is one of a great tenderness," wrote Palau i Fabre. "Never again, perhaps, was Picasso to describe such idyllic land-scapes, landscapes in which evil had no place. . . . For a large part of his life—perhaps for ever—Horta was to mean to him a Paradise Lost."

Pablo and the gypsy were at the center of that paradise. The gypsy was to the city boy a symbol of freedom as well as the incarnation of a sacred and awe-inspiring world. To solidify their loyalty with an age-old ritual, they took the knife that the gypsy carried everywhere, cut their wrists and joined the flow of their blood. But there was a serpent in their paradise: the world outside Horta. The gypsy saw it first and decided to act in the only way he knew how—violently and decisively. He drew his knife and cried out with the same passion that Patroclus felt for Achilles many centuries and cultures before: "I love you too much. I must go away. Otherwise I'll have to kill you because you are not a gypsy."

He could not remain on intimate terms with a man who was not a gypsy and who, he knew, would not share the life of a gypsy with him for much longer. He did not love less, but his love had become an unbearable weight, and so that same night he van-ished forever, wounding Pablo's feelings and leaving him even more bewildered. Everything about Horta seemed empty now. He left for Barcelona, alone this time, determined to throw him-self into the world which had separated him from the gypsy and, like Achilles, to conquer it. "In the great nation of the gypsies of art, Picasso is the most gypsy of all," a Castilian poet was to say about him in 1932, and Pablo always had a special, secret fond-ness for that remark. His relationship with the gypsy had been a turning point in his life, the moment when the gifted son of a

conventional middle-class family found justification for his rebelliousness and discovered the gypsy in himself.

When he arrived in Barcelona toward the end of February 1899, Pablo's mood of pessimism and darkness was matched by the mood prevailing in "the world outside Horta." The previous December, the Treaty of Paris had declared the independence of Cuba; the fall of Manila to the Americans brought the end of imperial Spain, an end that had come about through military disaster and humiliation. The streets of Barcelona were full of demobilized and crippled soldiers begging for alms, while the writers and artists who called themselves the "Generation of '98," disgusted with "a moribund society with suicidal governmental leadership," were turning in droves to socialism and anarchism. Fresh from the ardor and vitality of his life in Horta, Picasso found himself confronted everywhere with death: death in its aspect of decay and the decadence of a dying century; death in the skull-like faces of the repatriated soldiers; death in the pervading gloom.

Death invaded his work too. This was his black period, filled with people dying, bleak self-portraits and shadowy faces emerging from abject darkness. *The Kiss of Death, The Cry of Death, Two Agonies, Before Luisa's Tomb, Priest Visiting a Dying Man, Presence of Death*—they were all permeated with the presence and spirit of death. In different versions of *Woman Praying at a Child's Bedside* he painted what he remembered of his sister Conchita's death, with his mother praying beside her bed.

This was also the time of open rebellion against his father. Despite Don José's entreaties, he refused to enroll again at the Llotja and began to work in the tiny studio of the painter Santiago Cardona in the carrer d'Escudillers Blancs. The rest of the floor was a corset shop, and occasionally Pablo would take a little time off work to have some fun punching eyelets in the corsets. Don José, in Madrid to judge a painting competition, wrote to his wife: "I am pleased to hear that Pablo is working. . . . I showed [Don Antonio] the drawings, which he liked very much, but he told me that last year he did nothing useful; however, that's all over and done with." No matter how consistently he was disobeyed or disappointed, he continued to make his son the center of his life.

In a monumental act of defiance, Pablo left home for a few

weeks and moved into the brothel where Rosita del Oro worked. Filth rather than sensuality pervaded the brothels of the Barrio Chino. There was, of course, no electricity or running water, and rancid odors of garbage, urine, semen and sweat filled the air. The curtains were threadbare, the bedcovers mangy, the mirrors tarnished, the crumbling walls covered with obscene drawings. Such was the world Pablo chose to inhabit for a time. "This is what you are like, determined never to do like others," he wrote on a piece of paper—an affirmation of his emerging credo. His fierce independence, together with his burning black eyes and his intoxicating vitality, were by now established as the dominant elements of his personality.

"He could see farther than we could . . . he fascinated us," Pallarès said. But it was a man Pablo met in his new studio in 1899 who became the first fanatical exponent of Pablo as an artist hero. Jaume Sabartés was a writer and poet with long hair and round glasses, proudly Catalan and profoundly prone to the hero-worship and romanticism of the turn of the century. "I still remember my leave-taking after my first visit to his studio in Escudillers Blancs Street," he wrote breathlessly almost forty years later. "It was noon. My eyes were still dazzled by what they had seen among his papers and sketchbooks. Picasso, standing in the angle formed by the corridor that ran past his studio and the corridor leading to the front door, intensified my confusion with his fixed stare. As I stepped in front of him to say goodbye, I was ready to bow, stunned by the magic power that emanated from his whole being, the marvelous power of a magus, offering gifts so rich in surprises and hope."

Such was the note of awe that Sabartés began to sound in any conversation about Pablo. "We spoke of him as of a legendary hero," he later explained. And it was Sabartés who had led the way in forging the legend. From that first meeting, even though he had been introduced as Pablo Ruiz Picasso, Sabartés called him Picasso. Ruiz was a name common in Spain; Picasso uncommon, suitable to legend. As for Pablo, he accepted Sabartés' adulation as his due and caricatured him as a decadent poet, roaming a cemetery wearing a long black coat and a crown of roses, holding a solitary rose.

At the beginning of the new century, Picasso, as more and more people now called him, found a much larger studio at 17 carrer Riera de San Juan, which he shared with his new intimate friend Carles Casagemas, also a painter. Casagemas came from a prominent and prosperous family (his father was the United States consul in Barcelona), so that sharing in this case meant that Casagemas paid the rent and Picasso worked. He started by painting the walls with everything they would have liked to have if only they could afford it: "a great bed, a table loaded with exquisite food, a safe, and even a manservant and maidservant (the latter with more than usually exuberant breasts) awaiting the orders of the two new tenants." Casagemas was a surprising companion for Picasso. Sabartés' explanation was that "better than any of his other chums he was ready to help him with his plans, or listen to the endless ideas he kept dreaming up." The main way in which he could help him with his plans was financial; if Picasso was to break from his father, it was a good idea to have a friend who could subsidize his way. In fact, Picasso not only worked in Casagemas' studio; he often slept there, whenever he did not want to return home. As for "the endless ideas he kept dreaming up," most of them revolved around Paris and, more specifically, the Paris Universal Exhibition, where his *Last Moments* had been chosen as one of the paintings to represent Spain.

Casagemas, a year older than Picasso, was a complex man, refined and uncertain about his masculinity. He was given to platonic passions, the current one with his sister's daughter, Neus. Picasso did his best to introduce his friend to his own routine pleasures in the Chinatown brothels, but Casagemas would normally accompany him only as far as the door. He even introduced him to his favorite and did a drawing to commemorate the occasion, *Picasso Introducing Casagemas to Rosita*, but it seems that the drawing was the only result of this encounter. Casagemas took to gloom as others took to drink, and he shared a certain morbid taste of the time for cemeteries. After a visit to a cemetery near his parents' estate outside Badalona, Casagemas asked his friend to sit for him. But when Picasso got up after a while to see how his portrait was progressing, he discovered that

Casagemas had painted nothing. It was nothingness that he celebrated in his indolence, in his indifference to so much of life and in the philosophical nihilism he espoused.

Talk of nihilism, Catalanism, anarchism and modernism filled the smoky air of Els Quatre Gats, the cabaret that became Picasso's main haunt when he returned from Horta. It had been founded by Pere Romeu and inspired by Miguel Utrillo, who in 1899 started *Pel i Ploma*, soon to become the most important art magazine in Barcelona. The cabaret's name was chosen as an echo of Romeu's previous job at Le Chat Noir in Paris and because of the expectation that, as the Catalan saying went, there would be "just us four cats" in the new cabaret. That gloomy prophecy was soon overturned. Els Quatre Gats was from the beginning a huge success, "a Gothic tavern for those in love with the North," where Utrillo staged puppet shows, where Rusiñol, Casas and Nonell, among others, showed their work, and where anyone with an apocalyptic gleam in his eye would gravitate to discuss the new ideas. Enthusiasm contended with a sense of futility and the urge to create with the compulsion to destroy. The anarchist Bakunin was one of the imported heroes of Els Quatre Gats: "Let us put our trust in the eternal spirit which destroys and annihilates only because it is the unsearchable and eternally creative source of all life. The urge to destroy is also a creative urge."

Such was the intellectual milk that nourished Picasso in Barcelona at the turn of the century. Uneducated but quick to learn, Picasso devoured ideas and philosophies through his friends who had read and absorbed them. Pompeu Gener, who first introduced Nietzsche to Barcelona, and Jaume Brossa, another Nietzsche popularizer and a staunch anarchist, became Picasso's friends, and through long discussions they familiarized him with the Nietzschean staples of the death of God and the birth of the Superman, that extraordinary being who, alone on his mountaintop, can survive the death of God. *Yo*—the "I," or the ego—was the one word that, among the young artists and intellectuals at Els Quatre Gats, summed up the Nietzschean worship of the extraordinary man to whom all was allowed. "I myself am fate and have conditioned existence for all eternity," Nietzsche had declared, and Picasso readily responded to this trumpet call of

absolute freedom. Nietzsche's *The Will to Power* also struck a chord in his heart. Power was the only value set up by Nietzsche to take the place of love and the transcendent values that had lost their meaning for modern man. And Picasso, for whom transcendent values were associated with Spain's repressive Church, and who thought that he had tried love and it had failed him, found that philosophy admirably suited to his own needs and dreams of power.

The first self-imposed test of power for Picasso was the status of what had already become *his* gang at Els Quatre Gats versus the status of the established elders headed by Rusiñol, Casas and Nonell. At first it must have seemed an uneven battle. Even Nonell, who was only eight years older than Picasso, had already exhibited in Paris, while his exhibitions in Barcelona featuring haggard soldiers, cretins, beggars and political prisoners had made him a celebrated champion of the downtrodden. Rusiñol's festivals at Sitges, where he had his estate, had turned him into the champion of Art Nouveau, "the almost official spirit of Els Quatre Gats." As for Casas, who had studied in Paris, where he had absorbed Steinlen and Lautrec, he dominated Els Quatre Gats not only through his artistic influence but very directly through his large panel, at the entrance to the café, of himself and Pere Romeu riding a tandem. "You can't ride a bicycle with a straight back" was the caption. Still, a group of younger men, which included Pallarès, Casagemas, Sabartés, the brothers de Soto, Reventós and Junyer-Vidal, had its own table and kept a certain distance from the successful elders of Els Quatre Gats. They looked for their artistic direction to Pablo Ruiz Picasso, who was not yet nineteen.

On February 1, 1900, Picasso had his first exhibition at Els Quatre Gats, organized by his group. As Sabartés put it: "We wanted the public to know that there was someone other than Casas, that he was not the only portrait painter and his art not the sum total of Barcelona's talent. . . . Above all, we wanted to pit Picasso against the idol of Barcelona and enrage the public." And Picasso chose defiantly to exhibit mostly drawings, an art which Casas had rehabilitated, and mostly portraits, for which Casas was famous. But Barcelona barely took notice. The review of the exhibition that appeared, unsigned, in *La Vanguardia* was

written by Manuel Rodríguez Codolà, an assistant lecturer at the Llotja, who conceded Picasso's "extraordinary facility in pencil and brush work," but complained of "unevenness," "outside influences," "a lack of experience, and carelessness." It was the condescending review of an art teacher unable to accept the fact that an artist could find his own way without completing his studies at the Llotja.

Picasso was now more than ever ready to leave for Paris. For months he had been absorbing the French art journals to which Els Quatre Gats subscribed, studying the illustrations of Steinlen and Lautrec, delighting in their spirit. In a poster he drew advertising Els Quatre Gats, he let his imagination create a world of comfort and leisure, top hats and flowers in buttonholes, a world he no doubt hoped to inhabit. Pere Romeu was so taken by the poster's timeless ease that he used it for the menus.

The dream of Paris came closer to reality when Don José agreed to make whatever sacrifices were necessary to provide for a train ticket—there and back. The prospect of the journey pushed aside Picasso's obsession with death and sickness, and that spring he produced vibrant paintings of bullfights, full of sunshine, reflecting his own sense of renewal. In July they were shown in Els Quatre Gats, but received only a short mention in an obscure newspaper.

Picasso was not concerned. His head was already full of Parisian vapors. He had wanted both Casagemas and Pallarès to accompany him, but Pallarès had to finish the decoration of a chapel in Horta, and Picasso was in a hurry. So he prepared to conquer the French capital with Casagemas only. They had identical black corduroy suits made, and on the day of their departure, Don José and Doña Maria were at the station to see them off. But for Picasso the most important ritual was a drawing he had made of himself with the inscription Yo Rey—"I, the King." It was a talisman, an assertion of his powers to propitiate the fears and doubts that assailed him as he was about to cross the Spanish border for the first time.

2

"C'EST LA VIE"

PICASSO ARRIVED IN PARIS just a few days before his nineteenth birthday, speaking no French and having no place to stay. "I do not seek. I find," he once said, alluding to his art. In this instance he found, in quick succession, three places: a studio at 9 rue Campagne Première in Montparnasse, Nonell's studio at 49 rue Gabrielle in Montmartre, which Nonell was about to vacate before his return to Barcelona, and the Hôtel du Nouvel Hippodrome, where he and Casagemas stayed for a few nights between leaving their first studio and waiting for Nonell to leave his.

At the beginning, it did not seem to matter where he lived. Most of his time was spent on the streets, at cafés, the Louvre, the Universal Exhibition at the Grand and Petit Palais, the odd whorehouse, cabarets, the retrospective of French painting in the Champs-de-Mars, the popular theaters, where he applauded farces performed in a language he did not understand. Paris itself was theater for the wide-eyed young man from Barcelona. Parisians lived in the streets, they sang on street corners, they kissed on the benches and the café terraces and in the carriages passing by, they used the public pissoirs, they bought from sidewalk venders not only their roasted chestnuts, fruit, meat and cheese but also their beds, saucepans, hats and sideboards. And there was color, color and noise everywhere—bright advertising posters, and cabbies shouting at their horses and cracking their whips, and steam trolleys hooting, and newsboys yelling. All around him

he was suddenly breathing freedom. "If Cézanne had worked in Spain," he would say, "they would have burned him alive."

In the shadow of Sacré-Coeur, he jettisoned the stifling influences of Spain; but still feeling very much an outsider, he clung to the Catalan ghetto, eating, singing and getting drunk with Casagemas, Utrillo, Alexander Riera, the Catalan art collector, and Manuel Hugué—or Manolo, as everyone called the Spanish sculptor who managed to survive in Paris at the expense of many gullible souls. Anywhere else, Picasso would have looked strange —short and stocky in his cloth cap, his colorful ties and loud checks, a muffler around his neck to protect him against the October wind; but in Paris nobody seemed to care or even to notice.

On October 25, Picasso's nineteenth birthday, Casagemas wrote to Ramón Reventós in Barcelona a letter full of vivid detail and excitement about their new life. "The following day we got together at *petit-Pousset*, which is not the same as Ponset's tavern, and we all got drunk. Utrillo wrote nursery rhymes, Peio sang bawdy songs in Latin, Picasso made sketches of people, and I wrote verses of 11, 12, 14 and more syllables. . . . There's not a single one who can outdo us in gossiping seriously about people." He urged Ramón to tell Perico and Manolo and Romeu and Opisso that they must come to Paris, and yet the letter is full of youthful, chauvinistic contempt for things French.

Some nights we go to cafés—concerts or theaters *idem*. It's pretty nice but it usually ends up a mess. Sometimes they think they're doing Spanish dancing and yesterday one of them came up with a fart of *ollé ollé caramba cagamba* which left us cold and made us doubt our origins. The military style is also very much in vogue everywhere. Tell Romeu that he's crazy not to come here to open the shop—he must get the money in any way possible—rob, kill, assassinate, do anything to come because here he'd make money. The boulevard de Clichy is full of mad places like Le Néant, Le Ciel, L'Enfer, La Fin du Monde, Les 4 z'Arts, Le Cabaret des Arts, Le Cabaret de Bruant and a lot more which don't have the least bit of charm but make lots of money. A Quatre Gats here would be a mine of gold and muscles. Pere would be appreciated and not insulted by the passing mob as in Barcelona. There's nothing as good as that nor

anything like it. Here everything is fanfare, full of tinsel and cloth made of cardboard and papier-mâché stuffed with sawdust. And above all it has the other advantage of being of deplorable taste— *cursi, vaja, bunyol, carquinyol*. The Moulin de la Galette has lost all its character and l'*idem* Rouge costs 3 francs to enter and some days 5. The theaters too. The cheapest places and cheapest theaters cost one franc.

And on a philosophical note he concluded that "there's nothing left to do but adapt to circumstances: do what you can because everything turns out as the Lord wants it." Sprinkled throughout the letter there were loud protestations about how hard they were working: "Whenever there is light (daylight, because you can find the other kind of light everywhere all the time) we are in the studio painting and drawing." Picasso's contribution to the letter, which was signed by both of them, was a drawing of a woman, well endowed and smiling, whose presence conveyed the flavor of those days much more eloquently than Casagemas' words.

Picasso may have felt uneasy beyond the confines of the Catalan ghetto, but not when it came to women. His charm, his powerful physique, his seductiveness and his animal magnetism bridged easily the gulf of language and nationality. Among the women in whose arms he improved his French, quenched his lust and fed his machismo was a French model named Odette, who found a somewhat more permanent place in his bed, if not his heart. While Picasso was playing sex with no consequences, Casagemas was falling in love with a model of Spanish origin, Germaine Gargallo. "Germaine is for the time being the woman of my thoughts," he wrote on November 11 to Ramón Reventós, the nonchalance disguising the torment that Germaine's casual behavior was causing him. "In the coming week which begins tomorrow," he continued with all the strength of feeling reserved for resolutions that make no demands on today, "we're going to fill our lives fully with peace, tranquillity, work and other things that fill the soul with well-being and the body with strength. This decision has been reached after having a formal meeting with the ladies." The ladies in question were Germaine and Odette.

In the same letter Picasso was at pains to make it clear that

women did not interfere with the important task at hand. "All this about women, as seen through our letters and as Utrillo must be telling you, seems or must seem to take all our strength, but no! Not only do we spend our lives 'fondling' but I've almost finished a painting—and to be frank, I think I have it just about sold. Because of this, as lovers of the traditions of our beloved(!) country, which few of us are, we are saying goodbye to the bachelor life—as of today we are going to bed at 10 and we are not going out anymore to *calle de Londres*. Today Pajaresco has written a notice in the studio that we'll get up early and that we'll even try to 'fondle' at regular hours." Calle de Londres was a famous brothel on the rue de Londres, which Picasso stopped frequenting—at least for a while—after Pallarès, or Pajaresco, as he called him in the letter, arrived from Barcelona and tried to impose some order on his friends' lives. Germaine had found him a bed at a reasonable price, which they moved into the rue Gabrielle. And just as quickly, she found him a young woman to fill his new bed—her sister Antoinette.

Picasso may have been twisting the truth about going to bed at ten, but not about almost having finished and almost having sold a painting. The painting was *Le Moulin de la Galette*. "It was in Paris I learned what a great painter Lautrec had been," Picasso later said, and that first Parisian painting shows how stirred he had been by Lautrec, by Renoir and by the Impressionists in general. It also shows how he rebelled against their influence in the very process of assimilating it.

Among the Catalans who were drawn to Picasso was Pere Manyac, an art dealer in his early thirties who had begun to make a name for himself in the Parisian art world through a combination of his support of young artists, his moustachioed good looks, his vigor and his showmanship. He was a factory owner from Barcelona and, mainly because of his preference for young men, "the black sheep of a respectable family." When he was introduced to Picasso by Nonell, he was instantly mesmerized by him. Picasso was like a racehorse reined in, intense but with an air of youthful tenderness, sure of his extraordinary gifts and yet doubtful and lost in the teeming, indifferent city he had set out to conquer. Manyac stepped in and offered him one hundred fifty francs a month for the paintings he produced. He also offered himself as

protector and guide through the Parisian art world. While most
of his fellow artists in Montmartre were living in dire poverty,
Picasso, thanks to Manyac, was for the first time financially in-
dependent. And one hundred fifty francs a month was a substan-
tial amount when studio accommodations could be found for
fifteen francs and one could live on two francs a day.

Manyac also introduced Picasso to Berthe Weill, whose audac-
ity and willingness to support young artists made her gallery at 25
rue Victor-Masse an influential center in the art world of Paris.
She was referred to as *La Mère Weill*, or "little old lady Weill,"
but although she was short and stocky, she was in fact young and
lively. When she arrived at the rue Gabrielle one day at the hour
arranged by Manyac to see Picasso's work, there was no reply no
matter how many times she knocked. She left angrily, sought out
Manyac, who had a key to Picasso's studio, and together they
returned to the rue Gabrielle and walked into his room. They
found him under the bedcovers with Manolo—a childish prank
at the dealers' expense, but also an assertion on Picasso's part
that while Manyac might have been responsible for his survival
in Paris, he was nevertheless beholden to no one and owed Man-
yac nothing, not even the common courtesy of answering the
door when he had made an appointment for him. His very real
dependence on Manyac brought out the rebellious child in him
and was one of the reasons he wanted to leave Paris.

There were others. "He is a man," Gertrude Stein later wrote,
"who always has need of emptying himself, it is necessary that he
should be greatly stimulated so that he could be active enough to
empty himself completely." And he was active enough and stim-
ulated enough to empty himself of Paris in an outpouring of work
within sixty days of his arrival; he was now ready to return home.
Also, as Christmas approached, he felt more and more the out-
sider in a city that was, from every corner, proclaiming Christ-
mas, Christmas presents, Christmas galas and Christmas
belonging. He did not belong in Paris, and even though he did
not feel he belonged in Barcelona either, at least for the moment
that was where home was. What is more, he and Casagemas were
having problems with women, who did not behave as they were
supposed to. A prostitute, another Rosita with whom Picasso had
been having an affair, was becoming too much involved with

him, while Germaine was very ambivalent toward Casagemas, which was driving him to drink and talk of suicide. So on December 20, together with Pallarès, they left for Barcelona.

Once Picasso was in Barcelona, his homesickness evaporated; he could not wait to leave, and with Casagemas he journeyed to Malaga. They arrived on December 30 and tried to get a room at the hotel Tres Naciones. At that time, Spain was rife with a horror of anarchists, and the long hair and unkempt looks of the young men raised suspicions. They were unceremoniously turned away. Picasso cannot have been surprised by such a reaction; he had intended to shock, to disturb the conventional picture of reality. But he also demanded acceptance. So as soon as he was turned away from the hotel he called on Doña Maria, his aunt who lived next door, to vouch for him and Casagemas. He would look like an anarchist and still stay at the Tres Naciones.

His plan to quench Casagemas' fire for Germaine by dousing it with dancing girls and cabaret shows and casual sexual encounters did not work. Casagemas, following his own demons, returned to Paris, leaving his friend to make the rounds of brothels and cabarets alone. Picasso played and painted, drew and played for two weeks until he felt restless and ready to swim in a bigger pond. He decided to seek in Madrid the recognition and success that had eluded him in Barcelona and Paris. He found instead poverty and rejection.

It was a freezing winter, and in his garret in calle Zurbano, whether working by the light of a solitary candle or trying to sleep on his straw mattress, Picasso suffered desperately from the piercing cold. The hundred fifty francs that Manyac continued to send him was his only means of subsistence. So he was no less dependent on Manyac in Madrid than he had been in Paris. That was Manyac's intention. He could not control Picasso, but he was determined to keep him in his orbit by making himself indispensable. To stay abreast of his movements, he befriended Pallarès, who remembered him as one of his "most frequent visitors . . . [he] always wanted to have news of Picasso."

Manyac was helping Picasso survive, but survival alone was never Picasso's goal. He wanted to make his mark, to be heard, to stir Madrid—and the world—out of its torpor. A project that began dimly in his mind when he first met the young Catalan

writer Francesc d'Assis Soler soon became reality. The project was a magazine, *Arte Joven* (Young Art), with a clear mission: to provide a forum for young artists and intellectuals where they could invent their own gods and brandish their fists at the established ones. As with so many revolutionary attempts, *Arte Joven* was supported by a commercial venture, in this case the sales of an electric belt, invented by Soler's father and advertised as a panacea for all illnesses and disorders, including impotence. The profits, however, were sufficient to sustain only four issues of the magazine. Picasso tried to prolong its life by sending a copy to Uncle Salvador with a request for financial support. All he got back was an angry letter: "What are you thinking of? What's the world coming to? Who do you take me for? This is not what we expected of you. What an idea! And what friends! Just keep going the way you're going now and you will see . . . " Uncle Salvador was not about to lend his support to such irresponsible attempts to disturb the status quo. In fact, *Arte Joven*'s bark was much more revolutionary than its bite. Picasso's drawings showed his capacity for pitiless observation and his craving to shock rather than any real desire to destroy the establishment.

At the end of February, while he was working on the first issue of *Arte Joven*, he received a letter from Ramón Reventós in Paris which left him open to the pain he had first felt when his little sister died. Casagemas was dead. On February 17 he had asked Germaine, Odette, Pallarès, Manolo and Riera to a farewell dinner before his return to Barcelona. It turned out to be a much more final farewell. Crying, "Here's one for you," he had taken out a pistol and shot in the direction of Germaine. "And here's one for me," he then cried, and shot himself in the head. Germaine escaped unharmed, but he died in the hospital a few hours later.

Casagemas' mother died of shock as soon as she received the news of her son's violent death. Picasso's shock was like a slow detonation which overwhelmed him only months later after the disbelief at the news of his friend's suicide had worn off. The portrait of Casagemas accompanying the obituary that appeared in *Catalunya Artistica* was only the first in a series of works through which he sought to exorcise the pain and guilt that his friend's death had stirred in him.

On March 10 the first issue of *Arte Joven* appeared, with Picasso listed as art editor. There were to be three more issues; but the worldly life of Madrid no longer suited Picasso's mood, much more introverted and anxious since the news of his friend's death. He left for Barcelona and threw himself feverishly into his work. And when he was not working he spent his time walking up and down the Rambles rather than in the usual round of cabarets and whorehouses.

In times of crisis Picasso sought catharsis rather than consolation. So it was work rather than friends and aimless activity that became his haven. With perfect timing Manyac wrote to him from Paris about the likelihood of an exhibition of his works by Ambroise Vollard, the dealer of Cézanne and Gauguin. There was also a local exhibition of his work being organized at the Sala Pares by Utrillo, but Picasso's eyes were firmly set on Paris. He even refused to attend the opening in Barcelona when he found out that Ramón Casas' work was hung alongside his. Utrillo had meant it as a compliment, but Picasso's sense of destiny, fed by his pride, had taken hold of him, and he refused to be identified with any local artist, however prominent and admired.

In June 1901 he was back in Paris. He had been gone for six months, but he had grown by much more than that. It seemed as though he had sloughed off another skin of adolescence and had left it behind on the Rambles. This time his companion was Jaume Andreu Bonsoms, an old friend from Els Quatre Gats. But even more present with him than when they had embarked together on their first Parisian adventure was Casagemas. Manyac had arranged for him to have Casagemas' studio at 130 boulevard de Clichy, next door to L'Hippodrome, the restaurant where he had taken his life.

Manyac had also arranged to live in the small studio, which consisted of a little entrance hall and a bedroom, with a bathroom on the landing outside. Soon after he had moved in with Manyac, Picasso painted a portrait of him, looking fiercely manly and in control, his defiant posture and red tie giving him the air of a bullfighter. Was Picasso the bull? If he was, he seems to have surrendered to being cornered. As well as being the protector and the keeper, Manyac was the strategist. He introduced his young

protégé to his friends, took him to the races and to fashionable spots like the Jardin de Paris and asked him to draw the people he saw as potential clients. He took him to meet Ambroise Vollard, whom he had persuaded to put on the exhibition. He told him to do a portrait of Gustave Coquiot, the art critic who was to introduce Picasso's show, and offer it to him. And he was instrumental in picking the sixty-five works that would represent the rich diversity of Picasso's genius. There were prostitutes and society ladies, portraits and landscapes, interiors and street scenes tightly packed on the walls of Vollard's gallery.

The symbolist poet Félicien Fagus, writing about the Vollard exhibition in *La Revue Blanche*, described Picasso as "a brilliant artist," his personality rooted "in his impetuous, youthful spontaneity." He also wrote that "he is clearly in such a feverish hurry that he has not yet had time to forge his own personal style. . . . For him the danger lies in this very impetuosity, which could easily lead him into facile virtuosity and easy success. It is one thing to produce and quite another to produce something worthwhile, just as violence and energy are two different things."

The review gave Picasso a taste of the recognition he craved. As for the rest, he dismissed it, as he dismissed the unfavorable reaction of some of the public to the exhibition of his work in Barcelona. In fact, on July 13 he wrote to his friend Vidal Ventosa, gloating over it: "I can imagine the reaction of the illustrious bourgeois upon seeing my exhibition at the Sala Pares, but that ought to be as important to us as applause, that is to say, as you already know: if the wise man doesn't approve, bad; if the simpleton applauds, worse. So, I'm content." He continued by modestly summing up the Paris exhibition as having "had some success. Almost all the papers have treated it favorably, which is something."

The exhibition had indeed been a success; but even more significantly for Picasso's life, it led to his meeting the man who, for the next few years, would fulfill two of his three most constant and urgent needs: Max Jacob would become his caretaker and his worshiper. As for Picasso's third need for constantly and effortlessly available sex, he would no doubt have been eager to meet that need too, if only Picasso had been willing. Max Jacob went

to see the Vollard show and soon after, struck by Picasso's "fire" and "real brilliance," he arrived at boulevard de Clichy to pay his respects to the young master.

Max was twenty-five years old when he met Picasso. He had arrived in Paris from Brittany three years earlier, determined to become an "artist"—a poet and a painter. "Stick to poetry" was Picasso's advice, and to a very large extent Max took it. He called Picasso "my little boy," but listened carefully to what the little boy had to say. At first, of course, any listening and talking had to be done in sign language: "Picasso spoke no more French than I did Spanish," he remembered later of their first meeting at the boulevard de Clichy studio, "but we looked at each other and we shook hands with enthusiasm." Despite the absence of a common language, they took to each other right away, and the next morning Picasso and his Spanish friends descended on Max. "Picasso painted on a huge canvas," he later wrote, "which has since been lost or covered over, my portrait seated on the floor among my books and in front of a large fire. I remember having given him a Dürer woodcut, which he still has. He also admired my *images d'Epinal*, which I think I was the only person collecting at that time, and all my Daumier lithographs; I gave him everything, but I think that he has lost it all."

In many ways Max did give him everything, far beyond his Dürer and his Daumiers. This short, prematurely balding intellectual, who wore a monocle with the sensuality of a woman wearing a garter belt, had already gained considerable influence in the demi-monde of poets and painters which he had made his home. He would launch some and help the careers of others already launched, but none would he love as deeply and as unconditionally as he loved Picasso. A tormented homosexual all his life, Max called homosexuality "an atrocious accident, a tear in the robe of humanity" and never confused his love for Picasso with the homosexual cravings that led him to short, casual encounters followed by much longer, guilt-ridden confrontations with himself.

It was a demonically creative summer. The art critic François Charles would caution Picasso "for his own good no longer to do a painting a day," but Paris had unleashed a surge of experimentation in him. It was a summer of reveling in the city, of celebrat-

ing his freedom from Spanish conventional morality, of flower still-lifes, cancan dancers, the races, pretty children and fashionable ladies. Yet a noticeable change was beginning to take place in both his mood and his work. He had allowed Manyac to organize his life and influence his work, but he was growing increasingly resentful of his control. He had clearly relished for a while prolonging his adolescence by handing over the reins of his life to an older, more experienced and more worldly man; but whatever the exact nature of his relationship with Manyac, he was torn between the needs it fulfilled and the needs it frustrated. "I have tried to express the terrible passions of humanity by means of red and green," wrote Van Gogh in 1888, and in 1901 Picasso, spurred by his inner turmoil and by the festering pain of Casagemas' suicide, switched his focus to the solitude and pain of humanity and tried to express them by means of blue. So began the procession of beggars, lonely harlequins, tormented mothers, the sick, the hungry and the lame. And in their midst was Picasso himself, his own suffering on display in a blue self-portrait.

It was with a great sense of relief that in late October he waited at the Quai d'Orsay station to welcome Jaume Sabartés from Barcelona. With him was Mateu de Soto, who had arrived a few days earlier. "All I could think of," wrote Sabartés years later, "was the effort he must have made in order to be at the station at 10 A.M., and I was able to say only: Why did you get up so early?" "To come to meet you" was Picasso's simple answer, but in that matter-of-fact reply was hidden his need for someone to rescue him from his growing confusion and isolation, now that he was trying to spend less and less time with Manyac. Max Jacob had offered himself up as an intimate, a protector, a buffer between Picasso and the outside, hostile world, but Picasso was still too rooted in Spain and too uncomfortable with his French to be able to embrace his offer fully. "We were both equally lost children," Max said.

Picasso needed his Spanish friends around him, and they all needed a spot they could turn into the hub of their centrifugal existence, a little bit of Spain in the middle of a city that magnetized and overwhelmed them at the same time. They found it in Place Jean-Baptiste-Clément in Montmartre. It was called Zut, and Fredé, the owner, with his beret and his guitar, was soon

caught up in the spirit of life and extravagance that the Spaniards
—"my little ones" as he called them—radiated. He whitewashed
the walls of his worm-eaten establishment, and Picasso and
Ramón Pichot began painting on the empty space. Pichot
painted the Eiffel Tower with Santos-Dumont's airship hovering
above it, while Picasso painted what his friends nicknamed "The
Temptation of Saint Anthony," a hermit surrounded by naked
women, and a portrait of Sabartés in the pose of an orator hold-
ing a book in his hand.

But even the transformed Zut and the presence of Sabartés
and his other friends could not prevent the shadows around Pi-
casso from lengthening. Now he could not bear to be alone, and
even when he was working—that sacred time when normally he
tolerated the presence of no one—he wanted Sabartés close to
him. At nights, too, when they returned from the Zut or the
Café La Lorraine, Picasso and de Soto, who was often with them,
would accompany Sabartés to the Latin Quarter, where he lived,
and then he would accompany them back; and then once again
they would retrace their steps, until, exhausted, they would
sometimes part and sometimes, when Manyac was away, stay all
together in Picasso's room. There they slept on the floor, using
books as pillows and whatever clothes were around as covers,
while Picasso's canvases were wedged against any cracks and
openings to keep out the cold.

The bitter Parisian winter was only one of the enemies Picasso
felt pressing against him. Relations between him and Manyac
were increasingly strained. Not only was their personal relation-
ship a source of endless conflict, but his latest work was a deep
disappointment to Manyac, who found that there was no demand
for paintings of suffering and resignation and could not under-
stand why his protégé, whom he had so brilliantly shepherded all
these months through the Parisian art world, had abandoned his
colorful, joyful subjects for something so morbid and, more to
the point, so unmarketable.

Picasso began to long to leave the studio on the boulevard de
Clichy, which, for the last few months, had been dominated,
rather ominously, by the largest canvas he had painted in Paris:
The Burial of Casagemas. Its size meant that it could double as a
screen, hiding all sorts of objects that Picasso could not bear to

throw away. Haunted by Casagemas in his mind, he was now haunted by the presence of his burial in his own room. And there was fresh guilt to be exorcised over having gone to bed, after his return to Paris, with Germaine, the woman his friend had so desperately loved. Working in the studio that had been Casagemas' last home, he did several eerie portraits of his friend in his coffin. In *The Burial of Casagemas* he struggled with an inaccessible reality opened up by death, still allowing himself the hope that there was a hereafter where peace and love could reign. His battle with death and an unknown God continued, brought dramatically to the forefront by his continuing obsession with Casagemas' suicide.

Picasso's mood was the mood of the times. "A great many scientists and scholars today have come to a halt discouraged," the young symbolist poet Albert Aurier wrote at the turn of the century. "They have nothing to put on old Olympus, from which they have removed the deities and unhinged the constellations." It was this mood of existential nothingness that had seized Picasso. Tired of the seesaw between his passion for life and his preoccupation with death, and not knowing what other road to try, he soon began to feel that leaving Manyac and the studio would not be enough. He had to leave Paris. Against every part in him that ached to cut the umbilical cord with his family, he wrote to his father asking for the money he needed to get back to Barcelona.

Suddenly his life revolved around the arrival of the mail. In his need to free himself from Manyac, he had turned to Don José. Dependence on his father seemed at the moment a small price to pay to escape from his protector. "It was evident," wrote Sabartés, "that he was not working anymore because some strange preoccupation was channeling his thoughts in a different direction; but in spite of our coaxings he refused to leave the studio on the ground that he was waiting for the postman. Manyac also behaved queerly. He seemed to avoid the studio whenever we were there; but Picasso insisted on our remaining."

"Manyac and he were at odds" was all that the ever-loyal Sabartés delicately said on the subject. It was, in fact, more like open war, and whose side the victory would go to depended on whether a letter with money arrived from Barcelona. Money was

the only hold Manyac had left on the young man around whom his life revolved, and he hoped that Don José would be unwilling to bail out his rebellious son once more. As for Picasso, the whole world was reduced to his longing for the letter from Barcelona. Nothing, not even work, could distract him, as though without his full attention there would be no letter and no escape.

One night in January 1902, Picasso and Sabartés were at the studio of Paco Durio, the sculptor and ceramicist who executed Gauguin's bas-relief sculptures in red clay and colored glaze. Normally, Picasso became completely absorbed in his conversations with Durio—mostly about Gauguin, Tahiti and sculpture. But that night he was restless and could not wait to get home to check his mail. Sabartés and Durio accompanied him to boulevard de Clichy. When they walked into his room they found Manyac lying on the bed, his face hidden in the bedcovers, repeating to himself, as if in a trance: "The letter! The letter!" On the floor was the letter from Barcelona.

With the money from Don José in his pocket, Picasso refused to spend one more night under the same roof with Manyac. He had won. He turned to Manyac as he was lying defeated on his stomach, gave him "an ugly look, made a scornful grimace" and left forever the studio and the life they had shared.

A few days later he set out, a prematurely jaded and disillusioned twenty-year-old, on the return journey to the city he still felt was home. His break with Manyac went against all his ambitions and self-interest as an artist. It had the urgency and all-consuming intensity of a man gasping for air. Was he fighting just Manyac, or also his own homosexual leanings, which he found impossible to reconcile with his image of himself as "a man"?

The practical consequences of what he had done stared him in the face only when he found himself again in his parents' home. He now had guaranteed free board and lodging, but it was deeply wounding to his pride to find himself once again in a state of childhood dependence. In Paris, Barcelona had acquired a glow born of his overwhelming need to escape and his sense of being an outcast in the French capital. In reality his relief was drowned in the humiliation of still being dependent on Don José. The second return home was much more wounding than the first.

The first had seemed like a temporary reversal of fortune, the fortune that he knew was his, the fortune that clearly belonged to him and that he had claimed as his own when he wrote "I, the King" on his self-portrait. At least then he had made enough money to buy his own ticket home; this time he had had to appeal to his father's inexhaustible goodwill and wait for him to scrape together the rail fare. Torn between anger and resignation, he could not bear to be at home, and in the evenings he would do anything rather than go back while his parents were still awake. He would leave the café or cabaret he had been in as late as possible, and then, if that wasn't late enough, he would walk up and down the Rambles talking to whoever cared to talk to him, rather than run the risk of coming home before his parents were safely asleep.

Since fortune had not arrived on his own schedule, he despairingly felt that it would elude him forever. "*C'est la vie*," he wrote to Max. *C'est la vie* to be still unrecognized, still dependent on his parents, still surrounded by bad writers and imbecilic painters who understood nothing. "I'm showing what I'm doing to the *artists* here, but they think there is too much soul and no form. It's very funny. You know how to talk to people like that; but they write very bad books and they paint idiotic pictures. That's life. That's how it is." Still, neither anger nor resignation stopped him from working. And although the gods might not have given him what he wanted as and when he wanted it, they kept providing him with everything he needed to do his work—like his studio in Barcelona. It was not really his studio at all, since the rent was split between Angel de Soto, Mateu de Soto's brother, and Josep Roquerol i Faura, but still there was no doubt about whose canvases, paints and demons dominated it, and even de Soto referred to it as "Picasso's studio."

The sometimes despairing, sometimes bitterly tender expressionism of the Paris Blue Period became still more intense in Barcelona. The destitute women of Paris appeared in their Barcelona incarnation utterly crushed by life and a hostile world. In *The Two Sisters*, his painting of a whore and a nun—originally a whore and a mother—Picasso expressed for all time his starkly divided vision of women as madonnas or whores. And in his life, having idealized his mother to the point where he could not even

bear to talk to the real, imperfect Doña Maria, he spent his time watching, sleeping with or painting women who in his mind occupied the slot reserved for whores. Two of the smaller nude drawings he would keep for his own private collection, always an indication that a particular work had special meaning for him. On one of them he had written: *Cuando tengas ganas de joder, jode*—"When you are in the mood to screw, screw." In his struggle to define himself as a man, robust lust seemed the most appropriate emotion toward women.

He had barricaded his heart against love, but he could not barricade his mind against obsession. And that spring he found himself obsessed with La Bella Chelito, who had become the talk of Barcelona with her risqué songs, her uncensored sensuality and, above all, with "The Flea," a sketch during which she undressed in the course of trying to rid herself of the biting insect. As La Chelito undressed, the audience went wild. Picasso, who did not miss a single show, went wild later in the privacy of his own room, obsessively drawing Chelito in all sorts of suggestive gestures and postures. One day, when Sabartés arrived to see his friend around midday, Doña Maria showed him to the room where her son was still asleep surrounded by drawings of Chelito, piled up on the table and the chair and overflowing onto the floor.

"The charm of the beautiful dancer and singer had bewitched him to the point where his only recourse was to make these sketches in order to rid himself of the obsession," wrote Sabartés years later. "Delicate, graceful, exquisite, full of charm, they were a faithful record of his impressions and an inexhaustible source of suggestions. Each of them dashed off at one stroke, without lifting the pencil, they were like the essence of an idea jotted down with flowing pen, without halt so as not to miss the minutest aspect of a gesture, the smallest detail of the fine form of this female body, ardent and supple, undulant, voluptuous, and all the rest!" The continuous stroke, a hallmark of many of Picasso's masterpieces, was already a fully developed part of his art. Some traced it back to Spanish calligraphers in the seventeenth century, drawing baroque ornaments without lifting their pen, but Picasso, more prosaically, traced it back to Malaga and

all the children he had seen drawing in the sand with a single stroke.

Sabartés had arrived in Barcelona early in the spring, beckoned back by Picasso, who had missed his hero worship. After stopping at his house only long enough to cut his heretical long hair, he knocked at his friend's door, intent on surprising him in bed. But Picasso was already at his studio absorbed in work—in fact, so absorbed that he barely lifted his eyes to say "Hola! . . . How are things?" It was a sign of his tremendous power to give himself totally to what he was doing, but it was also an assertion of his power over his friend. Sabartés could leave Paris to be with him, rush directly to see him—a point Picasso was quick to establish —and he would still have to wait until the master was ready to receive him. And Sabartés, far from being offended, was flattered to be admitted to the inner sanctum at all, looking only at the paintings right in front of him in order not to distract his friend and idol any more than was inevitable by the fact that he had to breathe in the same room. "I knew very well that if I were to turn a picture or take a paper in my hands, his train of thought would be interrupted and he might be disturbed emotionally."

Sabartés later described their daily schedule, his own will and wishes so identified with Picasso's that he saw nothing strange or worth discussing in the fact that his days and nights, his whole existence, had been placed at his friend's disposal: "After lunch we met in Els Quatre Gats and from there I accompanied him to the studio. Henceforth, every day was the same. At times I left him at the foot of the stairs; at others, if he insisted, I went up with him. If he asked me to stay, I stayed, for if he wished it he was more at ease once he began to work than if he were alone, for with me at his side, he did not need to think about me." It was the relationship of king to courtier, the kind of relationship that, increasingly, Picasso was most comfortable with.

When he was not in the mood to work, Picasso would often visit the Junyer-Vidal brothers. He was particularly fond of Sebastià, also a painter, whom he immortalized and glamorized in many quick sketches—as a torero, dressed in a toga with a lyre and a scroll, or surrounded by wise old men and voluptuous women. He even drew a cheerful comic-strip sequence of Sebastià and

himself, culminating in the art dealer Durand-Ruel being over-whelmed by Sebastià's work and offering him a bagful of money for it. Picasso was, once again, dreaming of Paris, art deal-ers, recognition and success. But, deeply superstitious, he did not dare tempt fate by visualizing the success directly for him-self.

Paris became even more appealing with the news that Manyac had given up art dealing and was returning to Barcelona "for family reasons." Picasso had one immediate problem to solve before making the journey the opposite way: he had to buy an exemption from military service. Don José, whose devotion to his son continued impervious to his ingratitude, persuaded his brother Salvador to put aside his disapproval of his nephew's lifestyle and give him the money he needed. Picasso went to the drafting barracks with Josep Rocarol, also a painter, six months younger than himself. There they paid the going rate for avoiding military service, and on October 19, a few days before Picasso's twenty-first birthday, they took the train to Paris with third-class tickets and thirty-five pesetas in Rocarol's pocket. Again, Picasso chose a friend who could provide both companionship and finan-cial support, however minimal.

They rented a room too small for a squirrel in Montparnasse, and as Picasso had fantasized in his comic strip, he went imme-diately to see Durand-Ruel. But reality lagged a long way behind, and neither recognition nor money was forthcoming. Durand-Ruel's gallery was next to Vollard's, but Picasso was loath to knock on doors that had previously been opened by Manyac. It was only a week later, after Rocarol's money had run out, that he plucked up courage to go and see Berthe Weill. She bought a painting of Rocarol's for twenty-five francs, which paid for their hotel room and their meals for a few more days. And then the money ran out, and the two friends went their separate ways to struggle as best they could against the hunger and cold of another Parisian winter.

Scuttling about from hotel to hotel, Picasso had never been more alone, less certain about where the next meal would come from and less sure about his future, let alone his destiny. One night after he had failed to sell a charming pastel he had done, perhaps for the very purpose of making a sale, he went to visit

Rocarol at Mateu de Soto's studio, where he was staying. No one was in, but he ran into Rocarol a little later in the street. "I've just been in your studio," he said, and then went on to confess: "The door was open. I found some bread on the table and I ate it. I found some coins, too, and I took them."

It was a time of inner torment as well as physical hardship. In the nude drawings of himself, he looks vulnerable, unkempt and lost. As for the watercolors he did of a couple making love, Palau i Fabre has described the bodies as "two worms, intertwined and intertwining . . . Perhaps Picasso, who is hiding his head in his mistress' body, is already hiding something from himself, something that he does not want to see completely or from which he wants to distract his mind."

Was he hiding from himself doubts about who he was as a man? Was the extremely blurred quality of these drawings a reflection of his own confused sexuality, of his unresolved feelings toward the gypsy and Manyac, of his fear of confronting them? Were the relentless brothel rounds and the red-blooded masculinity an expression of his volcanic lust, or did they hide a deeper conflict? A large number of the drawings from this period he burned in the Hôtel du Maroc on the rue de Seine. He said it was to keep warm; but perhaps it was also to destroy the evidence of an inner turmoil he resolutely refused to deal with.

It was at the Hôtel du Maroc that Max Jacob visited him with a young man he was tutoring. "I trust the young gentleman will never forget having seen poverty coupled with genius," he commented later. Max, once again, appointed himself the genius' protector and could think of nothing else until he had got him out of that miserable room. "Pedagogy is the work I'm most proud of," he wrote months before his death, but for his "little boy" he abandoned tutoring and pedagogy and took a job as shop assistant at his uncle Gimpel's department store. As soon as he got paid, he hired a horse and buggy and moved all Picasso's belongings to the room he had rented at 137 boulevard Voltaire: "In the most natural way in the world Picasso came to live in my room," he wrote. "He would draw all night and when I got up in the morning to go off to the store, he would get into the bed to rest."

So the solitary bed posed no problems. But Max's temperament

did. He was constitutionally incapable of holding down a regular job. He could, in spurts, do just about anything to make some money—from being a baby-sitter and a notary's assistant to giving piano lessons and reading palms—but he could not clock in and clock out of a department store however desperate their situation. And desperate it was. When Max, rather predictably, was fired from his job, they put all their belongings on a handcart this time and dragged them to 35 boulevard Barbes, a much cheaper place, where they could not even afford paraffin for Picasso to work at night. Instead, he spent many dark hours listening to Max recite his favorite poems. One of them was Verlaine's "Creeds," which Max could have written himself to describe his feelings for Picasso:

> You believe in coffee grounds,
> Tea-cup omens, gambler's chance:
> I believe in your eyes' dance.
>
> You believe in fairy tales,
> Dreams and lucky days or ill:
> I believe the lies you tell.
>
> You believe in some vague God,
> A special Saint who guards you here,
> For so much sin, just so much prayer.
>
> I believe in coloured hours,
> Blue and rose, when your delights
> Are bared for me through sleepless nights.
>
> In all that I believe, my faith
> Is so profound, so deep, so true,
> That I can only live for you.

All Picasso's hopes were now pinned on the new show organized by Berthe Weill, which included some of his paintings that Manyac had left with her and some of his more recent work. The other artists in the show were Launay, Pichot and Girieud, and the preface to the catalogue praised Picasso's "indefatigable ardor to see and show everything" and the "wild light" that permeated his work. But nothing was sold. Picasso's mood became even

more nihilistic, and Max described one evening when they were both leaning over the balcony on their fifth floor and for a moment the same thought of putting an end to it all crossed their minds. But it was only for a moment. "We must not have ideas like that," Picasso said abruptly, as though wanting to shake both of them out of a dark trance.

In sharp contrast to the darkness of his life was the brilliance of the future that Max predicted by reading his palm: "All the lines seem to be born from the line of fortune of this hand. It is like the first spark in a firework display; this live star-point is only very rarely found, and then only in predestined individuals." So Picasso's hand confirmed what Max already knew.

But brilliant prophecies did nothing to assuage Picasso's deathly despair, which was there for all to see in his work. Charles Morice focused on it in the essay he wrote for *Le Mercure de France* while the Weill show was still on. "It is extraordinary, this sterile sadness which weighs down the entire work of this very young man. His works are already numberless. Picasso, who painted before he could read, seems to have received the mission to express everything that exists with his brush. He seems a young god trying to remake the world. But a dark god. Most of the faces he paints grimace; not a smile. His world is no more habitable than lepers' houses. And his painting itself is sick. Incurably? I do not know. But certainly there is a strength there, a gift, a talent. Such drawing . . . Such composition . . . In the final analysis should one wish to see this painting cured? Is this frighteningly precocious child not fated to bestow the consecration of a masterpiece on the negative sense of living, the illness from which he more than anyone else seems to be suffering?"

It was a powerful piece, and it shook Picasso. He wanted to meet Morice, as if the man who had so accurately diagnosed his state of mind might also be able to provide a cure. Morice, a good friend of Gauguin's, introduced him to *Noa Noa*, Gauguin's autobiographical poem. Picasso's deep-rooted pessimism was pitted against Gauguin's primitive, questing optimism. "Where are we coming from? Who are we? Where are we going?" asked Gauguin, and although Picasso never formulated those questions in words, they were all there in his work and in the pulsating restlessness of his life.

He was still haunted by Barcelona, as if he had not yet exhausted the lessons it could teach him and the questions it could answer. In January 1903 he finally succeeded in selling a painting, *Maternity by the Seaside*, to the wife of his paint supplier, and so at least did not have to face the humiliation of asking his father for the rail fare back. The rest of his paintings he rolled up and left in the care of Ramón Pichot, who in turn left them on top of a cupboard. "If he had lost them," Picasso said later, "there would have been no Blue Period, for everything I had painted up to then was in the roll."

Just before leaving, he once again sought to fill the gap between his expectations and reality by doing a comic strip of Max glorified—accepted into the French Academy, driven in a chariot to the Arc de Triomphe and, finally, wearing a toga and carrying an umbrella, receiving a laurel crown from Pallas Athena in the Elysian Fields. It was a token of his gratitude to Max, a king conferring honors on a loyal subject in drawing since he could not yet confer them in life. Once in Barcelona, portraits of his friends provided Picasso with his main light relief from the tragic intensity of his Barcelona blues. He painted Corina Romeu, Pere Romeu's wife, Angel de Soto, Sebastià Junyer-Vidal and the delightfully naive family portrait of the tailor Soler enjoying a *déjeuner sur l'herbe*, for which he received a few very welcome suits. He also did a series of bright watercolors of Catalan peasants and several lively portraits of young women. Otherwise, his canvases were still dominated by a tragic spirit.

He worked in the studio that he had shared with Casagemas in the carrer Riera de San Juan. Angel de Soto had moved there while Picasso was in Paris, another coincidence that seemed to have been designed by the gods who oversaw his life. It was there that, in May 1903, he painted *La Vie*, the richly symbolic masterpiece of his Blue Period, with an idealized Casagemas facing an older, disapproving woman holding a sleeping baby while a young, naked woman is leaning on his shoulder in loving surrender. In the center of the painting one unframed canvas shows two nudes clinging together and another a nude woman in a fetal position of utter despair. *La Vie* seems to have been the only point of contact between Picasso and his father during this stay in Barcelona. Don José personally prepared the huge canvas, as

he had done for *Science and Charity* seven years earlier. But Picasso was determined to avoid any closer intimacy that might make it harder for him to break away.

He moved out of his parents' home into a rented room near his studio, and he populated his blue world with elderly, pathetic, dejected, often blind or mentally defective men. The presence in many of these works of young boys, sometimes comforting the elderly men and sometimes ignoring them, was part of Picasso's own struggle between his guilt at the pain his withdrawal was causing his father and his determination not to be sidetracked from his own life and his own vision. The struggle must have been very deep: around the same time, he did a small Crucifixion study, identifying himself with the crucified Christ.

He missed Max, whose mystical leanings were another unspoken bond between the two friends. Picasso may not have been prepared to embrace his spiritual nature, but there would always be a special place in his life for those who did. "My dear Max," he wrote to him from Barcelona, "It's a long time since I've written to you and it really isn't because I'm not thinking about you. It's because I'm working, and when you're not working either you enjoy yourself or you go crazy. I'm writing to you from the studio. I've worked here all day. Do you get any holidays from *Paris-Sport* or *Paris-France*? If so, you ought to come to Barcelona to see me. You can't imagine how happy that would make me."

Now that other pressures weighed on him, Paris was once again wrapped in a glow of selective happy memories: "My dear old Max," his letter continued, "I think about the room on the boulevard Voltaire and the omelettes, the beans and the brie and the fried potatoes." He concluded his letter by reminding his friend of the misery they had also shared, and signed off, "Your old friend Picasso." Still, he was not yet ready to return to Paris. He remained enveloped by a sense of meaninglessness and incomprehension at all the suffering in the world and in himself. The oldest questions, born of man's wrestling with the evidence of human misery, hovered over *The Sick Child*, over *The Tragedy*, *The Ascetic*, *Poor People's Household*, *The Old Guitar Player*, *The Poor Man's Meal*, *The Old Man and the Child*, *Poor People at the Seashore*, and over most of Picasso's work in Barcelona: Why is there so much sickness and pain and sadness every-

where? Why do children have to go hungry? And if there is a God, why does he let his children suffer so?

Yet in the midst of the poverty and pain there were the wholesome peasants of Horta de Ebro, where he had known real joy, the sensual nudes and the satirical drawings, as if life were too mysterious, too contradictory, too vast to be contained in a single philosophical viewpoint, and man too full of passions to drown in tragic pessimism. The contradictory passions of his own nature took over when he decided to cover the whitewashed walls in Sabartés' little apartment on the carrer del Consulado. Its windows faced the Llotja, and in his continuing war with his father, Picasso derived a special pleasure from knowing that, as Palau i Fabre put it, "while Don José Ruiz was giving drawing classes for young ladies, almost under his very nose—or behind him—Picasso was decorating the walls with blue paintings quite unsuitable for young ladies." On one wall opposite the window he painted a half-naked Moor hanging from a tree. On the ground, with the hanged man looking on, a young couple, completely naked, were making passionate love. Out of the porthole in the partition he made a wide-open staring eye, and underneath it he wrote an inscription in capital letters: "The hairs of my beard are gods like myself, although separated from me."

Sabartés, who was present while Picasso was transforming his walls, described the scene with awe: "He did not remove his eyes from the wall; he seemed oblivious to outside contact. One might think some occult power guided his hand and caused it to follow, with the tip of his brush, some path of light which only he perceived, for the brush was never lifted from the wall, and the line which it left behind did not seem to proceed from an intention but to emanate from the wall itself."

Sabartés saw Picasso every evening and was endlessly available whenever his friend was too restless to work. In fact, he quoted Picasso inviting him up to his studio one night and adding: "What do you have to do? Come on, let's go up for a little while." Picasso clearly could not conceive of his friend having anything more important to do than being with him. And he was right. So powerful was his personality that not only was what Sabartés did with his time determined by Picasso, but so was the mood he was in. "If he was contented, we all were," he recalled later of their

gatherings in Picasso's studio. "For it is his fortune, or misfortune, to be able, quite unconsciously, to raise or to depress the spirits of those around him since it is impossible for him, even if he were to try, to dissimulate his state of mind."

Picasso was constantly creating. When he was not creating at work, he was creating states of mind and moods that affected those around him and transformed the world and everything in it until reality matched his own inner state. When that state was negative, people were "imbeciles" and the world a dark, morose place. When that state shifted, it was, as Sabartés put it, "as if he were not the same man of an hour ago. Were he now to meet the 'imbeciles,' he would converse with them with the utmost naturalness and would even find them pleasant, and they would be charmed by him. . . . Now everything seemed splendid entertainment."

At the end of 1903, Picasso rented a studio from the sculptor Gargallo, who had won a scholarship to Paris. He reveled in having, for the first time in his life, his own latchkey, the *only* latchkey, a symbol of a new independence which seemed to coincide with a strengthening of his own identity apart from his family and apart from Barcelona. He also began to make plans to leave for Paris, renting the studio of Paco Durio in Montmartre and sending his paintings there. It was clearly no hasty, impulsive decision, brought about in reaction to the hardships of life in Barcelona, to be reversed as soon as the hardships of life in Paris made him long for a retreat. The deliberateness of his plans meant that this time he was ready to expand beyond the limitations of his homeland and embrace his destiny no matter what suffering was involved.

On April 12, 1904, accompanied by Sebastià Junyer-Vidal, he left for Paris. In a sketch done around this time, a naked man is jumping into the void, his arms tight against his sides. At twenty-three, Picasso was ready to take a leap into the unknown—a leap that, however fearful, he believed, with that faith that reason knows nothing about, would lead to glory.

3

THE DOOR TO MANHOOD

NUMBER 13 RUE RAVIGNAN was Picasso's new address in Mont-
martre. It was, in fact, a way of life more than an address. The
dilapidated building that Max Jacob christened the Bateau-Lavoir
(the laundry boat), because it resembled the kind of houseboat in
the Seine where women used to do their washing, had sheltered
a long succession of struggling artists, including Renoir, the
painter Maxine Maufra and the theater producer Paul Fort. The
structure was as unconventional as the occupants of the two
dozen studios. The entrance was on the top floor and one walked
down the hill to the other three floors. There were secret stair-
cases, trapdoors, creaking floors and, according to legend, dark
cells designed for screaming wives and jealous mistresses. The
construction was based on the principle that privacy was an out-
moded bourgeois invention. "Love's sighs traveled easily through
the partitions," wrote the chronicler of Montmartre Roland Dor-
gelès, "and all the more so did the domestic outbursts that could
be heard from the hold of the houseboat to the hatchway. Then,
Picasso's dogs began to howl, Van Dongen's little daughter burst
into tears, the Italian tenor stopped singing, the sandwich man
came home drunk, threatening to wreck the whole place."

There were two dogs in Picasso's studio: Gat, a little fox terrier
that Utrillo had given him and that he had brought with him
from Barcelona, and Fricka, a mongrel bitch that he kept tied to
a rickety chair. There was also a white mouse in a drawer perfum-

74

ing the air with its acrid smell. The studio, cobwebbed and dirty to start with, was reduced within a few days to utter chaos and squalor. The floor was covered with cigarette stubs and half-used tubes of paint, and there were canvases strewn everywhere, including on the bed and in the bathtub. Such was the kingdom over which Picasso reigned; but even on the verge of starvation, he was always the host. Very soon after his arrival at the Bateau-Lavoir, the Spaniards who were already in Paris congregated around him to warm themselves by the fire of his genius and watch over his well-being as though they owed it not only to him but to posterity.

Manolo was one of the first to put himself at the service of the young master. He felt no compunction about living at the expense of his friends, stealing Max Jacob's pants, selling Paco Durio's Gauguin collection when he was away in Spain, or running a lottery with one of his statues as first prize and the same number on all the tickets. But while he had nothing but contempt for morality, he was a worshiper at the altar of genius. For Manolo, genius was a matter of grace, and he recognized in Picasso, eight years younger than himself, not only a painter of genius but the creator of unlimited universes.

To furnish his studio at the Bateau-Lavoir, Picasso decided to pay eight francs for whatever Gargallo, who was returning to Barcelona, left behind. Together with Manolo and a Spanish boy he knew, even more impoverished than they were, he took a handcart to the rue Vercingétorix at the other end of Paris, loaded it with Gargallo's footbath, his chair, his table and his mattress and began the grueling return journey through the streets of Paris and up the steep hill of Montmartre. They had promised the boy five francs, but once everything was unloaded, they had to confess to him that five francs was all they had between them for food. So they invited him, instead, to share a meal with them.

Life at the Bateau-Lavoir was a series of such negotiations—for furniture, for food, for canvases, sometimes even for life. The streets of Montmartre were full of apaches and petty criminals, and Picasso never left his studio at night without a gun and even then, always accompanied. Max Jacob had become his doting shadow. Together with Manolo and Angel de Soto, he made

himself responsible for trying to sell some of Picasso's drawings, a task that turned out to be much harder than they expected.

Summer came, and in Picasso's studio, which was freezing in the winter, the heat became too oppressive to work in. So he opened the door wide and, dressed in nothing but a loincloth, stood at his easel, exhibiting both his work and himself to the passersby. Rather overimpressed by his muscle power, he took up boxing; but after only a couple of informal rounds he had to admit that boxing was clearly not part of his destiny.

Blue was still dominant on his canvases, but a rose glow began to creep in, anticipating a major change in his life. On the afternoon of August 4, 1904, in the middle of an unexpected thunderstorm, he was on his way to his studio, carrying a little kitten he had rescued from the storm, when a beautiful, statuesque woman rushed into the Bateau-Lavoir, drenched to the skin. He blocked her path and thrust the kitten into her arms—an offering and an introduction. He laughed and she laughed with him and he took her to see his studio. Her name was Fernande Olivier. In a nude autobiographical drawing, dated August 1904, they have just made love and he is still stretched on top of her, his feet barely touching hers, her almond eyes closed, her wavy hair dark and rich. He commemorated the occasion as if he knew immediately that this was not just another sexual encounter. It was, in fact, the beginning of his first real relationship, the first time in his life he committed himself to a woman, not "till death do us part" but at least until it stopped being passionate, inspiring or convenient.

Fernande had been born in Paris on June 6, 1881, four months before Picasso was born in Malaga. Her real name was Fernande Bellevallée, and she was the daughter of Jewish parents who made elaborate hats with feathers and artificial flowers. At seventeen she had become involved with a shop clerk, Paul-Emile Percheron, and had a son by him. When the child was five months old, Percheron married her, but soon after both father and son disappeared without trace, and Fernande married the sculptor Gaston de Labaume. In Fernande's inventive reshaping of her life, she had never had a child or a shop-clerk husband. Instead, at seventeen she had had, as she described it, "an extremely unhappy try at marriage," which left her at twenty-two,

again in her own words, "already a little disillusioned with life," living alone at the Bateau-Lavoir as Madame de Labaume. Her introduction to the art world was both through her husband and through her sister, who was the mistress of the painter Othon Friesz.

"For good or for bad," Gertrude Stein would say, "everything was natural in Fernande." She was naturally beautiful, naturally intelligent, naturally creative and naturally lazy. She painted and drew, but she preferred to expend her creativity in inventing a life, a past and a new name for herself. The new name was Olivier, and it was as Fernande Olivier that she entered Picasso's world and became his first official mistress and his door to manhood. "There was nothing especially attractive about him at first sight," she wrote years later about her meeting with Picasso, "though his oddly insistent expression compelled one's attention. It would have been practically impossible to place him socially, but his radiance, an inner fire one sensed in him, gave him a sort of magnetism which I was unable to resist."

For him, there was a sense of recognition and inevitability. And it was exhilarating to have such a beautiful, worldly woman beside him—a glorious affirmation of his manhood. He loved the way she looked and the way she dressed and wore her floppy hats with such instinctive grace. But there was also fear and anxiety prompted by the challenge of adult sexuality and the prospect of a real relationship. In the fall of 1904, Fernande moved in with him. Yet his fears persisted. In *Woman Sleeping,* he painted himself sitting by the bed, lost in anxious thoughts and imaginings, while Fernande lies blissfully asleep. She had surrendered, while he was still troubled by this dramatic change in his life.

A curtain was all that separated Picasso's studio and Fernande's refuge when his friends descended on them at unexpected moments. The hideout was soon turned by Picasso into a shrine to their love. He covered a packing case with a red cloth and on the center of this altar he placed a drawing of Fernande and a blue vase with artificial flowers. Next to the drawing nestled the crumpled white linen blouse she had worn the stormy afternoon they met, with a red rose pinned on it. "When you are in love at that age," Picasso would explain, "you make gestures like that."

Having overcome his anxiety about her living with him, he was

now equally anxious that she be with him *all* the time. He asked nothing from Fernande but to exist as part of his life. He didn't care if she cooked, he didn't expect her to keep their place clean or even to sweep the floor, and he positively forbade her to do the shopping, his jealousy creating nightmarish visions of her being propositioned on the streets of Montmartre and succumbing to other men's advances. His needs perfectly matched her disposition. "Out of a sort of morbid jealousy," she wrote, "Picasso forced me to live like a recluse. But with some tea, books, a couch, not much housework to do, I was very, very happy. I was, I admit, extremely lazy." Her youthful indolence and her unbridled sensuality were the cornerstones of their relationship. She offered Picasso passionate and abandoned sex, at any time that suited the unpredictable rhythm of his work and his equally unpredictable moods. By regulating his sex life she brought some stability to his whole existence. In fact, she brought much more than that. Her equanimity balanced his anxiety and her healthy optimism was an antidote to his depressions—not a potent enough antidote, however, as she herself was astute enough to observe. "This rather sad, sarcastic man, who was sometimes a bit of a hypochondriac, found no consolation but only forgetfulness in his work and in the love of his work, for he always seemed to bear a great grief within him."

With Fernande, Picasso was becoming a man, no longer the adolescent who searched for women in whorehouses and thought only of himself. He was now living with a woman who looked as though she had stepped out of a Lautrec painting, who spoke beautiful, elegant French, who caught men's envious eyes wherever they went and whom, however minimally, he had to support. She was taller and looked a good deal older than Picasso, who, with his boyish face and a black forelock drooping on his forehead, appeared even younger than he was. "Yes, she is very beautiful," he would concede to his friends who marveled at his mistress' looks, "but she is old." It was part sarcasm and part the old Spanish superstition about protecting what you possess by underrating its value.

But Fernande's value was there for all to see in the metamorphosis that his work underwent. Rose became the dominant color, and circus performers, harlequins and *saltimbanques* re-

placed the derelicts of the blue world. He still portrayed out-siders, but there was more tenderness and more empathy in this world of the circus. Charles Morice, who had castigated Picasso for his "sterile sadness" in 1902, wrote another piece in March 1905 in which he saluted Picasso's new maturity and his deepened sensibility, compared with his earlier work when "he seemed to take delight in sadness without sympathizing with it. . . . There is no longer a taste for the sad, for the ugly in themselves; this premature depression, which logically must have led to the dark-ness of a deathly despair, is succeeded by a beneficent anomaly, a ray of light: it is the dawn of pity that comes—it is hope."

The hope appeared often in the shape of children, as in the picture of the young harlequin father together with the mother taking care of their baby. One of these drawings was dedicated to Fernande: a young woman, who looks like her, is playing with her child while her husband is joyfully playing his accordion.

Another figure who began to appear, though in considerable disguise, in Picasso's work in the spring of 1905 was the young poet Guillaume Apollinaire. His first portrayal was in the *Family of Saltimbanques* as a big buffoon who presides over the group and combines the qualities of two major archetypes, that of the jester and that of the wise old man. He also soon appeared as a youthful giant: hardly an accurate reflection of the plump Apol-linaire's physical prowess, but more a subjective portrayal of Pi-casso's admiration for his friend's intellectual powers and understanding of the ways of the world—qualities on which Pi-casso would often lean as he negotiated his way through the minefield of his life in Paris.

Apollinaire, naturally brilliant and highly intuitive, had an in-timate knowledge of the world and its vicissitudes forced upon him from birth. His mother, Angelica de Kostrowitsky, the daugh-ter of a Polish papal chamberlain, was expelled from her school in Rome when, in 1880, she gave birth out of wedlock to a son named in honor of his Neapolitan father, Guglielmo Alberto Dulcini. A few years later, after she had given him another son, her lover left her, and she changed her firstborn's name to Guil-laume Albert Vladimir Alexandre Apollinaire de Kostrowitsky—a rejection of the man who had rejected her. He was brought up, successively, in Monte Carlo, where his mother acquired a pas-

sion for gambling, in Cannes, in Nice, in Aix-les-Bains, in Lyon and in the Ardennes. Having failed to pass the baccalaureate, he found a job as a tutor which took him to Germany and Prague— an early instance of Apollinaire's supreme ability to bluff, not by coarse pretense, but by instantly absorbing whatever information, impressions or knowledge he was exposed to. This, coupled with an outsider's contempt for the world's rules and a juggler's skill at manipulating them to his advantage, made him a consummate survivor and an astute promoter. Within days of meeting Picasso, he was writing his first promotional piece on him. It also happened to be his first piece of art criticism. He had never before taken any interest in the visual arts and had an even scantier knowledge of them than he had of Prague, a city about which he wrote a short story that left the reader convinced he had spent his entire life there.

What he did for Prague he did for the Blue Period. When its existence was revealed to him in Picasso's studio at the Bateau-Lavoir two days after they met, it was alien to anything he had ever seen or thought about. But when he wrote about it, it was as if he had been its creator. He certainly evoked in words what Picasso had expressed in images. And in the process, he recreated the Blue Period not only for his readers but even for its creator, who had brought it to life out of his loins rather than his head.

Picasso had found his interpreter, and the inhabitants of his blue world had found their champion in prose that was really poetry: "These children, who have no one to caress them, understand everything. These women, whom no one loves now, are remembering. They shrink back into the shadows as if into some ancient church. They disappear at daybreak, having attained consolation through silence. Old men stand about, wrapped in icy fog. These old men have the right to beg without humility."

In Apollinaire, Picasso had also found an advocate who was big enough to contain his contradictions. "It has been said," he wrote in the first issue of a small review he was editing, "that Picasso's work shows a precocious disillusionment. In my opinion the contrary is true. Everything he sees enchants him and it seems to me that he uses his incontestable talent in the service of an imagination that mingles delight and horror, abjection and delicacy. His

naturalism, with its loving precision, has a counterpart in the mysticism which, in Spain, is to be found deeply rooted in even the least religious mind. . . . One feels that his slender acrobats, glowing in their rags, are true sons of the people: versatile, cunning, dexterous, poverty-stricken and lying."

The same words might have been used to describe these two brilliantly gifted outsiders at the time they met, toward the end of 1904, at an English bar near the Gare Saint-Lazare. Apollinaire was there every night, waiting for the train to Le Vesinet, the suburb where he lived with his mother and brother. The money he made from editing and writing was far too meager to allow him the freedom to live in Paris, away from his increasingly eccentric mother and close to his artist friends. Picasso always remembered his first sight of Apollinaire: he was in a group consisting of two black women with garish ostrich feathers on their heads and a big red-haired Englishman, all absorbed in a game of dice, too absorbed to give Picasso the rapt attention to which he was fast becoming accustomed.

Another meeting was arranged at which Picasso was accompanied by Max Jacob, who, as well as being the resident jester, poet and provider, had, in the absence of Sabartés, slipped with amazing ease into the role of chief courtier. Max's first impressions of Apollinaire were at least as colorful as Picasso's: "Without interrupting a speech at once gentle and violent on the subject of Nero, and without looking at me, he held out a short, wide hand (it made one think of a tiger's paw). When he had finished his speech, he rose and led us into the night with great bursts of laughter, and then the finest days of my life began."

There wasn't much room in this triumvirate for Fernande. Exploring the secrets of the universe in cafés, in Picasso's underheated studio, in the streets of Montmartre was strictly men's business. Nor was Fernande the only woman in his life. There was a bisexual model called Madeleine, and there was Alice Princet, with her long dark hair and sensuous lips. She had been living with Maurice Princet, an actuary whose passion was mathematics, since she was seventeen, and as Gertrude Stein said, was "faithful to him in the fashion of Montmartre, that is to say she had stuck to him through sickness and health but she had amused herself by the way."

Picasso was in a great mood to explore and experiment, and his experimentation did not stop at painting, nor did his explorations stop at talking and sex. Opium was, in this artists' colony where there were no rules and no brakes, a doorway into new worlds and expanded visions. Picasso tried it, enjoyed it and abandoned it, after praising it for having "the most intelligent of all odours." The paralyzing impact it had on his work, together with his hypochondria, proved more powerful than his quest for novel experiences.

It was in the summer of 1905, when he was feeling run-down and ready for another fresh start, that Tom Schilperoot, a well-to-do Dutchman he had met rubbing shoulders with the artists in Montmartre, invited him to spend some time at his home in Holland. "I had no money," Picasso remembered, "and I needed some for the journey. Max Jacob had none either, but he went down to see the concierge. He returned with twenty francs." This was an unusual time for Picasso—a time when he needed to break with opium and the residues of the Blue Period and jettison, at least for a while, the belief floating around Montmartre that only suffering can produce great art. So, with twenty francs in his pocket, with a man he barely knew and without the woman in his life, he crossed the border into a new country.

"I had a knapsack and I put my colours into it," he said of his disorganized departure. "The brushes wouldn't fit at first, but I broke the handles, stuffed them in and off I went . . . Before leaving I drew a lawyer, pointing warningly, à la Daumier, and signed it, 'H. Daumier.' When I came back from Holland, I found they had sold it for a Daumier—and now when I go into a museum, I feel a pang of fear at the thought of coming across it." He returned with, among other paintings, *The Beautiful Dutchwoman* and *Female Nude with Bonnet*, plump and with ample breasts, maternal more than sensual, although he did say that "the most beautiful female breasts are those that give the most milk." But to Fernande, who had been patiently waiting for him in the smoldering heat of his studio, he played down the appeal of these wholesome milkmaids. "It was a ridiculous sight," he said, "to see those boarding-school girls filing down the street with figures like soldiers in armor." Ridiculous or not, this was a drastic and welcome shift from the emaciated creatures of the

blue kingdom he had left behind. It was a shift that speeded up the transition from poverty to prosperity.

The harbingers of his newfound freedom from want were Gertrude and Leo Stein. Gertrude Stein, whom Picasso later described as his only woman friend, was in fact more masculine than many of his men friends. "Masculine, in her voice, in all her walk" was the way Fernande described her. "Fat, short, massive, beautiful head, strong, with noble features, accentuated regular, intelligent eyes." She also had a large private income, skillfully managed by her elder brother, Michael, back in the States, which made her rebellions as well as her independent views and bohemian lifestyle much easier to sustain. She was twenty-nine when she left Baltimore, having completed her medical studies, which had included a course in surgery. And another brother, Leo, bald and bearded and with gold-rimmed glasses, had in the meantime been living in Florence, painting and immersing himself in art. When they came together in Paris they made a formidable couple, the object of both sniggering and fascination. Fernande was one of those fascinated: "Both were dressed in chestnut-colored corduroy," she remembered, "wearing sandals after the fashion of Raymond Duncan, whose friends they were. Too intelligent to care about ridicule, too sure of themselves to bother about what other people thought, they were rich and he wanted to paint." They soon provided the informal focal point of contemporary art. They inspired, catalyzed and cross-fertilized—and, even more important at this stage of Picasso's precarious existence, they bought.

Picasso met the Steins at Clovis Sagot's, the former clown who had turned a pharmacy into an informal art gallery. "Who is the lady?" Picasso asked Sagot. "Ask her if she will pose for me." Leo Stein recalled later that "at the very moment when Picasso was demurely awaiting her word of acceptance, Gertrude was vocally expressing total dislike of the painting they had come to see." The painting was the *Young Girl with a Basket of Flowers*, and Gertrude so hated the girl's feet that she even suggested cutting them out and keeping only the head. Finally Leo prevailed, and the first Picasso, "with feet like a monkey's," entered the Steins' apartment, at 27 rue de Fleurus, intact.

"Picasso little by little was more and more French," wrote Ger-

trude Stein, recollecting the beginning of a friendship that was at least as momentous for her as it was for him. "And this started the rose or harlequin period. Then he emptied himself of this, the gentle poetry of France and the circus, he emptied himself of them in the same way that he had emptied himself of the blue period and I first knew him at the end of this harlequin period." Her official recollection was appropriately rose-tinted: "The first picture we had of his is, if you like, rose or harlequin, it is *The Young Girl with a Basket of Flowers*, it was painted at the great moment of the harlequin period, full of grace and delicacy and charm. After that little by little his drawing hardened, his line became firmer, his color more vigorous, naturally he was no longer a boy he was a man . . ."

The beginning of 1906 found Picasso ambivalent about that shift. His work was suddenly populated by nude boys and horses: *Nude Boy Leading a Horse, Rider Seen from Behind, Nude Rider, Nude Boy on Horseback*, culminating in *The Watering Place*, depicting an Arcadian world of male beauty, of instincts and horses being given free rein. Women were absent from all the versions of this work, except one in which some vague silhouettes could be female—in the background and playing no part in the main action. It was another moment of hesitation, of nostalgia for the idealized world that living with Fernande, or with any woman, forever closed to him.

Picasso's mind may have been elsewhere, but Fernande continued to be the main presence in his life. She was always at his side at the Steins', where he was now a frequent visitor, and Gertrude had classified her as a "femme décorative." It was at the rue de Fleurus that Picasso met Matisse. They were Gertrude's two great loves, and she wrote a short story, "Matisse, Picasso and Gertrude Stein," to celebrate that love: "All that could be known was what all of them said they knew and they did know what they knew and they said all that they could say in saying all that they did say."

Fernande, who was far too intelligent to be simply a *femme décorative*, observed it all and remembered Matisse as "very much master of himself. Unlike Picasso, who was usually rather sullen and inhibited at occasions like the Steins' Saturdays, Matisse shone and impressed people. With his regular features and

his thick, golden beard, he really looked like a grand old man of art. He seemed to be hiding, though, behind his thick spectacles, and his expression was opaque, gave nothing away, though he always talked for ages as soon as the conversation moved on to painting. He would argue, assert and endeavor to persuade. He had an astonishing lucidity of mind: precise, concise and intelligent . . . They were the two painters of whom the most was expected."

Matisse's appraisal of Picasso and himself was "as different as the North Pole is from the South Pole." While Matisse pursued serenity in his life no less than in his art, Picasso was a seismograph for the conflicts, turmoil, doubts and anxieties of his age. Matisse's objective was to give expression to what he described as "the religious feeling I have for life. . . . What I dream of is an art of balance, of purity and serenity, free of disturbing or disquieting subjects . . . an appeasing influence." Picasso had no clear intellectual objective, only a vague but all-consuming urge to challenge, to shock, to destroy and remake the world. The fascination they exerted over each other was the foundation stone of the relationship that began in Gertrude Stein's living room and that, despite all its ups and downs, lasted until the end of Matisse's life. It was the fascination of opposites.

While Matisse was dazzling the art world with his wild outbursts of color and joy, Picasso was painting the portrait of Gertrude Stein in a brownish-gray monochrome. It had become a daily ritual. Gertrude would walk through the Luxembourg Gardens to the Odéon, take the horse bus to Montmartre, walk up to the Bateau-Lavoir and then down one flight of stairs to Picasso's studio. On the door where Picasso had written in blue "Au rendezvous des poètes," there were always plenty of scribbled messages from poets and other friends: "Manolo is at Azon's . . . Totote has come . . . Derain is coming this afternoon . . ." There was a lot of coming and going in the studio, while Gertrude sat for hours in the dilapidated armchair, talking and listening at the same time, an ability that she considered the hallmark of genius. Picasso, in the blue coverall of a Parisian mechanic, would sit on the edge of a kitchen chair, staring hard at the canvas, and whenever there was a lull in the exchange of ideas and gossip Fernande would step in and read stories from La Fon-

taine. Her voice was beautiful and her diction flawless. One after-noon, Gertrude Stein and her two brothers came to the studio with Andrew Green, a friend of theirs from Chicago. He was overcome by Fernande's beauty. "If I could talk french," he said to Gertrude Stein, "I would make love to her and take her away from that little Picasso." "Do you make love with words?" Gertrude asked, laughing. Andrew Green was also overcome by Gertrude's portrait and "begged and begged that it should be left as it was. But Picasso shook his head and said, *non.*"

There were more than eighty sittings, and still Picasso could not create a head that said what he wanted it to say. Finally one afternoon in May he painted the whole head out: "I can't see you any longer when I look," he said to an astonished Gertrude. He knew that his existing forms did not express what remained in him unexpressed. As would always happen, even after many years in France, whenever he felt disconnected from the source of creation within himself, his sense of exile from Spain intensi-fied, as though return to his homeland would provide the renewal he needed.

An unexpected visit later in April made it possible for him to leave for Spain and even take Fernande. Apollinaire arrived at the Bateau-Lavoir bringing with him Ambroise Vollard. Picasso was in his studio with Fernande, Max Jacob and André Salmon, a young poet he had met in the fall of 1904. To the amazement of everybody present, the dealer who had not long before called Picasso mad proceeded to buy thirty paintings and leave behind two thousand francs, an incredible sum at their then rate of spending, more than enough to cover their household expenses for the next three years. It was a particularly moving moment for Max, who a few years earlier, when Picasso was sick, had tried to sell Vollard one of his friend's landscapes. "The bell tower is crooked," he was told disdainfully, and with this the dealer, re-fusing to waste any more time, had turned his back on him. Now he watched triumphant as Vollard loaded the cab that had brought him to Montmartre with thirty canvases until there was no more room left in the back and he had to sit in the front with the driver. "Max and I," wrote Salmon, "gaped at this sight. [He] clasped my hand without saying a word, without looking at me, utterly content, his eyes like seascapes, full of tears."

With his newly acquired wealth stuffed in the inside pocket of his jacket and fastened with a safety pin, Picasso left with Fernande for Barcelona. Fernande had prepared herself for her first trip to Spain by buying "a dress and a hat and perfumes and a French oil stove to cook on." They arrived on May 20, and as soon as he breathed Spanish air he seemed to come to life. Fernande was astonished by the transformation: "The Picasso I saw in Spain was completely different from the Paris Picasso; he was gay, less wild, more brilliant and lively and able to interest himself in things in a calmer, more balanced fashion; at ease, in fact. He radiated happiness and his normal character and attitudes were transformed."

Part of the transformation was in his attitude toward Fernande. He seemed more at ease both with himself and with her. He enjoyed introducing to her the city where he had grown up, his old studios, the streets he had walked, the cabarets he had haunted, and he loved introducing Fernande to his friends and his parents. Having her by his side, so chic in her Parisian dresses and big hats, was, despite his ambivalence, visible, delicious proof that since his last stay in Barcelona he had crossed the border between adolescence and manhood. As a financially independent man with a beautiful woman by his side, he had grown even more distant from his father. Don José asked no questions, and no answers were volunteered. Doña Maria was untroubled by any questions and fascinated by Fernande, who, as her son's chosen one, was invested by her with the qualities of a goddess.

Showing off Fernande to Barcelona and Barcelona to Fernande was not, however, sufficient to replenish his depleted resources. He had to go further and delve deeper. And so he decided to cross the border of civilization and leave with Fernande for Gosol. His friend Dr. Cinto Reventós had recommended Gosol to him, as he often recommended it to his patients, for "good air, good water, good milk and good meat." Only a hundred miles from Barcelona but nestled high in the southern slopes of the Pyrenees, Gosol was inaccessible except by mule. An aura of wildness enveloped both the landscape and the inhabitants, many of whom took advantage of their village's closeness to the Andorran border to take up smuggling as a way of life.

The euphoria Picasso had shared with the gypsy in Horta he now shared with Fernande in Gosol. They spent many of their days exploring the mountains and many of their nights listening to the smugglers' stories. He was magnetized by their primitive power, just as they were drawn to his inexhaustible vitality. The innkeeper, Josep Fontdevila, an ex-smuggler himself, was so overwhelmed by Picasso that he wanted to follow him to Paris. The portrait and nude studies of the innkeeper are testament to the fascination that the old smuggler, in turn, exerted on the young painter. "He loved anything with strong local color," remembered Fernande, "and a characteristic smell could fill him with ecstasy. It seemed as though nothing abstract or intellectual could move him." He needed exuberance all the more since his own natural state was contained, reserved and even morose. In fact, Fernande, whose insights into Picasso deepened with time and absence, described him years later as constitutionally driven "towards everything tormented."

But not in Gosol. Gosol was one of those happy interludes when he gloried in life, nature, adventure and his love for Fernande. He painted her again and again, reveling in her beauty and her womanliness. But there was distance in the reveling. Even in *The Harem*, where all four nudes are Fernande in different poses, she remains "the other," the woman contemplated rather than the woman possessed.

The primitive nature of the village, surrounded by savage mountains and rocks thrusting into the sky, compounded the effect of an exhibition of recently unearthed Iberian sculpture that he had just seen at the Louvre and his own inner call to express a primitivism without sentiment. It was a truly experimental, deeply creative time, and also a time of rare contentment. He shaved his head and shed his gloom, and in the sketchbook he kept, the Catalan Notebook, he wrote a sentence that captured his high spirits and self-confidence: "A tenor who hits a note higher than the one in the score. Me!" And Fernande's words echoed his feelings: "In that vast, empty, magnificent countryside, or in those mountains with their paths bordered by cypress trees, he no longer seemed, as he did in Paris, to be outside society." At last, in a world which was outside society, the outsider belonged.

At the beginning of August it all came to an abrupt end when the innkeeper's daughter fell sick with typhoid fever. Picasso, panic-stricken that he might catch it, got Fernande ready in the middle of the night. They left at five in the morning on mules for Bellver, then traveled by stagecoach to Ax, and from Ax by train to Paris. His deep fear of disease made him imagine that typhoid had by now spread throughout Spain, but perhaps it was also his desire to take raw, primitive Spain with him, undiluted by civilized Barcelona, that made him bypass the city.

Back in Paris, still steeped in the atmosphere of Gosol, he threw himself into painting *The Peasants* and, in one single session, Gertrude Stein's head. "He painted in the head without having seen me again," she wrote, "and he gave me the picture and I was and I still am satisfied with my portrait, for me, it is I, and it is the only reproduction of me which is always I, for me." When Alice B. Toklas arrived from San Francisco and became a regular at the rue de Fleurus, she told Picasso at dinner one night how much she liked the portrait. "Everybody says that she does not look like it," he replied, "but that does not make any difference, she will." And she did—a portrait of Dorian Gray in reverse. The head was a mask, yet it was she, and the harbinger of a new direction in Picasso's art: "I did not use models again after Gosol. Because just then I was working apart from any model. What I was looking for was something else."

That something else had been awakened in him in Gosol and was fed, back in Paris, by the growing enthusiasm around him for primitive art. The primitive-art departments at the Louvre and in the Trocadéro's museum of ethnography were receiving more and more attention, and many of his artist friends started buying masks and primitive statuettes from bric-a-brac dealers. Especially Matisse and André Derain, who, a little over a year older than Picasso, had recently moved to Montmartre and joined the *bande* at the Bateau-Lavoir. His favorite occupation, when he was not painting, was talking about painting. Salmon, in fact, accused him of "trying to force his friends to speculate on the whole problem of art every time they took a brush in their hands." In 1906, it was the problem of African and Oriental art on which he wanted his friends to speculate.

"On the Rue de Rennes," wrote Matisse, "I often passed the

shop of Père Sauvage. There were Negro statuettes in his window. I was struck by their character, their purity of line. It was as fine as Egyptian art. So I bought one and showed it to Gertrude Stein, whom I was visiting that day. And then Picasso arrived. He took to it immediately." Max Jacob's recollection was much more dramatic. "Matisse took a black wooden statuette off a table and showed it to Picasso. Picasso held it in his hands all evening. The next morning, when I came to his studio, the floor was strewn with sheets of drawing paper. Each sheet had virtually the same drawing on it, a big woman's face with a single eye, a nose too long that merged into the mouth, a lock of hair on the shoulder. Cubism was born."

Cubism was not yet born, but in the fall and winter of 1906, Picasso was definitely pregnant with it. And preparations were under way for the momentous event. He had a canvas mounted on specially strong material as reinforcement and ordered a stretcher of massive dimensions. Years later he talked to André Malraux of the moment of conception: "All alone in that awful museum, with masks, dolls made by the redskins, dusty manikins. Les Demoiselles d'Avignon must have come to me that very day, but not at all because of the forms; because it was my first exorcism-painting—yes absolutely . . . When I went to the old Trocadéro, it was disgusting. The Flea Market. The smell. I was all alone. I wanted to get away. But I didn't leave. I stayed. I stayed. I understood that it was very important: something was happening to me, right? The masks weren't just like any other pieces of sculpture. Not at all. They were magic things. But why weren't the Egyptian pieces or the Chaldean? We hadn't realized it. Those were primitives, not magic things. The Negro pieces were *intercesseurs*, mediators; ever since then I've known the word in French. They were against everything—against unknown, threatening spirits. I always looked at fetishes. I understood; I too am against everything. I too believe that everything is unknown, that everything is an enemy! Everything! Not the details—women, children, babies, tobacco, playing—but the whole of it! I understood what the Negroes used their sculpture for. Why sculpt like that and not some other way? After all, they weren't Cubists! Since Cubism didn't exist. It was clear that some guys had invented the models, and others had imitated them,

right? Isn't that what we call tradition? But all the fetishes were used for the same thing. They were weapons. To help people avoid coming under the influence of spirits again, to help them become independent. They're tools. If we give spirits a form, we become independent. Spirits, the unconscious (people still weren't talking about that very much), emotion—they're all the same thing. I understood why I was a painter."

Everything, the whole of creation, was an enemy, and he was a painter in order to fashion not works of art—he always despised the use of that term—but weapons: defensive weapons against surrendering to the spell of the spirit that fills creation, and weapons of combat against everything outside man, against every emotion of belonging in creation, against nature, human nature, and the God who created it all. "Obviously," he said, "nature has to exist so that we may rape it!"

It was a thoroughly destructive art manifesto, but it was accepted, integrated and bought, partly because it mirrored the destruction of the most destructive of all centuries, and partly because it was interpreted as a lesser destructiveness and a smaller rejection, not of "the whole of it" but, depending on the interpreter, of bourgeois society, traditional art, sexual inhibitions, outdated mores and conventions. So his ultimate message was ignored or laundered until it was seen only as an audacious call to liberate art and society from all shackles.

It was more, much more, than that. It was a rejection of life and creation, which he saw as inescapably dark and harrowingly evil, an evil that was the product not merely of man and political systems but of the forces behind creation. So there was no hope beyond this existential rejection, no light beyond the anonymous, merciless darkness, no beauty beyond the ugliness and no new morning of creation beyond the suspended apocalypse. It was all—"the whole of it"—closed, condemned and damned.

There was, fortunately, another world of beauty, tenderness and an almost pastoral vision to which he could sometimes retreat, both in his work and in his life. There was no border between the two worlds and no redemption to be found, but at least the existence of that other world enabled him to survive the orgy of destructiveness that he was about to unleash in his work.

Les Demoiselles d'Avignon may have come to Picasso in the

Trocadéro, but there were Iberian influences, Egyptian influences and many unconscious philosophical influences whose principal perpetrator was a man scarcely five feet tall with long black hair parted on his large head and falling on his narrow shoulders, and with mad, deep black eyes. It was Alfred Jarry, the creator of Father Ubu, who in his play *Ubu Roi* summed up his philosophy of destruction: "Hornsocket! We will not have demolished everything if we don't demolish even the ruins!" Jarry abhorred every aspect of contemporary society, its bourgeois pretensions, sham and hypocrisy, and his life no less than his art was devoted to its destruction. He carried a pair of pistols and contrived opportunities to use them to underscore his social role. When someone stopped him in the street one night and asked him for a light, Jarry murmured politely, "Voilà," while pulling his gun and producing a flash of light by shooting it in the air.

He had given Picasso a Browning automatic, which he loved to carry and use on similarly inappropriate occasions. He fired it in the air with particular relish once as an answer to some admirers' persistent questioning about his "theory of aesthetics." The admirers were silenced, and Picasso wallowed in his display of outrageousness, which, as Jarry had been preaching, whether practiced in art or in life, helped push the frontiers of art and society beyond the present contemptible reality.

Destructiveness was Jarry's rallying call, and a deep, barbaric destructiveness was at the center of *Les Demoiselles d'Avignon*. But even as Picasso was working on the *Demoiselles*, Jarry, only thirty-four years old, lay on his deathbed, having destroyed himself with alcohol and ether before he had succeeded in destroying society. The man whom Apollinaire had described as "the last of the sublime debauchees in an orgy of intelligence" surrendered to a longing deeper than his flamboyant mind just before he died and asked for a priest to administer the last rites. The arch-cynic who had declared that "God is the shortest path from zero to infinity . . . therefore, ultimately, the point tangential to both," felt compelled on his deathbed to seek that God's presence in the most time-honored and conventional form. It was only one more paradox in a life filled with paradox. The man who had lived and died a virgin had, in his plays, often set the raw sexuality and primitive power of black Africans against the decadence

and bankruptcy of their rulers. And in *Les Demoiselles d'Avignon*, Picasso, no less obsessed with raw sexuality for liberally indulging in it, chose, as André Salmon put it, savage artists as guides. He was "the apprentice sorcerer always consulting the Oceanic and African enchanters."

When Jarry gave Picasso his own revolver, he knew that he had found the man who would carry out his mission of destruction. It was a ritual act and was seen as such by all those present at the supper at which Jarry passed on the sacred symbol. "The revolver," wrote Max Jacob, "sought its natural owner . . . It was really the harbinger comet of the new century." So was the explosion that was named *Les Demoiselles d'Avignon*: five horrifying women, prostitutes who repel rather than attract and whose faces are primitive masks that challenge not only society but humanity itself. Even the Picasso *bande* was horrified. "It was the ugliness of the faces," wrote Salmon, "that froze with horror the half-converted." Apollinaire murmured revolution; Leo Stein burst into embarrassed, uncomprehending laughter; Gertrude Stein lapsed into unaccustomed silence; Matisse swore revenge on this barbaric mockery of modern painting and Derain expressed his wry concern that "one day Picasso would be found hanging behind his big picture."

"It is not necessary," Picasso later said, "to paint a man with a gun. An apple can be just as revolutionary." And so can a brothel. Georges Braque, who had just met Picasso when he saw *Les Demoiselles d'Avignon* in the fall of 1907, knew immediately that nothing less than a revolution was intended. "It made me feel," he said; "as if someone was drinking gasoline and spitting fire." He was shocked, but he was also stirred as he had never been before. Seven months younger than Picasso, he was to become his partner not only in the great pioneering adventure of twentieth-century art but also in a shared intimacy that was rare in Picasso's relationships and unique in his relationships with other painters. "The things Picasso and I said to each other during these years," Braque would say, "will never be said again, and even if they were, no one would understand them anymore. It was like being two mountaineers roped together."

Six feet tall and very handsome, Braque was good at boxing, good at dancing the jig and an accomplished musician who could

play Beethoven symphonies on his accordion. "I never decided to become a painter any more than I decided to breathe," he said. "I truly don't have any memory of making a choice." His father had been a painter, although he made a living as a decorator, and Braque had been apprenticed to him before leaving Le Havre in 1900 and settling in Montmartre. He attended the Ecole des Beaux-Arts and the Académie Humbert, and in 1906 he exhibited for the first time at the Salon des Indépendants. "What a great thing, that Salon!" Braque recalled years later. "I've never known anything better. Everybody who exhibited there could really not be admitted at any other Salon." In 1907, when he exhibited again, together with Matisse and Derain, all his canvases were sold. When he began to meet the Bateau-Lavoir group, he was more interested in his artistic experiments than in life. And even then he stressed the importance of knowing how to check one's inspiration with a ruler. It did not take him long, though, to get out of his proper blue suit and into the blue coverall that was Picasso's uniform and to start exploring the world of cafés, of writers and poets. Together with Picasso, Apollinaire and Salmon, he would cross the Seine to the Closerie des Lilas, where every Tuesday evening writers and artists would congregate to listen to poetry, drink and argue until two in the morning —unless there was a special program that kept them there until dawn.

The circle of friends was growing, and so were the quarrels and the bickering. "There never was a group of artists," Fernande was to remember later, "more given to mockery and the unkind and intentionally wounding word." Jean Moréas was one of the poets at these Tuesday evenings who particularly enjoyed needling Picasso: "Tell me, Picasso," he would ask, dripping with sarcasm, "had Velázquez any talent?" "What annoys me about painting," he added once, "is all the gear you need . . . easels, tubes of colors, paintbrushes . . . a studio! Now, I composed my *Strophes* simply walking along in the rain." Picasso's comeback was to ridicule Moréas in a portrait. He was not sufficiently sure either of his French or of himself to answer him face to face. Only in the midst of his own *bande* was he, for the moment, the sovereign artist around whom others gravitated, not merely convinced of his genius but touched by his incalculable power to enchant.

Apollinaire introduced Picasso to Braque, and Picasso introduced Apollinaire to Marie Laurencin with the excited promise that he had discovered a fiancée for him. She was studying painting at l'Académie Humbert, where she had already met Braque, and in 1907 she had exhibited for the first time at the Salon des Indépendants. She was twenty-two when she met Apollinaire, and like him, she was born illegitimate and lived with her mother in a small apartment. She never became his fiancée, but they quickly proved Picasso right by becoming inseparable for the next five years—which greatly displeased Fernande. She described Marie Laurencin to Gertrude Stein as "a mysterious horrible woman who made noises like an animal and annoyed Picasso." When finally Apollinaire brought her to the rue de Fleurus, Gertrude Stein found her in fact very young, very chic and very interesting. "Marie Laurencin," she wrote, "was terribly near-sighted and of course she never wore eye-glasses, no french woman and few frenchmen did in those days. She used a lorgnette." Despite Fernande's feelings about Marie Laurencin, the two couples were often together, and in *Apollinaire and His Friends*, Marie Laurencin immortalized the quintet—Apollinaire and herself, Picasso, Fernande and their beloved dog Fricka. It was the first painting she ever sold and it was bought by Gertrude Stein.

One evening in 1908, Fernande recalled, the four of them; as well as Max Jacob and Princet, whose wife, Alice, had just run away with Derain, gathered together at Azon's restaurant, taking hashish pills. The evening ended in Princet's deserted room, where, their guards down, they each disappeared into a private fantasy world. Princet wept; Max Jacob sat quietly in a corner, blissfully happy; Apollinaire was having the time of his life in an imaginary brothel; Marie Laurencin, ever controlled and dignified, left early to return to her mother and her cat, and Picasso was lost in a horrible vision that he had come up against a wall and could no longer progress or develop. In his nightmare he shrieked that he had discovered photography, that there was nothing left for him to learn, that he was condemned to paint the same thing over and over again and that he wanted to kill himself.

His fantasy hell was soon matched in reality. One hot night in June he was painting with the door of his studio open when

Fricka began to bark uncontrollably. He left the studio, following the dog, and found Wiegels, the German painter, hanging by the neck from a beam in his studio. Being confronted with death so unexpectedly and in such proximity was an alarming experience for Picasso. He grew progressively more depressed and worried about his own health. His diet became increasingly ascetic, his aperitifs were replaced by mineral water and he abandoned hash-ish pills, as he had abandoned opium, forever. But no amount of fear for his health would make him give up his pipe and his cigarettes, not even after he became convinced that his smoker's cough was the onset of consumption. He longed to escape from the Bateau-Lavoir, but was feeling too run-down and emotionally exhausted to undertake a long trip to the south. So he found a little cottage on a farm in La-Rue-des-Bois, only twenty-five miles outside Paris. Surrounded by meadows and forests, he became fascinated by the landscape as subject matter for his work, and green began to dominate the Rue-des-Bois paintings.

While Picasso was exploring a bypath, Braque in L'Estaque, in the South of France, was reinterpreting the familiar landscape that had once captivated Cézanne. The Salon d'Automne was clearly not ready for the reinterpretation. He submitted six land-scapes to it and they were all rejected, even though the Salon d'Automne had been founded, like the much more rebellious Salon des Indépendants, to provide an alternative to the stifling traditionalism of the established exhibitions. Matisse, Rouault and Marquet managed to persuade the rest of the jury to reverse the decision on at least two of them, but as far as Braque was concerned, it was a case of too little, too late, and he withdrew them all.

It fell on Henry Kahnweiler to organize the first Cubist exhibi-tion—a Braque show that took place in November 1908 in his gallery in the rue Vignon. The gallery, hung in gray velvet, was as discreet as its owner, who, still in his early twenties, was a model of elegant reserve. After leaving his native Germany, he had been a banker in London, and mixed with his artistic daring and his profound intellectual curiosity there was a banker's cau-tious meticulousness. Louis Vauxcelles in his review of the Braque show wrote scornfully of Braque's reducing everything to "little cubes." Later on, in another review, he became even more

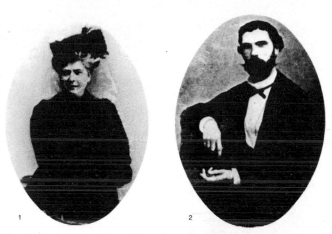

*[LEFT] Maria Picasso Ruiz, Picasso's mother. "If you become a sol-
dier," she told him, "you'll be a general. If you become a monk, you'll
end up as the Pope." [RIGHT] José Ruiz Blasco, Picasso's father, his
first teacher and the first to recognize and nourish his genius.*

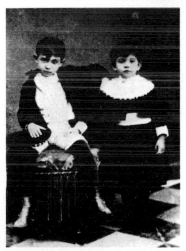

*Pablo with his sister Lola. Her birth, in the aftermath of an earthquake
when he was three years old, was a shattering event for him.*

Pablo's drawing of his sister Conchita,
whose death at the age of eight
convinced him that God was evil and
destiny an enemy.

Pablo, age fifteen, at a family
gathering, seated at the right.

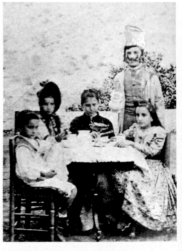

Pablo serving his young cousins,
adorned by a hat and a moustache
which, according to family legend,
he painted on the photograph
himself.

7

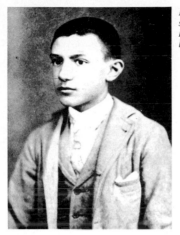

Pablo at fifteen. In between his studies at the School of Fine Arts, he spent endless hours in the brothels of Barcelona.

8

Portrait of Jaume Sabartés, the first fanatical champion of Picasso as an artist-hero.

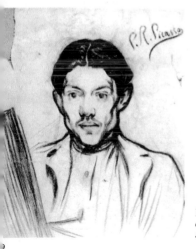

Picasso Bewildered, *a self-portrait drawn in 1898, his eyes peering anxiously into the future.*

9

10

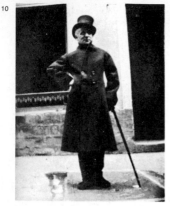

Max Jacob, a poet and guilt-ridden homosexual, became Picasso's protector and worshiper. Throughout his life, he would love no one as deeply and as unconditionally as he loved Picasso.

[BELOW LEFT] Living in poverty and obscurity in Paris, Picasso was nonetheless as sure of his physical prowess as he was of his artistic gifts.

11

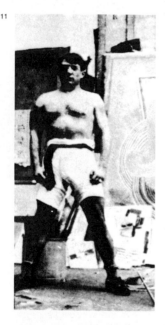

Picasso's portrait of Pere Manyac, the Catalan art dealer who, mesmerized by Picasso, offered himself as a guide through the Parisian art world.

12

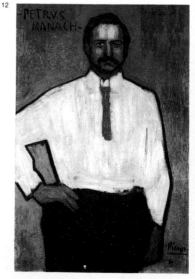

PETRVS MANACH

In 1904, Picasso rented a studio at the Bateau-Lavoir in Montmartre, which had sheltered a long succession of struggling artists.

Picasso in Montmartre. He would always remember the years at the Bateau-Lavoir as his golden age.

15

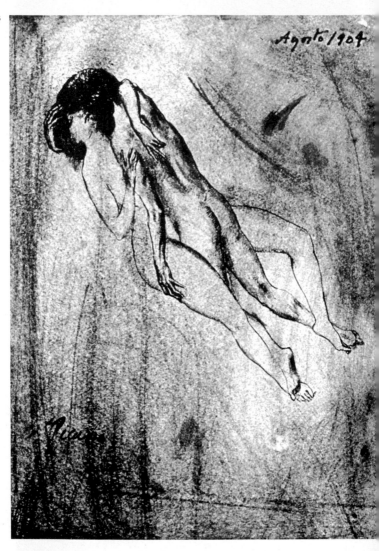

Agosto/1904

Fernande Olivier, elegant and assured, was Picasso's first mistress and his door to manhood. [OPPOSITE] He commemorated with a drawing the first time he made love to her, as if he knew that this was not just another sexual encounter.

The Watering Place. *At the beginning of 1906, his work was suddenly populated by nude boys and horses.*

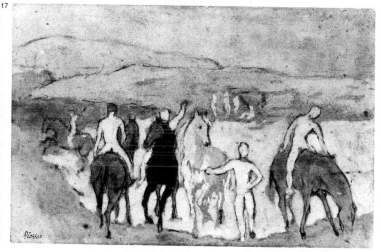

18

*In Gosol, nestled high in the
southern slopes of the Pyrenees, he
painted Fernande again and again,
reveling in her beauty and her
womanliness. But there was distance
in the reveling.*

*Gertrude Stein, seated beneath her
portrait, completed in 1906.
"Everybody says that she does not
look like it," Picasso said, "but that
does not make any difference, she
will." The head was a mask, yet it
was she and the sign of a new
direction in Picasso's art.*

19

scornfully exact and talked of Peruvian Cubism. Kahnweiler was pleased. With his deep-rooted sense of history, he took it as a very good sign that the artistic movement of which he was such a fervent champion had been christened by an adversary: "Movements which choose their own names," he said, "reveal either their artificial character or their dominance by an ambitious chief."

To the extent that Picasso felt himself part of a movement, it was a movement made of two. "Braque and I," he said, "worked with enthusiasm, and that was the main thing, putting much more into our efforts than usual, for we were involved in them body and soul." It was a quest that transcended ego and personal ambition, and to underline that what they sought was "pure truth without pretension, tricks or malice," they signed their canvases only on the back to preserve an anonymity uncontaminated by the tinge of personal glory. "Picasso and I," Braque said, "were engaged in what we felt was a search for the anonymous personality. We were inclined to efface our own personalities in order to find originality. Thus it often happened that amateurs mistook Picasso's painting for mine and mine for Picasso's. This was a matter of indifference to us, because we were primarily interested in our work and in the new problem it presented."

Picasso loved sailing in uncharted seas, confronting the unknown, with Braque as companion and confidant. "Picasso, amateur painter" was how he signed a note to the Steins at that time. "We had moved so far from all hitherto known and appreciated modes of expression," Picasso said later, full of nostalgia for that period, "that we felt we were secure against any suspicion of ulterior motive." And in 1931, during a particularly happy period in his life, he said to friends, "I'm feeling again as happy as I was in 1908."

It was a happiness born of a scientist's absorption in his laboratory experiments when the emotional turmoil and the petty irritations of daily life were all suspended. His relationship with Fernande also moved to the background of his life, the foreground occupied by Braque, their explorations and their intimacy. Fernande, who had mistrusted Braque from the beginning, now saw him clearly as a rival. Picasso's passion was being channeled into his work with Braque, and Fernande's role in his life had become, as Gertrude Stein observed, more mater-

nal than sexual. "Braque is the woman who has loved me the most," Picasso would later say. It was partly a comment on the intensity and intimacy of their relationship, partly an assertion of his supremacy and partly a testament to Braque's capacity for devotion. He had taken to calling Braque "cher maître" to mock Juan Gris, the young painter who had recently arrived at the Bateau-Lavoir from Madrid and had started reverentially addressing Picasso, who was only five years older, as "cher maître." Picasso was furious, especially since this was the time when he was consumed by the effort to purge his expression of all posturing and empty gestures. "I want an engineer to be able to construct the objects in my paintings," he said to Kahnweiler.

In November 1908, Picasso and Braque laid aside their experiments to indulge in a wave of sentimentality for a man whose painting celebrated childlike innocence, spontaneity and imagination. Henri Rousseau, known as the Douanier from his job as a customs officer, was a short, shy man in his mid-sixties who lived alone in a tiny room on the Left Bank and painted as unselfconsciously as he lived. He had exhibited for years at the Salon des Indépendants and at the Salon d'Automne, but his paintings, so alien to the spirit of the times, were at best seen as charmingly irrelevant and at worst heartily mocked. Until, that is, Apollinaire decided to take up Rousseau at the same time that he took up the Marquis de Sade and was busily writing an introduction to his *Collected Works* to be published the following year. He saw no contradiction in simultaneously proclaiming the need to bring to light the works of de Sade and the need to celebrate the purity and childlikeness of Rousseau and his work. He quickly enlisted Picasso, and together they began planning a grand banquet in the Douanier's honor to be held in Picasso's studio.

A huge streamer was put up at the entrance to the Bateau-Lavoir, leaving no one in any doubt about the purpose of the evening: "Hommage à Rousseau." There were about thirty guests, including Marie Laurencin and André Salmon and Pichot, the Spanish painter, and his wife, Germaine—the same Germaine over whom Casagemas had committed suicide—and Gertrude Stein and Alice B. Toklas, who was by now her live-in lover, and Maurice Raynal, who wrote one of the many elaborate

accounts of the banquet that overnight became a legend: "The walls at Picasso's studio had been cleared of their usual decorations and on them were hung only a few fine negro masks and a map of Europe, with Rousseau's large portrait of Yadwigha [the Polish schoolteacher who was his mistress] in the place of honor. The room had been decorated with garlands of Chinese lanterns. The table was set on trestles and laid with all sorts of things for the meal. . . . The two neighboring studios had been requisitioned, one to serve as a cloakroom for the ladies, the other for the men. Above the hubbub, the seating around the table was indicated according to strict etiquette, and while the room was seething with noisy protests, three discreet knocks sounded on the door. Immediately, the noise ceased and complete silence reigned. The door opened. It was the Douanier, wearing his soft felt hat, his stick in his left hand and his violin in his right."

He was ecstatically welcomed and seated on a throne made of a chair on a platform. True to the surrealist nature of the occasion, it soon became obvious that this was going to be a banquet without food. It had been ordered from the caterer Félix Potin but, as Picasso suddenly realized, for the following night. Alice Toklas suggested immediately that they telephone Félix Potin, but was reminded that this was Paris, not San Francisco, and that "one did not telephone and never to a provision store." Fortunately, Fernande had made a big pan of rice "à la valencienne," and a sortie to the local shops that were still open provided enough sardines, sausages, tarts and cream buns to supply food, if not fit for a banquet, at least enough for a meal. Apollinaire, acting as master of ceremonies, formally introduced the guest of honor, and in between courses as well as after dinner there were speeches and poems and music and dancing, all an offering to Rousseau. Pichot danced a ritual Spanish dance, Braque played the accordion, André Salmon climbed on a table and recited an ode to Rousseau, and Apollinaire recited a poem celebrating Rousseau that he had written for the occasion. Through it all, the Douanier sat on his throne, an ecstatic smile on his face, while a Chinese lantern above the chair was dripping wax directly on his head until the droppings formed a little clown's cap, which stayed there until finally the lantern caught fire. "It didn't take much," Fernande wrote in her memoirs, "to persuade Rousseau

that this was his apotheosis." After which he played on his violin the entire repertoire of his favorite tunes and made the ladies dance to his music.

In the early hours of the morning, as Picasso was helping the overwrought Douanier into a cab, Rousseau turned to him, thanked him for the happiest day of his life and said: "You and I are the greatest painters of our time, you in the Egyptian style, I in the Modern!"

Picasso and Braque, working side by side, continued in the struggle to extinguish the individual personality from their work. And as often happened when he was breaking new ground and creating a new language, Picasso longed to get back to Spain, as if in the Spanish light he could more clearly see the direction in which he was going. In the summer of 1909, as the questioning in his painting was becoming increasingly relentless and his dispute with the universe all the more intense, he longed not just for Spain, but for the harmony and exaltation that he had experienced, more than anywhere else, in Horta ten years earlier. After spending as little time as possible in Barcelona, Picasso and Fernande left for Horta, together with Pallarès. "He never mentioned Cubism," Pallarès said. Yet this was the new vision that dominated his work. Fernande took photographs of the town, and when they were later shown at the Steins' Saturday soirées, they very eloquently made Gertrude Stein's point: "It always amused me when every one protested against the fantasy of the pictures to make them look at the photographs which made them see that the pictures were almost exactly like the photographs . . . the Spanish villages were as cubistic as these paintings."

In Horta, even without the young gypsy, Picasso was once again renewed, inspired and invigorated. He played dominoes in the local café, he listened to the owner play the guitar, he chatted with the peasants, he rekindled his love for Fernande. He was happy, and nothing, not even the stoning of his windows by some irate villagers who had discovered the dreadful secret that he and Fernande were not really man and wife, was enough to make him unhappy. In fact, he was rather amused by the melodrama of the situation and responded in kind by firing his Alfred Jarry revolver in the air. The villagers were suitably quieted, and Picasso went

back to painting and promenading around the village with Fernande on his arm.

In his art he had succeeded in paring down the confusing detail of everything he saw to the underlying essential forms. He now wanted to discover a similar order beneath the confusion of his life. When he returned to Paris, the walls of the Bateau-Lavoir stared at him and oppressed him. He had to leave, and at the beginning of September he and Fernande moved to 11 boulevard de Clichy, near the place Pigalle. So dramatic was the contrast that the moving men were convinced they had won the lottery. "These people must have hit the jackpot," one of them exclaimed to Maurice Raynal, who was helping Picasso with the move. In a sense, they had. The jackpot consisted principally of the Russian collector Serge Shchukine, who had bought fifty of Picasso's paintings all at once, partly for the pleasure of shocking his aristocratic friends and relatives in Moscow. Picasso's days as an impoverished artist were over.

The building into which he moved belonged to Théophile Delcassé, a former Minister of Foreign Affairs who had engineered the Entente Cordiale. Picasso's studio apartment had an old-world elegance partly enhanced and partly diminished by his growing collection of furniture and knickknacks. One thing linked them: each had, for whatever reason, aroused his curiosity. There was a small fireside chair in threadbare upholstery, along with a huge Louis-Philippe couch covered in purple velvet with gold buttons, old tapestries on the walls, an immense cherrywood sideboard for the dining room, the Chippendale chairs his parents sent him from Barcelona, African masks and carvings, syrup bottles, musical instruments, a small picture of a young woman by Corot together with lots of cheap, colorful prints in straw frames. Presiding over the maintenance of all these treasured objects was a maid in a white apron, who found out very soon that many stringent conditions were attached to her job. She was not allowed to do any housework in the morning, as the noise would awaken the young couple, who often did not rise until noon, and she was never allowed to sweep the studio, as Picasso hated disturbing the dust, which would then rise and take revenge by sticking on his wet canvases. The maid, learning to

comply with her employer's habits, got up later and later herself and did as little work as possible, which suited everybody.

Fernande had no problem adjusting to having their meals cooked, nor to eating in a proper dining room served by their uniformed maid, nor to holding ladylike at-homes on Sunday afternoons. "In spite of all this," she wrote in her memoirs, "Picasso was less happy here than he'd been before." It would have been closer to the truth to say that *they* were less happy here together than they had been before. They had been growing further and further apart, and in an attempt to reawaken his interest and perhaps, she thought, the old passion, Fernande started having casual affairs. But all she awakened in Picasso was an occasional burst of anger.

His mind was on other things, his whole being absorbed by the journey he and Braque had undertaken. His needs for intimacy that had been largely met by Fernande were now satisfied through his relationship with Braque, and his old romantic comradeship with her, nurtured by poverty, had been eroded by prosperity and growing recognition. These were the most successful of times so far, but not the best of times. And Picasso's absorption in his work was taking its toll—his digestion suffered and he had to give up drinking wine and eating anything other than vegetables, fish, grapes and rice pudding.

The less the world around him responded to what he was doing, the more ferocious became his commitment "to go all the way," as he put it at the time. In a letter to Kahnweiler, who had just told him that one of his more loyal collectors did not like his latest work, he replied: "That's fine. I'm glad he doesn't like it! At this rate we'll disgust the whole world." The world had not fully embraced him; he would fully reject it. It was the logic of a hurt child, but it contained an arrogance that served him well during this time of isolation when so few could follow what he was doing.

Apollinaire was as loyal as ever, embracing everything Picasso did as "moving toward an entirely new art which will stand in relation to painting, as hitherto regarded, as music stands in relation to literature. It will be pure painting, just as music is pure literature." His preface to de Sade's *Collected Works* had just been published when Picasso moved to the boulevard de Clichy. No Sadeian chaos reigned, however, in Apollinaire's extremely

conventional and meticulously tidy tiny apartment on the rue des Martyrs, where he was exploring his own sexuality with Marie Laurencin. She complained later that they used to make love in an uncomfortable armchair rather than mess up his beautiful bedspread.

While Apollinaire was celebrating de Sade—at least intellectually—Max was discovering Christ. He had been leaning for a long time toward the occult, reading cards and coffee grounds, casting horoscopes, making talismans that even his most rational friends would not risk giving up, and reading palms. But there was a very definite leap between dabbling in the occult and a religious conversion. It happened on the night of October 7, just after Max had returned from the Bibliothèque Nationale. "I was hunting for my slippers," he said, "and when I lifted my head, there was someone on the wall. There was someone! There was someone on the crimson wallpaper. My chair fell to the ground, a flash of lightning had left me naked. Oh, immortal moment! Oh, truth! Truth, tears of truth! Joy of truth! Unforgettable truth! The heavenly body was there on the wall of my poor room. Why, oh Lord? Oh, forgive me! He was there in a landscape I had painted myself, but it was He! What beauty, elegance and gentleness! His shoulders, his movements! He wore a robe of yellow silk, with blue embroidery."

Partly because of the melodrama inherent in his religious expression and partly because of his dissolute lifestyle, the priests he appealed to, even those specializing in the conversion of Jews, were reluctant to receive him. So Max read all the sacred books, prayed in most of the churches of Paris and waited. The priests hesitated to accept the truth of his conversion, and his friends were inclined to ascribe it to his consumption of ether and his propensity for drama and exhibitionism, yet it was hard to deny Max's longing for spiritual truth—a crying out in pain against the futility of seeking to transcend the human condition without the intercession of the divine.

Picasso, who sought to transcend both himself and the human condition while calling himself an atheist, was nevertheless drawn to his friend's mystical disposition and his attempt to find a higher expression that went beyond revolt. As for Max's relationship to Picasso, it was subtly but definitely transformed after

his conversion. Before that fateful night when Christ appeared to him, he had confessed to Picasso: "You are what I love most in the world after God and the Saints, who already consider you as one of themselves." His conversion had imbued his life with meaning which he otherwise had sought in serving Picasso. It also made clear to him that art was not a sufficiently potent religion for him, although he continued to urge Picasso to banish all symbolist and romantic sensibilities from his Cubist art in the same way that he harked back to an earlier form of Christianity, unencumbered by centuries of stale conventions.

His relationship with Braque continued to dominate Picasso's life. No day passed without their visiting each other's studio, and no canvas was considered finished until they both declared it finished. "One evening," Picasso reminisced years later, "I arrived at Braque's studio. He was working on a large oval still life with a package of tobacco, a pipe, and all the usual paraphernalia of Cubism. I looked at it, drew back and said, 'My poor friend, this is dreadful. I see a squirrel in your canvas.' Braque said, 'That's not possible.' I said, 'Yes, I know, it's a paranoiac vision, but it so happens that I *see* a squirrel. That canvas is made to be a painting, not an optical illusion. Since people need to see something in it, you want them to see a package of tobacco, a pipe, and the other things you're putting in. But for God's sake get rid of that squirrel.' Braque stepped back a few feet and looked carefully, and sure enough, he too saw the squirrel, because that kind of paranoiac vision is extremely communicable. Day after day Braque fought that squirrel. He changed the structure, the light, the composition, but the squirrel always came back, because once it was in our minds it was almost impossible to get it out. However different the forms became, the squirrel somehow always managed to return. Finally, after eight or ten days, Braque was able to turn the trick and the canvas became again a package of tobacco, a pipe, a deck of cards, and above all a Cubist painting."

For Picasso that story was a perfect illustration of his twinship with Braque, of the symbiotic relationship on which they both thrived. Creation came out of their meeting of opposites: Picasso, intense, mercurial and temperamental; Braque, deliberate, intro-

spective and methodical but with a great capacity for loyalty and love. "Despite our very different temperaments," Braque would say, "we were guided by a common idea. Picasso is Spanish and I am French, and the differences that this entails are well known, but during those years the differences didn't count."

The nurturing stability offered by his relationship with Braque made it easier for Picasso to retreat from the world and allow this new phase of his work to ferment and unfold. His friends could not fail to notice how absorbed and faraway he seemed even when he was physically with them. If they dared intrude on his silences to find out if he was all right, he would often reply, as from the bottom of a deep cave, "I was thinking about my work," and quickly withdraw into his cave again. He could not resist attending Gertrude Stein's Saturday soirées or Apollinaire's Thursday at-homes, but when he was there, irritation seemed to be his dominant mood. He was irritated if Matisse was the center of attention, and irritated if the attention focused on him with questions about his work, and irritated at the slightest evidence that his work was misunderstood or, God forbid, mistreated. In fact, he exploded with anger when he discovered that Stein had varnished two of his paintings and had to be physically restrained from stalking out with them under his arm. One evening his irritation turned into rage when the German art critic Wilhelm Uhde and a group of young German students, who had come to Paris specially to see him, ran into him at the Lapin Agile and carried him triumphantly to the place du Tertre, singing popular German songs and exhausting first his sense of fun and then his patience. He pulled out his Alfred Jarry revolver and fired repeatedly into the air. It worked. The Germans were instantly dispersed, and he returned to the Lapin Agile—no happier, but gratefully alone.

It was a particularly misanthropic phase; but then, everyone in the Picasso *bande* was now less available and complaining about everyone else being less available. Apollinaire was busier than ever with his books and articles, with Marie Laurencin and with his Thursday nights, and at the same time ready for the kind of stability that only the year before he and his friends would have ridiculed as hopelessly bourgeois. The *bande* was growing up, and

Apollinaire, who had written ". . . we who are constantly fighting along the frontiers of the infinite and of the future," was now giving expression in a little poem to the changing mood:

> *I desire in my house*
> *A woman of sound mind*
> *A cat strolling among the books,*
> *At all seasons those friends,*
> *Without whom I cannot live.*

Picasso shared those sentiments, but he knew by now that although his cat at the boulevard de Clichy was the right cat to stroll among the books, Fernande was not the right woman to fill the house. Yet he was too absorbed in his work to pay much attention to the gradual disintegration of their relationship. As for ending it, that was not, and would never become, Picasso's way. He would simply find someone else and include alongside the dying relationship the one being born.

4

PASSIONS AND
BETRAYALS

IN JUNE 1910, Fernande wrote Gertrude Stein, who had left Paris for Fiesole: "We have made great friends with some clowns, acrobats, circus riders and tightrope-walkers, whom we met at the Café and spend all our evenings with." Among the new friends they had made through the circus were Louis Markus and Marcelle Humbert. Markus was a gifted Polish painter, whom Apollinaire christened Marcoussis, after the name of a small village outside Paris. He was twenty-five when he arrived in Paris in 1903, idealistic and eager to consecrate his life to art. Until he fell in love with Marcelle Humbert, painting had taken first place in his life. But during the three years that they had been living together, he gave her precedence over all his projects and ambitions. Marcelle's health was delicate, and determined to provide for her and protect her from the buffeting of the world, he started doing cartoons and journalistic work, which was more reliable and lucrative than his painting had ever been.

They had met Apollinaire at the Circus Médrano, and through him Braque, Picasso and Gertrude Stein. Marcoussis, who was stirred and inspired by the Cubist revolution, was a great admirer of Picasso, while Fernande was fascinated by Marcelle. Having nothing in common, the two women became good friends. Marcelle reminded Fernande of her great heroine Evelyn Nesbitt, the former model and chorus girl over whom her rich husband, Harry Thaw, had murdered the architect Stanford White.

Fernande, according to Gertrude Stein, adored Evelyn Thaw, who was described by *The New York Times* on the first day of her husband's trial as "a little bit of a thing who seemed as if she could never be the cause of all this trouble. . . . The regularity of her features which made her the delight of the artist remains, but the coloring is gone and the seven weary months of suspense have taken away forever the childish look which used to be one of her chief attractions."

Gertrude Stein summed up Evelyn Thaw as "small and negative." "Here was a little french Evelyn Thaw," she said about Marcelle, "small and perfect." It exactly echoed Fernande's feelings—and Picasso's. But for the moment, he was having an affair with another charming Marcelle, Marcelle Dupré, whom he had met on his rounds in Montmartre.

Short-lived affairs were not enough, however, to quell his restlessness. Seeking to renew himself, he left once again with Fernande for Spain. This time they went to Cadaqués, a little port on the Costa Brava, where Ramón and Germaine Pichot went every year. They were joined by the Derains, and together they spent time on the beach, in cafés and dancing the sardana. André Salmon called Picasso the Animator and Derain the Regulator, but for the moment they were joined by their enthusiasm for the revolutionary possibilities they were exploring in their art.

Alice Princet provided another link between them. Alice had been Picasso's lover, and was now Derain's wife. Sharing a woman—even if at different times—was for Picasso always a special bond with his men friends. "I can't have friends if they're not capable of sleeping with me," he would say. "Not that I require it of the women or want it from the men—but there should at least be that feeling of warmth and intimacy one experiences in sleeping with someone." In this case, it was as if he were going to bed with Derain through Alice, and as a result their friendship became more intense, more intimate—almost tangible. But despite this new closeness, Picasso missed Braque, wishing that he were nearby rather than in faraway L'Estaque, so that he could help resolve his doubts and questions as he delved deeper and deeper into his analysis of form. He returned to Paris unhappy with what he had achieved and with many of his canvases unfinished. Yet,

as Kahnweiler put it, "he had taken the great step, he had pierced the closed form."

Throughout the year, Picasso had struggled to give new expression to human faces and human bodies. "Spaniard that he is," Gertrude Stein summed it up, "he always knew that people were the only interesting thing to him . . . the souls of people do not interest him, that is to say for him the entire reality of life is in the head, the face and the body and this is for him so important, so persistent, so complete that it is not at all necessary to think of any other thing and the soul is another thing."

The soul, for Picasso, was another thing used, abused and falsified by the churchmen of his childhood, by the backward, prejudice-ridden Church of his native land. Yet he longed for substance and reality. "There is no other point of departure than reality," he later said. And for the surface appearance of objects and people, for their visible forms, he sought to substitute their hidden order and reality. "I work like the Chinese," he would say, "not after nature, but *like* nature."

By the end of 1910, when Picasso had completed his portrait of Kahnweiler, he had thoroughly pierced and fragmented the human form, sacrificing depth, volume, color, sensation and perspective to that sacred search for pure reality. These experiments with the disintegration of form reached a triumphant culmination in Kahnweiler's portrait, yet the new year found him increasingly anxious and restless. Intensely superstitious, he saw the disintegration of form as literal, as having a magical power to affect both his subjects and himself, which is perhaps why he never painted a Cubist self-portrait. Even for Braque's portrait, he used a man who resembled him rather than Braque himself as a model.

Kahnweiler later wrote of "the incredible heroism of a man like Picasso, whose moral solitude at that time was frightening." And Picasso was aware of the heroic risks he was taking. "Painting is freedom," he said once. "If you jump, you might fall on the wrong side of the rope. But if you're not willing to take the risk of breaking your neck, what good is it? You don't jump at all. You have to wake people up. To revolutionize their way of identifying things. You've got to create images they won't accept. Make

them foam at the mouth. Force them to understand that they're living in a pretty queer world. A world that's not reassuring. A world that's not what they think it is."

But he was anxious about such a total rupture with the past. Although he was self-confessedly subversive in his work, although he wanted to shock and disturb, he was just as passionately committed to reaching a wide audience rather than merely the refined elect. "I've never believed in doing painting for 'the happy few,' " he said. "I've always felt that painting must awaken something even in the man who doesn't ordinarily look at pictures, just as in Molière there is always something to make the very intelligent person laugh and also the person who understands nothing. In Shakespeare, too. And in my work, just as in Shakespeare, there are often burlesque things and relatively vulgar things. In that way I reach everybody. It's not that I want to prostrate myself in front of the public, but I want to provide something for every level of thinking."

Picasso's description of his inner struggle during his painting of Kahnweiler's portrait revealed his determination not to allow his art to become private, isolated and quirky. "In its original form it looked to me as though it were about to go up in smoke," he said. "But when I paint smoke, I want you to be able to drive a nail into it. So I added the attributes—a suggestion of eyes, the wave in the hair, an ear lobe, the clasped hands—and now you can. . . . If you want to give nourishment . . . in painting, which is not easy to absorb for most people, who don't have the organs to assimilate it, you need some kind of subterfuge. It's like giving a long and difficult explanation to a child: you add certain details that he understands immediately in order to sustain his interest and buoy him up for the difficult parts. The great majority of people have no spirit of creation or invention. As Hegel says, they can know only what they already know. So how do you go about teaching them something new? By mixing what they know with what they don't know. Then, when they see vaguely in their fog something they recognize, they think, 'Ah, I know that.' And then it's just one more step to 'Ah, I know the whole thing.' And their mind thrusts forward into the unknown and they begin to recognize what they didn't know before and they increase their powers of understanding."

Still, there were many people, among them collectors, painters and dealers, whose minds did not "thrust forward into the unknown." Even Vollard stopped buying Cubist works in 1910. As for Manolo, although, by Picasso's standards, he was clearly a man of creation and invention, he left no one in any doubt about his feelings: "Cubism, to be honest, I have never understood and I don't know what it is. Looking at one of the earliest cubist portraits of Picasso's, I asked him what he would say if the next day—let us suppose—when he went to the railway station to welcome his mother, she appeared in the form of a cubist figure!"

Picasso's patience as a teacher was very quickly exhausted, and his response to those who did not understand was, more often than not, to dismiss them. "Why should I blame anybody else but myself if I cannot understand what I know nothing about?" he once said, referring to his own inability to understand English. There was also an obsessively secretive side to his personality that loved the special bond among the initiated few, the code names, private language and special terms which affirmed their separation from the uninitiated. When Max Jacob's novel *Saint Matorel* was published in February 1911, the dedication to Picasso was a celebration of their hermetic relationship:

> *To Picasso*
> *for all I know he knows*
> *for all he knows I know.*

There was a constant inner tension in Picasso's life between his predilection for secretiveness and exclusivity and his almost Tolstoyan yearning to reach the least instructed Spanish peasant, the least sophisticated Parisian worker, and to feel that he belonged. That tension was more often than not resolved on the side of withdrawing into his self-created world in the company of the select few he had chosen to admit. The elect were not always the same. "I value things according to the degree of love I have for them," he once said. And it often appeared as if he valued people according to the degree of need he had for them. Ever since he had discovered Braque (an event quickly followed by Max's discovering Christ), he was no longer so dependent on Max to fulfill his needs for intimacy. Soon after Max moved to

Quimper to live with his parents, he wrote anxiously to Kahn-weiler: "Why is Picasso not writing to me? Is he angry?" Max was always dramatizing any shift in his closeness with his friends, pathetically dependent on their approval, if not their love. But Picasso was not angry with him; he was simply in no need of him for the time being. As for his anger, irritability and gloominess, they were attributable more to his cosmic discontent than to any particular individual, let alone Max, who had never been any-thing other than a constant source of nurturing and support.

He had been away from the Bateau-Lavoir for only a year, but it was already bathed in a golden, romanticized light which would grow more golden with each year that passed. To escape from Fernande, the white-aproned maid and the solid mahogany fur-niture of the boulevard de Clichy, he would often go back to the rue Ravignan and work in his old studio, which he had kept for storage.

Earlier than usual that year, he left Paris with his cat, his mon-key, his canvases and easels, but without Fernande. His destina-tion was a deserted eighteenth-century monastery in Céret, a little town in the Pyrenean foothills of French Catalonia, where Manolo had been living for three years with his wife, Totote, a bright, lively woman with a deep, throaty voice. Braque and Max Jacob soon joined him there, and when he was not working in his large studio overlooking the garden with its cherry trees, he was playing the Catalan host to his friends on the terrace of the Grand Café in the main street, or walking among the apricot groves and the vineyards on the hillside close to the Spanish border. But by the beginning of August he was missing Fernande, time and distance having eroded in his mind the problems of their relationship. On August 8 he wrote her a sweet, loving, yearning letter in stumbling, childlike French:

My dear Fernande

All day yesterday I had no letter from you and none today though I was expecting one let's hope I shall be happier this afternoon.

From a letter Braque sent me this morning I see that K. has already reached Paris so I hope you will be here in a very few days.

It is rather cooler here and in the evening the warmth is nice.

Don't worry too much about money it will be all right. Take the

train I took it is the best. Now I do believe that you will be coming soon. Braque tells me you will be here next week.

My family have been at Mahon for some time now. You should bring your parasol if you plan to go out in the daytime.

The monkey is really amusing we gave him the lid of a tin and he spends the day looking at himself in it he is very bright.

Work still goes well I am still working on the same things.

> I kiss you and love you
> always *PABLO*

The letter had its intended effect, and Fernande arrived at last and stayed with him until September 5. When they returned to Paris from the bucolic peace of Céret, they were catapulted into the second act of a drama being played out in the French press with the Louvre and *Mona Lisa* as its central characters.

On August 21, *Mona Lisa* had been stolen from the Louvre, a theft that led to national outrage over the security arrangements at the nation's great museum. By the time Picasso reached Paris, the drama was much closer to home. On August 28, Géry Pieret, a young Belgian dilettante straddling the fence between amusing, unscrupulous inventiveness and mild crookedness, went to the offices of *Paris Journal* with an Iberian statuette he had stolen from the Louvre, proudly demonstrating how easy it was to rob the place. Apollinaire read the headline in the next day's *Paris Journal* and was horrified. Géry Pieret had been temporarily working as his secretary, and the statuette had been at his home ever since Pieret had removed it from the Louvre. Even worse, a few years earlier Pieret had sold Picasso two other Iberian statuettes, which he had similarly acquired by removing them from the museum. Picasso was enchanted by them and, following Pieret's advice, had kept them hidden at the bottom of an old Norman cupboard. He had hardly given them any further thought until "The Louvre Burglaries" hit the front pages of the French press.

Apollinaire and Picasso went into a frantic huddle at the boulevard de Clichy. Terrified that they might be implicated, prosecuted, jailed or maybe even, in the climate of spreading xenophobia, expelled from the country, they decided they had to act. Their first thought, born of their growing panic, was to flee

the country. Fortunately, Fernande's common sense prevailed and they decided instead to dispose of the incriminating evidence by throwing the statuettes into the Seine. "I am sure," remembered Fernande years later, "that without realizing it they saw themselves as characters in a play; so much so that though neither of them knew the first thing about cards, they had, during the agonizing hours of waiting for the fateful moment when they were to leave for the Seine, pretended to play cards, like gangsters."

At midnight they put the statuettes in a suitcase and left for the Seine. By then fear had filled their minds, displacing all reality, and the whole city seemed full of suspicious shadows. They walked up and down the Seine looking for the right moment to get rid of their incriminating burden, but all moments seemed equally filled with risk. Finally, physically and emotionally drained, they gave up and returned to Picasso's apartment, where they spent the rest of the night plotting their next course of action. Early the following morning, Apollinaire went to the offices of *Paris Journal* and delivered the stolen treasures and a major scoop, on condition that the source would not be revealed. The condition was accepted—and instantly breached. On the evening of September 8, the police arrived at Apollinaire's apartment, searched all his papers, found letters from Géry Pieret and arrested him on charges of harboring a criminal, complicity in stealing the statuettes and involvement in a gang of international art thieves. In the meantime, Pieret, who had fled Paris, had been writing to the public prosecutor from every town he passed through in the Midi, giving him wilder and wilder stories about the thefts, culminating in his pathological confession that he had been the one who had stolen *Mona Lisa*.

"As soon as the heavy door of the Santé closed behind me," Apollinaire wrote later, "I had an impression of death. However, it was a bright night, and I could see that the walls of the courtyard in which I found myself were covered with climbing plants. Then I went through a second door; and when that closed I knew that the zone of vegetation was behind me, and I felt that I was now in some place beyond the bounds of earth, where I would be utterly lost. I was questioned several times, and a guard ordered me to take my 'kit': a coarse shirt, a towel, a pair of sheets,

and a woolen blanket; and then I was taken through interminable corridors to my cell, No. 15, Section II. There I had to strip naked in the corridor and was searched. I was then locked up. I slept very little, because of the electric light that is kept on all night in the cells."

Two days later, at seven o'clock in the morning, there was a knock at Picasso's door. "As the maid had not come down yet," Fernande remembered, "it was I who opened the door to a plain-clothes policeman, who flashed his card, introduced himself and summoned Picasso to follow him in order to appear before the examining magistrate at nine o'clock. Trembling, Picasso dressed with haste, and I had to help him, as he was almost out of his mind with fear. . . . The bus between Pigalle and the Halle-aux-Vins, in which he had to ride, was haunted for many a day by those unfortunate memories. The detective was not allowed to take a taxi at his client's expense."

The rising anxiety of the last few days, the long wait at the police station and finally the sight of Apollinaire being led into the magistrate's office, "pale, disheveled and unshaven, with his collar torn, his shirt unbuttoned, no tie, and looking gaunt and insubstantial, a lamentable scarecrow, who made one feel sad just to look at him," completely unbalanced Picasso and drove from his mind every thought of friendship, every vestige of loy-alty and all sense of truth. Only an animal instinct for survival was left, and if that meant denying his friend, so be it. And deny him he did, when he claimed that he had only the most superfi-cial acquaintance with the man who stood before him clearly in trouble and in need of help. Apollinaire started to cry, and Pi-casso, as if to outdo him, began to tremble and cry at the same time. The magistrate discharged him with a warning to stay within reach in case of need for further examination, and Apol-linaire was sent back to the Santé prison.

He was held at the prison for a total of five days, during which he was interrogated again and again regarding the theft not only of the statuettes but of *Mona Lisa*. He was described by his ac-cusers as "chief of an international gang come to France to de-spoil our museums." Finally, on September 12, he was taken from the Santé to the Palais de Justice. "It was at three o'clock," wrote *Paris Journal* the next morning, "that Apollinaire, pushing

through the crowd of reporters, photographers, and friends from the worlds of journalism, letters, and the arts, come to bring him the comfort of their sympathy, entered the magistrate's office. A policeman accompanied him. Apollinaire—we deplore this inadmissible harshness on the part of the prison authorities—was handcuffed."

It was the most devastating experience in the poet's life. From the moment he was photographed for the criminal records, with handcuffs and without his belt, his tie or his shoelaces, to his betrayal by the man he had loved and championed, and then to his provisional release by the magistrate at seven o'clock on September 12, he had endured a nightmare which gave form to his deepest fears and insecurities. Struck at the very roots was the life of social respectability and intellectual prestige that he had created for himself. Even after he was discharged from prison, many in the press, at the salons and at the cafés who were railing against the "internationalist spirit" and stood "for the genius of France against the foreign invasion" tried to use "the affair of the statuettes," as it was being called, to discredit not only Apollinaire but the whole artistic avant-garde and its infiltration by undesirable aliens.

"I still haven't recovered," Apollinaire wrote to a boyhood friend three months after his release. "I still await the solution with anxiety. . . . Try to find out how and in what conditions I can become naturalized. What would happen to me if I were expelled from France? These doubts make it impossible to find enough peace of mind to work. I ask only for peace and obscurity and I am the object of constant persecutions . . . " Even after the case was dismissed in January, he never completely recovered from the humiliation of being once again an outsider and an outcast. "It choked him," André Salmon wrote in his memoirs. "He was like a man who had swallowed a fishbone."

Even more difficult to swallow was Picasso's betrayal. But so much of himself, of his life and his work was invested in that relationship that swallow it he did. "Guillaume," wrote the painter Albert Gleizes, "had suffered very much in the course of the interrogations that the investigating magistrate had subjected him to. Especially in his affections. Didn't one of his dearest friends deny him when they were brought face to face, losing his

head so completely as to declare that he did not know him? Apollinaire spoke to me about this with bitterness, and without hiding his dismay." But in public, he acted as if nothing had changed, hiding both his dismay and his hurt. Even when he wrote about the whole affair to a friend, he referred to Picasso as "X," never by name.

His bitterness, however, found its way into his work. He gave a lecture on "The Dismemberment of Cubism" under the banner of Robert Delaunay and the new art he had invented, which Apollinaire christened Orphism. So now he had a new painter to defend, a new "ism" to champion and a new friend to play with. Jacques Villon, recognizing that here was Apollinaire licking his wounds, described the lecture as having "nothing whatever to do with painting." But Picasso chose to ignore what lay behind it. There were plenty of mutual protestations of admiration and friendship, and everything was as before. Except, of course, it wasn't, and never would be again, but they did their civilized best at pretending.

Picasso threw himself all the more passionately into his work with Braque, taking it to its next stage, to a new sign language which introduced collage into the increasingly severe and ascetic world of analytic Cubism. Art critics were outraged. "A return to barbarism and primitive savagery, a repudiation and an utter abasement of all the beauties in life and nature," cried *Le Journal*, while after the first Picasso exhibition in New York at the Photo-Secession Gallery in April 1911, *The Craftsman* expressed its concern that "if Picasso is sincerely revealing in his studies the way he feels about nature, it is hard to see why he is not a raving maniac, for anything more disjointed, disconnected, unrelated, unbeautiful than his presentation of his own emotions it would be difficult to imagine." One nude in the exhibition was held to be a fire escape, while one of the nicest things said about Cubist still-lifes was that they looked like "coloured, symbolical frontispieces to editions of Euclid."

At the end of November 1911, however, there appeared in London a review in *The New Age* by the critic John Middleton Murry which struck a chord that was to reverberate through the years in the response to Picasso's work. "I frankly," he wrote, "disclaim any pretension to an understanding or even an appre-

ciation of Picasso. I am awed by him. . . . I stand aside knowing too much to condemn, knowing too little to praise—for praise needs understanding if it is to be more than empty mouthing." This was the first time that the leitmotiv of awe mixed with incomprehension was sounded so clearly in relation to Picasso's work. In the future, praise, not just awe, would unblushingly become a constant companion of incomprehension. The reason for this unlikely pairing was stated by Middleton Murry in comparing Plato and Picasso: "I feel convinced," he wrote, "that it is but my weakness that prevents my following them to the heights they reach."

Plato in *The Republic* expelled all artists from his ideal state because they merely copied nature, which, in turn, was only a copy of the ultimate reality. "In fact," Picasso said, "one never copies nature, neither does one imitate it. . . . For many years, cubism had only one objective: painting for painting's sake. We rejected every element that was not part of essential reality." As Middleton Murry put it, "Plato was seeking for a Picasso. . . . He was looking for a different form of art, and that form was Picasso's art of essentials." When, in 1912, Picasso painted the first collage of the twentieth century, *Still-Life with Chair-Caning*, with a printed oilcloth across the bottom of an oval canvas and a newspaper, a glass, a pipe, a sliced lemon and a scallop shell around it, he was not imitating reality but displacing it. "When people believed in immortal beauty and all that crap," he would say, "it was simple. But now? . . . The painter takes whatever it is and destroys it. At the same time he gives it another life. For himself. Later on, for other people. But he must pierce through what the others see—to the reality of it. He must destroy. He must demolish the framework itself."

It was the beginning of synthetic Cubism, along the path Picasso had embarked on toward an art of essentials rather than an art of imitation. At the same time, he had set out on another journey. He was falling in love. During numerous evenings with Fernande, Marcoussis and Marcelle at the Ermitage, his new favorite brasserie near the boulevard de Clichy, his waning attachment to Fernande was being replaced by a growing passion for Marcelle.

The two women were a study in contrast. Gertrude Stein al-

ways referred to Fernande as "very large," but she was never larger than when next to Marcelle, who was very small. Fernande was older than Picasso—only four months older, but she suddenly seemed very much older. Marcelle was younger than Picasso—only four years younger, but next to Fernande, she appeared very much younger. Fernande was temperamental, sometimes unfaithful, sometimes angry—once so angry that she shook Picasso with such vigor, she shook off a button. Marcelle was gentle, so gentle and delicate that she was almost ethereal. Fernande had once spent eighty francs, when eighty francs was a fortune for them, on a bottle of perfume that did not even have any scent, but looked, in Gertrude Stein's words, like "real bottled liquid smoke." She had the flair to be extravagant even when she was starving, while Marcelle had the talent to make the tiniest budget stretch to delicious meals and a cozy home. Fernande was a seductress who allowed herself to be seduced, but always with her eyes open: "Your only claim to distinction," she once told Picasso, "is that you are a precocious child." Marcelle was ready to be swept off her feet, to surrender, to love without conditions. Fernande lived as if the world owed her a living; when there had been no money to buy bread, she would order an elaborate meal and when the delivery boy arrived with the full basket on his head, she would call to him through the door, her voice dripping authority and seduction: "I cannot open to you, I am all naked . . . Leave it at the door . . . I'll come by to pay." And he would. Marcelle did not have the strength to take on the world; she needed someone to protect her, and in return, she gave all of herself. Fernande gave herself if she felt like it and knew she could survive alone—giving French lessons or pawning her earrings or breaking the rules.

When the increasing distance between her and Picasso became too much for her to bear, Fernande let herself surrender to the charms of Ubaldo Oppi, a young Italian painter who was introduced to them at the Ermitage by the Futurist Gino Severini. "To live on one woman," Picasso would say later, "was not to be thought of." But to *leave* a woman was for him emotionally no less difficult. So he waited for Fernande to take the first step. "Fernande left yesterday with a futurist painter," he wrote to Braque. "What will I do about the dog?" Within twenty-four

hours of Fernande's running off with Oppi, he had lured Marcelle away from Marcoussis. On May 18 they left for Céret, where Manolo and the Pichots were staying. "I love her very much," he wrote to Kahnweiler, "and I am going to write it on my pictures."

It was one of forty letters that Picasso wrote to Kahnweiler between the day he arrived in Céret and the beginning of August 1912. At this time of emotional and physical upheaval, Kahnweiler became both his anchor and his conduit to the outside world. The letters were a catalogue of his preoccupations and obsessions. The first began with the arrangements he had made for Fricka, his monkey and his cats to be sent to him, and ended with a categorical "To no one give my address for the moment." References to the cause of all the upheaval, his relationship with Marcelle, were few and not very forthcoming. Secretive by nature, he became doubly so whenever he had something especially precious to protect.

To demonstrate how precious Marcelle was to him, Picasso renamed her Eva. It was the name she had been given when she was born at Vincennes, outside Paris, to Marie-Louise and Adrien Gouel. But following the fashion of the times, she had invented a new name for herself, and no one knew her any longer as Eva Gouel. By renaming her Eva, Picasso was not only giving her back her original name, but also sealing her place in his life as the first woman he truly loved. "Yes, we are together and I'm very happy" was all that he was prepared to disclose even to so trusted a friend as Kahnweiler. "But don't say anything to anyone," he once again admonished his dealer.

A week after he had eloped with his new love, his letter to Kahnweiler shows a man obsessed by his work rather than by the passion that had taken over his life. "You should also send me the brushes that are at the rue Ravignan, the dirty and the clean ones and the stretchers that were also at the rue Ravignan. . . . You should also send me the palette from the rue Ravignan it's dirty you will wrap it in paper together with the stretchers and the figures and the letters and the combs to paint fake wood. As for the colors you should send those from the rue Ravignan and those from the boulevard de Clichy. I am going to tell you where

they are and I am going to give you the list (really I am very sorry to give you such trouble)."

A few days later, by which time the letter would barely have arrived in Paris, he wrote again to his "cher ami" complaining about the absence of the materials necessary for his work. Picasso would brook no delay between a request and its fulfillment: "I really need my painting things. Manolo did give me a few colors but I work only with a green composed of cobalt violet vineyard black mummy brown and pale cadmium and I have no palette. . . . In spite of everything I work."

In the meantime, Kahnweiler, who didn't mind transporting canvases, paints and dirty brushes provided he got the finished product, wrote Picasso a politely pleading letter concerning the canvases stacked up in his studios: "Say, you would really do me a great service if in your next letter you told me which pictures you consider as finished, so that I might dispose of them, since after all eight days from now you won't know more than today and it's only a matter of making a decision. Thank you in advance." Crossing in the mail was Picasso's letter listing all the paintings that he was willing to sell him and including their prices. "The rest," he added, "are not yet presentable."

When Fernande, tiring of her escapade with the young Italian, returned to the boulevard de Clichy, she found Picasso gone. Blaming herself and unwilling to accept defeat, she decided to leave immediately for Céret, to stay with the Pichots and try to win him back. The news of her impending arrival reached Céret very quickly and drove Picasso into alternating fits of fury and anxiety. "I am really upset by all that," he wrote to his dealer-confessor on June 12, "first of all because I wouldn't like my great love for Marcelle to suffer in any way from the problems that they could cause me and I wouldn't like her to be at all upset either and I must have peace for my work. I have really needed it for some time."

Putting aside his concerns with Fernande, he proceeded to give Kahnweiler a progress report on his work, which seemed to restore his mood and make him eager for gossip and mild score-settling: "Apart from all that I'm working a lot I have done many drawings and I have started eight canvases already. I think my

painting is gaining in robustness and clarity well we shall see and you shall see but all this is far from finished and yet I am more sure of myself. And the exhibition in Cologne? I received this morning *La Voce*. You are telling me that you love a lot the style of the paintings Shchukine buys [*Les Demoiselles d'Avignon*]. I remember one day when I was in the middle of it Matisse and Stein came to see me and they laughed in my face. Stein told me (I was telling him something to try and explain it to him) but it's the fourth dimension and at this very moment he starts laughing. This for the history books . . ."

As he had feared, Fernande arrived and confronted the man whose life she had shared for the last seven years. She used all the weapons in her dramatic arsenal, from rage and recriminations to pleading and seductiveness. But when Picasso and Eva fled Céret to escape her, she had to admit that her attempts to turn the clock back were futile. Fernande's relationship with Picasso was over. In a sense, of course, it had been over for some time—held together by the fragile bonds of habit, inertia and Picasso's horror of separations and the void they left behind. But now Eva filled the void and in the haven of their new love he had nothing to fear. He would later confess to Gertrude Stein that Fernande's "beauty always held him but he could not stand any of her little ways."

"Apart from all that I'm working," he wrote to Kahnweiler. And this continued to be the main theme of his letters. Even on the eve of his flight from Céret his letter was full of little other than his work. "I don't find them too bad," he repeated twice in the same letter, in reference to the paintings he was sending his dealer—a combination of unaccustomed false modesty and genuine pleasure at the fact that his experiments were working out.

"Everything has to come to an end," Fernande wrote in her memoirs about their old haunt, the Lapin Agile, "and this all finished in about 1912." After Céret, she accepted the end of her relationship with Picasso equally philosophically. Being a fighter, she had fought to get him back; being a survivor, she yielded to the inevitable with dignity, as was obvious from the letter she sent to Gertrude Stein. In it she wrote about the pleasure their friendship had given her, but acknowledged that "she understood perfectly that the friendship had always been with Pablo and that

PASSIONS AND BETRAYALS

although Gertrude had always shown her every mark of sympathy and affection now that she and Pablo were separated, it was naturally impossible that in the future there should be any intercourse between them because the friendship having been with Pablo there could of course be no question of a choice."

Marcoussis took his revenge in a cartoon in *La Vie Parisienne* in which he drew himself jubilantly watching Picasso drag himself away in heavy chains. To overcome his anger and his pain, he portrayed all the responsibilities he had shouldered and the sacrifices he had made to take care of Marcelle as a burden. It was his way of trying to liberate himself from his deep love for the woman they now called Eva.

Picasso and Eva took refuge in Perpignan and then in Sorgues, near Avignon, where, away from Fernande and the weight of the past, he rented a small villa, Les Clochettes. "I've already started work on three canvases," he wrote to Kahnweiler, "an arlesienne a still life and a landscape with posters . . ." And a few days later he expressed relief that he had sent him the paintings he had done in Céret: "I would have probably spoilt them if I had gone on working on them here." But he had not signed the paintings. That indicated a completion too final, too irreversible and permanent, too much like a small death. Perhaps because he was unwilling to deal with his dread of endings, Picasso rather lamely attributed the absence of signatures to forgetfulness and readily approved Kahnweiler's decision to have them forged: "You were right to have my recent pictures of Céret signed by Boischaud. I had forgotten to do it before leaving there."

He was working well, he loved Eva, he loved the beautiful weather, the clear light, the fig trees in his garden and the bullfights at Nîmes. "But what a rare thing," he wrote to Kahnweiler when he got back from Nîmes, "is the intelligence specific to an art in any art. Only Mazantinito managed to do something but in spite of everything the fight was very pleasant and the day was beautiful I love Nîmes . . ." But he missed Braque. "Tell him to write to me and tell me when he is thinking of coming to see me," he told Kahnweiler.

At the end of July, Braque finally made the trip from Paris. It was a visit to his partner—and his honeymoon. A few months earlier, Picasso had introduced him to Marcelle Dupré, the young

123

woman with whom he was having an affair. He told Braque that he was introducing him to his future wife, and whether it was a prophecy, a command or a joke, it turned out to be the truth. Picasso had done everything he could to encourage Braque and make it come true; he even went along when Braque took Marcelle to Le Havre to introduce her to his parents. Once again, he had strengthened his intimacy with a male friend by passing on to him a woman who was his lover. He had also strengthened his bond with Marcelle, who felt that she owed her marriage to him; and since Braque did not know that they had been lovers, they shared a secret that united them even more. "That way," Picasso would say later, "I won't have an enemy in my friend's house."

Picasso's working habits were disrupted by Braque's arrival much more than they had been by his elopement with Eva. He abandoned his studio for at least a week and took up talking and walking and just being with Wilbur, as he called Braque, drawing a fond parallel between their own partnership at the frontiers of art and that of the Wright brothers in the sky. "It's been many days since I wrote to you," he explained to Kahnweiler, "but with Braque we have taken so many walks and talked so much about art that the time has flown. We went to spend two days in Marseille. Wilbur Braque wanted to look for a house at L'Estaque, or in another place near Marseille, but he came back to Sorgues and has rented a house. We have bought some negroes in Marseille and I bought a very nice mask and a woman with big tits and a young negro."

It was an idyllic time, with Picasso and Eva at Les Clochettes and the Braques close by at the Villa Bel Air. "Wilbur Braque is already installed," he wrote, "he is in the japanese farm. And nothing else new except that I am now parting my hair in the middle. I bought the toothbrushes I had mentioned I recommend them to you. If you were a smoker I would also recommend pipes from Marseille . . . "

Eva may have filled a large part of Picasso's life, but there were only cryptic references to her in his work. She was too precious to him, his work too fragmented and he himself too superstitious to paint her likeness in a Cubist portrait. But he wrote his love on his paintings: "J'aime Eva," he inscribed on a heart-shaped gingerbread in a still-life. "Ma Jolie," the title of a popular love

song, "Jolie Eva" and "Pablo–Eva" were other ways in which, with childlike joy, he proclaimed his love for Eva in his work. Even on a whitewashed wall of their villa, he painted a still-life with a Pernod bottle, a mandolin and a sheet of music with "Ma Jolie" on it. But the days were over when his paintings on white-washed walls were abandoned and lost forever. The still-life was removed, on Picasso's instructions, by a local mason and sent to Kahnweiler in a specially built packing case.

In the meantime, Kahnweiler had been busy moving Picasso from the boulevard de Clichy to 242 boulevard Raspail in Montparnasse. It was a move that marked many breaks: with Fernande and the last home they had shared together, with the bohemian world of Montmartre and with the old haunts of his past. It also marked the transfer of the center of gravity of the art world from Montmartre to the few square yards that constituted the Carrefour de Montparnasse, with the Café du Dôme on one side and the Rotonde on the other. They soon became the two principal watering holes for Picasso and for the new invaders from all over the world who came to Paris seeking what Apollinaire called a "refuge of fine and free simplicity" from which to launch their revolutionary attempts to overhaul the past. Poets, painters and political exiles such as Trotsky mingled and engaged in passionate discussions about remaking the world, sometimes in less than seven days.

War and revolution were in the air. The first newspaper scrap that Picasso used in his collages read "The Battle Is Joined." This was in the fall of 1912 and the phrase referred to the Balkan war, but it also reflected the struggle raging within himself to understand and express in his work the next step away from the past. The serenity of his still-lifes, of the first months of hope stirred by his new love and nurtured by his stay in Sorgues, was disturbed by the intrusion of war and violence around him and inside him. "Chauffeur Kills Wife," proclaimed the headline in *Newspaper and Violin*, while in *Bottle and Wineglass* the newspaper strip was about a soldier spitting out a bullet he had received in the head twenty-six years earlier. In the printed scrap in *Bottle, Cup and Newspaper* "la bande noire" vandalized public monuments, in *Bottle of Vieux Marc, Glass and Newspaper* a performer poisoned her lover, and in *Bottle and Wineglass* a

tramp accused himself of murder. The world that Picasso depicted was sick, the sickness made all the more disturbing by the juxtaposition of everyday objects and everyday reality with the violence and decay that surrounded them.

It was a juxtaposition with which he was all too familiar in his own life: the stability and growing prosperity of his increasingly bourgeois existence with a mistress who behaved like the most nurturing wife, side by side with the motley host of phantoms and monsters he sheltered within himself. And there was a deeper paradox—between his deep feeling for Eva and his outbursts of lyricism even during the most austere phases of Cubism, and the cold, analytical eye with which he dissected the world. "Picasso studies an object the way a surgeon dissects a cadaver," wrote Apollinaire in Paris around the same time that Josep Junoy in Barcelona declared: "With each new attempt he loses his eyes, his understanding, his heart. Only his hands, beautifully skilful, obey him . . . Picasso understands things without loving them; he interprets them ruthlessly. His love is dominance."

His urge to dominate and to possess was an inevitable by-product of the growing egocentricity that pervaded all his relationships, whether with the women in his life or with his male friends. Where once he had merely accepted adulation, now he demanded it. The closest he got to a deep communion of equals with another human being was with Braque, and even that relationship, after their return to Paris, began to lose some of its intimate intensity. There were, of course, changed circumstances—Braque's bride and Picasso's Eva, and his move to Montparnasse away from their old neighborhood. But beyond circumstance was Picasso's irresistible urge to flee, however subtle, gradual or disguised the flight, from any relationship that promised or threatened to reach uncomfortable depths of intimacy. And when he was not fleeing, or could not unquestionably possess and dominate, he sulked.

Juan Gris was frequently the cause of his petulance once it became clear that despite calling Picasso "cher maître" and exhibiting his portrait under the title *Homage to Pablo Picasso*, Gris had become very much his own painter and his own man. Gris was a Spaniard and yet he had become attached to Matisse, which, in the war going on in Picasso's mind, meant he had

crossed the enemy line and was siding with the Frenchman. Gris was also earning the admiration of Gertrude Stein, who was to write later that "the only real cubism is that of Picasso and Juan Gris. Picasso created it and Juan Gris permeated it with his clarity and his exaltation." "Tell me why you stand up for his work, you know you do not like it," Picasso once demanded of her in a rage. "Juan Gris was the only person," Gertrude Stein reported, "whom Picasso wished away."

Like a spoiled child who cannot bear sharing affection, he whined to Kahnweiler, who loved Gris and his work: "You know very well that Gris never painted any important pictures." He could not talk away Gris's importance, but neither could he learn to coexist with the younger Spaniard whom Kahnweiler called the "modest genius," no doubt to distinguish him from his compatriot. It was Picasso who had introduced Gris, soon after his arrival at the Bateau-Lavoir, to Kahnweiler. But then, at the time, Gris was still too little recognized, and too much the devoted disciple, for Picasso to worry about a competing talent. The slightest tinge of rivalry, however, especially with a fellow Spaniard six years younger than himself, brought out in Picasso the pout, the bark and the bite.

In the spring of 1913, when Picasso and Eva left the boulevard Raspail and returned to Céret, Gris came to visit them. There was something about Gris that continued to draw Picasso to him despite his irrational antagonism. Kahnweiler would later describe Gris as a "firm hand serving a pure soul and a clear mind," and it was that purity which attracted Picasso—the same kind of purity that had attracted him to Eva. In his work, Picasso was trying to portray the essence of things, and in his life, despite all his negations, he kept being pulled to people who seemed closer to that essence. If Fernande had been for him the door to manhood, then in Eva he sought the door to the mystery of another reality, which Gris had described as "produced solely by elements of the human spirit." It was that reality which Eva evoked even as she absorbed herself in the most mundane household tasks. She did not seem to be entirely of this world, and Picasso, who was solidly rooted in it, hoped to possess her mystery by possessing her. Max, who in April 1913 also came to visit Picasso and Eva in Céret, described her to Kahnweiler: "Eva's devotion to the

humblest domestic chores is admirable. She loves to write and laughs easily. There is an equanimity about her and she devotes all her attention to the task of looking after a rather grubby and phlegmatic guest . . ."

Kahnweiler's feelings about Gris paralleled Max's about Eva: "I felt his friendly presence, his affection always about us," he wrote. "He was gentle, affectionate, unassuming, but he knew his work was important and he was firm in defending his ideas. . . . That is what makes Juan Gris such an outstanding figure in art: *The complete identity of his life and art.* His art is pure and so was his life. He was not only a great painter, but a *great man.*" It was an accolade that the dealer would never bestow on Picasso. And Picasso's antagonism toward Gris was to become even more virulent as he was confronted with growing evidence of his integrity and his goodness. It was as if he had to disparage and destroy what he did not have or could not possess on his own terms.

There were echoes in his relationship with Juan Gris of his relationship with his father—of disparaging what he could not match. On May 2, he received in Céret the news that his father was critically ill. On May 3, Don José was dead. Picasso arrived in Barcelona just in time to see his father for the last time. He had become, from an unusually, a cruelly early age, his own ultimate authority, his father's selfless devotion more a source of resentment than of gratitude. But now he was gone, and Picasso's guilt was enormous. "You can imagine in what state I am," he wrote to Kahnweiler from Barcelona. When he returned to Céret, he was in such emotional turmoil that he could not work. "I hope," Eva wrote anxiously to Gertrude Stein, "that Pablo will make himself start working again, because only this will help him forget his pain a little."

Picasso crossed the border several times during the summer, but not once did he visit his mother. He knew well that being near grief would only make it harder to avoid confronting his own. And having avoided his relationship with his father through most of his life, he was equally determined to avoid dealing with his guilt. So he chose instead to spend his time at bullfights and at the circus in Céret, where he made fast friends with the

clowns, who, according to Max Jacob, "seemed to have been painted up as a Cubist studio joke."

But however hard he tried to elude them, sickness and death would not leave him alone. Eva became ill with what the doctors diagnosed as bronchitis. And in July, Picasso himself fell sick and discovered his health scrutinized in the Paris papers. He had unquestionably crossed the bridge from obscurity to the banality of fame. In September, as if death attracted him as much as it repelled him, he moved with Eva, who seemed unable to shake off her illness, to the rue Schoelcher, where the only view from their windows was an interminable vista of the Montparnasse cemetery.

Soon the huge new studio was crammed with finished and unfinished canvases, pieces of wire, cardboard and wood that he used for his collages, and a stockpile of tubes of paint that he wanted to make sure would last forever. With the days when he could not afford enough paints for his work still fresh in his mind, he was determined never to be short of tubes of paint again. And because there were times when he could not bear to look at a blank surface, he painted on cigar boxes, on the walls, even on a broken stool for no apparent reason other than that it had somehow found its way there.

Picasso was by now one of the artist-heroes of Montparnasse, pointed out as a local sight, among those Apollinaire had named the "men of the future." He dressed in an English-looking casual suit crowned by a checked cap, leaving the traditional bohemian garb for those conventional artists who were still relying on the past for their inspiration. Modigliani was one of the few younger painters who remembered being encouraged by the master. At the time, he was still struggling and unrecognized except as an arbiter of elegance, and not even Picasso's inventive imagination could dream up enough reasons to feel threatened by him. So they met publicly at the Rotonde—which immediately raised Modigliani's status in the eyes of the habitués. Picasso told him to keep on drawing: "One can never draw enough. No one has done more drawings than I have. I recall my father saying to me: 'I am quite willing for you to become a painter, but you must not begin to paint until you are able to draw well, and that is very

difficult.' . . . By the time I was fifteen I could do faces and figures and even large compositions—often without models—because, simply by practicing on pigeons' feet, I had learned how to capture the mystery of lines, even of nudes."

Gradually, thanks to Kahnweiler's efforts, Picasso's fame was crossing the borders of France preceded by his works, which during 1913 were exhibited in Munich, in Berlin, in Cologne, in Prague and in New York. On March 2, 1914, at the Hôtel Drouot, there was an auction which consecrated Picasso as a painter triumphantly successful in the marketplace. La Peau d'Ours, a collectors' club founded in 1904, was holding a sale of the works it had amassed in the last ten years, and the press had trumpeted the event as a barometer of the value of contemporary art. The first surprise was when a still-life by Matisse was bought for 5,000 francs—1,000 francs more than Gauguin or Van Gogh had fetched. Then, amid rising excitement and in the presence of many of his friends and at least as many of his enemies, Picasso's *Saltimbanques*, which had sold for 1,000 francs in 1908, was bought by Heinrich Thannhauser, from Munich, for 11,500 francs, a spectacular sum at the time for a modern work. Picasso's genius had become legal tender. It was an apotheosis and a validation of everything he was doing, even though the *Saltimbanques* and all his other works on sale predated his much more controversial Cubist period.

There followed a flurry of analyses of what it all meant. The most absurd conclusion was prompted by the hysterical xenophobia of the times: "Huge prices have been fetched," stated *Paris-Midi*, "for grotesque and infamous works by undesirable foreigners, and it is Germans who paid them or caused them to be pushed up to these levels. Their plan is becoming clearer." Picasso resolutely refused to be drawn into the fray. "One simply paints," he said; "one does not paste one's ideas on a picture." And in the spirit of this Olympian detachment, he left with Eva for Avignon and was soon joined by the Braques and the Derains. There, he produced paintings and collages of colorful and zestful brilliance. It was an explosion of lyricism that would later be described as "Rococo Cubism." Picasso was celebrating his love and, at the same time perhaps, defying or exorcising the increasingly menacing political situation. But if it was exorcism, it failed

to work. At the beginning of August, the war that many had said was impossible "at the present state of civilization" was actually declared.

For some it was the beginning of the Great Adventure; for others it was "the legalised return to the savage state." Apollinaire, who had spent the days before the outbreak of war at the casino in Deauville, watching the tango, which had just been imported into France, spread like wildfire on the dance floor, left for Paris feeling reborn: "Within myself I sensed new beings full of dexterity building up and organising a new universe." He was determined to enlist, and when his first attempt failed he tried again, this time in Nice. The stateless cosmopolitan, urged to join friends in Switzerland or friends in Spain, had decided instead to give himself to his beloved France. "I was overjoyed," he wrote, "when the Enlistment Board in Nice declared me fit."

Such was the atmosphere of passion and patriotism that surrounded Picasso. Braque and Derain immediately answered the call, and on August 2, the day war was declared by France, Picasso saw them off at the station in Avignon. "I never found them again," he told Kahnweiler after the war. Everyone had returned —yet no one had returned the same.

5

A WOMAN FOR THE NEW SEASON

WHEN PICASSO AND Eva returned to Paris in November 1914, Max Jacob, Gertrude Stein and Juan Gris were the only close friends left in the half-deserted city. Even Kahnweiler, who had been such a fixture in Picasso's life, was gone; still a German citizen, he had fled to Rome and from there to Bern, and all his pictures were held by the city as alien property.

As a citizen of neutral Spain, Picasso had no obligation to go to war. But in the prevailing atmosphere of high jingoism his position required explanation. His friends did the explaining for him. "We never dreamt," wrote the painter Jacques Villon, "of holding against him that he did not go to war. We knew he was worth much more than that. And besides, it was not his country that needed defending." Apollinaire, providing a list of who among the French avant-garde was where, wrote: "Derain is in a motorcycle unit in the North, Georges Braque was recently in Le Havre as a second lieutenant, Fernand Léger is at the front with the supply corps, Albert Gleizes has been at the front since the outbreak of the war, and Dufy is in Le Havre, waiting. . . . Picasso, whose health is too weak to allow him to do anything other than his invaluable work as an artist, 'has outdone Ingres in his admirable drawings without even trying,' according to a letter I received."

The chief weakness in Picasso's health was hypochondria, but Apollinaire had never allowed accuracy to interfere with a point

he was making. He was, however, accurate in describing the naturalistic tendency that had emerged in Picasso's work, and went hand in hand with the most austere Cubist style. "If one knows exactly what one is going to do," Picasso said once, "what good is it to do it? Because one knows it, it is of no interest. It is better to do something else." He had never been constrained by a particular style, let alone a particular school, and as early as the summer of 1914 he was working on an extremely naturalistic work, *The Painter and His Model*, which remained unknown and unfinished in his studio. Just as Picasso was exploring a new naturalism, the world around him looked increasingly Cubist. "If they want to make an army invisible," he said, "they have only to dress their men as Harlequins." Walking one night along the boulevard Raspail with Gertrude Stein, he saw a convoy of camouflaged artillery decked out in Cubist forms and colors. "It is we that have created that," he told her proudly.

One of Picasso's favorite pastimes during that first winter of the war was learning Russian. It was a project born partly of his fascination with Russia and mostly of his fascination with the Baroness Hélène d'Oettingen. He and Eva often dined with the Baroness and Serge Ferat, who was officially her brother, although some said that they had shared only a wet nurse and not a mother, and others said that he was in fact her lover. Whatever the exact nature of their relationship, they were a charming, affluent and intelligent couple, he a painter and she a writer under different pseudonyms. Part of Picasso's seductiveness was his willingness to be seduced, and he and the Baroness spent many long evenings together, absorbed, as far as the world was concerned, in advancing his knowledge of Russian. Eva, left behind at the rue Schoelcher, found herself increasingly often at the mercy of coughing fits. Gentle and taciturn, she had no resources to deal with Picasso's code of following his latest impulse, whatever the cost to those around her. She simply accepted him and the pain their relationship caused her, while her health took the brunt.

On the nights that they were together, he and Eva would often dine with Gertrude and Alice at the rue de Fleurus. Their dinners were a tragic shadow of Gertrude's brilliant prewar soirées. Zeppelins were flying over the city, and their conversation was punc-

tuated by the shrieks of sirens and Eva's fits of coughing. Again and again she would bolt from the dining room to the bathroom to hide from Picasso the fact that she was coughing up blood. One night there was an air-raid alarm, and all four of them rushed to the ground floor to take shelter with the concierge. After a while they returned to the dining room, where Eva and Alice tried to sleep while Gertrude and Picasso, the lights out, a single candle under the table, talked until the all-clear was sounded at two in the morning.

The war years were made harder for Gertrude by the absence from the rue de Fleurus of some of her favorite paintings. Leo Stein had moved to Florence, and their collection was divided as he outlined to her in a letter in January 1914. "I have been anxious above all things," he wrote, "that each should have in reason all that he wanted, and just as I was glad that Renoir was sufficently indifferent to you so that you were ready to give them up, so I am glad that Pablo is sufficiently indifferent to me that I am willing to let you have all you want of it." He took the Renoirs and the Matisses; she kept the Picassos and the Cézannes, with the heartbreaking exception of a Cézanne still-life with apples. "The Cézanne apples have a unique importance to me that nothing can replace," Leo wrote. "I am afraid you'll have to look upon the loss of the apples as an act of God." Gertrude found it hard to be as philosophical, and when Picasso observed how truly upset she was, he stepped in. "I will paint you an apple and it will be as fine as all of Cézanne's apples," he declared, and he fulfilled his promise for Christmas. "Any work more or less grows out of another," he said as he offered her his Cézanne apple inscribed "Souvenir for Gertrude and Alice."

The war had thrown Picasso and Gertrude closer together, and it was Picasso who abused the closeness. Matisse remembered arriving at the rue de Fleurus to finalize the arrangements he had discussed with Gertrude for giving some help to Juan Gris, who, with Kahnweiler gone, was close to starving in wartime Paris. As Matisse arrived at Gertrude's apartment for their meeting, he met Picasso coming out. Inside, he discovered that Gertrude had changed her mind. She would not, after all, help Gris. Picasso had used all his seductive charm to persuade Gertrude to abandon him. As it happened, Léonce Rosenberg, the dealer who

stepped in to take over Kahnweiler's painters, signed a contract with Gris and helped him survive.

Picasso's growing isolation, the dispersal of his friends, the war and his gnawing anxiety over Eva's deteriorating health brought to the surface the darkest, most ruthless side of his personality. There was another, deeper reason. He had hoped through Eva to get closer to an intangible reality that she represented for him, and for a while he did. But gradually other forces proved more powerful, and instead of Eva's drawing him away from his demons, she watched her own strength ebbing away. "Everyone talked about how much reality there was in Cubism," Picasso would say later. "But they didn't really understand it. It's not a reality you can take in your hand. It's more like a perfume—in front of you, behind you, to the sides. The scent is everywhere, but you don't quite know where it comes from." He knew that through Eva he was more aware of the "perfume." He suspected that Gris also had access to that reality, and the more disconnected from it he felt himself, the more vicious he became toward Gris.

It was Eva who had inspired *The Architect's Table*, a Cubist still-life with "Ma Jolie" written on it, which Picasso singled out as evoking the essence he longed to capture. He had painted it at the beginning of their relationship, when he was in touch with the harmony and the light she embodied for him. But that seemed a long time ago, and tenderness was now banished from his universe. Eva, who knew him from her heart and was profoundly sensitive and painfully affected by his depressions and his rages, was growing more frail every day. She did everything she could to conceal from Picasso the fact that she was suffering not from a passing bout of bronchitis but from tuberculosis. She hid the bloodstained handkerchiefs and applied thicker and thicker layers of rouge to disguise the pallor of her cheeks. She was terrified that if he knew, he would leave her.

The endless sea of stone crosses that confronted them whenever they looked out their window intensified the oppression that hung heavily over them both. It was no less oppressive when they went outdoors. At cafés and in the streets, men and women stared at him full of contempt for an able-bodied man who had stayed behind. It was as if they were questioning his manliness,

and he took refuge in sarcasm: "Will it not be awful," he said to Gertrude Stein, "when Braque and Derain and all the rest of them put their wooden legs up on a chair and tell about their fighting?" His black humor seemed even blacker when news reached Paris that Braque and Apollinaire had received dreadful head wounds and both had to be trepanned. Braque was moved from hospital to hospital before the operation, but not once did he hear from Picasso.

There was something icy cold at the center of Picasso's life, and something equally cold at the center of his art. "A wintry cosmic wind has torn off one veil of foliage after another," wrote the Russian art critic Nikolay Berdyaev in 1914. "All flowers and leaves are stripped away, objects are deprived of their outer coverings; all flesh, displayed in images of imperishable beauty, has disintegrated. We feel that there will never again be a cosmic spring. . . . It seems that after Picasso's terrible winter nothing will ever blossom as before. . . . He mercilessly lays bare the illusions of personified, material, synthetic beauty. Behind captivating, fascinating female beauty he sees the horror of disintegration and decomposition. Like a clairvoyant he sees through all veils, outer garments and intervening layers to the depths of the material world, where he perceives his composite monsters."

Since the outbreak of the war Picasso seemed to see only the demons behind the veils. Max Jacob might have provided some solace during these bitter, lonely times, but he was too absorbed in his relationship with Christ. Also, as he wrote to Maurice Raynal, "the Jews are men of intellect; what I need are men of heart." He had been receiving instruction in preparation for his conversion, but even his visions were unorthodox and took place at theologically unconventional locales. His latest vision had occurred at a movie house during a Paul Féval film titled *The Black-Suit Gang*. Fortunately, the Fathers at the Notre-Dame-de-Sion monastery were so eager to further the conversion of Jews to Christianity that they proceeded with Max's baptism.

He chose Picasso as his godfather, undeterred by the fact that if Picasso had any belief at all it was that there was a dark force reigning over the universe. "A good Catholic," he told Max, "is a man with a big apartment, a family, servants and a motorcar." As

a Christian name Picasso wanted to give him Fiacre, after the patron saint of French cabdrivers, which made Max suspect that his godfather was not treating the occasion with proper solemnity. Finally they agreed to call him Cyprien—one of Picasso's own Christian names. The baptism took place on February 18 at the Notre-Dame-de-Sion monastery, and Picasso gave his godson a copy of *The Imitation of Christ*, inscribed "To my brother Cyprien Max Jacob. Souvenir of his baptism, Thursday, February 18, 1915." As a prebaptismal present, he drew Max's portrait. "I pose at Pablo's," Max wrote to Apollinaire at the front. "He has a portrait of me in pencil which is very much the old peasant; it looks at the same time like my grandfather, an old Catalan peasant, and my mother."

Picasso was still working, but his usual urgency was replaced by a growing sense of futility. It was his least fertile year since he had moved to Paris, and yet he had never spent so much time at home and in his studio, especially after Gertrude left wartime Paris for neutral Spain. When it became impossible even for the determined Eva to hide from him the nature of her sickness, Picasso, terrified of catching it, often fled their apartment and spent hours working in his storeroom at the Bateau-Lavoir.

By fall, Eva had to be hospitalized in a clinic in Auteuil, a suburb on the other side of town. Picasso was living alone for the first time in years. He went to the clinic every day, but he needed someone to console him during the long, lonely nights. He found that someone in Gaby Lespinasse, a beautiful twenty-seven-year-old Parisian who was his neighbor at the boulevard Raspail. She had taken the name of Herbert Lespinasse, the American-born artist who was her lover when her affair with Picasso began. Between seeing Gaby and the long Métro journeys back and forth to visit Eva at the clinic, there was less and less time for work.

"My life is hell," he wrote to Gertrude Stein. But the sensual drawings of Gaby naked and the whimsical watercolors like *The Moonlit Bedroom, The Provençal Kitchen* and *The Provençal Dining Room* belie his protestations with their playfulness and their ardent inscriptions: " . . . Gaby my love my angel I love you my darling and I think only of you I don't want you to be sad To take your mind off things look at the little dining room I will be so happy with you . . . you know how much I love you . . . Till

tomorrow my love it is very late at night with all my heart Picasso." He also drew himself under the clock at the intersection of the boulevard Raspail and boulevard Edgar-Quinet, with a box of chocolates and Gaby silhouetted in her window. "The drawing," wrote the art historian Pierre Daix, "says with a remarkable clarity that, at that moment, it is hell which is an abstraction, and pleasure which blossoms in a classicism barely touched by cubism."

"As usual I never stop," he wrote to Gertrude Stein ambiguously. And he did not stop working or visiting the dying Eva or compulsively betraying her. "I have done a painting of a harlequin," he went on, "which in the opinion of myself and several others is the best thing I have done." It was certainly one of the most sinister things he had ever done, with its black background and the bitterly menacing smile of the harlequin.

In December, when the composer Edgar Varèse brought Jean Cocteau, the young poet of the glittering salons, to meet Picasso, the harlequin dominated his studio. The twenty-six-year-old Cocteau had been variously described as walking "with the pride of a wild bird that had dropped by chance into a poultry yard," as recalling better than any other young man Wordsworth's "Bliss was it in that dawn to be alive" or quite simply as "the frivolous prince"—the title of a volume of poems he had published at twenty-one. Impeccably elegant, he wore a gardenia in his buttonhole, which, rumor had it, he received every day from London. Picasso told his two visitors that he was very much in love with a young woman who was about to die. "I have never forgotten Picasso's studio," remembered Cocteau forty years later, "because the whole height of its prowlike bay window looked out on the Montparnasse cemetery. . . . Picasso and I eyed each other for quite a while. I admired his intelligence, and clung to everything he said, for he spoke little; I kept still so as not to miss a word. There were long silences and Varèse could not understand why we stared wordlessly at each other. In talking, Picasso used a visual syntax, and you could immediately *see* what he was saying. He liked formulas and summed himself up in his statements as he summed himself up and sculpted himself in objects that he immediately made tangible."

The long silences, the wordless staring, the clinging to everything Picasso said at that first meeting: Cocteau was in love and

on the scent of something ultimate. "He fell under Picasso's spell and remained there for the rest of his days," wrote Francis Steegmuller, Cocteau's biographer, while Cocteau himself described their meeting as having been "inevitable, written in the stars." As for Picasso, the frivolous prince was his bridge to a world he had barely glimpsed, of society, balls and banquets, princesses and counts, virtuosity and yet more uncritical idealization. But for the moment, Cocteau had to return to the front and Picasso had to get back to Eva. Though not for long.

A few days later, on December 14, Eva died. "My poor Eva is dead," he wrote to Gertrude Stein, "it was a great sorrow . . . she was always so good to me." Even though he experienced her death as the sun might lament the loss of a planet in its orbit, his grief was no less real. Ever since his little sister had so suddenly died, it seemed that death was always winning.

Kahnweiler, who had known Eva when she was with Marcoussis and had watched from the beginning the unfolding of her relationship with Picasso, was outraged at the news of her death. He called it a great crime, and he would always reproach Picasso for taking Eva away from the man who had nurtured and protected her, especially since it was obvious that she was not sturdy enough to withstand the vicissitudes of living with him.

Eva's funeral, far from being an occasion of healing mourning, compounded Picasso's mounting sense of guilt and isolation. There were only seven or eight friends present, and the miserable winter weather contributed to the general feeling of dejection. Juan Gris, who was forgiving enough to rally to Picasso's side, wrote about it to Maurice Raynal: "It was a very sad affair and the horror of the occasion was greatly heightened by Max's jokes." Max, who had had a little too much to drink on the long, bitterly cold journey from the clinic to the cemetery, ended up propositioning the handsome coachman of the hearse and turning the tragedy into burlesque.

It was the saddest Christmas of Picasso's life. Alone at the rue Schoelcher, haunted by memories of Eva, by sickness and death, he was too distraught even to be able to find refuge in work. At night, out of habit more than desire, he would drag himself to the Rotonde, dressed in a brown raincoat that was falling apart and a black-and-white-checked cloth cap. He would sit in the

back room, lost in his own gloomy world. Very occasionally something attracted his attention and he would catch fire. One night it was the ribbon of the Médaille Militaire on a soldier's jacket. It was as if it had charged him with electricity. "That yellow between the green stripes," he cried, "looks red to me; it *is* red!" Then he lapsed back into his dejected state.

The only corner of light in his universe was inhabited by Gaby. It was a corner filled with zest, tenderness and, unconnected as it was to the rest of his life, with unreality. He was very careful not to add to his own guilt the disapproval of the world over an affair that began while his great love was dying and continued while he was grieving. So no one knew about Gaby.

On December 29, while Picasso was living with the drawbridge still up, inaccessible even to the few friends who were left in Paris, Diaghilev's Russian Ballet staged a brilliant gala for the British Red Cross. It was an exuberant performance of Stravinsky's *Firebird*, conducted by the composer himself, which captivated all of war-weary Paris. Sergei Diaghilev, who had failed as a singer, a composer and an administrator of the Russian Imperial Theaters, succeeded brilliantly as the impresario of the Russian Ballet. He brought Nijinsky and Pavlova to Paris, he dazzled the balletomanes with luscious spectacles and he captivated the "chers snobs," the Parisian elite who flocked to his galas.

One of those most enchanted by Diaghilev, his ballets and his male dancers was Cocteau, who soon became virtually a member of the troupe. With Slavic affection, Diaghilev started calling him "Jeanchik," only keeping a watchful eye on him when it came to Nijinsky, "his fascinating young private leopard." "Astound me! I'll wait for you to astound me," Diaghilev challenged Cocteau once as they were walking through the Place de la Concorde after a performance. "I was quick to realize that one doesn't astound a Diaghilev in a week or two," Cocteau recalled. "From that moment I decided to die and be born again. The labor was long and agonizing. That break with spiritual frivolity . . . I owe, as do so many others, to that ogre, that sacred monster, to the desire to astound that Russian prince to whom life was tolerable only to the extent to which he could summon up marvels."

Diaghilev constantly needed new blood; and the French avant-garde needed a new stimulus and new ways to express their gifts.

It was Cocteau, that other great impresario, who engineered the alliance between two parties which were at first distrustful and even disdainful of each other. Discharged from the marines, his war over while the war still raged, Cocteau decided to bring Picasso into Diaghilev's circle. He began by introducing him to Erik Satie, the celebrated French composer who came from Normandy but whose deadpan eccentricity was, according to Cocteau, "inherited from Scottish ancestors. . . . He looked like a minor civil servant, with a little pointed beard, glasses, umbrella, bowler." Often, after they had had dinner together, Picasso would accompany Satie to Arcueil, where he lived, a two-hour walk from Montparnasse through deserted suburban streets. There was a certain formality to their intimacy, partly because, at fifty, Satie was fifteen years Picasso's senior. Their form of parting after these marathon walks typified the quaint stiffness of their relationship: "Good night, Mr. Picasso," "Good night, Mr. Satie," they would say, doffing their hats. No one was ever invited into Satie's sanctum. In fact, his friends crossed its threshold for the first time after his death, and there found more than a hundred umbrellas, some of them never taken out of their wrapping. It was on one of their evening walks that Picasso began to entertain the idea of moving to the suburbs. He knew he had to leave the rue Schoelcher, and he wanted to move far enough away so that the demons he had lived with in that house could no longer reach him.

Gertrude Stein was back in Paris, presiding over her soirées with renewed vigor. Satie was not the only new friend Picasso brought to the rue Fleurus. Gertrude remembered "Paquerette a girl who was very nice," and "Irene a very lovely woman who came from the mountains and wanted to be free." At the same time his secret affair with Gaby continued. "I have asked the good God for your hand," he had written to her on a small piece of paper on February 22, 1916. Had he also asked Gaby for her hand—or was asking the good God another flight of whimsy, along with the bead necklace and the little cherub and the doll's-house interiors he painted for her? In the vast arsenal of Picasso the seducer, truth was a negotiable commodity. He said once that "the artist must know the manner whereby to convince others of the truthfulness of his lies." And the man was as convincing

as the artist. He invented reality in his life no less than in his art, and words were part of the make-believe. He wrote to Gaby that he thought only of her and was asking the good God for her hand, but he also asked a beautiful black girl from Martinique to move in with him. His relationship with Gaby was soon over, while the girl from Martinique left after only a few weeks, unwilling to live with his dark moods, his rages and his silences. "He was sinister," she said simply.

There were many, however, who were perfectly prepared to pay the price of being his friend and who even found the sinister aspect of his nature fascinating. Cocteau was not only prepared to pay the price, he was ready to play any role, however sycophantic and even absurd, to court Picasso and coax him out of his isolation. When he climbed up the steps to Picasso's studio dressed as a harlequin, it was only one of the more colorful tributes he paid to the man whom he described as "*the* great encounter" of his life. Fortunately, his adulation did not deprive him of his irreverence. On May 1, the day that Picasso drew his portrait in an army-style uniform, he wrote to his great friend Valentine Gross, a beautiful young woman of splendid bearing and sharp intelligence, who was a painter and had drawn many of Diaghilev's dancers: "This morning, pose for Picasso in his studio. He is beginning an 'Ingres' head of me—very suitable for portrait of young author to accompany posthumous works after premature death."

It was the meeting of two worlds and two cultures, and it was Picasso who introduced Cocteau to his world first. Montparnasse was an exotic land to the society poet. "Picasso," he wrote to Valentine Gross in the middle of August, "keeps taking me to the Rotonde. I never stay more than a moment, despite the flattering welcome given me by the circle (perhaps I should say the cube). Gloves, cane and collar astonish these artists in shirtsleeves— they have always looked on them as the insignia of feeblemindedness."

Picasso was no longer at home in Montparnasse either. To everybody's surprise, he found a small Second Empire house with a garden at 22 rue Victor Hugo in the suburb of Montrouge, beyond the Porte d'Italie and the limits of Paris. Before he moved, he received a visit at the rue Schoelcher from Axel Salto,

publisher of the Danish art journal *Klingen*, who wrote an article giving a bird's-eye view of Picasso's studio and an account of the man which evoked many images that would later become the staple fare of the Picasso literature: "He had on a grass-green sweater and baggy trousers of brown velvet such as French artists still wear. He is small in stature and built like a bullfighter. His skin is sallow and his wicked black eyes are set close together; the mouth is strong and finely drawn. He reminded me of a race-horse, an Arab with a well-shaped neck. People said that he had secret powers and could kill a man by looking at him; they said other strange things too. There was something massive and su-pernatural about him. He was amiability itself, showing me all his possessions, including a peep show where you looked through a glass and saw a starry sky with angels flying about."

By the end of summer, the peep show with the angels and *Les Demoiselles d'Avignon* and the Cézanne watercolors and the Ma-tisses and the Derains and Rousseau's picture of the European potentates and the *Girl with Bare Feet*, which he had painted when he was twelve and which had been hanging over his bed— these and all his other possessions were packed and moved to Montrouge. Picasso, who hated moving, switched on his irresist-ible charm and again appealed to Max for help, while at the same time, as a kind of quid pro quo, he sent his godson the money he had asked for to help the Futurist Severini, who was suffering from tuberculosis:

My dear godson Max, I am sending you the money you requested and I would be very happy to see you again soon. I am right in the middle of moving and you will arrive just in time to give me a hand as you've always done as a friend. You know how little I ask of you on these occasions: only your moral support, some encouragement, in short, the friendly hand of Max Jacob. Meanwhile, here's mine. Your old friend, *PICASSO*.

Max, of course, obeyed the call and was there to lend much more than a friendly hand. As he had written to Tristan Tzara, one of the founders of the Dada movement, earlier in the year, "Picasso has been my friend for sixteen years, we have hated each other

and we have done each other as much bad as good, but he is indispensable in my life."

Picasso had hardly moved into his new home when burglars broke in and stole all his linen, leaving the pictures untouched. Meanwhile, Cocteau had succeeded in persuading him to undertake a new and audacious venture that would make his work much more widely known, perhaps even to surburban burglars. Cocteau's vision, in carrying out Diaghilev's command to astonish him, was for Erik Satie to write the music and for Picasso to design the costumes and stage sets for a new ballet. It sounded simple enough. It was in fact a plan of tremendous daring. "Montmartre and Montparnasse," wrote the man who dared to try, "were under a dictatorship. We were going through the puritanical phase of Cubism. Such articles as may be found on a café table, together with a Spanish guitar, were the only ones allowed. It was treason to paint a stage setting, especially for the Russian Ballet. Even Renan's heckling off stage could not have scandalized the Sorbonne more than Picasso upset the Rotonde café by accepting my invitation. The worst of it was that we had to meet Diaghilev in Rome, while the Cubist code forbade any travelling except from the North of Paris to the South, from the Place des Abbesses to the Boulevard Raspail."

But the only code Picasso followed was written on his gut. And there was something compelling about the opportunity of finding a new family after he had been orphaned by the war. At the end of August, Cocteau and Satie sent a postcard to Valentine Gross: "Picasso is doing *Parade* with us." Satie was happy, Cocteau ecstatic. Seducing the high priest of Cubism into theatrical design would remain for the rest of Cocteau's life a source of childlike pride. Years later, he never tired of recounting and romanticizing every detail: "In Montparnasse, in 1916, grass still grew between the cobbles. Vegetable sellers trundled their barrows, people palavered in the middle of the streets. It was in the middle of the street, between the Rotonde and the Dôme, that I asked Picasso to do *Parade*."

Cocteau brought them all together, but it was not long before family squabbles began to break out. "Make Satie understand, if you can cut through the aperitif fog," the exasperated Cocteau wrote to his friend and confessor Valentine Gross, "that I really

do count for something in *Parade*, and that he and Picasso are not the only ones involved. . . . It hurts me when he dances around Picasso screaming 'It's you I'm following! *You* are my master!' and seems to be hearing for the first time from Picasso's mouth things that I have told him time and time again. Does he hear anything I say?"

Ten days later, Satie was also unburdening himself to his "dear and sweet friend" Valentine Gross: "If you knew how sad I am! *Parade* is changing for the better, behind Cocteau's back! Picasso has ideas that I like better than our Jean's! How awful! And I am all for Picasso! And Cocteau doesn't know it! What am I to do? Now that I know Picasso's wonderful ideas, I am heartbroken to have to set to music the less wonderful ideas of our good Jean— oh! yes! less wonderful. What am I to do? . . . What am I to do? Write and advise me. I am beside myself." Less than a week later he wrote again to Valentine Gross to tell her that it was all settled. He and Picasso had prevailed against Cocteau's introduction of a megaphone issuing phrases and sounds and interfering with the music, the choreography and the decor. "Still, it's a great thing to be in the thick of the dog fights of great art," Cocteau had written before he lost this particular dog fight.

On October 7, the four had dinner together to discuss the work's progress at the home of Madame Errazuriz, a very rich Chilean art patron who had become the latest provider and arranger in Picasso's life, buying his work, finding him a maid for Montrouge and even giving him a sumptuous pink bedspread. Diaghilev had just arrived from Rome with Léonide Massine, who had taken Nijinsky's place as lead dancer and choreographer, now that Nijinsky had been annexed by a Hungarian ballerina in South America. Cocteau called the evening a *soirée Babel*: Madame Errazuriz was shouting in Spanish with Picasso, Diaghilev in Russian with Massine, and Satie in Sauternes dialect with Cocteau.

Picasso was enchanted to be again part of a hardworking family of sacred monsters. But Braque, back in Paris, saw no bridge between his world, his war and the new flamboyant direction taken by his prewar partner. Apollinaire, on the other hand, with his Croix de Guerre, his shaven head and the leather band around his head wound, was all too eager to join the troupe.

Cocteau referred to him as "Apollinaris" and found him rather
tiresome with "his Bolivar beard, his scar and his stupid war . . ."
But he had no option other than to accept him in the "family,"
since that was Picasso's will, and on December 31, 1916, he went,
along with Picasso and Max Jacob, to pay homage to Apollinaire
at a grand banquet organized to honor the poet on the publica-
tion of his latest book, *The Poet Assassinated*.

Apollinaire, who was still, despite his fascination with Picasso
and the lapse of four years and the war, deeply hurt by his be-
trayal over the affair of the stolen statuettes, chose *The Poet
Assassinated* to settle the old score. Picasso appears in the book
as the Bird of Benin, while the poet's girlfriend Tristouse is a
not-too-flattering portrayal of Marie Laurencin, who had left
Apollinaire despite all his pleading. The assassinated poet, Cro-
niamantal, was obviously Apollinaire himself. In the book, the
Bird of Benin seduces Tristouse, then proposes to sculpt a statue
to commemorate Croniamantal:

"A statue in what?" asked Tristouse. "Marble? Bronze?"
"No, that's too old-fashioned," replied the Bird of Benin. "I must
sculpt a profound statue out of nothing—like poetry, like glory."
"Bravo! Bravo!" said Tristouse, clapping her hands. "A statue out
of nothing, out of emptiness: it's magnificent."

It was a bitter allegory of the emptiness behind Picasso's protes-
tations of loyalty and friendship, but Picasso chose to ignore it
and join, with Apollinaire's friends, in the celebrations for the
publication of his book.

Despite outraged protests from the habitués of the Dôme and
the Rotonde, Picasso threw himself wholeheartedly into his new
adventure. "I am working at our project almost every day," he
wrote to Cocteau. "No one need worry." Later he said to the
young composer Francis Poulenc, "Long life to our followers! It's
thanks' to them that we look for something else!" And he *was*
looking for something else. On February 16, he took Cocteau to
Gertrude Stein's to introduce him and announce that they were
leaving the next day for Rome. "Voilà," they exclaimed on arriv-
ing at the rue de Fleurus, "we're leaving on our wedding trip."

It turned out to be a somewhat prophetic remark. "I have sixty

dancers," Picasso wrote to Gertrude Stein. "I go to bed late. I know all the Roman women." What he did not write to Gertrude was that among the sixty dancers of Diaghilev's Russian Ballet was a twenty-five-year-old Russian ballerina whose dainty good looks and restrained bearing had immediately intrigued Picasso and made him forget Eva and Gaby and Irène and Paquerette and the nameless casual encounters that had filled the void since Eva's death. Olga Koklova was the daughter of a colonel in the Imperial Russian Army and had been born in Niezin, in the Ukraine, on June 17, 1891. She had left home at twenty-one to join the Diaghilev Ballet and devote herself to dancing. Her talent was too small to compensate for the fact that by ballet standards, she had started too late, but Diaghilev liked to include in his company girls from a higher social class even if they were not very good at dancing.

Olga Koklova was, above all, average: an average ballerina, of average beauty and average intelligence, with average ambitions to marry and settle down. For Picasso, who had tried prostitutes, bisexual models, flamboyant bohemians, tubercular beauties and black girls from Martinique, Olga was so conventional in every way as to be positively exotic. And there was a touch of mystery about her, too. This time, it was not the mystery of another reality which Eva had radiated, but the mystery of another country. Picasso had always loved all things Russian, even more so since his encounter with the Baroness d'Oettingen. He who, even at the height of the war, read only gossip and the comics, could not read enough about the recent developments in Russia, the uprisings, the fate of the Tsar, the hopes of the people. In the spring of 1917, Russia fascinated him more than ever. The Revolution had just taken place, the Tsar had abdicated and a Provisional Government had installed itself in power.

So there were many different ingredients which at that particular moment in history and in Picasso's life combined to transform an average Russian ballerina into a spellbinding creature singled out from the *corps de ballet* as the object of his lavish attentions. There was the romance of old Russia, the Ukraine and the Imperial Russian Army; there were the convulsions of the Revolution that was expected to construct a new world out of the ruins of the old; there was the intense excitement that always

surrounded Diaghilev, the self-proclaimed "incorrigible sensualist" in his art as well as his life; and there was Picasso, weary of the struggle his genius entailed, weary of the inordinate intensity of his passions, weary of his inner isolation, and longing for normality, wrapped in a little imperial, revolutionary and artistic Russian mystery.

What Picasso was for Olga was much simpler. Women—and men—were transfixed by his black-marble stare, charmed by "his hands so dark and delicate and alert," enchanted by the unruly lock of his black hair. Some, like Cocteau, had felt "a discharge of electricity" when they met him; others, like Fernande, had been magnetized by "this radiance, this internal fire one felt in him." Still others were mesmerized by the dashing bohemian who knew about opium and women and cabarets and whorehouses, and spellbound by his vigor, the secrets he seemed to know and hide, his flair and his showmanship. And there were those who were simply overwhelmed at being in the presence of the sacred monster of Montmartre and Montparnasse and the revolutionary inventor of Cubism. But Olga cared nothing about art except as something to decorate an apartment, was revolted by bohemianism and was too firmly controlled to allow herself to be swept off her feet by animal magnetism. Also she was a performer, and her narcissism matched his. So she responded to his advances because he was important in her own immediate world, someone substantial enough to have been chosen by the legendary Diaghilev as the designer for *Parade*. And she responded with caution and calculation.

The dancers were staying at the Hotel Minerva, behind the Pantheon; Diaghilev, Massine, Cocteau and Picasso, at the Hotel de Russie, in the Piazza del Popolo. Picasso spent a lot of his time walking the distance between the two hotels, crossing "a city made of fountains, shadows and moonlight" to visit his ballerina. Cocteau, fired by the desire to imitate him, rather than any other desire, attached himself to another pretty Russian ballerina, and accompanied Picasso to his romantic rendezvous. In fact, Cocteau thought that his little Shabeska looked like Buster Brown's dog. But they got on very well together, and once her eyes were opened by her laughing colleagues, she joined with gusto in the game of shadowing Pablo and Olga. They too walked around

Rome; they too had tête-à-tête dinners in the Campagna; they too went to the movies; they too made sure that Cocteau's face and jacket were covered with ballerina's makeup like Picasso's. At the same time, and not only for show, Cocteau was busy wooing Diaghilev, beautifying himself with touches of rouge and lipstick whenever he was near. Diaghilev was already quite occupied with one of his leading dancers and an Italian valet, but everybody was in too good a humor, working too hard and too much impressed with everyone else to mind when amorous excursions didn't go exactly as planned.

Picasso worked in a studio in via Margutta at a table looking out onto the Villa Medici, but the floor of his hotel room and the tables where he had his meals were also quickly strewn with drawings of the *Parade* characters and sketches and caricatures of his collaborators and new friends. He drew on any blank surface— on menus, napkins and even on Diaghilev's ivory walking stick. He was particularly fascinated by the face of Stravinsky, with his thick lips, bull-fiddle nose and protruding ears. Stravinsky had arrived in March to conduct his *Firebird* and his *Fireworks* at Diaghilev's gala for the Italian Red Cross, and the performance opened not, as usual, with the Russian imperial anthem "God Save the Tsar," since there was no longer a Tsar to save, but with Stravinsky's orchestration of "The Song of the Volga Boatmen."

Stravinsky was a new discovery for Picasso, and Picasso for Stravinsky. Cocteau, feeling left out and homesick, made a drawing of them, with Stravinsky in a top hat bowing down to talk to Picasso in a bowler. The affinity between Picasso and Stravinsky was, as Francis Steegmuller put it, "a conjunction of major planets that seems to have left others somewhat on the outside." Picasso, who bragged about hating all music except flamenco, was fascinated by the composer who, six years after he himself had appalled his friends with the *Demoiselles*, had shocked the world with his *Rite of Spring*. He was also fascinated by Stravinsky's dandyism, which stretched to mustard-yellow trousers and yellow shoes, and the certainty he radiated that he was one of the men of the future.

When the company left Rome for Naples in the middle of March to dance at the San Carlo Opera House, the two men went along and spent most of the time together exploring the

aquarium, Vesuvius, Pompeii, quaint little shops, Neapolitan watercolors and each other. "The Pope is in Rome, God is in Naples" was Cocteau's summing up of their Neapolitan adventure. "One is excited by Naples but goes to bed with Rome" was Picasso's. He was endlessly curious about what he saw: "The artist must roam around with a tape measure," he said, "taking into account everything, touching everything." And he told an Italian they met that the goal of artists is "to do their best to seek out God's hiding place."

Stravinsky soon left Italy for his home in Switzerland with the portrait Picasso had drawn of him in his luggage. But at the Italian frontier at Chiasso, the military authorities examining his luggage refused to let the portrait pass. "This is not a portrait, but a map," they insisted. "Yes, it is a map of my face, but of nothing else," Stravinsky replied, but to no avail. Finally, since he was not going to be allowed to cross the border with the portrait, Stravinsky sent it back to Rome, and the British ambassador returned it to him in Switzerland by diplomatic pouch.

On April 30, after a performance in Florence, the company, with Picasso and Cocteau in tow, left for Paris. There was a holiday mood at the studio on the Buttes Chaumont, where a team of theatrical decorators was working hard under Picasso's instructions to finish the scenery, the costumes and the magnificent drop curtain which, with its harlequins and its "giant figures as fresh as bouquets," evoked all of Picasso's love and nostalgia for the fairy-tale world of the circus. The holiday mood continued after work. Olga had been to Paris before with the Russian Ballet, but it was all different now. Then, her dream had been to be a prima ballerina. Now, it was to be Picasso's wife, or rather to rise to the social status she craved by being his wife.

As for Picasso, for the last two months he had been involved in a new game and he was loving it. He had been physically obsessed with women, had been fascinated by women, had made passionate love to women, had had casual sex with women whose faces, names and bodies he had forgotten, but he had never courted a woman. And while Olga may have been inexperienced sexually and known little about men, she had been born with all the female survival instincts of knowing when to give a little, hold back a lot and promise everything. "No, no, Monsieur Picasso,"

she was overheard saying from her hotel room. "I'm not going to let you in." She was the perfect partner for the courting game. "Watch out. You have to marry Russian girls," Diaghilev warned Picasso. "You must be joking" was Picasso's cavalier response. After all, he had reached thirty-six having avoided matrimony, and as always, he prided himself on being in absolute command of any situation.

Finally, on May 18, 1917, *Parade* opened at the Théâtre du Châtelet. A hundred and fifty miles away, French soldiers were being slaughtered by the thousands in forays against German lines. There were mutinies among the troops, Russia had collapsed and Allied morale was at its lowest point. Inside the Châtelet, an extremely heterogeneous first-night crowd broke into clamorous applause at the appearance of Picasso's drop curtain. Among those clapping and cheering were the Princess de Polignac, the Count and Countess de Beaumont, Misia Sert, Debussy, André Gide, Apollinaire, Juan Gris, E. E. Cummings, Russian soldiers on leave and assorted poets and painters from Montmartre and Montparnasse whom Diaghilev had personally invited in an attempt to bridge the gulf between society and the ascetic avant-garde.

Then the curtain rose, the ballet began and with it the drama in the audience. The appearance of the gigantic managers in front of the circus booth, touting the performances that were to give the imaginary passersby a taste of the imaginary spectacle inside, was greeted with "Vive Picasso!" from the gallery and with boos from conventional balletomanes. "For the first time," Poulenc would write, "the music hall invaded art—with a capital A." But the audience was not yet ready to welcome the invasion and rally to Cocteau's call to "rehabilitate the commonplace." The American manager especially, an eleven-foot Cubist construction with skyscrapers, metallic tubes, cowboy boots and a top hat, insulted every preconception about what ballet characters should look like. And the managers didn't merely "dance"—they roared over the roar of Satie's music, which included the rattle of typewriters that sounded disagreeably like machine guns. Then there was an eight-foot construction in the shape of a horse, which Comtesse Anna de Noailles, *grande dame* of the literary salons, said would have made a tree laugh, and the American girl who

"mounts a race-horse, rides a bicycle, quivers like movies on the screen, imitates Charlie Chaplin, chases a thief with a revolver, boxes, dances a rag-time, goes to sleep, is shipwrecked, rolls on the grass of an April morning, buys a Kodak, etc."

The audience soon had enough. Amid all the hissing, the howls and the catcalls, there were even cries of "sales Boches," on the premise that in these terrible war years everything unpleasant and incomprehensible must be the work of the enemy. "If it had not been for Apollinaire in uniform," wrote Cocteau, "with his skull shaved, the scar on his temple and the bandage around his head, women would have gouged our eyes out with hairpins."

Picasso watched the offstage drama unfold as though it had nothing to do with him. He sat in Diaghilev's box next to Misia Sert, the impresario's great friend. Of partly Polish descent, she was described as "the queen of the Russian ballet" or, more graphically, by Valentine Gross, as "a fairy godmother one moment and a witch the next, frightfully malicious, adorably generous, out to destroy everything in the arts that hadn't been hatched or at least nurtured within her own four walls." In full evening dress, diamonds and a silver tiara, she looked, at the opening of *Parade*, as though she were at a different event. Picasso was wearing a red polo-neck sweater, but as Pierre Mac Orlan, the novelist and chronicler of Montmartre, would say about him later: "He resembled a prince dressed up like a mechanic not in order to keep his incognito but in order to be at ease. Taken all in all, he clearly dominated his group perhaps because he was stamped by the mysterious and magnificent sign of Fortune." And it was the princesses around him who looked out of place.

Cocteau, on the other hand, according to André Gide, who went to find him in the wings, "was looking tense, pained, prematurely aged. He knew that the set and the costumes were by Picasso and the music by Satie, but he was wondering whether Picasso and Satie might be by him." Reading the program notes for *Parade* would have quickly disabused him of any such notion. In them, Apollinaire celebrated "the musical innovator Erik Satie" and "the most audacious of choreographers, Léonide Massine" and, of course, Picasso, who "provokes astonishment that

quickly turns into admiration," but he ostentatiously ignored Cocteau. The battle was still on between Montparnasse and the facile, worldly brilliance incarnated by Cocteau. Picasso and Massine, Apollinaire wrote, "have consummated for the first time this marriage of painting and dance, of plastic art to mime that is the sign of the accession to the throne of a more complete art. . . . This new alliance—for until now costume and decor on the one hand, choreography on the other, have been linked only artificially—has resulted in *Parade* in a kind of surrealism which I see as the point of departure for a series of manifestations of this New Spirit."

For Apollinaire, *Parade* was a triumph of the New Spirit. For Debussy, so close to death, it had come too late: "Perhaps, perhaps," he was heard whispering leaving the auditorium, "but I'm already too far away from all that!" For one member of the audience, it was simply ludicrous: "Had I known it was so silly," he said to his companion, "I would have brought the children." As for those who had hissed and booed and been altogether outraged, *La Grimace* summed up their feelings: "The inharmonious clown Erik Satie has composed his music on typewriters and rattlers . . . His accomplice, the dabbler Picasso, speculating on the eternal stupidity of mankind . . ."

Satie was so incensed by the reviews that he dispatched a postcard to one of the critics: "*Monsieur et cher ami*, you are nothing but an asshole and an unmusical one at that." The critic sued for libel, and on a charge of criminal defamation, Satie was sentenced to a week in prison. Cocteau would later call *Parade* "a big toy"; but it was also the symbolic beginning of modern art, complete with all the components of a modern myth, including scandal, resounding uproar—soon to be followed by its acceptance as a resounding masterpiece—new heroes and even a new martyr in the imprisoned Satie.

By the time Satie was sent to prison, Picasso had left with Olga and the whole of Diaghilev's company for Barcelona. He was welcomed as a hero. It was his first visit since his father's death, and his friends turned it into a major celebration. There were parties given in his honor, nostalgic visits to the favorite haunts of his youth, flamenco dancing and a lot of talking late into the night with Pallarès and de Soto and Reventós and the Junyer-

Vidal brothers and Utrillo and Iturrino. They all got together and on July 12 held a banquet in Picasso's honor, with Iturrino proposing the toast, enthusiastic singing of the "Marseillaise" and "Els Segadors" and wide coverage in the press.

He did not stop working, and much of what he did was to draw Olga, always realistically, always looking elegant and dignified. She insisted on having her portrait done in a naturalistic style. "I want to recognize my face," she told him. She also insisted on being shown wearing a mantilla, so in *Olga in a Mantilla*, he hispanicized her, and as no mantilla was immediately at hand, he improvised with a bedspread. Under the props and behind her half-formed smile, the artist revealed a toughness, a possessiveness and an obstinacy in Olga's nature which the man himself did not perceive, or if he did, he chose to ignore. Despite what he had said to Diaghilev and even to himself, the decision to marry Olga was gathering force.

Yet in the underlying characterization of *Olga in a Mantilla*, and even more in the series he painted in Barcelona of a bull goring a horse, there was, at however deeply subliminal a level, a darkness, a doubt, a suspicion, penetrating the clarity of that decision. It was a suspicion shared by his mother. Soon after Olga was introduced to her, she had taken her aside and warned her that no woman could be happy with her son because he was available only for himself and for no one else. She also knew that her son could not be happy with that particular woman; but she welcomed Olga and went to see her dance in *Les Sylphides* and *Les Menines*. And she accepted gratefully the portrait of Olga in the mantilla that her son offered her, perhaps because he did not care to be confronted with the evidence of his own insights.

Since her husband's death, Doña Maria had been living with her daughter, who was married to a doctor, Don Juan Vilató Gómez. But during his visit to Barcelona, her son chose to stay at the Razini Pension at the harbor, where Olga was staying. One day, when Picasso and Olga were out walking, they were approached by a gypsy woman, who offered to tell Olga's fortune. "What's your name?" the gypsy asked. "My name is Carmen," replied Olga, who loved to pretend that she was Spanish. "And yours?" "Mine is Olga," said the gypsy, calling Olga's bluff.

On the day the company left to continue its tour in South

America, Olga was at the pier to wave her colleagues goodbye. The choice between a mediocre dancing career and a glorious marriage had not been hard to make. In late fall, they returned to Paris and began their life together in the little house in Montrouge. There is a drawing of them sitting at opposite ends of the huge dining-room table, Picasso flanked by his two dogs, Olga by the maid, an incongruous domesticity permeating the whole scene. And there is a photograph of them, with Olga, primly elegant in a full, striped dress and a bonnet, sitting next to a disheveled Pablo surrounded by his usual studio chaos. They did not even have a language in common that they both spoke well, so they were reduced to speaking French, with heavy Russian and Spanish accents. Living together in Montrouge was not easy, but she knew that he was ordering a whole new wardrobe and that Paul Rosenberg, who was soon to become Picasso's official dealer, had found them a grand new apartment in Paris. She felt that it was only a matter of time before order and elegance reigned over the whole of their life.

What if there were ugly, disjointed paintings piled up in his Montrouge studio? Hadn't he given her the prettiest little scene of their house for Christmas, with stars and snowflakes, and looking so much like something out of her native Russia? Still, the workers at their new apartment on the rue La Boétie were taking far too long, and Olga was growing impatient. So in the spring they moved to a large suite at the very chic Hôtel Lutetia, where she could receive without being embarrassed and where Picasso had a studio in which he could work. But every now and then, at the end of a fashionable dinner, he would leave his bride-to-be at the Lutetia and flee to Montrouge, where the house, which he was keeping as a warehouse, would double as an all-night studio and a much-needed retreat.

The signs and seeds of future disaster were there for all to see, but Picasso was somnambulating toward their wedding day as though on a course that no human hand could change. It was a course set by a weary, disappointed man. Tired of daring and burnt by his own sacred fire, he was hoping to find with Olga a haven of dignified tranquillity and even an excuse for daring no more. He wanted to escape from the exhausting search for absolute painting and the absolute in painting to a world of luxurious

ordinariness. He had sought to free art from material reality and now he was willingly walking into a world of boundaries, limitations and artificial conventions. The two strands of his personality—his Spanish mysticism, persisting despite all denials, and his French realism, ultimately unsatisfying despite all concessions to it—had converged on a most fragile and unlikely point of resolution: a small-time Russian aristocrat.

Years later, he would say that he had settled on Olga because she was pretty and belonged, however tangentially, to the Russian nobility. As a boy in Corunna, he had been rejected by Angeles' family because his social background was not sufficiently distinguished. A quarter of a century later, he would settle that score. There was also the wish to ally himself with society, with the elite of position and wealth, a world that was still uncharted territory for him. If he was going to be launched in it, he needed someone beside him. Whether or not Olga was the right partner for life, he knew that she was unquestionably the right partner for society. She made up for her ignorance of art by her intimate knowledge of the science of deportment, and for her lack of interest in ideas by her fanaticism about dress. Well bred and supremely graceful, whether entering and leaving a room or handling a glass of champagne, she seemed the right woman for the new season of his life. But was she also the woman for all seasons? He must have convinced himself that she was, because he agreed to sign a community-property document according to which everything they owned, including all his paintings, would be equally divided in case of a divorce—an eventuality he clearly did not consider likely, or he would not have consented to parting with half of his unsold output.

Growing up in Barcelona, Picasso had longed to blow apart the limitations and conventions of his middle-class background and become a rootless gypsy. He now sought to renew himself by embarking on the glittering life he had once ridiculed. Unable to derive enough self-acceptance from his achievements and his genius, let alone from his growing fortune, he looked to the mirage of society to fill the gap. The great revolutionary of twentieth-century art fell back in his life on one of the stalest of stale hopes: marrying into the aristocracy. "Is a painter serious?" Olga's aristocratic mother anxiously asked Diaghilev when she received

the news of her daughter's impending marriage. "At least as serious as a dancer!" he replied.

It was the beginning of what the Surrealist painter Matta called Picasso's *Harper's Bazaar* period. "He was so flattered," he said, "by all the attention, that from then on a schizophrenia pervaded his life: between his need for privacy and his need for more and more attention." "Picasso," wrote Juan Gris to Kahnweiler, "still does good things, when he finds time between a Russian ballet and a society portrait." His chief remaining link with the work and the world of his past was Apollinaire. And on May 2, in the Church of Saint Thomas Aquinas, Picasso stood beside him as his best man, together with Vollard, another ghostly figure from his past. Apollinaire was marrying Jacqueline Kolb, the beautiful redhead who had nursed him back to health and would again and again restore his flagging spirits.

On July 12, Apollinaire returned the honor. Together with Max Jacob and Jean Cocteau, ambassadors from the past and the future, he was a witness at Picasso's double wedding to Olga: first in a civil ceremony at the Mairie in the seventh *arrondissement* and then in a sumptuous religious ceremony at the Russian Orthodox church in the rue Daru. Matisse, Braque, Gertrude Stein and Alice B. Toklas, Diaghilev, Massine, Vollard, Paul Rosenberg—all were in the congregation as Picasso married Olga with pomp and circumstance, incense, flowers and candles.

At one point in the service, in a moving and richly symbolic rite of the Orthodox Church, Cocteau and Apollinaire held gold crowns over the heads of the bride and groom as they circled three times round the altar. There is a superstition associated with the rite that if, at the end of the three rounds, the bride's foot is first on the carpet, she will dominate the marriage. Max, the unquestioned authority on superstitions, was the only one aware of this piece of folklore, and when his anxiously watchful eye saw Olga's slender foot step first onto the small golden carpet, all his negative premonitions about his friend's wedding were confirmed. He had never liked Olga and she had never liked him. She tolerated his role at the wedding, but once she was safely ensconced as Madame Picasso, she made it quite clear that Max was by no means a welcome friend at the rue La Boétie.

The newlyweds took the Sud-Express to Biarritz, where they

spent their honeymoon at La Mimoseraie, the luxurious villa of Madame Errazuriz. Picasso was the perfect guest, painting murals on the whitewashed walls of his hostess' villa and charming their friends by drawing portraits of them and their children. At least, charming *most* of their friends. Paul Rosenberg's wife was far from happy with his portrait of her holding her child. Her son, Alexandre Rosenberg, recalled later that "she told him firmly that she would rather have been painted by Boldini, the fashionable Parisian portrait painter of the day. Silently Picasso took another canvas and a few minutes later presented her with a perfect example in the style she desired, signed Boldini."

Madame Errazuriz had no complaints about the murals on her walls. They were a celebration of womanhood and of Apollinaire. Between two female nudes, Picasso wrote a verse from Apollinaire's *Seasons*:

> *It was a blessed time we were on the beaches*
> *Gone from early morning feet naked and no hats*
> *And quickly like a toad's tongue*
> *Love wounded the hearts of fools and of the wise.*

From Biarritz, he wrote to Apollinaire, sending him a tobacco flower: "I see the *beau monde*. I've decorated a room with your poems. I'm not too unhappy here and I work as I've told you, but write to me long letters. Say the sweetest things to your wife. For you, my purest friendship." There were nostalgia and guilt in the letter, in the pressed flower and in the verse on the mural. There was also an attempt to recapture a lost intimacy which he clearly did not feel either with the *beau monde* or with his aristocratic bride. It was hardly the letter of an ecstatic honeymooner, but rather of a man content not to be too unhappy.

Gratefully, Apollinaire wrote back from Paris: "I am very glad to hear you have decorated the [Biarritz] villa like that, and am proud that my poems are there. The ones I am writing now will be more in keeping with your present concerns. I am trying to renew the poetic tone, but in a classical rhythm." He went on to expand on the new trend in his work, and ended his letter in praise of the man who had written that the heart has its reasons

that reason does not know: "What work today is newer, more modern, more economical and full of richness than Pascal? I think you like him and so you should. He is a man we can love." He and Picasso both shared Pascal's conviction that intuition is more powerful than reason, but Picasso strongly denied Pascal's faith in a beneficent force in the universe. "There is no good God," he kept repeating, as if the negative affirmation would silence his bursts of feeling that it might be otherwise.

Two months later, Apollinaire was dead. Weakened by his head wound, he succumbed to the Spanish flu that swept Europe toward the end of the war. Picasso was back in Paris, shaving in his bathroom at the Hôtel Lutetia, when the telephone call came announcing the news. His terrified expression in the mirror shocked him, and his instinctive, immediate response was to draw his self-portrait with that undisguised look of mortality he had seen staring back at him. It was both an exorcism and a *memento mori*. For the next twenty years, Picasso kept all his self-portraits secret and even spread the false story that the one he painted the moment the news of Apollinaire's death reached him was his last. "What a stupid invention!" he used to say about mirrors. The mirror had thrown back an image of himself he would rather not know: vulnerable, fragile and fearful of what fate might have in store for him. He could not abolish mirrors, but only many years after Apollinaire's death did he feel safe enough to end his taboo of secretiveness over his self-portraits.

On November 11, 1918, two days after the death of Apollinaire, the Armistice was declared. The war was over, France triumphant. As Apollinaire lay on his deathbed covered with flowers, the exultant crowds that gathered under his window on the boulevard Saint-Germain to celebrate the end of the war were shouting "A bas Guillaume!" ("Down with Guillaume!")—Apollinaire's namesake, Kaiser Wilhelm II of Germany. It was this cruel irony which sealed the life of a man who had longed to belong to France.

For Picasso, who feared mortality as the single most horrifying fact of existence, the death, at the unnatural age of thirty-nine, of the man with whom he had so closely shared the last fourteen years of his life was an agonizing shock. It was also another heavy

link in the chain of abrupt deaths—his sister, Casagemas, Eva and now Apollinaire—that suddenly removed from him people he had incorporated into his being. With each death, something withered in him, something broke, and the chain of mortality around his heart became a little heavier and harder to bear.

6

GENIUS IN BLACK TIE

THE WAR WAS OVER, and the modern world, disoriented and disillusioned, was born. Nothing was what it had been, and the strong suspicion was abroad that nothing was what it seemed. The weight of history had shifted from the existing order to those rebelling against it. The rebel of Els Quatre Gats and the Bateau-Lavoir chose this moment to move among the antique dealers and the fashionable art galleries of the rue La Boétie.

Gertrude Stein had described the beginnings of Cubism as a time when pictures began to want to leave their frames. With his marriage to Olga and his move to the rue La Boétie, the man who had been both celebrated and ridiculed as the inventor of Cubism had picked a gilded frame in which to confine himself. The irony of his choice was reflected in his work. In a drawing of Olga receiving at the rue La Boétie, Satie, Cocteau and the English critic Clive Bell are sitting uncomfortably in uncomfortable-looking chairs in Olga's meticulously neat drawing room. Every trace of disorder—and of Picasso—has been eliminated. In their bedroom, dominated by two brass beds, the same fastidiousness prevailed. When Olga's reign of order had finally confined her husband and his work to one room, he rented an apartment on the floor above and turned it into a warehouse and studio. He installed himself and his easel in what used to be the living room, where "the window faced south and offered a beautiful view of the rooftops of Paris, bristling with a forest of red and black

chimneys, with the slender, far-off silhouette of the Eiffel Tower rising between them." Each room had a marble fireplace with a mirror over it, and each was soon crowded with stacks of paintings, cartons, Negro masks, books and all sorts of tattered knick-knacks, leaning against the walls or spread over the floors, which slowly evolved into a collage of paint splotches, cigarette butts and dust. The doors connecting the rooms were left open, but the door to his studio-apartment was always locked, and no one —certainly not Olga or the white-aproned chambermaid with her feather duster—was allowed in unless specifically invited by him.

In the early summer, he left for London with Olga for rehearsals of *The Three-Cornered Hat*. Another Spaniard, Manuel de Falla, had written the music, and Diaghilev had asked Picasso to design the sets and costumes. Nineteen years before, when he had first left Barcelona, Picasso had dreamed of settling in London. Now he arrived not as a struggling artist but as a distinguished visitor, who installed himself in a suite at the Savoy Hotel and embarked on a round of fashionable parties. The dandy in him, pushed to the background first by poverty and then by the uniform of a bohemian lifestyle, was now let loose on Savile Row. The narcissistic side in his personality that had led him to parade on the Rambles as a teenager, sharing with de Soto the only pair of gloves they could afford, was at last allowed full sway. He ordered countless jackets, wore a gold watch in his vest pocket, and relished being appropriately and dashingly dressed for all the dinners at which, whether they were given for him or not, he was always the center of attention.

The dramatic transformation of his appearance and his lifestyle was heightened by the presence in London of his old friend Derain, who had come to design a ballet, *La Boutique Fantasque*. Defiantly antibourgeois, Derain was staying in a modest lodging near Regent's Park, and as Clive Bell put it, "their ways of life in London were as distinct as their addresses. Madame Picasso had no notion of joining in the rough and tumble of even upper Bohemia." At the party that Clive Bell and John Maynard Keynes gave for Picasso and Derain in their house in Gordon Square, Derain arrived wearing the same blue serge suit he wore everywhere, refusing to make any concessions to the tribal customs of society. He, like Braque, believed that any concessions, however

trivial, were signs of surrender to the "bourgeois despotism" they had sought to overthrow and, therefore, a betrayal of what their lives and their art were supposed to be about. All three men remained civil to each other, but behind their backs the insults flew. "The first time I saw her," wrote Alice Derain, referring to Olga, "I took her for a chambermaid; she was a plain little woman with freckles all over her face." Picasso's reference to Braque as "Madame Picasso" was a much subtler but infinitely more painful insult, demeaning Braque's work and hiding his own pain at the fact that so extraordinary a collaboration had dwindled into refined, surface civility.

Picasso may have become a dandy and a social lion, but his perfectionism and his capacity for hard work remained undiminished. When *The Three-Cornered Hat* opened at the Alhambra Theatre on July 22, 1919, he was backstage, with a stagehand carrying a tray of makeup, doing the faces of some of the dancers and supervising the rest. Karsavina, who was dancing the miller's wife opposite Massine, had her costume created actually on her, after Picasso had spent days watching her dance at the rehearsals. Enchanted with him and with her costume, she described it as "a supreme masterpiece of pink silk and black lace of the simplest shape; a symbol more than an ethnographic reproduction of a national costume."

The sets, the costumes, the music, the dancing, everything was a triumph, and Picasso took his bows in his new impeccable dinner jacket, complete with a bullfighter's cummerbund—correct and exotic at the same time. Picasso the magician had been born. Whatever anxieties, fears and personal doubts tormented him, he radiated an almost cosmic and irresistible self-confidence. Nothing seemed beyond him. In the eyes of growing numbers of critics and eager buyers, he was purely and simply a genius, and they praised and bought his works because a genius had produced them. Instead of his work bestowing greatness on him, from now on he would bestow greatness on everything he touched. As he said himself, "It's not what an artist does that counts, but what he is."

In an age beset by uncertainty, he came to incarnate artistic genius, and his mysterious power, like that of a primitive shaman, was reassuring. In an age obsessed by the idea of progress, he

dared to say that there was no progress in his work: "The several manners I have used in my art," he said, "must not be considered as evolution, or as steps towards an unknown idea of painting. I have never made trials or experiments. Whenever I had something to say I have said it in the manner in which I have felt it ought to be said."

Back in Paris, a few Cubist still-lifes apart, the manner required by what he had to say at this time was neoclassical realism, as if he wanted to restore order to his art as well as to his life. In fact, about the most iconoclastic thing that he did in 1919 was to spend his summer on the Côte d'Azur, which according to the fashionable wisdom of the time was utterly to be avoided in high summer when the sun was dangerously hot. He came back from Saint-Raphaël with a crop of drawings full of open windows through which flowed the Mediterranean sun. Paul Rosenberg loved them, and so did the crowd that flocked to the exhibition at his gallery on October 20. The first lithograph he had ever made decorated the invitation, and a closed window, this time with Olga in front of it, graced the cover of the catalogue.

But not all dissenting voices had been silenced. "What was the meaning of this and the other pictures?" asked Wilhelm Uhde. "Were they but an interlude, a gesture—splendid but without significance—which the hand made, while the soul, worn out on its long journey, rested? . . . Was he suffering moral isolation by living in a foreign country? Was he trying definitely to range himself on the French side?" André Fermigier went even further and called this period Picasso's "naturalization file." In fact, however he painted and however he lived, Picasso remained the irrepressible Andalusian he had always been. "All over Andalusia," García Lorca would say, "the people speak constantly of the 'duende' and identify it accurately and instinctively whenever it appears. . . . This 'mysterious power which everyone senses and no philosopher explains' is, in sum, the spirit of the earth. . . . The marvelous singer El Lebrijano used to say, 'On days when I sing with duende, no one can touch me.' "

And Picasso did feel that no one could touch him. He knew that whether in black tie or in a coverall, he was possessed by the duende. "It is my misfortune—and probably my delight—to use things as my passions tell me," he said. "What a miserable fate

for a painter who adores blondes to have to stop himself putting them into a picture because they don't go with the basket of fruit! How awful for a painter who loathes apples to have to use them all the time because they go so well with the cloth. I put all the things I like into my pictures. The things so much the worse for them: they just have to put up with it."

The chorus of praise grew even louder when, at the end of the year, *The Three-Cornered Hat* was performed at l'Opéra in Paris. And the performance continued at the grand party given by Misia Sert after opening night. Artur Rubinstein played Manuel de Falla's music, and Picasso, in high spirits, took the hostess' eyebrow pencil and drew a crown of laurel leaves on de Falla's bald head. The guests were enchanted by the magician's inventiveness —but fortunately for the composer, the enchantment fell short of scalping him to gain a Picasso. As Paul Morand observed, "All the women there were a little in love with Picasso, and Picasso was more than a little in love with Misia."

The crazy, glorious twenties had arrived a little ahead of the calendar. Paris became the magnetic center of "the lost generation," as Gertrude Stein would describe them. Hemingway was there, and James Joyce, and Scott and Zelda Fitzgerald, along with eccentric millionaires and self-exiled aristocrats. It was the perfect home for Dadaism, which, sired in Zürich by Tristan Tzara, was being nurtured in Paris by three Frenchmen, Louis Aragon, André Breton and Philippe Soupault. They had come together at the end of the war and "found that they had in common an overwhelming sense of revulsion against the culture of their country and their time . . . imbued with the mood of scorn toward a society whose traditions of family, religion and patriotism seemed nothing more than a facade." Tzara, short, boyish, monocled and, by his own description, charming, had fled his native Romania and settled in Zürich before coming to Paris, determined to "sweep everything away and sweep clean," while having a lot of fun in the process. As far as he was concerned it was too late for geniuses and solemn, great art. It was time to create poems by taking words out of a hat—which he did; time to bring down the temples, time to "spit on humanity" and, above all, time to treat it all as a big joke. Gertrude Stein, to whom Tzara was introduced as soon as he arrived in Paris, was not

impressed. But then, as Tzara had proclaimed, "the true Dadaists are against Dada."

At the Cabaret Voltaire in Zürich, where Tzara had spent the war proclaiming Dada as the true unfaith and anti-art as the true art, they had hung Cubist paintings on the walls as shock treatment for the old culture. In Paris, on January 28, 1920, at a big exhibition of Cubism at the Salon des Indépendants, the shock seemed to have been absorbed. Picasso was glaringly absent. His much-touted betrayal of Cubism had been received with sighs of relief by some and outbreaks of rage by others, appalled at his disloyalty. "Oh, no," Picasso would exclaim, "don't expect me to repeat myself. My past doesn't interest me anymore. Rather than recopy myself, I would prefer to recopy others. At least I would bring something new to them. I like discovery too much." No loyalty to a former discovery could survive the force of his inner promptings. "What, after all, is a painter?" he asked. "He's a collector who wants to make a collection by doing the paintings he saw in other collections. That's how it starts, but then it becomes something else."

In fact, as Kahnweiler's return to Paris in February showed, he felt no obligation to be loyal to a friend either. When his old dealer opened a new gallery at 29 *bis* rue d'Astorg, under the name of his partner André Simon, Picasso stayed with Paul Rosenberg. It was a decision that served his interests well. He could command higher prices from Rosenberg, and he could reach larger numbers of buyers among the uninitiated but affluent bourgeoisie. If he attached little importance to loyalty to his friends, he bristled at any suggestion, real or imagined, of disloyalty from them. When André Salmon published his long poem *Peindre*, with Picasso's portrait of him from their Bateau-Lavoir days as its frontispiece, he dedicated it to "André Derain, French painter." Picasso was livid. "Don't you think I'm a French painter?" he demanded like a hurt child. And even as Cocteau was obsequiously addressing him as *Cher Magnifique*, Picasso loved putting him down: "Cocteau was born with a pleat in his trousers. He is becoming terribly famous: you will find his works at every hairdresser's."

Yet he and Olga joined with relish the glittering, frivolous world to which Cocteau was his guide. And soon, Monsieur and

Madame Picasso were added to every fashionable guest list, including that of the Princess de Polignac, at whose grand salon, on the avenue Henri-Martin, the rich and the noble mingled with the gifted and with the Princess' women lovers. But it was Count Etienne de Beaumont who "opened the ball after the war." Gallant, refined, affected and imposing, he was married to Edith de Taisne, who would rather translate Greek poetry than go to another ball. For the sake of her husband, she did both. Picasso and Olga were often bidden to the lavish parties that the Beaumonts gave in their eighteenth-century mansion in the rue Duroc. A large number of them were extravagant costume balls on a theme such as the French colonies, or Versailles at the time of Louis XIV (on whom it was said the Count modeled himself). More intriguingly, the guests were once invited to arrive "leaving exposed that part of one's body that one considered the most interesting."

Of all his distinguished hosts and hostesses, Misia Sert was Picasso's favorite. "The relation between these two lawless creatures," wrote Arthur Gold and Robert Fizdale, Misia's biographers, "was complicated, but they had a kind of tacit understanding." Part of their understanding concerned José-Maria Sert, the Spanish painter and *grand seigneur* whom Misia married after living with him for twelve years. Picasso and Misia seemed to have reached an unspoken agreement from their respective vantage points that José-Maria was a much better lover than painter. Picasso called him Don José, the sarcasm directed at the pedantry of his paintings, which reminded him of the academicism of his teachers at the Lotja and of his first teacher, the other Don José in his life. And Misia, who was fanatical in her scheming for her husband's success and adored her "*vrai he-man*," despite all his infidelities, was nevertheless compelled to recognize that it was not her husband who was the Spanish genius resident in Paris. "Il était un Catalan / Qui n'avait aucun talent" (He was a Catalan who had no talent), Cocteau used to chant behind Sert's back. Gossip, malice that passed for wit and sometimes *was* witty, irony and gibes were the coin of the realm in that world, especially among the closest of friends. "*Chère madame*," wrote Marcel Proust to Misia on the occasion of her wedding to Sert, "I was very touched that you took the trouble to

write and tell me of this marriage which has the majestic beauty of something wonderfully unnecessary."

Picasso exchanged darts of irony and bouquets of admiration with the best of them; he attended the balls, the parties and the opening nights; but the *beau monde* never became much of a distraction from the compelling focus on his work. For Olga, it was the only focus. She put as much effort into their social life as she had put into her ballet training. To maintain her slender figure, she continued practicing every day, in between going to fittings for her ball gowns, choosing hats, which she loved, managing her staff and reciprocating the hospitality they received by holding small but impeccably elegant dinners at home. She must have thought herself happy. Picasso's unruly friends had been successfully banished, she was surrounded only by men and women of the highest distinction and, on her celebrated husband's arm, she finally received the attention and admiring glances she had always craved. So life seemed enviably in order.

Picasso, on the other hand, was *in* society, but never *of* it. Success may have acquainted him with some strange bedfellows, but he very shrewdly took the measure of that world even while he inhabited it. Years later, looking at a photograph of himself between Olga and Madame Errazuriz, he smiled knowingly and summed it all up: "*Commedia* . . ." "Picasso, having no need of anyone," Germaine Everling, Francis Picabia's mistress, would write, "has always kept himself aloof from those who might make him compromise himself." Unlike Cocteau, who, as Misia Sert lamented, felt compelled to please everybody, Picasso never succumbed to this particular social virus, and only very occasionally lapsed into wanting to please anyone but himself.

One of these lapses occurred early in 1920. He had been working for a large part of the winter on the sets and costumes for *Pulcinella*, his third Diaghilev ballet, this time with music by Stravinsky on a theme by Pergolesi. He was excited by the idea of bringing to life an eighteenth-century *commedia del'arte* with all his favorite characters, including Harlequin; but when he showed Diaghilev his sketches for the costumes, complete with side whiskers instead of masks, Diaghilev was appalled. In fact, he so hated Picasso's concept that at the height of their heated argument, he threw the sketches on the floor, stamped on them and stormed

out of the room, slamming the door behind him. Picasso not only continued to work on the project, he contented himself with the familiar boleros and tutus of *commedia del'arte* characters. For Massine's costume, he sketched a white smock, red tights, and a black mask with a grotesque nose. The compromise may not have been very good for art, but it was good for business. Only Cocteau, normally the greatest accommodator of all, was disappointed: "He improvised costumes," he complained, "but what are they worth in comparison with the costumes and pantomime he desired, the sketches for which still exist!"

The final set was a merging of Cubism and romanticism, and despite the deadlines, the disagreements, the compromises and the misunderstandings, the opening night at l'Opéra on May 15 was a huge success. Picasso, who had loved working with Stravinsky, delighted in the composer's reply to those who dissented from the chorus of praise and attacked him for his disrespect of Pergolesi's music: "You respect, but I love." Stravinsky wrote later that *Pulcinella* was "one of those productions—and they are rare where everything harmonizes, where all the elements —subject, music, dancing and artistic setting—form a coherent and homogeneous whole." Nevertheless, he soon "regretfully" reached the conclusion that a perfect rendering of his music could be achieved only in the concert hall, "because the stage presents a combination of several elements upon which the music has often to depend."

Picasso declared *Pulcinella* his favorite among all the Diaghilev ballets he worked on, and with his worldly acceptance of the limitations of any collaboration, he seemed much less frustrated than Stravinsky or even Cocteau by the imperfect rendering of his ideas. In Picasso, the unharnessable genius coexisted very happily with the cunning operator, using those who were in the process of using him. *Parade* had raised him to new heights of wealth and celebrity; he knew that another dazzling Diaghilev ballet, even if it meant a few concessions and compromises, could only add to his fame and the power it brought him.

The opening-night performance was followed by another magnificent party, this time more exotic than most. It was given by the Persian Prince Firouz in a small castle in Robinson, a village outside Paris. With the exception of the host and René d'Amour-

etti, an ex-convict, who lived in the castle and welcomed the guests on the steps, the guest list contained few surprises: the Beaumonts; the Serts; Cocteau and his very quiet but very astute monocled young lover, Raymond Radiguet, who was to immortalize the party in his novel *Le Bal du Comte d'Orgel*; the princess Eugène Murat; the painter Jean Hugo, a great-grandson of Victor Hugo who had married Valentine Gross; and, of course, Diaghilev, Massine, Stravinsky and the Picassos. "Prince Firouz," wrote Jean Hugo in his memoirs, "was a magnificent host. We drank a lot of champagne. Stravinsky got drunk, went up to the bedrooms, took the pillows, bolsters and mattresses and threw them over the balcony into the hall. There was a pillow fight and the party ended at three in the morning."

In the world Picasso moved through, his magnetism and his *bons mots* were at least as much a source of wonder as his paintings and his designs. At a later performance of *Pulcinella*, Jean Hugo was sitting next to Picasso in Misia Sert's box. Suddenly, Picasso turned to him and asked: "So, are you still painting by hand?" Hugo, taking the question at face value, would be puzzled by it for years: "What did he mean? That since photography had been invented, what are paintbrushes good for? That our work had become as useless as that of the gilders of ships' prows? I have not been able to stop reflecting on those words pronounced in the dark during the ballet."

Within a month of the opening of *Pulcinella*, Picasso and Olga had left Paris for the sea and the quiet of Juan-les-Pins. Olga was pregnant, and Picasso began the process of coming to terms with the fact that he, in many ways the perennial adolescent, would soon, at the age of forty, become a father. It was not a joyful process. Olga was very much disturbed by the changes in her body. For years she had religiously kept it slender and fit, and now it was turning into something that in her eyes was bulky and grotesque. Her growing self-absorption, irrationality and demands for attention exasperated her husband and confirmed all his own fears of devouring women. The giantesses that had made their first appearance in his work during his honeymoon became, with the progress of Olga's pregnancy and the regression in her personality, more gigantic and more ominous.

There was something impenetrable about these women and,

despite their volume and size, an abstract, inhuman quality in their masklike features and their placidity. Physical deformities and swellings had always produced anxiety in Picasso. As a child, he remembered hiding under the table and watching with alarmed fascination the huge calves of his aunt. "I dreamed that my legs and arms grew to an enormous size and then shrank back just as much in the other direction. And all around me, in my dream, I saw other people going through the same transformations, getting huge or very tiny. I felt terribly anguished every time I dreamed about that."

On February 4, 1921, Olga gave birth to a son. They called him Paulo, and asked Misia Sert to be his godmother. The pride and delight of being a father pushed Picasso's anguish to the background and inspired a series of tender sketches recording Paulo's first months. Sometimes, as if aware of the dramatic changes wrought during the child's first year, he recorded not only the date but the hour at which the drawings were done. Soon, however, the uneasy feeling appeared again in a succession of pictures of mother and child, isolated and inaccessible in their own world. There are male children but no men in this world, where time stands still—not in blissful timelessness but in a lumpish immobility from which every ounce of life's vital energy has been drained. And when there is activity, it is in slow motion, sluggish and leaden, a kind of absentminded surrender to the force of gravity.

Olga, who was able to hold only one idea or one concern in her mind at any one time, was lethargically but obsessively preoccupied with little Paulo. There were servants to ease her burden —nurse, chambermaid, chauffeur, cook—yet emotionally she seemed depleted, incapable of stretching beyond the nursery or the ossified niceties of fancy balls and opening nights. On May 22, there was one more opening night. *Cuadro Flamenco*, Picasso's fourth Diaghilev ballet, premiered at the Gaîté-Lyrique. It was no more than an echo of what had gone before, and this time Picasso had effectively invited himself to do the sets and costumes—and for the meanest of reasons.

Diaghilev had originally commissioned Juan Gris to design the ballet, but when he arrived in Monte Carlo, where the company was based in April, Gris discovered to his amazement that his

services were no longer required. "I don't know just what happened," he wrote to Kahnweiler. Picasso knew. Gris, his health already failing, had been late with his designs. And Picasso, a master of intrigue, with whose machinations Gris was totally unequipped to compete, immediately started spreading the rumor that Gris was too sick to do the job. To drive his point home to Diaghilev more forcefully, he sent his own sketches for the ballet, which were little more than a rehash of his *Pulcinella* sets—a stage within a stage—that Diaghilev had originally turned down. This time he accepted them, and Picasso won a double, hollow victory: he beat Diaghilev into submission and he beat Gris out of a glamorous job.

There was not much that *Cuadro Flamenco* could add to his life artistically, financially or socially. The only motive for forcing himself into it was his petty hatred of Juan Gris. With dignity and unspoken sadness, Gris left Monte Carlo and returned to his home in Bandol. Picasso's intrigue was successful, but the ballet itself was not. *Cuadro Flamenco*, after an indifferent reception in Paris and London, was dropped at the end of the season.

But whether a particular production was a success or not was no longer relevant. By 1921, Picasso epitomized artistic success. "Other artists have courted success, adapted themselves to society, betrayed their beginnings," wrote the art critic John Berger. "Picasso has done none of these things. He has invited success as little as Van Gogh invited failure. Success has been Picasso's destiny, and that is what makes him the typical artist of our time, as Van Gogh was of his." His income, however, was hardly typical among artists of any time. He himself estimated that by 1921, he was earning one and a half million francs a year.

His success prompted Aragon to create in his novel *Anicet ou le Panorama, roman*, published in Paris the same year, the painter Bleu, a parody of Picasso. Bleu is juxtaposed in all his riches and celebrity with Jean Chipre, a character based on Max Jacob who suffers in poverty and oblivion. "I have never painted except to seduce," Bleu concludes in the novel. Bleu and Chipre had been friends, struggling together in their youth, and years later, when they meet again, Bleu, "the genius of our times," has everything—money, fame and now a child—while Chipre, resigned to having nothing, goes into exile.

In June, Max, turning fiction into reality, exiled himself from Paris and moved to the little village of Saint-Benoît, near a Romanesque basilica on the banks of the Loire. From there he wrote to the painter Kisling: "If you had seen my last meeting with Picasso, you would have cried! Which is what I did afterwards. At other times we fought, but it was a pretext for making up again; now we do things for each other, but there is a coldness that prevails. This is the death of all my life! He is deader than Apollinaire."

There were to be other sporadic meetings, but something had broken between them and would never completely heal. Yet Max's adoration for Picasso persisted, and he could not stop talking about him. He had been Picasso's first champion, and despite his anguished feelings of abandonment, he remained his champion long after Picasso ceased to need one. He never tried to repay the pain he had received. "He abhors incomprehension and indiscretion," he said in explaining why he had not written about Picasso, "and I feel so much respect and gratitude toward him that I would not want to do anything to displease him. I have seen how pained he has been by the behavior of our best friends, and I will not imitate it. Certain friends have lived on his name, making the most of gossip, tittle-tattle and idle fancies. Later perhaps . . . we'll see . . . but much later and in fact, I do believe, never. Our common memories are something very sweet, very holy and often so very sad."

Others, however, had already begun writing about him, and in terms that added new luster to the Picasso myth and to the burgeoning legend. Léonce Rosenberg's publishing house, L'Effort Moderne, printed an album with forty-eight illustrations and a text by another of Picasso's friends from the Montmartre years, Maurice Raynal, exalting Picasso's power as a seer, who "raises man above his strictly animal condition and forces him to believe in the probability of liberty." André Salmon, another friend of his youth, had already described him as "crowned by grace, followed by those to whom he showed the way and preceded only by the man he used to be." In London, Clive Bell, even more emotionally, was also exploring the theme of Picasso's power: "Picasso is the liberator. His influence is ubiquitous . . . [He] is a born *chef d'école*. His is one of the most inventive minds in Eu-

rope. Invention is as clearly his supreme gift as sensibility is that of Matisse." And in the Prague journal *New Directions*, the Czech critic Václav Nebeský, who had never met Picasso, was lyrical about his "striving after a more complete and comprehensive realism . . . he places light and shadow on the surface of reality, as if bestowing kisses on his beloved—reality which under his hands becomes a monument more enduring than life itself."

This was the kind of power ascribed to Picasso as early as 1921 —to liberate, to create a reality more real and more precious than life, and to do all this alone, "preceded only by the man he used to be." Such critical acclaim was unparalleled for a contemporary artist, and in a pastel dated September 14, 1921, Picasso drew his hands with the joints protruding, looking all the more powerful and fit for the superhuman work of liberation and creation that critics had assigned him.

The summer of 1921 was an extraordinarily creative one. By way of explanation of his enormous productivity, he told Cocteau of a magical device that the Duke d'Olivares had attached to the coat of arms of the King of Spain. Its power was inscribed on the rim of a well: "The more that is taken from it, the larger it becomes." The site for new explorations in the classical vein and fresh experiments in the Cubist one was a large and very traditional villa in Fontainebleau, where he spent the summer, ensconced in the role of paterfamilias, complete with wife, son, animals, household staff and mahogany furniture. Once, when the gentility of the villa became too oppressive, he mused out loud that he was thinking of ordering a Parisian street lamp and a public urinal to disturb the tidy respectability of the grounds in which the villa was set.

Instead he created a disturbing masterpiece, and then a second version of it. In *The Three Musicians*, three figures, one dressed as Harlequin, one as Pierrot and one as a monk, are playing musical instruments. The notes of music were compelling, demanding to be heard, despite the tiny hands of the musicians and the confining format into which they have been squeezed. The two *commedia dell'arte* characters, ambassadors from the brittle world of mortality, are juxtaposed with the monk, representative of what is eternal in this shifting world of illusion. There is wit and there is music, but there is also darkness and a menacing

sense of claustrophobia in *The Three Musicians*. It was a mixture that mirrored the contradictory feelings in his own life—his delight at being a father, proudly watching his son grow, set against his gnawing sense of absurdity and entrapment in Olga's artificial world, a world into which he had been thrust but which he had also chosen.

Picasso and Olga saw 1922 in at a splendid New Year's Eve party given by the Beaumonts. Midnight approached, and one of the most important guests had not yet arrived. The host announced instead that Céleste, Proust's housekeeper, had telephoned for the tenth time to find out if it was drafty and if the herb tea for which she had given the recipe was ready. "Finally at midnight," wrote Jean Hugo in his diary, "there was a sort of stir in the crowd and we knew that Proust had arrived. He had entered together with the new year, the year of his death. . . . His pale face had become puffy; he had developed a paunch. He spoke only to dukes. 'Look at him,' Picasso said to me, 'he's still on his theme.' " Picasso may not have read Proust, but he had absorbed him.

He was fascinated by the literary life of Paris. At Jean Hugo's studio at the Palais-Royal, he heard Cocteau read *Le Diable au Corps*, the novel that Radiguet had almost finished. Madame de Beaumont fell asleep during the reading, but the book made Cocteau's twenty-year-old lover rich and famous. Four years earlier, when Radiguet was a precocious sixteen-year-old poet in a hurry, Apollinaire had teased him: "Don't despair; Monsieur Rimbaud waited until he was seventeen before writing his masterpiece." Radiguet had to wait until he was twenty.

While Radiguet was writing "with regal elegance" novels that were recognizable as novels, the Dadaists continued to rage against every existing form of literature and art. Picasso was present when Tristan Tzara put on one of his Dada spectacles at the Théâtre Michel. The evening included some poetry by Cocteau, whom Breton despised. Together with Aragon, Breton leaped onto the stage to protest, and in the process, swinging his heavy cane, he broke the arm of one of the actors, Pierre de Massot. Picasso, caught up in the troublemaking spirit, shouted from his box, "Tzara, no police here." Breton swore that he had shouted that Tzara had called the police here. Whichever it was, the

police stormed in just at that moment, and Breton, who was at least as good a hater as he was a lover, remained forever furious with Tzara, who in turn was to consider Picasso the cause—intentional or not—of his break with the Surrealists.

The cause was in fact much deeper and predated the bedlam at the Théâtre Michel. For some time now, Breton had been pushing Tzara aside and acting as the leader of their group. At the beginning of 1922, he had publicly attacked "a certain personage who hailed from Zürich" as " an impostor avid for publicity." He wanted to take the next step beyond Dada, and to that effect he formed the Surrealist group. In the review *Littérature*, which he had resuscitated, he declared that the time of Dada had passed, and that its usefulness had been to promote a certain "state of mind which served to keep us in a condition of readiness—from which we shall now start out, in all lucidity, toward that which calls to us." The summons Breton obeyed was to liberate man from his prosaic rationality. In the summer of 1921 he had been to Vienna to interview Freud, and he now urged his growing group of followers to explore the world of dreams and listen to their subconscious minds. The Surrealist movement was born, and Breton, with his consuming passion, striking looks and probing intellect, became its "pope" or "archimandrite," imposing on his proselytes a discipline as strict as if they belonged to a Jesuit order. He needed disciples, but he also needed idols, and Picasso, whom he had met in November 1918 in the passageway of Apollinaire's house, was cast in that role, untouchable and beyond all the strictures to which he subjected everyone else.

In June 1922, Picasso left the rebels' search for a new faith and all the attendant squabbles behind him for the peace and quiet of Dinard. In *Woman and Child*, the drawings of Paulo, the Dinard landscapes, the voluptuous pagan goddesses—in all his work of this time—there was a grace and a glow, an Arcadian serenity, a sense of the Rose Period revisited by a paterfamilias who, now in his forties, had added solidity to introspection and abundance to his vision of the world. And through it all, he would watch with wonder his little son's wonderment at the world around him. "I am that child," he said often, pointing at the children that peopled his canvases. "You see me here and yet I'm already changed. I'm already elsewhere. I'm never fixed." He

seemed to look at the world as a child, and as in a child's world, everything was for the first time and the only constant was that everything changes.

Talking to Aragon once, as they were playing with Paulo's electric train spread out on the carpet, he described a painting by Ingres in which the Spanish ambassador has just walked in and surprised Henry IV on all fours, playing the horse with a child on his back. "Me, I am going to paint a painting like that," Picasso said. "You will see President Poincarré playing with a small boy of ten on his shoulders and the Spanish ambassador, Mr. Quiñones de Leon, who enters unexpectedly. Eh? Is that perhaps what one should be painting today?"

He took a childish delight in exposing and exploding the pomp of the grown-ups' world. He loved to disobey, and so when Cocteau asked him to do the sets for his adaptation of *Antigone*, Sophocles' play on the theme of disobedience to authority, he accepted with alacrity. Cocteau's objective was to put "new dress on old Greek tragedy, adapting it to the rhythm of our own day." To that end he chose Paul Honegger to do the music, Picasso the decor and Coco Chanel the costumes because, as he explained, "she is our leading dressmaker and I cannot imagine Oedipus' daughters patronizing a 'little dressmaker.' " Cocteau's *snobisme* was so monumental that it easily transcended centuries and cultures. When *Antigone* opened on December 20, 1922, Oedipus, Antigone and Sophocles were hardly the attraction for the fashionable crowd which climbed up to Charles Dullin's Théâtre de l'Atelier in Montmartre. They came to rave over the miracles performed by the holy trinity of Cocteau, Chanel and Picasso, and over the insolence and wit with which they treated antiquity and the art of the past.

Like a flamenco dancer, Picasso thrived on the game, the dance of alternately tantalizing, exasperating, astonishing and delighting. Two days before opening night, he still had not produced a set, or even any designs for a set. Cocteau and Charles Dullin, the principal actor, were in a state of panic when Picasso finally arrived and presented them with a crumpled canvas. "Very well. Here's your set," he said defiantly. When the violet-blue canvas was hung, turning the stage into a cavern, he first created, with red chalk, the effect of marble, and then three Doric col-

umns. "The emergence of these columns," wrote Cocteau, "was so sudden, so surprising that we burst into applause. As we left the theater, I asked Picasso if he had calculated their approach, if he had closed in on them, or if he too had been surprised by them. He answered that he had been surprised, but that you always calculate unconsciously, that the Doric column results, like the hexameter, from an operation of the senses and that perhaps he had just invented such a column in the same way the Greeks had discovered it."

In the reviews of *Antigone*, it was Coco Chanel who stole many of the headlines with the costumes she made from the heavy Scottish woolens Cocteau had picked for her. "Chanel Becomes Greek" was the title of one of the reviews. Chanel, who was a great intimate of Misia Sert's, had met Picasso at one of the fashionable parties and was, as she would later confess, immediately "swept up by a passion for him. He was wicked. He was fascinating like a sparrow hawk, he made me a little afraid. I felt it when he arrived; something would shrivel within me. He is there! I wouldn't see him yet, but I would know that he was in the room. And then I would discover him. He had a way of looking at me . . . I trembled."

Chanel, whose couture house on the rue Cambon had become a landmark of fashion, lived in a lavishly decorated apartment on the rue du Faubourg Saint-Honoré. For Picasso, it was open at all times of the day or night. She even had a room set aside for him where he could stay when he longed to escape from Fontainebleau but did not want to be alone at the rue La Boétie when the whole household was away. Picasso admired the shrewdness, the vision and the talent that had brought Chanel from peasant poverty in Auvergnes to the heights of Parisian society. "That can't last," she said one night at the theater, looking at all the women in their over-ornate dresses. "I'm going to dress them simply, and in black." She did, and in the process turned herself into a multimillionairess and Chanel into a household name.

Antigone was another much-publicized success for Picasso. Like haystacks catching fire from one another, his fame was spreading. In May 1923, his first long interview appeared in *The Arts* in New York. It had been given in Spanish to Marius de Zayas and was full of the paradoxical pyrotechnics that lit up his

statements, sometimes illuminating, sometimes obscuring his thoughts. "We all know," he said, "that Art is not truth. Art is a lie that makes us realize truth, at least the truth that is given us to understand. I would like to know if anyone has ever seen a natural work of art. Nature and art, being two different things, cannot be the same thing. Through art we express our conception of what nature is not . . . If we are to apply the law of evolution and transformation to art, then we have to admit that all art is transitory." The interview was full of such sobering reflections on the inescapable limitations of art, reflections at which he himself would have balked only a few years earlier. The man who, together with Braque, had been engaged in a sacred quest for absolute painting now told a world trying to live on a purely aesthetic diet that at best, art can only raise the curtain of smoke and give man access to truth—but it is not truth, nor is it forever.

All around him, prodigious efforts were expended in producing glittering evenings that were, by definition, ephemeral. On June 23, after a performance of *Les Noces* by the Diaghilev ballet, the Picassos attended just such a celebration on a barge on the Seine, hosted by a striking American couple, Gerald and Sara Murphy. Handsome and rich, Murphy had taken up painting—until he came to the realization that "the world is too full of second-rate painting" and gave it up. That evening, Picasso was fascinated by Sara, a beautiful and effortlessly enchanting hostess, with a real gift for mixing luxury with bohemian spontaneity. He admired the miniature toys she had placed on the tables instead of flower arrangements; he watched Stravinsky trying to leap through a wooden laurel wreath; he chatted with Cocteau dressed as a captain and with Chanel sporting a short haircut that was to launch a new fashion among women. He stayed until dawn broke over the Seine and the party was over.

The summer of 1923 was spent in Antibes. It looked as though, at forty-two, Picasso had achieved access to everything the world could offer, and there was a solidity about his life which made it seem that it might, after all, last forever. His mother came to spend a few weeks with them and meet her little grandson. Gertrude Stein and Alice B. Toklas joined the family and slipped very naturally into the unlikely role of maiden aunts, wonderingly watching Paulo make mud pies on the beach. Somehow, and

without the benefit of a common language, Gertrude Stein and Doña Maria struck up conversation about Picasso. Gertrude Stein recalled the time she met him: "He was remarkably beautiful then, he was illuminated as if he wore a halo." "Oh," Doña Maria countered, "if you thought him beautiful then I assure you it was nothing compared to his looks when he was a boy." Picasso interrupted, wanting to know what they thought of him *now*. "Ah now said they together, ah now there is no such beauty left. But, added his mother, you are very sweet and as a son very perfect. So he had to be satisfied with that."

The portraits of both his mother and his wife that summer were naturalistic and extremely flattering. But underneath this picture postcard of extended family bliss, Picasso's well-varnished universe was beginning to crack. The process was speeded up by the time he spent in Antibes with Breton. He did his portrait, and passed long nights listening to the young orator discourse with his usual eloquence on his fanatical commitment to a Nietzschean "transvaluation" of all human values, "beyond good and evil" and "beyond the beautiful and the ugly." It was all strikingly reminiscent of the equally long nights he had spent at Els Quatre Gats, discussing Nietzsche and remaking the world. Picasso's deeper contact with the young revolutionary brought out in him the anti-bourgeois rebel lurking just below the surface. His will to destroy appearances resurfaced, and the enchantment of being part of a hard-playing and at times hardworking clan of sacred monsters began to give way to his urge to detonate the explosives that he carried in his heart. "Abandon everything," Breton had written in *Littérature*. "Abandon Dada. Get rid of your wife. Give up your mistress. Give up your hopes and your fears. Sow your children out in the woods. Give up the substance for the shadow. Give up your easy way of life, and that which passes for a job with a future. Take to the roads."

Picasso was ready to obey the call of the wilderness. Or almost ready. There was another ballet to be designed, this time for the Soirées de Paris, a company created by the Count de Beaumont to rival—as it turned out, only for a two-month season—Diaghilev's Russian Ballet. Satie wrote the music for *Mercure*, and Massine, who had been fired by Diaghilev, did the choreography.

The impresario's wrath had come down on Massine when he fell in love with Vera Savina, an English dancer in the company. Diaghilev had lost, all at once, both a choreographer and a lover, and his valet reported that he "nearly died of grief." His grief turned into rage when Massine proceeded to marry Savina and to join the Soirées de Paris, and as the opening performance of *Mercure* drew closer, Diaghilev grew increasingly anxious.

Picasso had thrown himself into his fifth and last ballet as he had not done since *Parade*, with one eye on Breton and his Surrealists, who detested the ballet as hopelessly bourgeois, and the other eye on Braque, Gris, Derain and Matisse, who had also begun to design for the ballet. Fiercely competitive, Picasso saw this as an attempt to muscle in on what he considered to be his fiefdom. "Matisse!" he exclaimed furiously when he heard that Matisse was to design Stravinsky's *Chant du Rossignol*. "What is a Matisse? A balcony with a big red flowerpot falling over it." He was assiduous in attending the rehearsals of *Mercure*, eager to supervise every detail. At one rehearsal, he pointed out to Jean Hugo the long white gloves with pleats at the wrist. "I didn't make the gloves," he said. "They thought I did, and that's fine: it's that sort of thing that amuses me."

On opening night, June 14, 1924, Breton, Aragon and the rest of the budding Surrealists started by booing, on principle, anything involving the Count de Beaumont and "the international aristocracy." They left applauding Picasso. They even wrote a letter of unqualified praise that was published in the *Paris Journal*. "We wish to express our profound and total admiration for Picasso, who, despising all sacrosanct convention, has never paused in his perpetual creation of the disquiet, the searching anxiety of our modern days, nor in giving it the highest form of expression. . . . Picasso, *far beyond his colleagues*, is now to be seen as the everlasting incarnation of youth and the unquestionable master of the situation."

In *Mercure*, Picasso had converged with the Surrealists. He had abandoned angularity and straight lines for the undulating, hallucinatory forms with which Breton sought to shake up the apparent objectivity of reality. "When we were children," Breton wrote in an article on Picasso and Surrealism, "we had toys that

would make us weep with pity and anger today. . . . We grow up until a certain age, it seems, and our playthings grow up with us. Playing a part in the drama whose only theater is the mind, Picasso, creator of tragic toys for adults, has obliged man to grow up and, sometimes under the guise of exasperating him, has put an end to his puerile fidgeting."

Picasso was fast growing tired of his own puerile fidgeting and of the social buzzing of the *beau monde*. When Diaghilev asked him to use his two giantesses running by the sea for the drop curtain of *Le Train Bleu*, which was to open in Paris two days after *Mercure*, he hesitated. His romance with the world of ballet was effectively over. He finally allowed the giantesses to be used, but remained completely detached from the execution of the project, which was entrusted by Diaghilev to Prince Schervachidze. Picasso's only contribution to the making of the curtain was to write "Dedicated to Diaghilev" on a work to which he had not added a single brushstroke, and sign it "Picasso 24." It was a gesture that fitted the Surrealist tone of the ballet, which, written by Cocteau with music by Darius Milhaud, really had nothing to do with classical ballet. "The first point about *Le Train Bleu*," wrote Diaghilev, "is that there is no blue train in it. This being the age of speed, it has already reached its destination and disembarked its passengers. These are to be seen on a beach which does not exist, in front of a casino which exists still less. Overhead passes an airplane which you do not see. And the plot represents nothing. Yet when it was presented for the first time in Paris, everybody was unaccountably seized with the desire to take the Blue Train to Deauville and perform refreshing exercises."

Once again, in 1924, the Picasso household spent the summer by the sea, this time at Juan-les-Pins. But the only exercise Picasso engaged in was occasionally paddling in the water with only a little more proficiency than his three-year-old son. The athletic image conveyed by his naked torso, stocky, hairy and always bronzed, had nothing to do with athletic prowess. It was an image, though, which he assiduously cultivated, for no matter how many women fell in love with him and no matter how much worship was heaped at his feet, he never reconciled himself to the fact that he was not quite five feet three.

By March 1925 the Picassos were in Monte Carlo, going to more parties and dining at Giardino's, the fashionable restaurant at the top of the hill. But Picasso, who never wanted a following, yet always needed a court, was weary of his present entourage, especially as it was becoming increasingly hard to reconcile the demands of the fire burning in him with the fashionable life they were leading. The more Olga sensed him withdrawing into his own world, where all access was denied her, the more frequent and extreme became her petty and irrational outbursts of jealousy. She was obsessed with his past, and did everything in her power to erase all traces of the existence of other women in his life. She tore up letters from Apollinaire and Max Jacob in which Fernande was mentioned, however casually. She helped push Max out of their lives, and she even stormed out of Gertrude Stein's apartment when during a reading of her Bateau-Lavoir memoirs she came across a passage referring to Fernande.

Olga's considerable will to power had now changed focus, from a drive for social recognition to a no less obsessive drive to possess her husband in the downward swing of their marriage as she had never possessed him in the upswing. He was as much the perpetrator as the victim of Olga's exasperating behavior. He had given her a taste of life and a glimpse of herself that she had never had before. And then with no explanation and for no reason she could understand, he withdrew, and the supply of affirmation and joy was abruptly halted. But by then it was too late. Like an addict who has tasted the artificial highs, she could not return to her previous existence. She needed larger and larger doses of his attention and his preoccupation with her, and when, instead, she received less and less, she felt angry and betrayed. Exasperated, she lashed out at him, forcing him to give her, however momentarily, the attention she was otherwise denied.

Anger begot rage and rage violence, and in the spring of 1925 Three Dancers was born. It was the beginning of a savage decomposition of the human body, and the evocation of the Crucifixion compounded the sense of doom and destruction that pervaded the picture. Picasso was already working on it when he heard the news of the death of his friend Ramón Pichot, who had married Germaine not long after Casagemas committed suicide because

of her. The death of a friend brought him once again face to face with the painful fear that death always stirred in him, and his old metaphysical anguish, the anguish that was always new, began to tug at him with fresh vigor, and to chafe. As for his ambivalence toward women, it was temporarily resolved in unqualified hatred —of Germaine, who had destroyed Casagemas and whom he now held responsible for destroying Pichot, of Olga, whose presence in his life was growing more oppressive, of women who had obsessed him in the past and women who might obsess him in the future.

On July 15, 1925, while Picasso was again in Juan-les-Pins with Olga and Paulo, the fourth issue of *The Surrealist Revolution* appeared, with *Les Demoiselles d'Avignon* reproduced for the first time, eighteen years after they were brought to life at the Bateau-Lavoir. "The position held by us now," wrote Breton in the same issue, "could have been delayed or lost if this man had at any point faltered in his determination. . . . For all these reasons, we claim him unhesitatingly as one of us, even though it is impossible and would, in any case, be impertinent to apply to his methods the rigorous system that we propose to institute in other directions." Returning the bouquet, Picasso broke his long-established rule against exhibiting as part of a group and allowed his work to be included in the first Surrealist exhibition at the Galerie Pierre in November.

At the outset, the "total subversion" advocated by Breton was supposed to be cultural and personal, a call to "burst the bonds of reason, of narrow rationalism." "I believe," wrote Breton, "in the future resolution of those two states of mind, dream and reality, in appearance so contradictory . . . into a super-reality." This resolution was to be achieved within the individual, and then through this personal transformation the longed-for social transformation would follow. But by 1926, revolution from the inside out seemed far too slow to change the world. So Breton proceeded to issue a manifesto calling on the Surrealists to join forces with the Communists. He even subjected himself to intense and humiliating cross-questioning by the high officials of the Communist Party, who were not prepared to accept the glamorous new recruit until they had scrutinized both the Surrealist publications and himself. Why did he publish reproductions of

works by this "madman" Picasso? Why was he promoting sexual freedom and the Marquis de Sade? And as the outraged Party official Michel Marty repeatedly demanded: "What do all these things *mean*?"

Breton stood firm on the integrity of artistic inquiry, but not when it came to disobedience within the Surrealist ranks. Those Surrealists who disagreed with him on joining forces with the Communists, among them Max Ernst, Jacques Prévert and André Masson, were, very simply, excommunicated. Despite his protestations that he would do everything in his power to ensure that art would "continue to be an *aim*, under no pretext becoming merely a *means*," Breton persisted in the thankless task of seeking to reconcile Marxism with art unencumbered by social realism. Picasso continued to be influenced by Breton and by Surrealism, and increasingly by Miró, the young Catalan painter who had arrived in Paris in 1919 and had been enriching the movement with his work for the last two years, but he remained for the moment, and for quite a long time to come, completely aloof from any political involvement. "I love it as the only end of my life," he said of art, although, like Breton, he often despaired of the stupidity, incomprehension and bad faith all around him and longed for the quick end to it all that dictatorships are supposed to provide. His panacea, however, was not a dictatorship of the proletariat, but "an absolute dictatorship . . . a dictatorship of painters . . . a dictatorship of one painter . . . to suppress all those who have betrayed us, to suppress the cheaters, to suppress the tricks, to suppress the mannerisms, to suppress charms, to suppress history, to suppress a heap of other things. But common sense always gets away with it. Above all, let's have a revolution against that!"

His revolution against everything he hated around him and in him was expressed in an explosion of violence in his work. *The Guitar*, which he created that year out of a ragged floorcloth, string, paint and pasted paper, was studded with seventeen two-inch nails, driven through the canvas and confronting the spectator. His original intention was a lot bloodier: he had wanted to cement razor blades on the canvas so that whoever touched it would actually bleed.

On November 22, 1926, Max Jacob, who was still at Saint-

Benoît, wrote a letter to Cocteau which threw some light on the rage convulsing Picasso:

Mon Jean,

You judge Picasso very accurately. He hates his paintings as one hates the demon, one's demon, and the "adored" woman. He is the man of all contradictions: at the very same time he rages at the life he is leading and at the idea that he could lead a different one. You say rightly: he hates everything and he hates himself: at the same time he loves all and his admirable productions too. He is what one would call an abyss, a chaos. As Vico has said about God, Picasso is not, he makes himself.

Cocteau's relationship with Picasso had been stretched to a temporary breaking point by a remark Picasso had made to a journalist from a Barcelona newspaper. "He is no poet," he had said. "Rimbaud is the only one. Jean is only a journalist. Apollinaire was an idiot and Reverdy knows only about Catholicism!" For days after his interview had appeared in a French paper, Picasso had instructed the maid to say that he was out whenever Cocteau called. And he called many times, trying to get an explanation from him. Unable to reach him, he invented his own explanation and told the French press that "the interview which had wounded him so sorely had turned out to be an interview with Picabia and not an interview with Picasso, his friend." Picabia protested and said this was a lie, while Picasso, despite Cocteau's beseeching, refused to withdraw the statements he had made in what Cocteau's mother called "that vile interview." In the end, it was Olga who resolved the public dispute when the Picassos ran into Madame Cocteau at the theater one evening. "I as a mother," Olga told Gertrude Stein, "could not let a mother suffer and I said of course it was not Picasso and Picasso said, yes yes of course it was not, and so the public retraction was given."

"You were hard done by," Max wrote to Cocteau, stirring things up at the same time that he was trying to smooth them over. "Picasso like Pascal is a man of outbursts of wit: Pascal took care not to publish his until two hundred years after the death of Louis XIV."

But Picasso was too much in love with his aphorisms to prac-

tice self-restraint. At any point, he was as likely to kick as to lick those around him. And at a tormented moment in his life such as this, the closer they were to him and the more dependent for love, attention or approval, the more likely he was to kick.

7

GODDESSES AND
DOORMATS

On the piercingly cold afternoon of January 8, 1927, Picasso was wandering near the Galeries Lafayette in the aimless state of mind advocated by the Surrealists as most propitious for unexpected discoveries and new beginnings, for the intervention of chance and the marvelous. Among the crowd coming out of the Métro was a blond and beautiful young woman whose face, with its classic Greek nose and blue-gray eyes, he had seen before—in his mind's eye and on his canvases. "He simply grabbed me by the arm," Marie-Thérèse Walter recalled, looking back on the moment that transformed her life, "and said, 'I'm Picasso! You and I are going to do great things together.' " For him it was a moment of recognition and of surrender to a sexual passion unfettered by the conventions of age, matrimony, time and responsibility.

If only Marie-Thérèse had emerged from the depths of the Métro with no past, no history and no family, Picasso's dream would have been undisturbed by reality. But she did have a past and a history and a mother, of Swedish origin, with whom she lived at Maisons-Alfort, just outside Paris, and who loved to read classical literature and to play classical music on the piano. She also had a half-brother and a half-sister, and a father who people said was a painter but whom she had never met; her birth certificate simply stated "Father unknown." She had been born in Perreux, in south-central France, on July 13, 1909, the year Pi-

casso and Fernande left the Bateau-Lavoir for a less bohemian existence. She knew nothing of art and Picasso. Up until now, her passions had all been athletic—swimming, cycling, gymnastics, mountain climbing. Her body was vibrant with strength as well as youth, and her face and her thick blond hair had the healthy glow of the open air.

The seventeen-year-old Marie-Thérèse may not have known who Picasso was, but Madame Emilie Marguerite Walter knew, and did nothing to discourage her daughter's natural curiosity about this exotic man, almost thirty years older than herself, with his thick accent and compelling charm. Their next meeting, intentional this time, was at the Métro Saint-Lazare two days later. As conversation between them was limited, he took her to a movie. "I resisted for six months," Marie-Thérèse would say later, "but you don't resist Picasso. You've understood me—a woman doesn't resist Picasso." On July 13, the day of her eighteenth birthday, he took her to bed. Many years later, Picasso would commemorate in a letter to her the importance of that date in his life. "Today 13th, July 1944 is the seventeenth anniversary of your birth in me and also your own birth into this world, where having met you, I have begun to live."

The greatest sexual passion of Picasso's life, with no boundaries and no taboos, had begun. It was a passion fueled by the secretiveness that surrounded the relationship and by the revelation of the childlike Marie-Thérèse as an endlessly submissive and willing sexual pupil who readily accepted all experimentation, including sadism, with absolute obedience to Picasso's will. She was an object which he alone possessed, proof of his power and sexual magnetism.

Most of the etchings with which Picasso illustrated Balzac's *Chef-d'Œuvre Inconnu* date from this year. Frenhofer, the painter in Balzac's story, has tried for years to bring to life the woman of his masterpiece: "For ten years I've lived with this woman, she's mine, mine alone, she loves me. Hasn't she smiled a big smile at each stroke of the brush I've given her? She has a soul, the soul with which I have endowed her . . . My painting is not painting, it's sentiment, passion! Born in my studio, she must stay virginally there . . ." Marie-Thérèse was no less Picasso's creation than the woman on Frenhofer's canvas. But the creator

was, in turn, obsessed and possessed by his creature, and sexual obsession became the dominant theme of his work. In *Woman in an Armchair*, painted in the same month he met Marie-Thérèse, sexuality and horror came together in a mixture of surrender and brutality, and the tone was set for the sexual deformations that were to follow.

On May 11, Kahnweiler sent a note to Gertrude Stein: "Poor Juan is very low. The doctor believes the end very near." Juan Gris died later that day in Boulogne, two months after his fortieth birthday. Picasso, who had in his own way done what he could to harm Gris during his life, was among the first to rush to Boulogne as soon as he heard the news of his death. "I had painted a big black picture," he said. "I did not know what it meant, but when I saw Gris on his deathbed, there was my picture." Those who had been true friends of Gris saw the inconsistency, even the hypocrisy, of his presence there. Alice B. Toklas described how he "came to the house and spent all day. . . . Gertrude Stein said to him bitterly, you have no right to mourn, and he said, you have no right to say that to me. You never realized his meaning because you did not have it, she said angrily. You know very well I did, he replied." And two days later, he who hated funerals and all official reminders of death's existence joined Gris's son as a pallbearer at the burial in the Boulogne cemetery. An enemy during a large part of Gris's lifetime, he now escorted him to his grave.

Picasso's reputation continued to grow. He had acquired a fervent new champion in Christian Zervos, the young Greek émigré who, a year earlier, had founded *Cahiers d'Art*, and who was to devote his life to cataloguing Picasso's work. "Painting is for Picasso like Yorick's skull," he wrote in the one-year-old *Cahiers*. "He constantly turns it around in his hands with an anxious curiosity. Nobody can say enough about the restlessness of this man who possesses all of painting and who knows that it does not consist of this or that formal representation of objects, but that it embraces all sorts of solutions and incalculable possibilities. These possibilities Picasso pursues ceaselessly." The German critic Carl Einstein, writing of Picasso's work in the same year, rhapsodized about the way that its "contrasting elements form

wondrous harmonies . . . and truth lies in the identity which underlies the tension between opposites."

Truth may have emerged from the tension between opposites in his art, but hardly in his life. He was torn between his hatred of Juan Gris and his mourning over his death, between his marriage to Olga and his passion for Marie-Thérèse, between his contempt for the social whirl and his participation in it. And the tension, the hatred, the anger—at Olga, at life, at God—erupted and poured onto his canvases.

In the middle of July, he left for Cannes, by then the summer watering hole of the fashionable. *Le Littoral* reported the arrival of "M. et Mme. Picasso et famille" at the Majestic, the most luxurious new hotel on the Croisette, the town's famous promenade. His entourage of wife, son and nanny had been enlarged by a chauffeur, Marcel Boudin, who drove him in his Hispano-Suiza up and down the Côte d'Azur. "As soon as a painter has enough money," Picasso said, "he should have a chauffeur; driving a car is very bad for a painter's wrists." He knew, of course, that Georges Braque loved driving race cars.

At the height of the season, Picasso's activities were reported in the local press alongside the comings and goings of Prince Umberto of Italy, Princess Galitzine, Prince Parma de Bourbon, Maurice Chevalier, Somerset Maugham and a vast array of old titles and new money. There were weekly grand balls in the garden of the hotel, gala dinners and, on August 18, an extravaganza particularly relished by Olga at which the orchestra consisted of White Russians who had fled the Revolution.

That was what Picasso was doing. What he was painting reflected a very different reality. He was recording not the glittering surface of civilization but its profound discontents, the darkness and ugliness underneath the glorious celebrations reported in the society press. The art historian William Rubin described Picasso as "perhaps the greatest psychologist of the century, the Spanish doctor who replaced the Viennese." He had begun to unleash on canvas the pain and fury that Freud had revealed among his patients in Vienna, giving visual expression to the violence that the Viennese doctor had uncovered in his consulting room. The fashionable, chic ladies "of the beyond," as Picasso called them,

were succeeded by nightmarish women, frightening and afraid, and the luxurious terraces of the Majestic by wooden cabanas, primitive and elemental. The first cabana in this 1927 series looked, in fact, more like a tomb than a beach cabana—a *memento mori* in the middle of his life's triumphant procession.

That frenetic summer was a kind of desperate dance. "He felt imprisoned," Matta said. "He was not interested in his surroundings, he was not interested in his wife, he was not interested in food and he did not drink—he could have lived in his kitchen, slept during the day and painted at night." Indifferent to many conventional luxuries, he once told Kahnweiler that what he wanted was "to be able to live like a poor man with plenty of money." The social bedlam he had welcomed he now resented, increasingly aware of the many drawn to him for his celebrity and their own aggrandizement, most of them tourists on the mountain peaks of creation that were his natural habitat. And they, thoroughly charmed and seduced, were by now ready to applaud anything that came from the wizard's hand. But his contempt for the social treadmill he was on stifled him. It was as if he were surrounded by buzzing insects: some, it is true, were amusing, some were beautiful, some were elegant and some were even talented, but the buzzing was driving him to distraction.

At the beginning of 1928, he rediscovered an old friend who, although as adoring as any member of his court, had the great advantage of being able to teach Picasso something he wanted to know. Julio González, a sculptor and metalsmith, possessed just the kind of expertise Picasso sought to harness at this time of inner turbulence when sculpting and construction had the solidity and quasi-therapeutic quality that he needed. With González' help, he created wrought-iron constructions and, later in the year, prompted by the proposal to establish a monument to Apollinaire, designs for sculptures that could act as Apollinaire's monument or fill the length of the Croisette in Cannes. If Braque was "Madame Picasso," then González was the gifted nephew who was allowed to be of assistance to the master and in the process elevate himself.

In the middle of July, Picasso once again left Paris for Dinard, accompanied by Olga, Paulo, and his English nanny—and preceded by Marie-Thérèse, who was ensconced nearby in a holiday

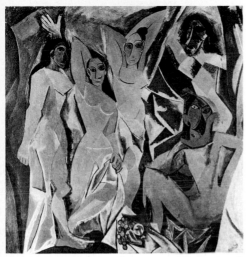

Daniel-Henry
Kahnweiler *organized
in his gallery in Paris
the first Cubist
exhibition.*

*A deep, barbaric destructiveness was at the center of
Les Demoiselles d'Avignon. Nothing less than a rev-
olution was intended. Picasso called it his "first exor-
cism-painting."*

*Henri Rousseau, known as the Douanier. "You and I are the greatest
painters of our time," he told Picasso, "you in the Egyptian style, I in
the Modern!"*

23

Georges Braque became Picasso's partner in Cubism, the great pioneering adventure of twentieth-century art. "Braque," Picasso said describing their early friendship, "is the woman who has loved me the most."

24

Picasso's days as an impoverished artist were over. In September 1909, he moved to 11 boulevard de Clichy, with Fernande, his cat, his dogs and his growing collection of knickknacks.

Picasso's waning attachment to Fernande was replaced by a growing passion for Marcelle Humbert, whom he renamed Eva. When she died in December 1915, it confirmed his feeling that death was always winning.

The poet Guillaume Apollinaire had been Picasso's friend and champion since 1905. His death at the end of the war was an agonizing shock to Picasso.

27

Picasso with the young poet Jean Cocteau, who introduced him to the world of the ballet, and with Olga Koklova, an average ballerina of average beauty, average intelligence and average ambitions.

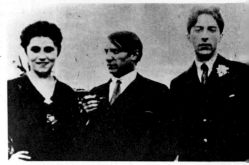

28

Sergei Diaghilev, the brilliant impresario of the Russian ballet.

[BELOW] *Picasso and Olga in Paris around the time of their marriage in 1918. He knew that she was, if not the right partner for life, unquestionably the right partner for society.*

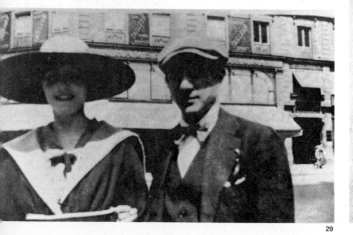

29

Stravinsky was a new discovery for
Picasso, and Picasso for Stravinsky.
In this drawing by Cocteau,
Stravinsky in a top hat is bowing
down to talk to Picasso in a bowler.

[BELOW] Picasso and the stagehands
on the drop curtain of Parade in
Rome. On opening night in Paris,
May 18, 1917, the legend of Picasso
the magician was born.

[*ABOVE AND RIGHT*] *During the 1920s, with Olga at his side, Picasso embarked on the glittering life he had once ridiculed: (above) at a ball with Olga and Madame Errazuriz, at whose villa they spent their honeymoon; (right) at a party on the beach in Antibes, Olga and the Count de Beaumont holding hands, Picasso in the center.*

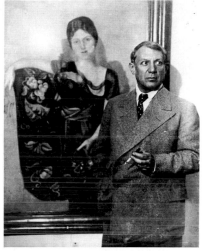

Picasso before Olga Picasso in an Armchair. *She insisted that he paint her in a naturalistic style. "I want to recognize my face," she told him.*

In 1927 Picasso met seventeen-year-old Marie-Thérèse Walter. It was the beginning of his greatest sexual passion, fueled by the revelation of the childlike Marie-Thérèse as an endlessly submissive and willing sexual pupil.

35

36

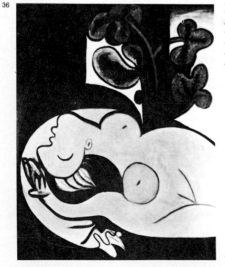

Nude on Black Couch portraying Marie-Thérèse. Surrender was her predominant response to the man she called her "wonderfully terrible" lover.

camp for children. It was an ingenious arrangement which delighted Picasso not only because of its watertight secrecy but also because of its perversity. The idea of visiting his young mistress at a children's camp added a frisson of risk, surrealism and masquerade to a relationship that was already bristling with sexual passion, a passion that continued to thrive on the often violent subjugation of the "woman-child" to her lover's will. So when Picasso had had his fill of flirting with the still younger girls in the camp and amusing himself watching his ample and athletic mistress swimming or cavorting on the beach, he would lead her to a cabana where the cavorting became a great deal more intense and serious. Her job was clear: to obey every command and caprice of the man she referred to as her "wonderfully terrible" lover. "I always cried with Pablo Picasso," Marie-Thérèse confessed more than forty years later. "I bowed my head in front of him."

"Some of the most vivid, lasting memories of Marie-Thérèse," according to the art historian Lydia Gasman, who talked with her at length later in her life, "were precisely Picasso's sadomasochistic sexual preferences. She recalled that at the beginning of their liaison, he 'asked' her to comply with his fantasies, and that she herself was so naive at the time that his demands made her laugh." "Pablo did not want me to laugh," Marie-Thérèse remembered. "He was always telling me: be serious!"

Exploring the limits of sexuality was serious business for Picasso. He sought not merely to satisfy his sexual urges but to reach, through indulging in what was culturally forbidden, the heightened state of being that the French writer Georges Bataille saw as the goal of eroticism. Bataille, who was fascinated by the connection between sexuality, transgression and transcendence that Picasso was experimenting with, described "the feeling of elemental violence which kindles every manifestation of eroticism. In essence, the domain of eroticism is the domain of violence, of violation. . . . What does physical eroticism signify if not a violation of the very being of its practitioners—a violation bordering on death, bordering on murder? The whole business of eroticism is to strike to the inmost core of the living being, so that the heart stands still."

This was the world of eroticism, violence and violation that

Picasso and Marie-Thérèse inhabited in Dinard. And the fact that she was legally under age and in a children's camp was a mainspring of his sexual ardor. At that time in France the "corruption of a minor" could result in a severe prison sentence, but flouting the law was part of the excitement that fired his passion. De Sade had written about the sovereign man with the authority to transgress and to infringe all taboos; and Picasso, who had always believed that everything was allowed to him, in life no less than in art, was now defying, all at once, law, morality and convention in the cabanas of a children's camp.

It is women who hold the key to the cabana in the series he painted in Dinard. "I am very fond of keys," he had said. "It seems to me very important to have one. It is true that keys have often haunted me. In the series of bathing men and women there is always a door which they try to open with a big key." The door was to his own unconscious, and for a long time the hope persisted in him that some woman would hold the key to the mystery that he remained to himself, despite his authoritative, all-knowing pronouncements. In the eroticism dominating his life at the moment, however, Marie-Thérèse was no more than the passive servant of her lover's will.

In the Cabana Text which he wrote in Spanish in 1935, in an automatic style favored by the Surrealists, the cabana was once again a symbol for his unconscious, while Marie-Thérèse, never mentioned by name, would appear variously as a "slice of melon which never remains quiet, laughing at everything as long as summer lasts," as the bluest of blues, a white or a lilac dove, the air, or a laughing mare. The more innocent and virginal his images of his teenage mistress, the more satisfying was her degradation. "Beauty is desired in order that it may be befouled," Bataille wrote; "not for its own sake, but for the joy brought by the certainty of profaning it." Picasso confessed once that women were divided for him into "goddesses and doormats." Few things gave him greater pleasure than transforming goddesses into doormats; and not only did the women allow themselves to be trampled on, but they became addicted to the trampling.

In the Cabana Series that he painted from 1927 to 1938, the beach cabin was a symbol for himself pitted against Olga and, especially, against the evil spirits weaving man's terrible destiny.

Man, he wrote, can do nothing but "watch the thread that destiny works," menacing with its "thousand offensive weapons." But he also believed that "spirits, the unconscious . . . emotion —they're all the same thing." And, as he added in one of the most perceptive comments he ever made about himself, perhaps his unconscious and his malevolent enemy destiny were, after all, "the same thing."

"Houses, and volcanoes, and empires . . . the secret of Surrealism," wrote Breton around the time of the Cabana Series, "resides in the fact that we are convinced that something lies behind them." Picasso was living his life as though that something were irredeemably malevolent, but there were those rare moments when he had a glimpse of the possibility that it might in fact be the source of salvation. Most of the time, although he knew that there was an invisible, intangible essence beyond visible appearances, he denied, with the manic intensity of someone who tries to still the gnawing fear that he is wrong, the existence of a transcendent reality.

Picasso had begun 1928 with a collage of a monstrous Minotaur. In ancient myth the Minotaur, half-man, half-bull, living in an underground labyrinth and feeding on human flesh, symbolized the devouring beast hidden in the labyrinth of man's subconscious. In Picasso's collage, nothing separates the Minotaur's huge head from his legs as he takes flight, propelled by the phallus stuck on between his legs. It was an image which mirrored his own behavior that year. In flight from Olga and his own anguish and guilt, he sought escape in the frenzied sexuality of his relationship with Marie-Thérèse. He was proving, at least in his own life, the truth of the saying that Spain is a country where men despise sex and live for it. But he paid a heavy price. For if what he did, and did with a vengeance, was evil, then he was evil, and if *he* was evil, then *all* was evil.

It was with renewed pleasure that he received the news of Max Jacob's return to Paris. Max was not only an emissary from happier times, he was also a staunch worshiper at the altar of sexual guilt. And back in the "inhuman and monstrous city," installed in the Hôtel Nollet—which, as he wrote himself, "was not the center of virtue"—Max had plenty of opportunities for both indulgence and guilt. The two old friends met often now that Pi-

casso was no longer trying to humor Olga's likes and dislikes. He drew Max's portrait with a laurel wreath crowning his bald head, and Max was as much in love with him as ever. It was a special kind of love, a "love-devotion," which he had tried to define in a letter to Cocteau a couple of years earlier: "The love-admiration (in the Magdalene–Christ sense) that I have for V . . . , for Picasso and for you and that you have for Raymond Radiguet is an admirable love, a homage rendered to God through his successful creations."

Picasso was, in fact, so successful a creation that not even the collapse of Wall Street in 1929 had any effect on him. The American collectors were licking their wounds, the French ones were hoarding gold and many artists all around Paris were forced to sell what they owned. Some, who had little or nothing to sell, were reduced to signing on at the canteens opened in Montparnasse and Montmartre. Picasso, instead, continued to sell the few pictures he was prepared to part with at higher and higher prices, and the servants, the nanny, the liveried driver, the Hispano-Suiza, all the luxuries to which he had grown accustomed, remained untouched. When he was asked by the Black Sun Press to draw a portrait of James Joyce for the frontispiece of *Tales Told of Shem and Shaun*, to be published that year, he refused. He never worked on commission, he said, and in any case, he cared nothing for James Joyce.

In 1929 he painted the last portrait of his son: *Paulo as Pierrot with Flowers*. Paulo was now eight, but in the portrait his father painted him as though he were four, graceful and somewhat ghostly. He had a closer relationship with the memory of his little son than with the reality of the growing Paulo. No longer an object of fascination as a product and appendage of himself, Paulo was fast becoming a separate human being. And separate human beings were not of much interest to Picasso unless they could be of some use, intellectually, socially, sexually, financially or emotionally—a tall order for an eight-year-old.

Paulo as Pierrot was a rare interlude in a period crowded with pictures of female monsters, looking more and more like robots. His women were reduced to dolls, abused and subjugated, and yet, in his misogyny, Picasso continued to fear them and portray them as menacing, agonized and destructive. The agony and

violence found their culmination in his drawings of Mary Magdalene, whose naked body is so convulsed with despair that it arches backward until her head and buttocks seem joined together, her nose and eyes looking like male genitals superimposed on her own—torment, frenzy, pain and sexuality all mixed together. And as so often in the past, in times of despair, Picasso turned to the theme of the crucified Christ. On February 7, 1930, he completed his celebrated *Crucifixion*, which was, as William Rubin put it, not a Crucifixion from the point of view of the spectator but a Crucifixion "from the hallucinated perspective of the man on the cross." There was no tenderness, no room for compassion, not even on the face of the Virgin Mary, which is full of anger and ferocity.

Yet the effect was beyond blasphemy and sacrilege. In her study on the *Crucifixion*, Ruth Kauffman described its subject as "human irrationality in the form of hysteria, brutality and sadism." Picasso's choice of the universal symbols of Christianity was, of course, hardly arbitrary. He would push religion out the door and watch it come back through the window. He declared himself an atheist, yet the worst thing he could say about Matisse was that he was "Van Gogh without God." He railed against God, yet in moments of despair and anguish he identified himself with his Son and sought to describe his indescribable suffering. He saw fate as malevolent and the world teeming with evil spirits, yet he was also intermittently filled with a sense of the miraculous. "Everything is a miracle," he said to Cocteau. "It's a miracle not to melt in the bathtub like a lump of sugar." But he had to have something to rail against, and it had to be big enough to be worth taking on. So he picked God and made him his lifelong antagonist, as ever-present in his life in the role of the Adversary as he was for the most devout mystic in the role of the Beloved.

The production of the *Crucifixion* was a turning point. It was as if some of Picasso's rage and despair had been released and left behind on the panel of the Calvary scene—at least for the moment. The paralysis of will from which he suffered when the darkness engulfed him eased enough to enable him to take steps to smooth at least some of the physical complications of his existence. He bought a seventeenth-century château in Boisgeloup, in Normandy, accessible only by car. In one move, the gray stone

château provided him with space vast enough for monumental sculpting, a retreat where he could legitimately escape from Olga, who was reacting to his withdrawal by becoming progressively more unstable, and a haven for himself and Marie-Thérèse. His new home even had a Gothic chapel at the gateway. As Gertrude Stein had told him, "If you are way ahead with your head you naturally are old fashioned and regular in your daily life." He was indeed old-fashioned in his choice of places to live, as soon as he had enough money to have a choice.

He spent the summer of 1930 in Juan-les-Pins, and in the fall, even more boldly, and with an eye on eliminating wasteful traveling time, he installed Marie-Thérèse in a ground-floor apartment at 44 rue La Boétie, directly across the street from himself and Olga. Efficiency was not, of course, his only motive. There was also the perverse pleasure he derived from knowing that he could get away with anything, that he could put his secret under the nose of his maniacally jealous wife and still keep it a secret, that he could write his own rules and break everyone else's.

At the same time that Marie-Thérèse began living at the rue La Boétie, Picasso accepted the offer of Albert Skira, a wealthy young Swiss, to illustrate Ovid's *Metamorphoses*. He completed most of the thirty etchings between the middle of September and the third week of October, purging himself of all the deformations and all the rage that he had poured onto his canvases in the last four years. The etchings are purely classical, with nothing fantastic and, in fact, with only one actual metamorphosis shown —that of the Daughters of Minias, who were turned into bats by Bacchus for choosing to stay home and weave rather than take part in the Bacchic orgies that were held as part of the worship of the god. Picasso showed wings beginning to grow on the bodies of the terrified sisters; he apparently relished both the punishment of the god and the moral of the myth. For the rest, most of the stories he picked to illustrate left out the gods and their magical acts of transformation. It was a humanistic and relentlessly classical rendering of Ovid, in the pure linear style of Greek vase painting. It marked Picasso's temporary metamorphosis from an artist overwhelmed by the dark creations of his subconscious to an artist of classic control and proportion.

On October 25, the day of his forty-ninth birthday, he com-

pleted the etching of the *Loves of Jupiter and Semele*. In the ancient myth, Semele, a mortal woman who becomes the god's lover, begs him to reveal himself in his full splendor and majesty, and when he does so, she is destroyed by the fire of his divine radiance. Picasso was, of course, Jupiter, and Marie-Thérèse was Semele. Once again he had looked to myth to express the nature of a living relationship.

To Marie-Thérèse, Picasso was no less a god than Jupiter was to Semele and Krishna to the cowgirls in Indian mythology. He expected the surrender to his will that a god expects from those who have dedicated their lives to serving him. And in return, like Jupiter and Krishna, he offered them moments of exaltation that had not been available to them before. "We are simply Your maid-servants and slaves," the young women cry to Krishna. And when the god is not with them "the night is empty, their cries go unanswered and moaning for the Krishna they adore, they toss and writhe on the ground." If one of them dares complain of his absences, his response is always the same: he is not to be judged by ordinary standards.

Marie-Thérèse led a life no less dominated, whether he was present or absent, by her all-consuming passion for Picasso. The fact that he was a celebrated painter played no part in their relationship. She knew nothing of the rest of his world, and the rest of his world knew nothing of her.

In April 1930, a special issue of *Documents*, the journal that had been founded by Georges Bataille in opposition to André Breton, was dedicated to Picasso. In one of the articles, the astonishing twists and turns in Picasso's work were seen as "a series of personal metamorphoses," springing "from a tragic doubt as to the apparent reality of the universe of forms. In him as in every great artist the spirit of revolt is stronger than faith, his faith in the outside world."

But the outside world continued to put its faith in him. He was showered with prizes and honors. Picasso described to the dealer Pierre Loeb the visit of some representatives from the French government to pick one of his paintings. "Four of them came. When I saw them, with their striped trousers, their stiff collars, their looks at the same time timid and distant, I looked back on my youth, which was so tough. I thought that those people could

have been more helpful in the past with a few hundred francs than today with hundreds of thousands. I began to show them some paintings, my best paintings, but I felt that what they wanted was the Blue Period. We made vague arrangements for another rendezvous to which I shall not go." Honors, and even untold wealth, could do nothing to erase the bitter memories of his early years, the time of deprivation and rejection that he carried with him to the end of his life.

Yet buried beneath this bitterness and anger was a love of life which, trembling always on the edge of horror, was occasionally allowed expression. The beginning of 1931 saw such a bursting forth of *joie de vivre* in the form of still-lifes full of orgasmic energy. A "private milestone" that he completed on March 11, 1931, and kept in his own collection was the *Still-Life on a Pedestal Table*. It is, in fact, a still-life only at first glance, revealing on closer inspection the luscious curves of Marie-Thérèse hiding in the fruit and intertwined with a male hiding in the table, with more sexual intertwining in the red-and-black tablecloth. The work teems with symbols, codes, secret double portraits and transformations within transformations, and it was rooted in Picasso's love of disguised portraits which fitted so perfectly his secretive personality: "Picasso's secretive form of portraiture," wrote Linda Langston, in her study *Disguised Double Portraits in Picasso's Work*, "gives the artist a public vehicle for the most private of confessions. The more personal, and therefore hidden, subject is the relationship between the artist and his women and what it tells us about his biography. Disguising his message behind a veil of impersonal subject matter limits access to his thoughts and his personality. In a sense these are 'trick mirrors' meant to prevent the viewer from seeing beyond the decoys—the bullfights and the still lifes."

In 1931, Picasso completed only twenty-eight paintings and drawings. He was becoming increasingly absorbed in three-dimensional transformations, assemblages of random objects—"the chance encounter of a sewing machine and an umbrella on a dissection table." The coach houses at Boisgeloup were transformed into sculpture studios, and when his summer at Juan-les-Pins with Olga and Paulo was over he started work there. It was

the beginning of Marie-Thérèse as sculpture, of the monumental heads with their phallic noses and their progressive distortions.

October 25, 1931, was his fiftieth birthday. He pushed aside the cards and telegrams that piled up at the rue La Boétie, refusing to celebrate the completion of half a century of life or give any indication that he sanctioned such an affront from destiny as the passing of time and the approach of old age. Instead he threw himself into the only two ways he knew of defeating old age and death: unbridled sexuality and obsessive work.

The grand retrospective being planned at the Georges Petit gallery for June 15, 1932, gave him an opportunity to be surrounded all at once by two hundred thirty-six canvases which had been gathered in Paris from around the globe—soldiers in his battle against the evil forces ruling the world. He was there to oversee their hanging at the gallery, to welcome and review them. To Tériade, another young Greek émigré who was Zervos' collaborator on *Cahiers d'Art*, he described them as "prodigal children returning home, clothed in gold."

A spate of articles preceded and followed the two landmarks of his fiftieth birthday and the grand retrospective, not all of them favorable. In a succession of articles, Waldemar George, a prolific art critic who had moved to Paris from his native Poland, described Picasso's work as "the clearest expression of modern disquiet" and his demons as "corresponding to the collective reality of the moment, to a modern neurosis, a thirst for mystery and a hidden desire for escape prevalent in a godless age." In one of the most damning comments on Picasso's art, George called it "a sterile demonstration or a gratuitous game," rooted in a "childish sickness," an exhibitionist's need to defy and shock. For George, Picasso, far from being free, was trapped in his anxiety and egocentricity—hallmarks of modern man.

In September of the same year another grand retrospective opened at the Zürich Kunsthaus. One of its twenty-eight thousand visitors was Carl Jung, and the result of his confrontation with an overview of Picasso's *oeuvre* was a devastating piece that appeared in the *Neue Zürcher Zeitung* on November 13, 1932. Struck by the similarity between Picasso's work and the drawings of his schizophrenic patients, Jung declared him a schizophrenic,

expressing in his work the recurrent, characteristic motif "of the descent into hell, into the unconscious, and the farewell to the world above." Comparing the images produced by his patients with those produced by Picasso, he wrote: "Considered from a strictly formal point of view, what predominates in them is the character of mental lacerations, which translate themselves into broken lines, that is, a type of psychological fissures which run through the image. . . . It is the ugly, the sick, the grotesque, the incomprehensible, the banal that are sought out—not for the purpose of expressing anything, but only in order to obscure; an obscurity, however, which has nothing to conceal, but spreads like a cold fog over desolate moors; the whole thing quite pointless, like a spectacle that can do without a spectator."

Whatever the validity of Jung's and George's insights, it was undeniable that as Picasso entered the sixth decade of his life, he was further away than ever from his youthful dream of creating a universal art, not just of achieving mastery in any style and any medium he chose but of transcending all styles to create something absolute and ultimate. He had the courage to die to many different artistic expressions and be born to new ones, but he lacked the courage to let go of the trapeze of his monumental egocentricity and his dazzling personality and trust that there was something beyond himself to catch him. And no number of magical canvases and sexual acrobatics could shield him, except momentarily, from his all-pervading sense of doom.

8

THE MINOTAUR
AND HIS MUSE

THE YEAR OF HITLER'S rise to power, 1933, was also the year that
the Minotaur, who had appeared in Picasso's work before, now
erupted with full force. Louis Fort, the copperplate printer intro-
duced to Picasso by Vollard, installed a handpress in the Boisge-
loup coach houses, and the series of etchings that were to
become known as the Vollard Suite began to appear. At first, the
etchings are almost idyllic: the bearded sculptor is relaxing in bed
with his beautiful young model, absorbed in the work that sur-
rounds them, satiated or for the moment indifferent to any prom-
ise of sexual bliss locked in his model's naked body. And then the
Minotaur arrives. He leers, he starts an orgy in which the sculp-
tor joins with abandon, he rapes the sleeping nude model, he is
killed in a bullfight and is resurrected to invade the sculptor's
studio all over again for more drinking and for yet more sex.
When Marie-Thérèse was later asked what happiness was for Pi-
casso, she replied: "He first raped the woman, as Renoir said, and
then he worked. Whether it was me, or someone else, it was
always like that."

On May 25, the first issue of the *Minotaure*, a magazine dedi-
cated to Surrealism, was published. It had a reproduction of a
surrealistic Minotaur by Picasso on the cover; around a drawing
of the Minotaur, which he had thumbtacked to a piece of corru-
gated cardboard, Picasso had placed pieces of ribbon, silver-paper
lace and faded flowers from one of Olga's hats. The monster had

been prettified, but it remained no less monstrous and irrationally destructive. The Minotaur had also invaded Picasso's life and made it impossible for him to stay in Cannes for the whole summer. So, in a fit of restlessness mixed with hope that his native Spain might prove some kind of resolution, he left in mid-August for Barcelona. The official team traveling in style in the grand Hispano-Suiza, with mirrors and crystal vases and flowers adding glamour to the polished interior, included Olga, Paulo, the dog and, of course, Marcel Boudin, the liveried driver, complete with white gloves. The unofficial team was made up of Marie-Thérèse, who met him in Barcelona and, in her by now perfect impersonation of an invisible shadow, succeeded in remaining unnoticed by press and family alike.

This triumph of secretiveness was all the more remarkable since Picasso's arrival and installation at the Ritz was a major event for the press and a momentous one for his family. "I was nine years old," remembered Jaime Vilató, his sister's son. "For me the arrival of my uncle was quite something; aside from the fact that he was practically a mythical being, since my mother spoke of him all day and all night, his arrival was like a show, a real show. He came with my cousin and with his wife and he also came with a dog. That was, at my age, nearly as important as his own arrival—the dog, the chauffeur, the car, the Ritz, it all seemed to me something quite marvelous." As for the press, its vigils at the Ritz were rewarded with articles headlined "Picasso Won't Talk."

Fernande Olivier, who had been out of his life for twenty-one years, would. When he returned to Paris, Picasso was confronted with the first extract of her memoirs in *Le Soir* and *Mercure*. At first he was incredulous that his sacred privacy had been violated, but incredulity turned into fury when all his attempts to prevent the continued serialization of Fernande's memoirs and the publication of her book proved in vain. Not that *Picasso and His Friends* was an offensive book. There was no bitterness in Fernande's lively account, even though she was scraping out a living teaching French to foreigners while the man whose toughest years she had shared was living like a king. But there were a great many insights into his character, and Picasso, to whom the admonition "Know thyself" was anathema, did not enjoy seeing

himself reflected in Fernande's mirror. Not only had she made self-deception harder, she had also disturbed his legend. "A picture," he had said, "lives only through the one who looks at it—and what they see is the legend surrounding the picture." He preferred it that way. Fernande had, with no malice or sensationalism, lifted some of the veils, and Picasso, even more than most legends, intensely disliked any tampering with his veils.

He was furious with Fernande, furious with Olga for trying to thwart his will, furious with Marie-Thérèse for obeying it all too readily, furious with himself for being brutal and then for feeling guilty. One day, overcome by his anger, he grabbed Olga by her hair, pulled her down and dragged her across the floor. "She asked too much of me" was his summing up of why their relationship had not worked. "It was the worst time of my life," he would say later. But beyond his private agony, he was foreshadowing, in how he felt as well as in what he painted, the horror that was to be loosed upon the world. His mounting rage culminated in July 1934 in a series of bullfight pictures in which barbarism and brutality plumbed new depths. Both Olga, sometimes portrayed as a horse and sometimes as a harridan, and Marie-Thérèse, in his favorite portrayal of her as a victim, were the targets of his convulsive rage. But its source was deeper, much more ancient and elemental. When the wounded bull devours the entrails of the horse it has just disemboweled, or when Marie-Thérèse as a wounded matador is carried on the back of a horse with its guts hanging out while the bull observes the scene with sadistic satisfaction undiminished by the sword sticking out of its shoulder, another reality has broken through, the savage reality of cruelty and destruction that in the next few years would claim millions of lives. The bull is bearing gleeful witness to a horror that is absolutely without mercy. On Picasso's canvases, war had already been declared.

It was in this bloodthirsty mood that at the end of August he left once more for Spain. But then, like Dionysus, the god he most resembled, he was "of many forms" and could easily transform himself: "Appear as a bull, or as a many-headed dragon, or as a lion breathing fire!" the chorus calls to Dionysus in *The Bacchae*. And the god was all these things and more: a boar, a bear, a panther, a snake, a tree, fire, water. Picasso's metamor-

phoses were just as varied. By the time he arrived in Barcelona, via San Sebastián, Madrid and Toledo, the primeval savage had become the charming, convivial, world-renowned artist visiting his native town with his family. The directors of the museum who had invited him to visit its new installations in the National Palace were not to know that his mistress was stationed in Barcelona, waiting, like a good and patient harem girl, to do her master's bidding, or that Madame Picasso and her husband were most of the time only on shrieking terms.

"Picasso's visit," wrote Carles Capdevila in *La Publicitat*, "has unexpectedly shown a different aspect of the man; we have come into contact with a much more human Picasso, quite different from the enigmatic and elusive man he is reputed to be. . . . 'I have to go home,' he said, 'I must work.' And as his car sped away, I thought that the word 'work' had acquired a special meaning. The final note of the conversation, the tone of the painter's warm, human observations suggested to me that Picasso had undergone a profound change. I may have been the unconscious victim of the charm of those unforgettable hours—I don't know—but for a while I had the impression that the great restless man had laid down Yorick's skull forever, having brooded over it with such care, and he now faced the world with joyous humility, guided by that lucidity which is only granted after long, fruitful years."

It was not the first and would most certainly not be the last time that someone fell victim to Picasso's powerful charm and was so utterly deceived by the particular guise in which he had chosen to present himself. Having "joyous humility" ascribed to him during one of the most tormented periods of his life was proof of the degree to which he had mastered the game of masks, impersonations and trick mirrors that he played on the world.

He could hide his fear, confusion and torment, but he still had to live with them. Back in Paris, he poured them out in the four powerfully moving etchings of *The Blind Minotaur*. The Minotaur, once again a symbol for himself, is being tenderly guided by a beautiful girl clutching a dove. There is an air of hopeless tragedy about the blinded beast, so strong and so vulnerable, as he struggles to find his way along the seashore. The young girl looks like Marie-Thérèse, but there is something transcendent

about her beyond any physical personality, more like Goethe's "eternal feminine which leads us upward."

In the first of the etchings, in the upper left-hand corner, there is a small sketch of *The Death of Marat*, which he had completed the summer before, upside down and completely crossed out with an X. It again expressed Picasso's primitive belief in the magic power of his art. *The Death of Marat* was about the terror of his own death at the hands of a hostile force—whether that was his wife, his mistress or an evil God. By canceling the action on paper, he was canceling it in life: " 'my . . . prayer book—the first notes written . . . backwards,' he wrote, have the magic effect of reversing evil fate, the 'spider's web,' into 'roses and periwinkles,' because 'all incantations [are] allowed.' " And incantations, whether verbal or visual, had the power to change reality—that was Picasso's magic conviction, except during those times of doubt from which he was seldom free and during which he was convinced of nothing.

When his friend and compatriot the sculptor Gargallo died that year at exactly his own age, he could not even bear to acknowledge that he was gone. One afternoon in the fall he was at André Level's gallery, in the rue La Boétie, when Gargallo's widow walked in. Seeing him from the back, she thought she had seen her husband's ghost: the same gray hair, the same neck, the same shoulders and back. When she realized who it was, she rushed up to him and cried out: "When I think that you are alive and that Gargallo is dead, and that you are the only one who has not even written to me . . . " "I am perhaps the only one who has really felt it," he replied without missing a second. It was, of course, totally untrue, but it was clever and it was fast, and it meant that he did not have to deal with anything real like the widow's emotions or his own.

For years now he had turned away from his wife's increasingly unstable emotions. As he wrote in one of his 1935 poems, the "eye of the bull"—another code name for himself—has a "thousand reasons to keep silent and turn a deaf ear to the flea who pisses the rain from so much coffee." It was a clear reference to Olga. One of Picasso's most vivid domestic images was of her constantly and neurotically drinking coffee, something he was particularly aware of since his own sensitive stomach had long

ago driven him to herb teas. But very early in 1935, it was no longer possible for him to maintain his wooden pose, hoping that Olga would stop screaming, Marie-Thérèse would stop giggling and, except when performing a specific function for him, both would disappear. At the beginning of the year Marie-Thérèse found herself pregnant and Picasso found himself confused. Events now ruled out inertia and frustrated his desire that nothing should disturb the status quo, fraught though it was with juggling and unpleasantness.

He was excited about the coming baby and the possibility that it would bridge the growing chasm between himself and Marie-Thérèse—so much so that at one point during her pregnancy he knelt in front of her and cried tears of gratitude. At the same time, although he wanted to rid himself of Olga's physical presence, he was paralyzed at the thought of divorce. Any final parting had the ring of death about it, and he was prepared to put up with a great deal to avoid major endings in his life. On top of his own innate terror, he had the expert advice of Maître Henri-Robert, one of France's leading lawyers, who had informed him that divorce would mean parting with half of everything he owned, including his work. So the French community-property law and the agreement he had signed when he married Olga saved him from doing the rational thing and pressing for a divorce. As for Olga, she never wanted a divorce in the first place. But none of this made the separation negotiations any less bitter, unpleasant or humiliating, especially when Olga's overeager lawyers had official seals put on the door of Picasso's sacred studio in the rue La Boétie just in case he tried to remove any of his paintings before a settlement was reached.

Even so, it was Olga's spirit that broke first. By now, she could not avoid the realization that her marriage was over, nor could she any longer ignore her husband's increasingly obvious hatred of her and the presence of her rival in his work. So at the beginning of July 1935, she had a final hysterical outburst under the conjugal roof and stormed out of the house, taking the puzzled Paulo with her. She did not go far, only around the corner to the Hôtel California in the rue de Berri, and in a sense she would never go far from her husband's life, growing progressively more demented at her obvious inability, no matter what she did, to

provoke a reaction or make a dent in his emotions. "An evil God," Picasso had once said to Kahnweiler, "has given me everything I detest—unless he is a demon." He might as well have said that God had given him everything he wanted, but that everything he wanted had not brought him what he was looking for.

This was the first summer Picasso had spent in Paris alone in the rue La Boétie. Marie-Thérèse, more than six months pregnant, was staying with her mother outside Paris at Maisons-Alfort, waiting for the divorce that Picasso had led her to believe was imminent, so that, as he had promised her and as he had assured her mother, they could be married before the baby was born—or soon after. On Marie-Thérèse's twenty-fifth birthday, Picasso, paralyzed with anxiety and indecision in the lifeless apartment that had never really felt like home, wrote a desperate letter to Sabartés: "I'm alone at home. You can imagine what has happened and what still is ahead of me . . ." At this time of deep crisis in his life there was no one in Paris he felt he could turn to. So he appealed to his childhood friend, whom he had not seen for more than thirty years, to come and share his life, organize him, take care of him, protect him from the world.

Picasso may have been desperate, but in his own understated way, so was Sabartés. After years of struggling as a journalist and novelist in South America, he had just returned to Barcelona with his South American wife and their retarded child. It had been an unhappy marriage, and the arrival of a handicapped child had compounded Sabartés' longing to leave his past behind him and escape into a new life. Now, quite unexpectedly, Picasso offered him that escape. In less than four months from receiving his letter, Sabartés was at the Gare d'Orsay, his wife and child abandoned forever in Barcelona.

At the hearing that was to determine the division of property, no one among their friends would testify for Olga. Misia Sert heard that, and she found it so unfair that she decided she would. When Picasso's lawyers claimed that Olga threw dishes, vases and anything breakable at him, Misia Sert protested, saying that she believed Olga "incapable of breaking any dishes." But when she was questioned about the reasons she thought Picasso wanted to separate from Olga, she had to remind herself quickly that she was testifying *for* Olga and stop herself from saying: "But, your

honor, simply because she is the most *emmerdante*, the most boring, woman I've ever known."

Meanwhile, Picasso had been bemoaning his fate to anyone who would listen: "Since his separation proceedings," Marie Laurencin complained to the art dealer René Gimpel, "Picasso has been acting in a way that one would excuse only in a woman. He no longer paints; he writes verses and proclaims: 'I'm a poet.' Try to understand this: he no longer paints because his wife is laying claim to millions for his canvases. He's like Marius on the ruins of Carthage." Whatever his concerns over Olga's financial claims, Picasso was also emotionally unable to cross the threshold of his studio even after the official seals were removed. The poetry he was writing in Spanish bristled with harbingers of evil and anthropomorphic images: The "room listens" and has a "shoulder," the "lemon" has "lips," the "cathedral . . . faints," the "shutters . . . kill," the "river repents." "The sun," he wrote, "scorches them and burns them to a crisp that they may sing deep songs in the night alone in the solitude of the solitudes hoping to find a bit of freshness."

He had always been a solitary man, but at this time in his life he truly experienced "the solitude of the solitudes." "In life," he said once, "you throw a ball. You hope it will reach a wall and bounce back so you can throw it again. You hope your friends will provide that wall. Well, they're almost never a wall. They're like old wet bed sheets, and that ball you throw, when it strikes those wet sheets, just falls. It almost never comes back." With every new relationship, Picasso had hoped that the woman would be able to throw the ball back. Olga had not been able to, and now it was becoming painfully clear that Marie-Thérèse too was unable to bounce the ball back—except in bed, and there, after nine years, the diminishing returns were inevitable. In the poetry he was writing, Marie-Thérèse was still the "white dove" and the "little girl"; but he was, quite simply, bored with his dovelike little girl.

On September 5, Marie-Thérèse produced her own little girl. The *femme-enfant* was now a mother, the salacious sex object a mother-figure. The baby was given the name of her father's dead sister, Maria de la Concepción, but on her birth certificate the identity of the father was declared as unknown. Soon after, talk-

ing on the telephone to his sister Lola in Barcelona, Picasso announced with pride that he had just had a daughter. "What do you mean you had a daughter?" protested Lola in amazement. "I didn't know anything about it." "Yes, yes," he continued. "It's necessary to increase production." But he gave no further explanations.

At almost exactly the same time that his daughter was born, Picasso, now fifty-three, met the woman who was to replace her mother. At the Deux-Magots, the new favorite meeting place of Breton and his Surrealist band, opposite the Romanesque church at Saint-Germain-des-Prés, Picasso was introduced to Dora Maar. Her full name was Henriette Theodora Markovitch, and she had been born in Tours "in the same year as *Les Demoiselles d'Avignon*," as she would later declare. Her mother was French and her father a Yugoslav architect. It was Paul Eluard who introduced her to Picasso, and it was Paul Eluard, as much as Dora, who became inseparable from the new epoch that was beginning in Picasso's life. He had first seen her a few days earlier and had been struck by her powerful profile, her rich black hair falling freely on her shoulders, the intensity of her dark eyes and the strange, macabre game she was playing. He watched her take off her gloves—black, with delicately embroidered roses—hold a long, sharp knife in her slender hands with their bright ruby fingernails and, time after time, drive the knife between her fingers into the wood of the table. When she missed, she would continue between the next two fingers while blood gradually covered her hand.

As Picasso soon discovered, she was a painter and a photographer, an intellectual muse of the Surrealist movement, a close friend of André Breton, an intimate and sometime mistress of Georges Bataille. She had changed her name from Markovitch to Maar, had lived for a long time in Buenos Aires, spoke fluent, beautiful Spanish and exuded the restlessness, bewilderment and anxiety of the modern intellectual.

In a conversation with Tériade, Picasso had described the best kind of painting as born of the union of a prince with a shepherdess. His shepherdess had given birth, and now he seemed convinced that shepherdesses might make good mothers but they made poor companions for princes. Dora Maar was no shepherd-

ess. She was as different from Marie-Thérèse as Eva had been from Fernande. Marie-Thérèse's life, apart from Picasso, was taken up by sport, Dora's by mental calisthenics. Marie-Thérèse's response to Picasso's portraits was that they "didn't look like her," to his paintings that they "didn't bowl her over" and to painting in general that "it didn't interest her." Dora, on the other hand, could discuss with passion and expertise Corot's photographic experiments and how they applied to Picasso's work, as well as whatever technical problems or philosophical questions were on his mind; she could share his friends and his preoccupations. Both the wife and the secret concubine would be succeeded by the official mistress whose tormented intellect was in perfect harmony with the tragic years ahead.

Of course, as always in the private life of this master procrastinator, nothing happened immediately. In fact, for the moment, the major change in Picasso's life was not the introduction of a new mistress but the arrival of his childhood friend from Barcelona. "On November 12, 1935," Sabartés wrote in his memoirs, "I returned to Paris, this time at the request of Picasso, with the intention of living with him in his house on the Rue La Boétie. He awaited me behind the railing of the waiting room of the Gare d'Orsay. It was my fifth arrival there, and the third time that he met me. . . . From that day on the course of my life followed his without my asking myself how long this illusion would last, since we had decided that it would be forever."

Soon Olga's impeccable apartment was crammed with heaps of newspaper clippings, sale catalogues, invitations, theater tickets, photographs, candies, letters, old telephone messages and souvenirs of many by-now-long-forgotten occasions. In the center of the mantelpiece on the studio floor, there was a sculpture in wrought iron that was Picasso's official temple of memories. "At first glance," Sabartés wrote, "it produces a startling effect because it gives that impression of dangerous equilibrium which is characteristic of Picasso's environment . . . there is a cork from a certain champagne bottle, a little flag, a pompon, a volute of iron, a little doll seated on one of the curves of the spiral, a little duster, a foolscap, banknotes out of circulation, antiquated chips; here and there divers miniature objects of varied shapes and colors hang from a silver thread like spiders, or adhere to the iron-

work like clinging vines. Picasso has found room for everything, and there they remain in the position dictated by his taste and his hand."

"Considering your love of innovation," Sabartés said to him once, "I cannot understand your mania for keeping things." "But man, you're mixing your terms!" Picasso was quick to reply. "What has one thing to do with the other? The thing is that I am not a squanderer. I have what I have because I keep it and not because I save it. Why should I throw away that which was kind enough to reach my hands?" But that was only one reason for the clutter in his life. Another was Picasso's horror of making any decision, however trivial. "Outside the realm of his art," wrote Sabartés, as shrewd an observer in certain areas of Picasso's life as he was blind in others, "there is for Picasso a vast distance between thinking and deciding, so that the minutest detail tortures him. . . . To ask that his room be swept or the windows washed costs him at least as much effort as doing it himself; and since he neither does it nor asks that it be done, the windows remain unwashed and the floor unswept. . . . Observing him at close range and pondering his strange ways, I sometimes think that perhaps he does not dare exert pressure upon events for fear that the air displaced by a voluntary gesture may shatter the equilibrium of his life and change his fate."

There was even a rationale behind his pathological reluctance to disturb the status quo, whether it was an established relationship or a few days' established dust. He gave aesthetic expression to it once when Roland Penrose, the English Surrealist painter and collector, noticed that the large Renoir hanging over the fireplace at the rue La Boétie was crooked. "It's better like that," Picasso said. "If you want to kill a picture all you have to do is to hang it beautifully on a nail and soon you will see nothing of it but the frame. When it's out of place you see it better." And in a relationship, when something is jarring or awry, you don't straighten it out but add something more jarring to it, like another relationship, and then watch what happens.

At this chaotic moment of his existence, he retreated into the secret world of his poetry, writing with a pen or a small stub of pencil in a notebook that he could hide in his pocket and often, when he was particularly concerned that no one should catch a

glimpse of what he was doing, locking himself in the bathroom. "They tell me you are writing," his mother said in a letter. "I believe that for you everything is possible. If one day they tell me that you have said Mass, I will believe that too." While his mother was asserting her absolute faith in him, the opium nightmare he had had all those years ago at the Bateau-Lavoir had come true: he could not paint. And unless he was writing, he could not bear to be alone. "No, man—don't go yet," he would say whenever Sabartés prepared to bid him good night before he was ready to be left by himself. "Are you sleepy already? Wait a while." And he would resort to any number of conversational gambits to keep Sabartés from going to bed: "Have a seat, my dear sir, and pray tell me what is your worthy opinion concerning the state of affairs . . . " Or, "So then, my dear sir, you are among those who appreciate laurel leaves better in a stew than on a crown?" Only when Sabartés sat down would he relax enough to stop rattling on like a nervous child. "Lighting a cigarette," Sabartés wrote, "he would take off his shoes and put on his slippers; going over to the washstand, he would begin to brush his teeth; but every time I kept silent, he would drop his toothbrush and liven up the conversation by means of his contradictory 'buts.' This is his forte."

Picasso once predicted that long after his death encyclopedias would describe him as "Picasso, Pablo Ruiz—Spanish poet who dabbled in painting, drawing and sculpture." Breton, in a 1935 issue of *Cahiers d'Art* dedicated to Picasso, saw his poetry as part of "the necessity for total expression by which he is possessed and which compels him to remedy . . . the relative insufficiency of one art in relation to another. . . . We have the impression of being in the presence of an intimate journal, both of the feelings and of the senses, such as has never been kept before."

In his poetry, Picasso suppressed punctuation in favor of a stream-of-consciousness style with echoes of the Surrealists' beloved automatic writing. Twenty years after Apollinaire, he declared punctuation obsolete—"a loincloth concealing the private parts of literature." He talked as if he were the father of this revolution, even though he was merely a good follower, walking in the footsteps of Mallarmé, Apollinaire and many of the Surrealists. But accuracy was never high on his list of values. As he

told Zervos, who wanted to check with him the accuracy of the notes he had made after a lengthy conversation they had had at Boisgeloup, "You don't need to show them to me. The essential thing in our period of weak morale is to create enthusiasm. How many people have actually read Homer? All the same the whole world talks of him. In this way the homeric legend is created. A legend in this sense provokes a valuable stimulus. Enthusiasm is what we need most, we and the younger generation."

A legend himself, he loved both being the source of enthusiasm and stoking the fire he had generated by seductive clowning and magic-making. "Noticing my growing enthusiasm," wrote the photographer and designer Cecil Beaton about his first visit to the rue La Boétie, "he demonstrated the ingenious craftsmanship of the various pieces; how a low stool turned into a pair of steps, or a desk possessed hidden levers, drawers and lids. . . . The large armchairs were covered in white linen. Suddenly Picasso indulged in a piece of legerdemain as he danced towards one of the chairs and in a bold gesture ripped off its cover to disclose a shining conch-shell of orange. One by one he threw off other covers to reveal chairs upholstered in brilliant satins that somehow reminded me of those sugared cushion-sweets of one's childhood. With a flick of his arm he conjured up a hot-yellow conch; then another butcher blue. Yet another crimson, and now an emerald green, Picasso's eyes flashed with excited enjoyment as each new colour appeared. These were the real colours of Spain, bold, unconforming and startling."

The side of Picasso that delighted in surprise and revelation was enchanted by his little daughter. He even sometimes washed her dirty diapers, partly as a distraction from the tortured meanderings of his mind, and partly as an act of atonement for being largely an absentee father. But most of his time was spent with Sabartés, either in the apartment or prowling the cafés of Saint-Germain. "They were almost always seen together, like the traveler and his shadow," wrote Brassaï, who was to photograph Picasso through many different moods, "the man with the most brilliant eyes in Paris accompanied by the most myopic man in Paris—at the Brasserie Lipp, at the Deux-Magots, and at the Café de Flore, the three centers of attraction at Saint-Germain-des-Prés. . . . At the Café de Flore the ceremonial was always

the same: the waiters, Jean and Pascal, would run to help Picasso off with his eternal trench coat; Monsieur Boubal, the Auvergnat proprietor of the Flore, would greet him and light his ever-present Gauloise; Picasso would nod and speak to the blond and smiling Madame Boubal, perched in the glass frame of her cashier's booth, and order a half bottle of Evian, which he never drank. Sabartés might discuss the events of the day with Spanish friends, but he never ceased watching Picasso like a mother hen."

Most of the time, they were accompanied on their rounds by Elft, the Afghan hound that was Picasso's latest four-legged companion; the dog went from table to table hoping that despite his master's disapproving glances, some compassionate soul would relent and give him a lump of sugar. The friends Picasso saw and with whom he shared a table at the cafés were no longer from the smart set but from the bohemia of his past and the intelligentsia of the present. "Olga," he had said, "likes tea and cakes and caviar. And me? I like Catalan sausage and beans." Cocteau described his new life as "the life of a tramp under a bridge of gold." He was spending time with the Braques again, and he was seeing more and more of the Surrealist poet Michel Leiris and his wife, Louise, or Zette, as her friends called her, who was Kahnweiler's sister-in-law, of Christian and Yvonne Zervos and, most important, in view of his growing influence in Picasso's life, of Paul Eluard.

"It is necessary for you to see yourself die to know that you still live," wrote Eluard in a poem dedicated to Picasso. Much gentler, more cerebral and emotionally more mature than Picasso, Eluard found in him the robust barbarian he worshiped intellectually and searched for in the African and Polynesian art he collected. He once declared himself above all happy to be alive in this troubled century because he had met Picasso. After Gala, his first wife, left him to become Salvador Dali's muse, mistress and impresario, he married a fragile and exotic girl from Alsace whom he had met on a Parisian sidewalk, ready to go to bed with any man who would give her a little money for something to eat. Nusch Eluard, who earlier had been a hypnotist's stooge in a circus and a small-time actress, became not only the inspiration for some of Picasso's most tender portraits but, for a time, his mistress. It was an offering from Eluard of the woman he loved

so passionately to the friend he also loved with passion, a form of primitive sharing and ultimate bonding, new neither to Picasso nor to Eluard, who expected from his women a "superior fidelity." "This man held in his hand the fragile key to the problem of reality," wrote Eluard in an article on Picasso in *Cahiers d'Art*. "His aim was to see that which sees, to liberate vision and achieve clairvoyance, and in this aim he was successful."

Picasso at least reciprocated Eluard's admiration, while Sabartés' role was becoming clearly defined as one of self-abnegation in the service of genius. Picasso was masterful at sustaining Sabartés' devotion by throwing in his way a few odd crumbs of love and appreciation. Each of these occasions was a golden moment in Sabartés' life, and every detail surrounding them acquired a special glow of significance. One such moment took place on December 11, 1935, "a little before lunchtime," as Sabartés recalled: "I put a cloth on the marble table top and smoothed it slowly and lovingly, made sure that the plates were as he wanted them, that nothing was missing, that nothing would upset him when he came in, that everything was exactly as he had seen it the previous evening, so that he might think that nothing had changed in the interval: the *biscottes* within reach, the napkin in its place, the knife here, the spoon there; the grated cheese and the compote within sight, the Evian water right beside him, and the glass and the teaspoon, etc. . . . Presently I heard steps along the corridor and then Picasso, preceded by the dog, appeared at the door, triumphantly waving a paper in his hand as if it were a flag. Handing it to me he said: 'Take it. It is your portrait.' " It was a portrait in words:

> *Live coal of friendship*
> *clock which always gives the hour*
> *joyfully waving banner*
> *stirred by the breath of a kiss on the hand*
> *caress from the wings of the heart*
> *which flies from the topmost height*
> *of the tree of the fruit-laden bower. . . .*

As Picasso read the poem aloud to the entranced Sabartés, he fueled his unquestioning loyalty despite Sabartés' knowledge that it would sooner or later be abused.

Like all the poetry Picasso was writing at the time, his tribute to Sabartés was written in Spanish. One of Sabartés' many jobs was to type the poems neatly and, after Picasso had been through them making changes with his multicolored pencils, to translate them into French. Having given up the hope of ever attaining genius himself, he relished being the transcriber and critic of genius. His life was becoming increasingly vicarious, and the more he slipped into the role of a shadow, the more he took on Picasso's shadow characteristics, reinforcing his hatreds, his prejudices, his fears and his paranoia. But through it all he remained his secretary in the original, deepest sense of the word—the one who held his secrets and, apart from a very occasional lapse, did not divulge them, no matter how tempted or provoked he might be.

At the beginning of January 1936, Sabartés left for Barcelona to attend the Picasso retrospective organized by the Amigos de las Artes Nuevas. At the opening, he read Picasso's poems following speeches by Miró, González and Dali. "He is 'ours,' " declared González with undisguised Catalan pride. "A ribbon-size Catalan flag which he keeps religiously in his pocket will convey to you the profound love he feels for the Catalan country, for the country of his youth." Dali was much less sentimental: "*Salvador Dali* is pleased to invite all unburied rotting corpses, all painters of crooked trees, in the more or less rural tradition, all the members and patrons of the Catalan Choral Society to visit the *Picasso* exhibition. The *Picasso* exhibition will be the extravagant station where we shall see for the first time the arrival in our country of the express train—first class only—of the Iberian intelligentsia and genius, thirty years late." But the most emotional part of the proceedings was Doña Maria, herself overcome by emotion, talking about her son.

On January 17, also in Barcelona, Eluard gave a lecture celebrating Picasso. "I speak of that which helps me to live, of that which is good," he began. Eluard's intimacy with Picasso was growing deeper, and Picasso had celebrated it in a drawing of Eluard on the eve of his departure for Barcelona, dated "this night the 8th of January 1936." From Barcelona the exhibition went to Bilbao, and from there to Madrid, where the young poets most associated with the triumphant Popular Front, García

Lorca, Rafael Alberti and Jose Bergamín, paid their homage to the man who was, for them, a national hero.

Back in Paris, the writs, the meetings with lawyers, the embittered letters from Olga continued to torment Picasso and to feed his primeval anger, described by Michel Leiris as his "anger at being born, mixed with a rage (or furious lust) for life." He longed to escape, especially after the opening of the exhibition of his recent works at the Rosenberg gallery, when a line of people appeared every day at the rue La Boétie trying to see him. Ladies talked breathlessly of "the prehistoric finally soaring into the air" in his pictures, while Kahnweiler simply exclaimed "Michelangelesque! Michelangelesque!" During Picasso's nightly excursions to the cafés, Sabartés was more and more often left behind. His instructions for the next day were frequently slipped under his door. "It is now 2 o'clock of the morning of the 9th day of March of the year MCMXXXVI," read the note written a few days after the Rosenberg opening. "Sabartés: You who know personally each and every hour ask Eight-Thirty to leap into my bed and awaken me."

It was a hopeless request. The greater his anger and his resistance to life, the harder it became for him to face each new morning. Sabartés' description of the daily struggle had all the ingredients of French farce: the letters; the invitations; the newspapers, *Excelsior*, *Le Figaro* and *Le Journal*; the latest clippings about him from the clipping service Lit-Tout; the sales catalogues—all scattered around Picasso on his bed, while he performed his morning ritual of asking Sabartés every few minutes what time it was.

"Don't you think," Sabartés would finally hazard, "it would be better for you to get up?"

"What for?"

"Why, just to take that worry off your head."

"Let's talk about something else. What time is it?"

By then it was often close to midday. And underneath the farce, a tragedy was being played out, the tragedy of a man whose "rage for life" had deserted him and who was receiving the world's adulation for his paintings at the very moment when he was incapable of painting—like an impotent old man congratulated for the sexual feats of his past.

PICASSO

On March 25, a week before the end of the Rosenberg exhibition he left, in the most profound secrecy, for Juan-les-Pins, with Marie-Thérèse and their daughter. Two days earlier, he had written to Marie-Thérèse reminding her to bring the "skins" and the "sheets" with her, and "to turn off the gas, the electricity and the water. . . . This 23rd day of March, MCMXXXVI," he added, using, as was his habit, Roman numerals to specify years, "I love you still more than yesterday and less than tomorrow. I will always love you as they say—I love you I love you I love you I love you I love you Marie-Thérèse."

Sabartés' job was to keep him posted on everything going on and forward his mail in a big envelope addressed to "Pablo Ruiz." "Like when we were youngsters," Picasso chuckled. He wanted to escape, but he could not bear to leave the world behind. The first thing he did after he settled in at the Villa Sainte-Geneviève, "a little house with the cutest garden, and close to the sea," was sleep. "Since I arrived here," he wrote to Sabartés on March 28, "I have been sleeping from nine or ten o'clock to eight-thirty or nine." During the day he went to Cannes to look over the boats in the harbor and bask in the sun, while Marie-Thérèse breast-fed Maria, swam and breast-fed her again.

For Picasso, the most restorative part of the holiday was sleeping twelve hours a day. It was peaceful and it was comfortable and it was a relief just to be out of the rue La Boétie and closer to nature. But despite the tone of his last letter to Marie-Thérèse, the old passion had not returned. Roland Penrose described Marie-Thérèse as the "only truly non-intelligent woman, the only really vulgar woman to have been part of Picasso's life. She was the kind of woman capable of saying when Picasso came to have lunch with her, 'Well, Pablo, what did you do this morning? I bet you've been painting again.' " In fact, Marie-Thérèse had been swept at seventeen into a sexual maelstrom where the aim was possession, fusion and dissolution, and it was, of course, her still precariously formed personality that was dissolved. She would never become a fully developed individual, capable of fascinating Picasso on nonsexual levels. Much more ominously for her future, she would never be able to cope effectively with the blows life dealt her.

Picasso had once told the story "of two lovers, one French, one

220

Spanish, who lived together happily loving one another until she learnt to speak his language: when he discovered how stupid she was—the romance was at an end." His relationship with Marie-Thérèse had been fostered not by a language barrier but by a powerful sexual passion. And now that habit had dulled intensity and forbidden explorations had become mundane, Picasso found himself in his idyllic retreat from the world without a suitable partner. As always, it was very hard for him to be alone when he was not working. Once, he even blamed it on the invention of watches. "It is very difficult to be alone today," he said, "because we have watches. Have you ever seen a saint with a watch? I have in fact looked everywhere but haven't found one even among the saints who are said to be the patrons of watchmakers." Soon he was eagerly looking forward to the daily bundle of mail from Sabartés. Even the choleric missives from Olga with their threats and demands, expressed in a manic mixture of French, Russian and Spanish, were a welcome intrusion into the quiet world of breast-feeding, sun and domesticity.

Then suddenly, at the beginning of April, he began painting again. The Minotaur and the young blond woman dominate the paintings of this period, which he kept a secret even from Zervos and which were revealed only through David Douglas Duncan's *Picasso's Picassos* in 1961. It did not take long for the playful Minotaur to become angry—about as long as it took Picasso to grow impatient and irritable with Marie-Thérèse. After a short time of living under the same roof, he began to find her cloying and unbearable. So on May 4, he killed her in a drawing and portrayed her naked body being carried by two nude women, one of whom had Dora Maar's dark, wavy hair. Capriciously enough, he concealed only the paintings from Zervos, not the drawings.

His letters to Sabartés were full of ribaldry. "I am writing you immediately," read one of his letters, "to inform you that as of this afternoon I am giving up painting, sculpture, engraving and poetry to devote myself exclusively to singing. Your most devoted and humble servant who shakes your hand, being your friend and admirer, Picasso." But Sabartés was not fooled. "His ironical remarks and jokes in Catalan," he recalled, "could not conceal his disquietude."

It was a telegram to Sabartés rather than a letter that an-

nounced Picasso's imminent arrival in Paris on the fourteenth. Waiting for him at the Gare de Lyon, Sabartés began to wonder why he had so suddenly chosen to return to the turmoil he had longed to escape. But for Picasso even hell was preferable to the purgatory of boredom. The first friend he sought out the very night he arrived was Eluard. The next day the poet dedicated another love poem "To Pablo Picasso," dated May 15, 1936:

> What a fine day when I saw again the man I can't forget
> Whom I shall never forget. . . .
> What a fine day a day begun in melancholy
> Black beneath green trees
> But which steeped suddenly in dawn
> Entered my heart by surprise.

That summer, Picasso's inner hell was matched by the hell that erupted in Spain. On July 18, the news reached Paris that civil war had broken out between the Republican government and the insurgent Nationalists. The murder of García Lorca soon after, at the age of thirty-eight, sent shock waves through the art world. "They are killing men here," wrote Saint-Exupéry, "as if they were cutting down trees." There was no question that Picasso's allegiance belonged immediately and instinctively to the Republicans seeking to put down the military uprising. But it was Eluard who, in their endless conversations, supplied him with the vocabulary of political indignation that he used in declaring himself for the Republic.

For the first time in his life, this grand solitary joined the stream of history. From now on, his isolation would be laced with a sense of solidarity and belonging. He even accepted with alacrity the offer of the Spanish government to become the honorary director of the Prado. It was the first and the last official position he would ever hold, and it was not so much honorary as symbolic. By then Franco's Nationalist troops were only twenty miles from Madrid, and in August, as his planes began bombing the city, the Prado treasures had to be rushed to the relative safety of Valencia.

The stifling heat, compounded by the political bulletins which were getting bloodier every day, made Paris particularly oppres-

sive. One night in early August, Picasso left in his Hispano, with Marcel driving, for Mougins, a little village in the hills behind Cannes. He went alone, but Éluard and Nusch were waiting for him there, and more discreetly, staying with a friend at Saint-Tropez, so was Dora Maar. Even though sexual freedom was an integral part of her Surrealist credo, she was keeping up appearances by waiting for the call a few miles away at a farmhouse by the sea. There was a tone to this trip very different from that of his spring trip to Juan-les-Pins: "My dear Jaumet," Picasso wrote to Sabartés, using his Catalan nickname, "I am not traveling incognito. You can give my address to anyone who asks for it." The secretiveness was left behind with Marie-Thérèse.

A couple of days after his arrival at Mougins, he went, together with the Eluards, Roland Penrose and the American photographer Lee Miller, who was to become Penrose's wife, to the farmhouse where Dora was staying. Ostensibly it was for lunch with the writer Lise Deharme, who was Dora's hostess. In fact it was an expedition for the king and a few chosen courtiers to bring back to court the lady picked to be his consort—for the rest of the summer, for the rest of the year, for many years to come, no one knew and everyone speculated. They all had lunch together, and then Dora and Picasso were left alone on the beach. During their walk, she crossed the bridge from her life as an independent woman to her life as Picasso's increasingly dependent official mistress.

Back at the Hôtel Vaste Horizon in Mougins, Picasso felt the exhilaration of a new beginning—a new woman; friends who loved him, or at least idolized him; two beautiful, flirtatious sisters, one a chambermaid at the small hotel, the other a jasmine picker; daily trips to the beach and alfresco lunches under the vines and cypress trees. At such a time, he longed to wipe out the past. As he said once, raising not for the first or last time the ghost of Bluebeard: "Every time I change wives I should burn the last one. That way I'd be rid of them. They wouldn't be around now to complicate my existence. Maybe that would bring back my youth, too. You kill the woman and you wipe out the past she represents."

"Living with someone young," he said on another occasion, "helps me to stay young." A quarter of a century younger than

he was, Dora certainly fulfilled that qualification. But she had much more than youth in her favor. "One felt immediately her presence, that this was no ordinary person," remembered the art historian James Lord. "She wasn't classically beautiful because there was something a little heavy about the jaw, but she was very striking. There was a radiance in her eyes, an extraordinarily radiant gaze, clear like the spring sky." It was a radiance reflecting her intelligence, and the clarity in her eyes was the same clarity heard in her voice. According to James Lord, her voice was what everyone who met her noticed first: "She had a beautiful voice, a very special, unique voice. I've never heard anyone else who had a voice like this—it was like the trilling of beautiful birdsong."

Beyond her painting, her photography and her ravenous intellectual appetite, Dora was also absorbed in Buddhism, mysticism and astrology. Before she left for Saint-Tropez, she had cast Picasso's horoscope and to her amazement discovered that it was very similar to that of Louis XIV. There was a clear collective destiny running through the horoscope: it could have been the life of a political leader rather than an artist. So Doña Maria had been right all along. Her son was destined to leave his mark on the world in whatever field he chose to apply himself.

Newly inspired, Picasso had abandoned writing and returned to painting, which was a tremendous relief to Gertrude Stein: "You see," she had said to him, "you can't stand looking at Jean Cocteau's drawings, it does something to you, they are more offensive than drawings that are just bad drawings now that's the way it is with your poetry it is more offensive than just bad poetry . . . you never read a book in your life that was not written by a friend and then not then and you never had any feelings about any words, words annoy you more than they do anything else so how can you write . . . well he said getting truculent, you yourself always said I was an extraordinary person . . . ah I said catching him by the lapels of his coat and shaking him, you are extraordinary within your limits but your limits are extraordinarily there . . . it is all right you are doing this to get rid of everything that has been too much for you all right all right go on doing it but don't go on trying to make me tell you it is poetry . . . well he said supposing I do know it, what will I do, what will you do said I and I kissed him, you will go on until you are more

cheerful or less dismal and then you will, yes he said, and then you will paint a very beautiful picture and then more of them, and I kissed him again, yes said he."

And he was more cheerful and less dismal than he had been for a long time. He loved holding court, and among his many attendants were Dora, Penrose, Paul and Nusch Eluard and Eluard's daughter Cécile, as well as the Zervoses, Paul Rosenberg, the poet René Char and the photographer Man Ray. Whether he was conjuring their portraits on the tablecloth with a burnt match or with color squeezed from a nearby flower, or producing little animals and little people out of corks and paper napkins, or giving a frenetic imitation of Hitler, holding a black toothbrush to his upper lip, Picasso, in his striped sailor's jersey, was a magician reducing sophisticated adults to enchanted, openmouthed children.

The holiday was marred toward the end of August when an automobile accident acquired in Picasso's mind the dimensions of a major disaster. Coming back from Cannes, the car he was in, driven by Roland Penrose, collided with a car coming in the opposite direction. Picasso was badly bruised but far more badly shaken. "Confidentially," he wrote to Sabartés on August 29, "a few days ago on my way from Cannes by car with an Englishman, I had an accident which has left me all smashed up, and I can hardly move. At first I thought I had broken a few ribs, but yesterday I had an X-ray taken and it seems that nothing is broken; but I am still mauled up and this will last at least another few days. Don't worry about it, though." Of course, Sabartés did worry, and Picasso, contrary to what he had written, would have been appalled if he had not. On September 14, a good three weeks after the accident, his letter to Sabartés was again dominated by his physical condition: "Sabartés, my friend, how are you getting along? I am beginning to recover, for until now I was a pitiful sight, as if beaten up by blows of the automobile . . ."

As soon as he felt well enough to get back into a car, he, Dora and the Eluards explored the local countryside. On one of their trips, they stumbled on the little village of Vallauris, which had been a center for potters since Roman times. Picasso was enthralled watching the craftsmen bake the local clay, mold it and then fire their creations in the local kiln. A seed was planted that

day which would bear fruit ten years later, when he turned his genius to pottery.

When he returned to Paris, the legal wranglings over the division of his property with Olga were approaching an end, and the thought of an end to anything—including such a bitter and time-consuming confrontation—set his nerves even more than usually on edge. The final legal compromise was designed to leave both parties unhappy: Olga got Boisgeloup, which she detested and which had been the almost exclusive domain of Marie-Thérèse, and Picasso was left with the rue La Boétie, now a relic of his fashionable married life. And, legally, Olga remained his wife.

Sabartés, conveniently at hand and already predisposed to be Picasso's whipping boy, became the receptacle of all his anger and frustration. To exacerbate matters, Sabartés had been joined at the rue La Boétie by a woman who had followed him from Barcelona, determined to marry him even though she knew he already had a wife. Bigamy being only a venial sin in Sabartés' book, she succeeded, and Mercedes Sabartés became her husband's faithful and long-suffering shadow, never once mentioned in his memoirs and made to subsist on next to nothing, since Picasso very rarely gave her husband any money.

Projecting all his grievances onto Sabartés, Picasso continually found or invented new things to blame him for. Mercedes was one of them. It was not so much her presence at the rue La Boétie that upset him as her presence in Sabartés' life—wasn't he, after all, supposed to be exclusively preoccupied with Picasso and to devote his life to him with absolutely no distractions? He began accusing Sabartés of meddling in his legal proceedings and even of taking Olga's part. And as if that had not hurt enough, he declared Sabartés a failure. "What has he achieved in his life?" he would ask his friends. "Nothing . . . He just has *me*."

Like a wounded animal, Sabartés tried to fight back. Breaking his code of secrecy, he began to talk about his friend and hero: how cruel he was, how mean, how authoritarian, what an exhibitionist, how he beat his women, how he let his mother go with no money . . . All this, of course, got back to Picasso, whose response was merciless. Sabartés was told to leave the rue La Boétie and never come back. And however hard Sabartés begged and pleaded and asked to be forgiven for sins committed and

imagined, the verdict stood. In the middle of January 1937, with a heavy heart, an empty wallet and Mercedes in tow, he left. "After shutting the door behind me," he wrote in his memoirs, which were all too discreetly silent about the reasons for his departure, "I thought about the future, how, when I came to see him, I would have to ring the bell, and wait, like one who comes in search of a crumb of friendship."

Sabartés' housekeeping duties were taken over by the two beautiful sisters from Mougins whom Picasso and Dora had brought back to Paris with them. The elder sister, called, as fate would have it, Sabartés, was the cook, and the younger sister, Inès, the chambermaid. Inès was to become a permanent fixture in Picasso's world, a confidante at least as much as a housekeeper and a point of stability in an ever-shifting landscape of new women and new homes.

No sooner had Picasso given up Boisgeloup than Vollard offered him a house ten miles from Versailles, at Le Tremblay-sur-Mauldre. With its barn converted into a studio and its relative proximity to Paris, it provided the perfect arrangement for this stage in his life. He settled Marie-Thérèse and Maria there, and over the weekends as well as once or twice a week he would visit them, work in the barn, play with the little girl, watch her sleep or—and this was the most arduous task—try to feed her, now that she was no longer being breast-fed. "As soon as my mother weaned me, which happened from one day to the next when I was a year and a half old," she remembered, "it was as if I'd told myself I prefer mother's milk, I don't like steak and french fries and therefore I categorically refused to eat. So my dad would dance all sorts of pirouettes to make me eat because he always had this fear that I would die. A child who doesn't eat dies—he was convinced of that."

Having tucked Marie-Thérèse away at Le Tremblay-sur-Mauldre, he threw himself into his relationship with Dora. He was living out in practice what he had already declared in theory: that contradictory things can happily coexist even though "critics, mathematicians, scientists and busybodies want to classify everything, marking the boundaries and limits, making one thing prevail over another." For the moment, Marie-Thérèse was only vaguely aware of Dora's existence, while Dora was assuming

—an assumption based, of course, on the impression conveyed by Picasso—that the only remaining bond between him and Marie-Thérèse was their daughter.

Secure in her intellectual ascendancy over the uncultured Marie-Thérèse, Dora was also taking steps to solidify her position in Picasso's daily life by looking for a large studio away from the rue La Boétie, which they both detested. She hoped that he would work in the new studio without having to retreat as often to the country and that the two of them could work together on photographic prints, which fascinated Picasso, or on their respective paintings. The first two paintings she gave him were heads, severe and imbued with a sacred, mystical quality. One of Dora's proudest possessions was a painting they coproduced which they jointly signed "Picamaar." Among Picasso's most valued relics were the bloodstained gloves that Dora had worn the night he watched her play her dangerous game with the knife at the Deux-Magots. He admired her courage, her independent spirit, her intellect. But he would almost immediately and compulsively try to destroy the very qualities that made her compelling. And the combat would be all the more exciting now that his taming techniques were lavished on a lioness rather than wasted on a mouse.

9

THE WAR WITHIN AND WITHOUT

15 October XXXVI

My love:

I have to stay with Paul—I cannot come to have dinner and afterwards I am going to see the "Catalans" who are here. Tomorrow I could come to have lunch soonest possible to see you, which is the most pleasant thing to do in this dog's life which I am leading.

I love you every moment a little bit more.

Yours,
Picasso

AT THE CENTER of his "dog's life" was Dora. The letter was addressed to Marie-Thérèse. As she recalled toward the end of her life, "there were bizarre things going on . . . Nusch, Dora." She might also have noticed that in his recent work she was growing flabbier and uglier, while the dark-haired woman would never again look as beautiful or as serene as she looked at the beginning of 1937. On March 2, Dora was even portrayed asleep. Having usurped Marie-Thérèse's primary place in Picasso's life, she had now also usurped her abandoned rest.

"It must be painful," he had said, "for a girl to see in a painting that she is on the way out." His love letters to Marie-Thérèse grew proportionately more passionate as his relationship with Dora intensified. And she believed them. Not because she was

stupid; not even because she did not know of the existence of "the other woman," which was already too public and too much a part of Picasso's life to remain a secret; but because he had invented the reality in which Marie-Thérèse lived. Together they had burned the bridges to any other reality, and now there was nowhere else for her to go. At the same time, he had scored a major victory over Dora—her grudging and pained acceptance of the fact that although she was the official mistress, she was not, and perhaps would never be, the only one.

While Picasso was establishing himself as the unquestioned master in his relationship with Dora, the insurgent generals in Spain were busy creating, as General Mola put it, "this impression of mastery" over the country. In order to achieve this, according to Mola, "it is necessary to spread an atmosphere of terror." And as the Republicans continued to control Madrid and most of the north and the east, the atrocities calculated to produce an atmosphere of terror became increasingly vicious and widespread. At the beginning of 1937, Picasso wrote a poem full of violent imagery, designed to ridicule Franco, who was presented as a loathsome, barely human hairy slug. "Dream and Lie of Franco" was written in Spanish, in his automatic style that eschewed any rules of syntax or grammar. As he had said to Sabartés: "I would prefer to invent a grammar of my own than to bind myself to rules which do not belong to me." The text was illustrated by eighteen etchings of matching violence, fury and horror. Franco, the Beast attacking Spain, was another emissary of Picasso's arch-enemy, fate.

The landscape of his private life was changing. By late March, he had moved into the new studio Dora had found him at 7 rue des Grands-Augustins and she had moved around the corner to 6 rue de Savoie. After the prissy elegance of the rue La Boétie, which he was still keeping as a storeroom simply because that was less emotionally disturbing than giving it up, he relished the quaint complexity of the rue des Grands-Augustins. The building was a perfect mixture of spaciousness and mystery, with its dark spiral staircase leading to the vast studios on two floors, the secret inside staircase, the haunted-looking passages, the snug corners, the endless succession of little rooms that were soon converted to fit all his needs—from a bedroom dominated by his bed cov-

ered in a lavish fur bedspread to an engraving booth where he installed his magnificent handpress. It took a lot of money to keep Picasso in bohemia. This particular bohemian setting was a seventeenth-century building redolent of historical associations: it had been the old Hôtel des Ducs de Savoie, it had been used by Jean-Louis Barrault as a rehearsal hall and it was the setting for Balzac's *Chef-d'Œuvre Inconnu* and his hero's desperate quest to capture the absolute in painting.

And now, thanks to Dora, Picasso had found in "Barrault's loft" a space vast enough for his own most celebrated work. He had been commissioned by the Spanish government to produce a canvas for the Spanish Pavilion at the Paris World's Fair. As usual, hating the sense of obligation engendered by commissions, he procrastinated, worked on other things, refused to fall into step with his commitment. It took the bombing of the historic Basque town of Guernica on April 26, 1937, to mobilize his creative frenzy, and then the huge canvas, twenty-five feet by eleven feet, was completed in only a month. In fact, many of the "preparatory studies" were done after the work was finished.

It was the first time that Picasso allowed himself an audience while he worked. Dora was a constant companion, photographing successive stages of the work; Eluard was a frequent witness, as were Christian Zervos, Andre Malraux, Maurice Raynal, José Bergamín, Jean Cassou—all, at different times, watching Picasso, brush in hand, sleeves rolled up, commenting on the progress of *Guernica* or obsessively talking about Goya. One thousand six hundred of Guernica's seven thousand inhabitants had been killed and seventy percent of the town destroyed by the forty-three German planes that had bombed it; but the impact of this raid of terror went far beyond the actual damage inflicted on the town and its people. Guernica, with its ancient oak tree under which the first Basque parliament had met, became a symbol for the triumph of hatred and irrational destruction, and helped convert a large section of Western public opinion to the Republican cause.

Before *Guernica* was shown at the Spanish Pavilion, there were rumors disputing Picasso's Republican sympathies, and despite his "Dream and Lie of Franco," claims were made that he was in fact pro-Franco. Eluard urged him to deny these stories and

clearly state his position. So, under his guidance, Picasso entered the political phase of his life. Once, painting *Guernica* would have been enough; now, while at work on the mural, he also produced a statement, which this time obeyed all the rules of grammar and syntax that he despised and clearly showed the hand of Eluard: "The Spanish struggle is the fight of reaction against the people, against freedom. My whole life as an artist has been nothing more than a continuous struggle against reaction and the death of art. How could anybody think for a moment that I could be in agreement with reaction and death? . . . In the panel on which I am working, which I shall call *Guernica*, and in all my recent works of art, I clearly express my abhorrence of the military caste which has sunk Spain in an ocean of pain and death."

He was not only setting a new, political direction for his future; he was also, with Eluard's help, inventing a political conscience for himself. The military caste he condemned was not, however, just a group of generals around Franco, but a state of mind present on both sides of the civil war. The dark authoritarianism he abhorred had, in fact, become part of his own personality, gratuitously inflicting pain and humiliation on those around him.

But symbols are more powerful than facts, and *Guernica*'s power was enormous. It was a distillation of forty years of Picasso's art, with the woman, the bull and the horse horrified companions in a black-and-white nightmare world. The novelist Claude Roy, a law student at the time, saw *Guernica* at the Paris World's Fair and described it as "a message from another planet. Its violence dumbfounded me, it petrified me with an anxiety I had never experienced before." Michel Leiris summed up the sense of despair engendered by *Guernica*: "In a rectangle of black and white such as that in which ancient tragedy appeared, Picasso sends us the announcement of our mourning: all that we love is going to die." Herbert Read went even further: all that we love, Picasso is saying, *has* died. "Art long ago ceased to be monumental. To be monumental, as the art of Michelangelo or Rubens was monumental, the age must have a sense of glory. The artist must have some faith in his fellow men, and some confidence in the civilization to which he belongs. Such an attitude is not possible in the modern world. . . . The only logical monu-

ment would be some sort of negative monument. A monument to disillusion, to despair, to destruction. It was inevitable that the greatest artist of our time should be driven to this conclusion. Picasso's great fresco is a monument to destruction, a cry of outrage and horror amplified by the spirit of genius."

During the creation of this public monument to destruction, his private games of destruction continued with no respite. One day, Marie-Thérèse, who had been relegated to the margin of his life ever since he had embarked on *Guernica* with Dora as his tragic muse, arrived at the rue des Grands-Augustins while he was working. "*Guernica* is for you," he announced. It was an unabashed lie, but by then Picasso did and said very little by accident. It was a lie designed to subjugate, to humiliate through deception, to destroy the dignity that would allow Marie-Thérèse to distinguish between falsehood and reality. *Guernica*, in fact, was the product not only of his genius but also of his relationship with Dora. Much more politically aware than he was, she helped him focus on the tragic events in his native land, stoked the fires of political passion, discussed with him the symbols he was using, and even worked on the panel herself. As Pierre Daix said, "We will never know all that *Guernica* owes to Dora Maar."

When Picasso was not crushing Marie-Thérèse through deception or cruelty, he would bind her through florid declarations of undying love. One day, while he was still working on *Guernica* with Dora photographing the progress of the work, Marie-Thérèse dropped in and tried to exercise the rights given her by the protestations of his deep and growing love. "I have a child by this man," she said to Dora, all her anger directed at her rival rather than at her lover. "It's my place to be here with him. You can leave right now."

"I have as much reason as you have to be here," Dora replied coolly. "I haven't borne him a child but I don't see what difference that makes."

Throughout this exchange, Picasso kept on painting as though he were an innocent and uninvolved bystander. Finally Marie-Thérèse asked him to arbitrate: "Make up your mind. Which one of us goes?"

Picasso, absolute master of the situation, recollected the incident with great relish: "It was a hard decision to make. I liked

them both, for different reasons: Marie-Thérèse because she was sweet and gentle and did whatever I wanted her to, and Dora because she was intelligent. I decided I had no interest in making a decision, I was satisfied with things as they were. I told them they'd have to fight it out themselves. So they began to wrestle. It's one of my choicest memories," he concluded, laughing at the thought of the two women coming to blows over him. James Lord pinpointed the irony that had escaped Picasso: his two mistresses engaged "in a fistfight in his studio, while he peacefully continued to work on the enormous canvas conceived to decry the horrors of human conflict."

At the very moment when in his art he was soaring like an eagle, in his life he was behaving like a hyena preying on others' weaknesses. He had told both Marie-Thérèse and Dora that the other one did not matter; and he knew that however many times he lied and was caught lying, they both would still be there. That was part of the power he relished—treating women as less than human and then watching them gradually surrender their humanity, and act as if he had been right all along and they were not only less than he was but less than human.

So he went on seeing them both, and painting them both: sometimes immediately recognizable—one all curves and bright colors, the other angular and dark—sometimes in code; sometimes apart, sometimes together and once as a pair of doves, one black, one white, jostled in a small, crowded cage. Sometimes he even enjoyed having Marie-Thérèse follow along, in relative secrecy, wherever he and Dora went for a vacation. But as two women did not make a big enough harem for him, he often made sure through Paulo, his unwitting accomplice, that Olga also knew where he was going, so that she would turn up to stake her wifely claims, assault the woman who happened to be in her lawful place and, most important, feed Picasso's insatiable hunger for power over others.

In the summer of 1937, however, he left for Mougins with Dora alone. But nothing in his life was uncomplicated, even in those few cases when things looked uncomplicated. Paul and Nusch Eluard were waiting for them at the Hôtel Vaste Horizon, and with the continuing encouragement of Eluard and the dejected acquiescence of Dora, he resumed with renewed vigor his

affair with Nusch. Dora's dejection was eloquently portrayed in his portrait of her selling flowers in the street, unable to find any buyers—and contributed considerably to the pleasure he got from going to bed with Nusch. At the same time, he painted a series of variations on Van Gogh's *L'Arlésienne*, and in the last one portrayed Eluard as a transvestite suckling a catlike creature. Even when he benefited from it, Picasso despised any evidence of weakness, and it was transparent from this portrayal of the castrated Eluard that he despised his "gesture of friendship" much more than he appreciated it. As he was to say later on, quaintly rewriting history: "But it was a gesture of friendship on my part, too. I only did it to make him happy. I didn't want him to think I didn't like his wife."

Nor was Nusch the only other woman in Mougins. There was also Rosemarie with the magnificent bosom, who, among other things, used to drive them all to the beach bare-breasted. In 1906, he had painted *The Harem* with four naked odalisques, held captive and guarded by slaves. This summer in Mougins, he was living out the fantasy. "Somebody once said to me," he later remarked, " 'You have the soul of a sultan, so you should have a harem.' It's true, I would have enjoyed being an Arab or an Oriental. I'm captivated by anything to do with the East. The West and its civilization are little more than crumbs out of the enormous loaf represented by the East."

Leaving aside the philosophical veneer of that confession, it was in the tension between the women in his life that he found the excitement of the sexual game. Or even in the tension between a woman and a pet. One day he returned from a trip to Cannes with a monkey that he had bought in a shop there and on which he proceeded to lavish all his affection. When, to his delight, Dora exploded with jealousy, Picasso simply redoubled his demonstrations of love to the monkey until finally she threatened to leave. Thrilled to see how effectively he could manipulate her emotions, he went on treating the monkey like a long-lost beloved, knowing that however outrageous he was, Dora would not leave.

It was not Dora but the monkey that finally had enough and one day bit its master's finger. Uproar followed, especially when Eluard drew from his vast reserves of knowledge the priceless

morsel of information that a king of Greece had died after being bitten by a monkey. The love affair was summarily terminated, the monkey was immediately dispatched back to the shop in Cannes and Picasso worried for days that he was going to go the way of the king of Greece. Dora, on the other hand, with her chief rival for Picasso's attention removed from the scene, was for the moment blissfully calm.

There was now only the new dog left in Picasso's animal entourage. Elft had been exiled to Le Tremblay–sur–Mauldre with Marie-Thérèse and Maria and replaced by Kazbek, an Afghan hound that would be immortalized when Picasso painted its features superimposed on Dora's—thus underlining, he explained, "the animal nature of women." New woman, new house, new dog. Picasso's relationship with his successive dogs was in fact very similar to his relationship with his successive women. Periods of intense closeness were followed by periods of total indifference; the timing and duration of both were determined solely by his whim or convenience.

There were happy moments with Dora in Mougins and some happy pictures of flowers in bloom and boats by the shore inspired by their excursions into the countryside. Most of the time they were driven around in the Hispano-Suiza by Marcel, who had in some ways replaced Sabartés as the repository of Picasso's man-to-man confidences. As soon as he had separated from Olga and his *mondaine* period came to an end, Picasso ordered Marcel to "undress" and discard forever his chauffeur's livery. Contrary to his expectations, Marcel was very disturbed. "I thought he would like it," Picasso said later, "but in fact I had taken something away from him. One can never be careful enough when dealing with the lives of other people. Once, when I was a boy, I saw a spider about to kill a wasp which was caught in its web. Oh, I said to myself, that horrible spider is going to hurt the poor wasp. So I took a large stone . . . and then discovered to my horror that I had killed both of them." Whether he liked it or not, Marcel "undressed" and fell in line with the bohemian luxury of his employer's life.

One of Picasso's more frequent trips in the Hispano-Suiza was to Nice to visit Matisse, who had lived there since 1916. He could not stop disparaging Matisse, but neither could he put him out

of his mind. So he would try to belittle him with remarks like "In comparison with me, Matisse is a young lady"; but he would not stay away from Nice. It was as though he knew, whether he admitted it or not, that Matisse had access to a world of secret harmonies that was closed to him.

"There are so many things," Matisse once wrote in a letter to the art historian George Besson, "I would like to understand, and most of all *myself*—after a half-century of hard work and reflection the wall is still there. Nature—or rather, *my nature*—remains mysterious. Meanwhile I believe I have put a little order in my chaos by keeping alive the tiny light that guides me and still energetically answers the frequent enough S.O.S." It was a statement that would have been utterly alien to Picasso: understanding his nature was never of interest to him, and neither was putting his chaos in order. Yet he was drawn to Matisse, while at the same time he felt compelled to snigger at him, like a schoolboy who ridicules what is outside his own domain of experience. "The art of balance, of purity and serenity" of which Matisse dreamed was a long way from Picasso's tortured art and, therefore, all the more an object of his unceasing fascination.

Back in Paris in the middle of September, he began torturing Dora's face in earnest. On October 26, the day after his fifty-sixth birthday, he completed the *Weeping Woman*. Roland Penrose remembered vividly the moment when he and Eluard arrived at Picasso's studio and saw the *Weeping Woman* for the first time, still on an easel, with the paint on it scarcely dry. "It was as though this girl, seen in profile but with both the dark passionate eyes of Dora Maar, dressed as for a fête, had found herself suddenly faced by heartrending disaster. For a while the impact of this small brilliant canvas left us speechless and after a few enthusiastic exclamations I heard myself say to Picasso 'Oh! may I buy that from you?' and heard in a daze his answer 'And why not?' There followed the exchange of a cheque for 250 pounds for one of the masterpieces of this century."

Picasso's explanation for so monstrously deforming his lover's face with pain was simple. "For years I gave her a tortured appearance, not out of sadism, and without any pleasure on my part, but in obedience to a vision that had imposed itself upon me." It was, in fact, a vision that he had, at least partially, im-

posed upon Dora. Although there was in Dora something of the archetypal modern intellectual, racked with anxiety and disquiet, Picasso focused on, encouraged and brought out all that was most tormented in her personality. And his distraught portraits of her, mirrors of disintegration, became like negative affirmations, self-fulfilling prophecies of what she was not yet but would soon become—a vision of the ugly duckling given to the beautiful swan. Just as there are people who have the talent to nurture what is healthiest in others, Picasso had the gift of promoting what was most neurotic and most sick in the people closest to him.

"I wasn't in love with Dora Maar," he would say later. "I liked her as though she were a man, and used to say 'You don't attract me, I don't love you.' You can't imagine the tears and hysterical scenes that followed!" He tormented her at the same time that he was proud of her intelligence, her talents and her strength. "Dora thinks he resembles an enormous shrimp," he would say about Kazbek; "I read it and so did Dora," about a manuscript; "Dora was here and we looked through them together," about some photographs. It was always "Dora said this," "Dora read that," "Dora noticed this," "Dora did that," while he manipulated her and attempted to crush the very strengths he admired.

In his business affairs no less than in his relationships, there was very little in Picasso's life that was not calculated, despite the prevailing appearance of haphazardness. And the secrecy that surrounded what he did with his money—whether he stuffed it under his mattress or deposited it in a Swiss bank account—was part of his continuous effort to avoid the "evil eye" of all the forces he feared. On November 27, 1937, he set off for Switzerland. This time there was another reason beyond dealing, like many an affluent businessman, with his financial affairs. The trip was camouflaged as a holiday or, in one report, as the result of "an unforeseen event that made it necessary for Picasso to pay a short visit to Switzerland." The truth was that his sixteen-year-old son had robbed a jewelry store and the only way to prevent Paulo Picasso from being sent to prison was to plead that he was mentally ill. So Picasso and "his sick son," as one article described him, arrived in Bern, and Paulo was put in Prangins, a clinic for people who could afford the fortune in Swiss francs that it cost

to stay there. Misia Sert saw her godson when she was in Switzerland for an eye operation and told him that instead of risking prison for paltry profits—robbing jewelry stores or selling drugs, which Paulo proudly confessed he had also done—"he could make much more money by stealing one of his father's paintings and selling it."

Having completed both his fatherly and financial business, Picasso went to lunch at a country inn outside Bern with Hermann Rupf, the Swiss collector of his work who had bought his first Picasso drawing at the Bateau-Lavoir in 1908. Kahnweiler had arranged a visit to Paul Klee, who, having escaped from Hitler's Germany, was living very modestly in a nearby suburb. Picasso arrived late, having lingered over a bottle of Dôle and a plateful of *marrons glacés*. It was a strange meeting between the German master of invisible reality, sick and slowly dying, and the robust Spanish master of all that was visible and decaying—so strange and strained, in fact, that Frau Klee took to the piano and brought Bach to the rescue. After Klee's death, Picasso described him in two words: "Pascal-Napoléon." Even though there was no bridge between their two worlds, he had clearly been affected by Klee's powerful mixture of intense spirituality and intense willpower.

On December 18, 1937, *The New York Times* published an appeal that Picasso had sent to the American Artists' Congress in New York: "It is my wish at this time to remind you that I have always believed, and still believe, that artists who live and work with spiritual values cannot and should not remain indifferent to a conflict in which the highest values of humanity and civilization are at stake." It was another of the committed political statements issued by the Eluard "factory" with Picasso's signature at the bottom. The result was mutually beneficial: Eluard's views were disseminated much more widely than they would have been without Picasso's name attached to them, and Picasso's fame spread far beyond those who were interested in art.

At the beginning of 1938, Picasso started spending more time at Le Tremblay–sur–Mauldre. The attraction, much more than Marie-Thérèse, was Maria. Now over two years old and looking just like her father, squat and square and with his piercing eyes, she became the new major figure in his work. He did not idealize

ner as he had Paulo; there is anxiety in her face and fear in the way she clings to her clumsy doll. "I was as solid as they come," she remembered, looking back almost fifty years later. "I only liked sweet things, so they made up all the things I should eat in a sweet pureé and my father would feed me. As my mother used to say all the time, it all gets mixed in the stomach anyway, and frankly even now I'd rather start dinner with a chocolate éclair than with a good, hearty soup. And my favorite birthday treat has always been a dinner consisting entirely of different kinds of chocolate desserts. I was brought up so differently from Paulo—he was constantly supervised, constantly attended to, always very elegant, with lots of expensive toys. I had 'home-made' toys which my imagination turned into anything I wanted. I didn't have baths imposed on me, I didn't have nannies imposed on me. We weren't at all a normal family, not at all, not at all . . ."

At her christening, her father, who was not officially her father, became officially her godfather. When her little friends asked what her name was, her father replied that it was Conchita—his diminutive for Maria de la Concepción. "Con-what?" they would ask again, aware, apparently, that *con* in French is a fool, an idiot. So her parents started calling her Maria, which from the little girl's lips soon began to sound like Maya. "Maya!" exclaimed her father. "It's perfect. It means the greatest illusion on earth." So Maya it was from then on—Maya Walter.

Nor was Maya's the only name confusion at Le Tremblay–sur–Mauldre. One day Picasso perversely announced to everybody that the two maids who took care of the house would forthwith be known as Marie-Thérèse. "So," Maya remembered, treating it as a joke, "when you called out Marie-Thérèse, all three arrived." Like most of Picasso's jokes it was at the expense of someone else. By giving the maids Marie-Thérèse's name, he found another way to diminish and humiliate her, to affirm her servility and continually remind her of her subordinate status.

In the guise of fun and games, he seemed to delight in depriving those around him of their dignity and treating them like clowns. One of his favorite games was to make them sing in a restaurant, one by one, whether they had any kind of voice or not. And such was his prestige and authority that they did. The more embarrassed they were, the more he loved his little game.

In the year that Hitler was busy swallowing Austria and Franco's war of attrition was bringing Republican Spain to its knees, Picasso was turning the domestic cock in his art into a symbol of cruelty and a harbinger of tragedy. "Cocks! There have always been cocks," he once exclaimed, "but like everything else in life, we have to discover them, just like Corot discovered the morning and Renoir young girls." Picasso not only discovered the cock, he changed all its traditional associations: "Here," wrote the art historian Willard Misfeldt, "the cock's shrill clarion suggests not the herald of the dawn but rather a watchman sounding an alarm filled with horror and premonition."

It was in this mood of anxious premonition that, one afternoon in April while he was walking Kazbek in Saint-Germain-des-Prés, he ran into Sabartés. They had not seen each other for well over a year. It was an awkward meeting; they were talking mostly about dogs when Picasso, as if nothing had happened between them, as if he had not cruelly abused his friend and thrown him out, offered him an invitation. "You never come around here any more. Come with me—do you want to?—and I'll show you my studio on the Rue des Grands-Augustins. It's very near by." But Sabartés' wounds were still too raw. The last year had been a horrible one. For him rejection by Picasso meant rejection by the universe. He had gone back to scraping out a precarious living writing the same kind of stodgy historical novels he had written in South America and leading a mundane existence without any of the excitement and purpose that his life had acquired in Picasso's orbit. Picasso's invitation to follow him to the rue des Grands-Augustins was a siren song, and like Ulysses, who had himself tied to the mast of his ship to avoid succumbing to temptation, Sabartés sought to resist it; he pleaded another engagement.

But it was only a matter of a little time and a little clever wooing. In June a multicolored missive arrived on Sabartés' doorstep: "Friend Sabartés you promised you would come to see me I know you do not like to meet people if you wish we can get together secretly whenever you wish come to Rue La Boétie in the morning write to me here yours Picasso now another thing Paco Durio wants to see you I have made an appointment with him for next Tuesday at three-thirty or four come we will wait for you today is Thursday June 30 MCMXXXVII."

This time the siren song was irresistible: Picasso's flamboyant spirit, expressed in words of bright red, orange, purple, green, sepia and blue, the promise of resuming their private, secret relationship and the prospect of seeing an old friend of their youth decisively tipped the balance. On July 5, "at the appointed hour," Sabartés arrived at the rue des Grands-Augustins. Having refreshed Sabartés' memory of what it was like to be back in the fold, Picasso left soon after for Mougins, once again disappearing from Sabartés' life and leaving him to wait for the next call.

It was a sudden departure. The Eluards, Dora and Picasso were having one of their usual after-dinner get-togethers at one of the Saint-Germain-des-Prés cafés when they impulsively decided that it was time to get out of Paris. They rushed home, packed their suitcases, loaded them into the Hispano-Suiza and, well past midnight, left for Mougins. A few days later, Marie-Thérèse with Maya also decamped to Mougins. Olga followed. Directly in the case of Marie-Thérèse, indirectly in the case of Olga, he had let them know where he was going to be, again creating as much outer tension as possible to mirror and balance his own unbearable inner tension.

With Hitler preparing to complete the seizure of Czechoslovakia, and Franco poised for the surrender of Republican Spain, this was a critical time in history. But political tension had a major impact on Picasso only when it corresponded to his private turmoil. That summer it did. The landscape he painted from his hotel room on August 18 had nothing to do with the bucolic Mougins countryside; it was a landscape of darkness, destruction and chaos. But even more revealing of his state of mind was the *Crucifixion* he drew on August 21 in which the Virgin Mary is eagerly gulping the blood that spurts from her son's side while Mary Magdalene lustfully clutches his genitals. The blatant misogyny of his latest *Crucifixion* was a reflection of the way he felt about the women in his life—invaded and suffering at their hands. He had invited them in, fed the rivalry among them, fostered and relished their dependence, and then wallowed in self-pity. The other side of the sadistic element in Picasso's personality was his masochistic "need to invent his own torments."

Sabartés, who shared Picasso's misogyny so profoundly that his memoirs portrayed a phantom all-male world, assiduously fed

Picasso's self-pity, especially when it took the form of the victimization he felt he had suffered at the hands of hostile destiny's main instrument, women. On November 3, soon after he had returned to Paris, Picasso wrote to Sabartés: "Friend Jaumet. Can you come this afternoon to the Rue des Grands Augustins? Do come and you'll see things that will make you laugh and cry and besides we'll talk about other things . . . "

Sabartés answered the call that afternoon and from then on he was there every morning, often before Picasso had got up. Picasso's initial excuse was that he wanted Sabartés to type everything he had written. And when Sabartés protested that he had already done that, Picasso replied with irrefutable logic: "That does not matter. What can you lose by copying them again?" They were making a fresh start with old material. "We have all of life ahead of us," said Picasso with even more feeling and at least as much conviction as when Sabartés had first returned to Paris to share his life.

One day, toward the end of 1938, when Picasso was visiting Gertrude Stein at her new home in the rue Christine, she told him how terribly upset she was over the loss of her little poodle, Basket. Many of her friends had been urging her to replace him with another white poodle, but Picasso warned her that he had done that once and "it was awful, the new one reminded me of the old one and the more I looked at him the worse it was . . . supposing I were to die, you would go out on the street and sooner or later you would meet a Pablo, but it would not be I and it would be the same. No, never get the same kind of a dog, get an Afghan hound." Gertrude disagreed, got another white poodle and named it Basket II. "Le roi est mort, vive le roi," she proclaimed, and accounted for Picasso's feelings by attributing them to a Spanish inability "to recognize resemblances and continuation."

On the morning of December 20, when Sabartés arrived at the studio, he found Picasso in bed, immobilized with a painful attack of sciatica. Any kind of movement was torture, and the massages and compresses his doctor recommended, together with a three-month rest in bed, did nothing to alleviate the pain. While a stream of visitors filed by, Sabartés stayed at his side. Talk was the only thing that could distract him from his pain, so

Sabartés listened while Picasso talked "about the things one plans to do but doesn't and the things one does without planning." He talked about his work, and they bandied Spanish proverbs back and forth. "How correct," Picasso said, "is the saying: 'If bearded he must be Saint Anthony; otherwise the Immaculate Conception.' That's just the way it is, and it is fine. What's the use of disguises and artificialities in a work of art? What counts is what is spontaneous, impulsive. That is the truthful truth. What we impose upon ourselves does not emanate from ourselves. . . . A guitar! Do you know that when I painted my first guitars I had never had one in my hands? . . . People think the bullfights in my pictures were copied from life, but they are mistaken. I used to paint them before the bullfight so as to make some money to buy my ticket."

On Christmas Day his faithful friend was rewarded with his portrait as a sixteenth-century nobleman of the time of Philip II, ruffles and all. It was the portrait of a twentieth-century courtier in the guise of an earlier century.

The pain never left him. "As far as that is concerned," he complained to Sabartés, "don't worry—I was never completely alone!" The prospect of its continuing for months drove him to follow the advice of the art dealer Pierre Loeb and let his uncle, Dr. Klotz, treat him by cauterizing the nerve. But no sooner had the doctor plugged in all his apparatus than a fuse blew and the operation had to be postponed until the following day so that an appropriate transformer could be found. "We have gained one day," Picasso told Sabartés as soon as they were left alone—one more day of illusion that the cure would work.

The next day, as the doctor, assisted by Marcel, was wiring his equipment, Picasso, increasingly irritable, slipped into one of his favorite roles: prophesying with absolute assurance that the worst that could happen *would* happen. "I may or may not be cured," he shouted, "but what is certain is that tonight we'll be in absolute darkness. We'll be lucky if they don't burn the house down. Why did I get myself involved in all this nonsense?" Fortunately, his prophecies were not self-fulfilling; the house did not burn down and the "nonsense" worked. It seemed like a miracle when Picasso jumped out of bed and pirouetted first on one leg and then on the other. He bowed like a circus artist and then fell back

on his bed, murmuring: "Now that the pain is gone I can have peace."

The new year had just begun when Picasso received news of his mother's death on January 13, 1939, followed less than two weeks later by the news of the fall of Barcelona on January 26. The immediate cause of Doña Maria's death at eighty-three was intestinal occlusion, but there was no doubt that the civil war had taken a heavy toll. Of her six grandchildren, only two had not gone to the front, her granddaughter and her youngest grandson, Jaime, who was fourteen when she died. Together with their mother they represented the entire family at the funeral.

Picasso stayed in Paris. "He could have come," Jaime Vilató said, "but given his temperament, he preferred to flee from those kinds of situations. He preferred when he knew that someone he loved had died not to speak of that person again." He grieved but he did not mourn, so new grief was added to the unlived grief already stored within him and the wall around his heart grew thicker. Later in the year, he wrote a poem about the "center of an infinite void" that he felt was dragging him down to its dark and destructive depths. The eagle, a symbol for Picasso, " 'vomits his wings.' . . . He 'vomits' the good in himself," in the same way that Picasso was turning more and more away from what was good and loving and compassionate in him. His mother had been a haven of unconditional love and acceptance, and even if years passed without his seeing her, while she existed the possibility of that kind of loving acceptance existed. When she died it died with her, and he was left oscillating between self-adulation and self-disgust without a resting point. "Like a god of irreverence and instability," the painter André Lhote wrote of Picasso in March of that year, "he offers each day a fresh symbol of universal decomposition."

On March 28, Madrid surrendered and the Spanish civil war was over. "Franco," wrote Paul Johnson in *Modern Times*, "had fought the war without passion, and when he heard it was over he did not even look up from his desk." Half a million refugees— soldiers and civilians, men, women and children—fled over the border into France and were thrust by the French government behind barbed wire, into camps where they were treated like animals. Among them were Picasso's two nephews, Javier and

Fin. If anyone claimed any of the refugees, the authorities were all too happy to let them go. So Picasso sent Marcel to the camp in Argelès in the South of France to claim his nephews. There was no problem getting them out; the only problem was making sure the prisoners heard on the loudspeaker when their names were called. The situation in the camps was so chaotic that a response to the loudspeaker was the only way of knowing if someone was there—no records were kept, and there were many stories of refugees who had been claimed but never found. Marcel brought Javier and Fin back to Paris, and they spent a year there before returning to Spain.

Around the same time, a young Spanish Republican, Mariano Miguel, entered Picasso's life as a kind of political secretary, coordinating all the different demands made on him for support of the defeated Republicans. The Quakers were sending Picasso money from the United States, and one of Miguel's main projects was to ensure that it was forwarded to the hospital which had been set up in Toulouse to take care of the civil-war refugees. Picasso's involvement was as a respectable figurehead—a prestigious trustee for Quaker funds, a member of a welcoming committee for Spanish intellectuals, a cosignatory of letters. But if a more personal response was required, he often seemed dispassionate, even heartless, as if he were afraid to become too closely involved with the misery of others. When Gargallo's daughter asked him to help one of his old friends who was wasting away in a refugee camp, no assistance of any kind was forthcoming. When the fifteen-year-old girl asked him for at least some old clothes he no longer wore, he brushed aside the request with a joke: "They are so dirty," he told her, "no one would want them once I take them off."

Picasso's only routine in the early months of 1939 was provided by his regular visits to Montmartre to work on his etchings at Lacourière's workshop. He had decided to have his poems collected in a book illustrated with his own prints, and Vollard and he had many enthusiastic meetings to discuss the idea. But everything was interrupted at the beginning of July when Picasso decided to take the Blue Train to Antibes, accompanied by Dora and followed on the road by Marcel with the Hispano full of luggage, canvases and paints. Man Ray had lent him his apart-

ment in the Palais Albert I, and life slowed down to a holiday rhythm that included lounging on the beach, siestas, evening walks on the seashore with Dora, and passionate letters to Marie-Thérèse. On July 19, he wrote:

My love,

I have just received your letter. I wrote several to you which you must have received by now. I love you more each day. You are everything to me. I will sacrifice everything for you, for our everlasting love. I love you. I could never forget you my love and if I am unhappy it is because I don't belong to you as I would have liked. My Love, my Love, my Love, but I want for you to be happy and to think only of being happy. I would give anything for that. I am having some problems in Switzerland—but all that is not important. Let them send all the tears to me if I can prevent you from shedding one. I love you. Kiss Maria our daughter and I embrace you a thousand thousand times.

> Yours,
> Picasso

On July 22, the holiday mood was shattered by the sudden news of Vollard's death. His driver, also named Marcel, had had an accident forty kilometers outside Paris, during which a small Maillol bronze in the back of the car fell against the neck of the dozing Vollard and fractured his cervical vertebrae. He died that same night in a Versailles hospital.

Picasso was deeply affected not so much by Vollard's death as by the details surrounding it. The coincidence of the art dealer meeting his death by a work of art, the coincidence of its being a work of Maillol, an artist Vollard loved and Picasso intensely disliked, and the further coincidence of both drivers being named Marcel reinforced his fears that he was surrounded by hostile forces. He automatically interpreted any coincidences or unaccountable occurrences as signs of evil destiny at work. So instead of provoking wonder in him, they provoked fear. He swore never again to allow Marcel to drive him, and took the train for Paris to attend Vollard's funeral.

Vollard was buried on July 28, and the next evening Picasso and Sabartés left Paris for the South of France, traveling all night

to arrive in time for a bullfight in Fréjus. Picasso's solemn pledge notwithstanding, they traveled in the Hispano with Marcel driving. With Vollard's fate still fresh in his mind, his main concern before they left was to disclaim any responsibility for the expedition by putting the onus of the decision on Sabartés, as if he wanted to inform the angry gods that the trip was entirely of Sabartés' doing, so that if anything dreadful happened, it would happen to the instigator of the trip, rather than to him. "Of course if you don't care to come along no one is going to force you," he told Sabartés, with every succeeding sentence making the trip to the bullfight seem less and less like his idea. "You know that it does not matter to me one way or another. One bullfight more or less—it's not so important after all! Especially the one we are going to see . . . nothing much . . . I warn you." As Sabartés resignedly summed it up, "From then on, it was as if I were to blame for all the nuisance, as if I had suggested the trip." But all went well, and the bullfight over, they drove on to Antibes. Sabartés checked into a hotel and for the next few days was given a guided tour of the Riviera. Dora was left behind while the men explored Nice, Juan-les-Pins and Monte Carlo.

War had been in the air for some time, but on August 23, when Hitler signed a nonaggression pact with Stalin, it became inevitable. Privately, Hitler called the new alliance "a pact with Satan to drive out the devil," but publicly there was much toasting and celebration. At the party held at the Kremlin that night there occurred what Paul Johnson described as "the sudden discovery of a community of aims, methods, manners and, above all, of morals. As the tipsy killers lurched about the room, fumblingly hugging each other, they resembled nothing so much as a congregation of rival gangsters, who had fought each other before, and might do so again, but were essentially in the same racket."

All around the world, countries, parties and individuals scrambled to adjust to the new reality. Britain and, more reluctantly, France began to mobilize; Communist parties everywhere reversed their anti-Nazi policies and advocated peace with Germany at all costs. Tourists fled, and within forty-eight hours, Antibes was transformed: it was overrun by troops, the beaches were deserted and only a few pockets of people remained at the cafés, glued to the radios. One by one, Picasso's friends were

leaving. But he postponed the decision, waiting for something, he knew not what, to tip the balance. Then the concierge of his building was called to arms, and that brought the reality of the war sufficiently close to home for Picasso to make up his mind. The next day, with Dora, Sabartés and Kazbek he took the morning express to Paris, leaving Marcel behind to roll up his canvases and follow in the car.

Paris was no comfort. Many of his friends, including Eluard, had left to join their regiments, and those who remained could talk of nothing but the impending war. Picasso was scared, uncertain about his next step and, to top it all, angry: "If it's to annoy me that they make war they are carrying it too far, don't you think?" he said to Sabartés, soon after they arrived in Paris. "But honestly, don't you think this is fate? First Vollard and then —just as I was beginning to do something. I swear that now I'm afraid to work. That's why I can't take anything altogether seriously. You saw what I was doing . . . It's nothing; of course I know that. But it seems to me that I was warming up. I was beginning to see somewhat clearly, and now this. But don't think it's the first time. Every year it's the same story . . . Just like last year. Always the same. It's lucky it stops there!" He really believed that hostile forces conspired, through the death of Vollard, through the imminent declaration of war and each year through some new disturbance they conjured up, to interrupt the flow of his work.

"He was a worried man, seeming helpless, not knowing what to do" was Brassaï's recollection of Picasso at the time. In fact, he was anxiously looking for the course of action that would least defy his enemy destiny, in the same way that later, when France was occupied, he urged Malraux not to tempt fate by volunteering for the French Resistance. He ordered dozens of crates and began to pack up his pictures from the rue La Boétie and the rue des Grands-Augustins. Brassaï called the task "as complicated as the dismantling of the Louvre." It proved so massive, in fact, that on September 1, Picasso abandoned it in favor of a quick exodus from Paris. He left for Royan, accompanied by Dora, Kazbek, Sabartés and Sabartés' wife. And this time, instead of Marie-Thérèse following him, he had picked the destination where she was spending the summer with the four-year-old Maya. He took

a room with Dora in the Hôtel du Tigre and told her that to do his work he had taken another room in the Villa Gerbier de Joncs. There was, actually, no need to take a room at the Villa Gerbier de Joncs; Marie-Thérèse and Maya were already installed there.

On September 3, the day after he had arrived in Royan, war was declared. To all his fears about the war was added an additional fear: he did not have the special permit he needed, as a foreigner, in order to remain in Royan without getting into trouble with the law. So, with Sabartés in tow, he returned for a day to Paris. A few days later, he was again back in Paris, this time to buy canvases. He stayed for two weeks, spending a large part of his time at all his familiar haunts, collecting a little news and many rumors.

As France mobilized for war, Picasso took care of the many details that went with his galloping success, the numerous exhibitions of his work around the world and especially the grand retrospective of forty years of his art that was to open in New York at the Museum of Modern Art in November. As part of the attendant publicity, he spent a day posing at the rue des Grands-Augustins, at Lipp's and at the Café de Flore while Brassaï photographed him for *Life*. He had mastered the publicity game before the world knew that such a game existed. In fact, in many ways he helped to invent and define it. He had always recognized, and every step of his life had confirmed, a very basic correlation between the money fetched by a painting and the legend built around the painter. And money, for Picasso, was not so much a medium of exchange as the only clear-cut and unequivocal barometer of his success.

At the outbreak of the war, the American Embassy invited Matisse and Picasso to come to the United States. Both refused. In Picasso's case, such a drastic break with his life, his women, his homes, his cafés and his habits was unthinkable. If anything, the war had exaggerated his fear of severing any ties, however perverse the contortions he put himself and everyone else through in order to maintain his life's unstable equilibrium. He had even started visiting Olga regularly. The excuse was to discuss Paulo, who was still in Switzerland, but his whole behavior toward Olga, including personally providing her with money in

dribs and drabs rather than arranging for it to be handled through their lawyers, showed that he was still not ready to cut the cord that bound them together.

Back in Royan, the shuttle between Dora and Marie-Thérèse continued while Sabartés watched it all, maintaining a stoic detachment. Together with Kazbek, he accompanied Picasso wherever he wanted company, and whenever his presence was not required, he removed himself from the scene. He always went with Picasso on his expeditions along the harbor, which culminated in their ritual visits to a small junk shop that Sabartés described as a "cemetery of domestic souvenirs." Picasso would lose himself there, absorbed in whatever he found—a broken kerosene lamp, the grate from a kitchen range, a rabbit skin or a twisted and dilapidated parrot cage. "You can't imagine," he told Sabartés, "how much I like to come here. If it were up to me, I would take everything with me or else stay here."

His usual routine was to shut himself up in his room after lunch and work until evening. One day, he came out in the street after finishing a painting of a little girl, and the first person he encountered was a little girl who looked exactly like the one he had just painted. Picasso's response was terror. Once again, anything that could not be accounted for was assumed to be a sign of evil at work. So pervasive was his fear of getting on the wrong side of these all-powerful forces of evil that one day in Royan he did not even dare knock on the door of a house he wanted to rent —a knock on the door being, in his mind, a sure way of tempting fate. Fortunately, there was a real estate office at the corner of the street where he could walk in without knocking. In the middle of January 1940, not long after that first inquiry, he was given the keys to the third floor of Les Voiliers, the sunny villa he had often admired from the bench on which he rested during his walks. It was neutral territory, away from Dora Maar and the Hôtel du Tigre and from Marie-Thérèse and the Villa Gerbier de Joncs.

Andrée Rolland, the landlady, who lived with her mother on the second floor of Les Voiliers, was very impressed by her tenant, especially as she did some painting herself. So she watched with interest the comings and goings from the third floor. There were very few. "I saw nobody, absolutely nobody, climb the steps

to Picasso's studio," she said, "except the indispensable Monsieur Sabartés." It was forbidden territory to Marie-Thérèse and Dora. One day, Marie-Thérèse, passing by, found the front door open and dared to cross the threshold of the villa. Andrée Rolland heard some noise and came out to see who it was. She found Marie-Thérèse staring with an anguished expression at a palette left in the entrance hall. "Do you know," she asked, "who placed this palette there?" When the landlady replied that she did not, Marie-Thérèse grew more insistent: "You saw nobody go upstairs?" "Nobody," replied Mademoiselle Rolland, and half-reassured, Marie-Thérèse went her way. Moments later, Dora returned to pick up the palette she had left in the entrance hall of the villa while she was doing some shopping. But, obeying the order issued by the master, she had not ventured past the hallway. Nor had Marie-Thérèse. Her fear, as soon as she saw Dora's palette, was that Picasso was not applying the rules equally to both of them, that he was playing favorites, that he had given Dora privileges he had denied her.

He kept the two women in different places, but he could not resist pulling whatever strings he could to set them against each other. That is precisely what he did when he insisted that Marie-Thérèse become friends with Jacqueline Breton, André Breton's wife, who was staying in Royan while her husband was stationed in Poitiers and whose closest friend in that small town was Dora. Picasso, knowing just how upset Dora would be, brought Jacqueline and Marie-Thérèse together—which happened also to be visually interesting for him, as the two women looked so much alike that they were often mistaken for each other. Maya and Aube, Jacqueline's daughter, became friends, Dora felt betrayed by Jacqueline, and once again Picasso was content to have stirred things up in the harem.

Whenever he wanted to get away from the upsets he had caused, he could simply withdraw to the third floor at Les Voiliers. In fact, keeping his women at bay seemed to be the main purpose of renting a studio there. He did very little painting, finding it difficult to adjust to the brilliance of the light and the beauty of the view. "This would be ideal for someone who considered himself a painter," he said to Sabartés. "A magnificent

spectacle for one willing to be seduced . . . I have spent the afternoon watching that lighthouse before me and the comings and goings of the ferry. One will never get very far if one goes on like this." The serenity of the landscape only made his restlessness worse, and at the beginning of February, the shuttle between Royan and Paris began again: most of February in Paris, back to Royan in March for two weeks, back to Paris, and then back to Royan in the middle of May. In this case Dora did have special privileges, traveling with him while Marie-Thérèse was left behind in Royan.

The German *Blitzkrieg* had conquered Belgium and invaded France, bypassing the "impregnable" Maginot Line. Now the German army threatened Paris, and it became clear that to stay in the city was to court danger. On May 16, the day that Picasso had decided to take the train back to Royan, he met Matisse in the street. "Where are you going like that?" he asked him. "To my tailor," replied Matisse. "What! But don't you know that the front is completely broken through, the army has been turned upside down, it's a rout, the Germans are approaching Soissons, tomorrow they will perhaps be in Paris?" "But even then," countered Matisse calmly, "our generals, what about our generals? What are they doing?" Picasso's answer summed up the contempt that both painters felt for the established traditions of their art: "Our generals, they're the professors of the Ecole des Beaux-Arts."

Back in Royan, he received news from the gardener at Le Tremblay–sur–Mauldre that the house had been requisitioned by the Germans. He waited anxiously for more news, full of fear about the fate of his paintings and sculptures. As soon as the gardener called to say that the Germans had gone on army maneuvers, he took Marie-Thérèse and left for Le Tremblay. They found the big pieces of furniture moved to the courtyard to serve as a canteen for the soldiers, and sheets, silk dresses, shirts and baby clothes used as cleaning cloths. But the aim of the first trip was to salvage the paintings and sculptures. After that, each time the Germans left for army maneuvers, they rushed back to steal more things from the thieves. Maya remembers that her parents went on talking long after the event about the stupid destruction

at Le Tremblay–sur–Mauldre. Her father was particularly upset over a medieval wax sculpture of Christ which the Germans had burned like a candle.

War was in his pictures—not this war, not any particular war, but the darkness and the anger and the hatred that cause wars. In June, the German army marched into Royan and Picasso painted one of his most brutal and vengeful images of woman-hood: Dora as the *Nude Dressing Her Hair*. The brutality was no less present in his life. He often beat Dora, and there were many times when he left her lying unconscious on the floor. The trans-formation of the princess into a toad and of sensuality into horror was complete. And in the dog-faced portraits he painted of Dora, he completed the transformation of woman into servile animal. As Mary Gedo put it, Dora, like Kazbek, "came whenever he whistled." More than two-thirds of what he did during 1939–40 consisted of deformed women, their faces and bodies flayed with fury. His hatred of a specific woman had become a deep and universal hatred of all women.

War continued to change the landscape of his life. On June 12, Kahnweiler fled Paris, joining the hordes of Jews who had es-caped into exile. France fell, and on June 22, an armistice was signed dividing the country into two zones: one, including Paris, occupied by the German army, and the other, Vichy, governed by the collaborationist Marshal Pétain, who had been reported as saying that "sex and food are the only things that matter."

In Royan, on August 23, Mademoiselle Rolland watched Mar-cel pile Picasso's pictures into the Hispano and Picasso himself get into the car, followed by Sabartés and Kazbek. "He cast a sad glance at Les Voiliers," she recalled. "He would never see the villa again. It was reduced to dust during the bombing of January 5, 1945." Dora left for Paris by train; Marie-Thérèse and Maya stayed behind. Every now and then Andrée Rolland would find herself next to Marie-Thérèse waiting at the market in the long lines caused by war shortages. "I'm here because of my little one," Marie-Thérèse would feel the need to explain, and then she would ask if Picasso had remembered to pay the rent. "He is capable of forgetting! If he forgets, tell me." She wanted to be helpful, but it was also touchingly obvious that, as Mademoiselle Rolland put it, "she wanted to make clear that she remained on

intimate terms, not just on terms of friendship, with her daughter's father."

Back in German-occupied Paris, Picasso continued to use both his apartments until it became so hard to maintain his black-market supply of fuel that he decided to move completely to the rue des Grands-Augustins. He had a monstrous Flemish stove installed because he fell in love with its curves and lines, but it consumed so much fuel and produced so little heat and so much noise that he finally had to give it up and replace it with a kitchen range. He ate most of his meals at Le Catalan, a black-market restaurant on the rue des Grands-Augustins, run by a well-fed Marseillais who spoke Catalan. Dora was waiting around the corner, at the rue de Savoie, for his summons, always ready to walk over to his studio or meet him in the street to go to lunch at Le Catalan. Whenever Picasso picked up the phone to call Dora, Kazbek would get up and go to the door. "He knew that it was Dora I was telephoning," Picasso commented once in amazement. "God knows how. It's easy enough to understand that his stomach could tell him it was lunchtime. But I often telephone other people at about this same time, and he doesn't budge. How do you explain the fact that he can scent Dora from the other end of the line?" Most often in the evenings, Picasso, Dora and Kazbek would be at the Flore, where Eluard would join them when he returned to Paris after demobilization.

In the fall, the Germans decided to inventory all bank vaults, and Picasso was called to the National Bank of Commerce and Industry on the boulevard Haussman, where he had two strong-rooms next to Matisse's which contained Cézannes, Renoirs, Matisses and, of course, plenty of Picassos. Holding one of Picasso's paintings in his hand, the chief of the Nazi officers present turned to him in amazement: "It's you who have painted that? And why do you paint like this?" Picasso replied that he didn't know. He had painted this picture because it had amused him. Suddenly the Nazi officer was struck by an enlightening realization. "Ah!" he cried. "It's a fantasy!" And excited at having finally understood, he signed all the requisite papers, stacked the "fantasies" back in their places and locked the vaults.

When the investigators came later to Picasso's apartment, they were struck by a photograph of *Guernica* lying on the table. "Did

you do this?" one of the officers asked. "No," Picasso replied.
"You did." The day after, sitting at the Flore, he quoted himself
with pride to a highly impressionable audience that included Si-
mone Signoret. "It was incredible," she wrote in her memoirs,
"to hear it from the mouth of the 'charlatan' himself the day after
he had pronounced it. . . . And to roar with laughter because it's
he who is telling it and not something we read later, solemnly
expressed, in a book on the Occupation." Was he recounting his
remark the day after he had pronounced it or the day after he
had invented it? Whatever the case, the story got better with each
retelling until it was not a mere Nazi officer who was Picasso's
straight man, but Otto Abetz, the German ambassador himself.

Before the end of the year, Marie-Thérèse and Maya moved
back to Paris. Since the Germans were occupying her house at
Le Tremblay–sur–Mauldre, she was busy looking for an apart-
ment. She found one a stone's throw away from the rue des
Grands-Augustins and at the same time was offered another one
on the boulevard Henri-IV. Picasso was categorical: "Take the
one on the boulevard Henri-IV," he said, and naturally Marie-
Thérèse obeyed. He continued to test the limits of her unques-
tioning obedience and even manufactured situations in which
she was likely to fail the test. When she returned to Paris, he gave
her a key to a suitcase filled with money and ordered her not to
open it. Marie-Thérèse related at length to the art historian Lydia
Gasman how "discovering that she had disobeyed him, Picasso
proceeded to reenact the role of Blubeard and accused her of a
serious transgression." Even the smallest transgressions were se-
rious when it came to his intimates. He had taken them beyond
prosaic, everyday reality and given them a taste of the extraordi-
nary. If the price for that entailed pain, so be it; and if it entailed
obeying without understanding why, so be it again.

As well as a heightened reality, Picasso offered Marie-Thérèse
a quasi-regular routine. He would visit her and Maya most
Thursdays and Sundays. And she would live for those visits until
in her mind they came to be her whole life. During the other five
days, she kept a room in the house locked and told Maya that her
father worked there and she should never disturb him. "We were
happy; no on else counted," Marie-Thérèse said years later. "I
knew that nothing would get better, but at least despite the whole

world and whoever else was around, there were the two of us. There were the two of us and the two of us alone. Not even children, not even Maya." In the fantasy she had built to sustain her life, there was not even room for her own daughter—just herself and her beloved. She tried desperately to displace the reality that if it were not for Maya he would have been even less of a presence in her life. In fact, on his weekly visits he spent more time drawing Maya or circus scenes to entertain her than being with Marie-Thérèse.

Every now and then, and only when invited, Marie-Thérèse visited him at the rue des Grands-Augustins. During one of these visits he showed her the closet where he kept stacks of gold ingots mixed with soap from Marseille. "If something happens to me," he told her, "all this is yours." Marie-Thérèse, who, since the Occupation began, had been using ersatz soap, the only kind she could get, pleaded with him: "I would much rather have the soap right away." Ignoring her request, Picasso locked the door to the closet. And Marie-Thérèse had to be satisfied with promises and declarations. "You've saved my life," he told her again and again, and he insisted that she write to him every day, "because without your letters I am sick." He wrote her letters in return, full of flowers, pigeons and ardent statements like "you are the best of women" and "I love only you."

These were the words not of a lover, abandoning himself to the childlike nature of intimacy and passion, but of a highly manipulative man, growing older and all the more expert at his manipulations. In a few months he would be sixty, and on January 14, 1941, he drew a self-portrait—a bird's-eye view in which an older man, balding and wearing glasses, is seen writing. It was a sort of frontispiece for a play he began to write that same day, a play clearly belonging to the Theater of the Absurd and the ritualistic Theater of Cruelty.

He called it *Desire Caught by the Tail*, and he finished it in three days. The proof that Big-Foot is the character in the play who most resembles him is the fact that so many of the other characters are in love with him. The Tart is in love with Big-Foot, Thin-Anxiety is in love with Big-Foot and even Fat-Anxiety is in love with Big-Foot. All the characters, even those not in love with Big-Foot, share the author's bitterness and cynicism encap-

sulated in the Tart's lines: "You know, I met love. He has scraped knees and he begs from door to door. He doesn't have a sou and is looking for a job as a conductor on a suburban bus. It's sad, but go to help him . . . he'll turn on you and sting you." Every act ends in disaster, the last one culminating in a golden ball, the size of a man, which bursts open the window and blinds all the characters. Big-Foot speaks the final lines: "Light all the lanterns. Throw flights of doves with all our strength against the bullets and lock securely the houses demolished by bombs."

There is no compassion in the play, and no hope. The same was true of all his work at this time. Life was condemned, and for reasons much deeper than the circumstances that surrounded him—much deeper and more final than the war and the first terrible winter of the German Occupation. When offered extra coal by the Germans, Picasso is supposed to have replied: "A Spaniard is never cold." In fact, he was frozen inside. "The sun in the belly with its thousand rays" that he had once said was everything seemed to have been eclipsed, its thousand rays turned into icicles. And the icy malevolence at the heart of his prodigious creativity was there in his oppressive images of the endlessly distorted Dora, there in his gloomy still-lifes, there—especially there—in the *Head of Death*. This sculpture was no *memento mori*, no anguished cry against the devastations of war and the vanity of earthly pursuits. It was a magic totem designed to conquer death not by transcending it but by defying it and pitting against it the power of its creator's say-so, make-so, will. As always, his preoccupation was with himself and his own death. Once a kitchen pot exploded and Picasso, sure that it was a bombing, "hid himself under a table, forgetting, to Marie-Thérèse's dismay, that both she and Maya were in the same room and counted on Picasso's protection."

Throughout 1942 the French Resistance was gathering force. Hitler's invasion of Russia in the summer of 1941 had led to an immediate shift in the allegiances of the French Communist Party, and French Communists began to swell the ranks of the Resistance. Eluard put aside all his earlier objections to the Communist Party's interference with artistic creation and the freedom of the individual, and threw himself with all his passion into the arms of the Party and the rigors of the Resistance. Like many

other intellectuals in Picasso's circle, he seemed untroubled by the paradox of aligning himself, in the name of his country's freedom, with Stalin's ruthlessly oppressive regime.

Picasso began to spend more time at home and less and less at the cafés. The Nazi patrols, the curfews, the yellow Stars of David, the swastikas flying over the public buildings, the missing friends—all the grim signs of Occupation had gradually robbed his excursions into Saint-Germain of most of their pleasure. But there was something else keeping him at home. It was more a home now than it had ever been, thanks to the arrival of Inès. She had spent the beginning of the war in Mougins, had married a young man named Gustave Sassier and had been installed by Picasso together with her husband in a small apartment below his at the rue des Grands-Augustins. From then on she never entirely left his life. She was beautiful, she was bright and she espoused him totally: his explosions, his women, his lies, his messiness, the strange hours he liked to keep. Yet she was feisty enough to have opinions on his work and conversations that did not bore him with total agreement. She also cooked; and she kept house, although not in any thorough way that might disturb his piles and his beloved dust.

His clothes had become aggressively bohemian—baggy trousers, torn pockets held together by safety pins, a watch dangling from his lapel by a shoelace, a Basque beret for his almost entirely bald head. It was as much a costume as the top hats and the red cummerbunds of his *beau monde* period, except that now instead of playing the dandy he was playing the man of the people.

He rarely got up before noon and started the day by receiving his court. The courtiers varied, but the ritual remained the same. They all waited in the antechamber and Sabartés would let them know, sometimes after they had been there for hours, whether Picasso would receive them or not. Controlling access to Picasso was the only way Sabartés had of controlling Picasso, and even then most of the time he was merely carrying out orders. Like any chief courtier worth his job, he was very quick to spot disloyalty—or to invent it. He was particularly on the lookout for any comment that fell short of adulation for Picasso's work.

Picasso himself knew very well that not all Picassos were great Picassos, and it only confirmed the contempt in which he already

held most people to hear them rave over *everything* they saw. "He despised the way people yielded to anything from him," remembered the art dealer Pierre Berès. "He could have shit on the floor and they would have admired it. Sometimes he would look at some pictures which were not good pictures and he would laugh: 'Ha! Ha! I showed them these and they just admired them and they were so happy!'"

He may have despised those uncritical worshipers, but he needed them. The only thing which upset him more than a long stream of visitors was their absence, especially if he found out that instead of coming to see him someone had chosen to visit Braque. And Sabartés always made sure that he did find out. He was masterly at prodding Picasso's paranoia and his conspiratorial view of life. He loved predicting misfortune and reinforcing Picasso's deeply ingrained sense that there was always a catastrophe around the corner. Picasso knew that, but knowing it did not stop him from falling for it. "If you spit on me," he chided Sabartés, "it rains."

On March 27, 1942, misfortune did strike. Julio González, who had guided Picasso's first serious steps into sculpture, died. Picasso was overcome by an oppressive sense of guilt and foreboding, of the kind that he had experienced after Casagemas' suicide. "I'm the one who killed him," he announced quite simply to the Catalan sculptor Fenosa a few days after González' funeral. In what way had he killed him? By leaving him out of the list of intimate friends that he went over every morning in a magical attempt to protect them from death? By harboring death wishes against him? By a narcissistic overvaluation of his power to affect reality? (Fenosa had overheard him, twelve years earlier, saying to himself again and again, "I am God, I am God . . . ") Or perhaps simply by using him when it served his purpose and, in the process, draining the life out of him? Whatever the reason for his overwhelming guilt, he sought to exorcise it through seven paintings on the death of González. It was his primitive magical thinking that led him to feel he had killed González, and it was through the magic he ascribed to his art that he hoped to expiate his guilt.

"I did not paint the war," Picasso said once, "because I am not one of those artists who go looking for a subject like a photogra-

pher. But there is no doubt that the war is there in the pictures which I painted then." It was, however, his private war, his personal combat against the universe and the hostile forces that he felt governed it—and it went on long after the war was over. In May 1942, he discharged his hostility onto a large canvas, six and a half feet high and nine feet wide. A helpless, nude woman is lying on a rack, her emaciated arms pulled up behind her neck in a ritual gesture of submission, her face tortured, her legs tied by invisible ropes. Another woman is sitting facing her, holding a mandolin she is not playing. It is *L'Aubade*, or *The Nude with a Musician*, which would be variously described as "a grisly, dizzying reinterpretation of Ingres' *Odalisque with a Slave*" or as a powerful testimony to Picasso's discovery of "new plastic signs with which to express his violence." "The spectator," wrote Mary Gedo, "like Alice in the court of the Queen of Hearts, becomes an unwilling participant in a cruel, confusing world."

Better to understand Picasso's world, or perhaps simply better to learn to live in it, Eluard welcomed to his home on May 21 Raymond Trillat, a graphologist, whose services were used at Necker Hospital for the education of retarded children. Eluard presented him with a letter by Picasso, without, of course, disclosing the writer's identity. "He wields trees . . . no arms," Trillat said. "He defends his poor self who is colliding against others, who is penetrated by others. He does not want to be ruined by others. . . . He loves intensely and he kills what he loves. . . . He is sad. Looks for an escape from his sadness through pure creation. . . . Bloody temperament, bilious. Nerves subject to great explosions followed by apathy." Eluard, who had kept a strictly expressionless face while transcribing what the graphologist said, was stunned: "For those who knew Picasso this is an impressive analysis."

"After all, you can only work against something," Picasso himself was to say to Malraux three years later. "Even if it's yourself. That's very important. . . . Since I work with Kazbek, I make paintings that bite. Violence, clanging cymbals . . . explosions. . . . A good painting—any painting!—ought to bristle with razor blades." In the same conversation he stressed that a painter "must create what he experiences."

He used razor blades in his life as creatively as he used them in

his art. He often asked Dora to call him at Marie-Thérèse's during his weekly visits, which he knew were sacred to her. And Marie-Thérèse never failed to be upset. "Who is it?" she would ask, delaying for a few more seconds the painful confirmation of what she already knew. "The ambassador of Argentina," he would reply, very pleased with himself. He also enjoyed sending Marie-Thérèse the identical dress that Dora had chosen at her dressmaker's. And once he had Dora's dress delivered to Marie-Thérèse's. Marie-Thérèse, who had withstood many far greater indignities unflinchingly, was outraged by this latest one. She called Picasso's home and when she was told by Inès that he was not there, she rushed to the rue de Savoie to unleash her anger on Dora. Dora fought back, while Picasso, hiding in the next room, overheard it all and, as he later recalled, basked in the turmoil of his latest creation.

Later in the day, Marie-Thérèse descended on Picasso at the rue des Grands-Augustins. Her anger had dissolved into the courage first to arrive uninvited and then to ask for what she most wanted: to bind herself more securely and more permanently to him. "It's a long time since you promised to marry me," she said. "You really should be thinking about your divorce." It was an unexpected twist, but it merely made the day's developments a little more amusing for Picasso. Men less brilliant at manipulation would have laughed in her face. Picasso split hairs: "You know, at my age, it's a little ridiculous, and on top of this we are in the middle of a war which does complicate things."

Minutes later, as if it were a staged event, the door opened and in walked Dora. Ignoring her rival, she turned to her lover like a hurt and perplexed child: "But after all, you love me, you do love me!" she cried.

Picasso's dozing demon awoke. At the sight of Dora's utter vulnerability, he walked up to Marie-Thérèse and, tenderly, put his arms around her neck. Then, turning to Dora, he delivered his solemn *coup de grâce*: "Dora Maar, you know perfectly well that the only one I love is Marie-Thérèse Walter. Here she is. It's her." The transformation of the intellectual priestess of Surrealism into Picasso's doormat had been accomplished.

Marie-Thérèse, strengthened by this unexpected declaration, sought immediately to consolidate her position by ordering Dora

to leave. Having lost every vestige of dignity and self-respect, she refused. While Picasso looked on, Marie-Thérèse once again ordered Dora out; Dora once again refused to move. Marie-Thérèse took her by the shoulders and shook her; Dora slapped her. This so inflamed Marie-Thérèse that using all her strength, she pushed Dora out the door.

It was, of course, a Pyrrhic victory. As soon as Dora had been thrown out, Picasso very calmly destroyed Marie-Thérèse's gathering illusions. "You know very well the limits of my love," he said. "After that," Marie-Thérèse summed up with sadness, "he gave me my five kilos of coal and I returned home. That was all." Marie-Thérèse took the Métro with her load of coal, which, like a beggar, she had to pick up each day from the rue des Grands-Augustins, and Picasso called Dora. Requited, his demon dozed again. Until the next time.

When it suited his mood or his purpose, he could be demonically charming. On April 10, 1942, he wrote to Andrée Rolland in Royan:

Dear Mademoiselle Rolland,

If you would like to continue to be so kind, this is what I dare ask you to do. Except for the box mattress, pad, bolster, and pillows (and blankets if there are any), I would like you to find someone who would be willing to have all my things sent here to my studio, 7 rue des Grands-Augustins, Paris 6th arrondissement. Keep the pad and do with it as you choose, but do not go to any trouble for something so unimportant, you have already been too kind to look after all these things which, certainly, have been a bother to you. If you had to pay something, tell me, I will send you what I owe you along with the mountain of thanks which I already send you in advance.

I miss the studio in Royan and I miss no longer seeing you. I'm thinking that one day you will come to Paris and that we will lunch together and that that day will, no matter what, be like a Sunday.

Through this letter, I have the chance to be able to place at your feet the bouquet of truly wonderful memories that I have of you.

Picasso

He drew a multicolored bouquet and enclosed it with the letter. During the summer he started the long process that was to

culminate in *Man with Sheep*—more than a hundred drawings of the shepherd and the lamb which ended as a bronze sculpture loaded with religious implications. But monstrous women kept invading his work. At the beginning of October, while he was painting Dora as a prisoner, with bars, a crust of bread and a jug of water, her mother died, and to the pain already in her face he added the pain of her mother's death. He went on painting her in a red-and-green-striped blouse with a white lace collar. "I invented it completely," he said about the blouse. "Dora never wore it. Whatever people may say or think about my 'facility,' it happens—even to me—to struggle over a painting for a long time . . . How I sweated over that blouse . . . For months I painted it and then repainted it . . . " By the time he had completed the painting, the bars, the bread and the water had all disappeared. But Dora remained a prisoner.

"Dora for me," he was to tell Malraux later, "was always the weeping woman. Always. Then one day I was able to paint her as the weeping woman. . . . That's all. It's important because women are suffering machines. And I hit upon the theme. . . . You shouldn't have too clear an idea of what you're doing. When I paint a woman in an armchair, the armchair implies old age or death, right? So, too bad for her. Or else the armchair is there to protect her . . . Like Negro sculpture."

In her portrait of October 1942, Dora is no longer weeping. Even this final right of release has been denied her. She stares ahead, her whole being consumed by an extraordinary effort *not* to weep. There is something more tragic and terrifying about Dora's mask of rigid composure and self-control than about her weeping. It is as if in the course of stifling her pain she has stifled her life.

"Portraits," Picasso had said, "should possess not physical, not spiritual, but psychological likeness." This was the psychological likeness of living death. "I must absolutely find the Mask," he had told Malraux. And now he had. It was not the Romanesque mask "of a face in harmony with its god . . . with what is sacred"; it was not the Negro mask "in harmony with what the black sculptors feared, loved and had no knowledge of in the spirits they depicted." It was the mask of a living void. "The Romanesque sculptors," Malraux wrote, recalling that conversation, "had

wanted to give expression to the revealed unknown, whereas Picasso gave expression to a form of the unknowable that nothing would ever reveal. All he knew or would ever know about it was his own feeling in regard to it—the feeling he had about a prayerless and communionless unknowable, a living void. . . . It is the art of our civilization, whose spiritual void Picasso sneeringly expressed, just as the Romanesque style expressed fullness of soul."

And Picasso expressed it so brilliantly, sometimes sneeringly, sometimes violently, because he had so thoroughly experienced it. "Pablo," Gertrude Stein once said, "has been persuading me that I am as unhappy as he is." Few men have dared confront the spiritual void of living in an alien universe as starkly as he did. And in that void, all that was left was a relentless, demonic productivity. Occasionally, through falling "in love," through being a father, through camaraderie, there was a temporary reconciliation with life, but ultimately only in work was there release. In work and in a kind of everyday petty and paltry cruelty. So anguish, cosmic rootlessness and destructive rage were the fertilizers of his prolific creativity and the seedbed of his sweeping mean-spiritedness. Gertrude Stein was right: she was not as unhappy as he was.

Of course the spirit in him had not died just because he lived and worked as though it were dead. In fact, it often drew him toward those who had chosen, in however stumbling, ambiguous or tormented a way, to make it central to their lives. Max Jacob was one of them. At the beginning of 1943, Picasso decided to brave the journey to Saint-Benoît-sur-Loire to see him. A few months earlier Max had told his friend Michel Béalu that he was forgotten, that he rarely heard from André Salmon and never from Picasso. He was now sixty-seven; he lived simply in the village near the basilica, went to Mass twice a day, wrote and painted his gouaches, knowing that any day the Gestapo could come for him as it had come for his brother, his sister and his brother-in-law. He took Picasso to the basilica, he showed him his gouaches and then they walked together along the Loire, talking of their youth and of the old days. Soon after Picasso left, Max went to the visitors' book at the basilica and there he wrote his name and the year of his death: Max Jacob, 1944.

The blackness was enveloping Picasso, but it could not extinguish his passion for life nor his hope for love. In May 1943, while he was dining at Le Catalan with Dora and Marie-Laure de Noailles, both the passion and the hope were rekindled as his eyes were riveted by two young women having dinner with the actor Alain Cuny. One had dark hair, dark eyes and a classical Greek face enhanced by the flowing, pleated dress she was wearing. The other, very slender with a tiny waist, had wide green eyes and a fresh, alert face set off by a green turban. One was Geneviève Aliquot; the other, Françoise Gilot.

10

A WINDOW TO THE ABSOLUTE

MADELEINE GILOT had given birth to Françoise on November 26, 1921—nine months after Olga Picasso had given birth to Paulo. Emile Gilot, a successful businessman very interested in educational theories, was determined to bring up his only child like a boy—a very well educated one. As a result, Françoise could read and write by the time she was four and was more familiar with the gods of Olympus and the formulas of algebra than with the children of her neighborhood in Neuilly. Until she was nine, instead of her going to school, a tutor came to the house to teach her under the stern supervision of her father. One of her greatest delights was to be entrusted, when her parents were traveling, to the hands of her maternal grandmother. "With her green eyes and white mane of hair, her swift movements, her love of poetry, her independent spirit," Françoise recalled, "she was the magnetic pole of my life. In my mind there was no limit to her power, and I felt that she could understand everything."

When the war began, Françoise was studying law, planning, in accord with her father's wishes, to become an international lawyer. But the war and the growing Resistance, joined by many of her friends, made her rethink what was really important to her. "I told my father," she remembered, "that it didn't mean anything to me any longer to become a lawyer when the law, and especially international law, didn't even exist. . . . So, in 1941, I decided to use the time I was spending earning a master's degree

at the school of law to pursue my studies of art." She had been drawing ever since she was a child, illustrating daydreams or stories she told herself, full of monkeys, devils and ghosts. But then, everyone in her family had a gift for drawing, so no one took her gift very seriously. Still, her mother agreed to pose for her, and so did her closest friend, Geneviève Aliquot.

Geneviève, who was a pupil of Maillol, was instrumental in Françoise's decision to give up the law for painting. A French Catalonian by birth, she was at the same time earthy and mystical —the perfect complement to Françoise's intensely rational mind and androgynous beauty. Theirs was a deep, passionate friendship. It had begun when Françoise was twelve and Geneviève thirteen and a half. "She walked into my class in the middle of the school year," Françoise said, "unbelievably beautiful, wearing a tango red sweater and a tight black skirt and looking like a visiting star rather than a schoolgirl. They sat her next to me, and I was so dazzled I could not stop watching her. At the end of ten days, after she had taken the measure of what was going on, she turned to me and said: 'You, you are going to do my homework from now on, because all this bores me enormously. You are obviously very intelligent, so doing the homework in two different ways will be an interesting exercise for your mind and will allow me to write poetry and paint.' I would never have done it for anyone else, but I did it for her."

At first, Geneviève called Françoise, who looked like a young boy, her page. "Up until I was fifteen," Françoise recalled, "I always dressed like a boy and had absolutely no desire to be feminine. It was not until I was fifteen that I reconciled myself to being a woman. I stopped being Geneviève's page, and we became equally absorbed in each other." Claude Bleynie, a painter who was a friend of both of them, described the deep bond between the two girls. "It was the kind of sublimated passion one often finds among adolescents, a romantic fixation that leaves no room for outsiders. There was a mystery they exuded when they were together: Françoise more active, more angular in her voice, her temperament, her whole way of being; Geneviève very much a woman, all rounded femininity and harmony in her proportions as well as her behavior."

Trying to decipher the riddle of Geneviève's beauty and mag-

netism, Françoise did countless sketches, drawings and paintings of her. In the process, her self-confidence as an artist grew, and she came closer to an understanding of the specific character of her art. "All that I did of her," Françoise would say later, "was two or three years in advance of what I could do of anyone or anything else. The freedom she radiated, her innate sense of truth, her regal beauty have always been the ideal touchstone of my life as an artist."

Her other close friend as well as her teacher was Endre Rozsda, a young Hungarian painter and great admirer of Picasso. For two years, from 1941 to 1943, he was Françoise's guide into the mysteries of Picasso's work. "When I started studying with Endre," she recalled, "I was crazy about Matisse, about the portrayal of sensuousness and joy in art, and I was not so crazy, aesthetically or technically, about Picasso. Geneviève and I had been to the Spanish Pavilion to see *Guernica*, but we were not moved by it artistically—only as a political act. It was through Endre Rozsda that I really discovered Picasso."

But Rozsda, half-Jewish and refusing to wear the yellow Star of David, was in great danger in Paris, especially as the Occupation grew more repressive. With the help of Françoise's father, who arranged for him to get the necessary papers, he decided to go back to Budapest. He felt that at least he had a better chance of hiding in his native land than in France, where he barely spoke the language. In February 1943, Françoise took him, together with his paintings, to the Gare de l'Est. She felt a sense of impending doom. So many of her friends had joined the underground, so many of them had already died, and now her friend and teacher was being forced to flee to save his life. As the train was about to leave, taking him away, she thought forever, she suddenly felt afraid and alone. "What's going to happen, Endre, what's going to happen?" she cried out to him. "Why do you worry like that?" he called back. "Before three months have passed, you will know Picasso." The prophecy hovered in the air, unexplained and unexplainable, as the train pulled out of the station.

Before three months had passed, she did know Picasso. He watched Françoise closely that night at Le Catalan and made quite sure that all his witty aphorisms and brilliant declarations

were clearly overheard. It was as if they had dinner together before they ever met. Finally, it was time for dessert. Leaving Dora behind and carrying a bowl of fresh cherries as his offering and introductory prop, he went to her table.

"Well, Cuny," he said. "Are you going to introduce me to your friends?"

"Françoise," said Alain Cuny after the introductions, "is the intelligent one and Geneviève is the beautiful one. Isn't she like an Attic marble?"

"You talk like an actor" was Picasso's noncommittal response. "How would you characterize the intelligent one?"

"Françoise is a Florentine virgin." It was Geneviève who had answered his question.

"But not the usual kind," amplified Cuny. "A secularized virgin."

"All the more interesting if she's not the ordinary kind. But what do they do, your two refugees from the history of art?"

"We're painters." Again it was Geneviève who spoke.

"That's the funniest thing I've heard all day," said Picasso, his incredulous laughter matching his words. "Girls who look like that can't be painters."

It was just the provocation Françoise needed to launch into a defense of the seriousness of their vocation. She told him that they were both devoted to their painting and that, as a matter of fact, they were having a joint exhibition at that very moment at Madeleine Decré's gallery in the rue Boissy d'Anglas, behind the Place de la Concorde.

"Well . . . ," he conceded, "I'm a painter too. You must come to my studio and see some of *my* paintings."

"When?" asked Françoise eagerly.

"Tomorrow. The next day. When you want to."

It was an invitation all the more seductive since during the Occupation no gallery was allowed to exhibit Picasso's "degenerate" art. So the following Monday morning the Greek goddess and the Florentine virgin arrived at the rue des Grands-Augustins, to be greeted by Sabartés with more than his usual surliness. While he was taking the new visitors to Picasso's studio, they passed the Matisse *Still-Life with Oranges*, which provoked Françoise's voluble admiration. She was sternly rebuked by Sabartés,

who would not tolerate enthusiasm for anyone other than his boss, especially when he was only a few feet away. He deposited them with Picasso, who was already surrounded by half a dozen people, and returned to his post.

Picasso was the most charming host and tour guide, waxing lyrical on all the literary and historical associations of the building, showing Françoise and Geneviève where he did his sculpting and where his engraving, and even letting the faucet in his engraving room run long enough for the water to get steamy. "Isn't it marvelous?" he said proudly. "In spite of the war, I have hot water. In fact, you could come here and have a hot bath any time you like." He was being generous with everything except the one thing he had invited them to see: his paintings. Just as they had resigned themselves to leaving without seeing any, he showed them a few. But very few. "If you want to come back," he said as they were about to go, "by all means come. But if you do come, don't come like pilgrims to Mecca. Come because you like me, because you find my company interesting and because you want to have a simple, direct relationship with me. If you only want to see my paintings, you'd do just as well to go to a museum."

"A minotaur," he was to tell Françoise later, "can't be loved for himself. At least he doesn't think he can. It just doesn't seem reasonable to him, somehow. Perhaps that's why he goes in for orgies." Picasso was, of course, the Minotaur. And with Françoise, from the very first, it seemed as if he wanted to test whether he could, after all, be loved for himself. When Françoise and Geneviève visited his studio for the second time, bringing him a pot of cineraria, his reaction was to laugh: "Nobody ever takes flowers to an old man like me!" Then he noticed that the color of the blossoms matched the color of Françoise's dress. "Is there anything you don't think of?" he asked.

He had been to see their exhibition, but he said nothing about it. And Françoise, who knew about his visit from the all-excited lady who ran the gallery, did not dare ask. Instead she watched silently as, this time, he kept his earlier promise and put painting after painting on the easel for them to see. Finally, at the end of this private show, he turned and fixed his eyes on her. "I saw your exhibition," he said. "You're very gifted for drawing. I think you should keep on working—hard—every day. I'll be curious to

see how your work develops. I hope you'll show me other things from time to time." She left his studio floating, determined to work—hard—every day, and to return.

Geneviève went back to the Midi, and from now on Françoise would come to the rue des Grands-Augustins alone. With each visit, Picasso found a new excuse to take her aside, away from the assembled court. One day, he wanted to give her some tubes of paint; another, some special drawing paper; a third, when she arrived drenched from cycling in the rain, the excuse was his concern over her soaking hair. "Just look at the poor girl," he told Sabartés. "We can't leave her in that state. You come with me into the bathroom and let me dry your hair." And when Sabartés protested that this was a job for Inès, Picasso ordered him to "leave Inès where she is," took Françoise to his bathroom, and dried her hair himself.

A few days later, while he was showing her his sculpture tools, he suddenly turned and kissed her on the mouth. She accepted this latest ministration as matter-of-factly as she had accepted the tubes of paint, the drawing paper and the hair-drying—which, of course, enraged Picasso. "That's disgusting," he told her. "At least you could have pushed me away. Otherwise I might get the idea I could do anything I wanted to."

Françoise told him that she was at his disposal, her tone making it clear that this was an assertion of control rather than an admission of surrender. "That's disgusting," he repeated. "How do you expect me to seduce anyone under conditions like that? If you're not going to resist—well, then, it's out of the question. I'll have to think it over."

A week later, having thought it over, he decided that something stronger than an unexpected kiss on the mouth was needed to get her off balance. Under yet another pretext, he took her to his bedroom, presented her with a book by the Marquis de Sade and asked her if she had read it. And when she replied that she had not, he cried with pride: "Aha! I shock you, don't I?" Far from being shocked, Françoise won this round by pointing out that she had no need of the Marquis de Sade, while he obviously did. "Are you crazy?" she added. "It's ludicrous to even talk about de Sade, let alone indulge in all that, when people are being tortured and suffering for real, not for sexual games. I have no

interest either in being a victim or in turning others into victims."
"You're more English than French" was his exasperated conclu-
sion. "You've got that English kind of reserve."

It was now the end of June. Endlessly inventive, Picasso picked
a highly original location for their next match. He led Françoise
up a ladder to a tiny room under the eaves at the top of the house,
from which there was a beautiful view of the rooftops of Paris—
and of a seven-foot phallus that some enterprising worker had
painted on the wall of an opposite building. In the middle of
extolling the view, he ever so casually cupped Françoise's breasts
in his hands. "*Tiens!*" he said. "That drawing in whitewash on
the wall over there—what do you suppose that represents?" Per-
fectly unruffled, Françoise replied that it was too abstract for her
to be able to tell. Slowly he took his hands from her breasts and,
with elaborate politeness, guided her down the ladder to rejoin
the group in the studio below.

It was their last meeting before Françoise left for Fontes, a
village near Montpellier, where Geneviève's family lived. Her
father was the head of the Resistance there, which brought Fran-
çoise closer to the daily dangers of the Nazi Occupation. From
Fontes, the two women cycled to Les Baux, where they stayed
for two weeks. Françoise's time at Les Baux was her life's major
turning point. "I remember every detail as though it was today,"
she said. "First of all, the place itself is so special. Dante was
there during his exile from Florence, and he was so affected by
the setting he made it part of the *Divine Comedy*. And in nearby
Arles, Van Gogh did all those extraordinary paintings. While I
was there, I had the most incredible mystical experience which
challenged every aspect of myself and my life. It was not a mo-
mentary thing: there was an inner struggle that went on for days,
during which I knew that I had to stop identifying with my ego
and my intellect if I was to enter into that transcendent state. I
felt on the edge of an abyss, and then on the other side I was sort
of remade, bit by bit, from nothingness into being."

As a result of this transforming experience, she decided to
leave home, to begin her life afresh as an independent human
being, without having to pretend that she was going on with her
legal studies when all she wanted to do was paint; without having
to visit Picasso furtively; without having to lie, hide or constantly

explain herself. Determined to live a life free of subterfuge, she wrote her father a long letter explaining the changes she had experienced. He was appalled and dispatched her mother to bring her home. "By the time we arrived at Neuilly," Françoise recalled, "he was even angrier and threatened to have me committed if I did not change my mind. He gave me half an hour in which to repent and revert to my old self." She took advantage of his brief absence to run to her grandmother's house for protection. It did not take long for her father to follow her, and exasperated by her uncustomary disobedience, he began beating her with all his strength. When her grandmother mercifully returned, Françoise's face was bleeding badly, but her father's wrath was unabated. The sight and authority of the seventy-five-year-old woman put a stop to the beating, though not to his threats to have them *both* committed if Françoise failed to return home and her grandmother continued to support her in her disobedience.

The break with her father would last for many years; the break with her old life would last forever. For the first time, cut off from her father's wealth and protection, Françoise had to earn her own living. While she was the beautiful, dutiful daughter, she had had everything she could possibly want: tutors and couture clothes and trips abroad and plenty of free time to ride in the Bois de Boulogne. Now she had the one dress she had been wearing the day she ran away, and to earn a living, she started giving riding lessons to beginners and training horses.

In November she went back to see Picasso. She found him in a state of extreme sadness, but she also found that she felt closer to him than ever before. "The impact of our meeting," she recalled, "would have been very different if we had met at a time of peace. The tragedy around us and the pounding of history made it extraordinary where otherwise it might have been something interesting but ordinary, without the metaphysical quality that it had. Also, in the perspective of war, the fact that Picasso was forty years older than I didn't mean a thing. After all, I could have died at any moment. And in any case, Pablo was more like a man of forty than a man who by the time I saw him again in November had had his sixty-second birthday."

From then on she was a regular at the rue des Grands-Augus-

tins, visiting Picasso in the mornings when she was not giving riding lessons. Another frequent visitor and a witness to the burgeoning love affair was Brassaï, who came to the studio to photograph the sculptures. "Don't you think that she is beautiful?" Picasso asked him one day, gesturing toward Françoise. "Take a photograph of her some day, will you? But be careful; her hair must be a little uncombed, a little disordered. Above everything, don't take it when she has just come from the hairdresser. I have a horror of those applied hair-dos." It was in line with his horror of pet cats. "I don't like pet cats, purring on a couch in a living room," he told Brassaï as they were looking at the sculpture of a pregnant cat he was working on, "but I adore cats that have gone wild, with their hairs bristling at the ends. They chase birds, stand on ledges, run through the streets like demons. They turn and stare at you with those ferocious eyes, ready to leap at your face. And have you ever noticed that female cats—free cats—are always pregnant? Obviously they don't think of anything but making love."

Whether he had noticed an overabundance of pregnant alley cats or not, Brassaï was not likely to contradict him. Even when Picasso was insulting him he did not contradict him. One day when he was setting up and pulling his tripod toward him, Picasso called out: "You'd be better off to stop pulling at that tripod and pull in your eyes"—a cheap, offensive reference to the way that Brassaï's eyes bulged out of his head. Françoise, who was present, was beginning to get an education in court behavior. "While Brassaï was laughing nervously," she remembered, "he stumbled on his tripod and fell backwards into Kazbek's large basin of water. Picasso beamed with pleasure, as though this was the best thing that had happened all day. Only later did I understand what all this meant. Brassaï and I had met at Endre Rozsda's studio and had spent a lot of time together. When he walked in that day, we both showed in front of Picasso how astonished we were to see each other—the kind of astonishment that comes from seeing someone you know well in a completely different context. At the time, I did not know, of course, that the politic thing would have been to greet each other with our eyes but never openly acknowledge that we knew each other. Pablo could not stand the fact that there was life—not just life with Picasso. He

wanted people to stop existing when they stopped being with him
—or at least to pretend that they did. As a result, among those
who knew him well, nobody ever made any allusion to what they
did when they were not with him; no one acknowledged the ex-
istence of an outside world. Sabartés looked suspiciously at Bras-
saï and at me, as though he had uncovered a conspiracy—we
might meet outside and say something about them or do some-
thing against them. A shadow had suddenly fallen on poor Bras-
saï."

The next morning Brassaï arrived at the studio and found the
entire household of Sabartés, Inès and Marcel tense and mourn-
ful, and Picasso looking like a raving Grand Inquisitor: "My little
pocket flashlight has disappeared! I left it right here, on this chair
. . . I am ab-so-lute-ly sure of it. And it isn't there now! And if it
isn't there, it's because someone took it! I spent the entire night
looking for it. . . . I will-not-tolerate things disappearing like
that, in my house. I demand ab-so-lute-ly that it be found, at
once!" Suddenly, Sabartés and Brassaï were both in the camp of
the suspect. In this spirit of unexpected comradeship, Sabartés
leaned toward Brassaï and whispered: "He did it himself, unques-
tionably . . . He must have put it someplace and then forgotten
it. Now, he's accusing everyone else. . . . That's him . . . I know
him." The next morning Brassaï inquired about the flashlight. "I
found it," replied Picasso nonchalantly. "It was upstairs in my
bathroom." At least for the moment, peace had been restored in
the studio and the accused had gone back to work.

Everyone around him had learned to adjust to his explosions
and his fluctuating moods, and only very rarely did they allow
themselves to vent their hurt feelings. Once, after Brassaï had
almost finished photographing the sculptures at the rue des
Grands-Augustins, he walked with Sabartés to the Métro, talking
to him about the sculptures left to be photographed at the rue La
Boétie. "I'll have to go back there. Picasso promised to take me
someday." This innocent statement unleashed a torrent of pent-
up resentment in Sabartés. "Promised?" he cried. "Get it through
your head, once and for all: promise and fulfillment are two
things which rarely coincide in him. I know something about it.
Generally speaking, I'm the one who suffers from his unfulfilled

promises. His promises . . . Listen—he made me a present of the second portrait he painted in 1901. But every time I wanted to take it home with me in Paris, he said, 'I'll give it to you in Barcelona.' Well, in Barcelona he gave it to the cabaret we used to go to. That picture was sold, and passed from hand to hand until one day he was able to buy it back. It came back to the rue La Boétie. But he has never given it to me. Even though he told me that it was *my* picture."

It was very hard for Françoise to adapt to the world of masks, suspicions and buried feelings that surrounded Picasso. But it was easy to adapt to him: "The fact that Pablo was older than my father meant that it didn't strike me as strange when he laid down the law or told me what to do or not to do. I would either agree or disagree, but it was not a problem in my mind. Because I was thinking, well at his age he has the experience and probably he knows best and maybe I'm just being too rebellious. We were very much attuned to each other then, and there was no real confrontation between us—partly, I think, because at that time I had not yet touched the ground; I was sort of floating in the air."

And that is how Picasso perceived her: as "sort of floating in the air." One day toward the end of the year, Sabartés, who was getting more and more depressed over Françoise's continuing presence in their lives, decided to speak up in front of her and predict, like a bad-tempered nanny, that no good would come of this. Picasso told him to mind his own business. "You don't understand anything," he said. "You haven't got the intelligence to realize this girl is walking a tightrope—and sound asleep, at that. You want to wake her up? You want her to fall? . . . And what you don't understand, either, is the fact that I *like* this girl. I'd like her just as much if she were a boy."

In fact, his first image of Françoise was of a young man rather than a young woman. She reminded him of the poet Rimbaud; she was more truly androgynous than anyone else he had ever met. Like many of the Surrealists, Picasso had been fascinated by the myth of the androgynous being that, as Breton had written, "offers man a view of himself as he had been in the past or as he will be in the future: more luminous, more close to harmony and to power than he is in his present condition." Fran-

277

çoise too saw herself as androgynous. She even signed her paintings at the time as F. Gilot, perceiving herself and wanting to be perceived as a painter rather than as a *woman* painter.

The character Françoise most identified with was Ariel in *The Tempest*—the representative of the fluid elements of water and air and the spiritual energies of nature. In Shakespeare's play, Ariel is invisible to everyone except Prospero. And that was Picasso's fantasy. After he had sent Sabartés away, he told Françoise that he would like her to stay at the top of the house and vanish from the world: "I'd bring you food twice a day. You could work up there in tranquillity and I'd have a secret in my life that no one could take away from me."

The fantasy appealed to Françoise too, especially since at that moment in her life the two things that mattered most were Picasso and her painting. Working hard at her grandmother's, in a large studio next to her room, she was signing her paintings "Ariane." The more important her relationship with Picasso became, the more fascinated she was by the myth of Ariadne, who had guided Theseus out of the Labyrinth after he had slain the Minotaur. Could she help Picasso slay the Minotaur in himself? Could she guide him out of his labyrinth? In the myth, Ariadne saves Theseus' life only to be abandoned by him on the island of Naxos. Dominating Françoise's bedroom was the mural she had painted of Ariadne deserted by her lover, with the god Dionysus descending from Olympus to save her and make her his wife. In Françoise's work at the time, there was an affirmation of inner strength—her forms more sculptural, the hope beyond the oppression and the sorrow of the Occupation more pronounced. There was the spiral of an ascending staircase in her portrait of her grandmother, and peace in the face of Geneviève portrayed at the Café de Flore with a string of doves around her neck.

To Picasso, Françoise was a marvel, a marvelous accident. As the girl young enough to be not his daughter but his granddaughter expressed her precocious opinions and pulled the rug out from under his tricks of seduction and control, a grudging respect welled up in him. One day in February 1944, he suggested that next time she should come in the afternoon and he would teach her engraving and not let anyone disturb them. She arrived promptly for her engraving lesson looking like a vision out of

Velázquez in a black velvet dress, her face framed by its high collar of white lace, her dark red hair swept up. Once again he was the one thrown off balance. "Is that the kind of costume you put on to learn engraving?" he asked. She replied that she had dressed not for engraving but for what she had assumed he had on his mind. "I wanted to look beautiful for you," she added.

There was both an innocence and a power in her directness which unnerved him. She kept dealing him cards he had not been dealt before. "You do everything you can to make things difficult for me," he said, throwing up his hands both literally and metaphorically. "Couldn't you at least *pretend* to be taken in, the way women generally do? If you don't fall in with my subterfuges, how are we ever going to get together?" He complained, and at the same time he loved it. "You're right, really," he conceded. "It's better that way, with the eyes open. But you realize, don't you, that if you don't want anything but the truth—no subterfuges—you're asking to be spared nothing. Broad daylight is pretty harsh."

He had issued a warning, but vibrant with all the courage of youth, she felt invincible. So far she was winning—the twenty-two-year-old virgin was outwitting the sixty-two-year-old roué who had explored to the full the dark outer limits of sexuality. The engraving lesson forgotten, he began showing her his Vollard etchings. A fair-haired nude is sitting opposite a standing nude with dark hair and dark eyes: "There you are. That's you. You see it, don't you? You know, I've always been haunted by a certain few faces, and yours is one of them." A few prints later, a Minotaur is watching over a woman asleep. "He's studying her," he explained, "trying to read her thoughts, trying to decide whether she loves him *because* he's a monster. Women are odd enough for that, you know. It's hard to say whether he wants to wake her or kill her."

No matter what he said, he still could not succeed in disturbing her equanimity. He was intrigued by the source of her strength; he sensed that it came from a higher place than experience, looks or brains. "You are the only woman I've met," he told her, "who has her own window to the absolute." He was excited about the possibility of a new kind of relationship in which there was reciprocity—perhaps even love. "I guess I'll die without ever having

loved," he had told her a few months earlier. And she had laughed and asked him not to make up his mind yet.

"What *is* it all about, anyway?" he asked her suddenly as they were looking through the Vollard prints. "Do *you* know?" There was hope in the challenge—hope that she might know, or at least, know a little more than he did. Françoise said that she didn't know for sure but that yes, she had taken the first steps on the journey of finding out. It was his cue to take her arm and lead her to the bedroom. He undressed her, then studied her. And then he marveled at how closely her body matched his image of her body. Tenderly, he put her on his knees, like a little girl he wanted to reassure, and told her that "whatever there was between us, or whatever was to be, was surely a wonderful thing and that we must both feel completely free; that whatever was to happen should happen only because we both wanted it."

"Suddenly," Françoise recalled, "I was flooded by some of the same feelings I had experienced in Les Baux: a sense of a new beginning; a deep trust, and a sense of belonging. In Les Baux I had felt that I was no longer just a separate individual but one with the universe. Now I felt one with Pablo." He lay beside her on the bed and, as he caressed her body with infinite gentleness, he told her that he too felt that "this instant is a true beginning. . . . I wish I were able to suspend time and keep things exactly at this point."

Françoise was lying in his arms filled with a peace so profound and a joy so complete that nothing else mattered and there was nothing left to achieve. She felt impervious to doubts, fears and even to the pessimism that had seeped into Picasso's very being and which now took over. "Everything," he told her, "exists in limited quantity—especially happiness. If a love is to come into being, it is all written down somewhere, and also its duration and content. . . . We mustn't see each other too often. If the wings of the butterfly are to keep their sheen, you mustn't touch them. We mustn't abuse something which is to bring light into both our lives. Everything else in my life only weighs me down and shuts out the light. This thing with you seems to me like a window that is opening up. I want it to remain open. We must see each other but not too often. When you want to see me, you call me and tell me so."

He was clearly stirred more deeply than ever before; but he also feared that what felt so different would turn out to be more of the same. By asking that they not see each other too often, he was prolonging not only their happiness but also his hope that the feelings he had tapped into would blossom into love. He did not trust life enough to give himself over to what he sensed would bring light into his darkness; and he did not trust himself enough not to destroy it. By asking to see her sparingly, he was seeking to protect what had begun to grow between them from the monster that, experience had taught him, he could not control.

Françoise left feeling that the great painter she had admired impersonally had, in the course of the last hour, been transformed into a man she could not help but love.

11

COMRADE PICASSO

In February 1944, the same month in which Picasso and Françoise set out haltingly on their journey together, Max Jacob was arrested at Saint-Benoît-sur-Loire and sent to the detention camp at Drancy, a stop in the long journey to Auschwitz or Dachau. On his way, he wrote to Cocteau: "Dear Jean, I'm writing this on a train out of the kindness of the gendarmes who surround us. We will very soon be in Drancy. This is all I have to say. Sacha, when they talked to him about my sister, said: 'If it was him, I could do something!' Well, it is me. I embrace you. Max." The restraint of his plea made his agony all the more poignant. From Drancy, one last appeal reached his friends in Paris: "May Salmon, Picasso, Moricand do something for me."

His friends had already begun to mobilize all the support they could find. Cocteau drew up a moving letter about Max, about the reverence in which he was held by French youth, about his invention of a new language that dominated French literature, about his renunciation of the world. And in a discreet postscript, he added: "Max Jacob has been a Catholic for twenty years." The appeal was personally delivered to Von Rose, the counselor in charge of pardons and reprieves at the German Embassy—who, miraculously, was a lover of poetry and an admirer of Max's work. Conspicuously absent from the petition's signatories was Picasso. His silence in behalf of one of his oldest and most intimate friends was thundering. When Pierre Colle, Max's literary

executor, went to the rue des Grands-Augustins to ask him to use his considerable authority with the Germans to intervene in Max's behalf, he refused, crowing his indifference with a quip: "It's not worth doing anything at all. Max is a little devil. He doesn't need our help to escape from prison."

On March 6, Von Rose announced that he had succeeded in obtaining a release order signed by the Gestapo, and a car with a few of Max's friends left immediately for Drancy. There they were informed that Max was dead. He had died the day before of pneumonia, fatally weakened by the conditions in prison and the freezing cold in his damp, filthy cell. The "little devil" had flown out of his prison through death. Did the Germans know that Max was dead when they signed the release order? Or was this a genuine reprieve that arrived too late? And would Picasso's intervention have made a difference?

Whenever Picasso himself got into trouble during the Occupation, whether because he was eating in a black-market restaurant when it was raided or because he had his sculptures cast in bronze when it was illegal or, more seriously, because he was caught smuggling currency out of the country, someone was able to hush matters up for him. If André-Louis Dubois in the Ministry of the Interior was not able to help, he would address himself to Otto Abetz, the German ambassador; and if he too was powerless, Dubois would go as high as Arno Breker, Hitler's favorite sculptor, who would appeal directly to Himmler's assistant, the SS General Müller. "If you lay a hand on Picasso," Breker had warned Müller at the time of the currency incident, "the world's press will cause such an uproar you'll be left dizzy." And he added that if he did not sign the documents putting an end to any action against Picasso, he would appeal directly to the Führer. Müller, who knew that on the Führer's orders statues from the squares of Paris had been melted down to provide bronze to cast the works of Arno Breker, knew better than to withhold his signature. In his memoirs, Breker recorded what Hitler thought: "In politics all the artists are innocents, like Parsifal."

Such was the power of Picasso's legend. That he did not use it to attempt to save his friend from death—whether he would have succeeded or not—was one of his life's greatest betrayals, as

much a betrayal of himself as of Max. Later in March, there was a memorial service for Max at the Saint-Roch church. Picasso was there—but not really there. Afraid to enter the church and be associated, even in death, with a prisoner of the Nazis, he hovered in the courtyard in front of the church, a passerby but not a participant.

One day Françoise, who already understood how averse Picasso was to taking risks, asked him why he had stayed in Paris when he could have found refuge in America. "Staying on," he said, "isn't really a manifestation of courage; it's just a form of inertia. I suppose it's simply that I prefer to be here." His inertia was perceived as a heroic stand, a passive form of resistance, and the perception was strengthened by the fact that many of his friends were involved in the Resistance. On March 19, Michel and Louise Leiris gathered many of those friends at their apartment for a reading of Picasso's play, *Desire Caught by the Tail*. The actors were Jean-Paul Sartre, Simone de Beauvoir, Georges Hugnet, Jean Aubier, Raymond Queneau and Dora Maar; the director was Albert Camus. In the audience, among others, were Braque, Eluard, Pierre Reverdy, Jean and Valentine Hugo and Señor and Señora Anchorena, a very rich Argentine couple, who had been imploring Picasso, in vain, to paint a door for them.

Four years later, in *What Is Literature?*, Sartre was to give philosophic expression to the underlying theme of *Desire Caught by the Tail*. He said with words what Picasso had said with images: "We have been taught to take Evil seriously. It is neither our fault nor our merit if we lived in a time when torture was a daily fact. Chateaubriand, Oradour, the Rue des Saussaies, Dachau, and Auschwitz have all demonstrated to us that Evil is not an appearance, that knowing its cause does not dispel it, that it is not opposed to Good as a confused idea is to a clear one, that it is not the effect of passions which might be cured, of a fear which might be overcome, of a passing aberration which might be excused, of an ignorance which might be enlightened, that it can in no way be diverted, brought back, reduced, and incorporated into idealistic humanism. . . . Therefore, in spite of ourselves, we came to this conclusion, which will seem shocking to lofty souls: Evil cannot be redeemed." Or as Big-Foot puts it at the beginning of Act Five: "The blackness of ink envelops the rays of

the sun's saliva." The conviction that evil was not redeemable permeated not only Picasso's work but his actions and, in the case of Max's death, his inertia when there was a compelling reason to take a stand against it.

In June, a ray of sun pierced the blackness, and evil was shown to be a daily fact but not an absolute reality. The Allied armies landed in Normandy, and by August they had reached Paris. They were joined by thousands of Parisians who rose against their oppressors. Picasso left the rue des Grands-Augustins and awaited the outcome of the battle raging in the streets at the boulevard Henri-IV with Marie-Thérèse and Maya. While violent skirmishes were taking place in the neighborhood, he allayed his anxiety by drawing Maya, a happy little girl now that she had her mother, her father and her grandmother all around her. In fact some of Maya's happiest memories are of air raids: "My whole class, from my school that was around the corner, would take refuge in the cellars of the house where we lived. It was wonderful; I adored it. We had our teacher narrating the old myths for us in the dark. We didn't even have candles. It was fabulous. Instead of telling us the stories of Little Red Riding Hood, she told us stories of the gods, of Ariadne, of Dionysus and the Minotaur. And she was sensational! Imagine all these stories in the dark . . . That's why my dad loved the air raids! As for me, I was the happiest then because every time I rediscovered both my family and the old myths. And I found the Greek and Roman gods perfectly normal—they all talked like my father."

Very soon it was not only his nine-year-old daughter who saw him as a Greek god. The Liberation of Paris, proclaimed on August 25, heralded a turning point in Picasso's life. He was no longer just world-famous, no longer merely a legend. He became a symbol of the victory over oppression, of survival and of the glory of old Europe. He was even asked to provide a drawing for the first page of an album of homage offered to General de Gaulle by the poets and painters of the Resistance. He was a celebrity they could co-opt to add more glamour to their triumph. Having always had a strong preference for symbols over reality, he accepted. There were thousands of anonymous heroes in the Resistance, but Picasso, although certainly no hero, was a monument, as well known as the Eiffel Tower and almost as accessible. He

posed for photographs with his favorite pigeon perched on his head or on his shoulder; he welcomed hundreds of American GIs who lined up to visit his studio; he said, "Thank you very much" in a charming Franco-Spanish accent to offerings of chocolate, coffee, fruit and tins of food; he answered patiently and graciously over and over again all questions about the length of time it took him to paint a picture, about how many he did a year, how many he sold and for how much.

"When the firing died down," wrote John Pudney in the *New Statesman* in London, "and one wept less often at the singing of the Marseillaise and less champagne was forced across one's altogether willing palate in the name of liberation, I went to see Pablo Picasso. . . . He said that the tendency in the creative artist is to stabilize mankind on the verge of chaos." Another early visitor to the rue des Grands-Augustins was Hemingway. Picasso was out, and the concierge, used to everybody leaving presents, asked if he had a gift to leave for Monsieur. Hemingway went back to his car and returned with a case of hand grenades, on which he wrote: "To Picasso from Hemingway."

Many who undertook the pilgrimage to the rue des Grands-Augustins simply waited. Françoise once counted twenty GIs sleeping around the studio. But more disturbing for her than those bodies strewn across the floor was a magazine cover she saw at a newspaper kiosk while cycling across the Place Clichy. It was a picture of Picasso with his half-wild pigeon, which normally would never let him come close if anyone else was in the room: "I suddenly felt as if both the pigeon and Pablo had been tamed and were available to be ogled and touched by the whole world."

According to at least one visiting American journalist, Picasso was, together with General de Gaulle, the man of the hour in liberated France. He loved the role and played it to the hilt. "It was not a time for the creative man to fail, to shrink, to stop working," he told his visitors, adding modestly: "There was nothing to do but work seriously and devotedly, struggle for food, see friends quietly, and look forward to freedom." And the visitors reported the great man's words. Some lucky ones were shown not only his work but his private quarters and then wrote admiringly about "the cool Spanish tiled floor of the bedroom" and the master's charming commentary on, for example, the twin washbasins

in the bathroom: "either a hand in each or an intelligent conversation while you wash." And all the world knew that he had plenty of young and beautiful friends with whom to share an intelligent conversation while he washed.

Now that so many saw him as a providential man, a man of destiny, he felt even more equal to the task of pitting himself against destiny, against life and God. After all, now more than ever, he was the venerable center of a burgeoning religion, with a daily stream of worshipers to the inner sanctum, as Sabartés called his studio. Nigel Gosling, an English journalist who brought him as offerings some Penguin books on British art and a huge red apple from Normandy, described him moving about "like a stumpy little oriental god. Smaller than expected (great men always are) he was sallow and very firm on his feet, his black monkey eyes startlingly round and wide under the bald dome and scant white hair. He was serious and courteous, but he gave off strongly the Dionysian incandescence of the genius."

In every religion there is, of course, a heretical voice amid the deafening chorus of adulation. Misia Sert, then in her seventies, provided it. "With the hands that moved me so," she wrote in her memoirs of her visit to Picasso after the Liberation, "he took down some canvases to put them within sight of my failing eyes. There were dozens and dozens of them. How I should have liked to be able to tell him that I adored them! How happy he would have been to see me carry one off! . . . Alas, in all that he was doing, there was nothing that I could have lived with. I loved him far too much to be able to deceive him about my feelings. . . . I found myself back in my car, weeping uncontrollably over all that might have been."

But dissent and tears over what might have been were a rare commodity at the rue des Grands-Augustins. The mood was one of celebration. A month after the Liberation, Eluard, full of conspiratorial excitement, whispered in the ear of Roland Penrose, who was among Picasso's visitors that day: "I have great news for you: in a week it will be announced publicly that Picasso has joined the Communist Party." On October 5, the news was not merely announced, it was trumpeted across the front page of L'Humanité, complete with photographs from the reception the day before during which Communist Party dignitaries saluted

their new brother's "profound humanity," his "moral preoccupations" and his "service to mankind" and welcomed him into "the bosom of the Communist Party, the great, brotherly family of workers, peasants and intellectuals."

The paper, the official organ of the Communist Party, talked at length about Picasso's greatness as a painter as though trying to convince itself. "If they asked today the artists of the Soviet Union, those of the Anglo-Saxon nations, as well as those of the Latin nations, they would all unanimously agree to designate Pablo Picasso as the first among them and as the master of contemporary painting." Greatness by referendum.

Picasso's entry into the Communist Party turned into a circus, and one of the more entertaining sideshows was the spectacle of Party functionaries going into contortions to demonstrate why his art, which was anathema to all the official canons of "socialist realism," was nevertheless great art. They gushed and they cooed, and Picasso responded in kind. "All human expression," he once said, "has its stupid side." And in his explanations about why he had joined the Communist Party, he proved it. "And what about the poor, all the poor?" he asked a protesting André-Louis Dubois, his protector during the Occupation. "Well, they're not going to put up with just anyone and just anything. They'll defend themselves, there'll be strikes, troubles, and during that time you want me to stay up on my balcony, watching the show? No, that can't be. I'll be down in the street with them." In fact, in the years to come, far from being "down in the street with them," he barely watched the show from his balcony.

His capacity to invent reality reached prodigious new heights in an interview he gave to *The New Masses*, which appeared a few days later in *L'Humanité* under the title "Why I Joined the Communist Party": "Joining the Communist Party is the logical conclusion of my whole life, my whole work. For, I am proud to state, I have never considered painting as an art of simple entertainment or escape; I wanted, by drawing and by color, since those were my weapons, to go deeper into the knowledge of the world and men, so that that knowledge might free each of us increasingly every day; I was trying in my way to say what I considered truest, most correct, best, which naturally would be the most beautiful, as all great artists well know. . . . These years of

terrible oppression have proved to me that I should struggle not only with my art but with my whole being. So I went to the Communist Party without the least hesitation, for fundamentally I had been with the Party from the very start. Aragon, Eluard, Cassou, Fougeron, all my friends know that perfectly well; and the reason why I had not joined officially before was a kind of 'innocence' because I used to think that my work and the fact that my heart belonged were enough; but it was already my own Party. Is it not the Communist Party that works hardest at understanding and molding the world, at helping the people of today and of tomorrow to become clear-minded, freer, happier? Was it not the Communists who were the bravest in France, just as they were in the USSR or my own Spain? What could possibly have made me hesitate? Fear of finding myself committed? But I have never felt more free nor more wholly myself! And then again I was so impatient to have a country of my own once more: I had always been an exile and now I am not an exile any longer. Until the day when Spain can welcome me back, the French Communist Party has opened its arms to me, and I have found in it those that I most value, the greatest scientists, the greatest poets, and all the glorious, beautiful insurgent faces I saw in those August days when Paris rose: I am once more among my brothers!"

Never before had he so thoroughly poisoned the well of truth. Was he incapable of comprehending the magnitude of the suffering imposed by Communism, the millions murdered or incarcerated in concentration camps, the simple fact that, morally, Stalin was no better than Hitler? Or did he believe that the end justified the means? The reports coming out of Russia provided ample evidence that Stalin and his pack meant business. Picasso worshiped strength and despised weakness. Weakness smelled of death to him, and he wanted to be as far away as possible from any displays of it, as though he might catch it. The Communist system claimed a monopoly of truth and sought a monopoly of power—and that suited his personality perfectly. It also demanded the total surrender of man's being to the Party—and that was something he was very comfortable with, since it was, after all, exactly what he demanded of those around him. Notwithstanding his rosewater expressions of concern for the little people, he admired totalitarianism. He was fascinated by its ap-

parent efficiency and its sheer power—no messy votes to be taken; no people to be democratically coaxed, cajoled and persuaded. It was just the way he liked to run his own life. In that sense, he spoke the truth when he claimed that "joining the Communist Party was the logical conclusion of my whole life." He had always been a good totalitarian himself, and now the hour had come when the man had found his match in the Party. And both man and Party acted as though holding and proclaiming an ideal were sufficient to abrogate the need to live by it.

Through joining the Communist Party, Picasso got a cozy, comfortable feeling of vicarious virtue and a great deal of applause. He said that he had always been an exile and now he was an exile no longer. But his exile was not from Spain—after all, he had voluntarily lived in Paris for thirty-seven years before the civil war—but from himself. And he sought to escape from the nagging pain of that exile and from the stifling prison of his self-absorption by joining the Party and enjoying a sense, however spurious, of belonging. And as there were few things as elitist as the Party of the people, many were thrilled to belong with him, and many Party nymphets all the more thrilled to belong *to* him, however fleetingly. They flocked to the rue des Grands-Augustins in search of autographs from the latest Party celebrity, and there they joined artistically minded *petit-bourgeois* schoolgirls waiting for a glimpse of the Great Artist. They often got more than that. The older Picasso was, the younger he liked his sexual partners. And in the confused euphoria of the Liberation, many underage French girls were initiated into the mysteries of sex by a man who was old enough to be their grandfather.

One of the young girls who found their way to the rue des Grands-Augustins, guided there by Eluard, was Geneviève Laporte. She was seventeen at the time and studying at the nearby Lycée Fénelon, where she was president of the National Student Front·and editor of the school newspaper. It was in that capacity that she arrived to ask Picasso for an interview, an explanation of his Communism and an explanation of his art, which, she said, her schoolmates did not understand. "Understand!" he cried. "What the Devil has it to do with understanding? Since when has a picture been a mathematical proof? It's not there to explain—explain what, for God's sake?—but to awaken feeling in the heart

of the person looking at it. A work of art must not be something that leaves a man unmoved, something he passes by with a casual glance. It has to make him react, feel strongly, start creating too, if only in his imagination. He must be jerked out of his torpor . . ."

"The philosophers have only *interpreted* the world in various ways; the point is to *change* it," Marx had said. Geneviève asked Picasso if he had read Marx. He had not. His main exposure to Communist doctrine, apart from Eluard and Aragon, had been through Laurent Casanova, one of the heads of the Communist underground who escaped from prison during the Occupation and found asylum from the Gestapo at Michel Leiris' apartment, around the corner from Picasso. Geneviève Laporte, on the other hand, had read a lot in an attempt to convince herself to become a Marxist and join the Party; she had even read Stalin's *History of the Communist Party of the Soviet Union.* "I did my best," she said, "but it was in vain, because there were too many arguments with which I could not agree." At their first meeting, Picasso showed her his Party membership card, and they agreed that there was something amusing in his being described as "Comrade Picasso." He, who never explained his art, tried once again, to explain his politics: "You see, I am not French but Spanish. I'm opposed to Franco. And the only way I have of publicizing this," the painter of *Guernica* added, "is to join the Communist Party and demonstrate that I am on the other side."

Soon, political discussion was muffled by their sexual dalliance. But unlike the rest of the young teenagers in Picasso's life, Geneviève remained an intermittent presence, contributing to the tension that was always, for him, an essential element of sexual excitement. At times, Françoise would run into her at the rue des Grands-Augustins, unaware that she too should be included in the long and growing catalogue of Picasso's lovers. "I had nicknamed her," she remembered, "the Swiss cheese; she was a rather big and sturdy girl and she kept bringing Pablo cheese!" Françoise was, in fact, unaware of the presence of any woman in Picasso's life other than Dora. As for Olga and Marie-Thérèse, he assured her that they belonged in his past.

By now, Dora knew of the existence of Françoise but could not believe she would ever be supplanted by "the schoolgirl," as

she dismissively called Françoise from the precarious heights of her intellectual eminence. "In bed, but not at the table," she told Picasso—which immediately led him to invite Françoise to join him and Dora at dinner. "I went," Françoise recalled, "but I took along André Marchand, who was in love with me and had done many portraits of me. So instead of looking like the little girl who wants to be with the Master under any conditions, I was there with my own escort, who, in the eyes of the world, was the man in my life. And Dora, who knew André Marchand independently, started inviting him to dinner with her and Pablo, hoping that he would bring me along. She thought that when Pablo saw that I was obviously with André, he would lose interest in me. It had, of course, exactly the opposite effect."

When a big retrospective of Picasso's work opened six weeks after the Liberation as part of the Salon d'Automne, Françoise was faithfully on duty. It was an unexpected duty. Some "brainless young people," as André Lhote described them, many of them students at the Ecole des Beaux-Arts, and "some gentlemen of advancing years" were so outraged by a combination of Picasso's work and Picasso's politics that they tried to pull down his paintings, shouting: "Take them down! Money back! Explain!" From that day on, Françoise took turns with other young art students standing guard in front of the paintings. It was a concrete manifestation of one of the very strong urges that pulled her to Picasso: her urge to protect him, to save him, now from threatening demonstrators and always from himself.

Only a few of those who crowded the Salon d'Automne turned violent, but many were stunned. "After the nightmare of the Occupation," explained Françoise, "it must have been a shock for the general public to be exposed to work that was so close in spirit to the years they had just lived through." Shock was also the leitmotif of Georges Limbour's review of the exhibition: "The canvases painted by Picasso in the last five or six years and exhibited at the Autumn Salon are as violent a shock to the visitor as any artistic spectacle could be. These intensely precise forms, aggressively strange, larger than life, weighing on the soul like objects of a greater density than is known on earth, whether of lead, china, wood or bone, plunge us at first sight into a strange but fascinating disquiet, until we recover our balance in the spe-

cial atmosphere in which they exist." There were numerous cartoons prompted by the exhibition, all on the same theme of shock and dejection. One of them shows a guide explaining to a visitor who is looking at a glum parody of Rodin's *Thinker*: "He's been like that ever since they hung a Picasso in front of him."

While Dora continued to stagger on as the official mistress of the present, Picasso was introducing Françoise to his past. At first he talked to her about it, and then he wanted to show her the relics. One afternoon, he asked Marcel to drive them to the top of Montmartre, where they got out of the car and walked to the Bateau-Lavoir. "That's where it all started," he told her gravely. And then he pointed to Juan Gris's studio, to Max Jacob's room, to the room where Soriol, the artichoke seller, lived, and finally to his own studio. "All we need to do," he said, "is open this door and we'll be back in the Blue Period. You were made to live in the Blue Period and you should have met me when I lived here. If we had met then, everything would have been perfect because whatever happened, we would never have gone away from the Rue Ravignan. With you, I would never have wanted to leave this place." For the first time, Françoise understood the meaning that the Bateau-Lavoir had for him: "It was a time of struggle, but there was meaning and hope in the struggle, and everything seemed possible—even happiness."

From the Bateau-Lavoir, he took her to a little house in the nearby rue des Saules. There, lying in bed, was an old lady, sick and with all her teeth gone. They talked for a few minutes, he laid some money on her night table and they left. For a while, he was silent; then he turned to Françoise and explained: "I want you to learn about life. That woman's name is Germaine Pichot. She's old and toothless and poor and unfortunate now. But when she was young she was very pretty, and she made a painter friend of mine suffer so much that he committed suicide." The lesson he wanted to teach Françoise about life was the same lesson that, whether intentionally or not, he was teaching the world through his work: that so much of life is about decay, degradation and death.

In February 1945 he began work on yet another painting on those same themes: *The Charnel House*. A heap of broken corpses is lying beneath a white table with an empty jug and an empty

saucepan. Penrose called the picture "the most despairing in all Picasso's work"; Barr called it "a *pietà* without grief, an entombment without mourners"; countless art critics and art lovers have concluded that it was inspired by the horror of the concentration camps. Like the lesson he wanted to teach Françoise about life, *The Charnel House* was only part of the truth. It was a Crucifixion without even a tiny glimpse of the overwhelming triumph of the Resurrection. It was the Nazi horror without the victory over it. It was once again darkness as an ultimate reality.

It proved too much even for him. Throughout the year, he kept working on it, abandoning it and returning to it. It was not finished in time for the Salon d'Automne, and it was still unfinished when it was shown in the Exhibition of Art and Resistance in the presence of that latter-day fugitive and now Communist Minister of Veterans' Affairs, Laurent Casanova. Casanova extolled "the great artists who had found in the heroic action of our brothers the elements of a new modern art," but official rhetoric notwithstanding, there were rumblings among Picasso's Party brothers about the kind of art he was producing. Picasso took the rumblings in his stride. "Even if they didn't want me," he said, "I'd still hang on to the Party." But he knew they would always want him; and he knew why: "The truth of the matter is that by means of *Guernica* I have the pleasure of making a political statement every day in the middle of New York City. No one else can do that . . . no minister or politician could do as much."

"If the Germans were to come back," Cocteau asked him one night at dinner, "what would you say to them now that you've joined the Communist Party?" Picasso, clearly proud of himself, replied: "Why, Jean, I'd say, 'Can't you tell that was just a joke?' " But while the Germans were safely away, he behaved like a good Party celebrity, turning out at mass meetings, reading speeches more often than not written by Eluard and, more important than anything else, giving interviews.

The man whose motto had been "Talking to the pilot is forbidden" was now anxiously asking Jerome Seckler, interviewing him for *The New Masses*: "Do you believe me?" Some of his statements were not easily believable. "I am a Communist and my painting is Communist painting," he assured Seckler, and then qualified it by adding: "But if I were a shoemaker, Royalist or

Communist or anything else, I would not necessarily hammer my shoes in a special way to show my politics." He wanted it to be clearly understood that he had "never been out of reality." "I have always been in the essence of reality," he repeated. The unasked question was: which reality? The reality of the Corot landscape and the Rubens of "a man and a woman bursting with love" that were hanging in his bedroom at the time? Or the reality of *The Charnel House,* which he had still been unable to finish?

In his introduction to the interview, Seckler wrote about the exasperation that he and his friends had experienced in analyzing Picasso: "The only conclusion we could ever arrive at was that Picasso, in his various so-called 'periods,' quite accurately reflected the very hectic contradictions of the times, but only reflected them, never painting anything to increase one's understanding of these times." It was a conclusion much more devastating than Seckler realized. Could Picasso's art really be reduced to nothing more than brilliant reporting on the century's discontents?

On March 24, a few days after his interview with Seckler had appeared in *The New Masses,* another interview appeared in *Les Lettres Françaises,* in which Picasso saw his art as creating itself in the image of the events of his time: "What do you think an artist is? An imbecile who has only eyes if he is a painter, ears if he is a musician, or a lyre at every level of his heart if he is a poet? . . . Quite the contrary, he is at the same time a political being, constantly alive to the heart-rending, exciting, or happy events of the world, wholly creating himself in their image. How would it be possible not to be interested in other people, and in the name of what ivory-tower nonchalance could one remain detached from a life they bring you so copiously? No, painting is not made for the decoration of apartments, it is a weapon to be used offensively and defensively against the enemy." Again there was an unasked question: who, or what, was the enemy?

"It was an invasion!" he complained to Brassaï in May. "Paris was liberated, but I was besieged, and still am." He complained, but he remained determined to conquer every single one of his besiegers. And his weapon was not his work—in some cases it was a positive handicap—but his ability to be so totally absorbed in whomever he was with, for the time he was with them, that

they felt he was an old friend. "I felt as though I had known him for years," wrote Seckler in his interview. And Marina de Berg, a young Russian dancer whom Brassaï took to the studio, echoed the same feeling. "It's curious," she said, "I saw him for the first time, and yet I have the feeling of having known him forever." He welcomed them in blue shorts and nothing else and changed into a steel-gray suit only shortly before they left. "Just between ourselves," confided Marina to Brassaï, "he was much better in his shorts than in that gray suit. When he is dressed he becomes too much the proper gentleman, and a tie does not become him at all. But in his shorts, he was incredible."

Marina gushed over Picasso but detested his sculptures and his paintings. "There are only monsters here! Horrors!" she exclaimed to Brassaï. And when Picasso joined them, she was no less forthright: "But these canvases of yours are shocking! They frighten me! . . . Sincerely, do you like these, Brassaï? Do you find that beautiful? You just say it out of snobbishness, all of you."

"If I understand you correctly," Picasso said to her, clearly amused by her audacity, "none of my canvases pleases you."

"Why, yes," Marina replied. "Yes . . . If you were to offer me one, I would choose this portrait."

Picasso and Brassaï burst out laughing. She had picked the only canvas in the room that was not by Picasso—a woman of Arles by André Marchand. Picasso grew more and more flirtatious, running his eyes up and down Marina, who was sitting with her high-heeled legs crossed and her head cupped in her hands: "But she is very beautiful—Marina. . . . This profile is adorable. If only I were an artist . . . "

"You would do my portrait!" she interrupted him in mock alarm. "No, thank you. I don't want it. You would reconstruct me just the way you have all those women over there—the eyes in the ears, the mouth in the nose."

"Why, no, I wouldn't treat you like other women," he assured her. "I would make you very beautiful. By the way, how old are you?"

"How old do you think I am? I never tell my age," she replied coquettishly.

"But to me, you can tell it to me. Whisper it in my ear . . . an old man like me . . . "

The seduction game continued with Picasso inviting Marina to come back so he could give her some helpful advice; asking her to dance a game of hopscotch right there in the studio and shouting "Encore! Encore!" when she did; offering to teach her how to fasten her ballerina's waistband properly, and promising to find Olga's ballet slippers that had such good leather in them and give them to her "next time." But there was no next time. He simply liked to introduce the future into the conversation to create a mood of intimacy, a sense of bonding that made him all the more irresistible—even when there was to be no future. Marina was enthralled, and in this case that was all he had wanted: seduction for seduction's sake.

So the legend of Picasso the magician spread, perpetuated even by people who could not bear his work. "People are always asking me for the most incredible things," he complained, suffering from the side effects of his omnipotent image. In this particular instance, an American girl, Katherine Dudley, had sent him twelve 1,000-franc banknotes that she had forgotten to have stamped in time for the revaluation of the currency. Now they were useless—could he do something about them? Yes, he could. Like a true magician, he revalued them to more than their original worth by cutting a woodblock and imprinting it on the face of each note. The only catch was that he never returned the notes. "Every time I see him," Katherine Dudley said almost twenty years later, "he waves his arms in the air and says, 'Yes, Katherine, I did revalue your notes, and I must give them back to you.' " He never did. He loved being a magician and he could not help being a trickster.

From the first moment she set eyes on him, Françoise had been struck by Picasso's resemblance to the *Seated Scribe*, the ancient Egyptian statue that she had so often seen in the Louvre. And now he looked more than ever before like the ancient scribe. In a first edition of a book of poems by Mallarmé, underneath the portrait he had drawn of the poet, he wrote: "NO MORE FORE-LOCK! Paris, May 12, 1945." What remained of his once famous black and recalcitrant forelock—a small bundle of white hairs—

was now buried in the Mallarmé poetry book. "One cannot both be and have been" was his resigned epitaph.

It was a conclusion that Dora had failed to reach. She could see in his work that not only had Françoise been in his bed *and* at the table, she had begun to enter his very being. Yet Dora could not accept that she was on the verge of being supplanted. And even if she could, she had so thoroughly sunk herself in Picasso's life, so totally subordinated herself to him, that she had effectively barricaded all exits. So however agonizing her pain and monstrous his indifference, she spent her days in a cocoon where he was the only reality, waiting by the telephone for his summons, always available to meet him wherever he wanted or to receive him at home. The only other person who maintained a tenuous presence in her life was her father. Since her mother's death he had lived at the Hôtel du Palais d'Orsay and once a week, when Picasso was with Maya and Marie-Thérèse, she went to dinner with him—always just the two of them, and always at the same place, the Hôtel Lutetia.

In the spring of 1945, Dora had an exhibition of her paintings, mostly very meditative and austere still-lifes, at Jeanne Bucher's gallery in Montparnasse. One afternoon, Françoise rode her bicycle to the gallery, wearing a multicolored striped dress. Dora was there, all in black. Soon after, Picasso arrived, very proud and pleased that the exhibition was receiving good reviews. The more the world admired Dora and the more her talents were recognized, the more pleasure he derived from her submission to him. His arrival at the gallery made Françoise feel suddenly very uncomfortable and out of place. She ran down the stairs to get to her bike as fast as possible. He followed her, shouting, "Where do you think you're going?"

This had already become the pattern of their relationship. Whenever Françoise withdrew or stayed away, he ran after her to seduce her back. But the moment he detected any signs of real tenderness and closeness in their relationship, he pushed her away: "I don't know why I told you to come. It would be more fun to go to a brothel." Or, "There's nothing so similar to one poodle dog as another poodle dog, and that goes for women, too." Once, as they were watching the dust in the sunlight that

streamed into the room, he told her: "Nobody has any real importance for me. As far as I'm concerned, other people are like those little grains of dust floating in the sunlight. It takes only a push of the broom and out they go."

She fought back—every single time, she fought back. It came as no news to her, she said, that he saw the rest of the world as easily disposable flecks of dust, but as it happened, unlike a fleck of dust, she had both the will and the ability to leave without being swept away. She left and did not return for three months. She was not an instrument he could play at will, he was beginning to discover, but a young woman with a strength that was a match for his own.

While Picasso and Françoise were carrying on their relationship in a state of armed neutrality, Dora was, quite simply, falling apart. One night, Picasso went to her apartment and, to his amazement, found that she was out. When she finally returned, with her hair disheveled and her clothes torn, she explained that she had been attacked by a man who had stolen her little Maltese lapdog. Ten days later, she was brought home by a policeman who had found her in the same disheveled and dazed state near the Pont Neuf. This time the story was that she had been attacked by someone who had stolen her bicycle. When her bicycle was found undamaged near the Pont Neuf, Picasso became convinced that all these stories were nothing more than a dramatic attempt to rekindle his interest in her. So, determined not to fall for this ruse and incapable of considering anyone's feelings but his own, he went on as though nothing were happening—until it became unavoidably clear that something was.

One night, when Picasso arrived to pick Dora up for dinner, he discovered that the dam holding back her humiliation and her suffering had broken and the released emotions were pouring out uncontrollably. "As an artist you may be extraordinary," she told him, "but morally speaking you're worthless." He tried to shut her up by warning her that he would not put up with that kind of talk. She went on regardless, urging him to repent while there was still time, and when he laughed in her face, undaunted, she reproached him for his shameful life and begged him to consider what lay in store for him after death. "You work out your own

salvation in the way you see fit and keep your advice to yourself,"
he snapped at her, but his words could not stem the flood of her
emotions.

The next morning, in breach of Picasso's rule that she was
not allowed at the rue des Grands-Augustins unless specifically
invited, Dora arrived unbidden and unannounced. She found
Picasso talking with Eluard. There were no preambles. "You both
should get down on your knees before me, you ungodly pair,"
she cried. "I have the revelation of the inner voice. I see things
as they really are, past, present and future. If you go on living as
you have been, you'll bring down a terrible catastrophe on your
heads." And to underline her words, she grabbed both men by
the arms and tried to bring them down on their knees. Sabartés
was immediately dispatched to call Dr. Jacques Lacan, the psy-
chiatrist whom Picasso consulted for every kind of medical prob-
lem, including the common cold. He came to the studio and left
taking Dora with him. He kept her in his clinic for three weeks,
treating her with electroshock and starting her in analysis, which
continued long after she left the clinic.

For the first time since their friendship began, Eluard was fu-
rious with the man he idolized—so furious that as soon as Dr.
Lacan had taken Dora away, he smashed a chair to pieces. He
remembered Dora beautiful and proud among the young Surre-
alists, with her mystical leanings and her sharp mind, and he
found it hard to forgive Picasso for the deep unhappiness he had
caused her, for the monstrous and innumerable humiliations he
had inflicted on her, for all the ways in which over the last ten
years he had gradually accomplished the transformation of the
goddess into a ragged doormat. "Picasso can't stand for his com-
panion to be sick," Eluard told Pierre Daix when he took him to
see Dora after she had returned from the clinic. "With him a
woman never has the right to give up the battle."

Picasso narrated Dora's woes to Françoise and extracted the
moral for her: "The present always has precedence over the past.
That's a victory for you." It was a very different moral from the
one that Françoise saw in Dora's story. She expressed her fears
and told him that for her the story was bristling with painful
warnings. "Let's drop that whole matter," he said in response.
"Life is like that. It's set up to automatically eliminate those who

can't adapt. . . . Life must go on, and life is us." When she protested that this was a very harsh way to deal with anyone less strong than himself, he accused her of being a dreamer: "That kind of charity is very unrealistic. It's only sentimentality, a kind of pseudo-humanitarianism you've picked up from that whining, weepy, phony Jean-Jacques Rousseau. Furthermore, everyone's nature is determined in advance."

Françoise recognized with some apprehension the philosophy of Nietzsche's loveless Superman who must suppress all compassion: "Love is the danger of the loneliest one." "I started to see that there were strange aspects to his character," she said. "Sadistic characteristics began to come to light, so I thought that although this is an important relationship it should remain in a context of freedom and separateness—and distance." Picasso, oblivious to the effect the revelation of his demonic side was having on her, invited her to spend the summer in the South of France with him—and Dora. She refused categorically, determined not to be a player in his game of setting one woman against the other even when one of them had been reduced to an emotional cripple. "Don't count on me," she told him, "to come between Dora and you; don't count on me to annoy Dora. You annoy Dora yourself." And she left to spend the summer in Brittany and maintain the distance she knew was necessary, not so much in order for their relationship to survive as for her to survive their relationship.

On June 15, 1945, it was as if time had stopped for a night. It was the première of Jacques Prévert's *Rendezvous* presented by the Ballets Roland Petit at the Théâtre Sarah-Bernhardt. What remained of the *beau monde* was there in force, hoping that the Diaghilev years might be resurrected. Etienne de Beaumont and Marlene Dietrich and Cocteau and Picasso—with Dora at his side—were in the audience, as was Brassaï, who had done the sets for *Rendezvous*. Picasso had agreed to do the drop curtain, but as opening night was approaching and he had not delivered, Boris Kochno, who had succeeded Diaghilev after his death, picked a still-life of a candlestick and a velvet mask that Picasso had done in 1943 and had it enlarged. There was applause but also some boos and jeers as the house curtain rose to reveal Picasso's drop curtain. "Beyond a slight tightening around his

eyebrows, Picasso shows no reaction whatever," wrote Brassaï, who was seated next to him during the performance. "He has seen other demonstrations of the sort. During the intermission he told me that tonight's display was no more than a tempest in a teacup compared with the scandal provoked by *Parade* in this same theater twenty-eight years ago." If he reflected that his own contribution was only an echo of years past, he did not say so.

At the beginning of July, Picasso and Dora left for Cap d'Antibes to stay with Marie Cuttoli, around whom, whether in Paris or in the South of France, there was always a salon of artists, intellectuals and politicians, among them her husband, who was a senator in the French Parliament. From Cap d'Antibes, together with Dora and Marie Cuttoli, he went to the village of Ménerbes in the Vaucluse to see the large house he had acquired sight unseen in exchange for a still-life. The owner had wanted a Picasso and he also wanted very badly to get rid of his house, which was full of memories of his recently dead wife. Picasso made a present of the house to Dora. It was both a farewell gift and the symbol of a permanent bond.

From Cap d'Antibes, he sent a letter to Françoise in Brittany informing her that he had rented a place for her in Golfe-Juan, in the house of Louis Fort, an engraver and a friend of his. "Please come at once," he wrote, "I'm terribly bored." To his surprise, Françoise replied that her holiday in Brittany was not very exciting but that nevertheless she was staying put. At the same time she wrote to her mother: "I am laughing at your advice to rest and do nothing because you know very well that laziness is the very essence of my nature and that I work only because I love painting even more than I love being lazy—and that's saying a lot. At present I'm drawing everything I come across, even a calf's head this morning, and it's not at all tiring. Just the opposite, for me drawing is the most wonderful thing, because it makes me enter semiconsciously into a dream world from which I have difficulty returning. That's why it's necessary to be surrounded by a great calm in order to pass from the everyday world to that perfect state where joy is possible. When I have at any moment to come down to earth to take a métro or discuss 'business' it's as if a spell is broken. But here I remain 'airing my soul' all day long. . . . There are so many things that I see and love

that I can't remain a mere spectator. I have to understand them, to possess them, and that I can do through drawing—for example, a person's character reveals itself to me the moment I'm groping for the outline of his face. . . . And the most striking thing is to discover the weakness hidden in everyone, the flaw that makes every man touching. You are overcome with great compassion when you find in each man the source of tears . . . "

She had started making sketches of Picasso in 1944, searching his face for the hidden weakness, for the source of tears. But she was struck by "the masklike fixity of his face; the burning intensity of his basilisk eyes, the geometry of his head that through a short neck was squarely implanted on his broad chest." Her fascination with him still stood in the way of revelation: the source of tears remained hidden.

When Françoise returned to Paris, instead of being overcome with compassion, she was overcome with misgivings. She feared, especially after what Picasso had told her of Dora's unraveling, that his urge to seduce was not in order to love, not even in order to possess, but in order to destroy. So she exercised all her self-discipline to stay away from the rue des Grand-Augustins. It was not easy: "Life away from Pablo had lost its zest, and there were moments when my yearning for him drowned everything else."

On November 26, as a present to herself for her twenty-third birthday, she went to see him. In the proofs of the lithographs he had been working on, she saw that he in turn had been preoccupied with her. There was a series of prints which depicted Françoise watching as another woman slept. He told her that he was not sure whether the sleeping woman was her friend Geneviève or Dora. He continued to make changes until the sleeping woman was transformed into a thoroughly abstract nude. Only then was he sure that she was Dora. The proof was in the two insects in the margin. He explained to Françoise that for him Dora had always been a Kafkaesque personality, and so he had got into the habit of transforming any spot on the walls of her apartment into a tiny insect. There were also birds in the margins of the prints. Those, he told Françoise, were for her.

As soon as Françoise was back, he began an intense campaign to persuade her to move in with him. She was not at all sure. While they lived apart she felt that there was a balance in their

relationship and protection from the fallout of his personality. "I knew that going to live with him was the thing *not* to do," she said, which made him all the more determined that she would. Later, he would accuse her of being the woman who always said no, but for the moment he loved the challenge of her strength and independence. One of his pastimes was to follow her in the car, with Marcel driving, while she was riding in the Bois de Boulogne. His favorite pastime, however, was going back and telling Marie-Thérèse about this new, marvelous, young woman in his life who was such a spectacular horseback rider. He knew exactly what would most upset Marie-Thérèse, who was so proud of her athletic prowess: another woman in his life who was a superb athlete and younger still.

Marie-Thérèse decided to compete, to show him that whatever the new woman could do on a horse, she could do better. She started riding in the Bois de Boulogne, where Françoise would often see her, her beautiful face instantly recognizable from Picasso's portraits, her robust body now plumper and heavy on horseback. It was a game in which, as Picasso knew well, Françoise held all the cards: her slim, androgynous body, shown to even greater advantage on horseback, her proud youth and, above all, the Joker he had placed in her hands—his fresh and growing enchantment with her. Marie-Thérèse soon abandoned riding; it had been one more hope that she could win him back now dashed by reality.

Marie-Thérèse had always been the secret lover, and for a while few knew about Françoise. But now he started introducing her to more and more of his life, including Fernand Mourlot's workshop in the rue de Chabrol, where he had gone every morning since the beginning of November. It was through Braque that he had met the famous lithographer, whose father, a lithographer himself, had bought the shop in 1914. The closest Picasso ever got to working people was in Mourlot's workshop. And they loved him; he shook hands with them every morning and they showed him their latest treasures, mostly pinup girls and pictures of cycling champions.

The only exception was Monsieur Tutin, the most skilled craftsman there, who hated Picasso's work. Yet since Picasso was constantly breaking the rules of lithography, it was Monsieur

Tutin who was given his work to print. When he threw up his arms in disgust with the work and in despair over the technical difficulties it caused, Picasso would alternately insult and cajole him. "All right, then," he would say, "I'll take your daughter out to dinner some evening and tell her what kind of printer her father is"; or, "I know, of course, that a job like that might be a little difficult for most of the people around here, but I had an idea—mistakenly, I can see now—that you were probably the one man who could do it." It worked every time: Monsieur Tutin would put both his disgust and his despair aside and achieve the impossible. As Fernand Mourlot summed it up: "Picasso looked, listened, and then did exactly the opposite of what had been shown him—and it worked."

There was hardly anyone around him who could resist his manipulations or his needling. Gertrude Stein tried, and sometimes even gave back as good as she got. "See what fame is, Gertrude?" he bragged once as he accompanied her on her round of marketing and watched every shopkeeper double her post-Liberation rations just because she was with the celebrated Monsieur Picasso. "The main thing," Gertrude replied grandly, "is that we are both defending mankind." When he took Françoise to meet her, he remained completely silent throughout Gertrude's long interrogation, which Françoise described as "an ordeal made worse by the menacing looks of Alice Toklas." On the way out, however, he pounced: "Well, Gertrude, you haven't discovered any more painters lately? . . . Oh, no doubt about it, Gertrude, you're the grandmother of American literature, but are you sure that when it comes to painting you've had quite as good judgment for the generation that succeeded us? When there was Matisse and Picasso to discover, things were simple, weren't they? But then you went on to Gris—which was down a notch. After that, your 'discoveries' haven't amounted to much."

He was even more vicious behind her back. "She is as fat as a pig," he told James Lord in an explosion of fury against her. "You know, she sent me once a picture of herself standing in front of a car and you couldn't even see the car. Gertrude, that pig, took the whole picture. And all that she says about me and my painting! To listen to her, the whole world would think that she created me piece by piece. But if you want to see what she really

understands about painting, all you have to do is look at the trash that she likes at the moment. She says the same about Hemingway. Actually, those two were made for each other. I've never been able to stand him, never. He never really understood bullfighting, not as a Spaniard understands it. He was a charlatan, Hemingway. I've always known it, but Gertrude never knew it." Lord was stupefied. He could not understand why, if that was how Picasso felt about Gertrude Stein, he had sent him to meet her. Nor was it easy to understand why he had taken Françoise to meet her, or why he accompanied Gertrude on her errands or why he bothered visiting her at the rue Christine.

But the torrent of his abuse was still gathering force, demolishing Hemingway on the way. "He came to see me after the Liberation and he gave me a piece of an SS uniform with SS embroidered on it, and he told me that he had killed the man himself. It was a lie. Maybe he had killed plenty of wild animals, but he had never killed a man. If he had killed one, he wouldn't have needed to pass around souvenirs. He was a charlatan and that's why Gertrude liked him. . . . As for Toklas, this little witch, do you know why she has bangs? She had a horn!" He burst out laughing; but it was not over yet: "In the middle of her forehead. A growth. Like a rhinoceros. They were a perfect couple, Gertrude and Alice: the hippopotamus and the rhinoceros. But Alice cut the horn and the bangs are supposed to hide the hole." He continued to laugh a little longer; then he added: "Now you know the true face of this slut Gertrude." With that final insult he was spent; he suddenly told James Lord that he was busy and showed him the door.

Lord was sufficiently disturbed to go straight home and, as a form of catharsis, record Picasso's tirade in his old green notebook. "There was something satanic about that man," he recalled forty years later. "There was something about him that was prepared to come to intimate terms with cruelty, with something very dark, almost sinister, in human circumstances. . . . There is something in his work which is frightening, sadistic. . . . I suppose the concept of the evil genius, like Hitler, is a perfectly reasonable concept. I wouldn't call Picasso an evil genius but he certainly harmed a lot of the people who came close to him. . . .

And at the same time, he could be very funny. He could also be very sweet and gentle and tender. When he wanted to be."

For the moment, he wanted to be all those things with Françoise, especially since she had not yet fully surrendered to him. In February 1946 she fell down the steps of her grandmother's house and broke her arm. While she was recuperating in the hospital from an operation on her elbow, a delivery boy arrived one afternoon carrying a monstrous azalea with red blooms and masses of pink and blue ribbons. "Pablo," Françoise recalled, "was once again thumbing his nose at good taste. The result was more amusing, and definitely more memorable, than the most beautiful conventional flower arrangement."

Once out of the hospital, she was presented with an ultimatum. Their relationship, he said, could not continue in this way: either it was going to become a full relationship, which meant living together, or it had to end completely. He suggested that she go to the place he had rented at Monsieur Fort's in Golfe-Juan and there make up her mind. "By that time," Françoise said, "I was very much in love with him, but there was also the fear in me of being absorbed by him. I really didn't know what I wanted, so I thought that it would be a good idea to go to the South of France and try to sort out my own feelings."

As soon as she arrived at Golfe-Juan, Françoise wrote to Geneviève asking her to come and stay with her. She felt that she needed someone to help her clear all the conflicting thoughts reeling in her head, and Geneviève was the person closest to her. A few days later, she also wrote to Picasso, thanking him for the house, telling him how much she liked being on the Mediterranean, how she loved the harbor, how old Monsieur Fort was a little bit crazy but fun to have around. She ended the letter by saying that it was good for her to be alone for the moment and that he should not make any effort to join her.

Her letter did not have the intended effect. Picasso was simply furious to read that she would rather be alone than with him. She meant for the moment; he interpreted it as forever, and ordered Marcel to get him to Golfe-Juan as fast as possible. It was six o'clock in the evening, the day after Geneviève had arrived from Montpellier, when Françoise heard a commotion in the

street. She went to the window and saw the large blue Peugeot that Picasso had been using during the Occupation. Marcel and Picasso emerged in a great state of agitation. She was stunned. "It was the last thing I expected," she recalled. "And I thought, Oh my God, Geneviève is here, Pablo is here, what a mess!"

He stormed into the house. It was their first real confrontation. "It was a very strange moment," Françoise remembered. "The war was over, peace had come back, and there I was, suddenly confronted with the same kind of violence on the personal level. He grabbed my arms, took his cigarette and held it right on my cheek for what seemed like forever. I could feel my face burning, but I was so stunned, I thought this whole thing was so incredible, instead of screaming I talked to him: You can destroy my beauty, I said, but you are not going to destroy me. You can burn me if you like, go ahead, but what you are burning is the thing you say you like. He just kept holding the cigarette there through everything I said, until finally he removed it. There was a big hole left and a scar that stayed for years. He pulled away the cigarette but his rage wasn't spent. What infuriated him even more was that I hadn't screamed and pleaded with him to stop, that he hadn't been able to break me. If anything, I dared him to go on, to show his true colors by destroying what he claimed he loved. The whole thing was so barbaric, so ludicrous, so uncalled for, I was too shocked even to be angry. Look at that, I said, look at it, it's ugly, and you did it, and you'll have to look at it now . . ."

At that point Geneviève, who had been out, came back to the house. Françoise may have been too shocked to be angry, but Geneviève was both shocked and enraged. She called Picasso a barbarian and told Françoise that if she stayed after what had happened, she was cooperating in her own destruction. She begged her to let her take her away that very night. But Françoise was too torn and disoriented to contemplate so drastic a move. Into the vacuum of her indecision stepped Picasso. His first action was to throw Geneviève out. Determined to save her friend, however, Geneviève went only as far as Chez Marcel, the little hotel down the street. As soon as she was gone, Picasso's next move was to ask Françoise for forgiveness, to implore her to stay and to live with him.

For the next two days, Françoise was in limbo. "Geneviève,"

she said, "is the only woman I have really loved in my life. It was
not a physical love but it was a very deep spiritual love, partly
because of the mystical awakenings we had shared at Les Baux.
Two very different roads, two very different lives lay in front of
me. I could imagine leaving Golfe-Juan with Geneviève and stay-
ing with her for the rest of my life, never looking back. Or staying
behind and facing the Minotaur. I was wondering whether I had
the strength to survive living with Pablo, and I was also wonder-
ing whether Geneviève had the strength to face the world living
with me. If we had decided to share our lives, whatever the truth
might have been, the world would have assumed that we were
lesbians, and at that time that would have meant complete rejec-
tion by many people, starting with her family. I had already been
rejected by my father, but could I ask that same sacrifice from
her? She and I had been to the same school, but she was a
boarder and never fully part of the life and freedom of Paris. She
was the most beautiful creature you can imagine, in the most
truly classical Greek style, but she was also rooted in the conven-
tions of the part of France she came from—very different from
Paris, even Paris in 1946. I was afraid that choosing such an
unconventional lifestyle might in the end destroy her."

Still she could not decide which would be the road not taken,
the life not lived. One afternoon, she drove with Geneviève and
Picasso to Antibes to see her grandmother. They left her there,
and when she came back to the house, she found Geneviève
angrier than she had ever been before and Picasso fuming.
Clearly, they both had a story to tell and both were determined
to fight for her. She chose to hear Geneviève first and walked
with her to her hotel.

"What can possibly be the attraction of living with a man who
is actually evil?" Geneviève cried even before they were out of
the house. She then told her what had happened. After they had
dropped Françoise at Antibes, Marcel had brought them back to
the house. "I'm going to take advantage of Françoise's absence
and you at the same time," he announced minutes after he had
told her—with a straight face, according to Geneviève—that he
wanted to give her a lesson in engraving. "What's more," he
continued, "I'm going to make you a child. That's just what you
need." Françoise told her that she should have laughed in his

PICASSO

face rather than get angry. "I'm beginning to fear," Geneviève replied, "that you have lost your capacity for anger." For the next hour, she used every argument her love for Françoise could muster to persuade her to leave with her the next morning for Montpellier. Otherwise, she told her, she would be overpowered by Picasso's destructiveness. She knew that there was nothing more she could do or say and nothing to be gained by her staying longer. More worn out than angry by now, she issued her own ultimatum: "You have the night to make your choice. Tomorrow morning I'm leaving."

When Françoise returned to Monsieur Fort's, Picasso was on the offensive, accusing Geneviève of trying to seduce him behind her best friend's back and then lying to her. And when Françoise threatened to leave in the morning with Geneviève, he accused both of them of having "some sort of unnatural relationship." Françoise refused to take him seriously and asked him instead "to stop wasting his Jesuitic tricks" on her. He began gyrating around her, calling her "Little monster! Serpent! Viper!" But he saw that none of that was working, and afraid that she might, after all, actually leave him, he changed his tactics and began wailing and wallowing in self-pity. He didn't have long to live, he moaned, and she didn't have the right to take away "whatever little bit of happiness" was left to him. He was fighting not only to keep Françoise but to defeat Geneviève and, in her, all the Spanish women of his childhood. He had often told Françoise how much Geneviève reminded him of his sister Lola, and this, together with the fact that Geneviève's mother was of Spanish background and that she was bent on thwarting his wishes, had been enough to make of her a hateful symbol of all the women who had dominated his early life.

The next morning, Françoise walked to Chez Marcel and announced to Geneviève that she was staying. "I was almost unbearably proud at the time," Françoise recalled. "I believed I could succeed at anything I tried, and as a result, I had really convinced myself that I could overcome the destroyer in Pablo and maybe even save him from himself."

For Picasso, Françoise's decision was a complete victory not only over her doubts and fears, not only over her treasured independence, but over Geneviève and all that she represented for

310

him and all that she was for Françoise. When the two young women faced each other at Chez Marcel, they both knew that their relationship had been too deep and too intense to survive in a diluted form. Françoise also knew that in giving up Geneviève she was cutting herself off from the friend who, together with her grandmother, had been the purest and most sustained source of love in her life. Geneviève was painfully sure of something else. "You're sleepwalking to your destruction," she told her friend before she took the train back to Montpellier.

12

"TRUTH DOES NOT EXIST"

FRANÇOISE HAD CLOSED one of the escape hatches; but she had not yet agreed to live with him. And Picasso, having failed to overpower her, now attempted to seduce her into freely choosing her surrender. It was February and too cold to sunbathe on the beach, but they walked by the sea, ate at Chez Marcel, talked about everything except the scar on her right cheek and drove to Vence to see Matisse. When they arrived at Le Rève, the villa he lived in across the street from a Dominican convent, they found him in bed, where he had spent most of his days since an operation five years before. He was working on his cutouts: cutting forms from already painted paper which he later arranged in their appropriate positions with the help of Lydia Delektorskaya, officially his secretary but in reality the woman with whom he shared the last years of his life. Françoise, on Picasso's instructions, had dressed in mauve and willow-green—two of Matisse's favorite colors. Matisse was so taken with her that he immediately volunteered to paint her, with her hair green, her complexion light blue and her arched eyebrows sticking up like circumflex accents.

Picasso was not pleased. On their way back to Golfe-Juan, he flew into a temper about Matisse's audacity. "Really, that's going pretty far," he fumed. "Do I make portraits of Lydia?" Then he warned Françoise that if Matisse made her portrait, she should be prepared to have an Oriental rug become the most important feature in the picture and her face just an empty oval form. But

never loath to use somebody else's good idea, he conceded that at last he now knew how to make her portrait himself.

As the time approached to return to Paris, he became obsessed with their living together. Magnetized by her self-sufficiency, he could not wait to put an end to it. Like a good advocate he appealed to both her emotions and her intellect. He told her that he needed her, that he *really* needed her. And then when she expressed her concern about abandoning her grandmother, he launched into a speech, fueled by her protests, that echoed all "the men of destiny" in history and fiction who had tried to convince themselves and the world that they were permitted everything. "As far as your grandmother's feelings are concerned," he began, "there are things one can do and make them understood, and there are other things that can only be done by *coup d'état* since they go beyond the limits of another person's understanding. It's almost better to strike a blow and after people have recovered from it, let them accept the fact. . . . It may cost a terrible price to act that way, but there are moments in life when we don't have a choice. If there is one necessity which for you dominates all others, then necessarily you must act badly in some respect."

The necessity could be the demands of his genius, his latest whim or the Communist dawn around the corner, but the philosophy was the same: the end justifies the means. Françoise tried to argue with him, to point out the inhumanity such beliefs could lead to. But there was no room for discussion, only for laying down the law of the strong and mighty, embellished by civilized rationalizations. "There is no total, absolute purity other than the purity of refusal. In the acceptance of a passion one considers extremely important and in which one accepts for oneself a share of tragedy, one steps outside the usual laws and has the right to act as one should not act under ordinary conditions. At a time like that, the sufferings one has inflicted on others one begins to inflict on oneself equally. It's a question of the recognition of one's destiny and not a matter of unkindness or insensitivity."

Françoise had never before heard him give such deliberate expression to what he believed. Normally, he preferred to dazzle the world with his pithy paradoxes that obscured as much as they revealed. Ignoring her obvious disturbance and her attempts to

contradict him, he warmed to his peroration: "We are always in the midst of a mixture of good and evil, right and wrong, and the elements of any situation are always hopelessly tangled. One person's good is antagonistic to another's. To choose one person is always, in a measure, to kill someone else. And so one has to have the courage of the surgeon or the murderer, if you will, and to accept the share of guilt which that gives. . . . In certain situations one can't be an angel. . . . There is a price on everything in life. Anything of great value—creation, a new idea—carries its shadow zone with it."

Françoise's response was to tell him that until then she had only contemplated the possibility that he was the devil; now she was sure. With a growing feeling of unease, she felt that his speech would have sounded perfectly fitting from the mouth of Raskolnikov in *Crime and Punishment*: "I didn't mean to kill her," Raskolnikov ruminates. "It just happened . . . Napoleon was right: a true leader is permitted everything. . . . All the others, they're just pygmies, leeches, slaves, trash, fertilizer for the future; they live obedient lives, they like to obey, they're bound to obey because it's their lot, the law of nature! Why, it's clear as day . . . The trouble is, how do you know who you are, a worm or a man, a man who has the right . . . the right to transgress, to overstep the bounds."

Picasso had no doubt: he was a man who had the right to overstep the bounds in pursuit of whatever he wanted. And now what he wanted was Françoise—totally and unconditionally. Mixed with his drive to possess and dominate was his rich instinct for life urging him to find the woman who would fulfill his incompleteness and help him, in some mysterious, indefinable way, to achieve the no less mysterious and indefinable state of "ultimate" painting—a struggle he often talked about to Françoise. At sixty-five and after a succession of colorful nymphs and sirens, the urge was all the more compelling—even desperate. He recognized his need for Françoise; he had had a glimpse of the possibilities opened up by their relationship—which was why, after Olga, she was the only woman he had wanted to live with. But he was not prepared to yield his other need which had by now become an addiction: for total control through constant manipulation.

314

On their way back to Paris, Françoise found an unexpected ally in Marcel. He interrupted Picasso's barrage of words every now and then to echo Françoise's arguments, asking him to give her more time, urging him not to put pressure on her, underlining the wisdom of what she was saying. As both Picasso and Françoise were sitting with Marcel in the front seat of the car, he was ideally positioned for his Greek-chorus impersonation.

Back in Paris, Dora's presence in Picasso's life moved to the top of Françoise's list of reasons for not living with him. He assured her that it was all over between him and Dora. One morning, he even arranged for the two of them to "run into" Dora at an exhibition of French tapestries, and he promptly invited her to join them for lunch at Chez Francis. It was the kind of situation, awkward and difficult for everyone else, that he thrived on. Dora buried her pain in dollops of caviar and everything else most expensive on the menu, and in a brilliant show of aphorisms, witticisms and sparkling conversation. Picasso refused to laugh at any of it, but went instead into ecstasies of appreciation every time Françoise so much as opened her mouth. "Isn't she marvelous?" he exclaimed to Dora. "What a mind! I've really discovered somebody, haven't I?" In front of Dora it was Françoise's mind that he raved about; in front of Marie-Thérèse it was her athletic prowess. As always, he was masterly at inflicting pain with a surgeon's precision. "Well, you don't need me to take you home, Dora" was his parting shot. "You're a big girl now." Dora made a desperate attempt at a comeback. "Of course not," she said, smiling. "I'm perfectly capable of getting home by myself. I imagine you need to lean on youth, though. About fifteen minutes ought to do it, I should think."

That was the only hope left to Dora: that his relationship with Françoise would soon be over. A couple of weeks later when Picasso dragged Françoise to Dora's apartment so she could hear from her directly that there was nothing more between them, Dora fell back on the same hope. "You're very funny," she said to him. "You take so many precautions in embarking on something that isn't going to last around the corner." She went on to say that she would be amazed if Françoise was not "out on the ash-heap before three months had passed." But she did do what he asked and told Françoise that she need not worry about caus-

ing the breakup between her and Picasso. She said it with pride
and with some contempt as she looked down on the "schoolgirl,"
who in her flat shoes, plaid skirt and loose sweater looked as
though not just twenty years but a whole era separated them.
More interesting to Françoise than Dora's assurance that there
was nothing left for her to break up was her parting accusation.
"You've never loved anyone in your life," she said to the man
with whom she had spent ten years. "You don't know how to
love."

Françoise was deeply shaken by that confrontation. She was
troubled by Picasso's callousness in initiating a meeting that he
knew would be one more blow to Dora's fragile equilibrium; trou-
bled by what Dora had said; troubled by one more warning signal
on top of all that had gone before. As soon as they were outside,
she told Picasso just how she felt. He reacted with the same kind
of violence that had led him to brand her cheek with his burning
cigarette. He threatened to throw her into the Seine, accusing
her of being unable "to feel intensely about anything" and of
having "no grasp of what life is really like." He pushed her to the
edge of the bridge against the parapet and forced her head down,
facing the river below her. Knowing by now that nothing incited
the demon in him as much as fear and weakness, she defied him
to throw her into the water. It was spring, she said, and she was
a good swimmer. He held her there a little longer and then re-
leased her; and she ran away from him as fast as she could.

But she came back. She knew, however, that her disregard of
the warning signals needed an explanation: "Picasso was like a
conqueror, marching through life, accumulating power, women,
wealth, glory, but none of that was very satisfying anymore. I
hoped that having conquered all he had wanted to conquer, he
would be ready to reach out with me for what is sublime in life
and divine in us. I also knew that Pablo's path was strewn with
casualties, and I had experienced his destructive side at first
hand, but I remembered my grandmother who used to say that
you love people for what they are, not for what they do. And I
was arrogant enough and trusting enough to believe that I could
do battle with the darkness in him and reinforce the light. I knew
it was a great challenge, but I was prepared to face the risks and

match myself against it." At the end of May 1946, she finally
decided to match herself against it full time. She moved into the
rue des Grands-Augustins—or rather, at the end of an evening
together she did not go home. It was Picasso who dictated the
letters she wrote to her grandmother and her mother to an-
nounce, without revealing very much, that she was going to stay
away and live a different kind of life.

It was right from the beginning a battle much more ferocious
than she had imagined. Looking back, Françoise called it living
"like Joan of Arc: wearing one's armor from day till night. Proving
your strength twenty-four hours a day." She also realized that
although she had said yes to living with him, it was a qualified
yes: "I was playing hide-and-seek. Sometimes I felt as though I
was invisible and therefore I didn't have to reveal more of myself
than I wanted to. Not all the wrongs were on his side. Part of me
never accepted that I had agreed to live with him. I never em-
braced him with my whole being. I could have given more of
myself. I could have given *all* of myself; but I didn't."

Having seen the destruction he wrought around him, she was
determined to shield herself. She knew that their relationship
could not be complete without surrender, but she also knew it
would be fatal to submit. She called their life together a *corrida*.
He clung to his defensive omnipotence, while she was deter-
mined not to cross the invisible line between surrender and sub-
mission, too mistrustful to allow herself to be vulnerable. She
did, however, immerse herself in his life, cutting off contact not
only with her family and friends but with her generation.

Taking up residence at the rue des Grands-Augustins was a
great upheaval for Françoise, but an even greater trial for Inès
and Sabartés. Inès had just given birth to a boy she named Gé-
rard, and her adjustment to becoming a mother was made much
harder by Françoise's arrival. There had, of course, always been
plenty of women in Picasso's life, but never one, in her experi-
ence, who lived with him. The rue des Grands-Augustins had
been Inès' realm, and now there was a resident queen. One of
Inès' charms was her beautiful, welcoming smile; with Fran-
çoise's arrival, she smiled less and retreated more often to her
small apartment beneath Picasso's studio, which, low-ceilinged

and poorly lit, was a shrine to her master, the walls covered with etchings, gouaches, lithographs and portraits of her painted as birthday gifts.

Sabartés was ambivalent about the upheaval. There were no women in the private myth he had created about his life with Picasso, just as there were no women in his narrative of Picasso's life which was published under the title *Picasso: Portraits and Memories* two months before Françoise moved into the rue des Grands-Augustins. The installation of a woman on the very premises from which he conducted his baroque dealings with the outside world was an unwelcome intrusion; it spoiled the atmosphere of mystery and drama he loved to create and Picasso loved to inhabit. But there were compensations for Sabartés in Françoise's permanent presence in the household. It brought about the official end of the age of Dora, whom he had always despised. It brought a greater peace to Picasso's life, for which Sabartés was particularly grateful, as he was a regular victim of Picasso's explosions. And most unexpectedly, it brought him a very competent partner in the effort to keep up with Picasso's obligations to his women and children and with all the complications of his business affairs.

Françoise described Picasso's need for Sabartés as "the need for a teddy bear to go to sleep." Gradually, however, she discovered that there were "plenty of thorns in the bear." In public it was always Picasso who chided Sabartés, calling him stupid and dismissing his writings as "nothing." But Françoise soon found out that in private it was Sabartés who quietly slipped into the role of judge and executioner and, under the cover of supreme righteousness and virtue, nibbled at Picasso like a vulture, undermining his relationships, feeding the histrionic element in his character and, Cassandra-like, prophesying that only bad would come of everything.

At the beginning, Françoise spent a large part of her time at the rue des Grands-Augustins watching Picasso paint, amazed at his stamina as he stood in front of a canvas sometimes for seven or eight hours at a stretch. She asked him once if he didn't get tired. "No," he replied. "That's why painters live so long. While I work I leave my body outside the door, the way Moslems take off their shoes before entering the mosque." One afternoon in May,

he asked her to pose for him. It was the beginning of what was to become *The Woman-Flower*—Françoise bursting into flower. "We're all animals, more or less," he explained to her, "and about three-quarters of the human race look like animals. But you don't. You're like a growing plant and I'd been wondering how I could get across the idea that you belong to the vegetable kingdom rather than the animal. I've never felt impelled to portray anyone else this way. It's strange, isn't it? I think it's just right, though. It represents *you*."

Later on, among the Celtic legends she loved to read, Françoise learned about the myth of Blodeuwedd, the girl-flower, who was created by a god with flower pollen and given in marriage to a hero who had been cursed and could not marry a mortal woman; after many adventures and misadventures, she was transformed into an owl and flew away into the night. "Neither Pablo nor I," said Françoise, "knew about the myth at that time. But soon thereafter we found a live owl in Antibes, and Pablo began to incorporate owls into many of his paintings."

At the beginning of July 1946, Picasso announced that they were leaving for the Midi, and that he wanted to stop in Ménerbes to show her Dora's house. To Françoise's alarmed surprise, as soon as they arrived, he told her that this was where they were spending their holiday. "I made her give us the house," he said, "and now I'm going to make sure that you stay here with me." It was not a happy holiday. Françoise felt that choosing Dora's house for a holiday was a callous act, showing a complete indifference both to Dora's feelings and her own: "Everything was a trap. He was the perfect trap setter, and his timing could not have been worse, since Dora was just recovering from her attack of insanity and I was just beginning my life with him." Her sense of unease was intensified by the swarms of scorpions which filled the house at night. The more worried she looked, the more amused Picasso was. He told her that Marie Cuttoli had been stung by a scorpion the year before when they were in the house together. "As you see," he added, "she didn't die. Of course, she *was* pretty sick for a while." One night, Françoise turned around and to her horror saw three scorpions crawling by her head. "That's the kind of crown I like to see on you," Picasso laughed. "They're my sign of the zodiac."

To add to the jarring atmosphere, there were the bugles. Every evening, all the buglers of Ménerbes, scattered in their farms around the valley, rehearsed for the Bastille Day celebration. The pandemonium started at sunset and went on until after ten o'clock, shattering the peace of the countryside. Françoise did not know where to hide herself from it. Picasso, on the other hand, who had no ear for music and a passion for the bugle, was in ecstasy over the inharmonious chorus. After the Liberation, blowing thirty notes on his French Army bugle became his most beloved daily ritual. So on July 14, when the time came for the torchlight tattoo with all the local buglers, Françoise could not drag him away: "It was an almost all-male celebration of unleashed wildness. The men naked to the waist with their bugles and their torches, the women forgotten. Traditionally, men and women dance together to celebrate Bastille Day, but not in Ménerbes—which pleased Picasso no end. He hated dancing. In fact, he considered it immoral and depraved, while sleeping around with countless women seemed to him the natural order of things."

After Bastille Day the bugle torture came to an end, but Françoise still could not wait to leave Ménerbes. Even though she was physically alone with Picasso, Dora seemed to be hovering in the house, while Marie-Thérèse was a definite presence in the rapturous letters he received from her every day. Françoise, who had looked forward to their time away as a kind of honeymoon after they had started living together, was actually expected to listen, every morning, to selected passionate passages from Marie-Thérèse's letters, punctuated by Picasso's commentary: "Somehow I don't see you writing me a letter like that. . . . It's because you don't love me enough. That woman *really* loves me. . . . You're too immature to understand things like that. You're not a fully developed woman, you know. You're just a girl." What he did not read to her were his no less passionate letters to Marie-Thérèse. They were, Maya remembers, "full of 'I love you' and 'I love you' and 'I love only you' and 'you are the best in the world.' "

Assaulted by scorpions, bugles, Marie-Thérèse's letters and Picasso's barbs, Françoise began to dream of escaping from Picasso and from the oppressive presence of his past—as far away as

Tunisia. Luc Simon, a painter friend, had arranged a job for her there, making designs to record the local arts and crafts before they disappeared. She plotted it all in her mind, and one afternoon when Picasso was out of the house, she left. Since she had no money, she had decided to hitchhike to Marseille and borrow from friends there her fare to North Africa. She had not been on the main road long before a car stopped for her. All seemed to be going according to plan except for one thing: the car was the blue Peugeot with Marcel at the wheel and Picasso in the front seat. His first reaction was anger and incomprehension: "You must be out of your mind," he cried. But then, as always when she wanted to leave him, he knew with uncanny accuracy just what to say to bring her back: "We may have a few difficulties in making the adjustment, but now that we've come together it's up to us to build something together. Let's not toss away our chance so lightly. . . . You mustn't listen to your head for things like that. You'll talk yourself out of the deepest things in life. What you need is a child. That will bring you back to nature and put you in tune with the rest of the world." By now, he had already pushed her inside the car, kissed her and held her close to him.

Once she was back, nothing seemed further from her thoughts than Tunisia. In fact, she decided to follow Picasso's advice to think less and obey her heart more, wherever it led her. "You won't know what it means to be a woman until you have a child," he had said, and she, who had up until then dismissed the idea of motherhood, was no longer so sure. "Before I went to live with him," she remembered, "that was one thing I absolutely had made up my mind on: I didn't want to have children. And that was one thing he absolutely had made up *his* mind on: I *was* going to have children." A little over a month later, back at Monsieur Fort's, where they settled after they mercifully left Ménerbes, she was pregnant.

They were beginning, as Picasso had put it, "to build something together." For Françoise one of the hardest adjustments was learning to be herself in a world in which everything revolved around him. Dominique Desanti remembered arriving one morning in Golfe-Juan to interview Picasso. She had caught the early train from Paris and arrived at Monsieur Fort's while Picasso was still asleep. "Françoise," she said, "offered to take me

to the beach until Pablo woke up. We walked to the beach and we chatted, among other things about her being pregnant, and suddenly she stopped and told me, 'I'm so glad you came early because I can have the illusion that you came a little bit for me and not only for him.' That was the first landmark of our friendship, because at that moment I understood everything—how difficult it must be to be the wife, the woman, with a man like him, who, even if he hadn't been a bit sadistic, even if he hadn't intended to be cruel, couldn't help being voracious. He had his hours, his ways, his moods, and was used to having everybody arrange their lives around them. He was a very conscious genius; he had a compelling drive to be a genius all the time, and as far as he was concerned, nothing compared in importance to what he had to do "

While Françoise was learning to maintain her own center in the middle of this tornado which sucked up everything in its path, he was learning to live with a woman who, as he had told her more than once, had "her own window to the absolute." He was intrigued by Françoise's regular practice of meditating. She told him, on one of the rare occasions they talked about it, that it helped free something inside her. He could understand that; years later he even talked in the same terms about his work: "If there's a single freedom in what one does, it's the freeing of something within oneself. And even that doesn't last." For a man who equated life with activity and passivity with death, there was something very uncomfortable in the stillness of Françoise's meditations. Yet there was also that vague, fearful feeling that stole into him more often around her than around anyone else that perhaps there was, after all, "a mysterious, inscrutable divineness in the world—a God—a Being positively present everywhere." That was how Pierre had expressed it in Herman Melville's Pierre: or, the Ambiguities, a book Picasso had discovered before the war and which had deeply affected him.

One day, as they were leaving the museum in Antibes, he steered Françoise to the small church next door. He stopped near the stone basin containing the holy water. "You're going to swear here that you'll love me forever," he said. Having heard him so many times trumpet his atheism and rail against God, she was amazed. "I think it's better done here than just anywhere," he

explained. "It's one of those things. You never know. There may
be something to all that stuff about churches. It might make the
whole thing a little surer. Who knows? I don't think we should
throw away the chance. It might help." So in the dark church,
she swore to love him forever, and he swore to love her forever.
Then they left, and he returned to his life's all-consuming task of
trying to outsmart his creator. But at the same time, whether by
seeking to consecrate their vows in a church or by keeping an old
Catalan statue of the Madonna in his studio, he made sure he
covered all the exits.

The Grimaldi castle, which housed the museum in Antibes,
now became Picasso's studio. He had begun to feel cramped and
frustrated at Monsieur Fort's, when Dor de la Souchère, the
curator of the museum, offered him the whole upper floor of the
castle. His generosity was magnificently repaid when Picasso,
during the next two months, covered huge panels with paintings
of nymphs, centaurs and fauns in pagan celebrations, with Fran-
çoise as an abandoned dancing nymph in *La Joie de Vivre*. The
moribund museum had been transformed. Until then the only
thing it could boast of was a collection of documents about Na-
poleon, who had landed at Golfe-Juan on his return from Elba.

It was while working in the old castle that Picasso came across
a little wounded owl, which became his constant companion; he
lavished on it all the pent-up caring and compassion he so rarely
allowed himself to feel for human beings. He put a splint on its
claw, and looked after it until the time came to return to Paris at
the end of November. Eating at Chez Marcel with Françoise the
day before they were to leave, he met Lionel Prejger, a business-
man and art lover who had gone there, as he himself said, "not
by chance but because I knew that Picasso went there and I
absolutely wanted to meet him." Prejger not only met him but
ended up with the owl, entrusted to his care until Picasso's return
to the South. He asked him for a letter authorizing him to keep
the owl, and Picasso, who normally bridled at the mere whiff of
a suspicion that anyone was trying to take advantage of him,
gladly gave him the autograph, provided his owl would be taken
good care of.

On November 28, a few days after Picasso and Françoise had
returned to Paris, Nusch Eluard suffered a stroke and collapsed

in the street. Paul Eluard was in Switzerland when he received the news; he returned to Paris shattered. Death had once again intruded into Picasso's life. But this time the presence of Françoise, the new life she carried and her own serene acceptance of death made it much easier for life and the future to assert themselves. "Françoise is expecting a child," Sabartés announced to Brassaï. "That makes him young again. He has never been so gay, so happy, so overflowing with energy."

After Nusch's death, Eluard was with Picasso and Françoise almost all the time. He soon discovered not only that he missed Nusch terribly but that he hated not being married. "He couldn't stand being alone," Françoise remembered. "He wanted to be married and then have an open marriage." The first person he thought of was Dora. A year earlier, he had said to her: "I can't imagine my life without Nusch. I can't envisage the thought of losing her. I couldn't get along without her." Now he thought of Dora as Nusch's replacement. Loving someone Picasso had loved, going to bed with someone Picasso had gone to bed with, becoming a vehicle for Dora to reenter their circle as Madame Paul Eluard, creating a fascinating new foursome with Dora, Françoise and Pablo—it suddenly seemed the best possible arrangement in his vision of the best of all possible worlds.

Having first secured Picasso's consent, Eluard asked Dora to marry him, rather assuming that, alone and dejected, she would accept with alacrity. She did not. "After Picasso," was her unexpected reply, "only God." Dr. Lacan, who continued to treat her both in therapy sessions and with electroshock, encouraged her to impose some structure on her mystical leanings and experiences by converting to Roman Catholicism. So Dora eschewed the opportunity to become Madame Paul Eluard and started on the road to conversion, which was to culminate in her joining the oblates of the Order of Saint-Sulpice while still living at the rue de Savoie. "It was not so much the episode of madness that destroyed Dora," Françoise said, "as the electroshock treatment. Lacan told me that he had succeeded in stabilizing her so that she would be able to lead a kind of normal life, and that, he said, was the best that could be expected. Out of guilt, Pablo was paying for her sessions with Lacan, but he never sent her checks, as he did to Olga and Marie-Thérèse. And Dora never asked for

anything. She survived because she never lost her dignity as a human being. He succeeded, though, in killing the artist in her. Her painting had been very beautiful, very subtle, very much her and never derivative; in many ways, in fact, it was quite alien to Picasso's. But something had broken inside her, and it was reflected in her work from then on."

In the winter of 1946, Picasso was almost happy to be alive. One of the beneficiaries of his unaccustomed benevolence was the American dealer Sam Kootz, who arrived from New York after Christmas, hoping to bolster the prestige of his gallery's crop of American painters—Gottlieb, Motherwell, Baziotes—with a few Picassos. "He never had the slightest notion," wrote Brassaï, who saw him while he was in Paris, "whether he was on the Left Bank or the Right, in Montparnasse or at the Place de l'Opéra. He never saw the Eiffel Tower, or even the Folies-Bergère. He never got out of his taxi long enough to risk a few steps in a Parisian street. I ask him if he has been to the Louvre. 'The Louvre? It isn't abstract enough for me,' he answers. He has only one thought in mind: Picasso." And he was lucky. Picasso invited him to lunch at the Brasserie Lipp and sold him the nine paintings he had selected without any of the usual tortures to which he subjected Kahnweiler and the other dealers.

His good mood was not the only explanation for this shift in his behavior. At least as important was his decision to teach Kahnweiler a lesson. Kahnweiler had refused to pay the higher prices Picasso demanded after he learned that the dealer had recently sold some Braques for more than the comparable Picassos he was selling at the time. It was no use telling Picasso that Braque painted far fewer paintings in a year and therefore could occasionally command higher prices, especially as he was already enraged by a book that Jean Paulhan, the editor of the *Nouvelle Revue Française*, had published earlier in the year under the title *Braque le Patron*. He never read the book; it was the title that infuriated him. There was only one *patron*, only one undisputed master, and that was not Braque, not even Matisse, and certainly not Rouault, whom Paulhan had dared put on the same level. Now and forever it was Picasso.

In New York, at least, the art public seemed to agree. "We opened the exhibition," Sam Kootz wrote, "in the middle of Jan-

PICASSO

uary 1947 to massive crowds, with police lines formed to allow
entry. We were all sold out by three o'clock that afternoon. . . .
I telephoned Picasso the good news that night. He was surprised,
but bridled at my desire to return to Paris to buy more paintings.
That was a valuable lesson that I learned immediately: that Pi-
casso liked to make the decisions."

Many were more than willing to fawn and play by his rules, but
Braque was not one of them. "Picasso used to be a great artist,"
he would say, "but now he's only a genius." Picasso could not
abide the thought that Braque would not be controlled, or that
some of their mutual friends liked Braque better than they liked
him; at the same time he could not stop himself from looking for
evidence that they did. He even sent spies to Braque's house, or
went himself, to find out who was there and how long they
stayed. If it turned out that among the visitors were friends of
his, such as Zervos or Fenosa, René Char or Pierre Reverdy, he
would be beside himself first with rage, then with self-pity. "I
don't like Reverdy any more," he said once in a burst of manic
petulance. "Besides, he's Braque's best friend, so he's no friend
of mine. . . . You know, Braque is really a bastard. He finds ways
of getting all my friends away from me. I don't know what he
does for them, but he must do something—something I can't do.
The result is, I don't have any friends any more. The only people
who come to see me are a bunch of imbeciles who want some-
thing from me."

He would often unleash similar torrents on the "imbecile" cur-
rently taking the trouble to visit him. Françoise tried to make him
see that he was doing everything in his power to drive people
away by being as unpleasant as he could possibly be. But logic,
however irrefutable, was useless in keeping his anger and his
moroseness at bay. He clung to them, defending them with ar-
guments which grew increasingly perverse: "If they really loved
me, they'd come anyway, even if they had to wait at the door for
three days until I felt like letting them in."

Most of his days began in just such a welter of self-pity. In fact,
it was then that his litanies of woe were longest and most wrench-
ing, as if the force which had propelled him to his present heights
had suddenly turned its back on him and withdrawn with no
warning. A stomachache was cancer; his doctor was interested

only in his painting and not in him, otherwise he would be at his bedside every day; his soul itched; nobody understood him, which was to be expected considering how stupid most people were; life was a terrible burden and his painting was going from bad to worse; he despaired; nobody could be more unhappy, and he wondered why he should continue to exist. With every word of woe he deepened the hole into which he was sinking.

Françoise had to work hard to lift him out of it, to prove to him that life was worth living, that everybody loved him, that his work was marvelous and what he could do if only he got out of bed more marvelous still. At last he was ready not only to begin his day but to liven things up by causing as much mischief as possible. By the time the sun had set he was a different man— invincible, a magician, an immortal genius. Sunrise would once again destroy this precarious equilibrium between invincibility and defeatism, between worldly immortality and inescapable death; and once again Françoise, work and the adoration of the court would restore it.

Françoise was by no means a court favorite. Her beauty, her intellectual precocity and her unwillingness to flatter anyone or to suffer fools gladly laid her open to hostility just as the original perception of her as an ambitious young painter profiting from the old master's infatuation had laid her open to suspicion. Both suspicion and hostility were very carefully held in check by her closeness to the source of power and of favors, many of which were as good as legal tender. Her pregnancy added further weight to the growing sense that she would not be easily dislodged.

At the beginning of May, Françoise, now almost nine months pregnant, decided to override Picasso's objections and see a doctor; the baby might be born any day, and no arrangements had been made for an obstetrician or a hospital. This was not an oversight on Picasso's part. On the contrary, the birth of his child was so important to him that his way of propitiating Fate and ensuring that all went well was to do nothing, which, so went his magical reasoning, would fool Fate into believing that he surrendered to her wishes, whatever they might be. "It's better," he had told Françoise, "not to act rather than to act whenever there is a choice." So he had not wanted to consult a doctor, convinced that "it brings bad luck to watch things too closely."

Finally he called Dr. Lacan, who, after he recovered from his shock that Françoise was very close to delivery and had not yet seen an obstetrician, introduced her to Dr. Fernand Lamaze. A week later, on May 15, at the Belvédere clinic in Boulogne, Françoise gave birth to a baby boy. A dream she had had more than three years earlier had come strangely to life. In the dream book she kept, she had written down the details. She was in a goat shed, with a baby carriage in the middle and two paintings by the carriage: one, a small portrait of Mademoiselle Rivière by Ingres, and the other, *The Representatives of Foreign Powers* by the Douanier Rousseau, which she later found out belonged to Picasso. When she arrived at the clinic, she discovered that the nurse was called Madame Rousseau and the midwife Madame Ingres, her black hair parted in the middle, as in so many of Ingres's portraits. When Dr. Lacan arrived, Picasso, who remembered reading Françoise's dream, asked him, fascinated, what the meaning of a goat shed was. It was a symbol for the birth of a child, the eminent psychoanalyst explained.

If his father had had his way, the child would have been named Pablo. It was as if Picasso, dissatisfied with his first son, hoped for a more worthy heir in his second, and so wanted him to have the same name, only this time in its full Spanish glory. But Françoise felt that having two sons with more or less the same first name was too much, and the baby left the clinic as Claude Pierre Paul Gilot—after Watteau's teacher Claude Gillot, who, like Picasso, was partial to harlequins.

"It was quite traumatic having a child," Françoise recalled. "First of all I had no sister or brother and no idea what you are supposed to do with a child. So I began reading all the books and becoming immersed in being a mother." In June, mother, father and child went back to Monsieur Fort's in Golfe-Juan. It soon became apparent that Claude's arrival had introduced a new twist to their relationship. "You see, getting a woman with child," Picasso confessed later to Geneviève Laporte, "is for me taking possession, and helps to kill whatever feelings existed. You can't imagine how constantly I feel the need to free myself."

Françoise would describe Picasso as "a survivor of a very old civilization. What made dealing with him so hard was not that I was twenty-five and he was sixty-six years old but that I was

twenty-five and he was sixty-six thousand years old. He wanted to give children to his women to make them heavier, unable to run around and more dependent on him. At the same time, it was a demand for intimacy, a challenge to the woman to throw open all his emotional doors and windows that he struggled to keep shut."

Years later, he bragged that he had made Françoise look after the children herself and refused to employ a servant. "My loyalties became divided," Françoise remembered. "If Claude cried or was hungry or whatever, he had first claim on my attention. Even though it was Pablo who had wanted a child, the experience transformed me but not him. I may not have wanted it, but once I went ahead with it and the child was born, partly I was the same and partly I wasn't."

For the moment, Picasso was fascinated with baby Claude, who looked with every day that passed more and more like him, and happy to have taken greater possession of his mother. "He always wanted her very near to him," said Dominique Desanti, who visited them a few times in Golfe-Juan in the summer of 1947. "They were a very striking couple together. She was so beautiful and he was really astonishing, so aesthetically they were very striking to look at." Watching them together was also like watching a tribal game of which only they knew the rules. "He would make aggressive remarks meant to put down and humiliate her in front of others and she would laugh and make what he said seem innocuous. He would refer to her as 'the woman.' 'What has the woman made for dinner?' he would ask. Or he would look at an erotically dressed woman on a postcard and sigh: 'What a dream to have such a woman in front of you.' And Françoise would laugh and diffuse it: 'It's very easy. We can do that. Just get me a dress like that and I'll put it on—it would be a very amusing disguise.' She never looked cross or humiliated; she always made you feel that they were acting in a play. That was his way of being; he was cruel whether it was with his woman, his best friends or whoever was around if he felt like it. So if you decided to live with him, you needed unusual strength and unusual maturity to find your part in his play and improvise the text."

Picasso had an explanation for "his way of being." "Max Jacob

once asked me," he said, "why I was so nice with people who didn't really matter and so hard on my friends. I told him I didn't care about the first group, but since I cared very much about my friends, it seemed to me I ought to put our friendship to the test every once in a while. Just to make sure it was as strong as it needed to be." It was a contradictory urge to drive those closest to him away while suffering panic if it looked as though they might actually desert him.

When he was not busy driving them away he loved amusing them, all the more so when the sun and the sea thawed some of the anger and the pain. Then, on the beach at Golfe-Juan or having dinner at Chez Marcel, he would put on a false nose, dress up like Charlie Chaplin, draw on the paper tablecloths with a wine-soaked finger, highlighting his designs with mustard and coffee; or, when a woman approached him for an autograph, he would offer instead to draw on her naked skin, especially if she was in a bathing suit. And the autographed women would not wash for days. Meanwhile, Françoise would watch his antics and play with Claude. Their best times were on those rare occasions when they were alone in the evenings. She would pick a book of poetry and read to him, and he would reciprocate by reciting from his favorite poets—Rimbaud, Mallarmé, Góngora and most often Eluard.

With Sabartés back in Paris, Françoise took over many of his duties, dealing with Picasso's business affairs and writing his checks for Olga, Paulo and Marie-Thérèse. He began his mornings by reading the mail that Sabartés forwarded from Paris, which always included a cryptic and highly coded letter from him and the latest press clippings from Lit-Tout, the service that kept Picasso up to date on everything that had been printed about him, including, of course, his latest witticisms: "But *Maître*, we never see you paint," a journalist ingenuously complained. "But *Mademoiselle*," he replied, "I also make love, and you never see me do that." Whatever he had said or done he would soon read in a clipping. There were also plenty of cartoons in the package, most of them takeoffs on his tendency to distort and deform. In one of them, a man was copying a Picasso painting and another was commenting: "Not bad! But I think that the right foot isn't sufficiently left."

Often in the evenings, Picasso would sit and write to Sabartés in a stream of consciousness. Then he would reread the letter and laugh to himself: "This is really pretty funny. I wonder if he will be able to understand what I mean." Sometimes he read passages to Françoise. "They were a little like his plays and his poems," she remembered, "full of floating visual images or color repetitions—the blue of the blue in the blue of the blue in the lesser blue of the mediterranean blue of the blue of the white of the horse and the scent of the arena at Nîmes. . . . The sentences never ended and it would be impossible to find any linear meaning in them. But his letters with their unconnected series of visual images had an impact, almost like that of a painting. He was trying all sorts of absurd and erratic thoughts out on Sabartés, mixed with instructions as to what he should or should not do for him. They were very long and, to an outsider, incomprehensible." For Sabartés they were a great compensation for the unfair treatment he often received at his friend's hands and for his minuscule wages, out of which he was even expected to pay his third-class rail fare when he visited Picasso in the South.

"Being unfair," Picasso told Françoise, "is godlike." "Once, coming back from a bullfight," she recalled, "we had a discussion about that. I told him that my greatest purpose in life was to become fully human, to incarnate in the flesh. It's not at all easy to become human, but that was my quest: to understand other people's needs, to see their point of view, to be fair. He said that he had no interest in being fair, that in fact he liked, he *really* liked being unfair. It made him feel more like a primitive god."

If being unfair made him feel godlike, surrounding himself with conflict made him feel alive, which was why he was so loath to take any steps that might reduce it. He even relished Olga's habit of following him when he left Paris. That summer was no exception, and Olga spoiled the peace of a morning on the beach by her threats, her abuse or simply her demands for attention. Once, when she became particularly abusive as she followed Françoise, Claude and Picasso in the streets of Golfe-Juan, he turned around and slapped her. When she started to scream, he threatened to call the police. She went on following them and, almost every day, sending him angry missives in a mixture of Spanish, Russian and French. Their main theme, played out in

innumerable variations, was that he had declined from his previous heights: "Your son is useless too, and he's going from bad to worse—like you." One of her favorite variations was enclosing a picture of Beethoven and telling Picasso that he would never be as great; another was enclosing a picture of Rembrandt with an inscription: "If you were like him, you would be a great artist."

Invariably Picasso was upset by her letters, and invariably he read them from beginning to end, however strongly Françoise urged him to leave them unopened, since by now he knew what they contained. Picasso and Olga were tied to each other with bonds of mutual loathing that no amount of common sense could loosen. She needed him to validate her existence, and in a curious way he needed her absorption in him, even her negative absorption. The more people there were living just for him, the more energies he gathered into himself and the more powerful he felt. The more rivers there were flowing in his direction, the more immense an ocean he became.

Even so, the summer of 1947 was a time of inertia and discontent. He went to every bullfight that took place in the area; he went back to the museum in Antibes and did the triptych *Ulysses and the Sirens*. And then he heard his own siren song. Georges and Suzanne Ramié, who were running the Madoura pottery in Vallauris, came to Golfe-Juan in August to invite him to see the three small pieces he had molded the year before, now fired and ready for his inspection. He went and he stayed. The Ramiés placed Jules Agard, their best potter, at his disposal and he began work. It was an escape from the agony of the blank canvas, especially at a barren time; it was companionship with the potters and the earth they worked; it was drawing on their energy and their expertise to recharge himself and multiply his powers; and it was a new medium of expression. He did not merely decorate, he transformed the pottery he held in his hands: a vase became an owl, a woman or a goddess, evoking ancient idols. His versatility, his vitality, his sharpness of vision, his magical inventiveness— all had now found a new form through which to astound the world. And, as his original designs could be copied, even more of the world would be astounded.

That same summer, people began flocking to the museum in Antibes to admire the paintings of the pagan world he had simply

left behind the summer before. One night, when Picasso and Françoise were having dinner at Chez Marcel with the Cuttolis, Monsieur Cuttoli told him what a good idea it would be if he made his gift to the museum official. "Furthermore," he continued where angels feared to tread, "you've lived here so long now, you ought to take out French citizenship. If you did, you could get your divorce and marry Françoise."

Picasso was furious at the senator's impertinence: "I invite you here as my guest and you dare say such things to me! Of course I left those paintings at the museum; but what gives anybody the right to start talking about gifts and donations? Since everybody is so fond of quoting that remark of mine, 'I don't seek; I find,' I'll give you a new one to put in circulation: 'I don't give; I take.' And as for your idea about changing my nationality, I represent Spain in exile. I'm sure Françoise wouldn't approve of my changing that any more than I do. I think she understands that she and our son come after Republican Spain in my scale of values. And *you* ought to understand right now that I have no intention of submitting my life to the laws that govern the miserable little lives of you *petits bourgeois*."

It was not over yet. He threw his plate into the sea, stamped his feet and snarled at his captive and frozen audience: "Well, why don't you eat? This food isn't good enough for you? My God, the stuff I get at your house sometimes! But I eat it anyway, for friendship's sake. You'll have to do the same." They ate and they pacified him and they talked of other things. The dinner went on and so did their friendship. As he boasted many times: "Nobody willingly leaves Picasso."

The Cuttolis were not alone in urging Picasso to be generous. Jean Cassou, the chief curator of the Museum of Modern Art in Paris, and Georges Salles, the director of French National Museums, hinted, suggested, implied and, in short, did everything except ask for some of his paintings for the Museum of Modern Art. The fact that they had not directly tried to influence his decision, together with the fact that Braque and Matisse were going to be extensively represented, finally made Picasso decide to donate ten paintings. As a sign of his gratitude, Salles had the paintings brought to the Louvre before they were hung at the Museum of Modern Art, and when Picasso returned to Paris in

December he invited him to be the first painter who ever saw his work hung in the Louvre. Salles even asked him to pick the painters next to whom he would like to see his own work. His immediate choice was Zurbarán, and after that Delacroix. "That bastard," he told Françoise after they had left the Louvre. "He's really good."

Among living artists, the one Picasso most enjoyed discussing aesthetic questions with was Alberto Giacometti, partly because he was too much of a visionary to think of them purely in aesthetic terms. Giacometti had further earned Picasso's secret respect by never fawning and kowtowing to him. The two men visited each other often, and sometimes, like naughty schoolboys, they went to a nearby café and pored over the pornographic magazines that Picasso had brought along. At other times, they discussed their work. "He accepted Giacometti's criticisms," James Lord said, "but at the same time resented having done so, and the perverse side of his nature—always powerful—led him to make fun of Alberto behind his back. . . . Making light of the sculptor's anxiety and frustration, he said, 'Alberto tries to make us regret the works he hasn't done.'"

When he was in a mood to be truthful, Picasso conceded that Giacometti's work represented "a new spirit in sculpture." He displayed a gratuitous meanness, however, one day at Giacometti's studio, when such an expression of appreciation could have made a difference to Giacometti's livelihood. He was there when, unexpectedly, Zervos arrived with an Italian collector. Three times Zervos asked Picasso if he agreed with him on the merits of a particular sculpture that he hoped the Italian might buy and three times Picasso refused to reply. The result was what he knew it would be. Faced with the conspicuous silence of the world's most celebrated painter, the Italian collector left empty-handed. "He amazes me," Giacometti said once. "He amazes me as a monster would, and I think he knows as well as we do that he's a monster."

In February 1948, after spending the winter in Paris, Picasso abandoned his studio, his cafés and his surprise visits to Giacometti and to Braque and returned to Golfe-Juan with Françoise and Claude, once again shadowed by the implacable Olga. Soon they were joined by Françoise's grandmother, who rented a

house up the street from Monsieur Fort's. She was not happy with Françoise's unconventional new life, but she had accepted it; besides, she was entranced by her great-grandson. She was, however, appalled by the half-demented woman who followed them whenever they took Claude out in his baby carriage. If her hearing had been better and her disbelief less strong, she would have been amazed to discover that the woman was Picasso's legitimate wife, threatening Françoise with unspeakable things for stealing her husband.

As the days went by, what was an intrusion and an irritation became unbearable. Olga, berserk with jealousy and anger and no longer content with shouting abuse, began assaulting Françoise, pinching, scratching, slapping and pushing her, especially if she was holding Claude in her arms. To make matters even worse, Madame Fort took sides in favor of the legal wife and started having her to tea every day. Olga would sit by the window and inform all Picasso's visitors that, as they could see, she was back living with her husband. Or if Françoise was out, she would wait for her to return and shout that the house belonged to her and her husband, and she had no business coming there.

Françoise, who could feel Olga's misery and loneliness, would not allow herself to fight back. At the same time, she could not go on living in a state of siege. She told Picasso that they had to find another house. Her plea ran counter to his philosophy of stoic inaction, but in the end he realized that Françoise was adamant. So he asked Madame Ramié to help them find another home. She did, and in May 1948 they moved to La Galloise, a small, rather ugly house in the middle of two acres of hillside in Vallauris.

On the day of the move, Picasso had second thoughts: "I don't know why I should go through with this. If I had had to move every time women started fighting over me, I wouldn't have had time for much else in my life." That said, he went on to the pottery, leaving Françoise, Marcel and his son Paulo to carry out the move. Going up and down the hill that led to the house until she was breathless with exhaustion, Françoise remembered the apocryphal story of a celebrated ceramist who had burned all his furniture so his kiln would not go cold. Picasso loved to tell the story, and he always added with pride: "I would gladly have

thrown my wife and my children in, if that was necessary to keep the fire going."

Françoise could understand the impulse to sacrifice for the sake of creation; she was simply unwilling to be immolated. In the new house, which he had bought and put in her name, she turned one room into her studio and worked for long hours while Picasso was at the pottery. With him out of the house, she even allowed herself the luxury of working with classical music in the background, which always disturbed Picasso, who disliked all music except flamenco and a theme from Stravinsky's *Petrushka* that he was often heard whistling. "I learned a lot from him about draftsmanship and graphic art," Françoise remembered, "but I was determined to keep my own style for myself. . . . I assimilated a great deal from him almost subconsciously. I was surrounded by him as if he were an element. As in an element—say, water—I swam, but the element wasn't telling me how to swim." Although Picasso never made any allowances for her work, he never put it down either. Indeed, Françoise became all the more valuable a possession in his eyes if, despite his demands on her time, her emotions and her sanity, she was able to go on creating.

Life in Vallauris was lived almost entirely in public. People arrived daily from all over the world to see him—sometimes expected, often unexpected. The composer Germaine Tailleferre, whom Picasso had not seen since his Diaghilev days, invited him to a concert at her home by the duo pianists Robert Fizdale and Arthur Gold, who had recently arrived from New York. He declined and instead invited all three of them to visit him in Vallauris. They arrived together with Tailleferre's teenage daughter, who looked remarkably like her mother at the time Picasso had known her. "*You* are the one I recognize," he exclaimed to the daughter. "Not you!" he said to the mother, in a tone implying that it was her fault that time passed, age showed and death was closer—for him as well as for her. And he said it again and again, as though repetition would make the realization less upsetting.

They talked of people they knew; nothing restored Picasso's humor more effectively than a good dose of gossip. He asked about Stravinsky: "How is he? . . . And Madame Stravinsky, who is she?"

"Why, she's Madame Stravinsky," replied Gold and Fizdale,

who had recently seen the Stravinskys in New York. "Madame Vera Stravinsky—the same Vera he's been with for years."

"Always the same Vera! Imagine!" Picasso cried in amazement at the thought of such alien mating customs. A guard at the bank where he stored many of his paintings had once told him how enviably different he was from so many other customers he had observed year in, year out, with the same woman, only older, while he was always with a new woman, each younger than the last. Picasso liked that. It was a way, he thought, of fooling destiny and death.

At the beginning of August, Picasso and Françoise drove to Vence to visit Matisse, who had been working on the design of a Dominican chapel and had even agreed to underwrite its cost. "You're crazy to make a chapel for those people," Picasso immediately began to rage. "Do you believe in that stuff or not? If not, do you think you ought to do something for an idea that you don't believe in?"

"Why don't you build a market instead?" he cried out on another occasion. "You could paint fruits and vegetables." Matisse reported the outburst to Father Couturier, the Dominican priest and champion of modern art who was also posing for the preparatory designs for the panel of Saint Dominic. "I couldn't care less," Matisse told him, his equanimity and his conviction both quite undisturbed. "I have greens more green than pears and oranges more orange than pumpkins. So why build a market?"

When Picasso and Françoise went to see him again and Picasso again criticized the project, Matisse was less aphoristic and more explicit: "As far as I'm concerned, this is essentially a work of art. It's just that I put myself in the state of mind of what I'm working on. I don't know whether I believe in God or not. I think, really, I'm some kind of Buddhist. But the essential thing is to put oneself in a frame of mind which is close to that of prayer."

And later, since Picasso would not let go of his obsessive fury at the thought of the chapel, Matisse told him, "Yes, I do pray; and you pray too, and you know it all too well: when everything goes badly, we throw ourselves into prayer. . . . And you do it; you too. It's no good saying no." Matisse had taken to treating Picasso like a recalcitrant but brilliant and precious son. He listened to him, but had no intention of heeding what he said.

Matisse's vision was clear and compelling: to create a simple "religious space" where people could come "to feel purified and freed of their burdens." "In the end," he told Picasso, "it's not worth trying to be too clever. You are like me: what we are all looking for in art is to rediscover the atmosphere of our First Communion." The First Communion was a powerful symbol for Matisse, embodying the serenity that he himself radiated.

It was this serenity, this peace beyond his understanding, that Picasso was fighting with his explosions against the idea of the chapel. And there was something else. Matisse gave expression to it at the dedication of the chapel: "This chapel for me is the culmination of an entire life's work and the flowering of an enormous, sincere and difficult labor. It is not a labor I chose, but for which destiny chose me at the end of my road . . . I consider it, despite all its imperfections, my masterpiece, an effort resulting from an entire life dedicated to the search for truth." Picasso too longed for such a culmination, for the "ultimate" painting, yet felt further and further away from it. "One swallows something, is poisoned by it and eliminates the toxic" was his description of his process of working. Since he believed that there was no truth to be revealed at the end of the road, did he really paint as a catharsis, merely to cast out the toxic, increasingly trapped in his own virtuosity?

When Father Couturier came to see him in Vallauris, Picasso took him by the arms and said laughingly: "I should confess every day; I need to confess more than anybody else in the world." But Father Couturier, Françoise recalled, "preferred to discuss art. 'When Picasso paints, he paints with his blood,' he said. 'Don't you rather think,' I protested, 'that he paints with other people's blood?' I was laughing, but he looked at me as though I had said something very, very naughty."

Picasso's soul ached again, but the shield of cynicism was held firmly over the pain. He threw himself into his pottery and fed off·the adulation that surrounded him. He and Françoise hardly ever had a meal alone; in fact, their meals became occasions for Picasso to hold forth and dazzle those already bedazzled with his monologues, dripping with the familiar paradoxes which they would take with them and dine on for months. His chief contribution to other people's conversation was as a stimulant *in absen-*

tia. While he was present, all that was required was to laugh, gape and admire. "Many of the people around us were friends in a very special sense," Françoise said. "They reminded me of the people the ancient Romans called 'clients,' people who did not belong to one of the important families, to a *gens*, but who attached themselves to the head of one of these families, to the *paterfamilias*, and followed in his wake. And the more important the person, the more clients he had."

Two recent additions were the painter Edouard Pignon and his wife, the writer Hélène Parmelin, card-carrying clients as well as card-carrying Communists. Penrose once commented on a conversation he had heard between Picasso and Pignon: "Pignon would try to explain his motives with clarity, whereas Picasso always spoke in metaphors without any thought of justification. The listener would realize that Picasso appreciated that truth is never easily accessible." In fact, Picasso's views on truth were far more dramatic. "What truth?" he told Parmelin. "Truth cannot exist. . . . Truth does not exist."

"It took me a long time to realize what a consummate liar he was," said Françoise. "One of the problems of having a constant court around us was that we had to work out our problems in public, which brought out all his histrionic qualities. And there were always those, often people I hardly paid any attention to, laying out the banana peels and mining the ground while I wasn't looking. My mother, whom I had started seeing again after Claude was born, kept warning me: 'Remember, it's always the secondary characters, like Iago, who are the origin of the drama.' And I would laugh at her. I had learned from my spiritual studies that darkness was only the absence of light, and I had wishfully interpreted that to mean that therefore there was no such thing as darkness. My mother had singled out Sabartés and Madame Ramié as two people she believed wished me ill and would bring me bad luck. But although I never liked Madame Ramié and I knew that she didn't like me, I never believed that she could do any actual harm until it was too late. As for Sabartés, Claude's arrival ended any friendship there was between us. It was no longer Pablo and he against the world. Now Pablo had a new family, which also meant that my presence wasn't going to be as ephemeral as Sabartés had thought."

Among the miscellaneous friends, clients, dealers, relatives and visitors traveling in Picasso's orbit, Françoise had started making her own friends. Javier Vilató, Picasso's nephew, also a painter and only a little older than herself, was one of them, as was his Greek girlfriend, Matsie Hadjilazaros. They spent long periods in Vallauris, and when they were not together, Matsie wrote Françoise long letters from Paris. In one of them, just after Claude's first birthday, she raved about the photographs of Claude that Françoise had sent her: "Words cannot express my delight. He is madly attractive—such virile bearing and such poise and aplomb." At the age of one, Claude was already a little man, in the image of his father.

Javier and Matsie came to spend a part of the summer of 1948 with Picasso and Françoise in Vallauris. "They were not living in our home, which was very small," Françoise said, "but they were really with us, meaning that there was real intimacy there." One day, while they were at the beach in Golfe-Juan, they were joined by a Greek friend of Matsie's, Kostas Axelos. He was twenty-four years old, tall and dark and with a throng of women back in Paris enamored of him. He had left Greece in 1945, and at the same time had left the Greek Communist Party. From the University of Athens he went to the Sorbonne and from there to Basel, where he studied philosophy with Karl Jaspers. He had recently moved back to Paris and was translating Heidegger while writing a book on Heraclitus.

"I prefer Heraclitus to Plato," Picasso told him when they met. He had not read either, but had an uncanny way of absorbing the essence of what he wanted to know. Plato mistrusted the personal sorcery of artists who led men astray from the truth. Picasso had heard that in his philosophical discussions with his poet friends; as a result, he did not like Plato. But he loved the paradoxical-sounding aphorisms of Heraclitus. So he and Kostas Axelos started off well together, and the good start turned even better when it became clear that Axelos was not the kind of man to indulge in flattery. In fact, he looked at the paintings Picasso showed him and said nothing. As far as he was concerned, art, which in ancient times had united the sky with the earth, was at an end. "Picasso's art," he said, "had already entered its period of decadence. And he knew it."

Picasso liked Axelos' mind, his fierce independence and his classical beauty. "Basically you have always loved classical beauty," Braque had once told him. "It's true," Picasso replied. "Even today that's true for me. They don't invent a type of beauty every year." Axelos, however, was much more interested in Françoise than he was in Picasso. He was struck by her beauty and by the depth of her thinking. "We were both rather unusual for our age," Françoise recalled. "Ever since I was a little girl, I felt linked to another dimension. I felt that I was living there as much as in the 'real' world. And I had never met anybody who was as sharply aware of the illusions of this world as Kostas. He and I reached depths in our discussions I had not reached with anybody else."

But before long, Axelos returned to Paris and to Heraclitus, while back in Vallauris, Picasso and Françoise decided to have another child. "I know just what you need," Picasso had told her. "The best prescription for a discontented female is to have a child. . . . Having a child brings new problems and they take the focus off the old ones." Françoise's reasons were altogether different. Having been an only child herself, she did not want Claude to be one. Also, with Claude now in his second year, Françoise looked back with nostalgia to her pregnancy, when Picasso had never been as good-humored and optimistic. Before the summer was over, she was once again pregnant.

13

THE LOSS OF
INNOCENCE

FRANÇOISE WAS IN HER first month of pregnancy when, on August 25, 1948, Picasso left for Poland to take part in the Communist-sponsored Congress of Intellectuals for Peace in Wroclaw. Everybody who knew how he hated travel and dislocation was amazed when he accepted the invitation. Three days before he was due to leave, to ensure that he did not change his mind, the Polish Embassy in Paris sent to Vallauris a woman whose mission was to trail him and forestall all his last-minute reasons for not going. Special arrangements were made to fly him direct to Poland without a passport, since he refused to accept one from the Franco government. He had never flown before and was really frightened of the trip. But the Polish emissary was determined, and so was Eluard, who felt that Picasso's presence at the conference would proclaim to the world the seriousness of his commitment to the Communist Party.

However critical their influence, still more important was Picasso's need for new stimulation. Pottery no longer engaged him. He felt that he had exhausted its possibilities, that the period of discovery was over. So he took Marcel with him as his aide, companion and butler and flew to Poland, having promised Françoise to write to her every day and stay away no more than four days. He stayed away three weeks. "He never stopped talking about the experience," recalled Dominique Desanti, who also attended the conference. "He was under the impression that he

now knew and understood everything about the Communist countries, while in fact he had seen absolutely nothing except what they wanted to show him, because everything was official. He saw the destruction of the war and the reconstruction of Warsaw, and he saw women working very hard in the streets, which he never forgot to mention whenever Françoise or I or any other woman around him would dare say that she was tired. 'You say you're tired,' he would come back, 'but if you saw those women in Wroclaw, then you would know what tired really is.' "

On the second day of the conference, Fadeyev, the Soviet Secretary of the Writers' Union, took the floor and proclaimed the need for Marxist thought, Marxist literature and Marxist art. He then proceeded to launch an unprecedented attack on Sartre, one of the most prominent Communist intellectuals, whom he called "a jackal equipped with a pen" and a "typewriting hyena." Dominique Desanti was sitting between Picasso and Eluard, who was stunned, as were most of those present. Picasso took off his earphones and began to make little drawings of everybody on his blotter. Later on at one of the official dinners, a member of the Soviet delegation stood up during the toasts and deplored Picasso's decadent painting and his "impressionist-surrealist" style. Picasso responded by calling him a "party hack" and giving him a lesson in art history. He told him that he should at least have got his terminology straight and damned him not for being an "impressionist-surrealist" but for being the inventor of Cubism.

"Everything that I am, and want to be, and care about," Giacometti had said, "is considered decadent by the Communists. Why should I take a stand that eliminates myself?" Picasso continued to choose to ignore that blatant contradiction even after he had been singled out for attack. And the Polish government continued to believe that Picasso's propaganda value outweighed his violations of artistic orthodoxy. They even forgave him his violation of the strict rules of Communist public propriety when, at a press conference, he took off his shirt and proudly showed off his beautiful terra-cotta muscles for the cameras—and the photographs were flashed around the world. But prudery was not allowed to interfere with the presentation to Picasso, by the President of the Republic, of the "Cross of a Commander with Star of the Order of the Polish Renaissance," thus recognizing the

contribution he had made to the Congress by his presence, by the considerable weight of his prestige and celebrity, and by the short speech he had given denouncing the detention of Pablo Neruda in Chile.

The day he was to leave, he asked Dominique Desanti to help him buy a present for "the woman." "The tone of his voice," she recalled, "clearly indicated that when he said 'the woman,' he really meant 'the bitch.' This was his lifelong ambiguity about women—they were the marrow of life and yet were held in contempt as though their demon would rise unbridled and overwhelm him. Contempt was his way of exorcising his fear of women's power."

From Warsaw, where he was also made a freeman of the city, Picasso flew back to Paris and stayed there for a week before returning to Vallauris. Not only had he failed to keep his promise to return in four days, but during the entire three weeks of his absence he had not written to Françoise once. Even worse, he had instructed Marcel to send her a daily telegram with the text left to his own initiative. It did not take Françoise long to figure out who was composing and sending the telegrams, since her name was always misspelled, the telegrams were signed not "Pablo" but "Picasso" and the ending was always the same: "Bons baisers"—a favorite working-class greeting.

Picasso had, of course, known that she would know. He rarely caused hurt by accident or oversight. He had intended to make it clear that *he* set the rules and she had to play by them; that it was his prerogative, if he so desired, to break every promise, do exactly as his whim dictated, have the driver compose and send pacifying telegrams designed to inflame her—and that still, when he felt like returning, she would be there to welcome him home. Françoise had a lot of time to think while he was away, to see his game, to feel her pain and, while looking after their first child and carrying their second, make her decision: "If he wanted us to live by his own rules and I was prepared to stay, then it was important for me to know what I was doing and to tell him: 'If I'm willing out of love to be a slave, I am the slave of love, not *your* slave. If my love ends, then so ends my slavery.'"

She told him, but not right away. He·climbed the stairs of La

Galloise flashing his irresistible smile, and asked her if she was happy to see him. "Here's for the bons baisers," she replied as she slapped him, and then locked herself in Claude's room for the night. Her love for him was still strong and so she would go on living by his rules, but not without some protest. And the more she protested, the more she was a goddess in his eyes rather than a doormat.

In October they returned to Paris. Soon after their return, he painted Françoise wearing the embroidered peasant coat he had brought her from Poland. There was a certain serenity in his work during this time. "It was an expressionist period," Françoise said, "but without the sadism that accompanied his work of other periods. There was no rage and fury in the paintings, and because they were softer, many people thought that they were weaker." In November, there was a show of his pottery at the Maison de la Pensée Française, which became the occasion for unbridled celebration among his fellow Communists. Léon Moussinac described him in *Les Lettres Françaises* as "the harbinger of the social role the artist will play in tomorrow's society . . . clay and fire, in Picasso's hands, become for us the living representation of matter and mind, their struggle and their victory." Others, who did not have an ideological ax to grind, found the works ingenuous and delightful but hardly major examples of his creative genius. "They expect to be shocked and terrorized" was Picasso's response. "If the monster only smiles, then they're disappointed."

For the moment, in his intimate life with Françoise, the monster was smiling. He loved Françoise's fuller shape, all the more so since she was carrying part of himself. They were constantly together. "Even when he was working," Françoise recalled, "he would come out every so often, smoke a cigarette and talk with me. It was a twenty-four-hour relationship. . . . There are men who give so little of themselves in love that you could never experience with them the transcendent aspect of love. Not so with Pablo. When he gave of himself he gave totally. It was easy for the woman to feel like Psyche in the myth of Psyche and Eros: having tasted of love divine, she would go to the end of the earth to find it again. Or in the case of Pablo, she would stay, no matter

what. It was very beguiling, especially as he was able to create a climate where the woman was glorified in paintings by the best-known artist in the world."

Françoise knew that it was very important for their relationship that he should feel loved for himself, not because he was a great painter or could glorify her in his work. "I told him many times," she recalled, "that I would always be happy to witness the birth of a great painting, but whether it was a portrait of me or not was entirely irrelevant. Also, frankly, I never recognized my essence in any of the paintings he did of me. 'You are glorifying my external features,' I told him once, 'but you still don't know *me*, and you don't even try.' My features were all that mattered to him. He had painted them even before I was born. He could work from the features to a personal interpretation of them, but, as I said to him many times, what was much more important to me was to work from the soul to a personal interpretation of that soul, whether through the features or abstractly. He never did that. He never sought access to my spirit. So he just missed me as a dynamic force. It was as if he had made a brilliant reproduction of a car without the motor."

She was intensely involved with his work, trying to explain her thoughts, to help him see that working from the soul would be a way to reach the ultimate in his painting. "I felt that there was no comprehension," she said, "that on this point we were really apart." But she went on trying. Determined, even while she was pregnant, to keep up with Picasso's late nights and Claude's early mornings and to continue with her own painting, she found herself sacrificing sleep, getting as little as four hours a night. As for Picasso, he was grappling with the new depths of intimacy that he and Françoise had reached. In the paintings and lithographs he made of her early in 1949, serenity jostles with aggression and chaos with a starry sky. Love and hate, trust and betrayal wrestled in the deep recesses of his soul, and afraid of probing the darkness to resolve the battle in the light, he began to flee from the new-found intimacy.

On April 19, the day of the opening of the second Peace Congress in Paris, Françoise went to see Dr. Lamaze. The baby was not due for another month, but he found her in such a run-down state that he instructed her to check into the Belvédere clinic at

once. She went back to the rue des Grands-Augustins, told Picasso what had happened and asked him if Marcel could drive her to the clinic. Irritated at the mere thought of having his day disturbed, Picasso told her that he needed Marcel to drive him to the Peace Congress. "If you need a car," he snapped, "you'll have to find another solution. Why don't you call an ambulance?" It was as if he felt he had already given her enough. Since he had given her the greatest of all things, since he had given her himself, since they had possessed the universe together, how could she be petty enough to ask for little things like a car to drive her to the clinic?

Fortunately, though Marcel had no sense of literary style in composing telegrams, he had an earthy sense of priorities. He intervened and suggested that nothing would be easier than to drop her at the clinic on the way to the Congress. But even a detour was too much of an inconvenience. Finally, a compromise was reached: Marcel took Picasso to the Congress and came back to fetch Françoise.

She arrived at the Belvédere clinic at five o'clock. At eight o'clock that night, she gave birth to a little girl. Picasso was notified at the Congress, and when he came to see Françoise and his newborn daughter, he was full of apologies for his earlier behavior. Posters of his celebrated dove, announcing the Peace Congress, were already plastered all over Paris. On the steps of the Congress he had met Hélène Parmelin and told her that he had decided to call his daughter Paloma. "He was anxious or pretended to be anxious, or both . . . he was anxious to know if giving the little girl this name was likely to make people laugh. He was really anxious. It was no laughing matter." Finally, the little girl was named Ann, after Françoise's grandmother, and Paloma after Picasso's dove: Ann Paloma Gilot.

That night, he and Eluard had dinner at the rue des Grands-Augustins with Ilya Ehrenburg, the Russian writer and "agitator of Soviet culture." They talked of Communism, peace and pigeons. "Picasso likes them," Ehrenburg wrote, "and always keeps some; laughing, he said that pigeons were greedy and cantankerous birds; he could not understand why they had been made into a symbol of peace." Certainly that was never Picasso's intention. It was Aragon who, after Picasso had failed to produce a poster

for the Congress, had picked a marvelous lithograph of a pigeon Picasso had completed at the beginning of January, declared it a dove and turned it into the poster of peace. He had left Picasso's studio at noon on the day before the Congress; by five o'clock that afternoon, the poster appeared all over Paris. From there, the dove flew around five continents, and Picasso became for millions the world over the man of the dove, the man of peace. "Poor old Aragon," Picasso chuckled as soon as Aragon had left his studio. "He doesn't know anything about pigeons. And as for the gentle dove, what a myth that is! There's no crueller animal. I had some here and they pecked a poor little pigeon to death because they didn't like it. They pecked its eyes out, then pulled it to pieces. It was horrible. How's that for a symbol of Peace?"

"This famous Picasso," wrote Parmelin, "did the dove of peace for the Peace Movement. There was the international power of the title. There was the power of art, whether consciously or unconsciously felt, and there was audacity. There was the power of his fame and celebrity." And there was, above all, the power of myth that transformed a man at war with the universe into "the man of peace"—and a cantankerous bird into the symbol of peace.

Overnight, as never before in his life and like no other artist ever, Picasso seized the public imagination. There were doves everywhere, even on the lapels of men's jackets and women's coats. Journalists and photographers tried to break into Françoise's room the day after Paloma was born to take photographs of the baby. As for *L'Humanité*, it had become not only the official organ of the Communist Party but the official chronicler of the Party's most celebrated member, with accompanying photographs of Picasso dressed and half-undressed, on the beach and at his studio, alone and with his photogenic young family.

With all the talk of "our brother Pablo Picasso," however, there was only one true brother for Picasso in the Communist Party and that was Paul Eluard. He never felt the same warmth for Aragon. It was, in fact, a long time since he had felt it for his son Paulo, who, three weeks after the birth of Paloma, became a father himself. He gave Picasso his first grandchild, named Pablo after his grandfather, but always called Pablito. Picasso had absolutely no interest in grandchildren, either the idea or the reality

of them, so Pablito's birth did nothing to strengthen the bonds between him and Paulo. The truth was that Picasso never forgave his son for not being extraordinary; in fact, it sometimes looked as if he had determined to punish him. Under the pretext of not spoiling him, he even took him away, one day, from the toy cars with which he was still playing in his teens and forced him to walk up and down the Champs-Elysées for hours begging the passersby for money while his father watched.

Paulo was twenty-seven years old when Pablito was born. He had stayed in Switzerland through the war, and returned to Paris after the Liberation, having avoided military service. Without a job, he was subsisting on a tiny allowance from Picasso and was already dependent on drugs and alcohol. His greatest joy was racing his Norton motorcycle. So far, he had followed in his father's footsteps only by siring Pablito out of wedlock. A year later, Emilienne Lotte, Pablito's mother, became Paulo's wife, but their life together continued to be lived within concentric rings of fear, anger and stifled pain, which Paulo would try to make bearable by getting stupendously drunk—or drugged.

His self-esteem was so low that he never even tried to shake off his dependence on his father. When his weekly allowance ran out, which it did long before the end of the week, he would go to his father for help. Unable to ask across the barrier of his isolation for the help he really needed, he asked for more money. And when his relationship with his father was particularly strained, he would ask Marcel to intercede. Ever since Paulo had ceased being of interest to his father—ever since, that is, he was no longer the adorable little boy in the harlequin costume—Marcel had served as a father figure for him. He even emulated the way Marcel talked and the way he walked. In the world of cars and motorcycles that he and Marcel shared he could escape from his psychotic mother, whose life revolved obsessively and forever around her husband, and from his own obsession with a father whose love he had never consciously known.

When Picasso and Françoise moved back to Vallauris in June 1949, Paulo began once again to spend time with them, staying at Chez Marcel in Golfe-Juan, where Marcel also stayed. If there was any change in his life since he had become a father, it was not noticeable. One night he and a friend brought back to the

small hotel a couple of girls they had picked up in one of the bars of Juan-les-Pins, where they had stopped during the night. Early in the morning, having run out of things to do with them and by then thoroughly drunk, they tried to throw them out the window, but the girls cried so hard and howled so loudly that the police commissioner arrived, and Paulo would have spent what was left of the night in jail if he had not been Picasso's son. But Isnard, the police commissioner, was proud to consider Monsieur Picasso his friend. In fact, he often visited La Galloise to regale him with the latest criminal gossip of the Riviera, which always cheered Picasso up.

A few hours after he had prevented Paulo from pushing the girls out the window, Isnard was in Picasso's bedroom describing the exact fashion in which his son had been caught "disturbing the peace." Picasso ordered Françoise to find Paulo and bring him to the house immediately. When he walked into his father's bedroom, Paulo, over six feet all, tried to hide behind Françoise. As soon as Picasso saw him, he started ranting, calling him "son of the White Russian" and throwing at him—and since Françoise was in front of him, at her too—everything that was within his reach and not nailed to the floor, including his shoes and the books on his night table. When Françoise protested that she was hardly to blame, he told her to stop "trying to pass the buck." Making up the rules as he went along, he continued: "He's my son. You're my wife. So he's yours, too. It amounts to that, anyway. Besides, you're the one who's here. I can't go out looking for his mother. You've got to stand up and take your share of the responsibility."

Paulo said nothing while his father ranted on at the top of his voice, calling him a "worthless creature" and "the lowest form of animal existence." He found his voice, however, as soon as Picasso expressed his disbelief that anyone could conceive of such an absolutely mad thing as throwing a woman out the window. He told his father that someone as familiar with the Marquis de Sade as he was should have no problem understanding such peccadilloes. At last the "worthless" son had found a shaky piece of common ground with his celebrated father. But Picasso was not about to discuss his taste for intensifying pleasure through pain —other people's, of course—with his firstborn. Instead he called

him "the most disgusting son in the world" and "a bourgeois anarchist," an insult he had picked up from his Party comrades, and spent the rest of the day in bed sulking. He could not bear to look at his own predilections in the distorted mirror of his son's behavior.

Every Thursday and Sunday, Marcel drove Picasso to Juan-les-Pins, where Marie-Thérèse and Maya were spending their summer holiday—less than ten miles away from Picasso's new family. For some time now, Françoise had been campaigning for an end to this artificial situation. She found it absurd to go on hiding behind a wall that did not even exist, pretending that there was nobody else in Picasso's life. Why, she kept asking, shouldn't Maya meet Claude and Paloma, and why shouldn't she meet Marie-Thérèse? Why have Maya continue to grow up in a lie, hearing at school or reading in newspapers and magazines things that her mother invariably denied at home? "It's the easiest way to go crazy," Françoise told Picasso, "not knowing if you are seeing the sun at noon or the moon. You pretend you are unusual; then let's really lead an unusual life, instead of playing hide-and-seek with the truth." He did not like the idea of Françoise trying to put an end to his games; but at the same time, he was intrigued by the possibilities opened up by such an encounter. He finally agreed to invite Marie-Thérèse and Maya to visit them at La Galloise. "With a bit of luck," he told Françoise, "you might even come to blows!"

But Françoise had begun to untangle Picasso's strategy. "He always put those around him in competition with each other— one woman against another, one dealer against another, one friend against another. He was masterly at using one person like the red flag and the other like the bull. While the bull was busy charging against the red flag, Pablo could, unnoticed, deal his wounding thrusts. And most people didn't even think to look who was hiding behind the red flag."

It was too late for Marie-Thérèse. For years now, Françoise had been the red flag with which Picasso had taunted her, and she had all too irrevocably allowed herself to fall victim to Picasso's strategy of dividing and conquering. "She had grown to hate Françoise," Maya said, "and she wanted me to hate her too." When, in the summer of 1949, Marie-Thérèse finally found her-

self in front of her adversary, there was only one thing she really wanted to say to her, and as soon as they were alone for a few moments, she did: "Whatever you may be thinking, there is no way that you could ever break our bond and take my place."

"I *can't* take your place," Françoise replied, "and I don't wish to. The place I'm in is one that was vacant." Françoise knew that Marie-Thérèse was only the red flag and not the enemy. And she also knew that "one truth does not annihilate another truth and one relationship does not invalidate another, in the same way that you don't love your first child less because you have a second one."

Having the blindfold taken off was at first very hard on Maya. Suddenly at thirteen, she was confronted with a little half-brother and a baby half-sister and another woman at the center of her father's life. "When she first saw them, she wanted to kill them," recalled Françoise, "but that, of course, had been instigated in her by her mother. When she was allowed to have her own experience of her father's new family, it all changed, and she was happy that the charade was over." Many years later, Claude would tell Maya's husband: "You know, the first children of Maya were myself and Paloma."

Maya had her mother's blond hair, but otherwise looked much more like her father. Her zany sense of humor and her philosophical approach to life were completely her own. Her eyes were blue—but, she said, "not the blue sky of the South of France but the blue sky of Paris, which is more gray than blue." She had just come back from England, where she had not learned much English but had acquired a taste for cornflakes and steamed pudding, and had learned something else, much more important: "I had made all these new friends and they were all so worried over exams, it helped me see clearly that it is not worth making a big deal either of our defeats or of our victories; it was enough to cross the frontier and a French defeat became Trafalgar, an English victory! It was a wonderful realization. Otherwise, the main words I learned were 'naughty girl.' The lady I was staying with did not stop telling me all the time I was there: 'Naughty girl, naughty girl!' As for my father, he kept writing letters and postcards that often had no other message except 'Write to me, Write to me, Write to me.' "

Despite Marie-Thérèse's attempts to poison Maya against Françoise, they were soon friends. Maya was grateful that thanks to Françoise, she was now part of a much bigger slice of her father's world, and Françoise enjoyed her feistiness and her inventive mind. Maya loved making up stories of battles and marriages and larks for her little brother and would hold him spellbound for hours. Sometimes she adapted well-known stories with twists of her own: "In my story of Little Red Riding Hood, the wolf ate Little Red Riding Hood and then Little Red Riding Hood ate the wolf from inside. And it went on for hours like that." There were times, however, when she found that a good thrashing was the only way to deal with Claude. "He was the king of troublemakers," she said. "No, not the king, the tsar, the emperor, the god of troublemakers, especially when it came to Paloma. He believed in his gut that little boys are superior to little girls and men superior to women, and the first woman on whom he could impose his macho will was his sister."

"Claude was very possessive," Françoise recalled, "so the arrival of Paloma was hard on him." What made it harder was that Françoise took a positively sensual pleasure in her little girl. "It seemed like the culmination of everything. When Claude was born I knew nothing about babies, so I was worried and fearful, especially as he had been born with a congenital heart defect. With Paloma, it was all different. Although she was born at eight months, she was perfectly healthy, and by then I felt competent to take good care of her. So I was much more serene than I had been after Claude's birth and I could really enjoy her. Also, it was nice to have a boy and a girl. I felt complete. Who could really want more?"

She seemed to have everything, and yet, gradually and at first almost imperceptibly, it became clear to her that the vital current was missing. It started with her health. She had heavy hemorrhages, and physically she was feeling spent. She found it very hard to recover from Paloma's birth, and her exhaustion and hemorrhaging made it impossible for her and Picasso to continue their active sex life. "Pablo had tremendous sexual needs and I began to feel harassed. Also, I felt tremendously burdened with the children and all the duties of our life and all the people around, especially as Pablo made it really hard for me to get any

stable organization going at the house that could support me and take some of the burden off. It was always 'No, I don't want him, no, I don't want her, no, I don't want this, no, I don't want that.' " Often in the night he would wake her up as many as half a dozen times, insisting that something was wrong with "the money," his nickname for the children, that he could not hear any breathing and that she should get up and check. He had started that pattern with Claude and continued now with Paloma. Making sure the children were all right would often wake them up, and Françoise had to spend even more time coaxing them back to sleep before she could go back to bed herself.

By the time fall came, Picasso had added another arduous task to her daily routine. He had bought an old perfumery in the rue du Fournas which he converted into his painting and sculpture studios, and he insisted that Françoise was the only person who could build the fires in the morning so that the place was warm enough for him to begin work there in the afternoon. So every morning from October on, no matter what time she had gone to sleep, Françoise stoked the furnace at La Galloise and then bicycled down to the rue du Fournas to start the fires there. Picasso would sleep until noon most days and wake up grumpy but recharged, while Françoise's health continued to deteriorate.

Her letters to her mother were full of requests for help in trying to contact Dr. Lamaze for advice on what she should do about her continuing hemorrhages: "Dr. Lamaze, who is very kind but so busy and a little distracted, has still not replied to my letter and I still don't know whether I should come to Paris or be treated here. If it is not too much trouble, could you please call him on Monday early in the afternoon, tell him that you are my mother and that you would like to know his answer to the letter I sent him (where I explain to him what the doctor here has told me). . . . If by chance my letter to him has been lost I could write to him again. . . . I would just like to know whether I could be treated here and if so what the treatment should be." A few days later she wrote another anxious letter to her mother: "I understand from your telegrams that he does not want to operate here; this is clear, but could I be *treated* here or do I have to come to Paris? . . . I embrace you with all my heart, Françoise. P.S. I just

tried to call Dr. Lamaze. He was not there—I left a message that I had not received his letter."

There was no telephone at La Galloise, and Françoise had to go back and forth to the pottery to call Dr. Lamaze; and if he was not there, he could not easily call her back. But that was not the main reason she had asked for her mother's help. She was still bleeding, she was exhausted and she wanted to know that someone cared enough for her to make phone calls, send telegrams and write concerned letters. Picasso, far from providing any kind of support, constantly complained about the state of her health. "I don't like sick women," he kept repeating. "Everything became my fault," said Françoise. "And I began to feel that it was all so unfair—that I had gone to the maximum to fulfill his wishes, from having the children to building the fires in his studio, and instead of what I did leading to a ripening of our relationship, it had all backfired. My health had never been worse, our sexual relationship was impaired and he was telling me both through his words and through his actions that I was no longer as convenient as I used to be. On top of that, I was feeling guilty, trying to master the weakness of my body and working even harder to compensate. It was the beginning of my resentment and my deep disenchantment."

The hardest thing was dealing with Picasso's withdrawal from her. Until Paloma's birth, except for his trip to Poland she had always been with him. Now, he would suddenly announce he was going to Paris for a few days and she would find herself alone with the children. "I had never envisioned our lives like that," she said. "At that time I was so involved with Pablo that without him there were moments when I was almost unable to breathe. There was such a symbiosis between us that it was as if not only one arm was cut off but half my body. It was really difficult to take; in fact, in order to take it I had to reenter myself. I had been completely out there with Pablo, and now I had to find myself again, first of all in order to know what was happening and then in order to know how to handle it."

At first when she began to look at what was happening, things were pretty fuzzy at the edges—events mixed with emotions and simple facts with complex feelings. Gradually, her thoughts came

into focus. She remembered the first time Picasso came to the clinic after Paloma was born. "So you are pleased," he had said. "Yes, of course," she had replied. It had not occurred to her that he might be any less pleased himself. Yet looking back, she realized that his tone had been strange—nothing obvious, just a signal that all was not well. "So, *you* are pleased," he had said.

"I didn't know at the time that it was a recurring pattern," Françoise said, "but after Maya's birth, Pablo began abandoning Marie-Thérèse and seemed unable to get on with his work. The birth of a girl in Pablo's life was clearly traumatic. He had made a pact with God over his little sister, and now he was reliving the trauma of that pact over the birth of his daughter: she might die and then he would feel terribly guilty, or she would live and his work would suffer. All his unresolved fears were activated again. He kept saying how beautiful Paloma was, but he was restless, agitated. It was a creatively barren time, and he even started talking about getting another apartment where I could be with the children when we were in Paris. I didn't like that at all, because either I was going to be with him or else. . . . He was beginning to disengage—not in words, but in deeds—and I was so sensitive to him that I began to feel as though I was falling from the eighth floor. And since our health comes from our whole being, it was my body that was paying the price even before my mind knew why."

She asked herself what she could do next. "The answer came back as a clear directive: to concentrate on my work even more, to concentrate on the children even more and to concentrate if not on Pablo himself, at least on my duty toward him, on what the Indians call dharma—seeing to it that he had a life as well balanced as possible and as free as I could make it from problems and people that distracted him from his work." She spent hours drawing and painting the children. In one of the long letters she wrote jointly to her mother and her grandmother, she described her efforts to draw Paloma while she was asleep: "The poor darling is really a martyr. I try all sorts of ways to keep her from sleeping at hours which don't work for me and to make her sleep when I'm there poised, pencil in hand. If she moves in her sleep, I try to rearrange her the way she was before, which ends up

waking her! . . . I'm continuing a gouache on a plywood panel, with Claude in Tyrolean costume, seated on the ground, chin pressed in hand. He's looking at his sister, who is stretched out on her stomach and hanging on to his other hand." Claude was still having trouble adjusting to the arrival of Paloma. "My mother went to a bad hotel," he would say, referring to the Belvédere clinic, "and she came back with a little sister, and I don't like her. I wanted a red one, and she is all white; she is too white!"

He was a bright, enchanting boy. In another letter to *Chères Dames*, as she sometimes addressed her mother and grandmother, Françoise proudly gave them examples of his intelligence: "Claude knows about everything. Yesterday he grabbed your last letter and casting a sly look my way, he started mimicking, '*Chère Françoise* bla bla tra bla bla,' pretending with inarticulate sounds that he was someone reading out loud. Then at the end he said, 'It's a letter from Grandmother,' and burst out laughing. All the time I was shaking with laughter myself because I had never read a letter out loud to him. He must have understood what it was all about all by himself. It seems certain that a great stock of knowledge is inborn and just a few clues are enough to unlock the memory—and the understanding."

Every now and then, Picasso would read a letter from Françoise's mother and grandmother in which they told her that they were praying for her. "But they ought to pray for me, too," he would complain. "It's not nice to leave me out." And when Françoise protested that since he was an avowed atheist, he should not care whether they left him out, he was all the more insistent: "Oh, but I do care. I want them to pray for me. People like that believe in something and their prayers certainly do something for them. So there's no reason why they shouldn't give me the benefit too."

He had nicknamed Françoise's grandmother "the great German orchestra conductor" because of her booming voice and her imposing personality, while the best thing she had to say about him was that he had very smooth skin "like a piece of polished marble." Otherwise she did not like him. And she had told him so to his face: "I don't care about you, you know. I care only

about her. If you think I come to see you, you are wrong. I just come to see my granddaughter. My granddaughter is my granddaughter whether you like it or not."

He could not stand the idea of someone indifferent to him, so he tried to seduce her. But she was not seducible. "Where shall I take you to dinner?" he asked one night.

"Dinner with you doesn't interest me," she told him. "I'd rather go to the casino, because I always have a lot of luck there. I don't think you would have the energy to stay up with me; I like to stay very late."

She was, in fact, a few years older than Picasso, and although she did have the most incredible luck when she gambled, she did not go to the casino that night. She just wanted to put him in his place, to let him know that not everyone was waiting to get marching orders from him.

One thought that did not cross her mind, either when she was with them or in her letters, was that Françoise, living with a multimillionaire, might actually be in need of money. "I have never been as poor in my life," recalled Françoise, "as when I was with Pablo. It's hard to believe, but that's the way it was. Marie Cuttoli had dresses made for me, since I couldn't afford any of my own. It was one more way to exert his power over me, to have me ask for things, since he believed that he could buy me emotionally if I needed him financially. And I didn't want to do this, especially since I loved him and I knew that if he could humiliate me he would lose his respect for me. If I asked for anything material, he could then accuse me of being trapped in the bourgeois game of possessions and he would be the pure one. The way his mind worked, I would then be nobody and he would once again be alone on the mountaintop. He was so acutely aware of the balance of power in a relationship. . . . So I asked for nothing—not for clothes, not for a better house, even though we were living in a really ugly, small house. And when I asked for more help with the children and the house, he would find all sorts of ingenious ways of refusing."

After Paloma was born, Picasso gave Françoise a beautiful watch as a gift. By then, she too was alert to any shift in the balance sheet of their relationship, so the following Christmas she returned the favor by buying *him* a very nice watch. "Per-

haps," she said, "we both felt that we needed to remind each other that the clock was ticking."

Time was passing, but not at the same rate for both of them. With the birth of her two children, Françoise had quickly moved from adolescence to the full bloom of womanhood, while for Picasso time mercifully moved more slowly, its passage marked on his children much more than on himself. He drew them and he painted them, often with Yan, the new boxer puppy, but there was something impersonal and detached about these pictures—the artist's ingenuity much more present than the father's warmth.

"He was put out by the children . . . disturbed," recalled Françoise. "He had thought they would make our relationship more stable, but the opposite had happened. They began to be in his way. 'They are not children, they are elephants,' he would complain. 'They take so much room.' It was better in French—*les enfants, les éléphants*. Then he started telling me how marvelous it would be to give him as many children as Oona gave Charlie Chaplin. I told him that that was really strange, wanting more children when he couldn't accept the noise and the inconvenience of two. He liked the idea of new life as he was nearing seventy, but he didn't want to be bothered by it."

In the fall of 1949, Gallimard published his second play, *The Four Little Girls*, which revealed a world full of games and anguish. "Let's play at hurting ourselves," says the First Little Girl, "and hug each other with fury making horrible noises. . . . Make the best you can, make the best you can of life. As for me, I wrap the chalk of my desires in a cloak, torn and covered with black-ink stains that drip full-throated from blind hands searching for the mouth of the wound." "In all our caperings," announces the Fourth Little Girl, "we are going to shout aloud the joy of being alone and mad." For Picasso, as he was entering his sixty-ninth year, making the best of life meant being away from La Galloise as often as possible. Françoise was left behind while he began to give full vent to his desires, practicing seduction and conquest without respite, intoxicated with his caperings, with his casual affairs and above all, with continuing proof of his virility.

La Galloise became less his home than the launching pad for his expeditions to Paris. One day, his old friend Dr. Reventós

came to see him at the rue des Grands-Augustins together with Pierrette Gargallo, the late sculptor's daughter. She had just arrived from Barcelona and brought Picasso a letter from his sister. "You are so lucky," she told him. "You have success, wealth, your health, a beautiful woman by your side, young children—you have everything." "No," he replied, "I don't. I'm missing five centimeters." There was something irrevocable about his dissatisfaction, as irrevocable as his height. "If we weren't unhappy," he had told Matisse that summer, "we wouldn't be painting. We paint because we are not happy." And because he was not happy he was chasing around, more and more anxious about death. Death was a major preoccupation of *The Four Little Girls*. "Isn't she stupid?" the Third Little Girl remarks contemptuously about the First Little Girl's obliviousness to the threat of death. Afraid that he was running out of time, Picasso was grabbing for happiness—or at least, temporary release from unhappiness.

Meanwhile, Françoise, who had been offered a contract by Kahnweiler, was losing—and finding—herself in her work and in her children. With Kahnweiler's contract, she was, for the first time since she had been with Picasso, financially independent. "It was a life raft," she said. "He had thought that giving me children would tie me down, and I couldn't leave, but now I was earning a living, and if necessary, I could take care of my needs and the needs of my children."

She was entranced by her little daughter. "As for the most beautiful of the most beautiful," she wrote to her mother and grandmother, "I'm doing a series of drawings of her next to me. I'm not working from life, but I'm trying to bring out the poetry that emanates from her elusive freshness—a little head, in the manner of Louis David, tufts of hair on the brow, eyes with lashes like rapid birds, a perfect cream of sleep, in contrast to the woman near her more bitter and worried than I really am when I'm able to liberate myself through drawings which follow one another rapidly, modulating their song like the lines of a poem. In the passion of my work I achieve a certain degree of happiness because it's not a question of conquering a particular artistic form or a new vocabulary, but rather of giving myself over completely in a way which leaves room neither for reflection nor for regret —in order to open the gates to lyricism. For me it's good to be

here among nature, the children. I absorb their influence and my thoughts are enriched and clarified."

Her letters to her mother and grandmother made no mention of Picasso. They were reports from that part of her universe where only her work and her children existed. "If only I had him inoculated against rage as well as against typhoid fever," she wrote after Claude had beaten up Paloma "on the sly." In another letter she announced with joy that the medical massages Claude was having had made his thorax much less constricted. In another, she described the packet of odds and ends that Claude had prepared on his own initiative for his grandmother. "You must send this right away together with the big balloon to amuse Grandma," he had told her. And Françoise wrote instead a two-page letter describing the packet.

It was a world in which Picasso was only a passing visitor. "To produce babies at my age is really ridiculous," he had said. And he now recoiled from any but the most perfunctory involvement in the life of his young family, while Françoise herself maintained a protective distance that precluded greater intimacy. He always used *tu* when he spoke to her, but she always addressed him with *vous*, as though she were talking to a parent or a teacher. "It infuriated him," Françoise said. "It had become a symbol of the distance I was trying to keep. Looking back, I needn't have done it. I could have called him *tu* or *mon chéri*; but I never did. Since he had turned our relationship into a battle, I too was using whatever weapon I could find."

Marcel joined in this game by calling Françoise "Mademoiselle." "You must stop calling her Mademoiselle," Picasso would reprimand him. "It's ridiculous. Here she is with two children. You must call her Madame." The more annoyed Picasso was, the more insistent Marcel became. "No, no. She's so young. For me she will always be Mademoiselle." It finally became a free-for-all, with Eluard and Paulo calling Picasso *"le malheureux fils père"* (the unfortunate celibate father). But what most upset him was arriving at a hotel with Françoise, Paulo and the children and being given one key for himself and one for "his son and daughter-in-law and the grandchildren."

When he was in Vallauris, Picasso spent most of his day at "the factory," as he called his new studio; everybody else referred to it

as "Le Fournas." He even had a housewarming party there, as though this were his true home; "Picasso is dining at Picasso's," read a huge poster hung over the fireplace. The painter Manuel Ortiz sang flamencos, and among those singing along were Edouard Pignon and Hélène Parmelin. Picasso had invited them to share "a painter's life" with him, and they were living and working in the rooms above his studio.

"We were all Communists, then as ever," wrote Hélène Parmelin, "and at the centre of the furious quarrelling about painting on the extreme left. Our leisure, our meals and our amusement all took place in an atmosphere composed of hot passion, fury, anecdote, drama and melodrama, active rebellion, eternal argument, laughter and depression. When showing us the oval lights through which the owner of this old mill used to keep an eye on his workmen, Picasso told us he had opened them specially so that we could watch him throughout the day to make sure he was keeping to the Party line. . . . Whenever he took visitors into the passage, he invariably said we were there to see he kept to the line; and that before our arrival he had always been deviating. But now, as soon as they see I'm deviating, he said, they just tap on the pane, or whistle, and I immediately return to the line, with a ruler."

They were there when Picasso finished his *Goat* in plaster, with two pottery milk pitchers for its teats, a palm branch for its backbone, a wicker wastebasket for its stomach, vine stalks for its horns. Each night the goat lost two inches of its plaster nose, and each morning Hélène Parmelin "picked up the nose and replaced it." Picasso loved collecting scrap pieces from the junk heap that was conveniently situated next to his studio and transforming them into his assembled sculptures. Sometimes Françoise walked along with him, pushing a baby carriage, into which he dropped whatever had caught his fancy. "Down with style!" he had proclaimed to Malraux. "Does God have a style? He made the guitar, the harlequin, the dachshund, the cat, the owl, the dove. Like me. The elephant and the whale, fine—but the elephant and the squirrel? A real hodgepodge! He made what doesn't exist. So did I."

It was a hodgepodge that went into making the *Little Girl Skipping Rope*, including a wicker basket that he used for her

body and two cumbersome shoes, both for the same foot, that he had found in the junk heap, for the little girl to wear. He wanted her not to touch the ground. "Since she was skipping, how did I keep her up in the air?" he asked rhetorically. "I pressed the rope down on the ground. No one ever noticed." There was method to his magic, but it was no less magical and its power no less inexplicable for that. "The eyes of the artist," he said, "are open to a superior reality; his works are evocations."

He continued to struggle with his belief that his work was "something sacred": "We ought to be able to say that word or something like it," he told Parmelin, "but people would take it in the wrong way. . . . We ought to be able to say that such and such a painting is as it is, with its capacity for power, because it is 'touched by God.' But people would put a wrong interpretation on it. And yet it's the nearest we can get to the truth."

On August 6, 1950, all the people around Picasso who would have put a wrong interpretation on a work of art being "touched by God" were gathered at the central square in Vallauris for the unveiling of *Man with Sheep*, which Picasso had offered to the Communist Municipal Council of the town. Françoise, in a bright flowered dress, was standing beside Picasso as the mayor proclaimed him an honorary citizen of Vallauris, and Laurent Casanova cried out with emotion. "Salute to Picasso, our brother in arms!" Casanova was there to do the unveiling. He had recently published *The Communist Party, the Intellectuals and the Nation*, in which he declared with the papal authority that was the hallmark of all his pronouncements that "religious art no longer inspires the true artists." The municipality of Vallauris, clearly in agreement with the great Communist leader, offered Picasso a deconsecrated chapel off the main square for him to decorate according to the dictates of his secular inspiration.

Eluard, Tzara and Cocteau were all there to witness the celebration; Cocteau, who had been flirting with the Communist Party, watched the proceedings from a second-story balcony with his great friend Madame Weisweiller. When he was in the South of France, which was more and more often, he and Edouard Dermit, his latest lover, known as Doudou, always stayed with her in Saint-Jean-Cap-Ferrat. Coming to visit Picasso at La Galloise after the high luxury of Santo Sospir, the Weisweiller villa,

he teased him about the "ostentatious simplicity" of his life. "You have to be able to afford luxury in order to be able to scorn it," replied the honorary citizen of Vallauris.

Picasso's involvement with the Communist cause continued, as if he hoped to discover through it a meaning and a significance to his life that had so far eluded him. Françoise, who was in correspondence with Endre Rozsda, her teacher and friend, now living in Hungary, asked Picasso many times to intervene through his Communist contacts so that Rozsda could come to France at least for a visit. "I never liked to ask Pablo for anything," Françoise recalled, "but I did ask for Endre. He was an abstract-surrealist painter and found it impossible to produce the social-realistic paintings that were the only kind allowed. So to earn a living, he ended up making puppets and working on stage sets, and unable to function under the Communist system, he had had a nervous breakdown."

The first time Françoise asked Picasso to help Rozsda, he replied: "Absolutely not. If he's not happy in a Communist country he has to be a bad person."

"Please don't give me that," Françoise said. "You know as well as I do that he's an artist who is not allowed to express himself. As an artist, if you were in that position, wouldn't you be grateful to have someone help you get out?"

"Certainly not," he said, "because I'm a good Communist." Françoise tried again and again, hoping to catch him at a moment when he was in a better mood and not such a good Communist. But the answer, every time, was the same.

In November he was awarded the Lenin Peace Prize, and in the same month he arrived at Victoria Station in London to take part in the third Communist Peace Congress which was to be held at Sheffield. He came off the train alone. As he explained to Roland Penrose, who was there to meet him, everybody else traveling with him had been refused entry at Dover. Both the government and the public mood in England were vociferously opposed to a congress dedicated to Communist propaganda in the middle of the Korean War. "And I," Picasso asked, "what can I have done that they should allow me through?" He did not like being perceived by the authorities as a safe revolutionary, but his one-minute speech at Sheffield justified that perception: "I stand for

life against death: I stand for peace against war." That was his peroration, and there was not a man alive who would, at least verbally, challenge it.

In January 1951, still in the grip of his Communist addiction, he painted *Massacre in Korea*. Based on the execution scene of Goya's *Third of May*, it was intended as a grand artistic protest against the American intervention in Korea. It turned out to be, as James Lord described it, "a faint bleat in the pandemonium of political propaganda"—too faint for the Party brothers he had aimed to please and too depressing for his nonpartisan admirers. "As a formal production," wrote Lord, summing up the disappointment, "it makes facile use of aesthetic devices long since done to death by the painter. That is its truest image of violence. Something had happened to Picasso. He was now a changed man, and artist. . . . He surrounded himself with mediocre sycophants and third-rate artists, none of whom could remind him that moments of major attainment were no longer at hand."

At the beginning of March, Kahnweiler arrived in Vallauris to see him. He had flown to Nice and was met by Marcel, who took him straight to the studio. It was only eight months until Picasso's seventieth birthday, and he seemed preoccupied with old age. He mimicked an old man, getting up with difficulty. "That's what's so terrible! Now we are still able to do whatever we want. But wanting and no longer being able to do: that's what's so terrible!" He did add, however, that for the moment he was feeling as though he was fourteen. And afraid of impending old age, that was how he was behaving. He was running in every direction away from Françoise. And one direction led to Geneviève Laporte. "I feel a constant urge to destroy what I have built up with much difficulty," he told her, and he seemed determined to destroy what he had built with Françoise. "Was Picasso afraid of his happiness," Geneviève Laporte asked, "afraid of succumbing to a more profound emotion than he was willing to cope with?"

Even when they were together, Françoise felt him far away from her. She withdrew into her own world, kept her suspicions and her fears to herself and watched while her relationship with Picasso began to feel more and more like a business partnership. She managed his dealings with galleries, publishers and the world, and immersed herself in her own work. Picasso was

pleased that she had a contract with Kahnweiler, pleased that Paul Rosenberg had also asked to represent her (but she was already taken), pleased that her drawings and lithographs would soon be illustrating books of poems by Verdet and Eluard. And Françoise was grateful for any signs, however spasmodic, that she existed for him as something more than a useful adjunct. At the same time, she was "chilled by the growing recognition that I had to pay for any signs of affection on his part by the pain he caused me when he immediately switched and became harsh and cruel. He called it 'the high cost of living,' but it was really the high cost of living with Pablo. Anytime he was at all loving or caring and I allowed myself to relax and be open and vulnerable, he would turn, and the battle would start again. The result was that I could never lower my guard."

When she was not attending to his business, to her own work or to the children, Françoise's main release was crying. As always, the smell of pain brought out in Picasso the impulse to inflict more pain. "You were a Venus when I met you," he told her once when he caught her crying. "Now you're a Christ—and a Romanesque Christ at that, with all the ribs sticking out to be counted. I hope you realize you don't interest me like that. . . . You should be ashamed to let yourself go—your figure, your health—in the way that you have. Any other woman would improve after the birth of a baby, but not you. You look like a broom. Do you think brooms appeal to anybody? They don't to me."

The cost of living with him was growing higher and higher. When early in 1951 Tériade asked her to write the text for a special issue of Verve devoted to Picasso's recent work, she replied, "Of course not!" It was her way of fighting back, of saying no when Picasso wanted her to say yes. And no amount of persuasion from Tériade or from Picasso would make her change her mind. She helped Tériade select the works to be photographed, but writing the text came to symbolize for her taking one step too many toward being absorbed by him. "I didn't see why, on top of everything else, I should be obliged to write a text of hagiography about him and his work. In the end, of course, it was nothing more than an absurd act of defiance. It didn't prove anything." It was another expression of the antagonism simmer-

ing in their relationship. "You are the son of the woman who always says no," Picasso complained to Claude, who at four years old could not have been expected to do very much about it.

On June 14, 1951, Picasso and Françoise were witnesses in the town hall of Saint-Tropez at the wedding of Eluard to Dominique Laure. They had met at a small gallery of ceramics in Paris and soon after, by chance, again in Mexico. Even before their wedding, they had settled in Dominique's apartment in Saint-Tropez, overlooking the harbor. But they were constantly back and forth between Saint-Tropez and Vallauris. One day, as they were driving home after lunch with Picasso and Françoise, Dominique commented on how well the lunch had gone. "Beyond any shadow of doubt," Eluard replied, "Pablo is at this very moment busy bad-mouthing us."

And he was. "If Paul thinks that I'm going to honor him again by going to bed with his wife," he told Françoise, "this time he's wrong. . . . When I don't like the wife of a friend, that takes away all the pleasure I get out of seeing that friend. She's all right by herself, but the combination, no. She's not the wife Paul should have." He thought that Dominique would have made a good wife for a sculptor, but that she was too Amazonian for a poet. And next time he saw Eluard, he told him: "A woman who is there, under foot, looking as solid as the Rock of Gibraltar, isn't very appropriate for a poet. You'll wind up not being able to write a line. You should be sighing and suffering for a pale young girl, and one who isn't here, to boot."

But what really annoyed him was not Dominique's solidity—after all, he usually preferred *his* women solid—but her refusal to join the adoring chorus. "One thing that I found insufferable," she recalled, "was the perpetual reverence around Picasso. It kindled my desire to provoke him—for which he always took his revenge. When, for example, he said once that he wanted to do my portrait, I told him that he would never be able to give me a bosom as beautiful as in the drawings that Valentine Hugo had made of me. He was not at all used to that kind of talk. He retaliated by making a dozen drawings of me, putting them all in an envelope, tying them with a string and tearing them up in front of my very eyes."

"There's no such thing as love," Picasso had told Françoise.

"There are only proofs of love." And he loved putting everyone around him through daily tests. He insisted on Dominique staying in a room in the dark and damp basement of La Galloise, on Françoise wearing a really ugly dress he had bought for her in a street market, on both Dominique and Françoise wearing the junky necklaces he had bought in Vallauris. Françoise passed that particular test by wearing both the dress and the necklace and was rewarded by being given one of the silver necklaces he had made himself. Dominique failed the test by never so much as putting on the ugly necklace—and she was punished by being given nothing.

"Eluard was fascinated by Picasso," Dominique recalled. "He loved him as if he were a woman; it was a kind of mental homosexuality." And Picasso confessed to Geneviève Laporte: "I'm a woman. Every artist is a woman and should have a taste for other women. Artists who are pederasts can't be true artists because they like men, and since they themselves are women they are reverting to normality."

Now that Picasso did not seem at all eager to re-create with Dominique the triangle that had existed between Eluard, Nusch and himself, Eluard was eager to bring someone else linked to his life into Picasso's bed. It was he who, in 1944, had introduced Geneviève Laporte to Picasso, and now, seven years later, he did everything he could to facilitate their affair. His attitude was not shared by Dominique. "Picasso had been to our house with Françoise and the children," she said, "and then eight days later he appeared again with Geneviève. And when I didn't want to receive them, he attacked my lower-middle-class values. I still found it shocking that with Françoise only a hundred kilometers away he would bring Geneviève to as public a place as Saint-Tropez, where everybody looked and everybody knew." Her husband, however, got a special thrill from his role of procurer and panderer. He sent a letter to Geneviève informing her that on Picasso's instructions he had found them an apartment close to theirs for the summer. Picasso was already in Paris, and the next day Marcel drove him and Geneviève to Saint-Tropez.

"Even if you were entirely free to choose," Eluard told Picasso, "there is no answer that would make you entirely happy." But for the moment, Picasso was busy inventing a past and re-creating

In 1935, Marie-Thérèse gave birth to Maya. The salacious sex object was now a mother-figure.

The Minotaur Carries Off a Woman. *Half man, half bull, the Minotaur, a symbol for Picasso himself, carries off the nude and limp body of Marie-Thérèse, while other women, including Dora Maar, are watching.*

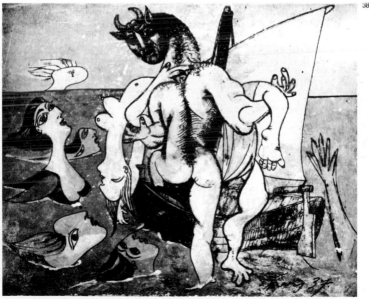

In Mougins, Picasso felt the exhilaration of a new beginning, this time with the painter and photographer Dora Maar. An intellectual muse of the Surrealist movement, Dora was as different from Marie-Thérèse as Eva had been from Fernande.

40

41

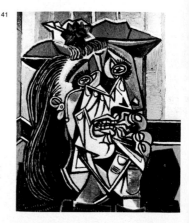

Dora, beautiful and brilliant, was transformed by Picasso into the Weeping Woman, her face distorted in torment. The goddess was turned into a doormat.

944: Picasso marching in the front ranks with his friend and political mentor, the poet Paul Eluard (on his right), to celebrate the liberation of Paris. He had become a symbol of survival, of the victory over oppression, a monument as familiar—and as accessible—as the Eiffel Tower.

Françoise Gilot was twenty-one years old when she was introduced to Picasso, and he was sixty-one. "You are the only woman I've met," he told her, "who has her own window to the absolute."

Geneviève Aliquot, Françoise's closest friend, begged her to leave Picasso rather than stay and cooperate in her own destruction.

45

46

[LEFT] Françoise was struck by Picasso's resemblance to the Seated Scribe, the ancient Egyptian statue in the Louvre, a resemblance she captured in her masklike portrait of him [ABOVE].

Inès Sassier, Picasso's housekeeper, bright, beautiful, feisty and willing to put up with everything: his explosions, his women, his lies, his messiness, the strange hours he liked to keep

47

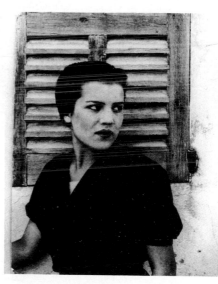

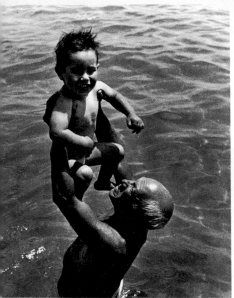

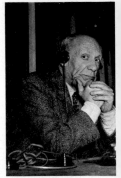

Picasso joined the Communist Party in 1944 and quickly became a good Party celebrity, appearing at conferences and mass meetings, including the Communist-dominated Peace Congress in Paris in 1949.

Picasso with Claude, his son by Françoise. His fascination with Claude would come to an end as his son grew older.

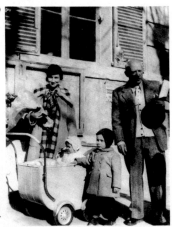

Picasso and Françoise with Claude and his baby sister, Paloma. "He kept saying how beautiful Paloma was," Françoise recalled, "but he was restless, agitated. It was a creatively barren time . . ."

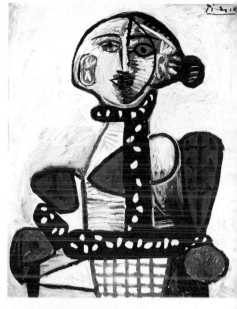

Portrait of Françoise wearing the embroidered peasant coat Picasso had brought her from Poland. "It was an expressionist period," Françoise said, "but without the sadism that accompanied his work of other periods."

Picasso visited Matisse in Vence and found him working on the design of a Dominican chapel. "You're crazy to make a chapel for those people," he exploded. But after Matisse's death he said quite simply: "In the end there's only Matisse."

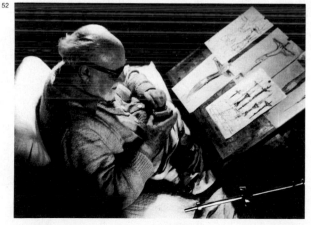

53

After Françoise left Picasso,
Jacqueline Roque, a salesgirl at
the pottery in Vallauris,
determined to make herself
indispensable to "Monseigneur."

54

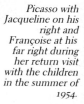

Picasso with
Jacqueline on his
right and
Françoise at his
far right during
her return visit
with the children
in the summer of
1954.

55

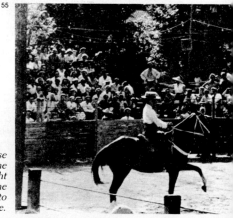

At Picasso's request, Françoise
performed, on horseback, the
ceremony of opening a bullfight
in his honor in Vallauris. In the
audience, Jacqueline clung to
Picasso's side.

the present to make them more seductive for Geneviève. "I've never been able to think of myself, and no one has ever bothered about me," he told her. "I have always been afraid of hurting other people, perhaps through cowardice. Take Françoise for example: I've never loved her. But she's like a cup full of memories which I don't want to drink from any longer; on the other hand I don't want to smash it. So what am I to do?"

Of course, the last thing he wanted was advice. As Eluard told Geneviève: "Picasso has only ever done in life what he intended to do." Acting the role of the long-suffering victim was part of what he intended. "You know, don't you," he told Eluard at a moment when he was sure that Geneviève could overhear, "that all my affairs of the heart have been spoiled by friction and suffering: two bodies enveloped in barbed wire, rubbing against each other and tearing the flesh. With her, it's been all sweetness and honey. She's a hive without bees." Geneviève did overhear and was "exhilarated," as he intended her to be.

"He will praise a fair girl's amiability," Leporello sings of Don Giovanni, "a dark one's constancy, a white-haired one's sweetness . . . so long as she wears a skirt, you know what his game is." Geneviève Laporte was the official "other woman," but by no means the only other woman in Picasso's life during this season of raging sexuality, fueled by fear of death, of old age, of the sap failing to rise. While Picasso was cavorting around the French coast adding "women of every rank, of every size, of every age" to Leporello's catalogue, Françoise was often in Paris visiting her grandmother at the clinic in Neuilly, where she had been since a stroke had left her paralyzed on one side. One day, when she was back in Vallauris and Picasso in Saint-Tropez, "visiting the Eluards" as he had told her, Madame Ramié took Françoise into a corner and told her that Picasso was in fact in Saint-Tropez with another woman. She was telling her as a friend, she said, for her own good, because she did not want her to hear about it from an outsider. It was only his latest adventure, she continued, but this time she felt that it was her duty to tell Françoise because she had heard that he was planning to go away with this woman to Tunisia.

"I felt as though I had been poisoned and the life was draining from me," Françoise recalled. "Of course I had suspected, but I

had put such thoughts out of my mind. And finding out from somebody who I knew wished me only ill made it so much harder."

When Picasso returned home, she asked him point-blank: "Is it true? Please tell me the truth. I am an adult. I can take the truth. Just tell me the truth."

"You must be crazy," he said with the utmost conviction, "to fall for the latest gossip. There is nothing going on."

He was so adamant that Françoise wavered. Maybe Madame Ramié had made it up, maybe her suspicions were all imaginings, maybe he was really only visiting the Eluards or going to the bullfights or taking care of business in Paris.

The next few weeks were filled with the anguish of knowing and yet not wanting to know. Stories of Picasso's affairs had even started to appear in the newspapers, but he continued to deny them as unfounded and libelous. Her feelings of betrayal would quiet for a while, then swoop out of their slumber and fill her whole being, leaving her wretched. It was in such a state that at the beginning of August, she received the news of her grandmother's death. She was at the pottery when the telephone rang, and the postal clerk, thinking he had Madame Ramié on the line, announced matter-of-factly: "Françoise Gilot's grandmother is dead." She left immediately for Paris. And there, at her grandmother's funeral, she saw her father again, for the first time in eight years. "It was awkward at first," Françoise recalled, "but very moving. He held my hand and asked me home after church, although he did say that he was doing it for my mother."

Yet he was also doing it for her. He too had read in the papers about Picasso's affairs, and he wanted Françoise to know that the past was past, that he would never again raise all the things that had separated them, and that if she needed him at this difficult moment in her life, he would be there to help her. "Ever since I was a child," Françoise recalled, "my father had instilled in me that the real aristocracy consists of people who have enough inner resources with which to escape from any situation in which they are trapped and be free again. What I knew he was telling me after my grandmother's funeral was that if I had enough inner resources to leave, he would provide me with emotional support and also make a will in the children's favor."

It was the moment that more than any other crystallized for Françoise what had happened to her. "There is no question that when I decided to go and live with Pablo, mixed with my love and my admiration for him was a strong desire to rebel against my bourgeois upbringing, to destroy once and for all my father's authority over me. And now here was my father feeling pity for me and offering his money and his protection. And here I was, a mother and yet a child again. For the first time I realized that my emotional situation was common knowledge. It was very demeaning, especially when he said that he had followed in the newspapers what had been happening and it was clear to him that if Picasso had wanted to have an affair he could have done it quietly without everybody knowing and that therefore he had actually wanted me to know. So my father had made the diagnosis about how sick things were, and now I had to face that conclusion."

She returned to Vallauris feeling very vulnerable and alone and longing to talk to Picasso. But no sooner was she back than he left for a bullfight in Arles. While he was away, Madame Ramié took her aside again and very conspiratorially, and for her own good, of course, revealed to her that the woman Picasso was with at that very moment was Geneviève Laporte. Françoise now had one clear objective: to hear from Picasso's mouth what the truth was. "I want you to have the courage," she told him as soon as he was back, "to tell me the truth—when it started, how long it has been going on and whether you want it to continue. Then I will know what I want to do myself. For over a year now I haven't questioned you and you have had ample time to tell me yourself. Now I'm asking."

He denied everything. He told her that nothing had happened, that nothing had changed and that he had no idea what she was talking about. And then he added, "Instead of asking about things that don't exist, you should know something that's real: whenever a third person enters any relationship, from either side, both people have asked for it—one maybe actively, the other passively; but both, in their different ways, have invited the third person in."

She asked him if he meant that it was her fault, perhaps because of her bad health, perhaps through her passive participa-

PICASSO

tion, that a third person had entered their lives. He denied that there was a third person, and whichever way she asked the question, he denied it again and again. "That," Françoise said, "was *the* mistake. There are always mistakes from both sides in a relationship, but that was the unacceptable mistake. I had accepted his long and eventful past and all the ways in which it infringed on our lives, and I might even have accepted the present if he had been open about it, but to go on refusing to admit what everybody else was talking about, to go on treating me like a fool was to attempt to deprive me of whatever self-esteem I had left."

Like the thirteenth strike of a clock, it threw into question all that had gone before it. Suddenly Françoise began to see the tissue of lies that had preceded the big lie; one by one all the excuses and all the reasons he had given for disappearing for days on end became transparent. "It was the loss of innocence and the end of trust," she said. "From then on not a day passed that I did not discover one more corpse in one more dark corner of a closet. I felt as though I was stepping deeper and deeper into a slimy pond. My whole universe had crumbled, and my grandmother's death coming more or less at the same time had intensified my loneliness and my despair."

To sustain herself through that time, she began putting Geneviève Aliquot back in her paintings. "It's ironic," Françoise said, "that it was the discovery of his affair with one Geneviève that brought about the unraveling of everything, and that it was my exploring of my love for another Geneviève through my painting that began gradually to restore my balance and my trust in life. I did not see her or contact her, but the knowledge that there was someone who had loved me and whom I had loved so deeply helped me live from one day to the next."

14

"NOBODY LEAVES A MAN LIKE ME"

IN AUGUST 1951, seals were placed on the doors of the apartment in the rue La Boétie. The legal proceedings that disputed the city's right to evict Picasso had failed. There was an acute housing shortage, the apartment was vacant and he had not lived in it for years; but he was still incredulous that the authorities had insisted on treating him as one among equals before the law. He refused to have anything to do with the move. Sabartés, Inès and Marcel were put in charge of crating all the works that had been abandoned at the rue La Boétie under years of accumulated dust and disorder. He had recently bought two small apartments in the rue Gay-Lussac for Françoise and the children, and as the threat of requisition hovered over them too while they remained unoccupied, he considered moving the whole family there for a while.

But first, on October 25, his seventieth birthday was celebrated by the entire town of Vallauris. Absent from the throng was Marcel. After more than twenty-five years in Picasso's service, he had been fired for taking his wife and daughter on an outing sixty miles from Paris, one Sunday, and driving the Oldsmobile into a tree. Françoise tried in vain to save Marcel's job. "You can't fire a man," she told Picasso, "just because he had an accident like that. Not a good man like Marcel, who has been so faithful to you, and not after twenty-five years. It could have happened to anyone." Picasso was unrelenting: "He knows that he's not supposed to drive the car on his days off." Marcel, as always, spoke

his mind. "You think you can do anything you want to anybody," he cried. "After all I've been to you, you are firing me without giving me another chance. You have no heart. You'll suffer for that. You'll see. You'll drive every decent human being away. Next, it will be Mademoiselle who leaves you." And with that prophecy hovering in the air, Marcel walked out of Picasso's life. Quite unstirred, Picasso bought a Hotchkiss and told Paulo that if he wanted any more money from him, he had to take Marcel's place and become his driver. Paulo obeyed.

After his birthday celebrations were over, Picasso, suffering from an attack of lumbago, had to take to his bed. It was there that, in November, he received a visit from Giacometti, who immediately became a target for one of his dark moods. "You don't like me as much as you used to," he growled. "You never come to see me anymore." Not living in the South of France was an unacceptable excuse; distance was no obstacle where his true friends were concerned. "Then," James Lord wrote, "Picasso performed one of those abrupt, unpredictable pirouettes of style so typical of him. He extended an invitation. What a lovely thing it would be, he said, if Alberto came to stay with him there in Vallauris. That would be proof of friendship. . . . Alberto's own lodging, though he may never have known this, would have been a dank room in the basement, where Picasso had recently lodged Eluard and his ailing bride. The invitation, of course, was the crudest kind of taunt. Picasso gleefully pressed Alberto to accept. Twenty years before, when they had first met, Alberto had wanted to make sure Picasso saw that he was not on his knees. Picasso had seen, had appreciated, but his craving to see people in that posture had not yielded to the years but only become more arrogant, and now he wanted a show of force to prove he could make Giacometti comply with a condescending caprice."

To add to the capriciousness of the invitation, Picasso did not extend it to Giacometti's wife, but suggested instead that she stay in a hotel room in Cannes or Antibes. And to avoid any delay in the execution of his whims, he wanted Tériade, who had accompanied Giacometti, to go back forthwith and fetch his suitcases.

But it was not to be. Giacometti refused to be manipulated. Picasso was furious. "I can't stand people who say no to me," he shouted.

"And I'm not interested in having a relationship with you if I cannot say yes or no as I please," replied Giacometti.

"I have reached a point in my life," Picasso continued, "where I don't want any criticism from anyone."

Giacometti had the last word: "Then you have reached the point when I go and do not return." That was the end of their friendship. Giacometti's view of Picasso the man had always been damning. No less devastating was his summing up, perhaps in a moment of wrath, of Picasso the artist: "Picasso altogether bad, completely beside the point from the beginning except for Cubist period and even that half misunderstood. French artist illustrator journalistic. . . . Ugly. Old-fashioned vulgar without sensitivity horrible in color or non-color. *Very bad painter once and for all.*"

Picasso was doing his best to cut himself off from all his friends who had any kind of spirit and mind of their own—who refused to say yes to him automatically. In this way he was able to make true his constant complaint that he was alone and there was nobody out there to match him. He had already fallen out with Chagall, whom he accused of not returning to his native Russia because there was no money to be made there. "I'm like a mosquito buzzing around Picasso," Chagall complained. "I sting him once, I sting him twice, and bang, he squashes me." Later on, when Picasso ran into Chagall in Antibes, he proudly waved his Communist Party card at him. "Yes," was Chagall's comeback, "but the day they oblige you to make paintings you don't want . . . ?"

"They never will," said Picasso.

"Then you see very well," Chagall said, "that you are no more Communist than I am."

Chagall's view of Picasso the artist was not much kinder than Giacometti's. "What a genius, that Picasso," he said. "It's a pity he doesn't paint." One night Françoise and Picasso ran into Chagall's daughter Ida at the ballet. Chagall's wife had just left him. "Papa is so unhappy," Ida told them, which provoked much laughter from Picasso. "Don't laugh," she reproached him; "it could happen to you." Picasso laughed even more heartily. "That's the most ridiculous thing I've ever heard," he said.

As Pablo and Françoise began their first winter together in the rue Gay-Lussac, the idea that she might leave him did indeed

seem ridiculous. She was unhappy, but had convinced herself that by staying she was doing the right thing, that instead of seeking her personal happiness she should do her duty by her children and by Picasso, at least in terms of providing some stability for him and bringing all the different elements of his life together. She even suggested that they get a big house and bring their own children and Marie-Thérèse and Maya and Paulo and Emilienne and Pablito and his newborn sister all under one roof. "My feeling was that we were a ship in a tempest and that we should at least try to save the people even if it meant jettisoning the cargo—the casual affairs and the lies and the unnecessary mysteries. I felt that with any new person aboard, however casual and short-lasting Pablo's involvement, there was less affection and less caring to go around. I had seen clearly his pattern of telling one person that everything wrong was on account of someone else in his life and I thought that by bringing everyone together we could put an end to that. We could have got a house big enough for everybody to have their own wing, and as far as I was concerned, Marie-Thérèse could oversee the whole household. So my attempt was at a sort of integration rather than the disintegration that was getting worse and worse."

He was aghast at her suggestion, and so was Marie-Thérèse. "She still thought," said Françoise, "that I would finally go and Pablo would be all hers. That's what he had led her to believe. As for Pablo, he was infuriated by my idea because underneath it all he was pretty conventional and trapped in his old tricks, in a vicious circle of lies and guilt, recriminations and self-pity."

Nevertheless, Françoise contacted a real estate agent and started looking for a big house in Paris. She even found one. "It was a big mansion at the Cité de Varennes," she said, "a palace compared with the rue Gay-Lussac, which was cramped and simply awful. I thought that living our eccentric life might be easier if at least we were living it in comfort. I suppose when you are desperate you are prepared to pin your hopes on anything. I finally persuaded Pablo to come and look at it. He got out of it by saying that he didn't like the style of architecture."

His eighth decade had not begun well, what with his lumbago attack, the inescapable awareness of old age and the need to

return to Paris to occupy the small apartments in the rue Gay-Lussac. The vital current that normally passed through him had short-circuited, and he was left drained and morose, unable to paint or even to write. He was suffering from an interminable cold and spent listless hours watching Françoise work, preparing for her spring exhibition at Kahnweiler's. The children too were sick, first with colds and then with measles, and altogether there was a dark cloud hovering over the rue Gay-Lussac.

Françoise had her thirtieth birthday in November, and his birthday present was to inform her that "any girl of eighteen is more beautiful than you." But over the last few months, she had gradually learned to shut off a part of herself, and what he said or did no longer hurt as much. "There was a crippling that took place," she said, "but at first I did not even notice it. I had tried to stop the pain of the betrayal I felt and in the process I had amputated a part of myself and of our relationship." She had been brought up to place a high premium on dignity and self-control, and now she continued to maintain all the forms of their life together, saying nothing about her pain, expressing none of her needs. "You go silent on me," Picasso complained once, "become sarcastic, a little bitter, aloof and cold. I'd like just once to see you spill your guts out on the table, laugh, cry—play *my* game." But she did not. Instead, she grew more aloof and distant. And she threw herself into her work for her first important show.

There was a guest book at the gallery with the title in Louise Leiris' handwriting: *Exposition Françoise Gilot*. Underneath is the date of the opening: 1 April 1952. The first entry is Paul Eluard's, the fifth Sabartés' and the seventh Picasso's. Three months later, Paul and Dominique Eluard wrote to Françoise saying how much they were missing her and Picasso in the South of France; a postscript summed up the feeling her show had aroused: "We are still under the strong impression your exhibition has made on us. And we are not alone; keep up the good work, Françoise." Cocteau was also impressed. "Françoise's painting," he wrote, "uses Picasso's syntax, but with a feminine vocabulary, full of grace. This syntax provides a backbone to her painting." And soon after the opening of her exhibition, she received a request from the state to buy at a reduced price a still-

life that a certain Monsieur Cogniat, who went by the very French title of Principal Inspector of Fine Arts, had particularly liked at her show.

Back in Vallauris, Françoise, encouraged by the reception of her show, devoted even more time to painting. Picasso, still unable to work, continued instead his forays around the French countryside, from bullfight to bullfight and from woman to woman, while Françoise locked herself for still longer hours in her studio. Paloma, who loved to sleep, never complained. In fact, she was so cooperative that she earned an accolade from her father: "She'll be a perfect woman. Passive and submissive. That's the way all girls should be. They ought to stay asleep just like that until they're twenty-one."

Claude, on the other hand, wanted a lot of attention and would always get it, sometimes by being rebellious and sometimes by being seductive. One day when Françoise was deep in painting, he knocked on her studio door. "Yes," Françoise answered absentmindedly. "Mama, I love you," Claude said, and when his mother replied, "I love you too, my darling" and went on painting, he waited for a few minutes and then tried another tack. "Mama, I like your painting," he said. "Thank you, darling. You're an angel," she replied, but still kept the door closed. Claude was not going to admit defeat: "Mama, what you do is very nice. It's got fantasy in it but it's not fantastic." "That stayed my hand," Françoise recalled, "but I said nothing. He must have felt me hesitate. He spoke up, louder now. 'It's better than Papa's,' he said. I went to the door and let him in."

Not surprisingly, the children too spent many hours painting and drawing. Claude, who was uncannily astute at the age of five, knew how to provoke a reaction from his father by signing what he painted "Henri Matisse" and then looking up innocently and exclaiming: "Now, there's a *real* painter!" It never failed to work. Claude wanted to rile his father; Paloma wanted to adore him. Whenever, at mealtimes, Picasso started drawing on the tablecloth or doing his magic tricks with paper towels and wine corks and flower petals, she would just watch, utterly absorbed and fascinated. Sometimes she herself would start drawing. Her father encouraged her but never advised her. He was loath to impede the freedom and spontaneity of a child's drawing with

expert direction. "When I was their age," he said after visiting a children's exhibition, "I could draw like Raphael, but it took me a lifetime to learn to draw like them." When Inès used to take to him drawings her son had done, he would draw things on the margins but never correct the little boy's creations.

When the celebrated bullfighter Luis Miguel Dominguín asked him for "a few basic notions of painting," he adopted a similar attitude: "The time will come when you will suddenly realize that without any help from outside, you've learned all you need to know. Until then anything I might explain to you would be of absolutely no use." Picasso may have trusted in very little, but he did trust a certain instinctive naturalness in painting. "Enough of Art," he said to Hélène Parmelin. "It's Art that kills us. People no longer want to do painting: they make Art. People want Art. And they are given it. But the less Art there is in painting the more painting there is."

"Despite the practice of a science, almost forgotten because it is intuitive, Picasso's art is reunited with the childish scribbles from that period of life when drawing is not yet a language," Maurice Raynal wrote in *Le Point* in October 1952. At the same time Picasso was completing the *War and Peace* murals for the chapel in Vallauris, where his art was truly "reunited with the childish scribbles." "None of my paintings," he told Claude Roy, "has been painted with more speed as far as the covered surface. . . . In modern painting, every touch becomes an act of precision and is part of a clockwork. . . . I wanted to paint as one writes, to paint as quickly and fast as the thought happens, within the rhythm of the imagination." He started with *War*: "What imposed itself first in my mind was the awkward and jolting course of one of those provincial hearses that one sees passing in the streets of little towns, so pitiful and screeching. I began to paint from the right side, and it's around this image that the rest of the painting was constructed." There is a harnessed battle steed in *War*, and in *Peace* fish in a bird cage and birds in an aquarium—an affirmation of limitless possibilities.

While he was working on *War and Peace*, Picasso remarked admiringly to Cocteau that Matisse had never succumbed to the solemnity of the old. And he wanted to make sure that he did not either. It was one more way to outmaneuver death. Bullfights

were another. The bullfighter's duel with death was his own. "A bullfighter can never see the work of art that he is making," he said. "He has no chance to correct it as a painter or a writer has. He cannot hear it as a musician can. He can only feel it and hear the crowd's reaction to it. When he feels it and knows that it is great, it takes hold of him so that nothing else in the world matters."

Picasso had known this urgency and this absorption in his studio; he relived it in the arena where the stakes were life and death. "It was one thing," Hemingway wrote of Dominguín, "to live to be the number one in the world in his profession and have that be the one true belief in his life. It was another thing to be almost killed each time he went out to prove it." The great bullfighters looked as though they had thrown the fear of death away—the greatest perhaps had—so maybe they had a secret that could armor Picasso against the great adversary, or at least against the growing fear that the adversary instilled. Going to a bullfight meant for Picasso observing all the rites, from inspecting the bulls and discussing with the breeder their relative merits to attending the solemn ritual, for those honored enough to be invited, of the dressing of the matadors in their magnificent embroidered costumes. Picasso, who was addicted to all sorts of rituals of good luck himself—including never leaving the house for a trip until a minute's silence had been observed by all, even the children—felt that a bullfight lost much of its power unless he had observed its every rite.

"The first matador," Françoise wrote in a letter home, "always offers up the bull to Picasso—that is to say, if the bull is killed, the honor goes to him." In the same letter, she described a bullfight they had gone to in Arles where one of the bullfighters was Conchita Cintrón, a young Chilean girl who, that day, fought two bulls from horseback: "She was extremely beautiful and mounted with great elegance. She dismounted only to kill the bulls. What's funny is that after the fight, since we were with the *mayoral*, the man who had brought the bulls from Spain and was wearing his distinctive costume, several people mistook me for her and had me sign autographs." Picasso had so loved it that when Françoise informed her "fans" they had got the wrong person, he told her to "stop arguing and just sign." She did, and

they all left happy. "One of the men even told me knowingly," Françoise recalled, "that he understood very well why I wanted to preserve my anonymity by signing with another name, but he wasn't fooled: *he* knew that I was Conchita Cintrón."

"You're going to think that I have bloodthirsty tastes," Françoise wrote at the end of her long letter, "but it's the combination of the rites, the spectacle, the crowd, the sun and the dust that all together make such a stunning mixture. Also, it's a little like the times I was competing on horseback—there is a nobility in all this, a chivalrousness in front of a very real danger that transcends the ordinary."

Toward the end of 1952, she was facing some extraordinary challenges in her own life. More than ever, she lived with Picasso in a state of armed neutrality in which anything short of complete submission on her part was perceived as capital disloyalty. One day he brought back from the foundry three small sculptures he had made to be worn as necklaces and gave them to her. She took two of them, told him how much she loved them, put one on right away and gave him back the third, suggesting that he give it to somebody else. Zette Leiris, who was there visiting them, said she would love to have it; she added that it was really beautiful, and in her opinion, the best of the three. "You see," he said, "there are people who appreciate all that I do and who are not choosy like you. How dare you find something *I* did ugly? Well, I'm giving it to Zette and that's that."

"I'm very happy that you are," Françoise said. "So she's pleased, I'm pleased, you're pleased—everybody is pleased."

"I'm not at all pleased," he protested.

"He was, in fact, furious," Françoise recalled, "all the more so because he really knew that the heavy-handed satyr's head of the necklace was a miss. But he no longer wanted to be challenged about the quality of his work. And there were enough people around telling him that everything was wonderful for him not to have to be. The truth, of course, is that one Picasso was not as good as another; some were overwhelming, others were unfinished or mediocre, and to say that they were all great was to belittle those that were. But he absolutely hated it if I ever said that one work was more beautiful than another; he could not bear to hear that there was a difference in the quality of his works.

But there was, and he knew it, and if you didn't, or pretended you didn't, he was in fact full of contempt for your judgment. So you couldn't win; there were only different ways to lose. But he couldn't win either. He attached no importance to the uncritical adulation of everyone around him, yet the more he doubted the direction and the power of his work, the more he cut himself off from anything but adulation. And grasping for a yardstick for the value of his work, he began to equate its worth with the money he could get for it. It was a bad confusion for an artist to make, since money has nothing to do with the creative process, yet he talked of his work more and more in terms of money."

At the end of October 1952, Picasso announced that he was leaving for Paris. Putting her pride aside, Françoise asked him again and again to take her with him. He refused, and for the first time she warned him that the more time they spent apart, the greater the chance that she would leave him. He laughed at the idea: "Nobody leaves a man like me. Besides, people who threaten things like that never do them." And he left for Paris. Despite all the defenses she had built over the last year, Françoise was shattered. "Suddenly," she said, "I found myself on the other side of the Magic Mountain that my deep love for him had created. At the beginning of our relationship, he often talked about ascending our Magic Mountain together. And even after all the disillusionment and the pain of the last year, there was still something left of the Magic Mountain. Now I was on the other side of it, and during the weeks Pablo was in Paris I realized that I was out of love and that the Magic Mountain had disappeared."

On November 18, Picasso called Françoise from Paris. Eluard was dead; he had died of angina. For the last twenty years, he had been the closest thing to an intimate friend in Picasso's life. "In fact," Dominique Eluard said, "it was Eluard who was a friend to Picasso; and the other way around only to the extent that Picasso was capable of friendship." At his funeral, Picasso was seated next to Eluard's widow, both of them surrounded by Party luminaries. It was the Party that had organized the funeral, and it was Eluard the Party member, rather than Eluard the poet, who was the principal subject of the day's tributes. "The whole world is there, composing, decomposing and recomposing," Eluard had written of Picasso's work. His death added to the

decomposition in Picasso's life, depriving him of a friend whose brilliance he could respect, especially since he was willing to subordinate his life to Picasso's, and to offer him, in return for his heavily qualified friendship, unconditional love.

Back in Vallauris, Picasso was confronted with the possibility of another loss. During his absence, Matsie Hadjilazaros had come to stay with Françoise and had urged her to leave him. Françoise, still torn, issued another warning: she told him that she could no longer find any "deep meaning" in their union and therefore could see "no reason for staying." It was a warning but also a covert plea that maybe there was still time to resurrect some meaning in their union and give her a reason for staying. Picasso's response was to act as though he wanted to give her every possible reason to leave. His life during the last months of 1952 became a comedy of Don Juanism indulged—an old man darting about the countryside, driven not so much by desire as by the fear of waning passion. It turned out to be an occupation infinitely more exhausting than work, and each time he returned to La Galloise, haggard and worn out, he would ask Françoise defiantly if she *still* wanted to leave him. "I began to despise him," she said, "and I could not forgive him for turning the man I had loved into the man I despised. He had been transformed into a dirty old man, and it was all so grotesque and so ridiculous that I could no longer even be jealous."

At the same time that her love for him died, so did her desire, and the mere thought of going to bed with him filled her with disgust. She began to find his continuing sexual demands repugnant and longed for his absences as fervently as she had once longed for him to return home. "Our relationship had lost all poetry and romance, so sex had become simply sordid," she said. "This was no progressive cooling and dwindling of desire; this was a real signal from the deep that something had snapped forever. What made it particularly disturbing was that the sexual part of our relationship had always been a very strong bond between us. It might have helped if I had gone to see an analyst who perhaps could have shown me a way through the accumulated resentments, but I never did. Instead, I went on feeling the whole weight of the unfairness. I'm so much younger, I thought, and this should be my season, the season of spring; instead, I'm being

trodden underfoot. I had somehow to wade my way through all these bitter thoughts and feelings, so I asked him to let me take the children and spend the next six months in the mountains. I thought that there I could reflect on everything without having to face each night that he was at home both the point of contention that sex had become between us and the realization that I had become sexually allergic to him. He refused categorically."

Ever since her childhood, Françoise had had an almost magical belief that the sacred quality of certain things depended on their integrity, on the fact that they were whole. She could not bear to have anything chipped around her, whether it was eighteenth-century porcelain or an ordinary mug that she loved. Her mother's advice was that if she cared so much about things being chipped, she should preserve them in a case and not use them. "But I could never do that," she explained. "The more I love something, the more I want to use it every day, and if it breaks or chips, then I just throw it away because I can't stand the idea of it no longer being whole. It was the same with Pablo. If our relationship could not have a certain wholeness, if it had degenerated into something trivial, then I would rather have nothing at all. I have always been a little absolute about that, a little too absolute and too intense. I know that it's not a very mature approach to life, but that's how I felt."

Despite her feelings, she went on working throughout the fall of 1952 to help prepare the big exhibitions of Picasso's work in Rome and Milan. To strengthen herself and find some harmony when all was in turmoil, she would often go to a small Roman Catholic church on the Croisette in Cannes. "It was very peaceful and always filled with flowers," she recalled. "And every time I went, I saw Olga there praying. She obviously preferred this little church to the Orthodox one, where I would have expected her to go. We never spoke, but in the dark of the church I felt that we mentally made peace with each other."

In Vallauris she was almost never with Picasso at his studio or at the pottery. So she did not know that he was spending quite a lot of time, at the pottery, chatting in Spanish with a young salesgirl while he was working. She was a cousin of Madame Ramié's in her late twenties who had been brought in to help out at the pottery at the end of the tourist season, when there was

almost nothing for her to do except amuse Picasso with her broken Spanish. She came from the Roussillon and was tiny—at least two inches shorter than Picasso—with big hazel eyes. Recently divorced, she had moved, together with her six-year-old daughter, to a house between Golfe-Juan and Juan-les-Pins. The house was called Le Ziquet—"the little goat"—and Picasso's nickname for her was Madame Z. Her name was Jacqueline Hutin, but soon after arriving in Vallauris, she returned to her maiden name, and reborn as Jacqueline Roque, she wiped from her life both her engineer husband and all the time she had lived with him in Africa. Catherine Hutin, her daughter, was the only remaining link to that life and to her past. And Jacqueline made sure that she was no distraction from her apparent goal of distracting Monsieur Picasso. Madame Ramié was more than happy with the way her newest salesgirl was occupying her time.

Toward the end of the year, Françoise went to Paris to discuss the sets and costumes she had been commissioned to design for Janine Charrat's ballet *Heracles*, which was to open in the spring. While she was there, she wrote a letter to Picasso telling him all the things that she had had such difficulty expressing to him in person: the tragedy of love denied that their relationship had become; the ways in which he had disfigured and violated their love; his betrayal not just of her and of what they had had together but, even more important, of what their love could have bloomed into; all the anguish he had caused her; and what had been the hardest thing for her to accept, his continued refusal to admit the truth about the other women in his life, even after she had confronted him with it. She ended the letter by saying that she would not return to Vallauris and to him unless he washed his hands clean—unless he finally told the truth.

He rushed to Paris. He knew, with the unerring instinct of all great manipulators, that the time had come for a theatrical confession. He arrived at the rue Gay-Lussac holding her letter in his hand. "Everything you wrote in the letter is the truth," he admitted. "And it's such a beautiful letter—you write so well. And not at all in a way that is demeaning to me." Then he cried. For the first time since she had known him, he cried and asked for forgiveness. He also promised that he would immediately end all affairs. And to prove that he meant it, he told her that at that

very moment Geneviève Laporte was waiting for him in the restaurant around the corner and that he was going to go down and tell her that it was over. He went and quickly came back and cried some more. But Françoise did not cry; she realized that just as he was leaving Vallauris to come to her to confess and ask for forgiveness, he had made an appointment to meet Geneviève in the neighborhood restaurant. Much as she would have loved to, Françoise could not believe that the man facing her with tears streaming down his face was a transformed man. Yet at the same time she decided, with her eyes open, to try once again. Yes, she said, she would stay and give their life together one more chance.

The next day at six in the evening as she passed the restaurant, Françoise saw Geneviève Laporte through the window, alone and waiting. The next day, at the same time, she was still waiting; and the day after that. For two hours each night she waited for the man who had told her "I've never wept over a woman," as he wiped his tears and left their "haven of bliss" to return to Françoise. He never came back to the restaurant, which had been one of their regular meeting places—not because he had really turned a new page, but very simply because he had had his fill of her. And there were so many others waiting in line, and time was running out.

"Picasso was a sun all on his own," Geneviève Laporte wrote in her memoirs. "He lit up, burned, consumed and reduced to ashes anyone who approached him, not even sparing himself." Like Marie-Thérèse before her, and encouraged by all the lies Picasso had fed her during their time together, she invented a lie to sustain herself: "How can I find the courage to write: 'I believe that I was the only profound love of Picasso's life and probably the last one?' "

So Geneviève Laporte joined the ranks of all those—men, women and children—who believed that they were the only profound love of a man who was incapable of loving shallowly, let alone profoundly. She also joined the ranks of those happy to offer themselves as a sacrifice to Picasso's sun. Long after she had finally given up waiting at the restaurant on the rue Gay-Lussac, her brief affair with Picasso continued to be the great event of her life; for her, it was clearly preferable to be "reduced to ashes" by his sun than to stay alive and whole out of his orbit.

Not so for Françoise. Back in Vallauris, she no longer allowed her life to revolve around him and his work. When in the morning he would go through his usual routine of self-pity, of how awful everything and everybody was, she no longer exhausted herself trying to alleviate his despair. Instead, she agreed with him and even predicted that everything would probably get worse. And then she went about her own business. After this had continued for days, by which time Picasso felt trapped in his own net, he threatened to commit suicide. "That would certainly be an effective solution to all your problems," she told him, determined not to be sucked into the melodrama, "and I plan to do nothing to stop you."

"You, who were so sweet and gentle, what have you become?" he asked in utter disbelief. "You've lost the Magic Mountain. You used to be a kind of somnambulist, walking on the edge of the roof without realizing it, living in a dream or a spell."

He was more right than even he knew. She *had* been under a spell—and unlike everyone else who had been under the same spell, she was waking from it. And she *had* lost the Magic Mountain and, still unsure of her bearings without it, was groping toward reality. In March 1953, he painted two pictures of Françoise attacking his dog Yan that were violent expressions of how he felt as, for the first time in his life, he was no longer in control of his relationship with a woman. "The dog's helplessness as he lies pinned to the floor," wrote Mary Gedo, "may reflect Picasso's own felt impotence in coping with his mistress."

In the same month he experienced his impotence in coping with the Communist Party. When he had first joined, he was overcome by an almost limitless sense of power; not only had he been treated like a hero of the people but he had successfully tested his belief, in the face of Kahnweiler's fears, that even in the middle of the Cold War, the bourgeois world he despised would not buy one Picasso fewer because he was a member of the Communist Party. In the last nine years, he had allowed himself to be turned into an instrument of Communist propaganda, attending conferences, giving interviews, letting his works be used for posters, providing drawings and lithographs for the chief Party organs, *Les Lettres Françaises* and *L'Humanité*. He had even made a cheerful drawing for the seventieth birthday of

the man who, in no more than the time Picasso had been a member of the Party, had been personally responsible for the murder of half a million people. On the drawing was Picasso's handwritten salutation: "To your health, comrade Stalin."

On March 5, at the age of seventy-four, Stalin died of a stroke which had left him speechless three days earlier. Aragon sent a telegram to Picasso in Vallauris asking urgently for a portrait of Stalin; it had to be ready by the next day. Working from a photograph of Stalin in 1903, Picasso produced a drawing that Françoise told him looked more like her father than Stalin. "Maybe if I tried to do a portrait of your father," he said, laughing, "it might look more like Stalin."

The drawing was published in the next issue of *Les Lettres Françaises* under the headline "What We Owe to Stalin." The furor that followed, though certainly laughable, was no laughing matter for the outraged Party faithful for whom Picasso's drawing was not sufficiently statesmanlike and dignified. On March 18, *L'Humanité* published on its front page a communiqué from the Party leadership: "The Secretariat of the French Communist Party categorically disapproves of the publication in the March 12 issue of *Les Lettres Françaises* of comrade Picasso's portrait of the great Stalin. Without questioning the integrity of the great artist Picasso, whose attachment to the cause of the working class is known to all, the Secretariat of the French Communist Party regrets that comrade Aragon, a member of the Central Committee and the director of *Les Lettres Françaises*, which otherwise leads a courageous fight for the development of realist art, allowed this publication. The Secretariat of the French Communist Party wishes to extend its thanks and congratulations to the numerous comrades who have immediately let the Central Committee know of their disapprobation. A copy of their letters will be forwarded to comrades Aragon and Picasso."

The following day, Aragon reproduced the communiqué in *Les Lettres Françaises* together with his own "self-criticism," in which, toadlike, he thanked the Party leaders for their rebuke and announced that he had made it his own. To complete his public humiliation, he published, as the Secretariat had directed him to do, excerpts from the outraged letters sent from the different Communist cells: "We found in the portrait neither the

genius nor the ever-alert intelligence, nor the kindness, nor the humor one sees in all the photographs of comrade Stalin . . ."; "Our comrade Picasso has altogether forgotten that he was first and foremost addressing himself to the workers in mourning, struck by this terrible blow . . ."; "We consider this a political mistake and because we love and honor Stalin, who will forever live in us, we think it is our duty as Communists to tell you what we think. . . ." There was also a Salieri-like letter from André Fougeron, the Party's model social-realist painter, who had finally found an opportunity to vent his bitterness at his celebrated colleague and comrade: "I wish to thank the Secretariat of the Party regarding its criticism of comrade Picasso's drawing which pretended to portray the great Stalin. The correction was absolutely necessary. . . . We were shocked, my wife and I, when we saw this drawing . . . the goodness and nobility which characterize Stalin to the highest degree are completely absent. . . . It would have been better to reproduce a photograph, or better still, the honest rendering of a Soviet artist—and fortunately there is no lack of them in the motherland—of the man whose terrible passing has put conscious humanity in mourning and has made it clench its fists before returning to the struggle."

Picasso kept mute. A few years later, he told Cocteau that "a government which would punish a painter for choosing the wrong color or the wrong line would be an impressive government." It was a statement that gave rare expression to that guilt-ridden part of him which wanted to be punished and was impressed with anyone strong enough to do it. He did not resign from the Party, nor did he defend himself or artistic freedom. Only after the uproar had died down did he ask angrily: "How can Aragon, a poet, endorse the view that it is the public which should be the judge of reality?" But at the height of the controversy, he fell back on his routine response concerning any problems with the Party: "There are always quarrels within a family." When the press descended on Vallauris and surrounded La Galloise, the artist-rebel was, in a remarkable turnabout, transformed into the obedient Party member. "I suppose it was the Party's right to condemn me," he told the assembled reporters, "but it's certainly the result of a misunderstanding, because I had no bad intention. If my drawing shocked or displeased anybody,

that's something else again. It's an aesthetic matter, which can't be judged from a political point of view."

There were many who refused to treat Picasso's membership and continued support of the Communist Party as an artist's whimsical eccentricity. Breton was one of them. When Picasso ran into him once in Golfe-Juan, he even refused to shake hands with him: "I don't approve of your joining the Communist Party nor with the stand you have taken concerning the purges of intellectuals after the Liberation." But Breton was no longer around, nor was Giacometti, nor Braque, nor anyone else who might raise a brazen dissenting voice.

At the end of March, Françoise left for Paris alone to work on the sets and costumes for *Heracles*. In her free moments, she saw a lot of Kostas Axelos. "I was so lonely at the time, he was really a godsend," she said. "At first it seemed so natural and convenient, I didn't think at all about what it might lead to." Then, gradually, he started to challenge all her reasons for staying with Picasso. When she talked of duty, he told her that she was really a coward, avoiding all the trials of her own generation by living with someone who had soared above the battle. When she talked of being prepared to sacrifice her personal happiness, he told her that she was in fact choosing what was most convenient, a position that gave her a lot of power by association. When she talked of not letting down her children, he talked of her betrayal of herself. Trained in the arts of persuasion, he was a formidable challenger. "He fought me inch by inch, personally and philosophically," Françoise said, "with all the verbal weapons in his arsenal. Greece had always held a fascination for me, and here was Kostas, the young, handsome philosopher-prince!"

At the end of April, Picasso arrived in Paris with the children. He knew that they were powerful reminders of the life they had built together and powerful allies, silently pleading his case. He dutifully attended the opening night of *Heracles*, sitting in a box with Françoise and Maya. At the end of the performance, Françoise left the box to go on stage to take a bow with the choreographer and the conductor. Kostas Axelos was waiting for her backstage; he kissed her, congratulated her and disappeared into the night, while Françoise went on with Picasso to a gala dinner being given by André Boll, who had written the story of the

ballet, in his elegant apartment on the Quai d'Orsay. It was her night, and as the guests were swarming around her to compliment and congratulate her, Picasso could be overheard muttering to himself: "Ballets always bring me bad luck."

At the rue Gay-Lussac, Picasso was writing poems in Spanish full of loneliness, violence and pain: "The black small mules of the burial started to ring the bells and to make coolness in the fire . . . in a corner sitting or rather lying down nude with loose ends face-up sliced to shreds by the colors of the rainbow . . . a boy of cardboard vomits his bullfighter's garb and turns on the light bulbs of the oil texture of the road . . . the wheel plants its teeth in the wound and sinks its stare around the well of the eye . . . the fingernails beating the roof with sun."

"It was suddenly a complete reversal of what our life had been like," Françoise said. "He was the one now waiting until I was ready to go back to Vallauris, and when I told him that I wanted to spend more time in Paris alone, he took the children and returned to the South of France to wait for me there. Kostas and I were still intimate friends, but nothing more. One night in June, soon after Pablo had left, we went to see a Jacques Tati movie, Les Vacances de Monsieur Hulot. I found it so silly that after half an hour we left. That night was the turning point in our relationship. Kostas put aside the philosophical arguments and addressed me man to woman. He told me that he loved me and that even though I didn't love him yet, he could, for a while, love for both of us and help sustain me while I mustered enough strength to leave Pablo. We became lovers—I think less because of compelling sexual desire and more because he wanted to assert, before I returned to Vallauris, that our relationship was real on many levels, including the sexual one."

As soon as she returned to Vallauris, she was inundated by telegrams and letters from Axelos, all of them intended to strengthen her resolve and all of them ending "I love you." Picasso asked her what was going on; she told him and added that she had decided to leave with the children on September 30. "I had finally reached the conclusion that my life with Pablo was like a sickness," she said, "and I knew that I had to eliminate everything that was sick in me." She enrolled the children at the Ecole Alsacienne in Paris and even made the train reservations,

but Picasso was still convinced that it was all for show. He repeated again and again that nobody leaves a man like him, a challenge that only made her all the more eager to leave. "Wait and see," she told him finally. "If nobody leaves a man like you, you are, in that case, going to see something you have not seen before."

It was a hot, tense summer, eased by the presence of Maya, who both understood and had the ability to clown her way through all awkward family moments. The arrival of Totote Hugué, Manolo's widow, and Rosita, her adopted daughter, also helped to lessen the tension for a while. They had brought with them the Count and Countess de Lazerme, who immediately invited Picasso and Françoise to visit them in Perpignan. Françoise declined; Picasso had made all too clear his fascination with the tall, beautiful Countess, and she saw no reason to add excitement to his new pursuit by her presence.

On August 12, he arrived in Perpignan with Paulo and Maya. It was the closest he had been to Spain for a long time. "He loved to take walks up a mountainous path," said Paule de Lazerme, who often accompanied him, "and stop for a long time at a plateau from which he could see Spain. He kept talking about Spain, and he loved to listen to the people in the streets speaking Catalan." Both Paule and Jacques de Lazerme were clearly thrilled by his presence, and to entice him back, they transformed the attic of their vast house into a studio for him. "Everything he touched came to life," Paule de Lazerme recalled wistfully. "Everything was always so different with him, improvised from one day to the next. I cannot understand why Françoise wanted to leave."

Picasso spent most of August and September going back and forth between Vallauris and Perpignan, with side trips to Nîmes and Collioure for the bullfights. He returned home from his last trip to Perpignan on September 29, and bragged to Françoise that in Perpignan he had been once again inseparable from Madame de Lazerme. Both that night and the next morning, when Françoise was busy with last-minute packing for herself and the children, he refused to face the fact that she was indeed leaving—as if his refusal to empower reality with his attention would make it go away. He watched silently and incredulously as the taxi arrived to take them to the station, the driver helped them with their

bags, and first the children and then Françoise got in. All along, he had refused to say goodbye; as the taxi pulled away, he uttered one word only, "Merde," and stalked back into the house.

In his angry grief, he, who in the past had talked to no one about his private life, now talked to everyone. And the court, already pulling long faces as the rumors of Françoise's affair with Axelos and her decision to leave had begun to circulate, now pulled out the knives. Feeding Picasso's outrage became everybody's favorite occupation that fall. Françoise was accused of selfishness, of wickedness and, worst of all, of having failed to understand the genius of our time. "The gossip about her was horrible," said Dominique Desanti, "but what it all came down to was that you just *don't* leave Picasso. She was not an intimate friend of mine at the time and I did not know all the reasons that made her decide to leave, but I felt for her as a woman and I understood her fight to be herself. As I could not have stood living with Picasso for a week, I had really admired her for having stood it for years. And I also knew that at a certain moment, if she was going to survive, let alone unfold and expand, she had to leave."

The other voice raised in Françoise's defense belonged to Elsa Triolet, Aragon's wife. She told everybody that leaving Picasso was the most courageous thing Françoise could have done, and dedicated her latest book to her with the following inscription: "No one loves anyone anymore, everybody goes to bed with everybody else, and even when it does not appear to be so, it really is so."

The story of their separation made great copy for gossip columnists, all the more so because of the presence of a young, handsome Greek in the background. "Their favorite quote," Françoise said, "was a remark I never made: 'I could not go on living with a historical monument.'" In fact, she ignored all requests for interviews and concentrated on creating her life without Picasso. Things had not gone at all as she expected. She had asked Picasso to speak to no one about their plans; to try to find between them a new way of relating to each other, in friendship, if not in love. But she soon realized that this was going to be impossible. "He could not bear the thought that I was free to leave him, that I was not dependent on him for my life. He was a sadist, and what

thrilled him was to apply the screw; and here I was depriving him of the opportunity. Also, he who always needed to understand everything in depth, who like a child took everything apart to see what was hidden inside, felt that I had removed myself from the scene before he had finished with me. Nobody before had done that to him. It was defeat, old age, death."

Françoise's decision to abandon him as death was drawing closer was indeed a symbol of life leaving him, of death displacing the vitality that had always been his hallmark. He talked of her treachery to anyone who would listen, as if through venting his anger, he could master his grief. But he suffered alone, and on November 28, a month after his seventy-second birthday, he stopped talking, took his despair in hand and started working. He worked feverishly, and in just over two months produced one hundred eighty drawings. Michel Leiris called the series a "visual diary of a hateful season in hell, a crisis in his private life leading him to question everything."

Françoise had lamented his transformation in the last years of their life together into a grotesque old man she despised. Now that she was gone, as in a revelation brought about by the bleak horror of his anguish, he mercilessly saw himself as she had seen him—only more so. In these confessional drawings, he is not only old and grotesque, but ugly, dwarfish, flabby and pathetic, trying to capture through his art the vitality that eludes him in life. He is extremely skillful, a superb craftsman, full of imagination and wit in all the different ways he portrays his model and himself, but an air of meaninglessness hangs over the whole enterprise of his art. And the young woman, the eternal feminine in many different guises and disguises, knows it. She is amused by him, but cannot take him seriously as an artist and certainly not as a lover. She is much more delighted playing with a monkey or fondling a cat, with its fur, as Rebecca West wrote, "soft against her smooth flesh, its nervous energy crackling against her serenity, her faculty of acceptance bringing the little animal into unity with herself. She is as strongly affirmative as a Greek goddess." She is the tree of life and the tree of knowledge. And the painter's despair is not just that he is an old man crying out against having to give up "his place at the feast of sensual pleasure"; it is, much more tragically, that he is an old man who will

die without knowing why he has lived and why he has painted. Neither his gifts nor his ceaseless sexual adventures have brought him any closer to the secret of life which the young woman seems to know and from which she seems to draw her serenity and her deep acceptance of everything, including the absurd little old man.

"Never will Picasso look like the photograph of Matisse, with his white goatee, spectacles and hat, offering a sweeter vision of 'a happy old age,' in harmony with the world," wrote the art historian Christine Piot. "The Spaniard always had the haughty reflexes of challenge and insolence—in the best tradition of the anarchist spirit and as unrepentant as Don Juan before the statue of the Commendatore at the end of Mozart's opera." The series of drawings, which he finished on February 3, 1954, was the closest Picasso came to repentance—to an end to self-deception and a willingness to confront a painful reality. As he had written in 1935, getting to the "bottom of the well" could lead to rising to heaven. It could have been the first step on a journey toward truth, whose existence he doubted or denied; toward life's secret which he continued trying to decipher "like a cryptogram"; toward some understanding and mastery of himself; toward the ultimate in painting which he still longed for. It could have been; but it was not.

At Christmas, Françoise had taken the children to Cannes, and Madame Ramié had picked them up at the station and taken them to their father. Shortly before the Easter holidays, Françoise wrote to him to tell him that she would like to bring the children herself and to see him. This time, some of his anger exorcised through the work of the last few months, he agreed that she and the children should spend the Easter holidays with him. He had heard that she had broken up with Axelos, and that had been balm to his ego. "I knew," he told her, "you wouldn't be able to make out with anyone except me." The truth was that she had not felt ready for a new commitment. Axelos had wanted to move in with her, while she needed her own time to heal. "As far as I was concerned," she said, "my relationship with Kostas had already been a great success. It had strengthened my resolve to move on with my life."

But she saw no point in telling Picasso all that, since he had

already made up his mind. He continued with his monologue, painting a progressively grimmer picture of life without Picasso: "I'm going to talk to you now like the old philosopher talking to the young philosopher. Whatever you do from now on, your life will be lived before a mirror that will throw back at you everything you have lived through with me. . . . That is why I have told you that you are headed for the desert, even though you think you're moving toward understanding and communication. You made your life with me, I passed my own brand of anxiety along to you and you assimilated it. So now, even a person who might be willing to dedicate himself completely to you, since he hasn't been tested in the same fire that you have, wouldn't be able to save you, any more than you were able to save me."

It was a prophecy, a curse, a rare admission that he needed saving and, above all, a powerful preamble to asking her to come back and take up their life together as friends, with no questions about what either of them did outside La Galloise. Françoise had heard that Jacqueline Roque had been spending a lot of time with Picasso. Jacqueline had apparently told many of their friends in many different ways that Picasso, at his age, should not be left alone, that he needed someone to take care of him and she was the best person to do it. Françoise also noticed when she went to her closet that her clothes had been worn and the hooks of her Spanish gypsy dress altered to fit someone broader. But Picasso had clearly decided that he was not yet ready to settle for a nurse and guardian, and Jacqueline was nowhere to be seen during the two weeks that Françoise spent in Vallauris with Picasso and the children.

"It's terrible that you have to go away again," he said as the time approached for them to leave. "There's nobody I can talk with about the things that interest me most, the way I can with you. The solitude is so much greater since you left. We may have had our troubles living together, but it seems to me it's going to be even harder living apart."

Françoise was moved. She had not expected him to be able to admit as much. She also knew that even if she could believe she would one day meet a man whom she could love as deeply as she had loved Picasso, she had definitely not met him yet. But could she trust him? That was the question she kept asking herself.

Could she believe that this was a real change and not one more trick? There were too many signs that she could not; that he was in fact unable to give up the old games that had worked so well in the past.

Before she arrived, he had begun making portraits of a young woman with a charming blond ponytail, Sylvette David. He had first noticed her in the rue du Fournas, across from his studio, where she was helping her English fiancé, Toby Jellinek, construct some very unusual chairs of iron, rope and felt. Now that Françoise was there, he tried to use the presence of a new woman in his art to rile her into submission. Realizing he had not changed, she urged him instead to make more pretty portraits of the pretty girl with the pretty ponytail and scrupulously avoided being around whenever she knew that Sylvette would be there posing. "You don't seem at all unhappy," he complained, for the first time outwitted at his own game. "You should refuse to admit another face into my painting. If you knew how Marie-Thérèse suffered when I began making portraits of Dora Maar and how unhappy Dora was when I went back to painting Marie-Thérèse . . . But you—you're a monster of indifference."

He still believed that a combination of jealousy, fear of life without him and his confession of his need for her would bring Françoise back. To make sure that she had enough to be jealous about, he asked her to go and see Madame Ramié, who, as he knew she would, told her that her place had been filled. In fact, Madame Ramié was for the first time openly mean to her. "She told me," Françoise recalled, "that I was shameless, that I had no compassion, that the poor man had already suffered enough at my hands and that I should leave him alone and never come back."

As Françoise knew very well by now, this was the official position of the Picasso court. She returned to Paris relieved that she no longer had to live a court life, but hopeful that she and Picasso could indeed be friends. He had, after all, told her that "the reward for love is friendship," and they had agreed that at the beginning of July she would bring the children back and stay for a month.

Shortly before Françoise returned to Paris, James Lord had arrived to pay a visit to Picasso. He came from Ménerbes, where

he had been staying with Dora Maar; she had not seen Picasso for some time and had given Lord a piece of scrap metal, the kind of junk that Picasso liked to collect, to give to him as a present from her. Picasso was not amused. Lord returned to Ménerbes, and a few days later, on their way back to Paris, he and Dora stopped in Argilliers to have dinner and spend the night at the Château de Castille, the home of the art historian Douglas Cooper. Before they even went into the house, they knew from the car parked outside who was there. It was a Sunday, and they assumed Picasso had come from a nearby bullfight. "Well, are you two married?" he asked sarcastically as soon as Dora and Lord walked in. "No, only engaged," Dora said with a smile, trying as ever not to be, at least verbally, outsmarted by him.

"His whole behavior that evening, which was a rather long one," Lord said, "was very, very perverse. First of all he tried to persuade everybody to go with him to Perpignan. Then, during dinner, he was extremely disagreeable to me and kept telling Dora how strange it was for him to have no woman in his life at the moment. 'There's no woman; I'm without a woman,' he kept repeating. The implication, obvious to everybody, was that maybe he and Dora could come together again. Then suddenly, after dinner, he turned to her and addressed her very affectionately: 'I want to be alone with you. I have things to tell you that I don't want anyone else to hear. Let's go over this way.' He pointed to a far corner of the main salon, which, incidentally, was filled entirely with his paintings. It was a Picasso room to start with, which gave an added significance to his presence there."

Everybody was watching, fascinated to see what would happen next. Picasso, knowing that all eyes were glued on them, milked every ounce of drama out of the situation. As Dora got up, with obvious pleasure, from her seat, he put his arm around her waist and walked her very slowly to the other end of the large room. "When they had got there," Lord continued, "without having said a word, he turned and quickly came back to his seat, leaving Dora in the far corner of the room. She had to come back alone and sit where she had been before, while he turned abruptly to Paulo, who had driven him there, and said, 'Come on, we're going.' Without saying goodbye, he left the room. Everybody followed him, leaving me alone with Dora. I went to her and put

my arms around her. She was obviously very upset and did not want to talk about it. It had been such a cruel, wounding thing to do—so humiliating and so unnecessary. It was the last time they saw each other; but despite it all, she continued to have a great veneration for him."

Picasso had told Dora that there was no woman in his life; the truth was that there were plenty of women, but no official mistress. He was, however, spending more time with Jacqueline. On June 3, he completed three portraits of her, all entitled *Madame Z: with Hands Crossed, with Flowers, with Legs Folded. Madame Z* was a sphinx-like Jacqueline, with an extremely long neck that she never possessed, a blade of steel showing in her eyes in a way it had not yet shown in her behavior. But on the stroke of Françoise's arrival, in July, Madame Z returned to the lowly state of a member of the harem, relegated to the background while the prodigal wife was in residence at La Galloise.

Picasso was in a constant state of agitation. He acted as though he knew that the sand was fast running through the hourglass of his relationship with Françoise and he hated wasting any of it sleeping. He announced to Françoise that "this time we are going to have some fun," and they spent long days at the neighboring bullfights and long nights in the nightclubs of Juan-les-Pins. He would not go home until he had seen the sun rise; and then he would often declare that there was no point in going to sleep and they would all get on with the next day.

On all occasions they were accompanied by an entourage of a dozen or so people, including Jacqueline and a group of Spaniards whom Picasso had entrusted with the job of organizing the first bullfight to take place in Vallauris. Most of the time, Jacqueline was content to be treated as though she did not exist. Twice, however, she spoke out. The first time was in Bandol, when Picasso insisted that Françoise share his hotel room, as she had always done when they traveled. Jacqueline, who knew that they had been sleeping in separate rooms at La Galloise, found this latest indignity too much to swallow; but instead of telling him that it was very hurtful for her, she told him that it was "immoral."

The second scene took place on the morning of the bullfight. It was being held in Picasso's honor and had been publicized as a

major event, with press and photographers everywhere. All his children were there, and so were many of his friends, including Cocteau, Jacques Prévert and André Verdet, and hundreds of tourists. Picasso had asked Françoise to do him "one last favor": "You're going out of my life. . . . But you deserve to leave with the honors of war. For me the bull is the proudest symbol of all, and your symbol is the horse. I want our two symbols to face each other in that ritual way." Françoise agreed to perform the ceremony of opening the bullfight on horseback.

Shortly before they were due to leave for the arena, Jacqueline arrived at La Galloise, disturbed and crying. She begged him to cancel Françoise's appearance. "It's so humiliating," she said, "and so ridiculous for all of us. What will people think? What will the newspapers say?" When it became clear that Picasso did not care in the least either about what the newspapers would say or about how Jacqueline felt, she quickly changed her tune and groveled for forgiveness. "You're right," she added. "On this, as on everything else, you're so right."

Jacqueline took her seat next to him in the grandstand, with Cocteau on his other side, and watched as Françoise made her dramatic entrance on horseback, rode around the arena making the horse perform the ritual dancelike movements and then read the proclamation that the bullfight which was about to begin was in honor of Pablo Picasso. There were shouts of "Vive Pablo!" from the two thousand spectators. He was exultant; to the charged atmosphere of a bullfight and a circus, he had added his favorite excitement of a triangle, with Françoise opening the bullfight while Jacqueline was sitting by his side. "You were wonderful," he told Françoise at the end. "Absolutely sublime. You've got to stay this time. You're the only one I have any fun with. You carry with you the right atmosphere. I'll die from boredom if you go."

But Françoise knew that she was "wonderful" and "absolutely sublime" because she had challenged him, because she had left, because she had made the horse do her bidding, because she had refused to subordinate her life to his, because she had her own window to the absolute at a time when he doubted whether he still had his. That was "the right atmosphere" she carried with her and took away when she left for Paris that night.

15

"ALL THE LIONS HAVE SHRIVELED UP"

"PICASSO WAS UNHAPPY, unhappy as only a Spaniard can be unhappy," Hélène Parmelin said. "So the procession of women began. It was horrible. People would come to see us to tell us about this one or the other one that he should meet. I remember one day a very famous woman came to see me to tell me that since I was such a good friend of Picasso's I should do something for him and that she knew this young Spanish woman, marvelously proportioned, intelligent, who would be so good for him. I told her that that was not my profession. It was incredible what was going on."

"It was unimaginable, extraordinary," echoed Dominique Eluard. "One day, coming out of his studio, I saw that all the court had been anxiously waiting to see if I was the chosen one." The press joined in the game, publishing pictures of every possible candidate. "The painter says nothing," one of the captions went, "but he has posing for him a young Italian, Mademoiselle Balmas. And some declare: 'Here is the future Madame Picasso!'"

The children watched and waited. "I accepted them all," said Maya, "the ones he brought home and the ones he collected while we were traveling. I used to say, 'She's the last one to date.' As they were getting younger and younger, I could really have fun with some of them." Paulo was less generous: "Whores for Daddy" was his conclusion.

With Françoise gone, Picasso could not bear to remain in Vallauris. So the court set itself up in Perpignan for the rest of the summer. In fact, he seriously considered staying there permanently, and the local Communists did their best to convince him to make the move to Perpignan. On August 19, he painted a beautiful portrait of his hostess, the Countess de Lazerme, but the rumor was that it was Rosita Hugué whom he wanted to marry. As for Jacqueline, Paule de Lazerme described her "watching him like a fox, clearly eager to fill the vacant place." Picasso treated her abysmally—when, that is, he bothered to take any notice of her at all. He made it so humiliatingly clear he did not want her around that one day she finally decided to drive back home. Picasso came down to lunch looking and sounding relieved. During lunch, Jacqueline called him from the road. "She threatened to kill herself," Picasso announced when he returned to the table, "if she could not come back to Perpignan." His response had been that she could do whatever she liked, provided she left him in peace. That night Jacqueline came back: "You told me to do whatever I liked; so here I am."

Her behavior for the rest of their stay at the Lazermes' showed that returning to Perpignan was the last time she would do whatever she liked. She started calling him "Monseigneur," addressed him in the third person, kissed his hand and was ready at any moment to spread herself out like a cloak for Monseigneur to walk on. She had clearly decided to accept every humiliation, stifle all pain and subordinate both her life and her will to his, provided she could just stay around. More significantly, by the time he took her with him to the rue des Grands-Augustins at the end of the summer, he had decided to accept her offering. Having failed in his life with a goddess, he settled for the peace of living with a doormat. It was the peace of the grave, but he was a tired man. "Françoise," Dominique Eluard explained, "had asked of him to stretch to a relationship which was on a higher level and in which she was much more than just mistress and vestal virgin. But ultimately, I don't think that he was capable of having anything other than a macho relationship with a woman."

In October, he painted *Jacqueline in a Rocking Chair*—a stocky, matronly little Jacqueline, a far cry from the idealized, long-necked, sphinx-like creature of the previous June. Prophet-

ically, he had painted Jacqueline as she was not yet, but as she would soon become. She had chosen her fate, and he had chosen a caretaker to keep the world at bay while he painted with no other goal than to hold death in check. She was a woman he could dominate; but he had not taken into account the tyranny of weakness.

Vallauris was full of memories Picasso wanted to obliterate. The Lazermes came to visit him at the rue des Grands-Augustins and he asked them to find him a house in Perpignan. "He kept on saying before Inès and Sabartés," Jacques de Lazerme wrote to Totote and Rosita, "that he felt good only in Perpignan and with our friends from the Roussillon. Twenty, thirty, forty, fifty times he asked me to find him a house in Perpignan. . . . During our stay Pablo gave us proofs of his trust and affection that still move us very much. He didn't want to let go of us—he didn't want us to leave." He went on to say that he had written to Picasso already and sent him pictures of a sensational Louis XV home like theirs, only bigger, with more than thirty rooms. But Picasso would never go back to Perpignan, and although the Lazermes visited him a few more times, their letters to Totote and Rosita were increasingly full of complaints: "We have absolutely no news of Pablo," and "We have heard nothing from Pablo."

On November 3, Picasso received the news that Matisse had died. In vain did Matisse's daughter, Marguerite Duthuit, try to reach him on the telephone to tell him of the funeral arrangements. He would not come to the telephone, nor would he go to the funeral. Matisse too was part of what he had left behind on the far shore for good—or at least, forever. "I have chosen," Matisse had said shortly before his death, "to keep inside me torments and anguish so as to transcribe only the beauty of the world and the joy of painting." Picasso had said, quite simply: "In the end, there's only Matisse." He knew that Matisse was a "key-holder," in the sense in which Breton had called the lover and the inspired artist "key-holders." He also knew that by settling for Jacqueline he had given up forever the hope of unlocking life's secret through love; and he was more and more doubtful that he would ever unlock it through art. But he kept working.

"When Matisse died," Picasso told Penrose, "he left his oda-

lisques to me as a legacy." And on December 13, he started work
on a series of fifteen canvases and two lithographs, all variations
on the theme of Delacroix's *The Women of Algiers*. Delacroix's
harem women were transformed into so many Jacquelines, but
all the dislocations, juxtapositions and decompositions could not
hide the fact that there was, as Anthony Blunt wrote, "a certain
dilution of imaginative power, and a certain monotony of idea
under the apparent variety."

"I wonder what Delacroix would say if he saw these paintings,"
Picasso said to Kahnweiler one day at the rue des Grands-Augus-
tins. Kahnweiler thought he would have understood. "Yes, I
think so," Picasso agreed. "I would say to him: 'You had Rubens
in mind, and painted a Delacroix. I had you in mind, and painted
something different again.' " When Kahnweiler returned to his
studio a few days later, Picasso showed him another of the can-
vases in the series. "I sometimes say to myself that perhaps this is
an inheritance from Matisse. Why shouldn't we inherit from our
friends, after all? . . . You never know how your work will turn
out. You start a picture, and it becomes something quite differ-
ent. It's strange how little the artist's intention counts for. It's
really tiresome: you always have a critic at your elbow saying 'I
don't like that' or 'It ought to be different.' He grabs at your
brushes, and they become as heavy as lead. He doesn't know
what he is talking about, but he is always there. Rimbaud was
right when he said 'I is someone else.' "

In December 1954, while Picasso was working on his harem
women, Paulo was lying in a hospital close to death after a lung
embolism following a hernia operation. His surgeon, Dr. Blon-
din, sent a telegram to Picasso urging him to visit his son. There
was no reply. On February 11, Paulo was still recovering, and his
father was three days away from completing his *Women of Al-
giers*, when Olga died of cancer in a hospital in Cannes. She died
alone and was buried with just her son and the Ramiés present.
Picasso had stayed in Paris.

At the rue des Grands-Augustins, he received a visit from Ro-
samond Bernier, who had returned from Barcelona bringing with
her the photographs she had taken for *L'Oeil* of the Picassos in
his sister's house. It was nineteen years since Picasso had seen
Lola. "But they're much better off than I am!" he cried, when he

saw a rare proof of *The Frugal Repast* hanging in one of the rooms. "Look at this engraving; it's worth a fortune now! I didn't remember it was down there."

In addition to the photographs, Bernier had brought messages and relics from another world, a world far away from Paris, which Picasso had long ago left behind but to which he was still very much connected. "Before I left," Rosamond Bernier wrote in *L'Oeil* of her visit to Barcelona, "they overwhelmed me with advice, first for Pablo, then for Javier, for my health, for my journey, and loaded me with gifts to bring to Paris. I wondered a lot about what could possibly be contained in the bursting shoe box that was destined for Pablo. When he opened it in his studio, he extracted from it a piggy bank in the shape of a rooster, made out of clay and painted in screaming colors. It made a metallic sound as he raised it: the family had put a few coins in it for good fortune. There was also in the shoe box a paper bag bearing the name of a pork butcher's shop, filled with enormous sugared almonds. 'Spain is nice,' Picasso said; 'one buys candy in the pork butcher's shop there.' Finally, neatly wrapped in silk-paper, there was a fistful of cottonseeds, perhaps for the garden in Vallauris. Picasso looked around his studio, where canvases, books, magazines, old notes, drawing pads, sculptures and the extraordinary collection of objects he accumulates were stacked up in piles, and said, all happy at the thought: 'Just what was needed; we'll plant them here.' "

While he was at the rue des Grands-Augustins, Françoise called him, asking to come and see him. She wanted to be the first to tell him that she was getting married. She had known Luc Simon, the man she was going to marry, since her school days, but had not seen him through all the years she had been with Picasso, although they had corresponded, and he had even found her the job in Tunisia when she wanted to escape from Picasso and Ménerbes. They had run into each other one day the previous spring at the Librairie La Hune in Saint-Germain-des-Prés, where he was decorating the shop windows to make some money to supplement what he earned from his paintings. "There was an exhibition of photographs on 'Picasso and Intimacy' in the bookstore," Luc Simon recalled, "and a friend who worked there came up to me and said, 'Didn't you say that you knew Françoise?

Well, here she is.' I went up to her and I could not believe my eyes. She was only two years older than me, but she was already an old woman. I was very moved, and I knew that my job was to give her back her youth."

They had been good friends in their teens, crazy about old movies and very cozy with each other. "It crystallized immediately for both of us," said Françoise, "that this time it was very different. We started seeing a lot of each other, and by the end of 1954 he had moved in with me. He was a very romantic man, and at thirty-one just the right age for the children, who were then six and four, to relate to as a father. They loved being with him, and that was one of the factors that helped me decide to stabilize our lives and get married."

Picasso's first reaction was rage. "It's monstrous," he told her. "You think only of yourself." Françoise protested that she had also been thinking of their children. "Luc will help bring up the children," she said. "He is not their father, but he will be a good stepfather, and it will be easier for them to lead a normal life." Picasso's anger was now mixed with incomprehension. "Is that what you call a normal life?" he shouted. "The only normal life would be you, me and the children." At that point, Françoise saw the door from the sculpture studio, which was ajar, open wider. They were clearly not alone.

As abruptly as he had flared up, he was friendly again. He went and got her a tangerine, and they sat talking like old friends in the same place where, twelve years before, their life together had begun. For a moment, a deep, intimate silence filled the room. Then the door opened a little wider. "I later discovered," Françoise said, "that Jacqueline had been anxiously eavesdropping from the sculpture studio. At the time I just knew we were being overheard. But there was another purpose to my visit, and I wanted to complete it. I told Pablo that before marrying Luc I intended to set up a trust for the children, a *conseil de famille*, with my father, Luc and him as trustees. Since the children officially had no father, I wanted to make sure they would be taken care of if anything happened to me. Also I wanted to establish that my marriage would not change Pablo's status in relation to his children."

Picasso listened to all she had to say, and then, suddenly, as if

he had just remembered her impending marriage, he started berating her for her ingratitude: "You owe me so much. This is your way of thanking me, I suppose. Well, I've got just one thing to say. Anybody else will have all of my faults and none of my virtues. I hope it's a fiasco, you ungrateful creature." He threw at her the watch she had given him: "Your time is no longer mine." She followed suit by returning the watch he had given her—at which point they both got a glimpse of how absurd and melodramatic they were being and started laughing. And then the door from the sculpture studio opened a little wider still.

Picasso did not want to stay in Paris, and he certainly did not wish to return to Vallauris. So the search began for another house in the South of France. The choice fell on La Californie, an ornate turn-of-the-century mansion overlooking Cannes that had once belonged to the Moët family, of champagne fame. The "king of junkmen," as Cocteau had called Picasso, took possession of his new kingdom in June, and with him went his jumble of trifles. In the vast rooms of La Californie, hundreds of canvases, on easels and lining the walls, jostled with years' worth of bric-a-brac: bullfight posters, a Turkish coffeepot, a wooden statuette from the Congo, old packs of cigarettes, a bronze owl, old brushes that would never be used again. With amazing speed, the elegant salon and dining room were converted into a colorful bazaar, while in the gardens his sculptures—the Boisgeloup heads of Marie-Thérèse, a she-monkey, a skull, a pregnant woman, a cat and an owl—looked like exotic fauna among the palms, the pines, the mimosas and the eucalyptus trees.

Soon after he had moved to La Californie, Picasso started work on a film at the Victorine Studios in Nice. He painted, Henri-Georges Clouzot directed, and Claude Renoir, the painter's son, was at the camera, recording Picasso's every move on tracing paper, using the special colored inks that made it possible to follow the creation of a painting from the other side of the paper. *Le Mystère Picasso*, as the film was to be called, was one more attempt to understand Picasso's mystery by filming him at work. When Clouzot, for technical reasons, cried "Stop," Picasso stopped; when Clouzot told him to hurry up because only two minutes' worth of film was left, he hurried up. The genius, stocky and bronzed, "his look sinewy like his body," his feet firmly

planted on the ground in his favorite Turkish slippers, obeyed the director. "He looked sometimes like an African witch doctor and sometimes like a Roman emperor," wrote André Verdet, "depending on the way the floodlights fell on his bald head."

"Are you happy with what you did?" Clouzot asked him during one of the breaks. "I find it already impressive." But it did not take much to impress those around him, and Picasso knew it.

"Yes, yes," he replied, "but still too external. . . . I have to get to the bottom . . . risk everything. Show all the paintings that could be behind a painting."

"That could be dangerous," cautioned Clouzot, content to film Picasso playing on the surface and to understand his mystery with the beam of a searchlight.

Picasso, however, wanted to go deeper; whatever his acolytes said, he knew the difference between being on the periphery and being at the center. "But that's what I love," he told Clouzot defiantly. "You have to risk adventure to surprise truth at the bottom of the well." And there were all the trappings of adventure in the Victorine Studios: sweat, tension, excitement, exhaustion; the buzzing, booming confusion of soundmen, gaffers and assorted technicians; the sepulchral tones in which Clouzot announced his intentions while feverishly sucking on his pipe: "My intention is to make a pedagogical film for those interested in art." "And to think that I wanted to make a cartoon!" sighed Picasso.

"The analysis of the drawings and pictures," Clouzot said later, "is gradual and progressive—you might call it chronological—as the creator's idea develops in front of your eyes." What he did not say is that during the filming of Le Mystère Picasso there were hundreds of cuts, takes and retakes which interfered not only with the thought patterns of the creator but with his health. Picasso always said no to anxious questions as to whether he was tired. Real men, after all, are never tired; they just collapse from exhaustion—which is what he did, once when the filming had to be interrupted for a few days and for several weeks when the filming was over. But the myth was a law unto itself, stronger than the fact of his collapse. "There was Picasso," wrote Hélène Parmelin, "who was exhausting because he was never tired"—a

statement that fed and perpetuated the image of the inexhaustible Picasso.

Jacqueline and Maya were at the studios the whole time Picasso was there. Jacqueline had been formally installed, together with her daughter, at La Californie, but not everybody was betting that it would be forever. And many outside the court still did not know exactly who she was. When somebody asked her one day at the studios, she replied: "Me? I am the new Egeria."

Inès was also often at the studios and in residence at La Californie. There was gossip in the court about the new Egeria and the still very attractive maidservant and confidante. According to Parmelin, Inès detested Jacqueline from the beginning; according to others, Jacqueline was jealous of Inès' twenty-year-long relationship with Picasso. "As far as I was concerned," Inès said, "there was only him. . . . Picasso was first and foremost before the whole world. I came almost every month from Paris. I would leave behind my husband, my child, the refrigerator full for them, and come wherever he was. . . . I never wore an apron. I was part of the household as if I was a wife, as I was with my husband. It made no difference to me whether it was Jacqueline or this one or the other one who was there. I was with him. Often when they were in bed at La Californie, I would sit at the bottom of the bed and we would talk. We would talk about everything, and even when she went to sleep, I would stay on and we would talk—because I really knew him."

With "the self-assurance of a child, or monarch," he was always surrounded, whether in his bedroom or in any room other than his studio, by people whose existence revolved around him. "To live next to him," Inès said, "you had to be able to forgive everything. You got hit on the head, but that allowed you to be next to him. If you had decided that that was what you wanted, you had to accept everything. It's clear that others were not able to stay the course."

During his first summer at La Californie, he could not forget, much as he would have loved to, the existence of the woman who had chosen not to stay the course. Françoise's maid from Guadeloupe had brought Claude and Paloma to La Californie for the summer, while Françoise was in Venice on an extended

honeymoon. She had asked Picasso many times to take her to Venice, a place she had loved since she was a child. He had repeatedly said no; but now he could not bear the thought of her being there with another man who was in fact her young, tall and handsome husband—all attributes which made the thought that much more irksome to him. "To claim that when you love somebody, you can accept the idea of seeing her go off with some young fellow is very unconvincing," he had told Françoise after seeing Chaplin's *Limelight*. "I'd rather see a woman die, any day, than see her happy with someone else. . . . I'm not interested in these so-called Christian acts of nobility."

Françoise had charged Maya with the task of taking care of the children while they were at La Californie, and it was Maya who sent her an urgent telegram in Venice saying that Paloma had acute appendicitis and had to be operated on as soon as possible. Françoise telegraphed back that she was flying to Nice that same day and would go straight to Vallauris to wait for Paloma there.

She arrived at La Galloise and found only the beds and some chairs left in the house. Jacqueline, the gardener told her, had come from La Californie the day before and taken all the paintings and drawings, including Françoise's, all her books, letters and personal belongings. Françoise called La Californie immediately to ask Picasso what all this meant. "Everything was yours when you were with me," he replied, "and nothing is yours if you are not with me. That's it."

Too shocked to argue, she merely asked him to send Paloma to her right away. "No one talks to me like that," he snapped. "I do," she said, and hung up. He still did not send Paloma. "I could not believe that he was prepared to play cat-and-mouse with his daughter's health," Françoise remembered. "I called and threatened to send the police."

Soon after, Paulo brought Paloma to La Galloise, and Françoise took her immediately to the hospital in Cannes. "Sleeping in that empty house felt so sinister," she said, "that while Paloma was in the hospital after the operation, I decided to stay with friends of mine, Maurice and Christiane Bataille, who lived at Cap d'Antibes." They were also great friends with Cocteau, who came to see Françoise in Paloma's room at the hospital, looking very conspiratorial. "Please don't tell anyone I'm here," he said.

"I came because I'm your friend and I want to tell you what's happening, but I would hate to be caught here." He then went on to explain that Picasso had received a terrible telegram from Luc telling him that he "deserved to be slapped in the face for acting in such an irresponsible way and putting Paloma's health at risk." Picasso was beside himself with anger at Luc's insolence. "You should have prevented Luc from sending the telegram," Cocteau told Françoise. "And *you* should have prevented Pablo from emptying my house," she replied. "I called Luc in Venice and told him what had happened. I had no idea what he was planning to do. So Pablo makes a mess; then Luc makes a mess. Now stay with me for a while, if you like, or go."

At that moment, Picasso walked in. "You traitor!" he cried at Cocteau. "What are you doing here?" He had seen Madame Weisweiller's Bentley waiting outside with the driver, and had rushed upstairs as fast as he could to make sure that he caught Cocteau in the room. Cocteau, who continued to worship him despite Picasso's oft-repeated gibe that "Cocteau is the tail of my comet," mumbled something and disappeared. Picasso left soon after. But he came back every day. "He wouldn't spend much time with Paloma," Françoise said, "but he wanted to know who was there so that he could put them on his enemies list. Paloma's room had, in fact, become like a salon, and she was there like a six-year-old queen watching everybody come and go. Pablo was convinced that I had injured and offended him so badly, first by leaving him and then by daring to marry another man, that everybody should be on his side and I should have no more friends on the face of the earth for I was so wrong and he was so right. But by then I had gone back to my old friends, and every time he came to the hospital he would see people he did not know, who were not part of his world and whose lives did not revolve around his. And that he could not stand."

As soon as Paloma was well, Françoise took the children and returned to Paris. So far she had not asked Picasso to support the children or give her any financial assistance. She had inherited money from her grandmother, she was earning money from the sale of her paintings and, with her father's backing, she was in no need of more. But after Picasso's behavior that summer, she made sure through her lawyers that she received child support.

"I did it more for legal reasons," Françoise said, "thinking ahead about establishing the children's rights, since I could no longer trust that he would behave toward them like a father." La Galloise had always been in her name; when she left, she had suggested that they both should have keys to it and keep it as neutral ground where they could come together with the children. Instead, he had emptied the house.

In Paris, Françoise had already sold the apartment at the rue Gay-Lussac and bought a much bigger one under construction at the rue du Val de Grâce. One weekend in the fall of 1955, when Claude and Paloma were with Picasso at Kahnweiler's house in the country, she received a call from him: "I'm not returning the children to you unless you give to Paulo all the drawings and etchings that are in your apartment." "You have to return the children first," she replied, "and then you can send Paulo to pick up the drawings." He returned the children, and the next morning she returned everything except *The Woman-Flower*, which he had specifically given her as a present.

It was an open declaration of war, followed by the conspicuous absence of an invitation for Françoise to exhibit at the Salon de Mai and finally, in November 1956, by a letter from Kahnweiler terminating her contract. "I began to feel as though I was living in a nightmare," Françoise remembered; "as though I was actually experiencing Jocasta's horrible dream in Cocteau's play: 'sticky paste which runs through my fingers. I shriek and try to throw this paste away, but this thing, this paste stays hanging on to me, and when I think I'm free of it, the paste flies back and strikes me across the face. And this paste is living. . . .' " The more good news there was in the bulletins Picasso received about Françoise's new life, as when he heard that she was pregnant, the more determined he was to destroy her. He made it very clear that from now on anybody who was her friend was his enemy. She soon got used to art dealers apologizing for not exhibiting her work, explaining that they could not risk his displeasure. Any evidence that she could not only exist but flourish without him was for Picasso proof of his waning powers. He was addicted to people being addicted to him, and although there were plenty around him who were, he was obsessed by the one stray sheep.

Maya, who was now twenty, began to feel the danger of being

absorbed, of becoming an extension of her father as Paulo had become. "I didn't want to be eaten up by him," she said. "I wanted *my* life. So I decided to leave for Spain and stay there." She had first gone to Spain in 1953, when Françoise arranged for her to stay with her aunt Lola, but this time it was different. Maya would never see her father again, even though she returned to France and married in Marseille. She had observed at first hand the expert flamenco movements of promising, taunting and withdrawing that he had for years danced around her mother. She refused to be another victim. A few months earlier, she had even heard that Picasso had called her mother up and asked her to marry him. "Look," he told her, "Olga is dead. We can be married." It is hard to believe that the woman who for nearly thirty years had lived only for him, for whatever scraps of actual attention and fantasy protestations of eternal love he could offer her, would have turned down an offer to spend the rest of his life with him. So it was another tease, another cruel game to humiliate Jacqueline further and tie Marie-Thérèse in yet more knots.

"He would often come to my room late at night," Maya remembered, "and tell me, 'Come, I'll show you what I've done.' Well, I was twenty years old; I didn't want to spend the rest of my life waiting for my daddy to come during the night to show me what he had just painted or drawn. At some point I had to say: 'You, you are Picasso; me, I am Maya.' If I had listened to him, I would have just stayed there. Why? Because I was whimsical, I was funny, I talk, I sing, I laugh, I cry, I jump, I dance. . . . He loved to joke with me in Spanish about whoever was around us. I'm the Spaniard of the family. You could say I'm three hundred percent a Spaniard! But I told him that now that he had found his nth lady, I'm leaving."

So she left, and there was less laughter and less singing and less fun in the house, while he and Jacqueline settled into a life of being devoured in the process of devouring each other—she by her smothering possessiveness and he by crushing first her spirit and then her humanity. "When everything went wrong," Hélène Parmelin wrote, "everything went wrong. To an unimaginable degree. The whole world was nothing but trash, friends and enemies alike, there was no truth anywhere, nothing mattered, all

was rotten, everything was spoiled, all he asked of the world was to be left in peace, and the bit of chalk he had put down there had disappeared. Jacqueline, I said I would see no one. Do you mean to say so-and-so came, Jacqueline? Well, why did you send him away? . . . Why did you let so-and-so in? I said I would see no one."

The Spoiled Child had met his match in the Terrible Mother, all too eager to enclose him in her deathly womb, the better to foster all that was dark, cruel, gross and mean-spirited in him. Even when he shut himself away to work, Jacqueline clung to him from behind the closed doors. "It's not merely that he might happen to want something," she said. "But I wouldn't be happy thinking that he might want something merely because I wasn't there." Parmelin observed the established routine: "One had to stay at La Californie, one's mind's eye on Monseigneur. Not go even to the bottom of the garden. Nor even outside the house. Besides, at fixed times, he had to be given his pills, or his drops: he was taking homeopathic medicines for whatever was the matter with him. What was the matter with him? Nothing. But he took the medicines. Small doses. Moreover, he might want something." Jacqueline would listen for every sound coming from his studio and attempt to interpret it: "What can my Lord, Monseigneur, be doing up there? I can't hear Monseigneur's thunder of Zeus any more! Perhaps things are going well. . . ."

If things went well for him, things went well for her. She was a vicarious being, a parasite whose power came from the life it fed on, helping to sap it long before he was clinically declared dead. She sank herself in him with a monomania that excluded even her own daughter, who had to subsist on the few emotional crumbs her mother could spare. "When one is lucky enough to have Picasso in front of one, one doesn't look at the sun!" she snapped when, one night at a restaurant, someone pointed out the beauty of the sunset to her. Jacqueline became his secretary, housekeeper, press-clipping service and translator of his will into action; and Picasso became the tool through which she could assert her will over the rest of the world, the means through which she could experience a sense of power that, even if her imagination had not been as limited as it was, she would never have imagined possible.

The main source of her power was her role as gatekeeper, although a lot of the time the gatekeeper was only a mouthpiece for Monseigneur's wishes. He was away, asleep, working, on the beach, at the bullfights, in Paris—any one of those authorized excuses would be used to send away the old friends or the new admirers he did not want to receive, or at least did not want to receive at that particular moment.

When Helena Rubinstein arrived from New York during their first summer at La Californie to have her portrait painted—after she had heard from her friend Marie Cuttoli that Picasso had agreed—it was often Picasso himself, in a badly disguised voice, who answered one of the many calls that she or her secretary Patrick O'Higgins made; and it was he who gave one of the many reasons why "Monsieur" could not come to the phone. Finally, she decided to turn up at La Californie unannounced. "Under an opera cloak quilted in shades of orange and lemon with calla lilies and sprigs of mimosa," wrote O'Higgins, "Madame wore a medieval tunic of acid green velvet." Her timing was perfect. Picasso was entertaining "a tall, lanky man who not only looked like Gary Cooper but who was Gary Cooper," and the presence of one of his movie idols had put him in a good and sociable mood. Helena Rubinstein was received; and not only received but drawn, even though Picasso had at first told her that he drew portraits only of women he had slept with. "She wasn't against it," he bragged in recounting the story, "though I certainly was. She was horrible, so fat . . ."

On three consecutive evenings, he made more than forty sketches, which he referred to as "police notes"—her hands, her neck, her eyes, her chin, her mouth. "That's enough," he finally said. "And my portrait?" she asked. "It will be a posthumous work," he replied. Jacqueline had already told Patrick O'Higgins, while Picasso was drawing "Madame," that there was never going to be a portrait: "He's just sketching her as a reference for a series of lithographs. He likes to use real people and Madame, Madame Rubinstein is . . . larger than life." Even before Picasso had played this trick on her, Helena Rubinstein referred to him as "the devil." Now she went around cursing him: "Damned be this devil."

No one was safe from Picasso's tricks, his corrosive sarcasm

415

and his malice. He was at the rue des Grands-Augustins when he first heard the news that Cocteau would be admitted to the Académie Française. Geneviève Laporte had come over to see him, and for once, reality pierced through the fog of her idolatry and she saw what she described as "a side of Picasso which made my blood run cold." "Jean wanted this consecration so badly because, as he roundly asserted, it had never been granted to a poet of his breed during his lifetime. I was therefore astonished to arrive and find Picasso coldly resentful. He had just completed a humorous drawing of a hideous bedroom, containing an iron bedstead with bars, on which was seated an elderly, potbellied couple, whose faces were the embodiment of stupidity and smugness. One—the woman, I think—was reading a newspaper, while the man was picking his toes. Picasso, with a mocking laugh, handed me this drawing, every line of which conveyed ugliness, commonness and stupidity, with the comment: 'The woman is reading in the newspaper "Jean Cocteau has been elected a member of the Académie Française" while her husband is scratching his toes.' "

His malice toward Cocteau was by no means exhausted. He agreed to design the sword hilt that was part of an Academician's traditional insignia; what he produced was a drawing of a toilet seat, a flushing chain and a toilet-bowl brush. Cocteau continued to refer to him as "mon maître Picasso," but every now and then he allowed himself the luxury of calling him instead "the abominable snowman," and directing the odd barbed comment at the poetry of the man he continued to hero-worship: "Picasso is trying his hand at metaphysics, but he knows nothing about it." That was mild stuff, however, compared with the malicious sarcasm Picasso continued to heap upon him during these years when Cocteau was his neighbor on the Côte d'Azur, living at Madame Weisweiller's and sharing with her his young bisexual lover as well as large quantities of drugs, her Bentley and the wealth of her banker husband, who was never there.

"The future is the only transcendence known to an atheist," wrote Roger Garaudy. On October 25, 1956, Picasso was seventy-five years old. It was growing ever harder to look defiantly to the future, to new adventures and new horizons, in search of the transcendence his soul yearned for. A few months before his

seventy-fifth birthday, he had had a powerful dream: "He was having lunch," Parmelin recalled. "And someone came rushing in wild with excitement and told him that a terrible thing had happened: all the lions have shriveled up. . . . " The word used in his dream for "shriveled up" was *ratatiné*—a word which after that day began to crop up often at La Californie. He used it and everyone around him began to use it. It became a word-symbol, conjuring up how he felt and how he desperately tried to pretend he did not feel: All the lions had shriveled up.

"I'd give anything to be twenty years younger," he had told Françoise when they first met. In October 1956, he was in fact thirteen years older. What made the passage of time harder to accept was that in the same month Françoise gave birth to a daughter, Aurélia—a daughter who, as well as not being his, was tangible proof of how much future there was that he would never be part of. Jacqueline had discovered that she could have no more children after Catherine, so there were to be no more births through which he could participate, however ambivalently, in the eternal course of life.

But the world insisted on celebrating his own birth. Countless letters, telegrams and presents flooded into La Californie, from old friends and from people he had never met. And there was a banquet, with speeches and fireworks, organized by the Communist municipality of Vallauris. The Pignons were there, the Leirises, Kahnweiler and the publisher Gustau Gili, who had come from Barcelona with his wife to persuade him to illustrate the *Tauromaquia*. The local Communist Party had tried to find out from Jacqueline, through the editor of *Le Patriote de Nice*, a newspaper that Picasso read every day, what birthday present he would like. She had said that he would like a goat; he had told her that he had always longed for a goat, and when he finally got one, that heartless Françoise had given it to some passing gypsies because it stank. The Party, after due deliberation, decided that a goat was not a sufficiently dignified present and gave him instead a huge basket of preserved fruits.

So his birthday passed and he had still not got his goat. Jacqueline, who knew that her power lay in fulfilling every wish of her "geriatric prodigy," bought him a nanny goat herself. Esmeralda, often to be found tethered to the bronze goat in the garden,

417

became part of La Californie—and so did her smell. But there was nobody left who dared complain.

"He liked people to like what he liked," Parmelin wrote. He also liked them to eat what he liked; he always ate sparingly himself, but insisted on everybody else around him overeating. Maya watched the beginnings of Jacqueline's metamorphosis from short and slim to short and stocky to short and fat. "He always liked to fatten up his women," she said, while Parmelin described how he "would do all he could to force you to eat, and force you to think it good, or at least to say you did, which was the limit. He crushed his raspberries disgustingly in milk, and said that I ought to adore them like that because the Russians always ate raspberries like that. . . . He filled my plate with this mixture the colour of grog-blossoms and was indignant when an ordinary mortal refused his raspberries through nausea. He adored ginger and ate huge pieces of it under my nose, offering it to me twenty times over. How could one not like something so good? . . . "

Parmelin called him "The King of La Californie." He was in fact the unabashed dictator of all he surveyed. "I want to show the world as I think it," he had told Ilya Ehrenburg. But the world, very inconveniently, was not behaving as he thought it. On November 4, 1956, the brutal Soviet regime, which he continued to think good, violently suppressed the Hungarian uprising. Earlier in the year, at the Twentieth Congress of the U.S.S.R. Communist Party, Khrushchev had bitterly denounced Stalin and his crimes. The French Communist Party, which remained wholly Stalinist even after the process of de-Stalinization was under way everywhere else, described the report, which was published in Le Monde, as "attributed to Khrushchev" and ignored it. Parmelin discussed it with "The King of La Californie" and attributed its publication in Le Monde to "the trickery of the American State Department." Many, less blinded by ideology or less indifferent to crimes, left the Party at this time; many more publicly tore up their membership cards after the French Communist Party supported the Soviet crushing of the Hungarian uprising. Picasso remained. "'We are Communists," he would say whenever another atrocity was revealed or another aesthetic dis-

agreement occurred. "There is only one Communist Party in France. Therefore we belong to that Communist Party."

Two journalists parked themselves outside La Californie after the publication of Khrushchev's secret report on Stalin, determined to get a comment from Picasso on what it revealed about the man whose seventy-fifth birthday he had celebrated with one drawing and whose death he had lamented with another. Picasso sent Lucette, the new maid, out to tell them to go and see Khrushchev. "After all," he added, "they won't go and ask Khrushchev for a statement about my secret reports. . . ." Everybody around him marveled at yet more evidence of the master's wit.

After the Hungarian suppression, Picasso did make a meaningless protest by signing, together with Parmelin, Pignon and another seven Party members, a letter addressed to the Central Committee of the Party. In it they asked for the summoning, with the minimum of delay, of "a special congress to discuss, realistically and truthfully, the innumerable problems facing Communists today." No special congress was ever summoned, and, had Picasso not been a cosignatory of the letter, the Central Committee would no doubt have expelled the less celebrated members who had dared to ask for a discussion. Instead, it merely published a letter in *L'Humanite*, in which the signatories were castigated: "They may even become obstinate in spite of the facts, but they have no right to attempt to impose their point of view on the party by illicit means."

"Look," Picasso said to Carlton Lake, who came to interview him for *The Atlantic Monthly*, "I am no politician. I am not technically proficient in such matters." In fact, resigning from the Party would have been not an act of politics but a humanitarian act from the man who had given *Guernica* to the world. Yet he could not let go of the Party. As death drew nearer and all avenues to transcendence seemed closed, the Party offered him at least "a new theology without God." It was no bulwark against his mounting despair, but it was a vague belief that at least offered some feeling of connection to offset his growing loneliness.

There was always another round of bullfights to go to; the Pignons seemed to be, at all times, arriving from Paris with fresh

gossip and the latest news on everything and everybody; there were as many people to see, calls to take and letters to read as he wanted to make time for; there was some work to do and many press clippings to read about his seventy-fifth-anniversary exhibitions, in the spring of 1957, at the Museum of Modern Art in New York and the Louise Leiris Gallery in Paris. He also had a whole menagerie of pigeons, parakeets and owls, Yan the boxer, Lump the dachshund and Esmeralda the goat; his children and Jacqueline's daughter and Inès' son had filled the house for the summer; and Jacqueline was there, always there, oppressively there. But Picasso had never been lonelier and less able to drown his loneliness in frenzied activity. "Symptoms of a desperate preoccupation appeared in Picasso's expression with an intensity and persistence never known before," wrote Parmelin of that terrible summer of 1957. "Everything bored him, the slightest thing upset him, the least hitch in the day's course seemed to destroy utterly his ability to eat, sleep, enjoy or rest."

Jacqueline made sure that her Monseigneur took his drops, drank his herb teas, ate his carrot-and-pea soup with no harmful condiments, put the proper liniment on the leg muscle that would not stop hurting; she made sure, that is, that the machine was well oiled and polished. But the machine had a soul, and of that she knew nothing. For her, as indeed for Parmelin, the torments of his soul and the torments he imposed on those around him were nothing more than moods brought about by Painting, that mythical catchall to which all good and all evil were attributed. When, in the middle of August 1957, he began working on his variations after Velázquez' *Las Meninas*, Parmelin, like those primitive people who believe that it is the waving of the trees that causes the wind, was convinced that it was Velázquez who was responsible for Picasso's unhappiness, his rages and even the deterioration in his health: "From the day the idea of *Las Meninas* raised its head, Picasso's healthy looks became ravaged. And the battle with or without, for or against, without and within Velázquez began."

Jacqueline fell sick and had to have a stomach operation, and even that was somehow magically attributed by Parmelin to the battle with Velázquez: " . . . her convalescence was abnormally prolonged and she had to spend much of her time lying down.

Or rather she should have done. In any case, she felt ill, and the length of her convalescence seemed to be physically linked to the birth of *Las Meninas*." It could have also been linked, more prosaically, to the fact that she went along to one bullfight after another with "her stomach open," as Picasso graphically put it.

From now on, Jacqueline would often be ill. She had problems with her stomach, problems with her eardrums, gynecological problems; a lot of the time she felt so listless and exhausted she could barely drag herself to bed. When she was sick, she slept in a room next to Monseigneur, so as not to bother him. And he would presage and reflect in his work the different stages of her recurring cycle of sickness and recovery. "Isn't it curious," he said, "that by the time she is ill I am painting pictures in which she appears to be better again? I don't understand it. I always seem to be ahead of events."

It was hard to distinguish cause and effect. What was certain was that Velázquez was not to blame, and that despite all attempts by Jacqueline, Parmelin and the rest of the court to put a gloss of frenetic creativity and companionable rituals on reality, things were desperate. "One is reminded," wrote John Berger, "of the last days of some old vaudeville star: everything, creaking now, is still *invented* as superlative. . . . The horror of it all is that it is a life without reality. Picasso is only happy when working. Yet he has nothing of his own to work on. He takes up the themes of other painters' pictures. . . . He decorates pots and plates that other men make for him. He is reduced to playing like a child. He becomes again the child prodigy."

From August 20 to November 17, Picasso locked himself in his studio, *mano a mano* with the great Spanish master. To prove that he was as great as Velázquez? To silence his doubts that he was not? To first test and then rape Velázquez' masterpiece? To try to go back to the beginning when everything was full of ardor and promise and his father had personally introduced him to the Prado and to *Las Meninas*? "Picasso really wanted to settle some score with those!" said Jacqueline. "I never saw him work like that!"

He worked and he complained. "What an appalling business," he kept saying. "One always thinks that to do a painting is just to paint. . . . And yet it's worse than death in the ring; it *is* death in

the ring." It was indeed death in the ring to be, in Berger's words, "condemned to paint with nothing to say" and to keep pouring into painterly exercises all the frustration and rage of having nothing to say and an overabundance of skill with which to say it. "He was horrible during the whole time this lasted," said Parmelin. "He was in a bad mood. It was a tragedy for him. *Las Meninas* were a tragedy. . . . He wanted to show them to us. He did not want to show them to us." Did he fear that Velázquez was the victor of "the *corrida* at Cannes," as Jacqueline called the battle raging on the second floor of La Californie, where Picasso had moved his studio?

Finally, he did show them. "Well?" he asked Parmelin as they came out of the studio. "Both ears and the tail," she replied, awarding him the highest honor that a bullfighter could receive in the arena. It was not "the enthusiasm of a clan always prepared to uncork in any circumstances the flagon of its devotion," she said. In fact, it was just that. The clan knew that nothing short of freshly unleashed enthusiasm would guarantee them tenure at court. The man who had defied the world and its opinions at twenty-six with *Les Demoiselles d'Avignon* now sought reassurance at seventy-six that his paraphrases of the Spanish master had worked.

"Picasso was not a man of certainty," said Parmelin. "He was a man of doubt. He often said, 'Listen, I'll show you after dinner. I don't know at all whether what I did is sublime or whether it's shit.' And that was the truth—he no longer knew." And neither did the world. UNESCO had commissioned him to do a mural for the Delegates' Lounge of its headquarters in Paris—over one thousand square feet. He worked on forty separate plywood panels on the floor, with Jacqueline and Miguel, his Spanish secretary, who was back on the scene and would stay on to assist Jacqueline with her secretarial duties, helping him with the moving and shifting. He became obsessed with the UNESCO, as he called it, and before it was moved to its intended home he wanted to have it unveiled in the public schoolyard in Vallauris. The unveiling was turned into a major media event, with journalists, photographers, Communist Party leaders, a delegation from UNESCO and, of course, a crowd. "Picasso," Parmelin wrote, "mobbed by the crowd, eventually reached the foot of the fresco

which was still concealed by curtains. There were both sun and limelights. The moment had come. The curtains were drawn apart. The UNESCO fresco was revealed."

The crowd applauded but was perplexed, as were the UNESCO representatives: Was this a masterpiece or was it a giant doodle? Georges Salles, who had been instrumental in persuading Picasso to accept the commission, tried to save the day in his speech. He named the mural *The Fall of Icarus*, and there was, indeed, "a desiccated Icarus, already a smoky white skeleton" suspended between the sky and the sea in which he was about to drown. It is always death that wins, the mural seemed to be saying, and the higher one rises, the greater will be the fall. It was a message of despair very appropriate to Picasso's emotional state, but extremely inappropriate to an international organization that was supposed to strive toward a better future. And its appropriateness aside, it was a vacant work, expressing the spiritual void in which Picasso lived and worked. A lot of official puffing and booming was required to whip up any enthusiasm for *The Fall of Icarus*, starting with the title given to the mural when it was installed at the UNESCO headquarters in September: *The Forces of Life and of Spirit Triumphing over Evil*. But those capable of noticing that the Emperor has no clothes knew better than to believe it.

In May 1958, de Gaulle returned to power and created the Fifth Republic. At around the same time, Picasso painted his *Still-Life with Bull's Skull*, a violent picture in which, as Penrose wrote, "the burning reds and yellows, a double reflection of the sun in the open window, and the monumental immobility of a horned skull in the foreground produce a shock like a deadly explosion within the calm of a distant blue sky." As Picasso told Penrose: "I painted this with four-letter words." His Communist friends were delighted. Finally, here was a picture painted, as Daix said, "practically on the date" that de Gaulle returned to power, which *could* be said to be a political picture, directed against "the great danger that Picasso saw, the danger of a return to fascism." Penrose added to the political motive the inspiration provided by an exceptional bullfight Picasso had just attended. In fact Picasso needed no stimulus from the outside world in order to produce yet another painting of rage and revulsion. He con-

tained within himself infinite reserves of both on which he could draw.

Like the bathers in *The Fall of Icarus* who are unaware of Icarus falling, Jacqueline and the courtiers who surrounded Picasso watched him plunge, in slow motion, into an abyss of despair, unaware, uncomprehending and utterly unable to help. "Picasso was in a sombre humour," Parmelin wrote of an evening at La Californie; "his eyes moved slowly from one to the other of us and over the kitchen. . . . He watched us laughing with all the interest of a visitor to the Zoo seeing the monkeys make human gestures. And when we stopped laughing, he said: Well, go on, laugh! In a fury! . . . It was appalling. . . . It was terrifyingly sinister. . . . The atmosphere was suddenly all awry. . . . In the end he succeeded in really frightening us, and only then did he laugh. . . . We went to bed, climbing slowly up the stairs, appalled by we knew not what, our hearts heavy, and our minds too. . . . We were unhappy and fed up. What a splendid evening."

No matter how appalling, sinister and frightening Picasso was, and no matter how appalled, unhappy and fed up they were, it was all splendid—because they were special enough and privileged enough to be in his presence. How could they possibly see the nightmare he lived in when they all—Jacqueline more than anyone—lived in their own dream of glory by association?

The tragic court had recently been enlarged by two characters straight out of Italian *opera buffa*. One was a Spanish barber and the other an Italian tailor. Picasso had met Arias, the Spanish barber, in Vallauris and trusted him enough to allow him to cut his hair—a major honor, since Picasso believed that if his hair trimmings fell into the wrong hands, they could be used to manipulate and control him. "By the time I met him," Arias recalled, "he had very little hair. . . . I cut it very short in the back and left more on top to disguise the baldness. And when I finished, I would always give him a kiss on the bald spot. Always." So Arias would arrive at La Californie, cut Picasso's hair, get the odd drawing in exchange, stay for dinner, talk about Spain, accompany him to the bullfights and begin gradually to feel like Picasso's spiritual son. "Let's go to the bulls," Picasso would tell him. "It's the only thing left to us."

Michele Sapone, the tailor from Nice via Naples, wormed him-

self into the court by fathoming Picasso's sartorial mixture of dandyism and bohemianism. He would arrive at La Californie, invariably unannounced and always received, with fresh supplies of the corduroys that Picasso loved, with swatches and rolls of fabric, suits and overcoats, and he would leave with fresh supplies of Picassos. "You work for me, and I work for you," the painter said to the tailor. Picasso's expanding and exotic wardrobe and the gallery that Sapone's son-in-law later opened in Nice attested to the fact that each kept his side of the bargain.

There were hundreds who were never admitted into the magic circle, or admitted sparingly. Jacqueline was in charge of foreign relations with the outside world, and Picasso made sure that she got the blame. "We've had so much trouble trying to talk to you," guests would say, having finally been received after only they knew how many attempts. "What!" Picasso would complain to Jacqueline. "They've called and I've been told nothing?" It was not for Jacqueline to contradict Monseigneur in public, or to say how implacable were his orders that he not be disturbed. In any case, who would have believed her when he stood there so innocent and so celebrated, so indignant and so amazed?

Nineteen fifty-four was the last year he saw Dora; 1955 was the last year he saw Françoise and Maya; 1958 was the last year he saw Marie-Thérèse and the last time he had any contact, however indirect, with Fernande. Eva was dead, and so was Olga. The circle was shrinking. Braque's wife, who had stayed in touch with Fernande, got through to Picasso and asked him to help her. Impoverished, arthritic and partially deaf, Fernande had been hospitalized with a serious case of pneumonia. Picasso stuffed an envelope with money and sent it to her. Proud to the end, Fernande had never approached him herself to ask for anything; her most precious possession, she told a reporter, was a little heart-shaped mirror that he had brought her from Normandy, all those lifetimes ago at the Bateau-Lavoir.

"There was a photographer there," remembered Marie-Thérèse of her first and last visit to La Californie, "who kept calling him 'Maître, maître . . . ,' and Picasso would nudge me with his elbow and say: 'Do you hear that? Do you hear that?' I would have loved to laugh, but I wasn't laughing; tears kept running and running down my face. . . . At one thirty I left, and I

went to have lunch in a restaurant all alone." She would never see her "wonderfully terrible" lover again.

Picasso was too tired and too resigned to change women. But he had to change something if life was to be at all tolerable. So he decided to change houses. La Californie was too crowded and with the current development of Cannes, no longer private enough. "I've become one of the monuments of the Côte d'Azur," he screamed one day. At the end of September 1958, he was in Arles with Jacqueline and the Pignons for the grape harvest bullfight. He was feeling particularly depressed, and was still dispirited when they arrived at the Château de Castille to have dinner with Douglas Cooper. It was in that state of mind, when just about anything was preferable to the status quo, that he first heard about the Château de Vauvenargues, near Aix-en-Provence. "You ought to see it," Cooper said, "it's a wonderful place." He said more: that it was up for sale and that Picasso ought to buy it.

"Coincidences do not exist," Picasso had said. "Everything is normally a coincidence, the strange being the natural." The next morning, at the Pavillon Vendôme, where Marie Cuttoli's collection of Picassos was on show, Picasso sighed, "If only I was Madame Cuttoli's Picassos, how happy I should be here!" If only he lived anywhere other than at La Californie and was anyone other than the Picasso he was, how happy he would be! Therefore, on to Vauvenargues!

In the eighteenth century, the Marquis de Vauvenargues had lived in his château and, at least according to the caretaker, had written his celebrated *Maxims* there. In the nineteenth century, Cézanne had immortalized the Mont Sainte-Victoire on which the château was built. In the twentieth century, Picasso owned it. Jacqueline hated Vauvenargues—its huge, dark, cold rooms, the secret staircases, the relics of Saint Severin in the tower, the fourteenth-century fortifications. But Picasso had never consulted her. "I've bought the Sainte-Victoire," he announced to Kahnweiler. "Which one?" the dealer asked, surprised that one of Cézanne's landscapes had come on the market without his knowing. "The real one," Picasso exulted.

"Men who do not love glory," ran one of the Marquis de Vauvenargues's maxims, "have neither enough spirit nor enough

virtue to deserve it." When Sam Kootz came to visit him in his new château, Picasso proudly announced: "Cézanne painted these mountains, and now I own them."

Hundreds of paintings and bronzes were moved from the vaults of his Paris bank to fill the rooms at Vauvenargues; a central heating system was installed, and a luxurious bathroom, whose walls he soon covered with jungle fauns and nymphs and a wild beast over the bathtub. In February he moved in, and the shuttle between La Californie and Vauvenargues began. "You know where you live," he told Parmelin. "You live in Paris; you have a house and know where you are. I'm not anywhere, don't know where I live, you can't imagine how awful that is." And indeed she could not; nor could all those around him. She thought it was funny. And everyone else thought, here goes Picasso again being an impossible genius.

16

MAMAN AND MONSEIGNEUR

ON JUNE 5, 1959, a monument to Apollinaire's memory was unveiled at the corner of the churchyard of Saint-Germain-des-Prés, opposite the rue Guillaume Apollinaire. The quest for the most appropriate monument had been so drawn out and so heated, it was hard to believe that what Picasso donated and Apollinaire's widow unveiled, in the presence of Cocteau, Salmon, city councilmen and many young Apollinaire enthusiasts, was a *Head of Dora Maar* that Picasso had done in 1941.

In Apollinaire's *The Poet Assassinated*, published in 1916, Picasso, appearing as the Bird of Benin, had sculpted "a statue out of nothing, out of emptiness" to honor the memory of Apollinaire's alter ego, Croniamantal: "The next day, the sculptor came back with some workmen who lined the pit with a layer of reinforced concrete eight centimeters thick, except at the bottom, where it was thirty-eight—all done so skillfully that this emptiness had Croniamantal's very shape and the hole was full of his spirit." Apollinaire had uncannily foreshadowed the empty gesture that Picasso's monument would be in real life.

That spring Picasso had done a series of drawings of Christ on the cross. As in many other anguished moments, he identified with Christ's Passion, but there was no solace or release in the identification. As he played out the last act of his life, love and compassion seemed to have been left in the wings, out of sight and out of reach. The people around him were real only in the

sense that stage props are real, and he treated them with equal consideration. There came a moment when even Hélène Parmelin revolted and allowed herself to separate the bewitchment of the Picasso myth from the actual experience of being with him. She and her husband had just arrived in Vauvenargues, where they found Picasso in "this kind of unbearable mood of his that reigns over the house and smothers it . . . with those moments of exasperation that make you long to get away and breathe your own air, far from this black and silent fury that you had nothing to do with."

Instead they went into his studio. "And what an atmosphere!" Parmelin wrote. "Picasso's eyes are like machine guns. His voice cuts like a knife." But the unexpected prospect of being shown paintings from his own collection, including his Cézannes, made the price of being machine-gunned by his eyes and cut by his voice seem worth paying. Like a menacing monarch, he ordered Parmelin to go "at once," fetch her camera and take pictures of the studio and the paintings. "You don't seem to know that these are not just any paintings!" he cried, choosing the insult that he knew would most hurt the woman who talked and wrote as if "Painting" was unquestionably more important than life. "Get moving instead of staying there doing nothing."

Parmelin went, masking her distress in embarrassed laughter. She returned with her camera, and had just started taking photographs when suddenly Picasso began screaming at her in a rage, telling her that he had never given her permission to photograph Renoir's red chalk drawing, and that in any case he had had enough of her photographs! At which point, after years of bearing his "unbearable" moods, something snapped in her: "I open the camera, tear out the roll of film and throw it in his face. And I tell him that Picasso or no Picasso, I don't give a damn and I'll never let anyone talk to me in this tone; that I'm not one of his courtesans or his tamed devotees. . . . Picasso and Pignon start to laugh hysterically, looking at each other. . . . I storm out. The sun bludgeons me. I find myself on the road, without a car and with no money. I walk, full of anger, determined never to see Picasso again."

Her determination lasted for a whole week, during which Parmelin tried to explain to Jacqueline, who kept calling her, why

she felt that way. "Being Picasso," she said, "does not mean that he has the power to act like a satrap. And Picasso or whoever, I couldn't care less." But she did care, she cared very much, and at the end of the week she capitulated. What it took was Jacqueline handing Picasso the phone. "But what have I done?" he said in a sugary voice. "I haven't done a thing!" Hearing him utter a few words, even if they were words denying all responsibility, was enough for Parmelin. Tamed, she once again returned to the fold.

The less powerful Picasso felt, the more like a satrap he behaved. In *Romancero of the Picador*, the suite he started working on in July, the picador has been reduced to an impassive voyeur, rambling into brothels, curiously unstirred as the girls dance, display themselves and go into all sorts of provocative contortions in an attempt to ignite some life in him. The picador seems drained of desire. In his life, too, new excitements lasted for shorter and shorter periods of time. The excitement with his new château was over in a few months. When Kahnweiler went to see him at Vauvenargues for the first time, he had told him that it was "a magnificent place, but too vast, too severe." "Too vast?" Picasso had protested. "I will fill it up. Too severe? You are forgetting that I am a Spaniard and that I enjoy sadness."

"The exaltation ceased suddenly," wrote Maurice Jardot, the director of the Louise Leiris Gallery. "Picasso was to paint only four more pictures at Vauvenargues between 13 May and 24 June [1959] and only five during the years 1960 and 1961."

"I'm a little bored," Picasso told Lionel Prejger when he visited him at Vauvenargues. "Your brother is a real estate agent in Cannes. You know my tastes; try to find me a house."

Prejger did just that and called him with the good news: "I think I've found you a house."

"I'll be there tomorrow," Picasso said. Notre-Dame-de-Vie, as it was called after a nearby chapel, was a secluded Provençal villa on a hill overlooking Mougins, surrounded by terraces of cypresses and olive trees. There was only one road leading to it, in utter disrepair, but the house itself had been completely restored, all white inside and with many modern bathrooms. Picasso liked it, bought it and had a new road built. The house was put in the name of a corporation, La Société du Mas de Notre-Dame-de-

Vie, consisting of Jacqueline, Kahnweiler, Picasso's banker Max Pellequer, Michel and Zette Leiris and Lionel Prejger and his brother. It was June 1961, however, before Picasso moved into his new home. He had told Reventós that when he had a house completely full, he left everything in it and moved to another house. But Vauvenargues would never be full.

The work that spanned all three of his houses in the South of France was *Le Déjeuner sur l'Herbe*. He began wrestling with Manet's painting in August 1959 at Vauvenargues and declared the battle over in December 1961 at Notre-Dame-de-Vie—twenty-seven paintings and one hundred thirty-eight drawings later. As other men cross swords, Picasso was crossing canvases. Christine Piot wrote that he was practicing painting as a martial art: "This image contains the rapidity, the extreme swiftness that has often been associated with him and sometimes reproached him; also the art of aiming straight for the center of the target with the eyes almost closed, as if by prescience . . . and the sense of opposing the existing order or disorder of the world, of challenging it as well as exorcising it, of fighting like an 'impeccable warrior.' " As well as crossing swords with Manet, he set out "to cut open the *Déjeuner*'s flesh and nourish his creative faculty with it."

Le Déjeuner sur l'Herbe became, as well, a vehicle through which he gave expression to his ambivalence and his growing fears about his relationship with Jacqueline. In a set of variations on the *Déjeuner*, he subjected their bodies to successive transformations until his body "shrinks in the final oil to an appropriate green shadow while across [from him] . . . sits the figure of Jacqueline predatorily in command." That was not at all how things looked during the years that he was wrestling with Manet, but as he felt his strength ebb, he was clearly fearful of Jacqueline's power in the future.

He was also sick of her constant sicknesses. When in May 1960 he went to see her in the hospital, where she was recovering from an abdominal operation, he complained that he could not work "with all that" and that really, "the last thing painting needed was what was going on." Like Eva before her, as soon as she was back on her feet, Jacqueline acted as though she were perfectly well. And Picasso was more than happy to go along with this fiction.

Jacqueline's greatest value to him lay in all the mechanical functions she performed, and on which he was increasingly dependent; therefore, he was most upset when they were disturbed. And she, bewitched and possessed, denied any feelings that might upset him. All these denials and undischarged emotions drained her energies, so that even when the doctors could find nothing wrong with her, she suffered from a dogged fatigue that weighed her down and often made her shuffle like an old woman.

While Jacqueline began to forget what being healthy felt like, Picasso worried over the slightest sign that all was not well with him. "He has always been so concerned about his health!" Kahnweiler said. "In reality he has never been seriously ill. Basically, he had nothing but neuroses. And do you know how he took care of himself? With cat skins! Several times I went to see him and found him in bed, with his shoulders covered in cat fur. The enormous amount of work he turns out gives the impression that he must overwork. Not at all: he watches over himself and takes care of himself very carefully. . . . He has himself examined frequently by his doctor; the same doctor, as a matter of fact, who took care of Matisse. Whenever he feels a need to rest and regain his strength, he simply stays in bed for two or three days."

In the summer of 1960, Roland Penrose, who had organized a major retrospective of Picasso's work at the Tate, did everything he could to persuade him to attend the opening. "Why should I go?" was Picasso's response. "I know them all, those paintings; I did them myself." The Tate show was the apotheosis of Picasso as the century's official genius, his work a series of imperishable masterpieces, his life an offering to humanity. The Queen herself said during a private visit to the exhibition that Picasso was "the greatest artist of this century," while Penrose wrote in his introduction to the catalogue that Picasso's work was "born of an understanding and a love for humanity. His art goes far beyond a facile enchantment of the eye. It fulfils a more essential purpose —the intensification of feeling and the education of the spirit." It was true in the same way that The Fall of Icarus was really The Forces of Life and of Spirit Triumphing over Evil and that, as the slogan said in Orwell's 1984, "War Is Peace."

While Penrose was extolling Picasso's love of humanity, Françoise was trying through lawyers to gain some basic rights for her

children—starting with the right to use their father's name, which Maya never had. During her prolonged negotiations with Maître Bacqué de Sariac, Picasso's lawyer, Françoise received an extremely unexpected proposal from Picasso. "Would you consider," Maître de Sariac asked on his client's instructions, "divorcing Luc Simon and marrying him? That would certainly be the easiest way to regularize the status of the children. Then you could divorce, but at least the children would have been legitimized."

"For the sake of the children": that was the argument to which Picasso's emissary kept returning as Françoise listened to him week after week during the final months of 1960. Marie Cuttoli, Paulo and Claude, who was now thirteen, joined the chorus encouraging her to say yes. "Mama, you should do it," Claude kept pleading with her when he came back home after his summer holidays at La Californie. And both he and Paloma told her again and again that Jacqueline and their father were fighting all the time and their relationship was going from bad to worse.

At first, Françoise was incredulous and could not bring herself even to contemplate the offer. But gradually, Picasso's proposal, like an earthquake, began to change the landscape of her life. Almost despite herself, she began to look at her life with new eyes. During the day, she worked in her studio in her family home in Neuilly. Her father had died in 1957, so only her mother was there now. She would return to the rue du Val de Grâce in the evening and she and Luc would have dinner with the children. "We were very well behaved in front of them," Françoise said, "but after they had gone to bed, there was argument after argument." Luc, who had been like a father to Claude and Paloma, was not happy about their taking Picasso's name. Picasso's hostility toward him since his marriage to Françoise had permeated the whole art world and had been devastating to his career; and now the children he loved would carry the name of the man who had done everything he could to destroy him.

Looking back over the years since her marriage to Luc, Françoise saw clearly for the first time how much Picasso's vindictiveness had poisoned their lives. Was it really possible, she began to wonder, to put an end to his corrosive resentment? To have a life in which she could talk to the father of her children without

going through lawyers? To be able to function in the art world without the stigma of Picasso's enmity? An awful burden lifted from her at the thought of life without the shadow that Picasso, the destroyer, had cast over her world.

There was something else that Picasso's proposal made her confront: that much though she loved Luc and mistrusted Picasso, she had never loved anyone with the intensity with which she had loved Picasso. And Luc knew it. He had even written a letter to Picasso telling him that "Françoise may be my wife, but she will always be yours." Life had not been easy with the Furies of Picasso's vengeance pursuing her, but Françoise had been able not only to survive but to heal her wounds and to grow. And with the benefit of distance, she had seen ways in which she might have been able to achieve greater intimacy and depth in her relationship with Picasso. She saw the mistakes that *she* had made. What if she had learned Spanish? She remembered how enchanted he was every time he saw her take an interest in anything Spanish, as when she had translated Góngora's poems; being able to speak the language of his birth would definitely have brought them closer together. What if she had been more flexible, if she had opened her heart more, if she had mistrusted less? What, above all, if spiritually she had reached a place where she could have loved him unconditionally without losing her own center, where she could have surrendered fully without capitulating to domination, and from which she could have led him away from his own self-destructiveness?

Maybe she was dreaming; maybe it was too late and there were too many ghosts from the past; but if she accepted Picasso's proposal, then at least her children would be legitimized, she would disarm some of Picasso's hostility and Luc would be able to follow his career without the curse of having Picasso as an adversary.

In January 1961, it was published in the official legal journal that Claude and Paloma had been awarded their father's name: Ruiz Picasso. At the end of February, Françoise asked Luc for a divorce. On March 2, in utmost secrecy, Pablo Picasso and Jacqueline Roque were married in the Town Hall of Vallauris in the presence of Paul Derigon, the Communist mayor, and Maître Antebi, a lawyer from Cannes, and his wife. The banns had not been published on the door of the Town Hall but, on Picasso's

request, kept extremely quiet. Jacqueline had been Madame Picasso for twelve days before the news hit the newspapers. During that time, Picasso had carefully refrained from informing Maître de Sariac, who had continued to clear the path for his client's marriage to Françoise.

On March 14, Françoise opened her morning paper and read that the man she was preparing to marry had been married twelve days before. The news made her shiver. She suddenly felt touched by evil. The man she had loved deeply and whom she had determined to try to love better had, in a plot befitting Mephistopheles, succeeded in persuading her to ask her husband for a divorce in order to marry him. And as soon as the divorce process had begun, he had married another. In a state of emotional upheaval, Françoise decided to go ahead with the divorce, even though there was no longer any immediate reason for it. She had never before seen so unequivocally Picasso's power of destruction.

"I had sworn to succeed in getting married with no journalists. It's done! I've won!" the press quoted Picasso. He had won—over the press and over Françoise. He had used Jacqueline to score what he thought was the ultimate victory over Françoise and in the process handed over his life to the instrument of his victory. Marriage transformed Jacqueline from victim to victor, and crossing the line from mistress to wife unleashed the destructiveness that had been nursed in her through six years of being treated as something subhuman. She was now Madame Picasso and the mistress of all he surveyed. Before they were married, there was never a trace of evidence in his bedroom that a woman had slept there—not a slip, not a lipstick. Now, his bedroom became clearly *their* bedroom. But that was a trivial assertion of her new status. A sinister assertion of her new power was the campaign she immediately began against his children.

Claude and Paloma had always provided a bitter reminder of the woman she had replaced; of the woman who had ridden triumphantly around the arena of Vallauris while she watched, swallowing one more humiliation; of the woman she hated more than any other. Claude and Paloma were also bitter reminders of the fact that she was never going to have her own children by Picasso. She had tolerated their presence for the holidays, as she

had tolerated everything and everybody that had been part of his life while she was uncertain about how permanent a part she would be. But now she knew and the world knew, and there would no longer be any brakes on the unimpeded exercise of her will. Also, the children were fast becoming adults, clever, attractive and now, to her horror, carrying their father's name. They were harder to tolerate, and she no longer had to. She started feeding Picasso lies, about how little his children cared for him, how they had been poisoned by their mother and even how the fourteen-year-old Claude had become a drug addict and should not be allowed to join them for the Easter holidays. Both children were promptly disinvited.

They came back; but their time at Notre-Dame-de-Vie was becoming rationed. And when they were there, Jacqueline did her best to humiliate them. One day she took them, together with her own daughter, to a cheap department store in Cannes. "I'm bringing you here," she told them, "because this is the place where you will be shopping for your clothes and whatever else you need." When Claude and Paloma protested that she did not have to worry about where they bought their clothes, since their mother took care of that, and certainly not at a place like this, she persisted: "I know, and that's the reason I brought you here. Because when you are older this is where you will have to go." It was a slap in the face, and a warning to the children, whose mother was working hard to give them not only their father's name but all their legal rights. It was also a slap in the face of her own daughter, who fared less and less well the older she grew and the more hardened against all feeling her mother became. She could not forgive Catherine the fact that she came from another life, another man and another world.

The isolation of Picasso took place by stages, but it began with the discounting of every emotional claim. What Jacqueline wanted was Picasso all to herself, and she was ruthlessly clear about how to achieve her goal, since what he wanted was to lose himself in work. Later on she would refer to Picasso's paintings during their life together as "their children," and she wanted nothing to interfere with the production of more and more "children"—certainly not the presence of real children from his past. There was a window on the second floor of Notre-Dame-de-Vie

looking down on Picasso's studio. From that window, Jacqueline watched for hours as Picasso made "their children." These were her great moments—just she and Monseigneur and the prospect of more and more of their children populating the earth.

For Picasso, work was the only weapon he could pit against death, his great adversary. At the end of October 1961, however, he left his work behind for a few days and threw himself into a celebration of his eightieth birthday that was compared to "a holy feast in Renaissance times." The host, in whose name four thousand invitations were sent out, was Paul Derigon, the same Communist mayor of Vallauris who had married him to Jacqueline. A Festival of Music, Song and Dance took place in Nice with, among others, Sviatoslav Richter playing the piano and Antonio dancing the flamenco. An intimate exhibition of fifty of his paintings was held in Vallauris, to which Picasso and Jacqueline were "escorted by helmeted motor-cycle police with white gauntlets." He was serenaded by guitars, given countless presents, heard many speeches in praise of his greatness and his humanity, attended a reception in his honor at the Palm Beach Casino in Cannes with a magnificent display of fireworks, and watched a bullfight, again given in his honor, in Vallauris. Dominguín and Ortega were the matadors, and this time Jacqueline had no rivals for the public's attention. The Terrible Mother was, in public, the young bride basking in the shadow of the great husband. And Picasso, who sometimes shrank from the limelight and sometimes missed it if it was not turned upon him, reveled in the adulation of the crowd.

On the occasion of his eightieth birthday, *France-Soir* published an interview Picasso had given to a young journalist, Sylvie Marion. He eagerly took the opportunity to show that his flirting days were not over. "Come here so that I can hug you," he told her. "There. Now you can say that you got a hug from Picasso for his eightieth birthday. That's all. What, you don't want my kisses? Jacqueline, that's not nice, is it? . . . You have beautiful eyes. Let me hug you again." Finally Marion got something other than hugs and kisses: "I'm not Marilyn Monroe," he said, cupping his hands around his nonexistent breasts. "To start with, I'm not that. . . . Well, tell them that if there were no mirrors, I wouldn't know my age, and that it took me eighty years to be-

come young. What? I already said that for my seventieth birthday? Well, tell them that I still believe it." Last came the statement that was used as the headline for the interview: "Love is the only thing that counts." And then as if to fill the gulf between his statement and his life, he repeated it: "That's what you must write, that Picasso said that love is the only thing that counts."

On the eve of his fortified isolation from all human contact, there was little in his life that had anything to do with love. Electronic gates were installed at Notre-Dame-de-Vie, with an intercom system to screen visitors and guard dogs to let loose if they persisted. In their isolation *à deux*, the Picassos were bonded by their mistrust of the outside world. "Everybody has his price," Jacqueline used to say, "and money, always, sooner or later, triggers madness." She meant, of course, money in other people's hands, people who, unlike her, were greedy and calculating. Because, as she had said about herself, she would have been "just as happy with a single Picasso postcard." Miguel Bosé, Luis Dominguín's son, recalled that "she was terribly jealous of any other presence in the house. She would make you suffer, feel distant, strange, anytime and in any place. . . . She was always there, always tense, keeping watch. She thought that all his friends took advantage of him, that they were his friends only because he was Pablo Picasso. And maybe she thought that way because 'all thieves think that everyone is a thief.' "

"At the end, nobody can see anything except himself," Picasso had said. "Thanks to the never-ending search for reality, he ends in black obscurity. There are so many realities that in trying to encompass them all one ends in darkness." The man who had proudly declared "I do not seek; I find" now had to admit that not only had he sought and failed to find, but he had also ended in black obscurity and darkness. He went on working—paintings, drawings, linocuts, seventy Jacquelines in 1962 alone—but it was work born of panic and of the frenzy that panic brings. Both in his life and in his work, he was retreating. It was the time of giving up, settling down and going back: giving up the hope of unearthing reality and truth; settling down as if life's gravity had taken such a toll that he had to marry his caretaker; and going back to the mother who would order his reality, meet his every

wish, demand nothing in return except to possess him. He did not even have to maintain the fiction of loving her. He could be as estranged, emotionally absent, cruel or unfair as he felt like, and she would still be there taking care of him, because that is a mother's job. He started calling Jacqueline "Maman." And of all the women in his life, Jacqueline looked most like his mother, and came to look more and more like her as she grew stockier and sturdier with every year. Picasso liked her to give him his bath and threw violent temper tantrums if she was not there when he wanted her.

He would not tolerate even a brief absence. Maurici Torra-Bailari, a Spaniard who had known Picasso ever since his early days in Paris, remembered an afternoon at Notre-Dame-de-Vie when after lunch he, his cousins and Jacqueline had gone for a drive to Vallauris: "He was going to take a nap and it was he who had suggested that Jacqueline come with us and be back by five, by which time he would be up. But he must have awakened earlier and Jacqueline wasn't there. Thunderbolts were in the offing. 'How could you leave me?' he cried as soon as we got into the house. 'You have abandoned me!' It was a child's tantrum, but even so, Jacqueline made no attempt to defend herself."

In his work too he was regressing—not to an earlier stage of his own life, but to an earlier, much earlier stage of man. The people populating his canvases were not modern; they were not even Egyptian or Greek. They were the old Mesopotamian people seen in the art that has survived from those ancient times: stout, squat, with hardly any neck, and above all, with the pupils suspended in their eyes, nowhere touching the lids—big, black holes, just emerging from the cosmic darkness, fearfully watchful and still in the grip of a primeval terror. At the end of October, while he was working on his *Rape of the Sabines*, he painted four *Warriors* who proclaimed that terror. "All four of these *Warriors*," wrote the art historian Gert Schiff, "bespeak the same horror. Is it caused by the evil deeds they are forced to commit in the name of some questionable good?" Or perhaps in the name of some questionable god who still demanded human sacrifice? On November 14, Picasso painted a portrait of Jacqueline, *Head of a Woman*, on which he "projected, with their facial distortions, all the horror of the *Warriors*." The sphinx has disappeared, and

Jacqueline, her eyes set in motionless horror, her breath held in primordial fear, is back in the world of the Mesopotamians.

"But as for them, they say nothing!" Picasso remarked about his *Warriors*. David's *Sabines*, Poussin's *Rape of the Sabines* and *Massacre of the Innocents* had been the starting point for the warriors, the massacres, the bloodshed and the destruction that filled his work for months. Then, at the beginning of February, it was over. But he was not at all sure that there had been any purpose to all that destruction. "Does one ever know what one is doing?" Parmelin asked. "Can any moral be drawn from it? Can anyone in the world give a painter certainty? . . . It is enough to see him looking at his warriors, to understand, that in spite of everything all his torment about them is far from being soothed."

And it would never be soothed. "Everything is changed," he said, "it's all over, painting is something quite different from what we believed, perhaps it's even the exact opposite." He knew that he had destroyed form, that the abstract painters who followed were eliminating the subject and that it was the end of painting as it had been and as he had practiced it. No wonder that he was so uncertain about what he was doing, no wonder that he was painting without purpose. "It was during this period," wrote Parmelin, "that he declared himself ready to kill modern art, and thus art itself, in order to rediscover paintingThen down with everybody, down with everything that's been done, down with Picasso! For also and at the same time and quite naturally it is Picasso and his painting methods he is attacking."

But what was to replace what had been? "We have to look," he said, "for something that develops all on its own, something natural, and not manufactured; it has to evolve just as it is, in its natural shape and not its shape in art. . . . We do the same thing over and over again, and yet we can do everything; what is there to stop us?"

It was the royal We. But he went on doing the same thing over and over, again and again. It looked different, prolific, fecund. But it was more of the same under different guises: sometimes it was warriors, and sometimes a painter and his model, sometimes musketeers, and sometimes more Mesopotamian Jacquelines, increasingly savage and repulsive. There were one hundred sixty

Jacquelines in 1963, as if he had to get rid of her in his work, since he had decided to cling to her in life. "In front of Picasso," François Mauriac wrote, "I've never been able to escape the contradictory evidence of genius and impostor. I always had the impression of witnessing a criminal attempt masterminded by a clever sorcerer, with the almost supernatural glare of a hatred for the human face." In the case of many of the Jacqueline portraits there was hatred for the human body as well. With his sexual prowess waning and with impotence around the corner, another reason was added to his deep misogyny. Lust denied turned to loathing for the female body, and sexual passion to disgust. Jacqueline's body was massacred in painting after painting and drawing after drawing. "Sometimes I dream that he loved me," she said. But it must have been hard to sustain that dream when, as the years went on, more and more of her was brutalized by his brush.

One morning, when they woke up in a hotel in Arles, ready for that day's bullfight, they called Parmelin and Pignon, staying in the room next door. "Have you made up?" they asked, as the Pignons had had a monumental fight the night before. "Of course," Parmelin answered.

"But really made up?"

"Yes, of course."

"So, you made love?" Jacqueline asked, clearly prompted by her husband.

"Please, Jacqueline," Parmelin protested.

"But did you make love?" Picasso screamed into the telephone. "It's no reconciliation if you didn't!"

"Yes, we did," Parmelin finally said, exasperated. "Are you happy now? We did make love."

"We did too! . . . We did too!" Picasso chanted, loudly enough for Parmelin to hear. Making love had become an event worth bragging about.

But then, so had staying alive. Two of the key people in his long life died in 1963: Braque in August, Cocteau in October. He went on working. Perhaps work could command death out of his orbit. If not work, then what? His children, far from giving him a sense of life going on, were a grim reminder of *his* life coming to

an end. During the Christmas holidays, he told Claude that this was the last time he could visit him. "I am old and you are young," he added. "I wish you were dead."

Paloma went back for Easter. "No, you cannot see him," she was told. So that Christmas of 1963 was the last time either child would spend time with their father. " 'Monsieur was out' for ten years," Paloma said, "the person I loved most in the world." It was a confrontation with their father's darkness that nearly crushed them; an explosion that still detonates in their lives. "When the door slammed shut," said Claude, "it was like a bolt of lightning." Already fragile as a result of his genetic heart defect, Claude was ill-equipped to deal with such a violent rejection. "I wish you were dead," his father had said, and as if he had been cursed, Claude tried to take his life by jumping off a wall. He did not succeed, and maybe he had not intended to succeed, but the burden of his father's rejection weighed heavily on him. Françoise decided that it might be easier if he left France for a while. She sent him to Cambridge in England, and in the first letter she received from him, he told her that he wanted to go to London and be a writer. His letter was so full of woe and grief that Françoise, worried, wrote back and asked him "as an exercise to draw a balance sheet," and write her another letter in which he put in red all that was good in his life and in blue all that was bad.

"Maybe I could see a little too much of what was going on," Claude said later, still trying to understand how something so unnatural could have happened. "That bothered my stepmother. She was always jealous of my sister and me. It troubled her, I guess, that we should be around to bring back memories of the past." Paulo's daughter, Marina, also blamed Jacqueline: "After the marriage, my grandfather seemed to lose his humanity. We saw absolutely nothing of him, we received absolutely nothing from him. My feeling is that most of that must have originated with Jacqueline; it could have come from no one else."

Jacqueline in fact was ultimately only an accessory. In the spiritual clash between darkness and light that had been raging in his soul and in his life for years, Picasso had chosen to side with the darkness and abjure the light. At the same time, he had chosen to spend the rest of his life with a woman who would

ensure that there would be no light around him to challenge the darkness. Together, they rejected all the emotional ties that make man human; together they rejected love. If it looked to his family as though the moment he married Jacqueline was the moment he lost his humanity, it was only because that was the moment he gave her the power to be his co-destroyer. But *he* gave her that power, and without him her capacity for evil would have been as commonplace and insignificant as, without him, she would have remained. Pure evil has a monumentality to which, alone, she could not have aspired. If she behaved like a monster, and made sure that there was no reason for him not to, it was thanks to him that all that was good in her had disappeared.

In March 1964, on the occasion of the sixtieth anniversary of Picasso's arrival at the Bateau-Lavoir, *Le Jardin des Arts* asked a host of art-world celebrities what they thought of Picasso. Cocteau's contribution was obtained shortly before his death: "What one 'thinks' of Picasso is irrelevant. One should quote and quote again Mallarmé's definitive answer to Degas, who complained about the laborious thought process required for the writing of a sonnet: 'But, Monsieur Degas, it is not with thoughts that one writes a poem, it is with words.' Picasso sanctifies defects. This is, for me, the only rule of genius. Everything else is play."

That was the attitude which permeated the outraged response of the Picasso faithful when, in the summer of 1964, excerpts of the book that Françoise had been writing with Carlton Lake about her life with Picasso appeared in *The Atlantic Monthly*. In November the book itself came out in New York, and *The New York Review of Books* became the first battleground for the war that was to rage on for the next year around *Life with Picasso*. "This breach of confidence," John Richardson wrote in his review, "is the more unconscionable, as Picasso loathes any public divulgence of his private views."

James Lord replied to the review. "Now the fact is," he wrote, "that Picasso himself has chosen to live in a fish bowl. He may not have bargained for the total transparency of the facet of it with which Madame Gilot has provided us, but he has no one to blame for that but himself, and it ill becomes others to take exception to it. I think it is significant that in spite of his strictures concerning the book and its author, Mr. Richardson never cate-

gorically states that this portrait of Picasso is a false one. He neglects to do so, I believe, for the excellent reason that he is in a position to know how astonishingly true to life the portrait is. . . . It is important to know how perverse, cruel, ruthless, sentimental, and promiscuous Picasso could be. Indeed, how could anyone honestly study his work and imagine him to be otherwise?"

"When I started to work on the book," Françoise said, "I didn't know when I would publish it or whether I would. I wanted to put things down while my memory was clear, and it was also a way to order my thoughts and my experiences and in the process free myself from them. What gave me the green light to publish was his decision to stop seeing the children. When they had nothing more to lose in terms of their father's affection, there was no more reason for me to delay publication. Also, I felt that if the book was published while he was still alive, he had a chance to respond if he wanted. At the same time, I was very careful to make no statements which I could not document and substantiate, and there were a lot of damaging facts that I did not include since he was still alive and, even though he was not acting like it, still the father of my children."

The tone of Françoise's book was captured in its closing paragraph: "My coming to him, he said [in 1944], seemed like a window that was opening up and he wanted it to remain open. I did too, as long as it let in the light. When it no longer did, I closed it, much against my own desire. From that moment on, he burned all the bridges that connected me to the past I had shared with him. But in doing so he forced me to discover myself and thus to survive. I shall never cease being grateful to him for that."

He seemed determined to force her to discover even more resources in herself in order to survive what followed in the spring of 1965, when *Life with Picasso* was about to appear in France. His holy ire descended on her in three steps. First, he asked the courts to seize the edition of *Paris-Match* in which the book was being serialized, citing as the reason "an intolerable intrusion" into his private life. On March 22, he lost his case. On March 25, he brought an action against Calmann-Lévy, Françoise's French publishers, asking the court to ban the book. The case was heard on April 12 and 13 and dismissed. "What saved

the day," Françoise said, "is that I had included in the book only what had already, in some form or other, been in the public domain and what I could document. I had deliberately left out everything else."

He had now lost twice. But he was not finished. On May 20, he filed an appeal asking again that the books be seized and destroyed. By now the battle had been joined by forty personalities of the art world who, organized by Parmelin, signed a manifesto published in *Les Lettres Françaises* demanding the banning of the book. Artists and intellectuals, ordinarily the champions of free speech, were seized by the collective hysteria that had spread among the *bien-pensants*. The most strident among them actually admitted that they had not read the book and were clearly determined not to do so in case it prejudiced them in favor of the author. "I am lucky enough to know the original and can voice my outrage at the fake," wrote Pignon. "In Picasso, there is no divorce between the man and the painter. It's of no use exalting the painter if one destroys the man. The two walk hand in hand, and Picasso's way of being a painter is a source of morality in itself. If there has been such an outrage among painters and sculptors, it is because Picasso is for us an example. . . . I am outraged when they want to make us believe that he is a destroyer. He is, on the contrary, a stimulus for the spirit, a giver of freedom, a radiant soul . . . "

It was all uncannily reminiscent of the language that had been used among those similarly "outraged" by the lack of sufficient reverence in Picasso's portrait of Stalin. Adding to the air of total unreality, Pignon, more than a year after Picasso had cut his children out of his life, wrote: "Françoise Gilot attempts to publicly disparage the father of her children; the fact that not even the bonds existing between the children and their father have been spared proves what kind of book this is." From then on, the publication of Françoise's book became the excuse for Picasso's refusal to see his children. The dates belied the claim, but the received wisdom had been set.

Joining the chorus of condemnation of both Françoise and the book—the Communist press naturally leading the way—there was André Marchand, prostrate before Picasso's genius: "A woman who has spent ten years with him should not confuse

petty personal affairs with the grand adventure of a creator"; there was Félix Labisse, disarmingly frank: "I have not read the book, but . . . since Picasso has found it disagreeable, I take his side out of friendship"; there was the open letter to Picasso from the "Vallauris Communists": "We cannot lend an ear to a pack of lies contained in a book that a sensationalist press and the Gaullist radio have been publicizing in order to slander you as a man, an artist and a Communist."

At the suggestion of André Parinaud, the editor of *Arts*, Françoise had written an article responding to the attacks. But the pressure from his peers proved too much for Parinaud. On May 15, he wrote to Françoise: "My dear friend, you will think that journalists belong to a strange body of people, but it is sad to say that what was news one day ceases to be news the next. When I proposed to publish your answer to the manifesto of the forty, I had at my disposal the necessary pages in the magazine and the artistic news that week was relatively scarce. Now, I find myself this week with 107 reviews of exhibitions on my hands. It would be a provocation to the painters and galleries to devote a whole page to what is called today '*l'affaire Picasso*,' but which on another level is beginning to weary intelligent people. I am sorry to return your article to you. I am convinced that you will understand my reasons. I ask you to believe, my dear friend, in the assurance of my best sentiments."

With Picasso's appeal still pending and the stampede to excommunicate Françoise undiminished, *l'affaire Picasso* had hardly lost its topicality. But the letter summed up the cowardice and hypocrisy that Françoise had encountered in the art world ever since she had committed the crime of leaving Picasso, and then compounded it by committing blasphemy. But there were defenders. "Giacometti was one of the friends," Françoise said, "who called me often to give me strength and say that he was thinking a lot of me." Arthur Koestler and François Mauriac were two men of letters who also stood behind her.

Picasso's lawyers, Bernard Bacqué de Sariac and Georges Izard, pleaded his case on June 23. "Our client," de Sariac said in court, "is not a Bluebeard, he is not intrinsically evil and does not think of money all the time. Nor is he . . . a primitive full of superstitions and fetishisms of all sorts."

"Even a famous man like Picasso," pleaded Georges Izard, "has a right to justice."

"Picasso," countered the lawyer for the defense, Paul Arrighi, "is not a stained-glass saint. He is fallible and therefore can be criticized. And Madame Gilot has not exceeded her historian's rights. A biography does not have to be a panegyric. . . . Finally, Picasso, the public man, has for over half a century now obligingly lent himself to publicity. He has been photographed for magazines dressed as a torero, a clown or quite simply naked in his bathtub. Today he displays a sudden and belated proclivity for secrecy."

"In a case such as the one submitted before us," the Assistant Public Prosecutor in the Court of Appeal concluded, in Solomon-like fashion, "intimacy does not belong exclusively to either lover." He had portrayed her, as he saw her, in his paintings; she had portrayed him, as she saw him, in her book. The judgment of the lower court was upheld and Picasso's appeal rejected. Picasso had "often exposed himself to public curiosity," the court ruling said. "He has not been apprehensive about publicity. . . . Her personal memories were uncontestedly linked to those of the painter. So she could not evoke the ones without retracing the others. But she has absolutely not sought scandal or the satisfaction of a desire for vengeance."

The day after her victory, she received a phone call from Picasso. It was the first time they had spoken directly to each other in the last ten years. "Once more you win," he said. "I congratulate you, because as you know I like only the winners of life. I cannot stand losers."

"Thank you," Françoise said, "but you did everything you could to turn me into a loser. And anyway, why should you love only the winners?"

That phone call, after three legal actions, after all that had been said in court trying to discredit her and after all that she had been through emotionally during months of consecutive trials, was a validation of the perversity of character that Picasso's lawyers had tried to deny in their court statements. He could recognize the existence of others only if after he had done everything he could to destroy them, they had not been destroyed. Otherwise, like Goethe's Mephistopheles, he could have no conscious-

ness of another's reality. Human beings were conjured up by him and conjured away by him—at will. Three times he had tried to conjure Françoise and her book away, and three times the courts had refused to follow his will.

17

"WHAT'S IT ALL ABOUT?"

"HE HAD A WARRIOR'S MENTALITY," Picasso's cousin Manuel Blasco said. "Fight during the day and fornicate at night." In November 1965, in conspiratorial secrecy, Picasso was taken to the American Hospital in Neuilly for gallbladder and prostate surgery. From then on there would be only fighting. For a warrior who had worn his virility like a badge, the end of his sexual life was a terrible calamity. It looked, in fact, as though the operation might signal the end of his fighting days too. During the rest of 1965 and up to December 1966, he drew and etched but he did no painting. It was the longest he had ever been away from the battlefield. "When a man knows how to do something," he told Luis Miguel Dominguín, "he ceases being a man if he stops doing it." He urged Dominguín never to retire from bullfighting. And he knew that he could not allow himself to stay for much longer out of the arena.

"They gave me quite a goring when they operated on me in Paris," he said. "It was a terrible shock. The scar is exactly like what a bullfighter has after an accident in the ring. The difference is that the bullfighters receive their scars when they're young, and they heal better." On another occasion he said, "They cut me open like a chicken." He varied the imagery but the shock remained. His magical wholeness had been violated, and he felt more than ever exposed to the vicissitudes of "evil destiny." Keeping the news of his surgery from the world was a

way not only of protecting his privacy but of protecting himself. When he and Jacqueline had taken the night train for Paris on their way to the American Hospital, heavily disguised, maybe he thought that he was fooling not only the press but destiny. They had boarded the train at the station in Saint-Raphael, instead of Cannes, and Dr. Hepp, who would perform the surgery, had checked him into the hospital as Monsieur Ruiz.

He had kept death at bay, but not the despised signals of his inescapable mortality. He had had to give up his Gauloises, his life's most constant companion; his failing eyesight meant that his magnetic gaze was more and more often hidden behind glasses; his growing deafness gave him one more reason to avoid people; and the deep scar from the operation—which, once the curtain of secrecy had been lifted, he defiantly displayed to the few still allowed to visit him—was a constant hateful reminder of what he had lost forever. "Whenever I see you," he told Brassaï, "my first impulse is to reach in my pocket to offer you a cigarette, even though I know very well that neither of us smokes any longer. Age has forced us to give it up, but the desire remains! It's the same with making love. We don't do it anymore, but the desire is still with us!"

The desire and the frustration, the rage and the self-lacerating despair were funneled into his work, and sex in anticipation, sex in action, sex in retrospect became the dominant motif of much of his painting—once he had sufficiently recovered from the "goring" to start painting again. The reports from Notre-Dame-de-Vie were that Picasso was back to normal—his own extraordinary normal, of course. In the same way that he had all his life pretended to be an excellent swimmer, he now pretended, as best he could, to be untouched by age. "He only knows how to float and splash about a bit along the shore," wrote Roberto Otero, a bullfighting aficionado who had succeeded in penetrating the iron curtain of Notre-Dame-de-Vie. "Still, the imitation is so realistic that from a distance nobody could tell if his 'swimming' is authentic or not." And his imitation of being "fresh as the morning dew" was so convincing—to all those who wanted to be convinced—that the myth of the perpetually vital genius lived on. "Nine months have passed since Picasso's operation," wrote

Otero in his journal on August 15, 1966. "His recovery has been remarkably swift. Even the doctors are astounded." But every now and then there were those allowed in who were not entirely blinded by the privilege of access. Cecil Beaton was one of them. "Picasso, sad to relate," he wrote, "had aged and it had taken the form of shrivelling him. There was something melancholy about his eyes, which had lost some of their brilliance; before they were black, but now they seemed a light brown."

What he had lost—and it was reflected in his eyes—was his capacity for joy. "In the end," he had said, "everything comes back to oneself. It's the sun in the belly with a thousand rays. The rest is nothing." Now he told Pignon: "One day you'll see what it's like, when old age arrives and your powers diminish." It was the closest he came to admitting that the sun in his belly was not what it had been. And the rest was nothing. "Painting face to face with the next world, even be it nothingness, is not the same as painting face to face with this one, even be it painting," wrote Malraux about Picasso painting face to face with death, sitting now rather than standing, doubled up over his canvas.

Malraux was Minister of Cultural Affairs at the time when a retrospective exhibition was contemplated to honor Picasso on his eighty-fifth birthday. The Gaullist Minister was, however, loath to approach the Communist Painter. "The trouble was that they considered themselves equals before eternity," someone said, observing their mutual suspicion. "You're mad" was Malraux's response when he was urged to visit Picasso at Notre-Dame-de-Vie. "He'd leave me standing at the gate, sending word that someone was coming to open. And I'd wait there for hours while they tipped off *L'Humanité*." Finally, Jean Leymarie was put in charge of the exhibition, and all that remained was to persuade Picasso to accept the honor. "We made our big decisions in the evening," Jacqueline recalled. "Pablo always worked late; afterward we'd go to the kitchen and eat something, and it was then that he would make decisions. I talked to him about the exhibition, and he said no. An hour later, before going to bed, he said: 'If that's what you really want, go ahead, but I'll have nothing to do with it.' And he stayed in bed for a week." Of course, when the time came he could not resist dealing with

almost everything, and he even warned Leymarie: "You'd have been better off never knowing me. You're going to have the worst problems."

At the beginning of October 1966, Leymarie had left for Paris after a working visit to Notre-Dame-de-Vie, when someone realized that he had forgotten to measure the paintings being sent to the Grand Palais. "There is a constant coming and going," Otero recalled. "Jacqueline, Louise Leiris and the director of the gallery, Maurice Jardot, are in the process of correcting Leymarie's oversight, recognizing that he was the victim of a tremendous emotional experience."

The next day, there was a lot of flattering banter around the dinner table about how futile was the attempt to evaluate realistically the works leaving for Paris "because the government of France would fall." "In any case," said Otero, "there is no great problem, since the security measures taken will be in keeping with the value of the paintings. There will be a police escort for the trucks from Mougins to the Grand Palais, with a show of force worthy of an extraordinary bank operation. And police headquarters will follow the convoy of paintings by radio patrol during the entire trip. As if all this were not sufficient, a representative from the Ministry will accompany the expert Louvre movers in one of the trucks. Picasso listens to this talk with a mixture of curiosity and childlike admiration. It was as if he had personally unleashed a storm at sea by having accepted the homage show."

The morning that the trucks with the paintings and the sculptures finally left for Paris, Picasso, watching them from his bedroom terrace, wondered absentmindedly what had happened to the *Man with Sheep*. "What a fool I am," he immediately corrected himself. "They just took it with them a moment ago. . . .These things happen, just like asking a widow about her freshly buried husband. The worst part is that I'm going to miss the man with the sheep. I'm so used to pissing on it from the first-floor studio."

On November 26, Malraux inaugurated the retrospective of paintings at the Grand Palais and of sculptures at the Petit Palais. By now he had convinced himself that the exhibition had from the beginning been his brainchild. And in *Picasso's Mask*, he

referred to it as the "retrospective show I had organized in 1966." Close to a million people had seen the exhibition, and it was, therefore, something definitely worth having organized in retrospect, even if he had washed his hands of it in prospect. "Picasso dominates his century as Michelangelo dominated his," Jean Leymarie, who *had* organized the show, wrote in his introduction to the catalogue. "Still more is no doubt to be unveiled. The man whose three resounding syllables fill the century and the planet has not finished surprising and casting his spell on us." In one of the radio shows dedicated to the exhibition, a priest announced that "if the history of our times had not been written, one could read it in Picasso's work." He meant it as a compliment.

"Are you going? All the newspapers say you're going," Palau i Fabre asked when he visited Picasso at Notre-Dame-de-Vie during the retrospective. "Oh, really? Well, then, it's certain that I'm not going." Breton had said of Picasso that he had "developed to the ultimate the spirit not of contradiction but of evasion." He had in fact reached new heights in both. On the day of the opening he was greatly amused by the thought of all the *other* painters flocking to the show instead of doing their own work, and of all the unpainted canvases he must have on his conscience as a result. And musing on the exhibition, he wondered what was the point of it all: "I really don't know why I let it happen. Basically, I'm against exhibitions and homages, as you know. Moreover, it is of no use to anyone. Painting, exhibiting—what's it all about?"

It was the question that set the tone of the last years of Picasso's life. He felt more and more like Sisyphus, condemned to roll his heavy stone up a hill, only to have it roll back as he reached the top—day after day. "Worst of all," he said, "is that he never finishes. There's never a moment when you can say, 'I've worked well and tomorrow is Sunday.' As soon as you stop, it's because you've started again. You can put a picture aside and say you won't touch it again. But you can never write THE END."

Against his growing sense of futility and waste he could only pit more work, more and more frenzied, faster and faster, coarser and coarser. He was still recovering from an attack of hepatitis when, in December 1966, he started painting again. His work was suddenly invaded by soldiers—seventeenth-century soldiers that

he named musketeers and that had come to him when, during his fallow period, he spent a lot of time studying Rembrandt. "When things were going well," Jacqueline said, "he would come down from the studio saying, 'They're still coming! They're still coming!'"

"You would think," someone was quoted as saying, "he is trying to do a few more centuries of work in what he has left to live." He had already enclosed the terrace and turned it into an additional studio, having complained that he no longer had enough room to paint in: "The house is full of paintings, everywhere. They breed like rabbits!" Zervos kept arriving to photograph whatever he produced—paintings, drawings, etchings. "It's like going to the movies—or to a bullfight," he said. Jacqueline and the rest of the court seemed convinced that there was greatness in numbers.

But what did *he* think? "The more time passed," Parmelin said, "the more concerned he was to protect his work and to achieve finally the painting he dreamed of—*the* painting of which he had been dreaming all his life." And Otero wrote later, "Picasso has been painting at the rate of two canvases a day." But quantity and speed and ingenuity and prodigiousness and all the other easy yardsticks of achievement were of no relevance to the ultimate painting he longed for. That he knew. Perhaps he hoped that the more he painted, the greater the chances that he might stumble on it. White canvases had become a source of reproach to him. "What could I do?" he said once after he had turned away a party of Andalusians from Malaga who had come to visit him. "I would have liked to see them—but how? You know, two months ago Jacqueline bought sixty canvases from a paint supplier who was going out of business. Well, there are still eleven canvases unpainted, absolutely blank!"

Famished for real nourishment, he voraciously devoured the canvases Jacqueline kept feeding him. Work had become his only source of satisfaction, and the more unsatisfactory it was, the more, like an addict, he went back for bigger and bigger doses. "I have only one thought: work," he said. "I paint just as I breathe. When I work, I relax; not doing anything or entertaining visitors makes me tired." Sartre had said, "Hell is other people," and Picasso paraphrased his wartime friend: "I suffer from people's

presence, not from their absence." And later, "I despise wasting my time with people. Not only now, but ever since I can remember."

As work gradually took over his whole being and everything else was starved out, he seemed further away both from humanity and from the ultimate painting, which he even tried to describe: "The extraordinary would be to make with absolutely no constraints a picture that would incorporate itself into reality. . . . The opposite of a photograph. . . . A painting that contained everything of a particular woman and yet would not look like anything known about her." The closest he would ever come during his last years to capturing the invisible in painting was in words.

He suffered from a recurring nightmare about thieves. "I dream," he said, "that they're robbing me of something. I'm not sure what, but I do know that I wake up screaming, 'Stop thief! Stop thief!' Then, on other occasions, I wake up in the night and mull over a thousand things while trying to get back to sleep. It's then that I begin to think about not having seen the tiny Degas painting, for instance. Well, at that point I wake Jacqueline and ask her to bring the painting. As soon as I see it, I can begin to think about something else. And sometimes we can't find it. That's frightful. Then I begin to suspect it was carried off by the person I last showed it to in the room I last saw it in. After two months the painting turns up in another place, but meanwhile I'm certain that Kahnweiler, or Pignon . . . stole it." This was the nightmare world of robbers and friends-turned-thieves, of fear and suspicion that, asleep or awake, he lived in.

His fearful fantasies became reality in the spring of 1967; he was evicted from the rue des Grands-Augustins. It was very hard for many to believe that the man who had just been honored by one of the twentieth century's most extravagant rites, a massive retrospective show visited by a million pilgrims, was being barred from his old studio, still filled with his works, for non-occupancy. Picasso had lobbied all his powerful friends to prevent it from happening and had even received assurances from the Minister of Cultural Affairs himself, but in the end bureaucracy, the law and his nightmares prevailed.

The task of cataloguing and moving everything fell on Inès and

her son, who slept in the studio during the process, surrounded by Picassos. "What do you owe Inès for the move?" someone asked Picasso when it was all over. "I owe her the whole of life, not the move," he replied. Four years later, the expulsion from the rue des Grands-Augustins still weighed on him as if it had just happened. "Have you heard the sad news?" he asked Brassaï when he arrived at Notre-Dame-de-Vie one day in 1971. "My studios at the rue des Grands-Augustins don't exist any longer! They took them from me. I lost them stupidly."

"It was," wrote Brassaï, "as if he were announcing the death of someone whom we both had known and loved."

"It's sad, isn't it?" Picasso repeated. "It's a terrible loss for me. . . . All traces of the half-century I spent in Paris are now totally and definitely erased."

Affected by Picasso's visible sadness, Brassaï observed in the article he wrote in *Le Figaro* that it was "as if they had expelled Elizabeth of England from Buckingham Palace under the pretext that she was sojourning at Balmoral or Windsor."

Picasso mourned his old studio, in which he had not set foot for twelve years, longer and more volubly than he had ever mourned a friend. His need to feel and express affection sought refuge in the past, and not in the people of his past but in the places. "What one *will* do is more interesting than what one has already done," he had said in the rue des Grands-Augustins days. He tried frantically to act as though that were still true, but the urgency was born of futility rather than passion.

Futility and disgust filled the suite of three hundred forty-seven etchings that he began working on in March 1968, a month after Sabartés' death and the loss of one more link to life and the past. He went on defying death by continuing to dedicate paintings to his dead friend as if he were still alive. And by working. Aldo and Piero Crommelynck, brothers and masters of printmaking, had installed their press at Mougins and worked closely with him on the series of etchings he produced between March and October. There were brothel scenes; there was Celestina, the procuress from Spanish picaresque literature; there was Raphael copulating with Fornarina while relentlessly painting on her body or on nothing at all; and there were lots of voyeurs, sometimes Picasso himself as an old dwarf or a tiny clown, sometimes a king, a

jester, the Pope, or a musketeer. "The proud musketeer," wrote Schiff, "has become an old geezer at a peep show for whom the glorious stage of the world has narrowed into a dark-centered cleft of flesh." The series was described as "erotic," but it was the eroticism of the gaping crotch and the Peeping Tom.

Picasso was sick. And the couples that filled his work in 1969, kissing, copulating and suffocating each other, bore the stamp of his sickness. His body was a sack of ills and frustrated desires. The body that had for so long served him so well had turned against him. He could not see well, he could not hear well, his lungs fought for breath, his limbs fought for the strength to sustain him and he fought for the unconsciousness of sleep. But a sickness much more frightening than the inevitable sicknesses of a man close to ninety was the soul-sickness of a man close to death and utterly disconnected from the source of life, a man staring at death and seeing his own fearful imaginings.

People who loved him and whom he had perhaps loved tried to break through the mass of his isolation. Maya, now married to the captain of a French liner and living with her two sons in Marseille, had arrived with her children at the electronic gate in Mougins and heard the gardener repeat the well-rehearsed words: "Monsieur Picasso is not in." Many times she had called and many times she had got a similar response. Claude had arrived at the electronic gate with his young American wife, three months after his wedding in New York. "Who are you?" a voice asked through the gate intercom.

"I'm Claude," he replied.

"Claude who?"

"I'm Claude Picasso. I want to see my father."

The voice went away. It came back: "He's too busy to see you."

"Well, can I come back tomorrow?" Claude persisted quietly.

"No. I don't think he'll have time tomorrow."

At that point a truck with repairmen arrived. They announced themselves and the gate was immediately opened.

"Why can't I go in, if you can?" Claude asked, as if these men, strangers to him and to his pain, might have the answer to the haunting question he had to live with.

"Oh, you need a passport to get in there," one of them answered, laughing. Clearly Claude's had the wrong name on it.

The monthly checks Picasso had been sending Marie-Thérèse for more than thirty years had suddenly stopped. They were her only means of support, and in a panic Marie-Thérèse wrote him a long, sad and bewildered letter. She quoted Confucius: "Joy is in everything. One must know how to bring it out." And then, as if suddenly struck by the precariousness of her life, she quoted Schopenhauer: "Life is but a struggle for existence fought with the certainty of being vanquished." In a *Composition with Letters and White Hand* Picasso had painted in 1927 and kept with him ever since, Marie-Thérèse's monogram appears on a disembodied hand, a symbol of fate. Forty-two years later, Marie-Thérèse wrote about "the hand": his that had struck and forgotten and hers extended like a stricken beggar's. "I say that the hand is frightening, the hand raised for false oaths, the hand that clenches the rifle, the hand that braids the barbed wire, the hand that strikes, the hand that kills. I say that the hand is wretched, the wounded hand, the hand that begs, the hand that forgets, the hand in chains, in despair, the hand of death . . . "

She sent the letter unsigned—a distress signal that she hoped would stir some compassion. Picasso received it as a threatening spell and even talked to his lawyer Roland Dumas about the "evil eye" and "black magic" in it. Superstition was more than ever alive in him, now that so much else was dead, and increasingly given to paranoia and the frenzies of occult explanations, he saw even in Marie-Thérèse "demons" from whom he had to protect himself. The hand was left begging.

Maya, anxious about her mother, wrote to an art-dealer friend of hers in Los Angeles. It was "a sad letter," Frank Perls recalled. "Maya complained bitterly about her mother's lot. . . . Marie-Thérèse was desperate. Maya wrote that her mother had some paintings by Picasso she would like to sell. Could I tell her how? Could I help?" Perls called Marie-Thérèse from Los Angeles. "Maya had told her she could trust me," he said. "Here was this beautiful woman—whom Picasso had made into monuments of beauty, mother of my friend Maya—crying. Over six thousand miles away, a blond woman was crying."

Two days later, Perls arrived at No. 1 boulevard Henri-IV and was met not by a beautiful blond woman but by "a little old lady." Her first question was "When did you see him last?" Perls was

struck by the instant confession: he was still the center of her life. What made it all the more striking was that her words echoed those of a beautiful young girl who, a couple of months before, had come up to him outside the Café de Flore and asked him a similar question: "When did you see my father last?" It was Paloma.

Around her dining-room table in her badly heated apartment, Marie-Thérèse talked and talked about the man of whom she had made a cult. She brought out the relics: a shoe box with all his letters and little packages of tissue paper in which rested his fingernail clippings. The eight paintings, the twenty-three drawings and the fifty-three lithographs she owned were all in the vaults of the Banque Nationale de Paris.

At five o'clock on February 6, Perls arrived at Notre-Dame-de-Vie together with Heinz Berggruen, the publisher and art dealer. After many phone calls, they had sufficiently aroused Picasso's curiosity about the pictures in their suitcase to have the gate opened for them. "Well, where are the hundred pictures?" he asked when they walked in. "Where could you get a hundred of my pictures?" As soon as they started unpacking them, he knew. They explained that Marie-Thérèse needed money and that they would like him to sign them. "Yes, oh, yes," he said. "I'll do that. Leave them here. I'll sign them. By tomorrow the signatures will be dry and you can take them then."

Maya had warned Perls that Picasso might try to keep her mother's pictures in Mougins—because of Jacqueline, she had said. Perls was worried about leaving them behind, but before he could respond, Jacqueline burst in. As was her habit, she had been eavesdropping behind the door. "What the devil does that mean?" she screamed. "That woman who you slept with once in a while on Thursday afternoons has *all* those pictures. . . . Never will you sign those pictures! Those pictures belong to you. They were only in storage with Marie-Thérèse. . . . If she needs money why doesn't she hire herself out as a *femme de ménage?*" Screaming more abuse, she stormed out.

Picasso, left alone with the astonished dealers, improvised a virtuoso performance of the unwilling villain. "Oh, well, what can I do? You see how furious she is. I wish I could help Marie-Thérèse. I wish I could help you, but I cannot." They tried to

remind him how much Marie-Thérèse needed the money. "Never mind," he said, "I know you are in good faith, but what can I do? Jacqueline would never forgive me, so that's that."

The idea of Jacqueline not forgiving Monseigneur was, of course, preposterous. As always, whenever it suited him, Picasso portrayed himself as Jacqueline's hapless victim. He had never intended to sign Marie-Thérèse's pictures. He did, however, very happily sign the unsigned lithographs that Berggruen had brought along with him. But then, they belonged to a Scandinavian collector he had never met. On another occasion he had spent a lot of time mixing the paint just right to provide the perfect signature to an unsigned Picasso that Tony Curtis owned and had asked him to sign. But then, Tony Curtis was a film star.

Perls called Maya. "I started all this," she had told him in Marseille when he stopped to see her on his way to Notre-Dame-de-Vie, "to help my mother live a more comfortable life, to keep her from begging for her monthly check; I hope she can get enough money to buy a little house here by the sea and live near her grandchildren." When Perls told her what had happened, she cried. "I am still an art dealer," Perls wrote, "but the last time I saw Pablo was not a nice day." He had never before dared call "the great, the grand old man" Pablo.

Marie-Thérèse, still in her badly heated apartment, with no money and no monthly check, decided to talk to a lawyer. Georges Langlois contacted Roland Dumas, and it took the two lawyers several months of negotiations before the payments to Marie-Thérèse were resumed. "Mon cher Langlois," was Dumas's first response, "it will be very difficult to resume the allowance because of the letter she sent him which has made him imagine the worst." And all too ready, like so many others in Picasso's life, to take the responsibility and the guilt, Marie-Thérèse told Langlois: "I have made a terrible blunder."

It soon became clear through the lawyers' many meetings and talks that Picasso was adamant about Marie-Thérèse not selling anything he had given her. Finally an agreement was reached, largely thanks to Roland Dumas, who, as Langlois said, did everything he could to calm down his client's irrational fears. Marie-Thérèse agreed not to sell any of Picasso's works during his lifetime, in exchange for which he agreed to provide her, through

his lawyer, with a letter recognizing her legal ownership of the works Perls had returned to her unsigned, thereby preventing any litigation after his death. He still did not sign the unsigned works, but he authenticated them as being indeed his and as being of value. "Without this," Langlois explained, "he had the right under the law to disown the works as being unsatisfactory, and even claim that he had left them with her but had intended to tear them up or otherwise destroy them. He could say that this was why he had not signed them. At this moment, Picasso or no Picasso, the works would have lost their market value."

It was explained to Picasso that by sending Marie-Thérèse money on a monthly basis for thirty years, he was acknowledging what in French law is called his "natural obligation" to her. Her monthly allowance was not only resumed, but increased. "After all," Langlois said, "I had to achieve something for her to justify my existence!" So what natural feeling had not accomplished, legal pressure did. It was the language of power which Picasso understood and spoke fluently.

The Marie-Thérèse case was closed, but Françoise's legal battle to legitimize her children went on. There the law was still on Picasso's side, so his instructions to Roland Dumas were unambiguous: to fight against all his children's claims. He had told Dumas that "his works were much more his children than the human beings that claimed to be his children." In 1970, the same year that Françoise married, in Neuilly, Dr. Jonas Salk, the celebrated scientist who had developed the vaccine against polio, the court in Grasse threw out her children's plea for recognition of paternity. "They have my name. Isn't that enough?" Picasso told a court reporter.

Even his own lawyers did not think so. In a dramatic turnabout, Maître Izard, who had pleaded against Françoise and her book, a member of the Académie Française and one of the best-known lawyers in France, would later offer to take on her children's case. "It was so extraordinary," Françoise said, "that at first I thought that it was another of Pablo's ploys, a way to guarantee that my children would never get their rights. But when I met with him, I saw that he really felt that Picasso had been in the wrong in trying to stop my book and extremely unfair in denying my children's rights." Six months later, Izard died of a

heart attack. "It was sad to lose him," Françoise said, "but still wonderful that he had joined us. And the fact that *he* had made the move, that he had switched sides, proved very important psychologically."

The other lawyer in the trial against her book, Maître de Sariac, had not switched sides, but was full of admiration for Françoise's goal: "Françoise cared enormously for the future of her children. That was her constant preoccupation, and her legal battles had one purpose only: to regularize their situation and give them all their rights. I have nothing but good to say about her. As I told her myself: 'I regret what has happened.' "

There were many who regretted not only what was happening in Picasso's life, but what was happening in his art. The exhibition of his last year's work at the Palais des Papes in Avignon in May 1970 provoked a slashing attack even from that great Picasso enthusiast and collector Douglas Cooper, who said that he "had looked long at the pictures and they were nothing but the incoherent scribblings of a frenetic old man in the antechamber of death." Picasso, who had once praised God for having no style, had himself abandoned style and finish and established craftsmanship, and had replaced them with savagery, decorative blues, reds and saffron yellows and a pornographic obsession.

In the same month that Picasso's exhibition opened in Avignon, in Paris a fire destroyed the Bateau-Lavoir. The place where it all began had been consumed in flames. Picasso staggered on. "If I spit, they'll take my spit, frame it and sell it as great art," he had once said. But among his idolizers, many had grown incoherent. "Wonders, wonders, wonders," wrote Rafael Alberti about the two hundred one paintings that Picasso had selected himself for another show in Avignon from what he had produced between the fall of 1970 and the summer of 1972. "There are so many wonders, the most profound and the most harrowing that have ever come out of Picasso. . . . Maybe images of anticipation of man after the next nuclear war. . . . Picasso has invented the way to clap with one hand; he has been able to fight himself in the bullring and put an end to his own life by thrusting his bullfighter's sword just beneath his shoulder; and then he was dragged around the ring by the mules and returned alive in the middle of the plaza."

On October 25, 1971, he celebrated, very quietly, his ninetieth birthday. His birthday present from Jacqueline was the installation of an elevator at Notre-Dame-de-Vie. His birthday present from the French state was the unveiling by the President himself of eight of his paintings in the Grand Gallery of the Louvre. "Speak to me with respect," he told the Pignons. "I'm going to be hung at the Louvre! Do you think the other Louvre painters will be furious? Will they all rise at night to throw me out?" That was when he was joking. Most of the time, though, he was full of bitterness: "What do they want—thanks?" It changed nothing, he would say, had absolutely no importance, and what was of real concern to him was elsewhere.

No one was allowed to mention his real concern: death. "Picasso will be 100 years old in ten years" was the hubristic headline of an article that Brassaï wrote for Le Figaro after his visit to Notre-Dame-de-Vie in 1971. "One must say, one must emphasize," Brassaï wrote, "that this man, unscathed by the anguish of old age and resplendent with all the visible signs of youth—this ninety-year-old Picasso whom the universe celebrates today is in great part the work, or rather the masterpiece, of Jacqueline Picasso." As well as informing the world that Picasso had discovered the secret of eternal youth, Brassaï foreshadowed the veneration of Jacqueline that grew exponentially the closer she got to being the great man's widow. "Calm, serene, devoted, she is the ideal companion of Picasso in his lofty age," he concluded after he had praised her extraordinary abilities as Picasso's secretary. He had asked Jacqueline to show him her latest photographs of Picasso, because, the great photographer added, "she takes very beautiful ones." "But Brassaï," she replied, "I have done nothing for years. I have no spare time. I am entirely at the service of my master."

"I am overburdened with work," Picasso told a reporter at Nice airport, where they had accompanied Roland Dumas on his way back to Paris. "I don't have a single second to spare, and can't think of anything else." That was Jacqueline's and Picasso's ultimate complicity. They were co-conspirators in a tragic game of hide-and-seek, tacitly determined to smother death with busy business: he busy with work, she busy with him. He would say, "He is an old man" of friends thirty and forty years younger, but

as for himself, wasn't everybody telling him that he was "more sprightly than ever"? Of his old friends only Pallarès remained. Picasso made quite sure when he came to visit that he did not sleep there, afraid that, being even older than himself, Pallarès might suddenly die under his roof and "contaminate" him. Yet whenever news of another friend's death reached him, he kept repeating defiantly: "You know, you must never equate age with death. The one has nothing to do with the other."

Socrates had taught that we should "practice death" daily, evaluating the lesser in life in terms of the greater. Picasso practiced daily, nightly and relentlessly the lie of denying death. He clung desperately to his identity as a painter, as though that was not only his shield, his defense, his talisman, but all that he was. Presiding over this colossal defense against truth was Jacqueline, handpicked by him for the purpose. And at the heart of this defensive strategy was work—frenzied work at the expense of everything, including good work. "I do worse every day," he said in a rare moment of self-awareness. But he did not let that stand in his way: "I have to work. . . . I have to keep going."

Among the one hundred fifty-six last etchings that he did between January 1970 and March 1972, there were forty inspired by the eleven Degas monotypes that he owned, portraying scenes in a brothel. He had brought one out to show to Brassaï. "The girls, clad only in long midnight blue stockings," Brassaï wrote, "are clustered around their madam, an old harridan dressed entirely in black, embracing her and kissing her cheeks. 'It's called *La Fête de Madame*,' Picasso explains. 'One of Degas's masterpieces, don't you think?' " Perhaps to punish Degas for producing what he no longer could, Picasso had turned Degas in his etchings into an impotent voyeur, plundering with his stare the female monsters parading their lacerated flesh. "Degas would have kicked me in the ass if he had seen himself like this," he told Pierre Daix. If Degas is ridiculed, womanhood is savaged in these forty variations on Picasso's misogyny, the repulsive whores' orifices obsessively and menacingly displayed.

"You live a poet's life," he told Parmelin, "and I a convict's." On June 30, 1972, he looked in the face the terror that consumed him, and drew it. It was his last self-portrait. The next day, Pierre Daix came to visit him. "I made a drawing yesterday," he told

56

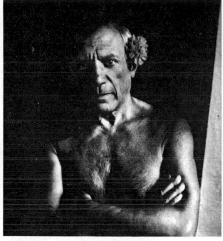

[RIGHT] Despite his clowning
for the cameras, Picasso felt
alone and unhappy, all the
more so when the news
reached him that Françoise had
married the painter Luc Simon
[BELOW, LEFT]. "I'd rather see a
woman die, any day," he said,
"than see her happy with
someone else."

57

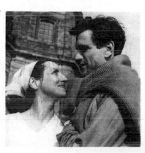

58

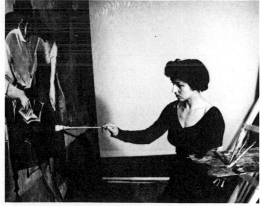

Françoise discovered
that Parisian art
dealers refused to
exhibit her work.
Picasso had made it
clear that anyone
who was her friend
was his enemy.

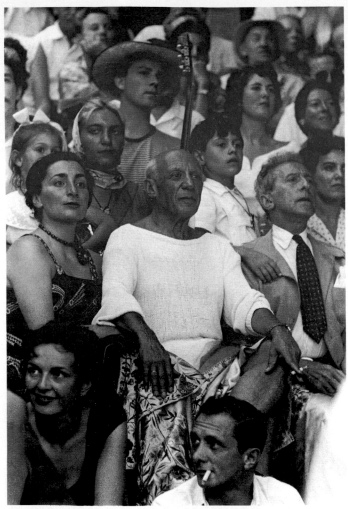

Picasso at a bullfight with Jacqueline and Cocteau, and (directly be-hind them) Paloma, Maya and Claude. "Let's go to the bulls," he would say. "It's the only thing left to us."

Picasso beneath The Fall of Icarus, the despairing mural he created in 1958 for the headquarters of UNESCO, an organization dedicated to hope. Was it, many wondered during the unveiling, a masterpiece or a giant doodle?

Drawing from a sketchbook Picasso began in June 1962. Sex in anticipation, sex in action, sex in retrospect was becoming the dominant motif of much of his work.

The Château de Vauvenargues, the second of three mag-
nificent homes Picasso owned in his later years, spending
millions to live in bohemian splendor.

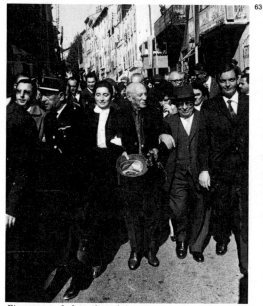

Picasso reveled in the adulation of the crowd during the
celebration of his eightieth birthday in October 1961. It was
compared to a "holy feast in Renaissance times," with fire-
works, a bullfight in his honor and speeches praising his
greatness and his humanity.

64

The isolation of Picasso began with the discounting of every emotional claim. His sister Lola, here with her two children, Jaime and Lola, were among those cut off from his life.

Picasso's children Claude, Paloma and Paulo, with Paulo's son Bernard, at a public homage to Picasso in 1966. Christmas 1963 was, however, the last time Claude and Paloma would spend time with their father. "When the door slammed shut," said Claude, "it was like a bolt of lightning."

65

The Peeing Woman, *1965. A growing disgust and loathing for Jacqueline and for the female body filled much of his work, despite public demonstrations of affection before the camera.*

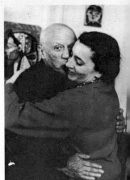

66

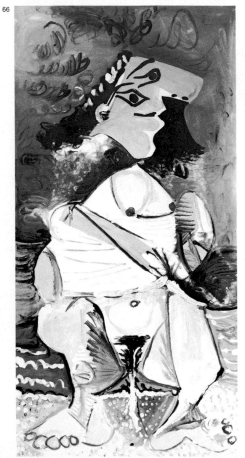

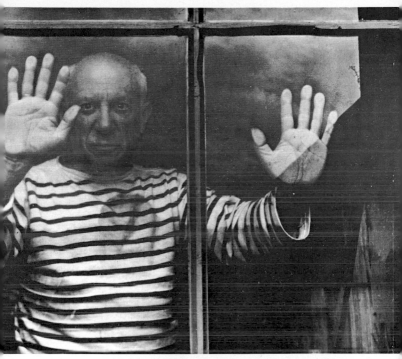

"You live a poet's life," he told Hélène Parmelin, *"and I a convict's."*

69

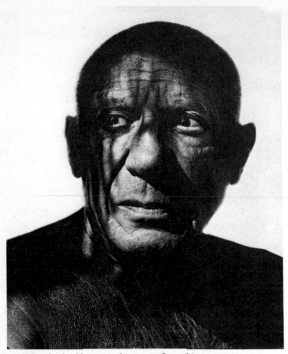

*What he had lost—and it was reflected in
his eyes—was his capacity for joy.*

70

*On June 30, 1972, he looked at the terror
that consumed him, and drew it. It was
his last self-portrait.*

him. "I think I have touched on something there. . . . It is not like anything ever done." He took the drawing and held it up to his face, then put it down, without any comment. It was the face of frozen anguish and primordial horror held next to the mask that he had worn for so long and that had fooled so many. It was the horror he had painted and the anguish he had caused and which, in his own anguish, he continued to cause. Two months after he drew his last self-portrait, Pablito, his first grandson, tried to see him. He arrived on his motorcycle and showed his identity card. He was turned away, and when he persisted, the dogs were let loose on him and his motorcycle was thrown into a ditch.

"We never mentioned his health," Parmelin said. "And he talked about the health only of Jacqueline." So the Pignons were told nothing when Picasso went into the hospital in the fall of 1972 with pulmonary congestion. Days later, after they had been calling the house and getting either no reply or no explanation, a card arrived from Jacqueline: "All is well." That was all that was ever said. In the meantime, rumors of his death were whispered in Paris.

"I no longer interest you," Picasso told the Pignons on the phone in December, his voice broken. "I know very well that I don't count." He had earlier accused Pignon of loving Tintoretto more than him because he had preferred to go to Venice rather than stay with him at Notre-Dame-de-Vie. Now he could not bear the thought that they could not be there on New Year's Eve: "Why, but why? . . . It's idiotic; just come!" Jacqueline was just as insistent: "Come on, don't create problems! Come immediately!"

They arrived on the morning of December 31. The Gilis were already there from Barcelona. Jacqueline was so tense that Parmelin felt that she was "continually on the edge of cracking up." "And tonight," Jacqueline exclaimed as they were sitting around Picasso's bed, "we are going to have a party!" As soon as she was out of the room, Picasso felt that he had to account for this tinge of hysteria: "She cannot see how I am, and yet I am all she can see." Jacqueline had buried the truth so deeply that for her the lie was now the truth. "Tonight we are going to have a party!" she repeated, as soon as she was back in the room. "Yes, yes, and we are going to dance too," Picasso said, humoring her. For him

it was becoming too hard to deny the signals his body was sending
him as it gradually capsized. Still, and even *in extremis*, protect-
ing the Picasso mask was in the forefront of his consciousness.
"Tell them, above all," the Pignons overheard him say to Jacque-
line as they were leaving his bedroom, "that they should tell no
one that I'm sick."

A part of him clung to the mask, but a part of him was too
exhausted to care. At different times during that grim New Year's
Eve, the control passed from one to the other. The house was
full of tension. "Why inflict this 'party' on him?" the Pignons
wondered to themselves. "Why not leave him in peace?" Exasper-
ated, Picasso endorsed their silent thoughts. He told them that
"Jacqueline was outside reality, that she's going to all this trouble
for nothing, that he wants to see nobody, that he only wants to
be left in peace, alone with his thoughts, that everybody should
go and have fun but that he doesn't want to move—for nothing
in the world." And he added: "It's already difficult being with
myself alone. I have to walk, to drink, to eat, 'not to let myself
go'; what does all that mean—and the good doctors and the good
advice? To be left alone, that's all I ask."

He was, for the moment, tired of everyone's efforts to hide his
death from him. Above all, he was tired of his own efforts, tired
of all the falsehoods, the deceptions and the self-deceptions. But
Jacqueline was determined that the game should go on, that they
should have "a nice time." So he put on the mask again and, arm
in arm with Jacqueline, took the elevator down to the party.
Antebi, his lawyer from Cannes, and his wife had already joined
the others. "See how we dressed up?" he said, pointing to their
party clothes. The Pignons, who moments earlier had felt and
acted as though they were at a wake, were all too eager to applaud
the performance and fool themselves: "The Picasso who enters is
the Picasso we know. Except for the voice. Animated, pleased,
proud like a conqueror, which he is. . . . I had the impression
that he felt cured, ready for anything, reinstated in everyday life
—the Picasso of the good old days."

In fact, he had only regained a few inches of lost ground—
enough to find the strength to see 1973 in with his mask tightly in
place. His face, the face of the last self-portrait, stayed rolled up
in the dark studio next to the living room. The only painting he

did that year was to rework *Character with a Bird*, his variation on Rembrandt's *Falconer*, in which he transformed "the watchful gaze of *The Falconer* into the frightened stare of an idol"—the stare of the rolled-up self-portrait.

On April 1, he wrote to Marie-Thérèse telling her that she was the only woman he had loved. Was he seeing her again as she had first been for him—a vision of beauty and purity, a promise of entering together a forbidden world where abandoned sexuality would lead to a heightened state of being? Or was the letter a Mephistophelian April Fool's joke, the last lie with which to secure her bondage to him, disorient her a little more and put one more nail in her cross? Perhaps he wrote to her from mere force of habit. Perhaps he spoke the truth.

On April 5, he called Pignon. It was the day before the opening of the exhibition of Pignon's *Red Nudes*: "Go on, don't spare them! . . . Paint nudes, nudes and more nudes! . . . Show them!" He went on in his broken voice: "mountains of breasts, mountains of bottoms." Jacqueline took the phone when the men had finished their men's talk. "You see," she told Parmelin, "everything is fine!"

On the morning of Sunday, April 8, Jacqueline called Pierre Bernal, Picasso's cardiologist in Paris. Dawn had barely broken. She had awakened him, but she sounded cool and matter-of-fact. "When are you coming to see us? You're still coming for Easter, aren't you?"

"No, not before May," he replied. "I have to go to the States right after Easter."

"So late . . . " she said in a tone which betrayed that this was not a casual call at a strange hour.

"Would you like me to come right away?" he asked.

"Yes, that's it. It would please him. He wants to see you. Come?" Dr. Bernal took the first plane to Nice. Florenz Rance, the local doctor, was already there when he arrived. He had been coming up to Notre-Dame-de-Vie almost every day. "A responsibility, rather like looking after the king of France!" he said.

Sitting up painfully against the pillows, in his beige pajamas, Picasso was gasping for breath. The fingers of the hand he extended to the doctor were blue and swollen. While Dr. Bernal was confirming with his instruments what his professional eye

had already seen, Jacqueline, trailing her long red dressing gown, paced up and down the room. Catherine and Miguel waited in another room. The cardiogram showed rattles in both lungs and a dangerously large congestion in the left lung.

"I knew the minute I walked in," Dr. Bernal said, "that it was the end. He asked me no questions. He did not realize that he was going to die. I tried to make Jacqueline understand, in the room next door, that it was going badly."

"We have already saved him," she said. "You are here. We are going to save him. He doesn't have the right to do this to me, he doesn't have the right to leave me . . . " These were the words she kept repeating through the morning like an incantation: "He doesn't have the right to do this to me, he doesn't have the right to leave me . . . "

"Where are you, Jacqueline?" Picasso cried from his bedroom. Left alone with Catherine, Dr. Bernal repeated to her what her mother refused to hear: "You know it's going very badly."

"I can see," replied Catherine.

"He cannot do this to me . . . " Jacqueline kept repeating, more to herself than to anyone else.

His heart and his lungs were both fast giving out. He tried to talk, but he was suffocating. His words, coming through his gasps for air, sounded like wailing, hard to understand. He mentioned Apollinaire and seemed far away from Notre-Dame-de-Vie, in the spectral world of his past. Then he was once again back in his room: "Where are you, Jacqueline?" He turned to Dr. Bernal: "You are wrong not to be married. It's useful." They were his last coherent words.

For two hours after that, he struggled convulsively for breath. At 11:45, Dr. Bernal was giving him an injection when he noticed that his heart had failed. He immediately started a cardiac massage. At the same time, he asked Miguel to give him mouth-to-mouth resuscitation and Jacqueline what turned out to be a last injection. "I could not convince her that the end had come," the doctor said. "Yet I had closed his eyes."

Someone in the room coughed. Jacqueline jumped and cried, "It's him." She compelled the doctor to take his pulse again. But the only sound he could hear was the murmur of the roses rustling against the window.

EPILOGUE

On the afternoon of April 8, in Barcelona, Manuel Pallarès, Picasso's oldest friend, was listening to the radio when the program was interrupted by a bulletin announcing the death of Pablo Picasso that morning. He took the next plane to Nice and arrived at the barbed-wire gates of Notre-Dame-de-Vie in time, he hoped, to pay his respects to his friend of eighty years for the last time. It was raining, and there were Afghan hounds and gendarmes guarding the gates. They announced his arrival on the entry telephone. No, came back the answer, Madame Picasso would not allow him in. The ninety-seven-year-old man was left standing in the pouring rain.

Maya, Claude and Paloma received the same answer. No, they would not be allowed to see their father for the last time; no, they would not be allowed at the funeral. Nor would his grandchildren, Pablito and Marina, or Inès—or, of course, Marie-Thérèse.

Inside Notre-Dame-de-Vie, Picasso was lying on his bed covered in an embroidered black Spanish cape. At 5:00 A.M. on April 10, the funeral hearse, with the widow, in a long black cape, sitting beside the driver, left Mougins for Vauvenargues, where she had decided to bury her husband. She had hated the old castle from the beginning, and he himself had grown to hate it, but it was secluded and less accessible than any alternative: he would be buried in the same isolation in which he had lived his last years. Paulo, drunk, was following the hearse, as were Cath-

469

erine; Arias, the barber; Miguel, the secretary, and the Gilis from Spain. There was a highway for a large part of the one hundred seventy kilometers from Mougins to Vauvenargues, but Jacqueline had chosen a longer mountain road. It had been snowing all night—a rare occurrence for April in the South of France—and along the narrow, curvy road, a truck abandoned in the recent snow blocked the way. Snowplows had to be summoned to clear the road before the cortège could negotiate the difficult turn, leave the mountain road and reach the castle by the highway.

The gravediggers and a delegation from the municipal council of Vauvenargues were waiting at the foot of the stone steps leading up to the castle. It was there that Jacqueline had decided to bury her husband. But the ground was too rocky for picks and shovels. The silence of the snowfall was suddenly shattered by the noise of pneumatic drills.

Later, a massive black bronze of a woman with a vase would tower over the grave. Unknown to Jacqueline, it was a statue of Marie-Thérèse that Picasso had modeled in Boisgeloup in 1933.

"I wrote to Miguel, his secretary," Marie-Thérèse recalled. "I told him: 'I can't come because they won't let me in. So please kiss him for me,' and then I thanked him for having worked for Picasso. When I found out that he would be buried at Vauvenargues, I went there and demanded to be let into the château. A policeman came with the gardener, and they told me that they were in so much sorrow inside that they couldn't receive me. I left, and afterward I learned that Claude and Paloma had also come with Maya and they had not been received either, so they had to go to the cemetery at Vauvenargues to place the flowers they had brought."

"When I die," Picasso had prophesied, "it will be a shipwreck, and as when a huge ship sinks, many people all around will be sucked down with it."

Pablito had begged his father to allow him to be present at his grandfather's funeral. Paulo, once again drunk, had told him that Jacqueline had categorically refused. On the morning of Picasso's funeral, the grandson who bore his name drank a container of potassium chloride bleach. He was taken to the hospital in An-

tibes, where the doctors found that it was too late to save his digestive organs. He died three months later, on July 11, 1973, of starvation. His life had been prolonged by a series of operations and grafts which had been paid for by Marie-Thérèse. She had sold some of her Picassos to try to save the life of his grandson.

"It will be worse than anyone imagines," Picasso had predicted about the settling of his estate. Without a will or testament, with three illegitimate children and with French law in a confusing state of transition concerning the rights of children born out of wedlock, it was not clear either who the heirs were or what exactly there was to inherit.

Nine months after Picasso's death, a law was passed that allowed illegitimate children to inherit from their parents, provided they had established proof of their descent before their twenty-second birthday. Françoise had already registered with the courts when Claude and Paloma were twenty-one, giving them the right to claim exclusion from the age barrier when the proposed legislation became law.

The law had thwarted Jacqueline's and Picasso's attempts to shut out his illegitimate children from their natural rights. Since his death, Jacqueline had clung to Picasso's ghost, as in life she had clung to him. The shutters to her bedroom were kept closed. "I have not opened them since Picasso . . . died," she explained, hesitating over "died." She would lay a place for him at the table; act out strange rituals with black capes and burning candles which the locals speculated about in hushed tones; and she had been known to announce that "Mstislav Rostropovich and Galina Vishnevskaya were here yesterday, and Vishnevskaya sang all night for me and for Pablo."

In March 1974, Claude and Paloma, and soon after, Maya, were recognized as legal heirs. On June 6, 1975, Paulo died, at fifty-four, of cirrhosis of the liver brought on by drug and alcohol abuse, leaving his two surviving children, Marina, twenty-four, and Bernard, sixteen, to inherit his share of the estate. So there were now six heirs: Jacqueline, Maya, Claude, Paloma, Marina and Bernard.

Still to be determined were what the estate consisted of and

what each heir would inherit. At the request of Claude and Paloma, a notary of the Central Civil Tribunal in Paris, Pierre Zecri, had been appointed the estate's official administrator. The valuation of all the thousands of works Picasso had left behind was entrusted to the eminent art expert Maurice Rheims. The wrangling over the heirs' shares was in the hands of assorted lawyers whose legal fees were estimated to have added up to one of the shares in the estate. "You can never get two members of the family," Claude said, "to agree on anything." Disharmony reigned, now as ever.

Finally, in September 1977, *l'affaire Picasso* was over. The estate was valued at $260 million—a figure assumed, since it was reached for tax purposes, to be an underestimate. The nearly 50,000 works that Rheims and his team had photographed consisted of 1,885 paintings, 1,228 sculptures, 2,880 ceramics, 18,095 engravings, 6,112 lithographs, 3,181 linocuts, 7,089 drawings and an additional 4,659 drawings and sketches in 149 notebooks, 11 tapestries and 8 rugs. Jean Leymarie and Dominique Bozo, who had been appointed director of what was to become the Musée Picasso in Paris, selected the works the state would receive in lieu of death duties. Jacqueline inherited the largest portion, almost three-tenths of the total estate and including Notre-Dame-de-Vie and Vauvenargues. Marina and Bernard each inherited slightly more than two-tenths of the total, one-tenth from the delayed inheritance of their grandmother Olga, with Marina receiving La Californie, and Bernard Boisgeloup. Maya, Claude and Paloma each inherited one-tenth of the total. They all drew lots for already divided groups of Picasso's Picassos—the number of lots they drew being dependent on their percentage in the estate. They were also allowed some sentimental selections: Marina chose a picture of her grandmother Olga; Claude a portrait of himself; Maya a statue of her mother.

On October 20, 1977, five days before the ninety-sixth anniversary of Picasso's birth and in the year of the fiftieth anniversary of their meeting, Marie-Thérèse hanged herself in the garage of her house in Juan-les-Pins. She was sixty-eight years old. In a farewell letter to Maya, she wrote of an "irresistible compulsion." "You have to know what his life had meant to her," Maya said.

"It wasn't just his dying that drove her to it. It was much, much more than that. . . . Their relationship was crazy. She felt she had to look after him—even when he was dead! She couldn't bear the thought of him alone, his grave surrounded by people who could not possibly give him what she had given him."

Just after midnight on October 15, 1986, Jacqueline called Aurelio Torrente, the director of the Spanish Museum of Contemporary Art in Madrid, to discuss the final details of the exhibition of her personal selection of Picasso's paintings that was to open in Madrid ten days later. She assured him that she would be there for the opening. At three o'clock in the morning, she lay on her bed, pulled the sheet up to her chin and shot herself in the temple. She had left behind a list of everyone she wanted at her funeral.

That was the dark, tragic legacy Picasso left behind in his life. The legacy of his art has to be seen in conjunction with the legacy of our time. He brought to fullest expression the shattered vision of a century that perhaps could be understood in no other terms; and he brought to painting the vision of disintegration that Schoenberg and Bartok brought to music, Kafka and Beckett to literature. He took to its ultimate conclusion the negative vision of the modernist world—so much that followed has been footnotes to Picasso. "He was without doubt," Pierre Daix wrote, "the most Faustian artist of a Faustian modernity, but the infinite that was his goal excluded any reconciliation with God."

His tragedy was that he longed for the ultimate in painting and died knowing that it had eluded him. Unlike Shakespeare and Mozart, whose prolific creativity he shared, Picasso was not a timeless genius. Jonson's epitaph for Shakespeare was that he "was not of an age, but for all time." And even Salieri would not have withheld that epitaph from Mozart. I began this book feeling, like the millions of pilgrims to the Picasso retrospectives, all too eager to place him on that narrow peak. I ended convinced that he was in fact a time-bound genius, a seismograph for the conflicts, turmoil and anguish of his age.

From that moment, the immense Picasso literature was suddenly alight with statements from those who, through the years,

had seen the fatal flaw in his titanic genius. As early as 1914, a Russian art critic, Yakov Tugendhold, wrote of Picasso's search for "the dimension of the infinite": "Tragedy presides over the work of this intrepid Don Quixote, this knight errant of the absolute . . . doomed to an eternal and hopeless quest. For art, which is essentially dynamic, cannot be everlasting; it only touches eternity when man, in love with the world, 'implores the fleeting instant to remain.' "

From the time that he shook the art world with *Les Demoiselles d'Avignon*, Picasso was out of love with the world. He saw his role as a painter as fashioning weapons of combat against every emotion of belonging in creation and celebrating life, against nature, human nature and the God who created it all. "I must obstinately remain at the moment among those who cannot see Picasso in the ultimate pantheon," wrote the artist and art critic Michael Ayrton in 1956. "If he is not here it is because whilst the whole achievement is miraculous I am conscious of a factor missing which is present in ultimately great painting, and this factor is the depth which accompanies ineloquence. The still centre."

"How difficult it is," Picasso had said soon after his eighty-fifth birthday, "to get something of the absolute into the frog pond." But however difficult, is it not the highest function of art to try to get something of the absolute into the frog pond of this world? With prodigious skill, complete mastery of the language of painting, inexhaustible versatility and monumental virtuosity, ingenuity and imagination, Picasso showed us the mud in our frog pond and the night over it. There is, of course, "no sun without shadow, and it is essential to know the night," yet there is a sense in all great art that beyond the darkness and the nightmares that it portrays, beyond humanity's anguished cries that it gives voice to, there is harmony, order and peace. There is fear in Shakespeare's *Tempest* and in Mozart's *Magic Flute*, but it is cast out by love; there is horror and ugliness, but a new order of harmony and beauty evolves out of them; there is evil, but it is overcome by good. "Despite so many ordeals," cries out Oedipus, "my advanced age and the nobility of my soul make me conclude that all is well."

Picasso's advanced age was filled with despair and fueled by hatred. As for his art, he had told André Malraux that "he had

no need of style, because his rage would become a prime factor in the style of our time." And his rage did become the dominant style of our time; but there are growing signs that something beyond rage is demanded by the present. "Modern artists," Meyer Schapiro wrote, "have greater resources than modernity allows them to disclose—resources which are often unsuspected by the artists themselves." It was a call to modern artists to explore the worlds that would be revealed "if their art were open to all that they felt or loved."

Looking back on Picasso's death, Michel Leiris wrote: "Two or three days later, I read the conclusion of a newspaper article by an art historian devoted to the departed Picasso. . . . He evoked in a few lines the legend according to which the passing from the pagan to the Christian era was proclaimed by a voice crying forth: 'Pan, the great Pan is dead!' The end of a world or the beginning of another?"

As we move toward the beginning of another world and a new century, what will Picasso, so irrevocably tied to the age that is dying, have to say to the age being born?

NOTES ON SOURCES

IN QUOTING from published sources, in some instances I have used an existing English translation and in others, where I felt it would be more effective, I have translated from the original French or Spanish edition. Accordingly, a book or an article is identified in the notes sometimes in its English translation and sometimes in its original edition.

The quotes from Françoise Gilot came from extensive interviews with her. In the matter of recollecting Picasso's own words, however, she and I agreed to use them as they appear in her book *Life with Picasso* so as to avoid the existence of two varying records of what he said.

Where I quote from interviews with friends of Picasso who have also published their recollections of him, I have distinguished in the notes which of the two sources the quote came from.

In the text I have, where appropriate, used Catalan spelling. Picasso's friends from Barcelona are, therefore, referred to by their Catalan names: for example, Pere Manyac rather than Petrus Mañach, Jaume Sabartés rather than Jaime Sabartés, even though Sabartés appears as Jaime Sabartés in the French and English editions of his books.

PICASSO

PREFACE

23 "One and one, two": Ibid., p. 35.

23 "What are we going to do": Ibid.

24 "It is rather curious": Palau i Fabre, *Picasso: The Early Years, 1881–1907*, p. 32.

24 "When I was a little boy": Alberti, *Lo que cante y dije de Picasso*, p. 228.

24 "Are you a father": Fundacio Picasso-Reventós, ed., *Homenatge de Catalunya a Picasso*, p. 28.

24 "I still remember one of my first": Palau i Fabre, *Picasso: The Early Years, 1881–1907*, p. 32.

25 "ask him a couple of questions": Sabartés, *Picasso: An Intimate Portrait*, p. 36.

25 "Let us see": Ibid.

25 "You can't imagine": Ibid., p. 35.

25 "Had he not concentrated": Ibid., p. 39.

25 "I'll show them what I can do": Ibid.

26 "In Corunna my father": Sabartés, *Picasso: Portraits et souvenirs*, pp. 16–17.

26 "not to say anything": Ibid., p. 11.

26 "In Damas Street we had": *Picasso e a Corunna*, p. 4.

27 "Without so much": Palau i Fabre, *Picasso: The Early Years, 1881–1907*, p. 41.

27 "For being a bad student": *Picasso e a Corunna*, p. 4.

27 "Don José Ruiz Blasco": Palau i Fabre, *Picasso: The Early Years, 1881–1907*, p. 42.

28 "they should put out": Berger, *The Success and Failure of Picasso*, p. 32.

28 "My father cut off the feet": Sabartés, *Picasso: Portraits et souvenirs*, p. 38.

28 "In the hands is where": Cabanne, *Pablo Picasso*, p. 25.

28 "Wanted to Purchase": Sabartés, *Picasso: An Intimate Portrait*, p. 29.

29 "something very tender and profound": Palau i Fabre, *Picasso: The Early Years, 1881–1907*, p. 69.

30 "a dyed-in-the-wool republican": Sabartés, *Picasso: An Intimate Portrait*, p. 30.

31 "My uncle Salvador": Palau i Fabre, *Picasso: The Early Years, 1881–1907*, pp. 75–76.

32 "Picasso was in a hurry": Ibid., p. 86.

32 "all in one day": Cabanne, *Le Siècle de Picasso*, vol. 1, p. 47.

32 "I took a good look at the model": Ibid.

33 "the Spanish government": Trend, *A Picture of Modern Spain*, p. 4.

33 "hundreds, even thousands": Tuchman, *The Proud Tower*, p. 86.

33 "Better to be symbolists": Cabanne, *Pablo Picasso*, p. 30.

34 "The anger of the Spanish Anarchists": Brenan, *The Spanish Labyrinth*, p. 191.

34 "He was appealing": Cabanne, *Pablo Picasso*, p. 33.

35 "the center of perdition": Carandell, *Nueva guía secreta de Barcelona*, p. 183.

35 "The First Communion": Palau i Fabre, *Picasso: The Early Years, 1881–1907*, p. 101.

36 "These two drawings": Ibid., p. 54.

37 "Every time I draw a man": Cabanne, *Pablo Picasso*, p. 20.

37 "so small that her feet": Interview with Françoise Gilot.

38 "If you become a soldier": Gilot and Lake, *Life with Picasso*, p. 60.

38 "Excellent . . . Failure": Cabanne, *Pablo Picasso*, p. 34.

38 "I detest that period": Kahnweiler, "Huit Entretiens avec Picasso," *Le Point*, vol. 7, no. 42 (October 1952), p. 30.

39 "Bah! A pittance": Cabanne, *Pablo Picasso*, p. 40.

39 "What painters, dear Bas": Palau i Fabre, *Picasso: The Early Years, 1881–1907*, pp. 134–35.

40 "all he could afford": Ibid., p. 139.

41 "Whatever I know": Verdet, *Les Grands Peintres: Pablo Picasso*, p. 10.

42 "Pallarès was the sturdy piece": Interview with Françoise Gilot.

42 "I have no true friends": Malraux, *La Tête d'obsidienne*, p. 25.

42 "The predominant note in the output": Palau i Fabre, *Picasso: The Early Years, 1881–1907*, p. 152.

42 "I love you too much": Interview with Françoise Gilot.

42 "In the great nation of the gypsies": Gomez de la Serna, "Le Toréador de la peinture," *Cahiers d'Art*, nos. 3–5, 1932, p. 124.

43 "Generation of '98": Leighten, "Picasso: Anarchism and Art, 1897–1914," p. 49.

43 "I am pleased to hear that Pablo": Palau i Fabre, *Picasso: The Early Years, 1881–1907*, p. 155.

44 "This is what you are like": Cabanne, *Le Siècle de Picasso*, vol. 1, p. 79.

44 "He could see farther": Ibid., p. 73.

44 "I still remember my": Sabartés, *Picasso: Portraits et souvenirs*, p. 26.

44 "We spoke of him": Cabanne, *Pablo Picasso*, p. 47.

45 "a great bed": Palau i Fabre, *Picasso: The Early Years, 1881–1907*, p. 182.

45 "better than any": Cabanne, *Le Siècle de Picasso*, vol. 1, p. 80.

46 "a Gothic tavern": Blunt and Pool, *Picasso: The Formative Years*, p. 7.

46 "Let us put our trust": Berger, *The Success and Failure of Picasso*, p. 22.

46 "I myself am fate": Stambaugh, *Nietzsche's Thought of Eternal Return*, p. 59.

47 "the almost official spirit": Palau i Fabre, *Picasso: The Early Years, 1881–1907*, p. 128.

47 "You can't ride a bicycle with": Ibid., p. 127.

47 "We wanted the public to know": Cabanne, *Le Siècle de Picasso*, vol. 1, p. 82.

48 "extraordinary facility in pencil": Palau i Fabre, *Picasso: The Early Years, 1881–1907*, p. 512.

48 "I, the King": Ibid., p. 198.

CHAPTER TWO

49 "I do not seek": Picasso, "Lettre sur l'Art," *Formes*, February 1930, p. 2.

50 "If Cézanne had worked": Raynal, "Panorama de l'oeuvre de Picasso," *Le Point*, vol. 7, no. 42 (October 1952), p. 5.

50 "The following day": Letter, Casagemas to Reventós, 25 October 1900, in McCully, ed., *A Picasso Anthology*, pp. 27–28.

51 "Whenever there is light": Ibid., p. 27.

51 "Germaine is for the time being": Letter, Casagemas to Reventós, 11 November 1900, ibid., p. 31.

52 "All this about women": Letter, Picasso to Reventós, 11 November 1900, ibid., p. 30.

52 "It was in Paris I learned": Cabanne, *Pablo Picasso*, p. 54.

52 "the black sheep of": Palau i Fabre, *Picasso: The Early Years, 1881–1907*, p. 204.

53 "He is a man": Stein, *Picasso*, p. 5.

54 "most frequent visitors": Palau i Fabre, *Picasso: The Early Years, 1881–1907*, pp. 211–12.

55 "What are you thinking of": O'Brian, *Picasso*, p. 94.

55 "Here's one for you": Palau i Fabre, "L'Amistat de Picasso amb Casagemas," in *Casagemas i el seu temps*, p. 77.

57 "a brilliant artist": Fagus, "L'Invasion espagnole: Picasso," in Palau i Fabre, *Picasso: The Early Years, 1881–1907*, pp. 1901–1902.

57 "I can imagine the reaction": Letter, Picasso to Ventosa, 13 July 1901, in McCully, ed., *A Picasso Anthology*, p. 35.

58 "Stick to poetry": Andreu, *Max Jacob*, p. 27.

58 "Picasso spoke no more French": Jacob, "Souvenirs sur Picasso contés par Max Jacob," *Cahiers d'Art*, no. 6, 1927, p. 199.

58 "Picasso painted on a huge": Ibid.

58 "an atrocious accident": Andreu, *Max Jacob*, p. 62.

58 "for his own good": Charles, "Les Arts," *L'Ermitage*, no. 9 (September 1901), p. 240.

59 "I have tried to express": Van Gogh, *Van Gogh: A Self-Portrait*, p. 320.

59 "All I could think of": Sabartés, *Picasso: An Intimate Portrait*, p. 38.

59 "We were both equally lost children": Jacob, "Souvenirs sur Picasso contés par Max Jacob," *Cahiers d'Art*, no. 6, 1927, p. 199.

61 "A great many scientists": Aurier, "Les Peintres symbolistes," in Nochlin, *Impressionism and Post-Impressionism*, p. 135.

61 "It was evident": Sabartés, *Picasso: An Intimate Portrait*, p. 80.

61 "Manyac and he were at odds": Ibid.

62 "The letter! The letter": Ibid., p. 82.

63 "I'm showing what I'm doing": Letter, Picasso to Jacob, 13 July 1902, in McCully, ed., *A Picasso Anthology*, p. 38.

64 "The charm of the beautiful dancer": Sabartés, *Picasso: An Intimate Portrait*, pp. 89–90.

65 "Hola! . . . How are things": Ibid., p. 85.

65 "I knew very well": Ibid.

65 "After lunch we met": Ibid., p. 86.

66 "for family reasons": Palau i Fabre, *Picasso: The Early Years, 1881–1907*, p. 311.

67 "I've just been in your": Ibid., p. 316.

67 "two worms, intertwined and": Ibid., p. 314.

67 "I trust the young gentleman": Cabanne, *Pablo Picasso*, pp. 81–82.

67 "Pedagogy is the work": Andreu, *Max Jacob*, p. 90.

67 "In the most natural way": Jacob, "Souvenirs sur Picasso contés par Max Jacob," *Cahiers d'Art*, no. 6, 1927, p. 200.

68 "You believe in coffee grounds": Verlaine, *The Sky Above the Roof*, p. 101.

68 "indefatigable ardor": Cabanne, *Pablo Picasso*, pp. 82–83.

69 "We must not have ideas like that": Vallentin, *Picasso*, p. 47.

69 "All the lines seem to be born": Palau i Fabre, *Picasso: The Early Years, 1881–1907*, p. 326.

69 "It is extraordinary": Breunig, "Studies on Picasso, 1902–1905," *Art Journal*, Winter 1958, p. 192.

70 "If he had lost them": Crespelle, *Picasso: Les femmes, les amis, l'oeuvre*, p. 59.

71 "My dear Max": Letter, Picasso to Jacob, 1903, in McCully, ed., *A Picasso Anthology*, p. 41.

72 "while Don José Ruiz": Palau i Fabre, *Picasso: The Early Years, 1881–1907*, p. 368.

72 "The hairs of my beard": Sabartés, *Picasso: An Intimate Portrait*, p. 95.

72 "He did not remove his eyes": Ibid., pp. 93–94.

72 "What do you have to do": Ibid., p. 97.

72 "If he was contented": Ibid., p. 92.

73 "as if he were not": Ibid., pp. 97–98.

CHAPTER THREE

74 "Love's sighs traveled easily": Dorgelès, *Bouquet de Bohème*, p. 102.

76 "an extremely unhappy try at marriage": Olivier, *Picasso et ses amis*, p. 7.

77 "For good or for bad": Stein, *The Autobiography of Alice B. Toklas*, p. 27.

77 "There was nothing especially": Olivier, *Picasso and His Friends*, p. 16.

77 "When you are in love": Vallentin, *Picasso*, p. 56.

78 "Out of a sort of morbid jealousy": Olivier, *Picasso and His Friends*, p. 17.

78 "This rather sad, sarcastic man": Crespelle, *Picasso: Les femmes, les amis, l'oeuvre*, p. 11.

78 "Yes, she is very beautiful": Ibid., p. 69.

79 "sterile sadness": Morice, "Exposition de MM. Picasso, Launay, Pichot et Girieud," *Mercure de France*, vol. 45, no. 156 (October–December 1902), p. 804.

79 "he seemed to take delight": Morice, "Exposition d'oeuvres de MM. Trachsel, Gérardin, Picasso," in Lipton, *Picasso Criticism, 1901–1939*, pp. 30–31.

80 "These children, who have no one": Apollinaire, "Les Jeunes: Picasso, peintre," *La Plume*, no. 372 (15 May 1905), pp. 478–80.

80 "It has been said": "Picasso, peintre et dessinateur," in Apollinaire, *Chroniques d'Art, 1902–1918*, p. 28.

81 "Without interrupting a speech": Mackworth, *Guillaume Apollinaire and the Cubist Life*, p. 66.

81 "faithful to him in the fashion": Stein, *The Autobiography of Alice B. Toklas*, p. 24.

82 "the most intelligent of all odours": Penrose, *Picasso: His Life and Work*, p. 140.

82 "I had no money": Palau i Fabre, *Picasso: The Early Years, 1881–1907*, p. 417.

82 "I had a knapsack": Ibid.

82 "Before leaving I had drawn": Daix and Boudaille, *Picasso, 1900–1906*, p. 274.

82 "The most beautiful female breasts": Vallentin, *Picasso*, p. 62.

82 "It was a ridiculous sight": Olivier, *Picasso et ses amis*, p. 43.

83 "Masculine, in her voice": Ibid., p. 101.

83 "Both were dressed in chestnut-colored corduroy": Ibid.

83 "Who is the lady": Brinnin, *The Third Rose*, p. 70.

83 "at the very moment when Picasso": Ibid.

83 "Picasso little by little": Stein, *Picasso*, p. 7.

84 "The first picture we had": Ibid.

84 "All that could be known": Stein, *Matisse, Picasso and Gertrude Stein*, p. 204.

84 "very much master of himself": Olivier, *Picasso and His Friends*, p. 88.

85 "as different as the North Pole": Ibid., p. 84.

85 "the religious feeling I have": Matisse, *Écrits et propos sur l'Art*, pp. 49–50.

85 "Manolo is at Azon's": Kahnweiler and Crémieux, *My Galleries and Painters*, p. 38.

86 "If I could talk french": Stein, *The Autobiography of Alice B. Toklas*, p. 48.

86 "I can't see you any longer": Ibid., p. 53.

86 "The bell tower is crooked": Jacob, "Souvenirs sur Picasso contés par Max Jacob," *Cahiers d'Art*, no. 6, 1927, p. 202.

86 "Max and I gaped at this sight": Crespelle, *Picasso and His Women*, p. 68.

87 "a dress and a hat and perfumes": Stein, *The Autobiography of Alice B. Toklas*, p. 53.

87 "The Picasso I saw in Spain": Olivier, *Picasso and His Friends*, p. 93.

87 "good air, good water, good milk": Palau i Fabre, *Picasso: The Early Years, 1881–1907*, p. 440.

88 "He loved anything with strong": Olivier, *Picasso and His Friends*, p. 126.

88 "towards everything tormented": Ibid., p. 95.

88 "A tenor who hits a note": Picasso, *Carnet Catalan*, p. 11.

88 "In that vast, empty, magnificent": Olivier, *Picasso and His Friends*, p. 94.

89 "He painted in the head": Stein, *Picasso*, p. 8.

89 "Everybody says that she does not": Peignot, "Les Premiers Picassos de Gertrude Stein," *Connaissance des Arts*, no. 213 (November 1969), p. 125.

89 "I did not use models again": Cabanne, *Pablo Picasso*, p. 111.

89 "trying to force his friends": Mackworth, *Guillaume Apollinaire and the Cubist Life*, p. 72.

89 "On the Rue de Rennes": Cabanne, *Pablo Picasso*, p. 110.

90 "Matisse took a black wooden": Ibid.

90 "All alone in that awful museum": Malraux, *Picasso's Mask*, pp. 10, 11.

91 "Obviously, nature has to exist": Ibid., p. 17.

92 "Hornsocket! We will": Jarry, "Ubu Roi," in Leighten, "Picasso: Anarchism and Art, 1897–1914," p. 154.

92 "the last of the sublime debauchees": Apollinaire, "Feu Alfred Jarry," in *Oeuvres complètes de G. Apollinaire*, p. 855.

92 "God is the shortest path": Jarry, *Faustroll*, p. 121.

93 "the apprentice sorcerer": Salmon, *La Jeune Peinture française*, p. 44.

93 "The revolver sought its natural owner": Jacob, *Chronique des temps héroïques*, p. 48.

93 "It was the ugliness of the faces": Salmon, *La Jeune Peinture française*, p. 48.

93 "one day Picasso": Kahnweiler and Crémieux, *My Galleries and Painters*, p. 39.

93 "It is not necessary": "Shafts from Apollo's Bow: A Blast from the North," *Apollo*, October 1947, p. 90.

93 "It made me feel": Cabanne, *Le Siècle de Picasso*, vol. 1, p. 200.

93 "The things Picasso and I said": Vallier, "Braque, la peinture et nous," *Cahiers d'Art*, no. 1, 1954, p. 14.

94 "I never decided to become a painter": Ibid., p. 13.

94 "What a great thing, that Salon": Ibid., pp. 13–14.

94 "There never was a group of artists": Olivier, *Picasso and His Friends*, p. 50.

94 "Tell me, Picasso": O'Brian, *Picasso*, p. 132.

95 "a mysterious horrible woman": Stein, *The Autobiography of Alice B. Toklas*, p. 26.

95 "Marie Laurencin was terribly near-sighted": Ibid., p. 60.

97 "Movements which choose their own names": Vallentin, *Picasso*, p. 101.

97 "Braque and I worked with enthusiasm": Sabartés, *Picasso: Portraits et souvenirs*, p. 222.

97 "Picasso and I were engaged in what we felt": "Testimony against Gertrude Stein," *Transition*, no. 23 (February 1935), pp. 13–14.

97 "We had moved so far": Vallentin, *Picasso*, p. 111.

97 "I'm feeling again as happy": González, "Picasso Sculpteur," *Cahiers d'Art*, nos. 6–7, 1936, p. 189.

98 "Braque is the woman who has loved me": Daix, *Picasso Créateur*, p. 101.

98 "I want an engineer": Kahnweiler, *Confessions esthétiques*, p. 212.

99 "The walls at Picasso's studio": Raynal, *Picasso*, pp. 45–48.

99 "one did not telephone": Stein, *The Autobiography of Alice B. Toklas*, p. 104.

99 "It didn't take much": Olivier, *Picasso and His Friends*, p. 69.

100 "You and I are the greatest painters": Penrose, *Picasso: His Life and Work*, p. 145.

100 "He never mentioned Cubism": Cabanne, *Pablo Picasso*, p. 130.

100 "It always amused me": Stein, *Picasso*, pp. 8–9.

101 "These people must have hit the jackpot": Olivier, *Picasso and His Friends*, p. 135.

102 "In spite of all this": Ibid., p. 136.

102 "That's fine": Kahnweiler and Crémieux, *My Galleries and Painters*, p. 43.

102 "moving toward an entirely new art": Apollinaire, *Les Peintres cubistes*, p. 14.

103 "I was hunting for my slippers": Mackworth, *Guillaume Apollinaire and the Cubist Life*, p. 124.

104 "You are what I": Steegmuller, *Apollinaire: Poet among the Painters*, p. 131.

104 "One evening": Gilot and Lake, *Life with Picasso*, pp. 76–77.

105 "Despite our very different": Vallier, "Braque, la peinture et nous," *Cahiers d'Art*, no. 1, 1954, p. 14.

105 "I was thinking about my work": Mackworth, *Guillaume Apollinaire and the Cubist Life*, p. 90.

106 "we who are constantly fighting": Berger, *The Success and Failure of Picasso*, p. 56.

106 "I desire in my house": Apollinaire, "Le Bestiaire," in *Oeuvres poétiques*, p. 8.

Chapter Four

107 "We have made great friends": Letter, Olivier to Stein, 17 June 1910, in McCully, ed., *A Picasso Anthology*, p. 67.

108 "a little bit of a thing": "Thaw Trial Begins; Defense Still Hidden," *The New York Times*, 24 January 1907, p. 2.

108 "small and negative": Stein, *The Autobiography of Alice B. Toklas*, p. 111.

108 "I can't have friends": Gedo, *Picasso: Art as Autobiography*, p. 213.

109 "he had taken the great step": Kahnweiler, *The Rise of Cubism*, p. 10.

109 "Spaniard that he is": Stein, *Picasso*, pp. 13–14.

109 "There is no other point": Zervos, "Conversation avec Picasso," *Cahiers d'Art*, nos. 7–10, 1935, p. 174.

109 "I work like the Chinese": Roy, *L'Amour de la peinture*, p. 85.

109 "the incredible heroism": Warnod, *Washboat Days*, p. 123.

109 "Painting is freedom": Malraux, *Picasso's Mask*, p. 110.

110 "I've never believed in doing painting": Gilot and Lake, *Life with Picasso*, pp. 72–73.

110 "In its original form": Ibid., p. 73.

111 "Cubism, to be honest": Pla, "Vida de Manolo contada por el mismo," in McCully, ed., *A Picasso Anthology*, p. 69.

111 "Why should I blame anybody else but myself": De Zayas, "Picasso Speaks," *The Arts*, vol. 3, no. 5 (May 1923), p. 319.

111 "I value things according": Vallentin, *Picasso*, p. 114.

112 "Why is Picasso not writing to me": Henry, "Max Jacob et Picasso," *Europe*, nos. 492–93 (April–May 1970), p. 201.

112 "My dear Fernande": Olivier, *Picasso et ses amis*, pp 207–8.

114 "I am sure": Olivier, *Picasso and His Friends*, p. 148.

114 "As soon as the heavy door": Steegmuller, *Apollinaire: Poet among the Painters*, pp. 211–12.

PICASSO

115 "As the maid had not": Olivier, *Picasso and His Friends*, p. 148.

115 "pale, disheveled and unshaven": Ibid., p. 149.

115 "chief of an international gang": Steegmuller, *Apollinaire: Poet among the Painters*, pp. 206–7.

115 "It was at three o'clock": Ibid., p. 206.

116 "internationalist spirit": Mackworth, *Guillaume Apollinaire and the Cubist Life*, pp. 137–38.

116 "I still haven't recovered": Ibid., p. 136.

116 "It choked him": Steegmuller, *Apollinaire: Poet among the Painters*, p. 229.

116 "Guillaume had suffered": Ibid., p. 217.

117 "nothing whatever to do with painting": Ibid., p. 236.

117 "A return to barbarism": O'Brian, *Picasso*, p. 181.

117 "if Picasso is sincerely revealing": "The Revolutionary Artists," *The Craftsman*, vol. 20, no. 2 (May 1911), p. 237.

117 "coloured, symbolical frontispieces": Carter, "The Plato-Picasso Idea," *The New Age*, vol. 10, no. 4 (23 November 1911), p. 88.

117 "I frankly disclaim any": Murry, "The Art of Pablo Picasso," *The New Age*, vol. 10, no. 5 (30 November 1911), p. 115.

118 "I feel convinced that it": Ibid.

118 "In fact, one never copies nature": Picasso, "Lettre sur l'Art," *Formes*, February 1930, pp. 2, 4.

118 "Plato was seeking for a Picasso": Murry, "The Art of Pablo Picasso," *The New Age*, vol. 10, no. 5 (30 November 1911), p. 115.

118 "He was looking": Letter, Murry to Carter, in Carter, "The Plato-Picasso Ideal," *The New Age*, vol. 10, no. 4 (23 November 1911), p. 88.

118 "When people believed": Malraux, *Picasso's Mask*, p. 127.

119 "very large": Stein, *The Autobiography of Alice B. Toklas*, p. 46.

119 "real bottled liquid smoke": Ibid., p. 26.

119 "Your only claim to distinction": Ibid., p. 96.

119 "I cannot open to you": Dorgelès, *Bouquet de Bohème*, p. 106.

119 "To live on one woman": Parmelin, *Picasso Plain*, p. 115.

119 "Fernande left yesterday": Cabanne, *Pablo Picasso*, p. 149.

120 "I love her very much": Letter, Picasso to Kahnweiler, 12 June 1912, in Centre Georges Pompidou, *Donation Louise et Michel Leiris*, p. 168.

120 "To no one give my address": Letter, Picasso to Kahnweiler, 20 May 1912, ibid., p. 165.

120 "Yes, we are together": Letter, Picasso to Kahnweiler, 22 May 1912, ibid.

120 "But don't say anything to anyone": Ibid.

120 "You should also send me": Letter, Picasso to Kahnweiler, 24 May 1912, ibid., p. 166.

121 "I really need my painting things": Letter, Picasso to Kahnweiler, 1 June 1912, ibid.

121 "Say, you would really do me": Letter, Kahnweiler to Picasso, 6 June 1912, ibid.

121 "The rest are not yet presentable": Letter, Picasso to Kahnweiler, 5 June 1912, ibid., p. 167.

121 "I am really upset by all that": Letter, Picasso to Kahnweiler, 12 June 1912, ibid., p. 168.

121 "Apart from all that I'm working a lot": Ibid.

122 "beauty always held him": Stein, *The Autobiography of Alice B. Toklas*, p. 112.

122 "I don't find them too bad": Letter, Picasso to Kahnweiler, 20 June 1912, in Centre Georges Pompidou, *Donation Louise et Michel Leiris*, pp. 168–169

122 "Everything has to come to an end": Olivier, *Picasso and His Friends*, pp. 157–58.

122 "she understood perfectly": Stein, *The Autobiography of Alice B. Toklas*, p. 112.

123 "I've already started work": Letter, Picasso to Kahnweiler, 29 June 1912, in Centre Georges Pompidou, *Donation Louise et Michel Leiris*, p. 169.

123 "I would have probably spoilt": Letter, Picasso to Kahnweiler, 4 July 1912, ibid.

123 "You were right to have": Letter, Picasso to Kahnweiler, 9 July 1912, ibid.

123 "But what a rare thing": Ibid.

123 "Tell him to write to me": Letter, Picasso to Kahnweiler, 29 June 1912, ibid.

124 "That way I won't": Interview with Françoise Gilot.

124 "It's been many days since I wrote to you": Letter, Picasso to Kahnweiler, 11 August 1912, in Centre Georges Pompidou, *Donation Louise et Michel Leiris*, p. 169.

124 "Wilbur Braque is already installed": Letter, Picasso to Kahnweiler, 15 August 1912, ibid.

125 "refuge of fine and free simplicity": Mackworth, *Guillaume Apollinaire and the Cubist Life*, p. 158.

125 "Chauffeur Kills Wife". Leighten, "Picasso. Anarchism and Art, 1897–1914," p. 251.

126 "Picasso studies an object": Cabanne, *Pablo Picasso*, p. 160.

126 "With each new attempt he": Junoy, "L'Art d'en Picasso," in McCully, ed., *A Picasso Anthology*, p. 88.

127 "the only real cubism": Stein, *The Autobiography of Alice B. Toklas*, p. 91.

127 "Tell me why you stand up": Ibid., p. 212.

127 "Juan Gris was the only person": Ibid., p. 211.

127 "You know very well that Gris": O'Brian, *Picasso*, p. 201.

127 "modest genius": Kahnweiler, "Juan Gris," in San Francisco Museum of Art, *Picasso–Gris–Miro*, p. 73.

127 "firm hand serving": Ibid., p. 72.

127 "produced solely by elements": Larrea, "Light Illumined," ibid., p. 38.

127 "Eva's devotion to the humblest": Daix, *Picasso Créateur*, p. 138.

128 "I felt his friendly presence": Kahnweiler, "Juan Gris," in San Francisco Museum of Art, *Picasso–Gris–Miro*, p. 72.

128 "He was gentle, affectionate": Ibid., p. 69.

128 "You can imagine in what state": Letter, Picasso to Kahnweiler, 5 May

1913, in Centre Georges Pompidou, *Donation Louise et Michel Leiris*, p. 170.

128 "I hope that Pablo": Daix, *Picasso Créateur*, p. 139.

129 "seemed to have been painted": Letter, Jacob to Kahnweiler, end of April 1913, in Jacob, *Correspondance*, vol. 1, p. 90.

129 "men of the future": Mackworth, *Guillaume Apollinaire and the Cubist Life*, p. 161.

129 "One can never draw enough": Salmon, *Modigliani: A Memoir*, pp. 132–133.

130 "Huge prices have been fetched": Daix, *Picasso Créateur*, p. 145.

130 "One simply paints": O'Brian, *Picasso*, p. 202.

130 "Rococo Cubism": Penrose, *Picasso: His Life and Work*, p. 194.

131 "the legalised return": Mackworth, *Guillaume Apollinaire and the Cubist Life*, p. 177.

131 "Within myself I sensed": Ibid., p. 176.

131 "I was overjoyed": Ibid., p. 179.

131 "I never found them again": O'Brian, *Picasso*, p. 207.

CHAPTER FIVE

132 "We never dreamt of holding": Cabanne, *Pablo Picasso*, p. 171.

132 "Derain is in": Apollinaire, "Living Art and the War," in *Apollinaire on Art*, pp. 439–40.

133 "If one knows exactly": "Propos sur l'Art," *Le Monde*, 13 April 1973, p. 18.

133 "If they want to make": Cabanne, *Pablo Picasso*, p. 171.

133 "It is we that have created": Stein, *The Autobiography of Alice B. Toklas*, p. 90.

134 "I have been anxious": Brinnin, *The Third Rose*, p. 197.

134 "The Cézanne apples have": Ibid.

134 "I will paint you an apple": O'Brian, *Picasso*, p. 211.

134 "Any work more or less grows": Cabanne, *Pablo Picasso*, p. 171.

135 "Everyone talked about how much": Rubin, in The Museum of Modern Art, *Picasso in the Collection of the Museum of Modern Art*, p. 72.

136 "Will it not be awful": Stein, *Everybody's Autobiography*, p. 119.

136 "A wintry cosmic wind": Berdyaev, "Picasso," in McCully, ed., *A Picasso Anthology*, p. 111.

136 "the Jews are men of intellect": Andreu, *Max Jacob*, p. 45.

136 "A good Catholic is a man": Ibid., p. 44.

137 "I pose at Pablo's": Penrose, *Picasso: His Life and Work*, p. 206.

137 "My life is hell": Daix, *Picasso Créateur*, p. 154.

137 "Gaby my love": Richardson, "Picasso's Secret Love," *House and Garden*, October 1987, p. 180.

138 "The drawing says": Daix, *Picasso Créateur*, p. 155.

138 "as usual I never": Ibid., p. 154.

138 "with the pride of a wild bird": Steegmuller, *Cocteau*, p. 71.

138 "I have never forgotten": Cabanne, *Pablo Picasso*, p. 176.

139 "He fell under Picasso's spell": Steegmuller, *Cocteau*, p. 137.

139 "My poor Eva is dead": Daix, *Picasso Créateur*, p. 155.

139 "It was a very sad affair": Cabanne, *Le Siècle de Picasso*, vol. 1, p. 293.

140 "That yellow between": Crespelle, *Picasso and His Women*, p. 114.

140 "his fascinating young private": Steegmuller, *Cocteau*, p. 73.

140 "Astound me": Ibid., p. 82.

140 "I was quick to realize": Ibid.

141 "inherited from Scottish": Ibid., p. 133.

141 "Good night, Mr. Picasso": Cabanne, *Pablo Picasso*, p. 180.

141 "Paquerette a girl who": Stein, *The Autobiography of Alice B. Toklas*, p. 169.

141 "I have asked the good": Richardson, "Picasso's Secret Love," *House and Garden*, October 1987, p. 180.

141 "The artist must know": De Zayas, "Picasso Speaks," *The Arts*, vol. 3, no. 5 (May 1923), p. 315.

142 "He was sinister": O'Brian, *Picasso*, p. 215.

142 "*the* great encounter": Steegmuller, *Cocteau*, p. 137.

142 "This morning, pose": Ibid., p. 147.

142 "Picasso keeps taking me": Ibid., pp. 163–64.

143 "He had on a grass-green sweater": Salto, "Pablo Picasso," in McCully, ed., *A Picasso Anthology*, p. 125.

143 "My dear godson Max": Henry, "Max Jacob et Picasso," *Europe*, nos. 492–493 (April–May 1970), p. 204.

143 "Picasso has been my friend": Ibid.

144 "Montmartre and Montparnasse": Hilton, *Picasso*, p. 134.

144 "Picasso is doing *Parade*": Gold and Fizdale, *Misia*, p. 191.

144 "In Montparnasse, in 1916": Steegmuller, *Cocteau*, p. 165.

144 "Make Satie understand": Ibid., p. 167.

145 "dear and sweet friend": Ibid.

145 "Still, it's a great": Gold and Fizdale, *Misia*, p. 191.

146 "his Bolivar beard, his scar": Steegmuller, *Cocteau*, p. 164.

146 "A statue in what": Apollinaire, *Le Poète assassiné*, p. 115.

146 "I am working at our project": Steegmuller, *Cocteau*, p. 173.

146 "Long life to our followers": Ibid., p. 174.

146 "*Voilà*, we're leaving": Ibid.

146 "I have sixty dancers": Letter, Picasso to Stein, April 1917. From the Yale Collection of American Literature, Beinecke Rare Book and Manuscript Library, Yale University.

148 "his hands so dark and delicate and alert": Stein, *The Autobiography of Alice B. Toklas*, p. 22.

148 "a discharge of electricity": Cabanne, *Pablo Picasso*, p. 176.

148 "this radiance, this internal": Penrose, *Picasso: His Life and Work*, p. 98.

148 "a city made of fountains": Steegmuller, *Cocteau*, p. 177.

149 "a conjunction of major planets": Ibid., p. 181.

150 "The Pope is in Rome": Mugnier, *Journal de l'Abbé Mugnier*, p. 309.

150 "The artist must roam around": Ibid., p. 334.

150 "to do their best to seek out": Ibid., p. 309.

150 "This is not a portrait": Cabanne, *Le Siècle de Picasso*, vol. 1, p. 305.

150 "giant figures as fresh": Steegmuller, *Cocteau*, p. 185.

150 "No, no, Monsieur Picasso": Wiser, *The Crazy Years*, p. 42.

151 "Watch out. You have to": Crespelle, *Picasso and His Women*, p. 121.

151 "For the first time": Poulenc, *Moi et mes amis*, p. 89.

151 "rehabilitate the commonplace": Lieberman, "Picasso and the Ballet, 1917–1945," *Dance Index*, vol. 5, nos. 11–12 (November–December 1946), p. 266.

152 "mounts a race-horse": Ibid., p. 275.

152 "If it had not been": Cabanne, *Pablo Picasso*, p. 190.

152 "the queen of the Russian": Steegmuller, *Cocteau*, p. 69.

152 "a fairy godmother one moment": Ibid.

152 "He resembled a prince": Mac Orlan, "Rencontre avec Picasso," in Lipton, "Picasso Criticism, 1901–1939," p. 152.

152 "was looking tense, pained": Crespelle, *Picasso and His Women*, p. 122.

152 "the musical innovator Erik Satie": Apollinaire, *Chroniques d'Art, 1902–1918*, p. 426.

153 "have consummated for the first time": Ibid.

153 "Perhaps, perhaps": Poulenc, *Moi et mes amis*, p. 89.

153 "Had I known it was so silly": Lieberman, "Picasso and the Ballet, 1917–1945," *Dance Index*, vol. 5, nos. 11–12 (November–December 1946), p. 267.

153 "The inharmonious clown Erik Satie": Mackworth, *Guillaume Apollinaire and the Cubist Life*, p. 223.

153 "*Monsieur et cher ami*": Gold and Fizdale, *Misia*, p. 195.

153 "a big toy": Sanouillet, *Francis Picabia et 391*, p. 60.

154 "I want to recognize my face": Interview with Françoise Gilot.

154 "What's your name": Ibid.

156 "Is a painter serious": Crespelle, *Picasso and His Women*, p. 122.

157 "He was so flattered": Interview with Matta.

157 "Picasso still does good": Cabanne, *Pablo Picasso*, p. 191.

158 "She told him firmly": Penrose, *Picasso: His Life and Work*, p. 224.

158 "It was a blessed time": Apollinaire, *Calligrammes*, p. 240.

158 "I see the *beau monde*": Daix, *La Vie de peintre de Pablo Picasso*, p. 164.

158 "I am very glad to hear": Apollinaire to Picasso, 11 September 1918, in McCully, ed., *A Picasso Anthology*, p. 132.

159 "There is no good God": Penrose, *Picasso: His Life and Work*, p. 225.

159 "What a stupid invention": Sabartés, *Picasso: Documents iconographiques*, p. 11.

CHAPTER SIX

161 "the window faced south": Brassaï, *Picasso and Company*, p. 5.

162 "their ways of life in London": Bell, *Civilization and Old Friends*, p. 171.

163 "the first time I saw her I took": Crespelle, *Picasso and His Women*, p. 124.

163 "A supreme masterpiece of pink": Cabanne, *Le Siècle de Picasso*, vol. 1, p. 348.

163 "It's not what the artist does": Zervos, "Conversation avec Picasso," *Cahiers d'Art*, nos. 7–10, 1935, pp. 176–77.

164 "The several manners I have used": Penrose, *Picasso: His Life and Work*, p. 244.

164 "What was the meaning of this": Uhde, *Picasso and the French Tradition*, pp. 54–55.

164 "naturalization file": Cabanne, *Pablo Picasso*, p. 209.

164 "All over Andalusia, the people": García Lorca, *Selected Letters*, pp. 42–43.

164 "It is my misfortune": Zervos, "Conversation avec Picasso," *Cahiers d'Art*, nos. 7–10, 1935, p. 173.

165 "All the women there were": Gold and Fizdale, *Misia*, p. 232.

165 "found that they had in common": Josephson, *Life among the Surrealists*, p. 111.

165 "sweep everything away and": Ibid., p. 108.

165 "spit on humanity": Ibid.

166 "The true Dadaists": Wiser, *The Crazy Years*, p. 40.

166 "Oh, no, don't expect me": Georges-Michel, *De Renoir à Picasso*, p. 100.

166 "What, after all, is": Cabanne, *Pablo Picasso*, p. 202.

166 "Don't you think I'm a French": Ibid., p. 215.

166 "Cocteau was born with": Gold and Fizdale, *Misia*, p. 215.

167 "opened the ball": Radiguet, *Count d'Orgel*, p. 21.

167 "leaving exposed that part": Steegmuller, *Cocteau*, p. 227.

167 "The relation between these": Gold and Fizdale, *Misia*, p. 232.

167 "*Il était un Catalan*": Ibid.

167 "*Chère Madame*": Ibid., p. 217.

168 "*Commedia* . . .": Cabanne, *Pablo Picasso*, p. 203.

168 "Picasso having no need of anyone": Everling, "C'était hier: Dada . . ." *Les Oeuvres Libres*, no. 109 (June 1955), p. 149.

169 "He improvised costumes, but": Lieberman, "Picasso and the Ballet, 1917–1945," *Dance Index*, vol. 5, nos. 11–12 (November December 1946), p. 287.

169 "You respect, but I love": Tierney, *The Unknown Country: A Life of Igor Stravinsky*, p. 91.

169 "one of those productions": Stravinsky, *Autobiography*, p. 133.

169 "Because the stage presents": Ibid., p. 132.

170 "Prince Firouz was a magnificent": Hugo, *Avant d'oublier, 1918–1931*, p. 67.

170 "So, are you still painting by": Ibid., p. 66.

170 "What did he mean": Ibid., pp. 66–67.

171 "I dreamed that my legs and arms": Gilot and Lake, *Life with Picasso*, p. 119.

172 "I don't know just what happened": Cabanne, *Pablo Picasso*, p. 222.

172 "Other artists have courted success": Berger, *The Success and Failure of Picasso*, p. 203.

172 "I have never painted": Aragon, *Anicet ou le panorama, roman*, p. 112.

173 "If you had seen my last": Henry, "Max Jacob et Picasso," *Europe*, nos. 492–93 (April–May 1970), p. 208.

173 "He abhors incomprehension and": Jacob, *Correspondance*, vol. 1, p. 122.

173 "raises man above his": Raynal, "Picasso," *L'Art d'Aujourd'hui*, no. 1 (Spring–Summer 1924), p. 22.

173 "crowned by grace": Salmon, "Picasso," *L'Esprit Nouveau*, no. 1 (May 1920), p. 67.

173 "Picasso is the liberator": Bell, *Since Cézanne*, p. 84.

174 "striving after a more": Nebeský, "Pablo Picasso," in McCully, ed., *A Picasso Anthology*, p. 150.

174 "The more that is taken": Vallentin, *Pablo Picasso*, p. 255.

175 "Finally at midnight": Hugo, *Avant d'oublier, 1918–1931*, p. 127.

175 "Don't despair; Monsieur Rimbaud": Gold and Fizdale, *Misia*, p. 236.

175 "with regal elegance": Steegmuller, *Cocteau*, p. 283.

175 "Tzara, no police here": Penrose, *Picasso: His Life and Work*, p. 248.

176 "a certain personage who": Josephson, *Life among the Surrealists*, p. 148.

176 "state of mind which served": Ibid., p. 151.

176 "I am that child": Kay, *Picasso's World of Children*, p. 177.

176 "You see me here": Verdet, in Musée de l'Athenée, *Picasso*, in Ashton, ed., *Picasso on Art*, p. 96.

177 "Me, I am going to": Baron, *L'An I du surréalisme*, p. 60.

177 "new dress on old Greek": Steegmuller, *Cocteau*, p. 292.

177 "she is our leading dressmaker": Charles-Roux, *L'Irrégulière*, p. 357.

177 "Very well. Here's": Cabanne, *Pablo Picasso*, p. 224.

178 "The emergence of these": Cocteau, *Le Rappel à l'ordre*, p. 289.

178 "swept up by a passion": "Retouches pour un portrait," *Le Crapouillot*, no. 25 (May–June 1973), p. 41.

178 "That can't last": Wiser, *The Crazy Years*, p. 71.

179 "We all know that Art": De Zayas, "Picasso Speaks," *The Arts*, vol. 3, no. 5 (May 1923), p. 315.

179 "the world is too full": Wiser, *The Crazy Years*, p. 177.

180 "He was remarkably beautiful": Stein, *The Autobiography of Alice B. Toklas*, p. 221.

180 "Abandon everything": Josephson, *Life among the Surrealists*, p. 151.

181 "nearly died of grief": Gold and Fizdale, *Misia*, p. 235.

181 "Matisse! What is a": O'Brian, *Picasso*, p. 264.

181 "I didn't make the gloves": Hugo, *Avant d'oublier, 1918–1931*, p. 177.

181 "the international aristocracy": Penrose, *Picasso: His Life and Work*, p. 249.

181 "We wish to express": O'Brian, *Picasso*, p. 265.

181 "When we were children": Breton, "Le Surréalisme et la peinture," *La Révolution Surréaliste*, no. 4 (15 July 1925), pp. 29–30.

182 "The first point about": Lieberman, "Picasso and the Ballet, 1917–1945," *Dance Index*, vol. 5, nos. 11–12 (November–December 1946), p. 300.

184 "The position held by us now": Breton, "Le Surréalisme et la peinture," *La Révolution Surréaliste*, no. 4 (15 July 1925), p. 28.

184 "For all these reasons": Ibid., p. 30.

184 "burst the bonds of reason": Josephson, *Life among the Surrealists*, p. 221.

184 "I believe in the future": Ibid.

185 "What do all these things *mean*": Ibid., p. 336.

185 "continue to be an *aim*": Breton, *What is Surrealism? Selected Writings*, p. 180.

185 "I love it as the only": Zervos, "Conversation avec Picasso," *Cahiers d'Art*, nos. 7–10, 1935, p. 177.

185 "an absolute dictatorship": Ibid.

186 "*Mon Jean*, You judge Picasso": Jacob, *Choix de lettres de Max Jacob à Jean Cocteau*, pp. 83–84.

186 "He is no poet": Ibid., p. 81.

186 "the interview which had wounded": Stein, *The Autobiography of Alice B. Toklas*, p. 222.

186 "I as a mother": Ibid.

186 "You were hard done by": Jacob, *Choix de lettres de Max Jacob à Jean Cocteau*, p. 81.

CHAPTER SEVEN

188 "He simply grabbed me": Farrell, "His Women," *Life*, 27 December 1968, p. 74.

189 "I resisted for six months": Ibid.

189 "Today 13th, July 1944": Letter, Picasso to Walter, 13 July 1944, in Hong Kong Museum of Art, *Picasso Intime: Collection Maya Ruiz-Picasso*, p. 57.

189 "For ten years I've lived": Gagnebin, "Erotique de Picasso," *Esprit*, January 1982, p. 71.

190 "Poor Juan is very low": Mellow, *Charmed Circle*, p. 311.

190 "I had painted a big": Cabanne, *Pablo Picasso*, p. 252.

190 "came to the house and spent": Stein, *The Autobiography of Alice B. Toklas*, p. 212.

190 "Painting is for Picasso like": Zervos, "Les Dernières Oeuvres de Picasso," *Cahiers d'Art*, no. 6, 1927, p. 189.

190 "contrasting elements form wondrous": Einstein, "Picasso," in McCully, ed., *A Picasso Anthology*, p. 169.

191 "As soon as a painter": Interview with Françoise Gilot.

191 "perhaps the greatest psychologist": Rubin, *Dada and Surrealist Art*, p. 280.

191 "of the beyond": Cabanne, *Le Siècle de Picasso*, vol. 2, p. 345.

192 "He felt imprisoned": Interview with Matta.

192 "to be able to live": Kahnweiler and Crémieux, *My Galleries and Painters*, p. 10.

193 "wonderfully terrible": Cabanne, "Picasso et les joies de la paternité," *L'Oeil*, no. 226 (May 1974), p. 10.

193 "I always cried": Ibid.

193 "Some of the most vivid": Gasman, "Mystery, Magic and Love in Picasso, 1925–1938," p. 64.

193 "I bowed my head": Ibid., p. 1444.

193 "Pablo did not want": Ibid., p. 60.

193 "the feeling of elemental": Bataille, *Death and Sensuality*, p. 16.

194 "I am very fond of keys": O'Brian, *Picasso*, p. 279.

194 "slice of melon which": Gasman, "Mystery, Magic and Love in Picasso, 1925–1938," p. 60.

194 "Beauty is desired in order": Bataille, *Death and Sensuality*, p. 144.

194 "goddesses and doormats": Gilot and Lake, *Life with Picasso*, p. 84.

195 "watch the thread that": Gasman, "Mystery, Magic and Love in Picasso, 1925–1938," p. 72.

195 "thousand offensive": Ibid., p. 71.

195 "spirits, the unconscious": Malraux, *Picasso's Mask*, p. 11.

195 "Houses, and volcanoes": Breton, *Point du jour*, pp. 69–70.

195 "inhuman and monstrous city": Andreu, *Max Jacob*, p. 59.

196 "The love-admiration": Jacob, *Choix de lettres de Max Jacob à Jean Cocteau*, p. 134.

197 "from the hallucinated": Rubin, *Dada, Surrealism and Their Heritage*, p. 127.

197 "human irrationality in the form": Kauffman, "Picasso's Crucifixion of 1930," *Burlington-Magazine*, vol. 3 (September 1969), p. 559.

197 "Van Gogh without God": Interview with Françoise Gilot.

197 "Everything is a miracle": Steegmuller, *Cocteau*, p. 350.

198 "If you are way ahead": Stein, *The Autobiography of Alice B. Toklas*, p. 246.

199 "We are simply Your maid-servants": Prabhupada, *Krishna*, p. 209.

199 "the night is empty": Archer, *The Loves of Krishna*, p. 42.

199 "a series of": McCully, in McCully, ed., *A Picasso Anthology*, p. 173.

199 "from a tragic doubt": Pierre-Quint, "Doute et révélation dans l'oeuvre de Picasso," in McCully, ed., *A Picasso Anthology*, p. 176.

199 "Four of them came": Loeb, *Voyages à travers la peinture*, p. 54.

200 "Picasso's secretive form": Langston, "Disguised Double Portraits in Picasso's Work, 1925–1962," p. 12.

200 "the chance encounter": Lautréamont (Ducasse), "Les Chants de Maldoror," in Rubin, *Dada, Surrealism and Their Heritage*, p. 19.

201 "prodigal children returning home": Brassaï, *Picasso and Company*, p. 4.

201 "the clearest expression": George, "Fair Play: The Passion of Picasso," *Formes*, April 1930, p. 8.

201 "corresponding to the collective": George, "Les Cinquante Ans de Picasso et la mort de la nature-morte," *Formes*, April 1931, p. 56.

201 "a sterile demonstration": George, "Grandeur et décadence de Pablo Picasso," *L'Art Vivant*, no. 135 (August 1930), p. 594.

201 "childish sickness": Ibid., p. 597.

202 "of the descent into hell": Jung, "Picasso," in Lipton, "Picasso Criticism, 1901–1939," p. 281.

202 "Considered from a strictly": Ibid., pp. 289.

202 "It is the ugly, the sick, the grotesque": Jung, "Picasso," in *The Collected Works of C. G. Jung*, p. 138.

CHAPTER EIGHT

203 "He first raped the woman": Cabanne, "Picasso et les joies de la paternité," *L'Oeil*, no. 226 (May 1974), p. 7.

204 "I was nine years old": Interview with Jaime Vilató.

205 "A picture lives only": Zervos, "Conversation avec Picasso," *Cahiers d'Art*, nos. 7–10, 1935, p. 174.

205 "She asked too much of me": Penrose, *Picasso: His Life and Work*, p. 271.

205 "It was the worst": Cabanne, *Le Siècle de Picasso*, vol. 1, p. 484.

205 "Appear as a bull": Otto, *Dionysus: Myth and Cult*, p. 110.

206 "Picasso's visit has": Capdevila, "Picasso, al Museu," in McCully, ed., *A Picasso Anthology*, pp. 189–90.

207 "eternal feminine which leads": Goethe, *Faust*, Part Two, Act V, lines 12, 110–11.

207 "my . . . prayer book": Gasman, "Mystery, Magic and Love in Picasso, 1925–1938," p. 421.

207 "When I think that you": Interview with Pierrette Gargallo.

207 "I am perhaps the only one": Ibid.

207 "eye of the bull": Sabartés, "La Literatura de Picasso," *Cahiers d'Art*, nos. 7–10, 1935, p. 236.

209 "An evil God has given me": Kahnweiler, "Entretiens avec Picasso," *Quadrum*, November 1956, p. 74.

209 "I'm alone at home". Sabartés, *Picasso: Documents iconographiques*, p. 68.

209 "incapable of breaking any dishes": Gold and Fizdale, *Misia*, p. 287.

209 "But your honor": Ibid.

210 "Since his separation proceedings": Gimpel, *Journal d'un collectionneur, marchand de tableaux*, p. 452.

210 "room listens": Gasman, "Mystery, Magic and Love in Picasso, 1925–1938," p. 35.

210 "the solitude of the solitudes": Sabartés, *Picasso: An Intimate Portrait*, p. 169.

210 "In life you throw a ball": Gilot and Lake, *Life with Picasso*, p. 47.

211 "What do you mean you": Interview with Jaime Vilató.

211 "in the same year as": Interview with James Lord.

212 "didn't look like her": Crespelle, *Picasso and His Women*, p. 138.

212 "On November 12, 1935": Sabartés, *Picasso: An Intimate Portrait*, p. 103.

212 "At first glance it": Ibid., pp. 108–9.

213 "Considering your love of innovation": Ibid., p. 110.

213 "But man, you're mixing your terms": Ibid.

213 "Outside the realm of his art": Ibid., p. 106.

213 "It's better like that": Penrose, *Picasso: His Life and Work*, p. 66.

214 "They tell me you are writing": Blumenkranz-Onimus, "Picasso Ecrivain ou la revanche de la couleur," *Europe*, nos. 492–93 (April–May 1970), p. 143.

214 "No, man—don't go yet": Sabartés, *Picasso: An Intimate Portrait*, p. 104.

214 "Lighting a cigarette he": Ibid.

214 "Picasso, Pablo Ruiz": Acoca, "Picasso—Super Compadre," *Washington Post*, 24 October 1971, p. A15.

214 "the necessity for total expression": Breton, "Picasso Poète," *Cahiers d'Art*, nos. 7–10, 1935, pp. 186–87.

214 "a loincloth concealing the": Sabartés, *Picasso: Portraits et souvenirs*, p. 125.

215 "You don't need to show": Barr, *Picasso: Fifty Years of His Art*, p. 272.

215 "Noticing my growing enthusiasm": Beaton, *Self Portrait with Friends*, p. 40.

215 "They were almost always": Brassaï, *Picasso and Company*, pp. 41–42.

216 "Olga likes tea": Interview with Josep Palau i Fabre.

216 "the life of a tramp": Crespelle, *Picasso and His Women*, p. 143.

216 "It is necessary for you": Penrose, *Picasso: His Life and Work*, p. 277.

217 "This man held in his hand": Eluard, "Je parle de ce qui est bien," *Cahiers d'Art*, nos. 7–10, 1935, p. 168.

217 "a little before lunchtime": Sabartés, *Picasso: An Intimate Portrait*, p. 114.

217 "Live coal of friendship": Ibid., p. 115.

218 "He is 'ours' ": González, "Desde Paris," in McCully, ed., *A Picasso Anthology*, p. 193.

218 "*Salvador Dali* is pleased to invite": Dali, "Invitation to the Picasso Exhibition, Barcelona," in McCully, ed., *A Picasso Anthology*, p. 191.

218 "I speak of that which": Eluard, "Je parle de ce qui est bien," *Cahiers d'Art*, nos. 7–10, 1935, p. 165.

219 "anger at being born": Leiris, *La Règle du jeu*, vol. 3, *Fibrilles*, p. 262.

219 "the prehistoric finally": Sabartés, *Picasso: Portraits et souvenirs*, p. 129.

219 "Michelangelesque! Michelangelesque": Ibid., p. 130.

219 "It is now 2 o'clock of the": Sabartés, *Picasso: An Intimate Portrait*, p. 123.

219 "Don't you think it would be better": Ibid., p. 107.

220 "skin," "sheets," "to turn off the gas": Letter, Picasso to Walter, 23 May 1936, in Hong Kong Museum of Art, *Picasso Intime: Collection Maya Ruiz-Picasso*, p. 52.

220 "Pablo Ruiz": Sabartés, *Picasso: An Intimate Portrait*, p. 127.

220 "a little house with": Ibid.

220 "Since I arrived here": Ibid.

220 "only truly non-intelligent woman": Farrell, "His Women," *Life*, 27 December 1968, p. 74.

220 "of two lovers, one French": Beaton, *Self Portrait with Friends*, p. 157.

221 "It is very difficult": Blumenkranz-Onimus, "Picasso Ecrivain ou la revanche de la couleur," *Europe*, nos. 492–93 (April–May 1970), p. 160.

221 "I am writing you": Sabartés, *Picasso: An Intimate Portrait*, p. 128.

221 "His ironical remarks and jokes": Ibid., p. 129.

222 "What a fine day": Penrose, *Picasso: His Life and Work*, p. 283.

222 "They are killing men here": Roy, "Le Peintre et l'Histoire," in Fermigier, ed., *Picasso*, p. 205.

223 "My dear Jaumet": Sabartés, *Picasso: An Intimate Portrait*, p. 134.

223 "Every time I change wives": Gilot and Lake, *Life with Picasso*, p. 349.

223 "Living with someone young": Interview with Françoise Gilot.

224 "One felt immediately": Interview with James Lord.

224 "She had a beautiful voice": Ibid.

224 "You see, you can't stand looking": Stein, *Everybody's Autobiography*, p. 37.

225 "Confidentially, a few days": Sabartés, *Picasso: An Intimate Portrait*, p. 135.

225 "Sabartés, my friend": Ibid.

226 "What has he achieved in": Cabanne, *Le Siècle de Picasso*, vol. 3, p. 29.

227 "After shutting the door": Sabartés, *Picasso: An Intimate Portrait*, p. 137.

227 "As soon as my mother": Interview with Maya Picasso.

227 "critics, mathematicians": Del Pomar, "Con las buscadores del camino," in Ashton, ed., *Picasso on Art*, p. 121.

Chapter Nine

229 "My love, I have to stay with Paul": Letter, Picasso to Walter, 15 October 1936, in Hong Kong Museum of Art, *Picasso Intime: Collection Maya Ruiz-Picasso*, p. 53.

229 "there were bizarre things": Gasman, "Mystery, Magic and Love in Picasso, 1925–1938," p. 436.

229 "It must be painful": Richardson, "Your Show of Shows," *The New York Review of Books*, 17 July 1980, p. 22.

230 "this impression of mastery": Johnson, *Modern Times*, p. 328.

230 "I would prefer to invent": Sabartés, *Picasso: An Intimate Portrait*, p. 119.

232 "The Spanish struggle is the fight": Barr, *Picasso: Fifty Years of His Art*, p. 202.

232 "a message from another planet": Cabanne, *Le Siècle de Picasso*, vol. 3, p. 21.

232 "In a rectangle of black": Leiris, "Faire-part," *Cahiers d'Art*, nos. 4–5, 1937, p. 128.

232 "Art long ago ceased": Read, "Picasso's Guernica," *London Bulletin*, no. 6 (October 1938), p. 6.

233 "*Guernica* is for you": Cabanne, *Le Siècle de Picasso*, vol. 3, p. 19.

233 "We will never know": Daix, *Picasso Créateur*, p. 263.

233 "I have a child by this man": Gilot and Lake, *Life with Picasso*, p. 210.

233 "I have as much reason": Ibid.

233 "Make up your mind": Ibid.

233 "It was a hard decision": Ibid., p. 211.

234 "in a fistfight in his studio": Lord, *Giacometti*, p. 181.

235 "But it was a gesture of friendship": Gilot and Lake, *Life with Picasso*, p. 137.

235 "Somebody once said to me": Laporte, *Sunshine at Midnight*, p. 73.

236 "the animal nature": Richardson, "Your Show of Shows," *The New York Review of Books*, 17 July 1980, p. 23.

236 "I thought he would like it": Laporte, *Sunshine at Midnight*, p. 20.

237 "In comparison with me": O'Brian, *Picasso*, p. 331.

237 "There are so many things": Letter, Matisse to Besson, December 1938, in National Gallery of Art, *Henri Matisse: The Early Years in Nice, 1916–1930*, p. 57.

237 "The art of balance": Matisse, *Ecrits et propos sur l'Art*, p. 50.

237 "It was as though this girl": Penrose, *Scrap Book, 1900–1981*, p. 88.

237 "For years I gave her": Crespelle, *Picasso and His Women*, p. 153.

238 "I wasn't in love with": Laporte, *Sunshine at Midnight*, p. 69.

238 "Dora thinks he resembles": Brassaï, *Picasso and Company*, p. 92.

238 "I read it and so did Dora": Ibid., p. 188.

238 "Dora was here and we looked": Ibid., p. 151.

238 "an unforeseen event": Penrose, *Picasso: His Life and Work*, p. 317.

239 "he could make much more money": Gold and Fizdale, *Misia*, p. 286.

239 "Pascal-Napoléon": Grohmann, *Paul Klee*, p. 93.

239 "It is my wish at this": *The New York Times*, 18 December 1937, p. 22.

240 "I was as solid as they come": Interview with Maya Picasso.

240 "Con-what": Ibid.

240 "Maya! It's perfect": Ibid.

240 "So, when you called out": Ibid.

241 "Cocks! There have always": Daix, *La Vie de peintre de Pablo Picasso*, p. 286.

241 "Here, the cock's shrill": Misfeldt, "The Theme of the Cock in Picasso's Oeuvre," *Art Journal*, vol. 28, no. 2 (Winter 1968–69), p. 152.

241 "You never come around": Sabartés, *Picasso: An Intimate Portrait*, p. 138.

241 "Friend Sabartés you promised": Ibid., p. 139.

242 "at the appointed hour": Ibid.

242 "need to invent his": Gedo, *Picasso: Art as Autobiography*, p. 188.

243 "Friend Jaumet. Can you": Sabartés, *Picasso: An Intimate Portrait*, p. 139.

243 "That does not matter. What can": Ibid., p. 140.

243 "We have all of life": Ibid., p. 141.

243 "it was awful": Brinnin, *The Third Rose*, p. 364.

243 *"Le roi est mort"*: Ibid.

244 "about the things one plans": Sabartés, *Picasso: An Intimate Portrait*, p. 145.

244 "How correct is the saying": Ibid., pp. 145, 146.

244 "As far as that is concerned": Ibid., p. 148.

244 "We have gained one day": Sabartés, *Picasso: Portraits et souvenirs*, p. 162.

244 "I may or may not be cured": Ibid., p. 167.

245 "Now that the pain is": Ibid., p. 169.

245 "He could have come, but": Interview with Jaime Vilató.

245 "center of an infinite void": Gasman, "Mystery, Magic and Love in Picasso, 1925–1938," p. 141.

245 "vomits his wings": Ibid., p. 447.

245 "Like a god of irreverence": Lhote, "Picasso," *La Nouvelle Revue Française*, March 1939, p. 531.

245 "Franco had fought the war": Johnson, *Modern Times*, p. 338.

246 "They are so dirty": Interview with Pierrette Gargallo.

247 "My love, I have just received": Daix, *Picasso Créateur*, p. 272.

248 "Of course if you don't": Sabartés, *Picasso: An Intimate Portrait*, p. 176.

248 "From then on, it was": Ibid.

248 "a pact with Satan to": Johnson, *Modern Times*, p. 358.

248 "the sudden discovery of": Ibid., p. 360.

249 "If it's to annoy me": Sabartés, *Picasso: An Intimate Portrait*, p. 184.

249 "He was a worried man": Brassaï, *Picasso and Company*, p. 40.
249 "as complicated as": Ibid.
251 "cemetery of domestic": Sabartés, *Picasso: An Intimate Portrait*, p. 193.
251 "You can't imagine how": Ibid., p. 194.
251 "I saw nobody, absolutely": Rolland, *Picasso et Royan*, p. 21.
252 "Do you know who": Ibid., p. 20.
252 "This would be ideal for": Sabartés, *Picasso: An Intimate Portrait*, p. 203.
253 "Where are you going like that": Penrose, *Picasso: His Life and Work*, p. 327.
254 "came whenever he whistled": Gedo, *Picasso: Art as Autobiography*, p. 193.
254 "sex and food are": Johnson, *Modern Times*, p. 365.
254 "He cast a sad glance at": Rolland, *Picasso et Royan*, p. 33.
254 "I'm here because of my": Ibid., p. 34.
255 "He knew that it was Dora": Brassaï, *Picasso and Company*, p. 106.
255 "It's you who have painted that": Cassou, *Une Vie pour la liberté*, p. 162.
255 "Did you do this": Signoret, *La Nostalgie n'est plus ce qu'elle était*, p. 58.
256 "It was incredible to hear it": Ibid.
256 "Take the one on boulevard": Cabanne, *Le Siècle de Picasso*, vol. 3, p. 90.
256 "discovering that she had": Gasman, "Mystery, Magic and Love in Picasso, 1925–1938," p. 213.
256 "We were happy": Cabanne, "Picasso et les joies de la paternité," *L'Oeil*, no. 226 (May 1974), p. 9.
257 "If something happens to me": Ibid.
257 "You've saved my life": Ibid.
257 "you are the best of women": Ibid.
258 "You know, I met love": Picasso, *Le Désir attrapé par la queue*, Act VI, Scene 1, lines 87–91.
258 "Light all the lanterns": Ibid., line 138.
258 "A Spaniard is never cold": Besson, "Lettre à Pierre Betz," *Le Point*, vol. 7, no. 42 (October 1952), p. 37.
258 "The sun in the belly": Breton, *Anthologie de l'humour noir*, p. 319.
258 "hid himself under a table": Gasman, "Mystery, Magic and Love in Picasso, 1925–1938," p. 39.
260 "He despised the way people": Interview with Pierre Berès.
260 "If you spit on me": Interview with Françoise Gilot.
260 "I'm the one who killed him": Gedo, *Picasso: Art as Autobiography*, p. 198.
260 "I am God": Richardson, "Picasso and Marie-Thérèse Walter" (unpaginated), in William Beadleston Fine Art, *Through the Eye of Picasso, 1928–1934*.
260 "I did not paint the war": Garaudy, *D'un réalisme sans rivages: Picasso, St. John Perse, Kafka*, p. 89.
261 "a grisly, dizzying reinterpretation": Gedo, *Picasso: Art as Autobiography*, p. 197.
261 "new plastic signs": Daix, *Picasso Créateur*, p. 281.
261 "The spectator, like Alice in the court": Gedo, *Picasso: Art as Autobiography*, p. 197.

261 "He wields trees": Boeck and Sabartés, *Picasso*, p. 509.

261 "For those who knew Picasso": Cabanne, *Le Siècle de Picasso*, vol. 3, p. 101.

261 "After all, you can only": Malraux, *Picasso's Mask*, p. 140.

261 "Since I work with Kazbeck": Ibid., p. 139.

262 "Who is it": Cabanne, *Le Siècle de Picasso*, vol. 3, p. 104.

262 "It's a long time since you promised": Ibid., pp. 104–5.

262 "Dora Maar, you know": Ibid, p. 105.

263 "Dear Mademoiselle Rolland": Rolland, *Picasso et Royan*, pp. 43–44.

264 "I invented it": Brassaï, *Picasso and Company*, p. 224.

264 "Dora for me was": Malraux, *La Tête d'obsidienne*, pp. 128–29.

264 "Portraits should possess": Janis, *Picasso: The Recent Years, 1939–1946*, p. 27.

264 "I must absolutely find": Malraux, *Picasso's Mask*, p. 97.

264 "of a face in harmony with its god": Ibid.

264 "in harmony with what the black sculptors": Ibid.

264 "The Romanesque sculptors": Ibid., p. 98.

265 "Pablo has been persuading me": Stein, *The Autobiography of Alice B. Toklas*, p. 77.

Chapter Ten

267 "With her green eyes": Gilot, *Interface: The Painter and the Mask*, p. 13.

267 "I told my father that": Interview with Françoise Gilot.

268 "She walked into my": Ibid.

268 "Up until I was fifteen": Ibid.

268 "It was the kind of": Interview with Claude Bleynie.

269 "All that I did of her": Interview with Françoise Gilot.

269 "When I started studying with": Ibid.

269 "What's going to happen": Ibid.

270 "Well, Cuny. Are you going": Gilot and Lake, *Life with Picasso*, pp. 14–15.

270 "Well, I'm a painter too": Ibid., p. 15.

271 "Isn't it marvelous": Ibid., p. 18.

271 "If you want to come back": Ibid., pp. 18–19.

271 "A minotaur can't be loved": Ibid., p. 50.

271 "Nobody ever takes": Interview with Françoise Gilot.

271 "I saw your exhibition": Gilot and Lake, *Life with Picasso*, pp. 20–21.

272 "Just look at the poor girl": Ibid., p. 22.

272 "That's disgusting": Ibid., p. 24.

272 "Aha! I shock you": Ibid., p. 25.

272 "Are you crazy": Interview with Françoise Gilot.

273 "You're more English": Gilot and Lake, *Life with Picasso*, p. 25.

273 "*Tiens!* That drawing": Ibid., p. 26.

273 "I remember every detail": Interview with Françoise Gilot.

274 "By the time we arrived": Ibid.

274 "The impact of our meeting": Ibid.

275 "Don't you think that": Brassaï, *Picasso and Company*, p. 102.
275 "I don't like pet cats": Ibid., p. 52.
275 "You'd be better off to stop": Gilot and Lake, *Life with Picasso*, p. 43.
275 "While Brassaï was laughing": Interview with Françoise Gilot.
276 "My little pocket flashlight": Brassaï, *Picasso and Company*, p. 66.
276 "He did it himself": Ibid.
276 "I found it": Ibid., p. 67.
276 "I'll have to go back there": Ibid., p. 97.
276 "Promised? Get it through": Ibid., p. 98.
277 "The fact that Pablo": Interview with Françoise Gilot.
277 "sort of floating in the air": Ibid.
277 "You don't understand anything": Gilot and Lake, *Life with Picasso*, p. 46.
277 "offers man a view": Beguin, "L'Androgyne," *Minotaure*, Spring 1938, p. 66.
278 "I'd bring you food": Gilot and Lake, *Life with Picasso*, p. 47.
279 "Is that the kind of costume": Ibid., p. 48.
279 "I wanted to look beautiful": Interview with Françoise Gilot.
279 "You do everything you can": Gilot and Lake, *Life with Picasso*, p. 48.
279 "You're right, really": Ibid.
279 "There you are. That's": Ibid., p. 49.
279 "He's studying her, trying": Ibid., p. 50.
279 "You are the only woman": Interview with Françoise Gilot.
279 "I guess I'll die without": Gilot and Lake, *Life with Picasso*, p. 47.
280 "What *is* it all about": Ibid., p. 51.
280 "whatever there was between us": Ibid., p. 52.
280 "Suddenly, I was flooded": Interview with Françoise Gilot.
280 "this instant is a true beginning": Gilot and Lake, *Life with Picasso*, pp. 52, 53.
280 "Everything exists in limited": Ibid., pp. 53–54.

CHAPTER ELEVEN

282 "Dear Jean, I'm writing": Andreu, *Max Jacob*, p. 77.
282 "May Salmon, Picasso, Moricand": Ibid., p. 79.
282 "Max Jacob has been a Catholic": Ibid.
283 "It's not worth doing anything": Ibid., p. 80.
283 "If you lay a hand on Picasso": Breker, *Paris, Hitler et moi*, p. 235.
283 "In politics all the artists": Ibid., p. 171.
284 "Staying on isn't really": Interview with Françoise Gilot.
284 "We have been taught to": Sartre, *What Is Literature?*, p. 217.
284 "The blackness of ink envelops": Picasso, *Desire Caught by the Tail*, Act V, Scene 1, line 27.
285 "My whole class, from": Interview with Maya Picasso.
286 "When the firing died down": Pudney, "Picasso—A Glimpse in Sunlight," *The New Statesman and Nation*, 16 September 1944, p. 182.
286 "I suddenly felt as if": Interview with Françoise Gilot.

286 "It was not a time": Janis, *Picasso: The Recent Years, 1939–1946*, p. 4.

286 "the cool Spanish tiled floor": Pudney, "Picasso—A Glimpse in Sunlight," *The New Statesman and Nation*, 16 September 1944, p. 183.

287 "like a stumpy little oriental": Gosling, "Picasso: The Greatest?" *Observer Review*, 15 April 1973, p. 29.

287 "With the hands that moved": Gold and Fizdale, *Misia*, pp. 297–98.

287 "I have great news for you": Cabanne, *Le Siècle de Picasso*, vol. 3, p. 145.

288 "profound humanity": Cachin, "Picasso a apporté son adhésion au Parti de le Renaissance Française," *L'Humanité*, 5 October 1944, p. 1.

288 "If they asked today the artists": Ibid.

288 "All human expression has": Interview with Françoise Gilot.

288 "And what about the poor": Dubois, *Sous le signe de l'amitié*, p. 148.

288 "Joining the Communist Party is": Gaillard, "Pourquoi j'ai adhéré au Parti Communiste," *L'Humanité*, 29–30 October 1944, p. 1.

290 "Understand! What the Devil": O'Brian, *Picasso*, p. 375.

291 "The philosophers have only": Marx, "Theses on Feuerbach," in *Collected Works: Marx and Engels, 1845–47*, vol. 5, p. 5.

291 "I did my best, but": Laporte, *Sunshine at Midnight*, p. 6.

291 "You see, I am not French": Ibid., p. 7.

291 "I had nicknamed her the": Interview with Françoise Gilot.

292 "In bed, but not at the table": Ibid.

292 "I went, but I took along": Ibid.

292 "brainless young people": Daix, *La Vie de peintre de Pablo Picasso*, p. 319.

292 "After the nightmare of": Interview with Françoise Gilot.

292 "The canvases painted by": Limbour, "Picasso au Salon d'Automne," in McCully, ed., *A Picasso Anthology*, p. 222.

293 "He's been like that": *Point de Vue*, 20 April 1945, p. 4.

293 "That's where it all started": Gilot and Lake, *Life with Picasso*, p. 79.

293 "All we need to do is open": Ibid., pp. 80–81.

293 "It was a time of struggle": Interview with Françoise Gilot.

293 "I want you to learn about life": Gilot and Lake, *Life with Picasso*, p. 82.

294 "the most despairing in all": Penrose, *Picasso: His Life and Work*, p. 356.

294 "a *pietà* without grief": Barr, *Picasso: Fifty Years of His Art*, p. 250.

294 "the great artists who": Cabanne, *Pablo Picasso*, p. 372.

294 "Even if they didn't want": Ibid., p. 373.

294 "The truth of the matter": Otero, *Forever Picasso*, p. 119.

294 "If the Germans were to": Cabanne, *Pablo Picasso*, p. 373.

294 "Talking to the pilot is": Ibid., p. 133.

294 "Do you believe me": Seckler, "Picasso Explains," *New Masses*, 13 March 1945, p. 5.

294 "I am a Communist": Ibid., p. 7.

295 "never been out": Ibid., p. 5.

295 "a man and a woman": Ibid., p. 6.

295 "The only conclusion we could": Ibid., p. 4.

295 "What do you think an artist": Cabanne, *Pablo Picasso*, p. 371.

295 "It was an invasion! Paris": Brassaï, *Picasso and Company*, p. 150.

296 "I felt as though I had known him": Seckler, "Picasso Explains," *New Masses*, 13 March 1945, p. 6.

296 "It's curious, I saw": Brassaï, *Picasso and Company*, p. 189.

296 "There are only monsters here": Ibid., p. 181.

296 "But these canvases of yours": Ibid., p. 182.

296 "But she is very beautiful": Ibid., p. 183.

297 "People are always asking me": Ibid., p. 188.

297 "Every time I see": Ibid.

297 "NO MORE FORELOCK": Ibid., p. 150.

298 "Where do you think you're": Gilot and Lake, *Life with Picasso*, p. 86.

298 "I don't know why I told you": Ibid., p. 84.

298 "There's nothing so similar": Ibid.

299 "Nobody has any real importance": Ibid.

299 "As an artist you may be": Ibid., p. 88.

299 "You work out your own": Ibid.

300 "You both should get down": Ibid., pp. 88–89.

300 "Picasso can't stand for": Daix, *Picasso Créateur*, p. 298.

300 "The present always has": Gilot and Lake, *Life with Picasso*, p. 89.

300 "Let's drop that whole matter": Ibid., p. 90.

301 "That kind of charity is": Ibid.

301 "Love is the danger of": Barrett, *Irrational Man*, p. 200.

301 "I started to see that": Interview with Françoise Gilot.

301 "Don't count on me to": Ibid.

301 "Beyond a slight tightening around": Brassaï, *Picasso and Company*, p. 179.

302 "Please come at once. I'm": Gilot and Lake, *Life with Picasso*, p. 90.

302 "I am laughing at your": Letter, Françoise Gilot to Madeleine Gilot, September 1944 (property of Françoise Gilot).

303 "the masklike fixity of": Gilot, "Mano a Mano," *Art and Antiques*, October 1985, p. 77.

303 "Life away from Pablo had": Interview with Françoise Gilot.

304 "I knew that going": Ibid.

305 "All right, then, I'll": Gilot and Lake, *Life with Picasso*, p. 94.

305 "I know, of course, that": Ibid.

305 "Picasso looked, listened": Cabanne, *Pablo Picasso*, p. 380.

305 "See what fame is, Gertrude": Ibid., p. 371.

305 "The main thing is": Ibid.

305 "an ordeal made worse by": Interview with Françoise Gilot.

305 "Well, Gertrude, you haven't": Gilot and Lake, *Life with Picasso*, p. 70.

305 "She is as fat as": Lord, *Où étaient les tableaux . . .*, p. 33.

306 "He came to see me after": Ibid., p. 34.

306 "There was something satanic about": Interview with James Lord.

307 "Pablo was once again": Interview with Françoise Gilot.

307 "By that time, I was very": Ibid.

308 "It was the last thing I expected": Ibid.

308 "It was a very strange moment": Ibid.

308 "Geneviève is the only woman": Ibid.

309 "What can possibly be the attraction": Ibid.

309 "I'm going to take advantage": Gilot and Lake, *Life with Picasso*, p. 97.

310 "You have the night to": Interview with Françoise Gilot.

310 "some sort of unnatural": Gilot and Lake, *Life with Picasso*, p. 98.
310 "to stop wasting his": Interview with Françoise Gilot.
310 "whatever little bit of happiness": Gilot and Lake, *Life with Picasso*, p. 98.
310 "I was almost unbearably": Interview with Françoise Gilot.
311 "You're sleepwalking to": Ibid.

CHAPTER TWELVE

312 "Really, that's going": Gilot and Lake, *Life with Picasso*, p. 100.
313 "As far as your grandmother's": Ibid.
313. "There is no total": Ibid.
314 "We are always in": Ibid., p. 101.
314 "I didn't mean to": Dostoevsky, *Crime and Punishment*, adapted by Lyubimov and Kariakin, Act I, Scene 1, line 10.
315 "Isn't she marvelous? What": Gilot and Lake, *Life with Picasso*, p. 104.
315 "You're very funny. You": Ibid., p. 106.
316 "You've never loved anyone": Ibid.
316 "to feel intensely about": Ibid., p. 107.
316 "Picasso was like a": Interview with Françoise Gilot.
317 "like Joan of Arc: wearing": Daix, *Picasso Créateur*, p. 298.
317 "I was playing hide": Interview with Françoise Gilot.
318 "the need for a teddy bear": Ibid.
318 "No. That's why painters": Gilot and Lake, *Life with Picasso*, p. 116.
319 "We're all animals more or": Ibid., p. 119.
319 "Neither Pablo nor I": Gilot, "Mano a Mano," *Art and Antiques*, October 1985, p. 78.
319 "I made her give us": Interview with Françoise Gilot.
319 "Everything was a trap. He": Ibid.
319 "As you see, she didn't": Gilot and Lake, *Life with Picasso*, p. 126.
319 "That's the kind of crown I": Ibid., p. 129.
320 "It was an almost all-male": Interview with Françoise Gilot.
320 "Somehow I don't see you writing": Gilot and Lake, *Life with Picasso*, p. 130.
320 "full of 'I love you' ": Interview with Maya Picasso.
321 "You must be out of your mind": Gilot and Lake, *Life with Picasso*, pp. 130–31.
321 "You won't know what": Ibid., p. 132.
321 "Before I went to live": Interview with Françoise Gilot.
321 "Françoise offered to": Interview with Dominique Desanti.
322 "If there's a single freedom": Parmelin, *Picasso: Intimate Secrets of a Studio at Notre Dame de Vie*, p. 67.
322 "a mysterious, inscrutable": Melville, *Pierre: or, the Ambiguities*, p. 357.
322 "You're going to swear here": Gilot and Lake, *Life with Picasso*, p. 134.
323 "not by chance but": Interview with Lionel Prejger.
324 "Françoise is expecting": Brassaï, *Picasso and Company*, p. 191.
324 "He couldn't stand being": Interview with Françoise Gilot.

324 "After Picasso, only God": Ibid.

324 "It was not so much the episode": Ibid.

325 "He never had the slightest notion": Brassaï, *Picasso and Company*, p. 229.

325 "We opened the exhibition". Kootz, "The Reality Gap: Picasso," p. 3.

326 "Picasso used to be a great": Lord, *Giacometti*, p. 322.

326 "I don't like Reverdy any more": Gilot and Lake, *Life with Picasso*, pp. 143–44.

326 "If they really loved me": Ibid., p. 144.

327 "It's better not to act": Interview with Françoise Gilot.

328 "It was quite traumatic having": Ibid.

328 "You see, getting a woman with": Laporte, *Sunshine at Midnight*, p. 36.

328 "a survivor of a very": Interview with Françoise Gilot.

329 "My loyalties became divided": Ibid.

329 "He always wanted her": Interview with Dominique Desanti.

329 "Max Jacob once asked": Gilot and Lake, *Life with Picasso*, p. 182.

330 "But *Maître*, we never": Jahan, "Ma Première Rencontre avec Picasso," *Gazette des Beaux Arts*, October 1973, p. 234.

331 "This is really pretty": Interview with Françoise Gilot.

331 "They were a little like": Ibid.

331 "Being unfair is godlike": Ibid.

332 "Your son is useless too": Ibid.

332 "If you were like him, you": Gilot and Lake, *Life with Picasso*, p. 154.

333 "Furthermore, you've lived": Ibid., p. 199.

334 "That bastard. He's": Ibid., p. 203.

334 "He accepted Giacometti's": Lord, *Giacometti*, p. 206.

334 "a new spirit in sculpture": Gilot and Lake, *Life with Picasso*, p. 207.

334 "He amazes me. He": Lord, *Giacometti*, p. 486.

335 "I don't know why I": Gilot and Lake, *Life with Picasso*, p. 210.

335 "I would gladly have": Interview with Françoise Gilot.

336 "I learned a lot from him": Ibid.

336 "You are the one I recognize": Gold and Fizdale, *Misia*, p. 307.

336 "How is he? . . . And": Ibid., pp. 307–8.

337 "You're crazy to make a chapel": Gilot and Lake, *Life with Picasso*, p. 263.

337 "Why don't you build a market": Couturier, *Se garder libre*, p. 50.

337 "I couldn't care less": Ibid.

337 "As far as I'm concerned": Gilot and Lake, *Life with Picasso*, p. 263.

337 "Yes, I do pray": Couturier, *Se garder libre*, p. 71.

338 "to feel purified": Chutkow, "Looking at the Painter's Provence," *The New York Times*, 24 August 1986, p. 14.

338 "In the end, it's not": Couturier, *Se garder libre*, p. 111.

338 "This chapel for me is": Chutkow, "Looking at the Painter's Provence," *The New York Times*, 24 August 1986, p. 14.

338 "One swallows something": Dor de la Souchère, *Picasso in Antibes*, p. 56.

338 "I should confess every day": Couturier, *La Vérité blessée*, p. 170.

338 "preferred to discuss art": Interview with Françoise Gilot.

339 "Many of the people": Ibid.
339 "Pignon would try to explain": Penrose, *Pablo Picasso: His Life and Work*, p. 413.
339 "What truth? Truth cannot": Parmelin, *Picasso: "The Artist and His Model," and Other Recent Works*, p. 110.
339 "It took me a long time": Interview with Françoise Gilot.
340 "Words cannot express my": Letter, Hadjilazaros to Gilot, 18 May 1948 (property of Françoise Gilot).
340 "They were not living": Interview with Françoise Gilot.
340 "I prefer Heraclitus": Ibid.
340 "Picasso's art had already": Interview with Kostas Axelos.
341 "Basically you have always loved": Guttuso, "Journals," in Ashton, ed., *Picasso on Art*, p. 74.
341 "We were both rather": Interview with Françoise Gilot.
341 "I know just what you": Gilot and Lake, *Life with Picasso*, p. 212.

CHAPTER THIRTEEN

342 "He never stopped talking": Interview with Dominique Desanti.
343 "a jackal equipped with a pen": Ibid.
343 "Everything that I am": Lord, *Giacometti*, p. 251.
344 "The tone of his voice": Interview with Dominique Desanti.
344 "If he wanted us to live": Interview with Françoise Gilot.
345 "Here's for the *bons baisers*": Ibid.
345 "the harbinger of the social role": Moussinac, "Tous les Arts," *Les Lettres Françaises*, 25 November 1948, p. 7.
345 "They expect to be shocked": Gilot and Lake, *Life with Picasso*, p. 219.
345 "Even when he was working": Interview with Françoise Gilot.
346 "I told him many times": Ibid.
346 "I felt that there was no comprehension": Ibid.
347 "If you need a car, you'll": Gilot and Lake, *Life with Picasso*, p. 222.
347 "He was anxious or": Parmelin, *Picasso Plain*, p. 179.
347 "Picasso likes them and": Ehrenburg, *People and Life, 1891–1921*, p. 220.
348 "Poor old Aragon": Laporte, *Sunshine at Midnight*, pp. 7–8.
348 "This famous Picasso did": Parmelin, *Picasso Plain*, p. 179.
350 "son of the White Russian": Interview with Françoise Gilot.
350 "trying to pass the buck": Gilot and Lake, *Life with Picasso*, p. 249.
350 "worthless creature": Ibid.
351 "the most disgusting son": Ibid., p. 250.
351 "It's the easiest": Interview with Françoise Gilot.
351 "With a bit of luck, you": Ibid.
351 "He always put those": Ibid.
351 "She had grown to hate": Interview with Maya Picasso.
352 "Whatever you may be": Interview with Françoise Gilot.
352 "one truth does not annihilate": Ibid.
352 "When she first saw them, she": Ibid.
352 "You know, the first children": Interview with Maya Picasso.
352 "not the blue sky of the South of France": Ibid.

352 "I had made all these new": Ibid.

353 "In my story of Little Red": Ibid.

353 "He was the king of troublemakers": Ibid.

353 "Claude was very possessive": Interview with Françoise Gilot.

353 "Pablo had tremendous sexual needs": Ibid.

354 "Dr. Lamaze, who is very": Letter, Françoise Gilot to Madeleine Gilot, October 1949 (property of Françoise Gilot).

354 "I understand from your telegrams": Letter, Françoise Gilot to Madeleine Gilot, October 1949 (property of Françoise Gilot).

355 "I don't like sick women": Interview with Françoise Gilot.

355 "I had never envisioned": Ibid.

356 "So you are pleased": Ibid.

356 "I didn't know at the time": Ibid.

356 "The answer came back as a clear": Ibid.

356 "The poor darling is really": Letter, Françoise Gilot to Madeleine Gilot and Anna Renoult, October 1949 (property of Françoise Gilot).

357 "My mother went to": Interview with Françoise Gilot.

357 "Claude knows about everything": Letter, Françoise Gilot to Madeleine Gilot and Anna Renoult, 30 October 1949 (property of Françoise Gilot).

357 "But they ought to pray": Gilot and Lake, *Life with Picasso*, p. 231.

357 "the great German orchestra conductor": Interview with Françoise Gilot.

357 "like a piece of polished marble": Ibid.

357 "I don't care about you": Ibid.

358 "Where shall I take you": Ibid.

358 "I have never been as poor": Ibid.

358 "Perhaps we both felt": Ibid.

359 "He was put out by": Ibid.

359 "Let's play at hurting": Picasso, *Les Quatre Petites Filles*, Act I, Scene 1, lines 11–13.

360 "You are so lucky": Interview with Pierrette Gargallo.

360 "If we weren't unhappy": Couturier, *La Vérité blessée*, p. 166.

360 "Isn't she stupid": Picasso, *Les Quatre Petites Filles*, Act I, Scene 1, line 33.

360 "It was a life raft": Interview with Françoise Gilot.

360 "As for the most": Letter, Françoise Gilot to Madeleine Gilot, February 1950 (property of Françoise Gilot).

361 "If only I had him": Letter, Françoise Gilot to Madeleine Gilot, March 1950 (property of Françoise Gilot).

361 "You must send this": Letter, Françoise Gilot to Madeleine Gilot and Anna Renoult, March 1950 (property of Françoise Gilot).

361 "To produce babies at my age": Cabanne, *Le Siècle de Picasso*, vol. 4, p. 242.

361 "It infuriated him": Interview with Françoise Gilot.

361 "You must stop calling her": Ibid.

361 "*le malheureux fils père*": Ibid.

361 "his son and daughter-in-law": Ibid.

362 "a painter's life": Parmelin, *Picasso Plain*, p. 24.

362 "We were all Communists": Ibid., pp. 19–20.

362 "picked up the nose and": Ibid., p. 16.

362 "Down with style": Malraux, *Picasso's Mask*, p. 18.

363 "Since she was skipping, how": Ibid.

363 "The eyes of the artist are": Dor de la Souchère, *Picasso in Antibes*, p. 23.

363 "We ought to be able to": Parmelin, *Picasso Says*, p. 32.

363 "Salute to Picasso, our": Cabanne, *Pablo Picasso*, p. 372.

363 "religious art no longer": Casanova, *Le Parti communiste, les intellectuels, et la nation*, p. 24.

364 "You have to be able": Vallentin, *Pablo Picasso*, p. 391.

364 "I never liked to ask": Interview with Françoise Gilot.

364 "Absolutely not. If": Ibid.

364 "And I, what can": Penrose, *Picasso: His Life and Work*, p. 367.

364 "I stand for life against": Ibid., p. 368.

365 "a faint bleat in the pandemonium": Lord, *Giacometti*, p. 322.

365 "As a formal production, it": Ibid.

365 "That's what's so terrible": Centre Georges Pompidou, *Donation Louise et Michel Leiris*, p. 174.

365 "I feel a constant urge": Laporte, *Sunshine at Midnight*, p. 80.

365 "Was Picasso afraid of": Ibid., pp. 80–81.

366 "chilled by the growing recognition": Interview with Françoise Gilot.

366 "You were a Venus when I": Gilot and Lake, *Life with Picasso*, p. 337.

366 "Of course not": Interview with Françoise Gilot.

366 "I didn't see why, on": Ibid.

367 "You are the son of": Ibid.

367 "Beyond any shadow of": Interview with Dominique Eluard.

367 "If Paul thinks that": Interview with Françoise Gilot.

367 "A woman who is there, under": Gilot and Lake, *Life with Picasso*, p. 300.

367 "One thing that I found": Interview with Dominique Eluard.

367 "There's no such thing as": Gilot and Lake, *Life with Picasso*, p. 301.

368 "Eluard was fascinated by": Interview with Dominique Eluard.

368 "I'm a woman. Every": Laporte, *Sunshine at Midnight*, p. 69.

368 "Picasso had been to our": Interview with Dominique Eluard.

368 "Even if you were entirely": Laporte, *Si tard le soir*, p. 153.

369 "I've never been able to think": Laporte, *Sunshine at Midnight*, p. 25.

369 "Picasso has only ever done": Ibid.

369 "You know, don't you, that": Ibid., p. 81.

369 "He will praise a fair girl's": The Catalogue Aria from Mozart's *Don Giovanni*.

369 "women of every rank, of every": Ibid.

369 "I felt as though I had been": Interview with Françoise Gilot.

370 "Is it true? Please": Ibid.

370 "You must be crazy to": Ibid.

370 "Françoise Gilot's grandmother is": Ibid.

370 "It was awkward at first, but": Ibid.

370 "Ever since I was a child, my": Ibid.

371　"There is no question that": Ibid.
371　"I want you to have the courage": Ibid.
371　"Instead of asking about": Ibid.
372　"That was *the* mistake. There": Ibid.
372　"It was the loss of innocence and": Ibid.
372　"It's ironic that it was": Ibid.

CHAPTER FOURTEEN

373　"You can't fire a man just": Interview with Françoise Gilot.
374　"You don't like me as much as you used to": Lord, *Giacometti*, p. 324.
374　"Then Picasso performed one": Ibid., pp. 324–25.
374　"I can't stand people who": Interview with Françoise Gilot.
375　"Picasso altogether bad, completely": Lord, *Giacometti*, p. 325.
375　"I'm like a mosquito buzzing": Haggard, *My Life with Chagall*, p. 19.
375　"Yes, but the day they oblige you": Couturier, *La Vérité blessée*, p. 217.
375　"What a genius, that Picasso. It's": Gilot and Lake, *Life with Picasso*, p. 282.
375　"Papa is so unhappy": Ibid.
376　"My feeling was that we were a": Interview with Françoise Gilot.
376　"She still thought that": Ibid.
376　"It was a big mansion at": Ibid.
377　"any girl of eighteen is": Ibid.
377　"There was a crippling that": Ibid.
377　"You go silent on me": Gilot and Lake, *Life with Picasso*, pp. 339–40.
377　"We are still under": Letter, Eluard to Gilot, 2 July 1952 (property of Françoise Gilot).
377　"Françoise's painting uses": Cocteau, *Le Passé défini*, p. 344.
378　"She'll be a perfect woman": Gilot and Lake, *Life with Picasso*, p. 256.
378　"Yes": Ibid., p. 257.
378　"Now, there's a *real* painter": McKnight, *Bitter Legacy*, p. 162.
379　"When I was their age": Penrose, *Picasso: His Life and Work*, p. 307.
379　"a few basic notions of painting": Dominguín, *Toros y Toreros*, p. 8.
379　"Enough of Art. It's": Parmelin, *Picasso: Women, Cannes, and Mougins, 1954–63*, p. 30.
379　"Despite the practice of a science": Raynal, "Panorama de l'oeuvre de Picasso," *Le Point*, vol. 7, no. 42 (October 1952), p. 21.
379　"None of my paintings": Roy, *L'Amour de la peinture*, in Ashton, *Picasso on Art*, pp. 157–58.
379　"What imposed itself first": Ibid., p. 157.
380　"A bullfighter can never see": Hemingway, *The Dangerous Summer*, p. 198.
380　"It was one thing": Ibid., p. 195.
380　"The first matador always": Letter, Françoise Gilot to Madeleine Gilot, October 1952 (property of Françoise Gilot).
380　"She was extremely beautiful": Ibid.
380　"stop arguing and": Interview with Françoise Gilot.

381 "One of the men even": Ibid.

381 "You're going to think that": Letter, Françoise Gilot to Madeleine Gilot, October 1952 (property of Françoise Gilot).

381 "You see, there are people": Interview with Françoise Gilot.

381 "He was, in fact, furious": Ibid.

382 "Nobody leaves a man like me": Ibid.

382 "Suddenly I found myself": Ibid.

382 "In fact it was Eluard who": Interview with Dominique Eluard.

382 "The whole world is there": Eluard, "Je parle de ce qui est bien," *Cahiers d'Art*, nos. 7–10, 1935, p. 168.

383 "deep meaning": Interview with Françoise Gilot.

383 "I began to despise him": Ibid.

383 "Our relationship had lost all poetry": Ibid.

384 "But I could never do that": Ibid.

384 "It was very peaceful and": Ibid.

385 "Everything you wrote in the letter": Ibid.

386 "I've never wept over a woman": Laporte, *Sunshine at Midnight*, p. 26.

386 "Picasso was a sun all": Ibid., p. 25.

386 "How can I find the courage to": Ibid., p. 26.

387 "That would certainly be an": Interview with Françoise Gilot.

387 "You, who were so sweet and gentle": Gilot and Lake, *Life with Picasso*, p. 348.

387 "The dog's helplessness as he": Gedo, *Picasso: Art as Autobiography*, p. 217.

388 "Maybe if I tried to do a": Gilot and Lake, *Life with Picasso*, p. 278.

388 "The Secretariat of the French Communist": *L'Humanité*, 18 March 1953, p. 1.

388 "We found in the portrait neither the genius": *Les Lettres Françaises*, 19 March 1953, p. 9.

389 "I wish to thank the Secretariat": Ibid.

389 "a government which would punish a painter": Cocteau, *The Journals of Jean Cocteau*, p. 82.

389 "How can Aragon, a poet": Daix, *Picasso Créateur*, p. 330.

389 "There are always quarrels within a": Ehrenburg, *People and Life*, 1891–1921, p. 221.

389 "I suppose it was the Party's right": Gilot and Lake, *Life with Picasso*, p. 278.

390 "I don't approve of your joining the Communist": Ibid., p. 138.

390 "I was so lonely at": Interview with Françoise Gilot.

390 "He fought me inch by": Ibid.

391 "Ballets always bring me bad": Ibid.

391 "The black small mules of the": Picasso, poem dated 5 May 1953. From the archives of the Harry Ransom Humanities Research Center, University of Texas at Austin.

391 "It was suddenly a complete reversal": Interview with Françoise Gilot.

391 "I had finally reached the conclusion": Ibid.

392 "Wait and see. If nobody": Ibid.

392 "He loved to take walks": Interview with Paule de Lazerme.

392 "Everything he touched came": Ibid.

393 "The gossip about her was": Interview with Dominique Desanti.

393 "No one loves anyone anymore": Interview with Françoise Gilot.

393 "Their favorite quote was a remark": Ibid.

393 "He could not bear the thought that": Ibid.

394 "visual diary of a hateful": Leymarie, Picasso: The Artist of the Century, p. 269.

394 "soft against her smooth flesh": West, Introduction, in Marlborough Fine Arts Gallery, Picasso: 63 Drawings, 1953–54; 10 Bronzes, 1945–53, p. 5.

394 "his place at the feast of sensual pleasure": Ibid., p. 6.

395 "Never will Picasso look like": Piot, "Décrire Picasso," p. 235.

395 "bottom of the well": Gasman, "Mystery, Magic and Love in Picasso, 1925–1938," p. 157.

395 "like a cryptogram": Breton, Nadja, p. 150.

395 "I knew you wouldn't be able": Gilot and Lake, Life with Picasso, p. 359.

396 "I'm going to talk to you now": Ibid.

396 "It's terrible that you have to go away": Ibid., p. 360.

397 "You don't seem at all unhappy": Ibid., p. 352.

397 "She told me that I was shameless": Interview with Françoise Gilot.

397 "the reward for love is friendship": Ibid.

398 "Well, are you two married": Interview with James Lord.

398 "His whole behavior that evening": Ibid.

398 "When they had got there": Ibid.

399 "this time we are going to have some fun": Interview with Françoise Gilot.

400 "one last favor": Gilot and Lake, Life with Picasso, p. 362.

400 "It's so humiliating": Interview with Françoise Gilot.

400 "You were wonderful": Gilot and Lake, Life with Picasso, p. 363.

CHAPTER FIFTEEN

401 "Picasso was unhappy": Interview with Hélène Parmelin.

401 "It was unimaginable": Interview with Dominique Eluard.

401 "The painter says nothing, but": "Picasso change de modèle," Radar, 12 December 1953, p. 7.

401 "I accepted them all": Interview with Maya Picasso.

401 "Whores for daddy": Daix, Picasso Créateur, p. 329.

402 "watching him like a fox, clearly": Interview with Paule de Lazerme.

402 "She threatened to kill herself": O'Brian, Picasso, p. 424.

402 "You told me to do whatever": Ibid.

402 "Françoise had asked of him": Interview with Dominique Eluard.

403 "He kept on saying": Letter, Jacques de Lazerme to Totote and Rosita Hugué, 15 December 1951. From the archives of the Biblioteca de Catalunya.

403 "We have absolutely no": Letter, Jacques de Lazerme to Totote and Rosita Hugué, 20 April 1956. From the archives of the Biblioteca de Catalunya.

403 "I have chosen to keep": Diehl, Henri Matisse, p. 75.

403 "In the end there's only Matisse": Daix, *La Vie de peintre de Pablo Picasso*, p. 359.

403 "When Matisse died, he": Penrose, *Picasso: His Life and Work*, p. 396.

404 "a certain dilution of imaginative power": Blunt, *Picasso's "Guernica,"* p. 5.

404 "I wonder what Delacroix": Kahnweiler, "Entretiens avec Picasso au sujet des *Femmes d'Alger*," *Aujourd'hui*, no. 4 (September 1955), p. 12.

404 "I sometimes say to myself that perhaps": Ibid., translated in McCully, ed., *A Picasso Anthology*, p. 252.

404 "But they're much better off": Bernier, "48, Paseo de Gracia," *L'Oeil*, no. 4 (15 April 1955), p. 10.

405 "Before I left, they overwhelmed": Ibid., p. 13.

405 "There was an exhibition of": Interview with Luc Simon.

406 "It crystallized immediately for": Interview with Françoise Gilot.

406 "It's monstrous. You": Gilot and Lake, *Life with Picasso*, p. 365.

406 "Luc will help bring up": Interview with Françoise Gilot.

406 "I later discovered that": Ibid.

407 "You owe me so much. This": Gilot and Lake, *Life with Picasso*, p. 342.

407 "king of junkmen": Cocteau, "Pablo Picasso: A Composite Interview," *The Paris Review*, Summer–Fall 1964, p. 64.

407 "his look sinewy like": Verdet, *Les Grands Peintres: Pablo Picasso*, p. 3.

408 "He looked sometimes like": Ibid.

408 "Are you happy with what you did": Ibid., p. 6.

408 "But that's what I love. You": Ibid.

408 "My intention is to make": F.K., "Picasso devant la caméra," *Jardin des Arts*, no. 15 (January 1956), pp. 178–79.

408 "The analysis of the drawings": Klady, "Return of the Centaur," *Film Comment*, vol. 22, no. 2 (March–April 1986), p. 20.

408 "There was Picasso, who": Parmelin, *Picasso Plain*, p. 135.

409 "Me? I am the new Egeria": Ibid., p. 58.

409 "As far as I was concerned, there": Interview with Inès Sassier.

409 "the self-assurance of a child": Duncan, *Viva Picasso*, p. 1.

409 "To live next to him, you had": Interview with Inès Sassier.

410 "To claim that when you love somebody": Gilot and Lake, *Life with Picasso*, p. 351.

410 "Everything was yours when": Interview with Françoise Gilot.

410 "No one talks to me like that": Ibid.

410 "I could not believe that": Ibid.

410 "Sleeping in that empty house": Ibid.

410 "Please don't tell anyone": Ibid.

411 "deserved to be slapped": Ibid.

411 "You should have prevented": Ibid.

411 "You traitor! What": Ibid.

411 "Cocteau is the tail of my comet": Steegmuller, *Cocteau*, p. 490.

411 "He wouldn't spend much": Interview with Françoise Gilot.

412 "I did it more for legal reasons": Ibid.

412 "I'm not returning the children": Ibid.

412 "I began to feel as though": Ibid.
412 "sticky paste which runs through": Cocteau, *La Machine infernale*, Act I, p. 45.
413 "I didn't want to be eaten": Interview with Maya Picasso.
413 "Look, Olga is dead": McKnight, *Bitter Legacy*, p. 139.
413 "He would often come to my room": Interview with Maya Picasso.
413 "When everything went wrong": Parmelin, *Picasso Plain*, p. 107.
414 "It's not merely that he": Ibid., p. 90.
414 "One had to stay at La Californie": Ibid.
414 "What can my Lord": Ibid., p. 167.
414 "When one is lucky enough": Crespelle, *Picasso and His Women*, p. 199.
415 "Under an opera cloak quilted": Cabanne, *Pablo Picasso*, p. 473.
415 "a tall, lanky man who": Ibid.
415 "She wasn't against it, though": Laporte, *Sunshine at Midnight*, p. 77.
415 "That's enough": Dali, *Comment on devient Dali*, p. 270.
415 "He's just sketching her": Cabanne, *Pablo Picasso*, p. 474.
415 "Damned be this devil": Dali, *Comment on devient Dali*, p. 270.
416 "a side of Picasso which": Laporte, *Sunshine at Midnight*, p. 4.
416 *"Mon maître Picasso"*: Penrose, *Picasso: His Life and Work*, p. 412.
416 "the abominable snowman": Laporte, *Sunshine at Midnight*, p. 4.
416 "Picasso is trying his hand": Ibid.
416 "The future is the only transcendence": Garaudy, *D'un réalisme sans rivages*, p. 57.
417 "He was having lunch. And": Parmelin, *Picasso Plain*, p. 84.
417 "I'd give anything to be": Gilot and Lake, *Life with Picasso*, p. 348.
417 "geriatric prodigy": Gedo, *Picasso: Art as Autobiography*, p. 225.
418 "He liked people to": Parmelin, *Picasso Plain*, p. 106.
418 "He always liked to fatten up": Interview with Maya Picasso.
418 "would do all he could to": Parmelin, *Picasso Plain*, p. 106.
418 "The King of La Californie": Ibid., p. 74.
418 "I want to show the world": Ehrenburg, *People and Life*, 1891–1921, p. 218.
418 "the trickery of the": Parmelin, *Picasso Plain*, p. 85.
418 "We are Communists. There": Ibid., p. 188.
419 "After all, they won't go": Ibid., pp. 74–75.
419 "a special congress to discuss": Daix, *La Vie de peintre de Pablo Picasso*, p. 362.
419 "They may even become obstinate": Penrose, *Picasso: His Life and Work*, p. 411.
419 "Look, I am no politician": Ibid.
419 "a new theology without God": Popper, *Conjectures and Refutations*, p. 363.
420 "Symptoms of a desperate": Parmelin, *Picasso Plain*, p. 229.
420 "From the day the idea of *Las Meninas*": Ibid.
420 "her convalescence was abnormally": Ibid., p. 230.
421 "her stomach open": Ibid., p. 232.
421 "Isn't it curious": Richardson, "Understanding the Paintings of Pablo Picasso," *The Age*, 22 December 1962, p. 22.

421 "One is reminded": Berger, *The Success and Failure of Picasso*, pp. 180, 181.

421 "Picasso really wanted to settle": Malraux, *Picasso's Mask*, p. 45.

421 "What an appalling business": Parmelin, *Picasso Plain*, p. 230.

422 "condemned to paint with": Berger, *The Success and Failure of Picasso*, p. 185.

422 "He was horrible during": Interview with Hélène Parmelin.

422 "the *corrida* at Cannes": Parmelin, *Picasso Plain*, p. 235.

422 "Well": Ibid., p. 242.

422 "the enthusiasm of a clan": Ibid., p. 237.

422 "Picasso was not a man of certainty": Interview with Hélène Parmelin.

422 "Picasso, mobbed by the crowd": Parmelin, *Picasso Plain*, p. 210.

423 "a desiccated Icarus": Boggs, "The Last Thirty Years," in Penrose and Golding, eds., *Picasso in Retrospect*, p. 140.

423 "the burning reds and yellows": Penrose, *Picasso: His Life and Work*, p. 425.

423 "I painted this with four-letter words": Ibid.

423 "practically on the date": Interview with Pierre Daix.

423 "the great danger that Picasso saw": Ibid.

424 "Picasso was in a sombre humour": Parmelin, *Picasso Plain*, pp. 214–15.

424 "By the time I met him, he": From a roundtable discussion between Eugenio Arias, Maya Picasso and Josep Palau i Fabre, aired in Barcelona, in December 1984.

424 "Let's go to the bulls. It's": Ibid.

425 "You work for me, and": Cabanne, *Pablo Picasso*, p. 475.

425 "We've had so much trouble": Parmelin, *Voyage en Picasso*, p. 39.

425 "There was a photographer there": Cabanne, "Picasso et les joies de la paternité," *L'Oeil*, no. 226 (May 1974), p. 10.

426 "I've become one of the monuments": Daix, *Picasso Créateur*, p. 348.

426 "You ought to see it, it's": Parmelin, *Picasso Plain*, p. 245.

426 "Coincidences do not exist": Ibid., p. 130.

426 "If only I was Madame Cuttoli's": Ibid., p. 246.

426 "I've bought the Sainte-Victoire": Daix, *La Vie de peintre de Pablo Picasso*, p. 372.

426 "Men who do not love glory": Vauvenargues, *Maximes et pensées*, p. 40.

427 "Cézanne painted these mountains, and": Kootz, "The Reality Gap: Picasso," p. 22.

427 "You know where you": Cabanne, *Pablo Picasso*, pp. 492–93.

Chapter Sixteen

428 "a statue out of nothing": Apollinaire, *Le Poète assassiné*, pp. 115–16.

429 "this kind of unbearable": Parmelin, *Voyage en Picasso*, pp. 31–32.

429 "And what an atmosphere": Ibid., p. 32.

429 "You don't seem to know": Ibid.

429 "I open the camera": Ibid., pp. 33–34.

430 "Being Picasso does": Ibid., p. 35.

430 "But what have I done": Ibid.

430 "a magnificent place, but": Brassaï, *Picasso and Company*, p. 271.

430 "The exaltation ceased": Penrose, *Picasso: His Life and Work*, p. 430.

430 "I'm a little bored": Interview with Lionel Prejger.

431 "This image contains": Piot, "Décrire Picasso," p. 113.

431 "to cut open": Cooper, "Les Déjeuners: Un changement à vue," in Galerie Louise Leiris, *Picasso: Le Déjeuner sur l'herbe, 1960–61* (unpaginated).

431 "shrinks in the final oil": Boggs, "The Last Thirty Years," in Penrose and Golding, eds., *Picasso in Retrospect*, p. 151.

431 "with all that": Parmelin, *Voyage en Picasso*, p. 104.

432 "He has always been so concerned": Brassaï, *Picasso and Company*, p. 270.

432 "Why should I go": Penrose, *Picasso: His Life and Work*, p. 434.

432 "the greatest artist of this century": Ibid., p. 433.

432 "born of an understanding": Penrose, Introduction, in The Tate Gallery, *Picasso*, p. 8.

433 "Would you consider": Interview with Françoise Gilot.

433 "Mama, you should do it": Ibid.

433 "We were very well behaved": Ibid.

434 "Françoise may be my wife, but": Ibid.

435 "I had sworn to": *L'Aurore*, 14 March 1961, p. 1.

436 "I'm bringing you here because": Interview with Françoise Gilot.

437 "a holy feast in": Penrose, *Picasso: His Life and Work*, p. 436.

437 "escorted by helmeted": Ibid.

437 "Come here so that I can": Marion, "Pour ses 80 ans Picasso m'a dit," *France-Soir*, 19 October 1961, p. 2D.

438 "Everybody has his price": Dupont, "Quand la vie se fait trop noire," *Paris-Match*, 31 October 1986, p. 82.

438 "just as happy with a single": Ibid.

438 "She was terribly jealous of": Interview with Miguel Bosé, *Epoca*, December 1986, p. 40.

438 "At the end, nobody": Kahnweiler, "Gespräche mit Picasso," in Ashton, ed., *Picasso on Art*, p. 82.

439 "He was going to take a nap and": Interview with Maurici Torra-Bailari.

439 "All four of these *Warriors*": Schiff, "The *Sabines* Sketchbook," in The Pace Gallery, *Je Suis le Cahier: The Sketchbooks of Picasso*, p. 185.

439 "projected, with their facial distortions": Ibid., p. 186.

440 "But as for them, they": Parmelin, *Picasso Says*, p. 81.

440 "Does one ever know what": Ibid., p. 80.

440 "Everything is changed, it's": Ibid., p. 84.

440 "It was during this period": Ibid.

440 "We have to look for": Ibid.

441 "In front of Picasso, I've": Crespelle, *Picasso: Les femmes, les amis, l'oeuvre*, p. 213.

441 "Sometimes I dream that": Trustman, "Ordeal of Picasso's Heirs," *The New York Times Magazine*, 20 April 1980, p. 43.

441 "Have you made up": Parmelin, *Voyage en Picasso*, p. 31.

442 "I am old and you": Interview with Françoise Gilot.

442 "No, you cannot see him": McKnight, *Bitter Legacy*, p. 102.

442 "When the door slammed shut, it": Ibid., p. 157.
442 "as an exercise to draw": Interview with Françoise Gilot.
442 "Maybe I could see a little": McKnight, *Bitter Legacy*, pp. 157–58.
442 "After the marriage, my": Ibid., p. 75.
443 "What one 'thinks' of Picasso is": Cocteau, "Picasso 1964, enquête," *Jardin des Arts*, March 1964, p. 7.
443 "This breach of confidence is": Richardson, "Trompe l'Oeil," *The New York Review of Books*, 3 December 1964, p. 3.
443 "Now the fact is that": Lord, letter to the editor, *The New York Review of Books*, 28 January 1965, pp. 20–21.
444 "When I started to work on": Interview with Françoise Gilot.
444 "My coming to him, he": Gilot and Lake, *Life with Picasso*, p. 367.
444 "an intolerable intrusion": From the trial documents, made available by Calmann-Lévy, the publisher of *Life with Picasso* in France.
444 "What saved the day is": Interview with Françoise Gilot.
445 "I am lucky enough": "Quarante Peintres déclarent: Françoise Gilot a trahi Picasso," *Arts*, no. 1003 (28 April 1965), p. 28.
445 "Françoise Gilot attempts": Ibid.
445 "A woman who has spent ten": Ibid.
446 "I have not read the book": Ibid.
446 "We cannot lend an ear": "Les Communistes de Vallauris écrivent à Picasso," *Le Patriote de Nice*, 27 June 1965, p. 5.
446 "My dear friend, you": Letter, Parinaud to Gilot, 15 May 1965 (property of Françoise Gilot).
446 "Giacometti was one of the friends": Interview with Françoise Gilot.
446 "Our client is not": Lacroix, "Picasso: Ni Barbe-Bleue ni saint de vitrail," *L'Intransigeant*, 24 June 1965, p. 1.
447 "In a case such as": From the trial documents, made available by Calmann-Lévy, the publisher of *Life with Picasso* in France.
447 "often exposed himself to": Ibid.
447 "Once more you win": Interview with Françoise Gilot.

CHAPTER SEVENTEEN

449 "He had a warrior's mentality": Interview with Manuel Blasco.
449 "When a man knows how": Cabanne, *Pablo Picasso*, p. 561.
449 "They gave me quite a goring": Olano, *Picasso intimo*, p. 88.
449 "They cut me open like": Cabanne, *Pablo Picasso*, p. 527.
450 "Whenever I see you, my": Brassaï, "The Master at 90," *The New York Times Magazine*, 24 October 1971, p. 96.
450 "He only knows how": Otero, *Forever Picasso*, p. 160.
450 "Nine months have passed since": Ibid., p. 159.
451 "Picasso, sad to relate": Beaton, *Self Portrait with Friends*, p. 376.
451 "In the end everything": Breton, *Anthologie de l'humour noir*, p. 319.
451 "One day you'll see what": Interview with Hélène Parmelin.
451 "Painting face to face with": Malraux, *Picasso's Mask*, p. 78.
451 "The trouble was that": Cabanne, *Pablo Picasso*, p. 532.
451 "You're mad": Ibid., p. 533.

NOTES ON SOURCES

451 "We made our big": Malraux, *Picasso's Mask*, p. 3.

452 "You'd have been better": Cabanne, *Pablo Picasso*, p. 533.

452 "There is a constant": Otero, *Forever Picasso*, p. 75.

452 "because the government of": Ibid., p. 81.

452 "In any case, there": Ibid., pp. 81–82.

452 "What a fool I am. They": Ibid., p. 99.

453 "retrospective show I": Malraux, *La Tête d'obsidienne*, p. 9.

453 "Picasso dominates his century": Leymarie, Preface, in Grand Palais–Petit Palais, *Hommage à Pablo Picasso*, p. 1.

453 "Are you going? All": Interview with Josep Palau i Fabre.

453 "developed to the ultimate the": Grenier, "Picasso et le mouvement surréaliste," in Fermigier, ed., *Picasso*, p. 161.

453 "I really don't know why": Otero, *Forever Picasso*, p. 99.

453 "Worst of all is": Parmelin, *Picasso: Intimate Secrets of a Studio at Notre Dame de Vie*, pp. 67–68.

454 "When things were going well": Malraux, *Picasso's Mask*, p. 76.

454 "You would think he is": Whitman, *Come to Judgment*, p. 224.

454 "The house is full of": Otero, *Forever Picasso*, p. 113.

454 "It's like going to the movies": Ibid., p. 124.

454 "The more time passed": Interview with Hélène Parmelin.

454 "Picasso has been painting": Otero, *Forever Picasso*, p. 135.

454 "What could I do": Ibid., p. 191.

454 "I have only one thought": Galerie Beyeler, *Picasso: Works from 1932 to 1965* (unpaginated).

454 "Hell is other people": Sartre, *No Exit*, p. 47.

454 "I suffer from people's presence": Gilot and Lake, *Life with Picasso*, p. 301.

455 "I despise wasting my": Otero, *Forever Picasso*, p. 157.

455 "The extraordinary would be": Parmelin, *Voyage en Picasso*, p. 82.

455 "I dream that they're": Otero, *Forever Picasso*, p. 166.

456 "What do you owe Inès": Interview with Inès Sassier.

456 "Have you heard the": Brassaï, "Picasso aura cent ans dans dix ans," *Le Figaro*, 8 October 1971, p. 31.

456 "It was as if he were": Ibid.

456 "It's sad, isn't it? It's": Ibid.

456 "as if they had expelled Elizabeth": Ibid.

456 "What one *will* do": Malraux, *Picasso's Mask*, p. 70.

457 "The proud musketeer has": Schiff, *Picasso: The Last Years, 1963–1973*, p. 55.

457 "Monsieur Picasso is not in": Perls, "The Last Time I Saw Pablo," *Art News*, vol. 73 (April 1974), p. 40.

457 "Who are you": McKnight, *Bitter Legacy*, p. 98.

458 "Joy is in everything": Letter, Walter to Picasso. From the files of Georges Langlois.

458 "Life is but a struggle for": Ibid.

458 "I say that the hand is frightening": Ibid.

458 "a sad letter": Perls, "The Last Time I Saw Pablo," *Art News*, vol. 73 (April 1974), p. 37.

458 "Maya had told her she could": Ibid.
458 "When did you see him last": Ibid., p. 38.
459 "Well, where are the hundred pictures": Ibid., p. 41.
459 "Yes, oh, yes. I'll": Ibid.
459 "What the devil does that": Ibid.
459 "Oh, well, what can": Ibid.
460 "Never mind, I know": Ibid.
460 "I started all this": Ibid., p. 40.
460 "I am still an art dealer": Ibid., p. 42.
460 "*Mon cher Langlois*": Interview with Georges Langlois.
460 "I have made a terrible blunder": Ibid.
461 "Without this he had the right": Ibid.
461 "After all, I had to achieve": Ibid.
461 "his works were much more his": Ibid.
461 "They have my name": McKnight, *Bitter Legacy*, p. 79.
461 "It was so extraordinary": Interview with Françoise Gilot.
462 "It was sad to lose him": Ibid.
462 "Françoise cared enormously": Interview with Bernard Bacqué de Sariac.
462 "had looked long at": Cabanne, *Pablo Picasso*, p. 569.
462 "If I spit, they'll": Interview with Matta.
462 "Wonders, wonders, wonders": Alberti, *Picasso: Le rayon ininterrompu*, pp. 23–24.
463 "Speak to me with respect. I'm": Parmelin, *Voyage en Picasso*, p. 62.
463 "What do they want": Ibid., p. 63.
463 "One must say, one": Brassaï, "Picasso aura cent ans dans dix ans," *Le Figaro*, 8 October 1971, p. 31.
463 "Calm, serene, devoted, she": Ibid.
463 "she takes very beautiful ones": Ibid.
463 "But Brassaï, I have done": Ibid.
463 "I am overburdened": Cabanne, *Pablo Picasso*, p. 558.
463 "He is an old man": Parmelin, *Voyage en Picasso*, p. 142.
464 "You know, you must never": Ibid.
464 "I do worse every day": Cabanne, *Le Siècle de Picasso*, vol. 4, p. 243.
464 "The girls, clad only": Brassaï, "The Master at 90," *The New York Times Magazine*, 24 October 1971, p. 31.
464 "Degas would have kicked": Daix, *La Vie de peintre de Pablo Picasso*, p. 398.
464 "You live a poet's life": Berger, *The Success and Failure of Picasso*, p. 181.
464 "I made a drawing yesterday": Daix, *Picasso Créateur*, p. 378.
465 "We never mentioned his health": Parmelin, *Voyage en Picasso*, p. 140.
465 "All is well": Ibid.
465 "I no longer interest you": Ibid., p. 150.
465 "continually on the edge": Ibid., p. 159.
465 "Tonight we are going": Ibid., p. 162.
466 "Tell them, above all": Ibid., p. 166.
466 "Why inflict this 'party' on him": Ibid., p. 170.
466 "Jacqueline was outside reality": Ibid.

466 "It's already difficult being": Ibid., p. 171.
466 "See how we dressed up": Ibid., p. 175.
466 "The Picasso who enters": Ibid.
467 "the watchful gaze of": Schiff, *Picasso: The Last Years, 1963–1973*, p. 36.
467 "Go on, don't spare them": Parmelin, *Voyage en Picasso*, p. 36.
467 "When are you coming": Bernal, "Alors Jacqueline l'enveloppa dans la grande cape noire," *Paris-Match*, 21 April 1973, p. 75.
467 "A responsibility, rather": McKnight, *Bitter Legacy*, p. 9.
468 "I knew the minute I": Bernal, "Alors Jacqueline l'enveloppa dans la grande cape noire," *Paris-Match*, 21 April 1973, p. 76.
468 "Where are you, Jacqueline": Ibid.
468 "You are wrong not to be": Ibid.
468 "I could not convince": Ibid., p. 117.

EPILOGUE

470 "I wrote to Miguel, his": Cabanne, "Picasso et les joies de la paternité," *L'Oeil*, No. 226 (May 1974), p. 10.
470 "When I die, it": Interview with Françoise Gilot.
471 "It will be worse": Cabanne, *Pablo Picasso*, p. 567.
471 "I have not opened them": Trustman, "Ordeal of Picasso's Heirs," *The New York Times Magazine*, 20 April 1980, p. 66.
471 "Mstislav Rostropovich": Ibid., p. 64.
472 "You can never get": McKnight, *Bitter Legacy*, p. 138.
472 "irresistible compulsion": Ibid., p. 139.
473 "He was without doubt": Daix, *Picasso Créateur*, p. 387.
473 "was not of an age": Jonson, "To the Memory of My Beloved, the Author Mr. William Shakespeare: and What He Hath Left Us," in *The Complete Poetry of Ben Jonson*, p. 373.
474 "the dimension of the infinite": Tugendhold, "French Pictures in the Shchukin Collection," in McCully, ed., *A Picasso Anthology*, pp. 109–10.
474 "I must obstinately remain": Ayrton, *Golden Sections*, p. 99.
474 "How difficult it is": Leymarie, *Picasso: The Artist of the Century*, p. ix.
474 "no sun without shadow": Camus, *Le Mythe de Sisyphe*, pp. 167–68.
474 "Despite so many ordeals": Ibid., pp. 166–67.
474 "he had no need": Malraux, *Picasso's Mask*, p. 258.
475 "Modern artists have greater": Schapiro, *Modern Art: 19th and 20th Centuries*, p. 134.
475 "Two or three days later": Leiris, *La Règle du jeu*, vol. 4, *Frêle Bruit*, p. 314.

BIBLIOGRAPHY

BOOKS—CATALOGUES—DISSERTATIONS

Alberti, Rafael. *A Year of Picasso Paintings, 1969.* New York: Harry N. Abrams, 1971.

———. *Lo que cante y dije de Picasso.* Barcelona: Editorial Bruguera, 1981.

———. *Picasso: Le rayon ininterrompu.* Paris: Cercle d'Art, 1974.

Andreu, Pierre. *Max Jacob.* Paris: Wesmael-Charlier, 1962.

Apollinaire, Guillaume. *Apollinaire on Art: Essays and Reviews, 1902–1918.* New York: Viking, 1972.

———. *Calligrammes: Poems of Peace and War, 1913–1916.* Berkeley: University of California Press, 1980.

———. *Chroniques d'Art, 1902–1918.* Edited by L. C. Breunig. Paris: Gallimard, 1960.

———. *The Cubist Painters, Aesthetic Meditations.* New York: George Wittenborn, 1962.

———. *L'Oeuvre du Marquis de Sade.* Paris: Bibliothèque des Curieux, 1909.

———. *Oeuvres complètes de G. Apollinaire.* Edited by P. M. Adéma and M. Decaudin. 4 vols. Paris: Balland et Lecat, 1966.

———. *Oeuvres poétiques.* Paris: Gallimard, 1965.

———. *Les Peintres cubistes.* Paris: Hermann, 1965.

———. *The Poet Assassinated and Other Stories.* San Francisco: North Point Press, 1984.

———. *Le Poète assassiné.* Paris: Au Sans Pareil, 1927.

———. *Selected Writings of Guillaume Apollinaire.* London: Harvill Press, 1950.

Aragon, Louis. *Anicet ou le panorama, roman.* Paris: Gallimard, 1972.

———. *Aragon, Poet of the French Resistance.* Edited by Hannah Josephson and Malcolm Cowley. New York: Duell, Sloan and Pearce, 1945.

Archer, W. G. *The Loves of Krishna.* London: Allen and Unwin, 1957.

Artcurial, Paris (May–July 1985). *Les Noces Catalanes: Barcelone–Paris, 1870–1970.* Introduction by Henri-François Rey.

Ashton, Dore, ed. *Picasso on Art: A Selection of Views.* New York: Viking, 1972.

Auric, Georges. *Eluard, j'étais là.* Paris: Bernard Grasset, 1979.

Axelos, Kostas. *Systématique ouverte.* Paris: Editions de Minuit, 1984.

Ayrton, Michael. *Golden Sections.* London: Methuen and Co., 1957.

Azéma, Jean-Pierre. *From Munich to the Liberation, 1938–1944.* New York: Cambridge University Press, 1984.

Baker, William E. *Jacques Prévert.* New York: Twayne Publishing, 1967.

de Balzac, Honoré. *Le Chef-d'oeuvre inconnu.* Paris: Garnier-Flammarion, 1981.

Baron, Jacques. *L'An I du surréalisme.* Paris: Denoël, 1967.

Barr, Alfred H., Jr. *Picasso: Forty Years of His Art.* New York: The Museum of Modern Art, 1939.

———. *Picasso: Fifty Years of His Art.* New York: Arno Press, 1980.

Barrett, William. *Irrational Man: A Study in Existential Philosophy.* New York: Doubleday & Co., 1958.

Barzun, Jacques. *The Energies of Art.* New York: Harper & Brothers, 1956.

Bataille, Georges. *Death and Sensuality: A Study of Eroticism and the Taboo.* New York: Walker and Co., 1962.

———. *Documents.* Paris: Gallimard, 1968.

———. *Visions of Excess: Selected Writings, 1927–1939.* Minneapolis: University of Minnesota Press, 1985.

Beaton, Cecil. *Self Portrait with Friends: The Selected Diaries of Cecil Beaton, 1926–1974.* Edited by Richard Buckle. New York: Times Books, 1979.

de Beauvoir, Simone. *La Force de l'âge.* Paris: Gallimard, 1960.

Becker, Lucille F. *Louis Aragon.* New York: Twayne Publishers, 1971.

Bell, Clive. *Civilization and Old Friends.* Chicago: University of Chicago Press, 1973.

———. *Since Cézanne.* London: Chatto and Windus, 1922.

Benjamin, Roger. *Matisse's "Notes of a Painter": Criticism, Theory, and Context, 1891–1908.* Ann Arbor: University of Michigan Research Press, 1987.

Berger, John. *The Success and Failure of Picasso.* New York: Pantheon, 1980.

Berlin, Isaiah. *Against the Current: Essays in the History of Ideas.* New York: Viking, 1980.

Besnard-Bernadac, Marie-Laure, Michèle Richet, and Hélène Seckel. *The Picasso Museum, Paris.* New York: Harry N. Abrams, 1986.

Besson, Georges. *La Peinture française au XXe siècle.* Paris: Braun & Cie., 1949.

Billy, André. *Avec Apollinaire: Souvenirs inédits.* Paris and Geneva: La Palatine, 1966.

Blunt, Anthony. *Picasso's "Guernica."* New York: Oxford University Press, 1969.

———, and Phoebe Pool. *Picasso: The Formative Years.* Greenwich, Conn.: New York Graphic Society, 1962.

Boeck, Wilhelm, and Jaime Sabartés. *Picasso.* Paris: Flammarion, 1955.

Boix, Esther, and Richard Creus. *El Siglo de Picasso.* Barcelona: Ayntamiento de Barcelona, 1981.

Brassaï. *Picasso and Company*. New York: Doubleday & Co., 1966.

Breker, Arno. *Paris, Hitler et moi*. Paris: Presses de la Cité, 1970.

Brenan, Gerald. *The Spanish Labyrinth: An Account of the Social and Political Background of the Civil War*. Cambridge: Cambridge University Press, 1950.

Breton, André. *Anthologie de l'humour noir*. Paris: Jean-Jacques Pauvert, 1966.

———. *Nadja*. Paris: Gallimard, 1928.

——— *Point du jour*. Paris: Gallimard, 1970.

——— *Le Surréalisme et la peinture*. New York: Brentano's, 1945.

———. *What is Surrealism? Selected Writings*. Edited by Franklin Rosemont. New York: Monad, 1978.

Brinnin, John Malcolm. *The Third Rose: Gertrude Stein and Her World*. Reading, Mass.: Addison-Wesley Publishing Co., 1987.

Broude, Norma, and Mary D. Garrard, eds. *Feminism and Art History: Questioning the Litany*. New York: Harper & Row, 1982.

Buckle, Richard. *In the Wake of Diaghilev*. New York: Holt, Rinehart & Winston, 1982.

Cabanne, Pierre. *Pablo Picasso: His Life and Times*. New York: William Morrow & Co., 1977.

———. *Le Siècle de Picasso*. 4 vols. Paris: Denoël, 1975.

Camus, Albert. *Le Mythe de Sisyphe*. Paris: Gallimard, 1942.

Cannavo, Richard. *La Ballade de Charles Trenet*. Paris: Robert Laffont, 1984.

Carandell, José Maria. *Nueva guía secreta de Barcelona*. Barcelona: Sedray Ediciones, 1978.

Carco, Francis. *L'Ami des peintres*. Geneva: Du Milieu du Monde, 1944.

Casanova, Laurent. *Le Parti communiste, les intellectuels, et la nation*. Paris: Editions Sociales, 1951.

Cassou, Jean. *Picasso*. Paris: Braun & Cie., 1940.

———. *Une Vie pour la liberté*. Paris: Robert Laffont, 1981.

Centre Georges Pompidou. (22 November 1984–28 January 1985). *Daniel-Henry Kahnweiler: Marchand, éditeur, écrivain*.

——— (22 November 1984–28 January 1985). *Donation Louise et Michel Leiris: Collection Kahnweiler-Leiris*.

——— (4 November 1982–17 January 1983). *Paul Eluard et ses amis peintres: 1895–1952*.

Césaire, Aimé. *Lost Body*. Illustrated by Pablo Picasso. New York: George Braziller, 1986.

Charles-Roux, Edmonde. *L'Irrégulière*. Paris: Bernard Grasset, 1974.

Chevalier, Denys. *Picasso: Epoques bleue et rose*. Paris: Flammarion, 1978.

Cirici-Pellicer, Alexandre. *Picasso avant Picasso*. Geneva: Pierre Cailler, 1950.

Cirlot, Juan-Eduardo. *Picasso: Birth of a Genius*. New York: Praeger, 1972.

Cocteau, Jean. *Correspondance avec Jean-Marie Magnan*. Paris: Pierre Belfond, 1981.

———. *Entre Picasso et Radiguet*. Paris: Hermann, 1967.

———. *Entretiens avec André Fraigneau*. Paris: Union Générale d'Editions, 1965.

———. *The Journals of Jean Cocteau*. Edited by Wallace Fowlie. New York: Criterion Books, 1956.

———. *La Machine infernale*. Paris: Bernard Grasset, 1934.

————. *Oedipe-Roi: Roméo et Juliette*. Paris: Plon, 1928.

————. *Le Passé défini*. Paris: Gallimard, 1983.

————. *Le Rappel à l'ordre*. Paris: Librairie Stock, 1926.

Cooper, Douglas. *Picasso and the Theatre*. Paris: Cercle d'Art, 1967.

Coquiot, Gustave. *Cubistes, futuristes, passéistes*. Paris: Librairie Ollendorff, 1923.

Couturier, Marie-Alain. *Se garder libre*. Paris: Editions du Cerf, 1962.

————. *La Vérité blessée*. Paris: Plon, 1984.

Crespelle, Jean-Paul. *Picasso and His Women*. New York: Coward-McCann, 1969.

————. *Picasso: Les femmes, les amis, l'oeuvre*. Paris: Presses de la Cité, 1967.

————. *La Vie quotidienne à Montmartre au temps de Picasso, 1900–1910*. Paris: Hachette, 1978.

Crossman, Richard, ed. *The God That Failed*. Chicago: Regnery Gateway, 1983.

Daedalus, ed. *Casagemas i el seu temps*. Barcelona, 1979.

Daix, Pierre. *Picasso Créateur: La vie intime et l'oeuvre*. Paris: Editions du Seuil, 1987.

————. *La Vie de peintre de Pablo Picasso*. Paris: Editions du Seuil, 1977.

————, and Georges Boudaille. *Picasso, 1900–1906: Catalogue raisonné de l'oeuvre peint*. Paris: La Bibliothèque des Arts, 1966.

Dali, Salvador. *Comment on devient Dali*. Paris: Robert Laffont, 1973.

Dallas Museum of Art (11 September–30 October 1983). *Picasso the Printmaker: Graphics from the Marina Picasso Collection*. Catalogue by Brigitte Baer.

Danz, Louis. *Personal Revolution and Picasso*. New York and Toronto: Longmans, Green and Co., 1941.

Deharme, Lise. *Les Années perdues*. Paris: Plon, 1961.

Descargues, Pierre. *Picasso*. New York: Felicie, 1974.

Diehl, Gaston. *Derain*. New York: Crown Publishers, 1977.

————. *Henri Matisse*. Paris: Editions Pierre Tisné, 1958.

————. *Picasso*. New York: Crown Publishers, 1987.

Dominguín, Luis Miguel. *Toros y Toreros*. Paris: Cercle d'Art, 1961.

Dor de la Souchère, Romuald. *Picasso in Antibes*. New York: Pantheon, 1960.

Dorgelès, Roland. *Bouquet de Bohème*. Paris: Albin Michel, 1947.

Dostoevsky, Fyodor. *Crime and Punishment*. Adapted by Yuri Lyubimov and Yuri Kariakin. Washington: Arena Stage, 1986.

Dubois, André-Louis. *Sous le signe de l'amitié*. Paris: Plon, 1972.

Dufour, Pierre. *Picasso, 1950–1968*. Geneva: Skira, 1969.

Duncan, David Douglas. *Goodbye Picasso*. New York: Grosset & Dunlap, 1974.

————. *The Silent Studio*. New York: Norton, 1976.

————. *Viva Picasso: A Centennial Celebration, 1881–1981*. New York: Viking, 1980.

Elgar, Frank, and Robert Maillard. *Picasso*. New York: Praeger, 1957.

Eluard, Paul. *A Pablo Picasso*. Geneva: Trois Collines, 1944.

————. *Lettres à Gala, 1924–1948*. Paris: Gallimard, 1984.

————. *Pablo Picasso*. New York: Philosophical Library, 1947.

Ehrenburg, Ilya. *People and Life, 1891–1921*. New York: Alfred A. Knopf, 1962.

Fairweather, Sally. *Picasso's Concrete Sculptures.* New York: Hudson Hills Press, 1982.

Fargue, Léon-Paul. *Le Piéton de Paris.* Paris: Gallimard, 1939.

Felman, Shoshana. *Jacques Lacan and the Adventure of Insight: Psychoanalysis in Contemporary Culture.* Cambridge: Harvard University Press, 1987.

Fermigier, André, ed. *Picasso.* Paris: Hachette, 1967.

Flanner, Janet. *Men and Monuments.* New York: Harper & Brothers, 1947.

Fondation Pierre-Gianadda, Martigny (1981). *Picasso: Estampes, 1904–1972.* Catalogue by André Quenzi.

Foster, Joseph K., ed. *Posters of Picasso.* New York: Crown Publishers, 1957.

Fundacio Picasso-Reventós, ed. *Homenatge de Catalunya a Picasso.* Barcelona: Fundacio, 1982.

Galerie Beyeler, Basel (November 1966–January 1967). *Picasso.*

———— (February–April 1967). *Picasso: Works from 1932 to 1965.*

Galerie Louise Leiris, Paris (6 June–13 July 1962). *Picasso: Le Déjeuner sur l'herbe, 1960–1961.*

Gallwitz, Klaus. *Picasso: The Heroic Years.* New York: Abbeville Press, 1985.

Galtier-Boissière, Jean. *Mon Journal depuis la libération.* Paris: La Jeune Parque, 1945.

Garaudy, Roger. *D'un réalisme sans rivages: Picasso, St. John Perse, Kafka.* Paris: Plon, 1963.

García Lorca, Federico. *Deep Song and Other Prose.* New York: New Directions, 1980.

————. *Lament for the Death of a Bullfighter.* London: William Heinemann, 1953.

————. *Selected Letters.* New York: Marion Boyars, 1984.

Gasman, Lydia. "Mystery, Magic and Love in Picasso, 1925–1938: Picasso and the Surrealist Poets." Ph.D. dissertation, Columbia University, 1981.

Gedo, Mary Mathews. *Picasso: Art as Autobiography.* Chicago: The University of Chicago Press, 1980.

Geiser, Bernard. *Picasso: 55 Years of His Graphic Work.* New York: Harry N. Abrams, 1955.

George, Waldemar. *Pablo Picasso.* Rome: Editions de Valori Plastici, 1924.

Georges-Michel, Michel. *De Renoir à Picasso: Les peintres que j'ai connus.* Paris: Arthème Fayard, 1954.

Gère, Charlotte. *Marie Laurencin.* Paris: Flammarion, 1977.

de Gibon, Yves. *Témoignages d'un rendez-vous manqué.* Paris: Paul Mari, 1980.

Gide, André. *Journal.* 2 vols. Paris: Gallimard, 1961.

Gilleminault, Gilbert, and Philippe Bernet. *Les Princes des années folles.* Paris: Plon, 1970.

Gilot, Françoise. *An Artist's Journey.* New York: Atlantic Monthly Press, 1987.

————. *The Fugitive Eye: Poems and Drawings.* San Diego: Aeolian Press, 1976.

————. *Interface: The Painter and the Mask.* Fresno: California State University, 1983.

————. *Paloma Sphinx*. Paris: Françoise Gilot, 1975.

————, and Carlton Lake. *Life with Picasso*. New York: McGraw-Hill, 1964.

Gimpel, René. *Journal d'un collectionneur, marchand de tableaux*. Paris: Calmann-Lévy, 1963.

Giraudy, Danièle. *Picasso: La mémoire du regard*. Paris: Cercle d'Art, 1986.

Gleizes, Albert. *Puissance du cubisme*. Paris: Présence, 1969.

Goethe, J. W. *Faust*. Basel: Zbinden, 1982.

Gold, Arthur, and Robert Fizdale. *Misia: The Life of Misia Sert*. New York: Alfred A. Knopf, 1980.

Grand Palais, Paris (22 February–15 April 1985). *Edouard Pignon*. Paris: Centre National des Arts Plastiques, 1985.

———— (11 October–7 January 1980). *Picasso: Oeuvres reçues en paiement des droits de succession*.

Grand Palais–Petit Palais, Paris (November 1966–February 1967). *Hommage à Pablo Picasso*.

Grohmann, Will. *Paul Klee*. London: Lund Humphries, 1954.

Habasque, Guy. *Le Cubisme*. Geneva: Skira, 1959.

Haessly, Gaile Ann. "Picasso on Androgyny: From Symbolism through Surrealism." Ph.D. dissertation, Syracuse University, 1983.

Haggard, Virginia. *My Life with Chagall*. New York: D. I. Fine, 1986.

Hanoteau, Guillaume. *Ces Nuits qui ont fait Paris*. Paris: Arthème Fayard, 1971.

Hemingway, Ernest. *The Dangerous Summer*. New York: Charles Scribner's Sons, 1985.

Hilton, Timothy. *Picasso*. London: Oxford University Press, 1975.

Hirschl & Adler Galleries, New York (16 January–27 February 1988). *Picasso: The Late Drawings*. Essay by Jeffrey Hoffeld. New York: Harry N. Abrams, 1988.

Hong Kong Museum of Art (12 December 1982–19 January 1983). *Picasso Intime: Collection Maya Ruiz-Picasso: The Centenary of the Birth of Picasso*. Hong Kong: Urban Council, 1982.

Horodisch, Abraham. *Picasso as a Book Artist*. Cleveland: World Publishing Co., 1962.

Hugo, Jean. *Avant d'oublier, 1918–1931*. Paris: Arthème Fayard, 1976.

Institute of Contemporary Arts. *Homage to Picasso on his 70th Birthday: Drawings and Watercolours since 1893*. London: Lund Humphries, 1951.

Jacob, Max. *Choix de lettres de Max Jacob à Jean Cocteau, 1919–1944*. Paris: Paul Morihien, 1949.

————. *Chronique des temps héroïques*. Paris: Louis Broder, 1956.

————. *Correspondance*. Edited by François Garnier. 2 vols. Paris: Editions de Paris, 1953.

————. *Lettres, 1920–1941*. Edited by S. J. Collier. Oxford: Basil Blackwell, 1966.

————: *Lettres à Marcel Béalu*. Lyon: Editions Emmanuel Vitte, 1959.

————. *Lettres à Marcel Jouhandeau*. Edited by Anne S. Kimball. Geneva: Librairie Droz, 1979.

————. *Lettres à Michel Levanti*. Edited by Lawrence A. Joseph. Limoges: Rougerie, 1975.

————. *Lettres à Michel Manoll.* Edited by Maria Green. Mortemart: Rougerie, 1985.

————. *Lettres mystiques, 1934–1944, à Clotilde Bauguion.* Paris: Calligrammes, 1984.

————. *Morceaux choisis.* Paris: Gallimard, 1936.

James, Henry. *The Ambassadors.* New York: Heritage Press, 1963.

Janis, Harriet and Sidney. *Picasso: The Recent Years, 1939–1946.* New York: Doubleday & Co., 1946.

Jarry, Alfred. *Gestes et opinions du Docteur Faustroll.* Paris: Bibliothèque Charpentier, 1911.

————. *Oeuvres complètes.* 8 vols. Paris: Gallimard, 1972.

————. *The Supermale.* New York: New Directions, 1964.

Johnson, Paul. *Modern Times: The World from the Twenties to the Eighties.* New York: Harper & Row, 1983.

Jonson, Ben. *The Complete Poetry of Ben Jonson.* Edited by William B. Hunter. New York: New York University Press, 1963.

Josephson, Matthew. *Life among the Surrealists.* New York: Holt, Rinehart & Winston, 1962.

Jouffroy, Jean-Pierre, and Edouard Ruiz. *Picasso: De l'image à la lettre.* Paris: Messidor/Temps Actuels, 1981.

Jung, C. G. *The Collected Works of C. G. Jung.* Bollingen Series, edited by William McGuire, vol. 15. Princeton: Princeton University Press, 1966.

Kahnweiler, Daniel-Henry. *Confessions esthétiques.* Paris: Gallimard, 1963.

————. *The Rise of Cubism.* New York: Wittenborn, Schultz, 1949.

————, and Francis Crémieux. *My Galleries and Painters.* New York: Viking, 1961.

Kamber, Gerald. *Max Jacob and the Poetics of Cubism.* Baltimore: Johns Hopkins University Press, 1971.

Kay, Helen. *Picasso's World of Children.* New York: Doubleday & Co., 1965.

Kiki. *The Education of a French Model.* New York: Bridgehead Books, 1954.

Kootz, Sam. "The Reality Gap: Picasso." Unpublished memoirs from the papers of Mrs. Sam Kootz.

Krasovskaya, Vera. *Nijinsky.* New York: Schirmer Books, 1979.

Lacan, Jacques. *The Four Fundamental Concepts of Psychoanalysis.* New York: Norton, 1978.

Laffranchle, Jean. *Louis Marcoussis.* Paris: Editions du Temps, 1961.

Langston, Linda Frank. "Disguised Double Portraits in Picasso's Work, 1925–1962." Ph.D. dissertation, Stanford University, 1977.

Laporte, Geneviève. *Si tard le soir, le soleil brille.* Paris: Plon, 1973.

————. *Sunshine at Midnight: Memories of Picasso and Cocteau.* London: Weidenfeld and Nicolson, 1975.

de Lautréamont, Comte (Isidore Ducasse). *Chants de Maldoror.* London: Allison and Busey, 1970.

Léautaud, Paul. *Journal littéraire.* Vol. 16. Paris: Mercure de France, 1964.

Lee, Thomas Louis. "The Passion and Picasso." Master's thesis, University of Louisville, 1969.

Leighten, Patricia Dee. "Picasso: Anarchism and Art, 1897–1914." Ph.D. dissertation, Rutgers University, 1983.

PICASSO

Leiris, Michel. *Manhood: A Journey from Childhood into the Fierce Order of Virility.* San Francisco: North Point Press, 1984.

———. *La Règle du jeu.* Vol. 3, *Fibrilles.* Paris: Gallimard, 1966.

———. *La Règle du jeu.* Vol. 4, *Frêle Bruit.* Paris: Gallimard, 1976.

Lemaire, Anika. *Jacques Lacan.* Brussels: Pierre Mardaga, 1977.

Leymarie, Jean. *Picasso: The Artist of the Century.* New York: Viking, 1972.

———. *Picasso: Blue and Rose Periods.* New York: Harry N. Abrams, 1954.

Lippard, Lucy R., ed. *Dadas on Art.* Englewood Cliffs, N.J.: Prentice-Hall, 1971.

———. *Surrealists on Art.* Englewood Cliffs, N.J.: Prentice-Hall, 1970.

Lipton, Eunice. "Picasso Criticism, 1901–1939: The Making of an Artist-Hero." Ph.D. dissertation, New York University, 1975.

Loeb, Pierre. *Voyages à travers la peinture.* Paris: Bordas, 1946.

Lord, James. *Giacometti.* New York: Farrar, Straus & Giroux, 1985.

———. *Où étaient les tableaux . . .* Paris: Mazarine, 1982.

Los Angeles County Museum of Art. *The Spiritual in Art: Abstract Painting, 1890–1985.* New York: Abbeville Press, 1986.

Lottman, Herbert R. *The Purge.* New York: William Morrow & Co., 1986.

———. *La Rive gauche.* Paris: Editions du Seuil, 1981.

Mackworth, Cecily. *Guillaume Apollinaire and the Cubist Life.* London: J. Murray, 1961.

Mac Orlan, Pierre. *La Vénus internationale.* Paris: Gallimard Folio, 1966.

Malraux, André. *Picasso's Mask.* New York: Holt, Rinehart & Winston, 1976.

———. *La Tête d'obsidienne.* Paris: Gallimard, 1974.

Marais, Jean. *Histoires de ma vie.* Paris: Albin Michel, 1975.

Maritain, Jacques. *Creative Intuition in Art and Poetry.* New York: Meridian Books, 1955.

Marlborough Fine Arts Gallery, London (May–June 1955). *Picasso: 63 Drawings, 1953–54; 10 Bronzes, 1945–53.* Introduction by Rebecca West.

Marx, Karl, and Frederick Engels. *Collected Works: Marx and Engels, 1845–47.* Vol. 5. London: Lawrence & Wishart, 1976.

Matisse, Henri. *Ecrits et propos sur l'Art.* Paris: Hermann, 1972.

———. *Matisse on Art.* Edited by Jack D. Flam. New York: E. P. Dutton, 1978.

Mauriac, François. *Bloc Notes.* 5 vols. Paris: Flammarion, 1958–1971.

Mayer, Susan. "Ancient Mediterranean Sources in the Works of Picasso, 1892–1937." Ph.D. dissertation, New York University, 1980.

McCully, Marilyn, ed. *A Picasso Anthology: Documents, Criticism, Reminiscences.* Princeton: Princeton University Press, 1982.

McKnight, Gerald. *Bitter Legacy: Picasso's Disputed Millions.* London: Bantam Press, 1987.

Mellow, James R. *Charmed Circle: Gertrude Stein and Company.* New York: Praeger, 1974.

Melville, Herman. *Pierre: or, the Ambiguities.* New York: New American Library, 1964.

Melville, Robert. *Picasso: Master of the Phantom.* London: Oxford University Press, 1939.

The Metropolitan Museum of Art, New York (7 March–12 May 1985). *Picasso*

Linoleum Cuts: The Mr. and Mrs. Charles Kramer Collection in the Metropolitan Museum of Art. New York: Random House, 1985.

Minotaure. 4 vols. Reprint. New York: Arno Press, 1968.

Montreal Museum of Fine Arts (22 June–10 November 1985). *Pablo Picasso: Meeting in Montreal.*

Mourlot, Fernand. *Picasso Lithographs.* Boston: Boston Book and Art, 1970.

Mugnier, L'Abbé Arthur. *Journal de l'Abbé Mugnier.* Paris: Mercure de France, 1985.

Murdoch, Iris. *The Fire and the Sun: Why Plato Banished the Artists.* Oxford: Clarendon Press, 1977.

Musée Cantini, Marseille (11 May–31 July 1959). *Picasso.* Catalogue by Douglas Cooper.

Museo Rufino Tamayo, Mexico City (November 1982–January 1983). *Los Picassos de Picasso en México: Una Exposición Retrospectiva.* Introduction by William S. Lieberman.

Museum Het Kruithuis, Hertogenbosch (22 June–11 August 1985). *Picasso Ceramics.*

The Museum of Modern Art, New York (22 May–16 September 1980). *Pablo Picasso: A Retrospective.* Catalogue by William Rubin.

—— (3 February–2 April 1972). *Picasso in the Collection of the Museum of Modern Art.* Catalogue by William Rubin, Elaine L. Johnson, and Riva Castleman.

—— *"Primitivism" in 20th Century Art: Affinity of the Tribal and the Modern.* 2 vols. Edited by William Rubin. Boston: New York Graphic Society Books–Little, Brown & Co., 1984.

—— (24 January–19 March 1950). *The Sculptor's Studio: Etchings by Picasso.* New York: The Museum of Modern Art, 1952.

National Gallery of Art, Washington, D.C. (2 November 1986–29 March 1987). *Henri Matisse: The Early Years in Nice, 1916–1930.* Catalogue by Jack Cowart and Dominique Fourcade. New York: Harry N. Abrams, 1986.

Neruda, Pablo. *Memoirs.* New York: Farrar, Straus & Giroux, 1976.

Nietzsche, Friedrich. *Thus Spoke Zarathustra.* New York: Penguin Books, 1978.

Nijinsky, Vaslav. *The Diary of Vaslav Nijinsky.* Edited by Romola Nijinsky. New York: Simon and Schuster, 1936.

Nochlin, Linda. *Impressionism and Post-Impressionism, 1874–1904: Sources and Documents.* Englewood Cliffs, N.J.: Prentice-Hall, 1966.

O'Brian, Patrick. *Picasso: Pablo Ruiz Picasso.* New York: G. P. Putnam's Sons, 1976.

Odajmyk, Volodymyn Walter. *Jung and Politics.* New York: New York University Press, 1976.

Olano, Antonio O. *Picasso intimo.* Madrid: Editorial Dagur, 1971.

Olivier, Fernande. *Picasso and His Friends.* New York: Appleton-Century, 1965.

——. *Picasso et ses amis.* Paris: Librairie Stock, 1933.

Ory, Pascal. *Les Collaborateurs, 1940–1945.* Paris: Editions du Seuil, 1976.

Otero, Roberto. *Forever Picasso: An Intimate Look at His Last Years.* New York: Harry N. Abrams, 1974.

Otto, Walter F. *Dionysus: Myth and Cult.* Dallas: Spring Publications, 1981.

Oxenhandler, Neal. *Max Jacob and Les Feux de Paris.* Berkeley: University of California Press, 1964.

Ozenfant, Amédée, and Charles Jeanneret. *La Peinture moderne.* Paris: G. Crès et Cie., 1927.

The Pace Gallery, New York (2 May–1 August 1986). *Je Suis le Cahier: The Sketchbooks of Picasso.* Edited by Arnold Glimcher and Marc Glimcher. New York: Atlantic Monthly Press, 1986.

————— (30 January–14 March 1981). *Picasso: The Avignon Paintings.*

Padrta, Jiří. *Picasso: The Early Years.* New York: Tudor, 1960.

Palau i Fabre, Josep. *Picasso en Catalunya.* Barcelona: Poligrafa, 1966.

—————. *Picasso: The Early Years, 1881–1907.* New York: Rizzoli, 1981.

—————. *Picasso vivent, 1881–1907.* Barcelona: Poligrafa, 1979.

—————. *El Secret de "Las Meninas" de Picasso.* Barcelona: Poligrafa, 1981.

Parmelin, Hélène. *Aujourd'hui.* Paris: René Julliard, 1963.

—————. *Picasso: Intimate Secrets of a Studio at Notre Dame de Vie.* New York: Harry N. Abrams, 1966.

—————. *Picasso Plain.* New York: St. Martin's Press, 1963.

—————. *Picasso Says.* South Brunswick, N.J.: Barnes and Co., 1969.

—————. *Picasso: "The Artist and His Model," and Other Recent Works.* New York: Harry N. Abrams, 1965.

—————. *Picasso: Women, Cannes, and Mougins, 1954–63.* London: Weidenfeld and Nicolson, 1965.

—————. *Voyage en Picasso.* Paris: Robert Laffont–Opera Mundi, 1980.

Penrose, Roland. *Picasso: His Life and Work.* Berkeley: University of California Press, 1981.

—————. *Portrait of Picasso.* London: Thames and Hudson, 1981.

—————. *Scrap Book, 1900–1981.* New York: Rizzoli, 1981.

—————, and John Golding, eds. *Picasso in Retrospect.* London: Granada, 1973.

Peyre, André. *Max Jacob quotidien.* Paris: José Millas-Martin, 1976.

Picasso e a Corunna. Conoce a tua Cidade, no. 1. Corunna: Axuncamento da Corunna, 1982.

Picasso, Pablo. *The Artist by Himself: Self-Portrait from Youth to Old Age.* New York: St. Martin's Press, 1980.

—————. *Carnet Catalan.* Introduction by Douglas Cooper. Paris: Berggruen, 1958.

—————. *Le Carnet des carnets.* Paris: Les Ateliers de Daniel Jacomet, 1965.

—————. *Carnet Picasso La Corunna, 1894–1895.* Introduction by Juan Ainaud de Lasarte. Barcelona: Gustavo Gili, 1971.

—————. *Carnet Picasso Madrid, 1898.* Introduction by Xavier de Salas. Barcelona: Gustavo Gili, 1976.

—————. *Carnet Picasso Paris, 1900.* Introduction by Roa M. Subirana. Barcelona: Gustavo Gili, 1972.

—————. *Le Désir attrapé par la queue.* Paris: Gallimard, 1945.

—————. *Desire Caught by the Tail.* London: Calder and Boyars, 1970.

—————. *Drawings.* New York: Harry N. Abrams, 1959.

BIBLIOGRAPHY

————. *Forty-nine Lithographs, Together with Honoré de Balzac's The Hidden Masterpiece, in the Form of an Allegory.* New York: Lear, 1947.

————. *The Four Little Girls.* London: Calder and Boyars, 1970.

————. *Gongora.* New York: George Braziller, 1985.

————. *Oeuvres.* 33 vols. By Christian Zervos. Paris: Cahiers d'Art, 1932–1978.

————. *Picasso's Vollard Suite.* Introduction by Hans Bolliger. New York: Thames and Hudson, 1985.

————. *Les Quatre Petites Filles.* Paris: Gallimard, 1968.

Piot, Christine. "Décrire Picasso." Doctoral dissertation, Université de Paris I, Panthéon-Sorbonne, 1981.

Poore, Charles. *Goya.* New York: Charles Scribner's Sons, 1938.

Popper, Karl. *Conjectures and Refutations.* New York: Basic Books, 1963.

Porel, Jacques. *Fils de Regane.* Paris: Plon, 1951.

Porzio, Domenico, and Marco Valsecchi. *Understanding Picasso.* New York: Newsweek Books, 1974.

Poulenc, Francis. *Moi et mes amis.* Paris: La Palatine, 1963.

Prabhupada, A. C. B. *Krishna.* Boston: Iskcon Press, 1970.

Prado Museum. *Guernica–Legado Picasso.* Madrid: Ministerio de Cultura, 1981.

Prévert, Jacques. *Paroles.* Paris: Gallimard Folio, 1972.

Queneau, Raymond. *Bâtons, chiffres et lettres.* Paris: Gallimard, 1965.

Quinn, Edward. *Picasso: Photos, 1951–1972.* Woodbury, N.Y.: Barron's Educational Series, 1980.

————. *The Private Picasso.* Boston: Little, Brown & Co., 1987.

Radiguet, Raymond. *Count d'Orgel.* New York: Grove Press, 1953.

Ramié, Georges. *Picasso's Ceramics.* New York: Viking, 1976.

Raphael, Max. *Proudhon, Marx, Picasso: Three Studies in the Sociology of Art.* Edited by John Tagg. Atlantic Highlands, New Jersey: Humanities Press, 1980.

Raynal, Maurice. *Picasso.* Paris: G. Crès et Cie., 1922.

Reese, Lawrence L. Ruiz. "Scientific Analogies in Cubism, 3 Parts." Ph.D. dissertation, University of California, Los Angeles, 1981.

Reverdy, Pierre. *Note éternelle du présent: Ecrits sur l'Art, 1923–1960.* Paris: Flammarion, 1973.

————. *Pablo Picasso.* Paris: Nouvelle Revue Française, 1924.

Rilke, Rainer Maria. *The Selected Poetry of Rainer Maria Rilke.* Edited by Stephen Mitchell. New York: Vintage Books, 1984.

Rolland, Andrée. *Picasso et Royan aux jours de la guerre et de l'occupation.* Royan: Andrée Rolland, 1967.

Roy, Claude. *L'Amour de la peinture: Goya, Picasso et autres peintres.* Paris: Gallimard, 1956.

————. *"Moi je."* Paris: Gallimard, 1978.

————. *Picasso: La guerre et la paix.* Paris: Cercle d'Art, 1954.

Rubin, William. *Dada and Surrealist Art.* New York: Harry N. Abrams, 1968.

————. *Dada, Surrealism and Their Heritage.* New York: Museum of Modern Art, 1968.

Sabartés, Jaime. *Picasso: An Intimate Portrait.* New York: Prentice-Hall, 1948.

————. *Picasso: Documents iconographiques.* Geneva: Pierre Cailler, 1959.

————. *Picasso: Portraits et souvenirs*. Paris: L. Carré, 1946.

Sachs, Maurice. *Au temps du boeuf sur le toit*. Paris: Editions de la Nouvelle Revue Critique, 1939.

————. *La Décade de l'illusion*. Paris: Gallimard, 1950.

Salmon, André. *La Jeune Peinture française*. Paris: Société des Trente, 1912.

————. *Modigliani: A Memoir*. New York: G. P. Putnam's Sons, 1961.

————. *Montparnasse*. Paris: André Bonne, 1950.

————. *Propos d'atelier*. Paris: G. Crès et Cie., 1922.

————. *Souvenirs sans fin*. 3 vols. Paris: Gallimard, 1955–1961.

San Francisco Museum of Art (14 September–17 October 1948). *Picasso–Gris–Miro: The Spanish Masters of Twentieth Century Painting*.

Sanouillet, Michel. *Francis Picabia et 391*. Vol. 2. Paris: Eric Losfeld, 1966.

Sartre, Jean-Paul. *No Exit and Three Other Plays*. New York: Vintage Books, 1955.

————. *What Is Literature?* New York: Philosophical Library, 1949.

Scarpetta, Guy. *L'Impureté*. Paris: Bernard Grasset, 1985.

Schapiro, Meyer. *Modern Art: 19th & 20th Centuries: Selected Papers*. New York: George Braziller, 1979.

Schiff, Gert. *Picasso: The Last Years, 1963–1973*. New York: George Braziller–Grey Art Gallery, 1983.

Schneede, Uwe M. *Surrealism: The Movement and the Masters*. New York: Harry N. Abrams, 1973.

Shapiro, Theda. *Painters and Politics: The European Avant-Garde and Society*. New York: Elsevier, 1976.

Signoret, Simone. *La Nostalgie n'est plus ce qu'elle était*. Paris: Editions du Seuil, 1976.

Silver, Kenneth Eric. "Esprit de Corps: The Great War and French Art, 1914–1925." Ph.D. dissertation, Yale University, 1981.

Sorlier, Charles. *Mémoires d'un homme de couleurs*. Paris: Le Pré aux Clercs, 1985.

Soupault, Philippe. *Ecrits sur la peinture*. Paris: Lachenal & Ritter, 1980.

Spies, Werner. *Les Sculptures de Picasso*. Lausanne: Clairefontaine, 1971.

Stambaugh, Joan. *Nietzsche's Thought of Eternal Return*. Baltimore: Johns Hopkins University Press, 1972.

Steegmuller, Francis. *Apollinaire: Poet among the Painters*. London: Rupert Hart-Davis, 1963.

————. *Cocteau*. Boston: Little, Brown & Co., 1970.

Stein, Gertrude. *The Autobiography of Alice B. Toklas*. New York: Vintage Books, 1961.

————. *Everybody's Autobiography*. New York: Random House, 1937.

————. *Matisse, Picasso and Gertrude Stein with Two Shorter Poems*. Millerton, N.Y.: Something Else Press, 1972.

————. *Picasso*. Boston: Beacon Press, 1959.

Stravinsky, Igor. *Autobiography*. New York: Simon and Schuster, 1936.

————. *Selected Correspondence of Igor Stravinsky*. Edited by Robert Craft. New York: Alfred A. Knopf, 1982.

————, and Robert Craft. *Expositions and Developments*. New York: Doubleday & Co., 1962.

BIBLIOGRAPHY

Subirana Torrent, Rosa Maria. *The Picasso Museum of Barcelona*. León: Editorial Everest, 1975.

Sutton, Denys. *André Derain*. London: Phaidon Press, 1959.

The Tate Gallery, London (27 April–10 July 1983). *The Essential Cubism: Braque, Picasso and Their Friends, 1907–1920*.

——— (6 July–18 September 1960). *Picasso*. London: Arts Council of Great Britain, 1960.

Taurines-Méry, Blanche-Jean. *Des Influences subies par Picasso*. Paris: Triquet-Robert, 1950.

Thirion, André. *Revolutionaries Without Revolution*. London: Cassell, 1976.

Thomas, Denis. *Picasso and His Art*. Northbrook: Book Value International, 1981.

Tierney, Neil. *The Unknown Country: A Life of Igor Stravinsky*. London: Robert Hale, 1977.

Trend, John Brande. *A Picture of Modern Spain: Men & Music*. Boston and New York: Houghton Mifflin Co., 1921.

Tuchman, Barbara W. *The Proud Tower: A Portrait of the World Before the War, 1890–1914*. New York: Macmillan, 1966.

Turkle, Sherry. *Psychoanalytic Politics: Freud's French Revolution*. New York: Basic Books, 1978.

Tzara, Tristan. *Picasso et les chemins de la connaissance*. Geneva: Skira, 1948.

Uhde, Wilhelm. *Picasso and the French Tradition*. New York: Weyhe, 1929.

Vallentin, Antonina. *Pablo Picasso*. Paris: Albin Michel, 1957.

———. *Picasso*. Garden City, N.Y.: Doubleday & Co., 1963.

———. *This I Saw: The Life and Times of Goya*. New York: Random House, 1949.

Van Gogh, Vincent. *Van Gogh: A Self-Portrait*. Edited by W. H. Auden. London: Thames and Hudson, 1961.

de Vauvenargues, Marquis. *Maximes et pensées*. Paris: Editions André Silvaire, 1961.

Verdet, André. *Les Grands Peintres: Pablo Picasso*. Geneva: René Kister, 1956.

Verlaine, Paul. *Pablo Picasso au Musée d'Antibes*. Paris: Falaize, 1951.

———. *The Sky Above the Roof*. London: Rupert Hart-Davis, 1957.

Vian, Boris. *Manuel de Saint Germain des Près*. Paris: Chêne, 1974.

Vitz, Paul C., and Arnold B. Glimcher. *Modern Art and Modern Science: The Parallel Analysis of Vision*. New York: Praeger, 1984.

Vlaminck, Maurice. *Paysages et personnages*. Paris: Flammarion, 1953.

———. *Portraits avant décès*. Paris: Flammarion, 1943.

Vollard, Ambroise. *Souvenirs d'un marchand de tableaux*. Paris: Albin Michel, 1937.

Warnod, Janine. *Washboat Days*. New York: Grossman Publishers, 1972.

Webb, Peter. *The Erotic Arts*. Boston: New York Graphic Society, 1976.

Weill, Berthe. *Pan! dans l'oeil!* Paris: Librairie Lipschutz, 1933.

Wertenbaker, Lael. *The World of Picasso, 1881*. New York: Time-Life Books, 1967.

Whelpton, Barbara. *Painters' Provence*. London: Johnson Publications, 1970.

Whitman, Alden. *Come to Judgment*. New York: Viking, 1980.

William Beadleston Fine Art, New York (31 October–14 December 1985).

Through the Eye of Picasso, 1928–1934: The Dinard Sketchbook and Related Paintings and Sculpture. Essay by John Richardson.

Wiser, William. *The Crazy Years: Paris in the Twenties.* New York: Atheneum, 1983.

ARTICLES

Acoca, Miguel. "Picasso—Super Compadre." *Washington Post*, 24 October 1971.

Alberti, Rafael. "Picasso et le peuple espagnol." *Europe*, nos. 492–93 (April–May 1970).

Allard, Roger. "Picasso." *Le Nouveau Spectateur*, 25 June 1919.

Apollinaire, Guillaume. "Les Jeunes: Picasso, peintre." *La Plume*, no. 372 (15 May 1905).

———. "Lettre inédite d'Apollinaire adressée à Picasso." *Cahiers d'Art*, 22e Année, 1947.

Arnoux, Alexandre, et al. "Picasso 1964, enquête." *Jardin des Arts*, no. 112 (March 1964).

Ashton, Dore. "Sculpture: Pour faire une colombe il faut d'abord lui tordre le cou." *XXème Siècle*, no. 30 (June 1968).

Bauret, Gabriel. "*Les Demoiselles d'Avignon:* Manifeste du cubisme?" *Europe*, nos. 638–39 (June–July 1982).

Beguin, Albert. "L'Androgyne." *Minotaure*, Spring 1938.

Bernal, Pierre. "Alors Jacqueline l'enveloppa dans la grande cape noire." *Paris-Match*, 21 April 1973.

Bernier, Rosamond. "48, Paseo de Gracia." *L'Oeil*, no. 4 (15 April 1955).

Besson, Georges. "Lettre à Pierre Betz." *Le Point*, vol. 7, no. 42 (October 1952).

Blumenkranz-Onimus, Noemi. "Picasso Ecrivain ou la revanche de la couleur." *Europe*, nos. 492–93 (April–May 1970).

Blunt, Anthony. "Picasso in Rome and at Lyons." *Burlington Magazine*, no. 95 (October 1953).

Bouvier-Ajam, Maurice. "Picasso et les jeunes générations." *Europe*, nos. 492–493 (April–May 1970).

Brassaï. "The Master at 90: Picasso's Great Age Seems Only to Stir Up Demons Within." *The New York Times Magazine*, 24 October 1971.

———. "Picasso aura cent ans dans dix ans." *Le Figaro*, 8 October 1971.

Breton, André. "Picasso Poète." *Cahiers d'Art*, nos. 7–10, 1935.

———. "Le Surréalisme et la peinture." *La Révolution Surréaliste*, 15 July 1925.

Breunig, L. C., Jr. "Studies on Picasso, 1902–1905." *Art Journal*, Winter 1958.

Cabanne, Pierre. "Picasso et les joies de la paternité." *L'Oeil*, no. 226 (May 1974).

Cachin, Marcel. "Picasso a apporté son adhésion au Parti de la Renaissance Française." *L'Humanité*, 5 October 1944.

Carter, Huntly. "The Plato-Picasso Idea." *The New Age*, vol. 10, no. 4 (23 November 1911).

Cassou, Jean. "Le Rideau de *Parade* de Picasso au Musée d'Art Moderne." *La Revue des Arts*, January–February 1957.

Chalon, Jean. "Françoise Gilot passe du murmure au cri." *Le Figaro*, 18 May 1963.

Charles, François. "Les Arts." *L'Ermitage*, no. 9 (September 1901).

Chutkow, Paul. "Looking at the Painter's Provence." *The New York Times*, 24 August 1986.

Cocteau, Jean. "Pablo Picasso: A Composite Interview." *The Paris Review*, Summer–Fall 1964.

Cohen, Ronny. "Picasso's Late Work: Swan Song or Apotheosis?" *Artforum*, vol. 22 (March 1984).

"Les Communistes de Vallauris écrivent à Picasso." *Le Patriote de Nice*, 27 June 1965.

Dadaule, Jacques. "Les Colombes." *Europe*, nos. 492–93 (April–May 1970).

Daix, Pierre. "Picasso et la morale." *Les Lettres Françaises*, 17 June 1965.

Dali, Salvador. "Les Pantoufles de Picasso." *Cahiers d'Art*, nos. 7–10, 1935.

Dupont, Pepita. "Quand la vie se fait trop noire." *Paris-Match*, 31 October 1986.

Eluard, Paul. "Je parle de ce qui est bien." *Cahiers d'Art*, nos. 7–10, 1935.

"Entretien sans complexe." *Plexus*, vol. 3 (August–September 1966).

Everling, Germaine. "C'était hier: Dada . . ." *Les Oeuvres Libres*, no. 109 (June 1955).

Fagus, Félicien. "L'Invasion espagnole: Picasso." *La Revue Blanche*, 15 July 1901.

Farrell, Barry. "His Women: The Wonder Is That He Found So Much Time to Paint." *Life*, 27 December 1968.

Fermigier, André. "La Prodigieuse Aventure de Picasso." *Le Nouvel Observateur*, no. 105 (16 November 1966).

Fifield, William. "Pablo Picasso—A Composite Interview." *The Paris Review*, vol. 8, no. 32 (Summer–Fall 1964).

F.K. "Picasso devant la caméra." *Jardin des Arts*, no. 15 (January 1956).

Fournier, Albert. "Ateliers et demeures de Picasso." *Europe*, nos. 492–93 (April–May 1970).

Gagnebin, Murielle. "Erotique de Picasso." *Esprit*, January 1982.

———. "Picasso, iconoclaste." *L'Arc*, no. 82 (1981).

Gaillard, P. "Pourquoi j'ai adhéré au Parti Communiste." *L'Humanité*, 29–30 October 1944.

Gay, Paul. "Lettre à une amie." *Le Point*, vol. 7, no. 42 (October 1952).

George, Waldemar. "Les Cinquante Ans de Picasso et la mort de la nature-morte." *Formes*, April 1931.

———. "L'Exposition Picasso." *L'Amour de L'Art*, vol. 7 (1926).

———. "Fair Play: The Passion of Picasso." *Formes*, April 1930.

———. "Grandeur et décadence de Pablo Picasso." *L'Art Vivant*, no. 135 (August 1930).

———. "Picasso et la crise actuelle de la conscience artistique." *Chronique du Jour*, no. 2 (June 1929).

———. "The Picasso Exhibition." *Formes*, May 1932.

———. "Picasso par Maurice Raynal." *L'Amour de l'Art*, vol. 2 (1921).

Gilot, Françoise. "Henri Matisse at Peace." *Art and Antiques*, October 1986.

———. "Mano a Mano." *Art and Antiques*, October 1985.

Gomez de la Serna, Ramon. "Le Toréador de la peinture." *Cahiers d'Art*, nos. 3–5, 1932.

González, Julio. "Picasso Sculpteur." *Cahiers d'Art*, nos. 6–7, 1936.

Gosling, Nigel. "Picasso: The Greatest?" *Observer Review*, 15 April 1973.

Granville, Pierre. "Marcoussis, poète du cubisme." *La Galerie des Arts*, no. 18 (July–September 1964).

Henderson, Linda D. "A New Facet of Cubism: The 'Fourth Dimension' and Non-Euclidean Geometry Reinterpreted." *The Art Quarterly*, vol. 34 (Winter 1971).

Henry, Hélène. "Max Jacob et Picasso: Jalons chronologiques pour une amitié: 1901–44." *Europe*, nos. 492–93 (April–May 1970).

Jacob, Max. "Souvenirs sur Picasso contés par Max Jacob." *Cahiers d'Art*, no. 6, 1927.

"Jacqueline et Pablo les mariés de l'au-delà." *Paris-Match*, 31 October 1986.

Jahan, Pierre. "Ma Première Rencontre avec Picasso." *Gazette des Beaux Arts*, October 1973.

Johnson, Ron. "The *Demoiselles d'Avignon* and Dionysian Destruction." *Arts Magazine*, vol. 55, no. 2 (October 1980).

———. "Picasso's *Demoiselles d'Avignon* and the Theatre of the Absurd." *Arts Magazine*, vol. 55, no. 2 (October 1980).

Junoy, Josep. "L'Art d'en Picasso." *Vell i Nou*, vol. 3, no. 46 (1 June 1917).

Kahnweiler, Daniel-Henry. "Entretiens avec Picasso." *Quadrum*, November 1956.

———. "Entretiens avec Picasso au sujet des *Femmes d'Alger*." *Aujourd'hui*, no. 4 (September 1955).

———. "Huit Entretiens avec Picasso." *Le Point*, vol. 7, no. 42 (October 1952).

———. "Le Sujet chez Picasso." *Verve*, vol. 7, nos. 25–26 (1951).

Kauffman, Ruth. "Picasso's Crucifixion of 1930." *Burlington Magazine*, vol. 3 (September 1969).

Klady, Leonard. "Return of the Centaur." *Film Comment*, vol. 22, no. 2 (March–April 1986).

Lacroix, Jean-Paul. "Picasso: Ni Barbe-Bleue ni saint de vitrail." *L'Intransigeant*, 24 June 1965.

Lapouge, Gilles. "Les Maisons de Picasso." *L'Arc*, no. 82 (1981).

Lefèvre, Frédéric. "Une heure avec M. Jean Cocteau." *Nouvelles Littératures*, 24 March 1923.

Leiris, Michel. "Faire-part." *Cahiers d'Art*, nos. 4–5, 1937.

Lhote, André. "Chronique des Arts." *La Nouvelle Revue Française*, August 1932.

———. "Picasso." *La Nouvelle Revue Française*, March 1939.

Lieberman, William S. "Picasso and the Ballet, 1917–1945." *Dance Index*, vol. 5, nos. 11–12 (November–December 1946).

Lord, James. "Giacometti and Picasso: Chronicle of a Friendship." *The New Criterion*, June 1983.

Mac Orlan, Pierre. "Rencontre avec Picasso." *Annales Politiques et Littéraires*, 15 July 1929.

BIBLIOGRAPHY

Madaule, Jacques. "Les Colombes." *Europe*, nos. 492–93 (April–May 1970).

Marion, Sylvie. "Pour ses 80 ans Picasso m'a dit." *France-Soir*, 19 October 1961.

Mellow, James R. "Picasso's Working Autobiography." *Art News*, vol. 85 (Summer 1986).

Milhau, Denis. "Picasso, la réalité et le théâtre." *Europe*, nos. 492–93 (April–May 1970).

Misfeldt, Willard E. "The Theme of the Cock in Picasso's Oeuvre." *Art Journal*, vol. 28, no. 2 (Winter 1968–69).

Morice, Charles. "Exposition de MM. Picasso, Launay, Pichot et Girieud." *Mercure de France*, vol. 45, no. 156 (October–December 1902).

Moussinac, Léon. "Tous les Arts." *Les Lettres Françaises*, 25 November 1948.

Murry, John Middleton. "The Art of Pablo Picasso." *The New Age*, vol. 10, no. 5 (30 November 1911).

Newhouse, John. "An Air of Mystery." *New Yorker*, 30 December 1985.

Nietzsche, Friedrich. "I Myself Am Fate." *The London Times Literary Supplement*, 2 March 1973.

Parrot, Louis. "Hommage à Pablo Picasso." *Les Lettres Françaises*, September 1944.

———. "Picasso au Salon." *Les Lettres Françaises*, October 1944.

Peignot, Jérome. "Les Premiers Picassos de Gertrude Stein." *Connaissance des Arts*, no. 213 (November 1969).

Penrose, Roland, and Timothy Hilton. "Miró." *Art Monthly*, no. 68 (July–August 1983).

Perls, Frank. "The Last Time I saw Pablo." *Art News*, vol. 73 (April 1974).

Pernod, Pierre-Arnold. "Le Chef-d'oeuvre inconnu." *Europe*, nos. 492–93 (April–May 1970).

———. "Picasso 1964, enquête." *Jardin des Arts*, no. 112 (March 1964).

Picasso, Pablo. "Lettre sur l'Art." *Formes*, February 1930.

———. "Pourquoi je suis Communiste," *L'Humanité*, 29–30 October 1944.

"Picasso change de modèle." *Radar*, 12 December 1953.

Pierre-Quint, Léon. "Doute et révélation dans l'oeuvre de Picasso." *Documents*, no. 3 (1930).

Pignon, Edouard "Chez Picasso." *Le Point*, vol. 7, no. 42 (October 1952).

Piscopo, Ugo. "Un Taureau est un taureau." *Europe*, nos. 492–93 (April–May 1970).

Prejger, Lionel. "Picasso découpe le feu." *L'Oeil*, no. 82 (October 1961).

"Propos sur l'Art." *Le Monde*, 13 April 1973.

Pudney, John. "Picasso—A Glimpse in Sunlight." *The New Statesman and Nation*, 16 September 1944.

"Quarante Peintres déclarent: Françoise Gilot a trahi Picasso." *Arts*, no. 1003 (28 April 1965).

Radcliff, Carter. "Art: Setting the Stage." *Architectural Digest*, May 1984.

Ramié, Georges. "Céramiques." *Verve*, vol. 7, nos. 25–26 (1951).

———. "The Contents of Picasso's Art." *Verve*, vol. 7, nos. 25–26 (1951).

Raynal, Maurice. "Panorama de l'oeuvre de Picasso." *Le Point*, vol. 7, no. 42 (October 1952).

———. "Picasso." *L'Art d'Aujourd'hui*, no. 1 (Spring–Summer 1924).

Read, Herbert. "Picasso's *Guernica*." *London Bulletin*, no. 6 (October 1938).

"Retouches pour un portrait." *Le Crapouillot*, no. 25 (May–June 1973).

Reverdy, Pierre. "Solidarity of the Genius and the Dwarf." *Art News Annual*, no. 25 (1957).

———. "Un Oeil de lumière et de nuit." *Le Point*, vol. 7, no. 42 (October 1952).

"The Revolutionary Artists." *The Craftsman*, vol. 20, no. 2 (May 1911).

Richardson, John. "The Catch in the Late Picasso." *The New York Review of Books*, 19 July 1964.

———. "Picasso's Secret Love." *House and Garden*, October 1987.

———. "Trompe l'Oeil." *The New York Review of Books*, 3 December 1964.

———. "Understanding the Paintings of Pablo Picasso." *The Age*, 22 December 1962.

———. "Your Show of Shows." *The New York Review of Books*, 17 July 1980.

Sabartés, Jaime. "Couleur de Picasso: Peintures et dessins de Picasso." *Verve*, vol. 5, nos. 19–20 (1948).

———. "La Literatura de Picasso." *Cahiers d'Art*, nos. 7–10, 1935.

Saint-John, Jeffrey. "Judging the Art of Picasso." *Chicago Tribune*, 16 April 1973.

Salmon, André. "Picasso." *L'Esprit Nouveau*, no. 1 (May 1920).

Seckler, Jerome. "Picasso Explains." *New Masses*, 13 March 1945.

"Shafts from Apollo's Bow: A Blast from the North." *Apollo*, October 1947.

Sollers, Philippe. "De la virilité considérée comme un des beaux-arts." *Art Press*, Summer 1981.

Taylor, Brandon, Douglas Cooper, and Gary Tinterow. "The Essential Cubism." *Art Monthly*, June 1983.

"Testimony against Gertrude Stein." *Transition*, no. 23 (February 1935).

Tilman, Pierre. "Le Style c'est une infirmité." *Opus International*, no. 81 (Summer 1981).

Trustman, Deborah. "Ordeal of Picasso's Heirs." *The New York Times Magazine*, 20 April 1980.

Tzara, Tristan. "Picasso et la peinture de circonstance." *Le Point*, vol. 7, no. 42 (October 1952).

Vallier, Dora. "Braque, la peinture et nous." *Cahiers d'Art*, no. 1, 1954.

Wildenstein, Daniel. "Hommages à Picasso: Le peintre qui a eu le plus d'influence sur son siècle." *Gazette des Beaux-Arts*, October 1973.

de Zayas, Marius. "Picasso Speaks." *The Arts*, vol. 3, no. 5 (May 1923).

Zervos, Christian. "Conversation avec Picasso." *Cahiers d'Art*, nos. 7–10, 1935.

———. "Les Dernières Oeuvres de Picasso." *Cahiers d'Art*, no. 6, 1927.

———. "Les Dernières Oeuvres de Picasso." *Cahiers d'Art*, no. 6, 1929.

———. "Picasso à Dinard." *Cahiers D'Art*, no. 1, 1929.

———. "Projets de Picasso pour un monument." *Cahiers d'Art*, nos. 7–10, 1929.

ACKNOWLEDGMENTS

In October 1981, Mort Janklow took me to lunch and asked me if I would be interested in writing a biography of Picasso. David McCulloch, he went on to explain, had just decided not to continue with the Picasso biography he was doing for Simon and Schuster. Since then I have heard many reasons why he made that decision, but it was only after my book was ready to go to press that I called David McCulloch to ask him directly. "We need monsters in our mythic life," he replied, "but I didn't want one in mine. . . . In the end, I didn't want Picasso for my roommate for five years."

I will always be grateful to Mort Janklow for setting me out on what has proved to be a remarkable journey, and to David McCulloch for his decision to move on to Truman, although there were many gruesome moments during the last five years when I did envy him. At those times I was sustained by the devotion to the project of my two principal research assistants, Marcy Rudo and Guillaume Israel.

On New Year's Eve 1987, Guil died at the age of twenty-seven of cardiac arrest in Paris, and as I write this, a month later, part of me still refuses to believe it. Guil had become an important part of this book and therefore of my life. He brought to the research task a determination to overcome all obstacles that stood in the way of getting the material we needed, as well as his talent for unearthing important information we did not even know existed and his infectious sense of humor. To the pain over the loss of a friend and trusted colleague was added the pain of knowing how much promise had just begun to be fulfilled.

Living in Barcelona and speaking Catalan as fluently as she speaks Spanish, Marcy Rudo made the library of the Picasso Museum on the carrer Montcada her second home, and the staff of the museum her friends. Both she and I are very grateful to them for all their help. When she was not in the vaults of the museum, Marcy was traveling around Spain tracking down and interviewing Picasso's relatives, friends, children of friends and friends of friends. Whether in libraries or in conversation, she

ACKNOWLEDGMENTS

discovered important facts and wonderful stories, which were
invaluable in shaping the book. For all this as well as for intro-
ducing me to Picasso's Barcelona and for being the most delight-
ful companion during our interviewing trip in the South of
France, I am deeply grateful to Marcy.

I am also grateful to all those who, in interviews for the book,
gave so generously of their memories and of themselves. They
include: Monique Agard, Eugenio Arias, Kostas Axelos, Brigitte
Baer, Jacques Baron, Jacques Barra, Laurence Bataille, Made-
leine Baudouin, François Bellet, Pierre Berès, Georges Bernier,
Rosamond Bernier, Manuel Blasco, Claude Bleynie, Janot
Bongiovani, Henri Cartier-Bresson, Henri Colpi, Aldo Cromme-
lynck, Pierre Daix, Lydia Delektorskaya, Diane Deriaz, Jean Der-
val, Dominique Desanti, Gaston Diehl, Luis Miguel Dominguín,
Roland Dumas, David Douglas Duncan, Dominique Eluard, Lu-
ciano Emmer, Fenosa, Francesco Fontbona, Pierrette Gargallo,
Joan Gaspar, Miquel Gaspar, Bernard Gheerbrant, Gustau Gili,
Françoise Gilot, Henriette Gomès, Raimon Noguera de Guz-
mán, Jany Holt, Maurice Jardot, Joyce Kootz, Georges Langlois,
Sarah Schultz Lanver, Geneviève Laporte, Paule de Lazerme,
Louise Leiris, Michel Leiris, William Lieberman, Raimon Llort,
Florence Loeb, James Lord, Matta, Joan Merli, Jacques Mour-
lot, André Ostier, Alain Oulman, René Pallarès, Hélène Parme-
lin, Josep Palau i Fabre, Christine Piot, Wladimir and Ida
Pozner, Lionel Prejger, Claude Renoir, Jacint Reventós, Alex
and Carole Rosenberg, Mario Ruspoli, Bernard Bacqué de Sa-
riac, Luc Simon, Gérard Sassier, Inès Sassier, Pilar Solano,
Antonio Tamburro, Maurici Torra-Bailari, Gilbert and Lilette
Valentin, André Verdet, Dina Vierny, Jaime Vilató, André Vil-
lers, and Maya Picasso Widmaier.

This book was researched and written in many cities on two
continents and in each city there were those who worked hard to
help make it a reality. In Paris, I am grateful to Philippe Gué-
guen, Katharine Adamov, and Pascale Breton; in Barcelona, to
Joan Espinach, who became our official expert in Catalan history
as well as Catalan spelling. In Los Angeles, Danielle Israel and
Karen Davidson transcribed mountains of French interview tapes
while Chris Meeks supervised the turbulent transition from my
Mont Blanc fountain pen to my Kaypro computer. Christine

ACKNOWLEDGMENTS

Richards, my personal assistant, supervised us all, and even moved with me to Houston and then to Washington, providing invaluable continuity to my peripatetic existence. In Washington she fell in love and moved back to Los Angeles, but not before arranging to leave the Picasso project and me in the wonderfully capable hands of Amy Davis, who put together, in no time, a new team, including Cleve Clamp, who took charge of our Kaypros, and even managed to coax our laser printer to cooperate with our computer and produce the right-looking French and Spanish accents.

When the time came to move me and the hundreds of Picasso files and books to Houston, Amy Davis came with me and for this as well as for all her work on the book, I thank her from my heart. It was in Houston that the book was completed, and therefore it was in Houston that deadlines that seemed comfortably far away loomed threateningly close, weekends were absorbed into the week and days merged into nights. I cannot thank enough all those who helped me meet each succeeding deadline. Sonja Walsh and Billie Redden stayed up one night until 3:45 A.M. putting my last-minute changes into the computer so that the manuscript could leave for New York early in the morning. I am also thankful to Martha Braddy, Ana Mestre Brown, Charles Gibson, Kenn Kubasik, Maria Murphy, Vickie Rylander and Dolores Vasquez, who rolled up their sleeves and willingly pitched in, no matter how mechanical the task; and to Emily Ballew, Billie Fitzpatrick, Karen Haigler, Shannon Halwes, Karen Kossie, Allison Leach, Lynn Weekes and Cornelia Williams for their help with the final preparation of the source notes.

I am also grateful to Bill Lieberman, Chairman of Twentieth-Century Art at the Metropolitan Museum in New York, for all his guidance, to Peter Marzio, Director of the Museum of Fine Arts in Houston, and his wife, Frances, for all the help they and the staff of the museum provided me with, to Janis Ekdahl at the Library of the Museum of Modern Art in New York and to Jacqueline Koenig, who helped me build my own Picasso library.

Through the last months, my mother kept "Elli's kitchen" going, feeding our Picasso "team" and surprising us each day with new delicacies. My sister Agapi has continued, however many thousands of miles apart we may be, to be a precious source of

541

wisdom and enthusiasm. They have, as always, my love and gratitude.

It is hard to describe what a privilege and a blessing it is to have as an editor a man who is not only a superb editor but a great friend with whom you have developed over the years a foundation of trust which can sustain any amount of editorial back-and-forth. My gratitude to Fred Hills for his masterly guidance and for the countless ways in which he improved the book is matched only by the sheer pleasure it is to work with him. Fred and I had cut our teeth together on *Callas*, so I was a little apprehensive when he introduced me to Burton Beals and turned our cozy editorial duet into a trio. But it took only one lunch before Burton and I were finishing each other's sentences. Over marathon sessions on the telephone or at various conference rooms at Simon and Schuster, Burton's perfectionism and his willingness to spend hours puzzling over a difficult paragraph or even sentence both inspired me and fed my compulsiveness. By the end, I knew that I had gained not only a new editor but a new friend.

It was a great pleasure to work again, after many years, with Alex McCormick, my editor at Weidenfeld and Nicolson in London. This time her editorial advice was offered through the mail, the telephone and the fax machine rather than in person, but it was no less valuable and important. Many thanks also go to Angela Dyer, whose helpful suggestions were incorporated into the final draft, and to Leslie Ellen, Lynn Chalmers, Eileen Caughlin and Kim Ruhe for their copyediting and proofreading. I am grateful to Jenny Cox, Fred Hill's talented editorial assistant, for all the many ways in which she helped this book see the light of day and to Vincent Virga for producing a picture section that gives powerful expression to the themes that are at the heart of the book, as well as for all the creative suggestions he made after reading the manuscript. My deep thanks also go to Marcella Berger, Marie Florio, Helen Niemirow and Karen Weitzman at the subsidiary rights department of Simon and Schuster, who presented the final manuscript so convincingly to the world; to Frank Metz and Fred Marcellino for turning the design of the cover into a labor of love; to Eve Metz for her imaginative design of the book itself; to Julia Knickerbocker and Ellen Archer for taking the sting out of book promotion; to David Wolper for buying the

ACKNOWLEDGMENTS

television rights to the book on the strength of one conversation and before he had seen a single page; and to Dick Snyder for his unfailing enthusiasm, guidance and support. I also wish to express my thanks to Peter Matson in New York and to Michael Sissons in London for their help and encouragement, and to Pat Kavanagh, Jane Brewster, Mitchell Lee Brozinsky and Rick Edelstein.

The first draft of the book was read by Mort Zuckerman, and I am grateful to him for all his advice as well as for the many ways in which, over the years of working on this book, my thinking was crystallized through our conversations. The penultimate draft was read by James Lord. I am deeply thankful to him not only for his suggestions and his generosity but for his own work on Giacometti and for our conversation in Paris soon after I began working on this book—treasuries both of information and of understanding to which I often returned.

No amount of gratitude can ever adequately honor the immense debt I owe Bernard Levin. He read every chapter of the first draft and then discussed with me every succeeding draft; he bolstered my courage; he was always there when I needed to discuss an idea or a sentence; he argued, he agreed, he encouraged, and he brought to the task his passion for ideas and for the English language.

The book is dedicated to my husband. Over the last two years, Michael has shared both my life and my work. He spent endless nights working at one desk while I was writing at another, filling the isolation that any writing labor requires with a loving intimacy that nurtured and strengthened me. He listened to freshly written pages, read and reread the manuscript and, like a seasoned marathon runner, helped me push through "the wall" whenever it seemed an ordeal to face another blank page or another page filled with Fred's comments in blue and Burton's in green! And fervently though he looked forward to life without Picasso, he never stopped urging me to review, revise and retouch until the last moment—and a little beyond.

PICTURE CREDITS

3. Picasso Museum, Paris
4. Pablo Picasso, *Conchita's Face*, 1894, drawing from a sketchbook, Picasso Museum, Barcelona/ARS.
5. Manuel Blasco
6. Manuel Blasco
7. Lee Miller Archives
8. Pablo Picasso, *Jaume Sabartés Seated*, 1900, charcoal and watercolor on paper, Picasso Museum, Barcelona, Sabartés Donation, 1960/ARS.
9. Pablo Picasso, *Picasso Bewildered*, 1898, Conté pencil on paper, Heirs of the Artist/ARS.
10. Lee Miller Archives
12. Pablo Picasso, *Pedro Mañach (Pere Manyac)*, 1901, oil on canvas, National Gallery of Art, Washington, Chester Dale Collection, 1962/ARS.
14. Picasso Museum, Paris
15. Pablo Picasso, *The Lovers*, August 1904, pen and ink, India ink, lead pencil and watercolor on paper, Picasso Museum, Paris/ARS.
16. Picasso Museum, Paris
17. Pablo Picasso, *The Watering Place (Arcady)*, 1906, gouache on pulp board, The Metropolitan Museum of Art, New York, Bequest of Scofield Thayer, 1982/ARS.
18. Pablo Picasso, *Nude with Clasped Hands*, 1905–06, gouache on canvas, Art Gallery of Ontario, Toronto, Gift of Sam and Ayala Zacks, 1970/ARS.
19. Pictorial Parade
20. Pablo Picasso, *Les Demoiselles d'Avignon*, 1907, oil on canvas, The Museum of Modern Art, New York, Acquired through the Lillie P. Bliss Bequest/ARS.
22. Bettmann Archive
23. Picasso Museum, Paris
24. Lee Miller Archives
25. Picasso Museum, Paris
26. G. D. Hackett
27. G. D. Hackett
28. Bettmann Archive
29. Lee Miller Archives
30. G. D. Hackett
31. Picasso Museum, Paris
32. © Juliet Man Ray, 1986/Lee Miller Archives
33. Lee Miller Archives
34. Pictorial Parade
35. Lee Miller Archives
36. Pablo Picasso, *Nude on a Black Couch*, 9 March 1932, oil on canvas, Private Collection/ARS.

37. Luc Joubet © ARS N.Y./SPADEM, 1988
38. Pablo Picasso, *The Minotaur Carries Off a Woman*, 1937, India ink and matte ripolin on cardboard/ARS.
39. Lee Miller Archives
40. Man Ray © ARS N.Y./SPADEM, 1988
41. Pablo Picasso, *Weeping Woman*, 26 October 1937, oil on canvas, Private Collection/Lee Miller Archives/ARS.
42. Lee Miller Archives
43. Françoise Gilot
44. Françoise Gilot
45. The Louvre, Paris
46. Françoise Gilot, *Portrait of Pablo Picasso*, 1945, tempera on Arches paper, collection of Claude Picasso.
47. Inès Sassier
48. Lee Miller Archives
49. Wide World Photos
50. Wide World Photos
51. Pablo Picasso, *Woman Seated (Françoise Gilot in a Polish Coat)*, 1 November 1948, oil on canvas, Collection of Mr. and Mrs. Samuel Goldwyn, Jr./ARS.
52. Rapho/Photo Researchers
53. Paule de Lazerme
54. Paule de Lazerme
55. Françoise Gilot
56. Gjon Mili, *Life Magazine* © Time Inc.
57. Françoise Gilot
58. Françoise Gilot
59. Brian Brake/Photo Researchers
60. Pictorial Parade
61. Pablo Picasso, pencil drawing colored with crayon, from a spiral sketchbook, Number 165, page 36, 2 August 1962. Reproduced from *Je Suis le Cahier: The Sketchbooks of Picasso*. Published by The Atlantic Monthly Press/Pace Gallery © 1986 The Pace Gallery
62. Pictorial Parade
63. UPI
64. Inge Morath/Magnum
65. Wide World Photos
66. Pablo Picasso, *The Peeing Woman*, 16 April 1965, Musée National d'Art Moderne, Centre Georges Pompidou, Paris/ARS.
67. Pictorial Parade
68. Doisieau–Rapho/Photo Researchers
69. Horst Tappe/Pictorial Parade
70. Pablo Picasso, *Self-Portrait*, 30 June 1972, crayon and colored crayons, Tokyo, Fuji Television Co. Gallery, Ltd./ARS.

INDEX

545

INDEX

Dumas, Roland, 458, 460, 461, 463
Duncan, David Douglas, 221
Duncan, Raymond, 83
Dupré, Marcelle, *see* Braque, Marcelle Dupré
Durand-Ruel, Paul, 66
Durio, Paco, 62, 73, 75, 241
Duthuit, Marguerite, 403

Eden Concert, 34–35
Effort Moderne, L', 173
Ehrenburg, Ilya, 347, 418
Einstein, Carl, 190–91
Elft (Picasso's dog), 216, 236
Eluard, Cécile, 225
Eluard, Dominique Laure, 367, 377, 382; Picasso and, 367, 368, 401, 402
Eluard, Nusch, 216, 223, 225, 229, 234, 242; death of, 323–24; Picasso's affair with, 216–17, 234–35, 368
Eluard, Paul, 211, 222, 223, 225, 239, 242, 284, 290, 324, 330, 361, 366, 368, 377; Communist Party and, 258–59, 287, 342, 348, 382; death of, 382–83; Maar's breakdown and, 300; on Picasso, 217, 218, 261; third marriage of, 367; Spanish Civil War and, 231–32; World War II and, 249
Ernst, Max, 185
Errazuriz, Madame, 145, 158, 168
Esmeralda (Picasso's goat), 417–18, 420
Everling, Germaine, 168
Excelsior, 219

Fadeyev, Alexander, 343
Fagus, Félicien, 57
Falconer, The (Rembrandt), 467
Fall of Icarus, The (The Forces of Life and of Spirit Triumphing over Evil) (Picasso), 423, 424, 432
Family of Saltimbanques (Picasso), 79, 130
Female Nude with Bonnet (Picasso), 82
Fenosa, Appelles, 260, 326
Ferat, Serge, 133
Fermigier, André, 164
Fête de Madame, La (Degas), 464
Féval, Paul, 136
Figaro, Le, 219, 456, 463
Firebird (Stravinsky), 140, 149
Fireworks (Stravinsky), 149
Firouz, Prince, 169, 170
First Communion, The (Picasso), 35
Fitzgerald, F. Scott, 165
Fitzgerald, Zelda, 165
Fizdale, Robert, 167, 336–37
Flight into Egypt (Picasso), 38
Fontdevila, Josep, 88

Fort, Louis, 203
Fort, Paul, 74
Fougeron, André, 389
Four Little Girls, The (Picasso), 359, 360
France-Soir, 437
Franco, Francisco, 222, 230, 231, 232, 241, 242, 245
French Communist Party, 258, 289, 418
French Resistance, 249, 258, 267, 273, 284, 285
Freud, Sigmund, 176, 191
Friesz, Othon, 77
Frugal Repast, The (Picasso), 405

Gallimard, 359
Galloise, La, 335, 410, 412
Garaudy, Roger, 416
García Lorca, Federico, 164, 218–19, 222
Gargallo, Antoinette, 52
Gargallo, Germaine, *see* Pichot, Germaine Gargallo
Gargallo, Pablo, 73, 75, 207, 246, 360
Gargallo, Pierrette, 360
Gasman, Lydia, 193, 256
Gauguin, Paul, 56, 62, 69, 130
Gedo, Mary Mathews, 254, 261, 387
George, Waldemar, 201, 202
Giacometti, Alberto, 334, 343, 374–75, 390, 446
Gide, André, 151, 152
Gillot, Claude, 328
Gilot, Ann Paloma, *see* Picasso, Ann Paloma
Gilot, Claude Pierre Paul, *see* Picasso, Claude Pierre Paul
Gilot, Emile, 267, 274, 370–71, 433
Gilot, Françoise, 12, 14, 266–68, 274, 277–78, 286, 302–3, 326, 327, 425; and Aliquot's relationship with, 268–269, 278, 307–11, 372; art of, 268, 269, 270, 271–72, 273, 278, 302–3, 336, 346, 356–57, 360–61, 366, 372, 377–78; Axelos' relationship with, 14, 390, 391, 393, 395; ballet designed by, 385, 390–91; Boudin and, 315, 344, 347, 361; Brassaï and, 275–76; on bullfighting, 380–81; and children's rights, 14, 406–7, 411–412, 432–33, 434, 461–62, 471; daughters born to, 347, 417; first meeting Picasso, 266, 269–70; grandmother of, 274, 334–35, 357–58, 369, 370; health of, 353, 354–55; Jacqueline Picasso and, 435–36; Kahnweiler and, 360, 366, 377, 412; leaving Picasso, 391–94, 400; *Life*

548

INDEX